A Private Eye:
Dada, Surrealism, and More
from the Brandt Collection

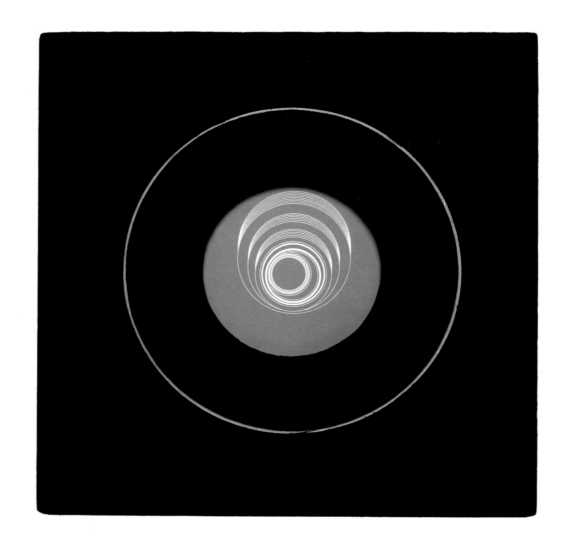

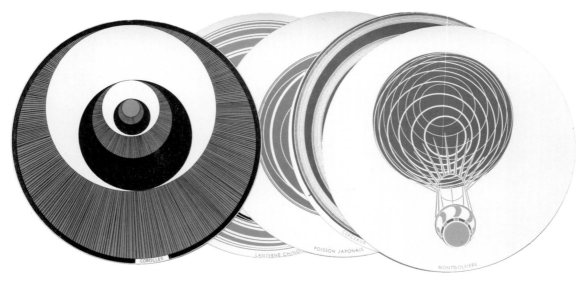

A PRIVATE EYE: DADA, SURREALISM, AND MORE FROM THE BRANDT COLLECTION

Herbert F. Johnson Museum of Art • Cornell University

This catalogue accompanies an exhibition organized by the Herbert F. Johnson Museum of Art at Cornell University, curated by Andrea Inselmann, and presented at:

Herbert F. Johnson Museum of Art
Cornell University
Ithaca, New York
October 21–December 24, 2006

COVER, BACK COVER, AND FRONTISPIECE:
Marcel Duchamp, *Rotoreliefs (Optical Disks)*, 1965 (see p. 36).

INSIDE FRONT AND BACK COVERS:
Guillaume Apollinaire, *Une page de nombreux dessins originaux à l'encre (Page of Various Original Drawings in Ink)* (see p. 17).

Photographs by Julie Magura, Johnson Museum of Art
Designed and edited by Andrea Potochniak, Johnson Museum of Art

Photo of Marcel Duchamp (p. 12) by Ugo Mulas, copyright © Ugo Mulas Estate. All rights reserved.

Francis Picabia, *Intervention d'une femme au moyen d'une machine (Intervention of a Woman by Means of a Machine)*, 1915 (p. 111), courtesy of Dr. Arthur Brandt.

© 2006 Herbert F. Johnson Museum of Art, Cornell University. All rights reserved.

Library of Congress Control Number: 2006935452
ISBN-13: 978-0-9646042-3-0
ISBN-10: 0-9646042-3-X

Published by:
Herbert F. Johnson Museum of Art
Cornell University
Ithaca, New York 14853
www.museum.cornell.edu

Contents

Foreword

Some collectors add perhaps one object every year or two to their holdings; others are always at work, accumulating bottomless treasure troves of art. Dr. Arthur Brandt is one of the latter: his boundless energy, his extraordinary love of the art of his chosen period, and his profound knowledge of both the works and the artists themselves are, in themselves, a precious phenomenon that we must greatly admire.

Like any born collector, he lives in the midst of his works—they are the physical extension of his inner life—and it is difficult for him to be separated from them for any length of time. We are, therefore, doubly grateful to him for these loans, and for his scholarly assistance in preparing the catalogue.

It is a privilege also for us to publish Francis Naumann's essay in this catalogue; his knowledge of Dada and Surrealism as a whole, and of this collection and this collector in particular, is unsurpassed, and this familiarity and commitment come out beautifully in his essay.

We are also grateful to Andrea Inselmann, curator of modern and contemporary art at the Johnson. In her half-dozen years here, Andrea has transformed the presence and relevance of the art of our time at this Museum and throughout Cornell and beyond; her deep commitment to living art—and living artists—has made a real impact on this institution. This exhibition and catalogue are one more example of her belief in the power of art to transform our inner life.

Frank Robinson
The Richard J. Schwartz Director

Acknowledgments

The Herbert F. Johnson Museum of Art at Cornell University has been fortunate over the years to present many exhibitions drawn from outstanding private collections assembled by Cornell alumni. *Surrealist Drawings from the Drukier Collection*, curated by Nancy Green, senior curator of prints, drawings, and photographs, and on view at the Museum in 2003, included over 150 works and was closest in scope to the current exhibition selected from Dr. Arthur Brandt's collection.

The Johnson Museum's contemporary exhibition and acquisition program often includes artists whose work descends from the early breakthroughs in the last century by the Dada and Surrealist artists. It is therefore with great pleasure that the Museum is presenting *A Private Eye: Dada, Surrealism, and More from the Brandt Collection,* which features many representative works of the period, particularly by Man Ray, Marcel Duchamp, Francis Picabia, Yves Tanguy, Hannah Höch, George Grosz, and the German Dada artist Kurt Schwitters. Arthur

Brandt's collection of collages by Schwitters is probably the largest in private hands in this country.

I should note that because of the Dada practice of producing various editions of works, sometimes over a period of decades, a strict chronological sequence here is virtually impossible. I have tried to illustrate works together within each artist's section that seem to speak to each other across different media.

Projects of this scope require the hard work and dedication of many people. I would like to take this opportunity to express my gratitude, first and foremost, to Dr. Arthur Brandt, whose enthusiasm and passion for these materials is infectious. We had to organize many trips to New York and elsewhere to keep up with his collecting, which most recently included two fabulous pieces by Marcel Duchamp, a 1965 edition of *Rotoreliefs* and a 1958 edition of *Boîte-en-valise*. The "museum valise," of course, includes reproductions of some of Duchamp's

most important pieces, such as diminutive versions of three Readymades, *Air de Paris*, *Traveler's Folding Item*, and *Fountain*. Arthur's apartment is filled with treasures from floor to ceiling, with many works stored in bins and closets. The works included in the exhibition constitute only a portion of his collection. My sincerest thanks also go to Laila Robins, Arthur's long-time assistant. The exhibition could not have come together without her tremendous help in locating works and their records. I would also like to thank Francis Naumann for his wonderful tribute to Arthur Brandt, the collector. We are honored to be able to include his essay in this catalogue, as he is one of the most respected scholars in the field of Dada and Surrealism, especially for his work on Marcel Duchamp and the early career of Man Ray. His lecture in conjunction with the exhibition will be of real benefit to the Cornell community.

Here at the Museum, I would like to express my thanks to Liz Emrich, exhibitions assistant, who helped with every aspect of this project from the very beginning. The Museum registrar, Matt Conway, kept his usual cool in accommodating numerous shipping requests as works continued to be added to the show. Thanks also to the Museum photographer, Julie Magura, who photographed all the pieces for publication in the catalogue and exhibited great patience with reproduction requests trickling in over the past few months. My intern, Alexander Mark Thimons (Cornell Class of '07), made countless trips to the Fine Arts Library, assisting me with research and the compilation of the bibliography. I should also thank assistant curator Andy Weislogel for his help with translations from the French. Andrea Potochniak, the Museum's publications coordinator extraordinaire, deserves a special thank-you. Her generous offer to design the catalogue made its publication possible in time for the opening of the exhibition. Our collaboration on the catalogue turned it into a wonderful and extremely helpful documentation of the Brandt collection. My thanks are also due to our preparators, Wil Millard, George Cannon, and David Ryan, who made the installation of the exhibition a truly collaborative effort. Last but not least, I would like to thank our director, Frank Robinson, for nurturing the Museum's relationship with Dr. Brandt for many years and for making it possible for me to work with these amazing works of art.

Andrea Inselmann
Curator of Modern and Contemporary Art

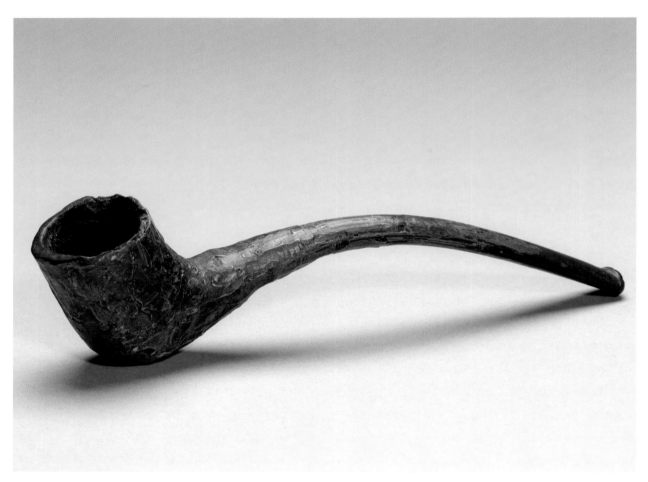

fig. 1

Pipe Dreams
A Chess Player's Guide to Art Collecting

In the early 1950s—when Arthur Brandt was still a teenager, and long before he gave a thought to collecting works of art—he encountered a formidable force in the world of contemporary art, though, at the time, he didn't realize it. Brandt, a budding mathematician preparing to enter medical school, was also an avid chess player, and frequented various clubs devoted to the game in New York City. One afternoon, while walking through Washington Square Park, he stopped by the park's southwest corner to watch people at cement tables playing chess, an activity that continues at the same place to this very day. The strength of the players varies, from amateurs and wood-pushers to ranked professionals. There are also a fair number of chess hustlers, players who openly challenge passers-by and kibitzers (those watching and commenting upon games in progress) to play, with the intent of enticing them into wagering.

Brandt observed among the crowd a thin, elderly gentleman, whom he recognized from visits to the Marshall Chess Club on West 10th Street. They began talking and eventually decided to play a game themselves. During the course of the match, both players took out pipes and started smoking: Brandt had a Dutch meerschaum pipe with a long, curved stem and large bowl, an unusual accoutrement for a teenager, while the older man smoked a worn pipe that appeared to be—curiously—hand painted (fig. 1). As the game progressed, Brandt, seeing his position improving, mentioned to his opponent that he admired his pipe, and proposed that they wager their respective pipes on the outcome of the game. The man accepted, claiming that he also admired his opponent's pipe, and wouldn't mind winning it. Brandt's position continued to improve, however, so he eventually won the game and the pipe. The gentleman handed over his possession with a smile, saying that they should play again. Indeed, they often did, meeting over cups of coffee at the Café Greco, still a fixture on MacDougal Street in the heart of Greenwich Village. After their first game, however, Brandt recalls having lost more often than he won, so eventually the man walked away with his pipe, too.

Whereas the gentleman had freely offered his name, it meant little to the young premed student at the time. Only years later would it come to mean a great deal to realize that he had played chess—and won the pipe of—no one less

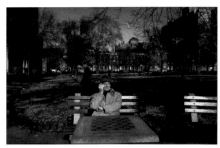

fig. 2 *Marcel Duchamp, New York, 1965*

than the famous artist and chess player, Marcel Duchamp (fig. 2).

Some twenty-five years would pass before Arthur Brandt began collecting, but this experience with Duchamp must have engrained itself in his psyche, for it lies at the core of an aesthetic nurtured and refined over time, as he went on to acquire works of art. An impressive selection of works by Duchamp now form part of the Brandt collection (see pages 32-43), many acquired fairly recently. The *Boîte-en-valise*, for example, contains miniature reproductions of Duchamp's most important works, often described as a portable museum in a suitcase (page 39). A majority of works in the Brandt collection are small in scale, and, because there are so many of them and not enough wall space in his home, a good number lie about in their frames resting against walls or pieces of furniture. Visitors are free to pick these works up off the floor and examine them, in the same fashion that a person examines the individual reproductions in a Duchamp valise. The effect is impressive, for viewers gain an intimacy with the objects and a sense of discovery that would not otherwise be possible.

Such experiences are bound to occur with many works in the collection by Kurt Schwitters, the German Dada artist who magically transformed street detritus into the visual equivalent of poetry. In some cases, the materials in his collages are organized into cohesive geometric compositions (page 131), while others retain the random quality of the object as originally found (page 134). Some of these works were clearly intended to be playful: one collage displays the image of a winged cupid, his index finger extended as if making a rhetorical point, while the word "Announcements," clipped from a newspaper, appears, appropriately, at his side (page 137). Another is intended as an homage to Herbert Read, the renowned British art historian, whose head is positioned awkwardly on a recamier, next to a little girl who cuddles up to a reclining woman bearing a mustachioed male head (page 136).

The humor that these works elicit is common to many works in the collection, especially those by the American painter, photographer, and object-maker Man Ray, the only artist in the collection represented by more works than Schwitters. The Man Rays range from a modest Impressionist-style rendering of boats in a harbor at sunset (page 78)—made in 1910 when the artist was only twenty years old and still signed his work "ER" [Emmanuel Radnitzky]—to works from the 1960s and 1970s, made in the last decades of the artist's life. The collection contains watercolors and drawings from the New York and Ridgefield years (pages 79, 80, and 81); photographs from the Surrealist period

in Paris (page 83); a watercolor study made during the years when Man Ray lived in Hollywood; and an assortment of objects made in Paris in the last years of the artist's life, from a unique example of his famous iron (page 100) to *Torso*, a large metal object conceived in 1946 but realized in a subsequent edition (page 94). Some of these works are little more than a simple combination of objects with poetic titles, such as *La Boîte à Pandore* [Pandora's Box], made from a glass vial extracted from a carpenter's level (page 96), and *Optic Topic*, a metal mask encased in a black wood box (page 97). These editions were made in the years when Man Ray enjoyed his first widespread public recognition (about the time when Arthur Brandt met the artist in Paris, through the introduction of the French art dealer Marcel Fleiss).

Dr. Brandt has always maintained that he purchased whatever he liked and could afford, much of it coming from artists he knew and whose work he admired (his first major acquisitions were of paintings by Robert Goodnough, a former neighbor and friend). Over time, he was drawn increasingly to Dada and Surrealist works. Among the most important of these works is a large watercolor drawing by Francis Picabia (page 111), and a comparably sized painting by Kurt Seligmann (page 141). The Picabia, made in 1915, is a rare mechanical work made during the artist's second sojourn to New York. Although the image is abstract, its subject is revealed in its somewhat cryptic title: *Intervention d'une femme au moyen d'une machine* [Intervention of a Woman by Means of a Machine]. Since the artist inscribed these words prominently in the lower-right corner of the composition, it would appear that he wanted viewers to find this subject within the image, although anyone not intimately familiar with his work would experience difficulty in doing so. The Seligmann painting dates from 1933, when the artist was living in Paris and participating actively in the Surrealist movement. His *Buste d'homme* is characteristic of his painting from this period, in that he fuses the magic realism of Miró with the floating, unarticulated geometric shapes employed by painters of the French Abstraction-Creation group of the 1930s. In 1938, just before war broke out in Europe, Seligmann moved to the United States, where over the course of the next two decades, he perfected a style in which macabre, anthropomorphic figures clad in armor are either dancing or engaged in mythical combat, several examples of which are preserved in the Brandt collection (see page 140).

To single out only these works would be to miss the essence of this eclectic and multifaceted collection. One should take special note of the drawings and other works on paper by the great German artist of erotica, Hans Bellmer

(pages 19-23); four exceptional black-and-white Ernst-like collages by the little-known but highly talented German art historian, critic, and photographer Franz Roh (pages 116-119); a tiny but magnificent painting by Pierre Roy of an ordinary house broom leaning against the balustrade of a staircase in the hallway of a French apartment building with a storm inexplicably brooding overhead (page 121); an impressive group of watercolor, gouache, ink, and pencil drawings by the American Surrealist Leon Kelly (pages 64-67); a small but masterful painting (page 144), five drawings (see pages 143, 145, and 146), and a gouache by Yves Tanguy (page 147); and a deftly rendered pencil drawing of an egg shrouded in drapery by Tanguy's wife, the American painter Kay Sage (page 122).

As it turns out, the chess game that Dr. Brandt played with Marcel Duchamp over fifty years ago was an auspicious event, not necessarily because he won, but because the experience continues to affect—however unconsciously—the way he goes about collecting works of art. The same intellect that won a pipe—which, to this day, is one of Dr. Brandt's prized possessions—plays a crucial role in each acquisition, and, just as the chess game involved a degree of calculated risk, works are added to the collection with the reasonable assurance that they will match the quality and historical context of other works already acquired. This is an ongoing game that we can be fairly certain Dr. Brandt will not lose.

Francis M. Naumann

Catalogue
of the
Exhibition

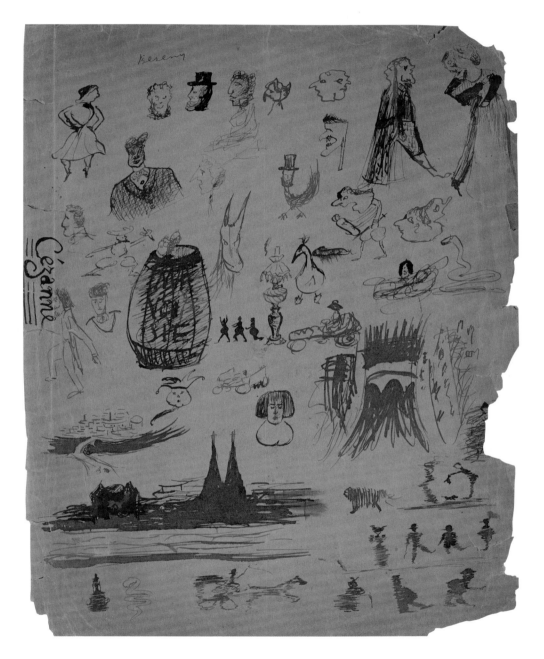

Une page de nombreux dessins originaux à l'encre
(Page of Various Original Drawings in Ink)
Ink
12 x 9 1/4 in.

Herbert Bayer
Austrian, 1900–1985

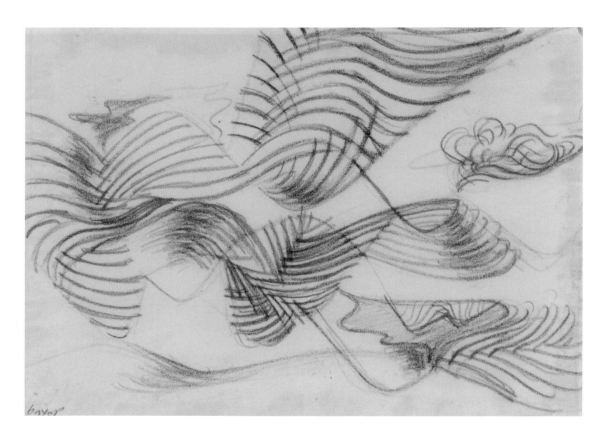

Convolution in the Sky, 1948
Crayon on paper adhered to card
5 1/2 x 7 1/2 in.

Hans Bellmer
German, 1902–1975

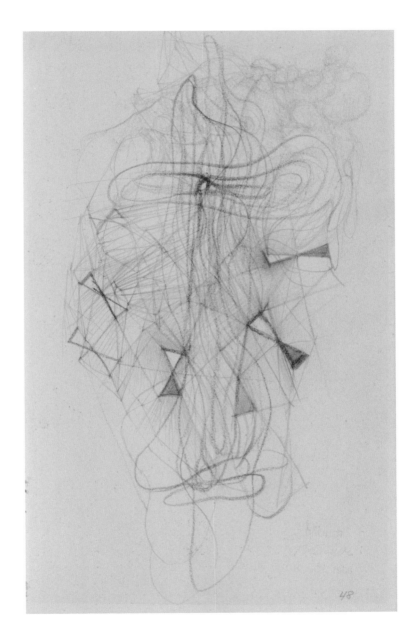

Untitled, 1948
Pencil and crayon
7 1/2 x 4 1/2 in.

Hans Bellmer
German, 1902–1975

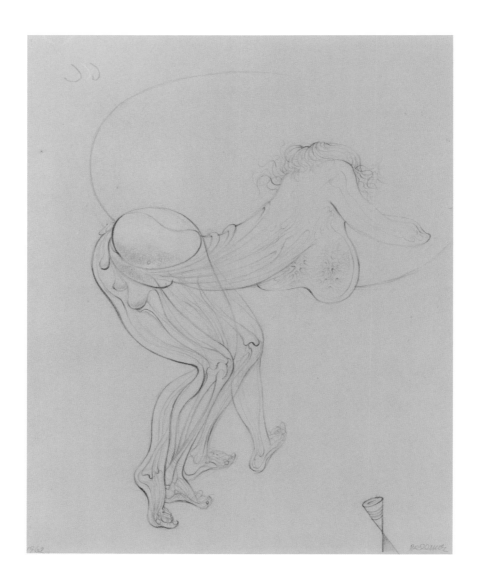

Fille-Phallus (Girl-Phallus), 1962
Pencil
4 1/2 x 3 1/2 in.

Hans Bellmer
German, 1902–1975

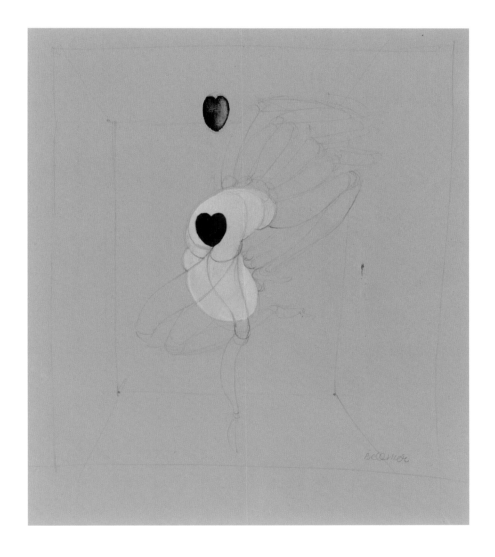

Poupée au coeur noir (Doll with Black Heart), ca. 1960
Pencil, ink, and collage
9 3/4 x 8 1/8 in.

Hans Bellmer

German, 1902–1975

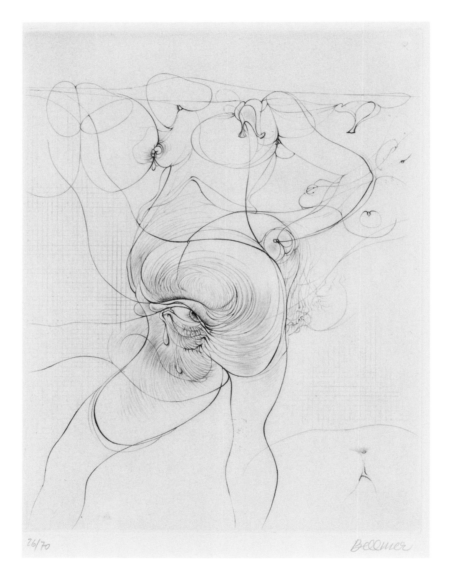

26/70 Bellmer

Untitled
Drypoint and etching, ed. 26/70
12 x 9 1/4 in.

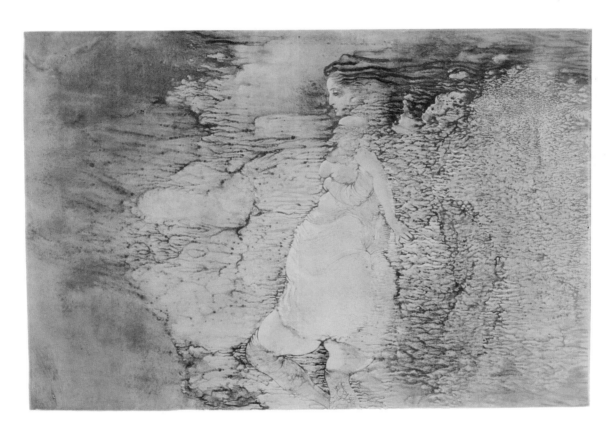

Woman and Child
Lithograph, ed. 156/200
14 x 19 in.

Victor Brauner
Romanian, 1903–1966

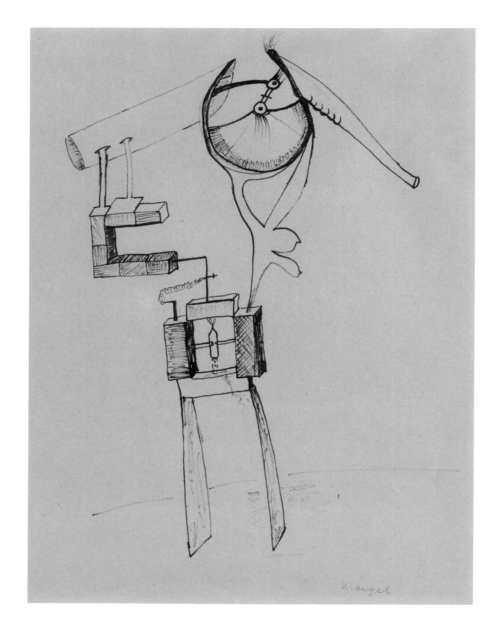

Personnage mécanique (Mechanical Character),
ca. 1935–1940
India ink
10 1/2 x 8 3/4 in.

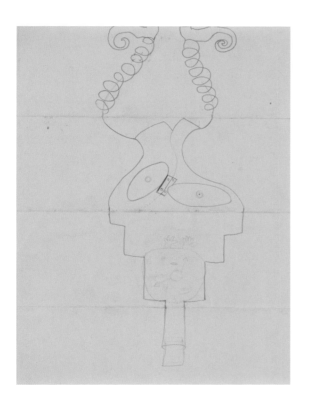

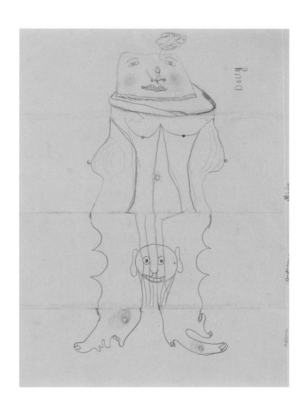

A collaboration by four artists:
Andrien, Bellmer, Dolly, and Thérèse
Pencil
12 1/2 x 9 1/2 in.

Salvador Dalí
Spanish, 1904–1989

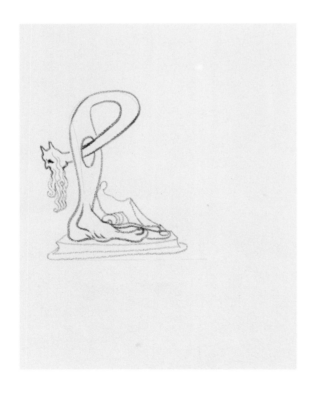

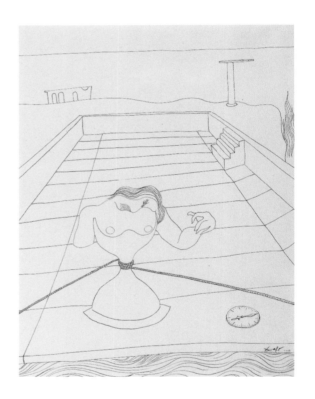

P (detail), ca. 1974
Pencil and crayon
26 1/4 x 20 3/4 in.

*Vierge enchaînée et horloge
(Chained Virgin and Clock)*, 1950
Ink
14 x 11 in.

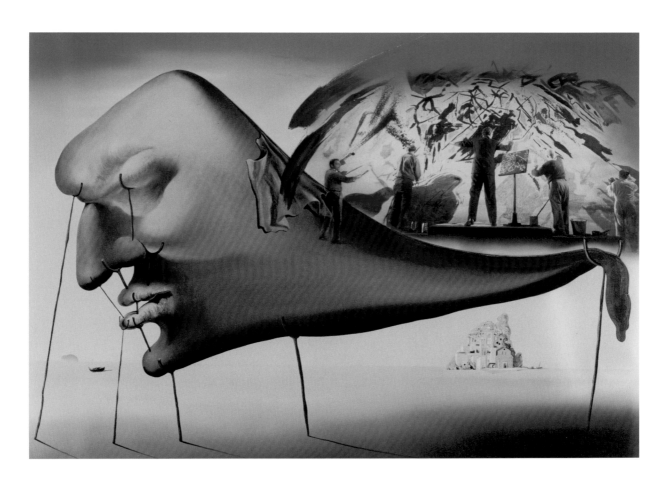

Le sommeil (Sleep), ca. 1955
Gouache and collage
12 x 15 1/2 in.

Sonia Delaunay
Ukrainian, 1885–1979

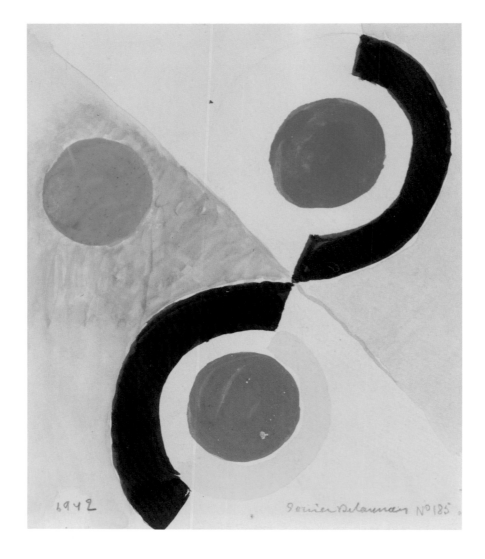

Rythme coloré esquisse (Colored Rhythm Sketch), 1942
Gouache
5 3/4 x 4 7/8 in.

Paul Delvaux
French, 1897–1994

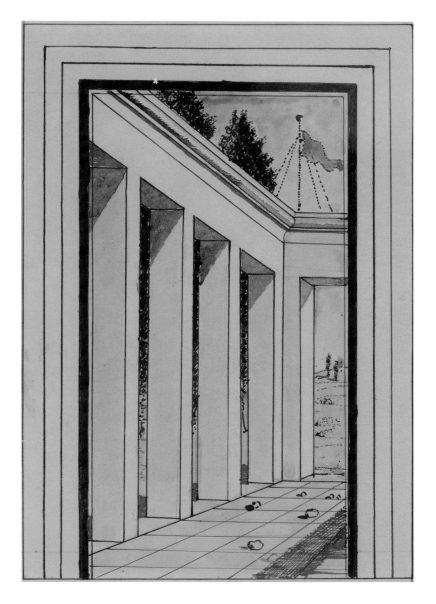

Pillars and Flag
Ink and watercolor
9 1/2 x 7 in.

Burgoyne Diller
American, 1906-1965

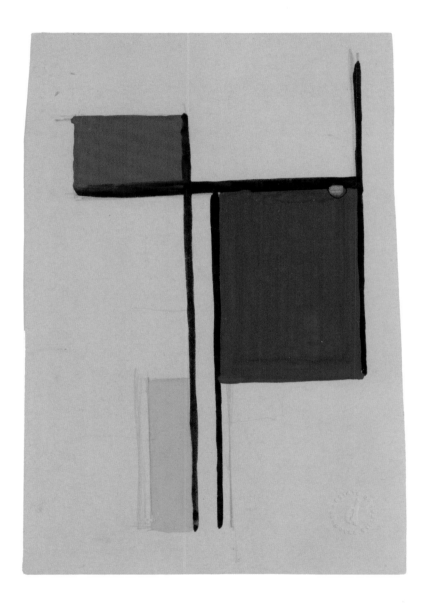

Study for Constructions, ca. 1934–1936
Pencil, ink, and watercolor
5 7/8 x 3 3/4 in.

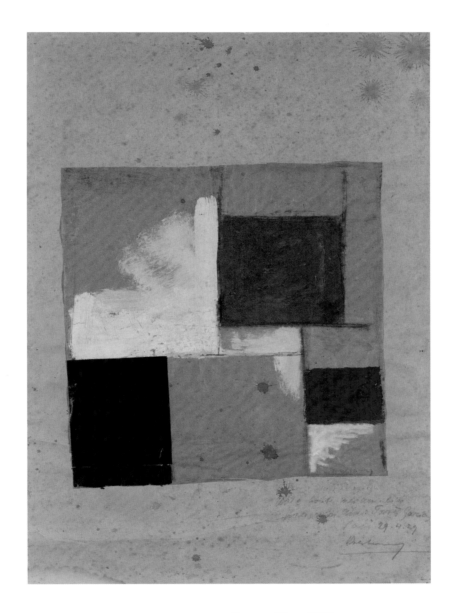

Composition, 1922
Gouache and collage
19 1/2 x 13 1/2 in.

Marcel Duchamp
French, 1887–1968

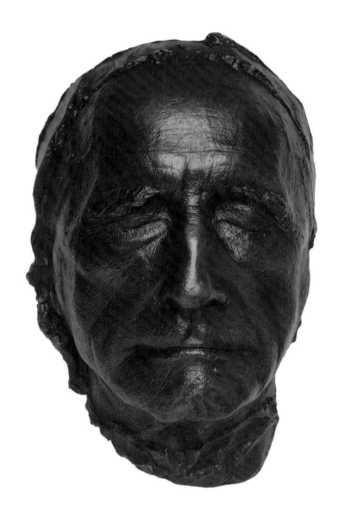

Life Mask, before 1952
Bronze, multiple
10 3/8 x 6 1/4 x 5 1/4 in.

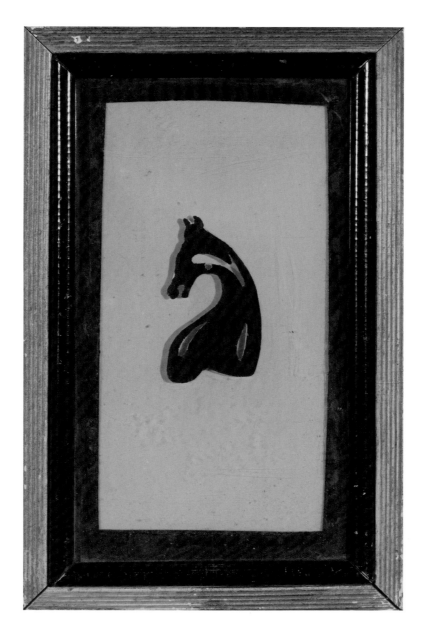

Chess Knight, 1943
Collage mounted between two pieces of glass
8 x 5 x 1/2 in.

Marcel Duchamp
French, 1887-1968

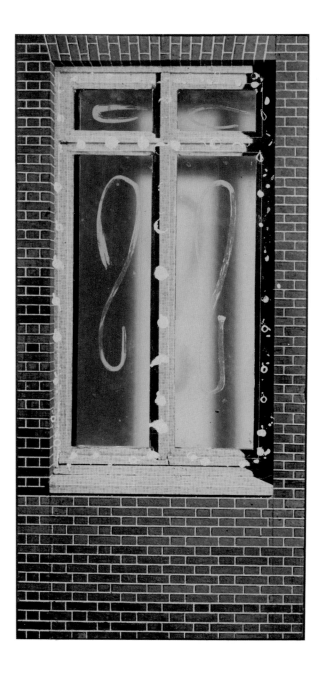

La bagarre d'Austerlitz (The Brawl at Austerlitz),
1936 after 1921 original
Printed cardboard cut out with a printed sheet
of cellophane
9 1/2 x 4 1/2 in.

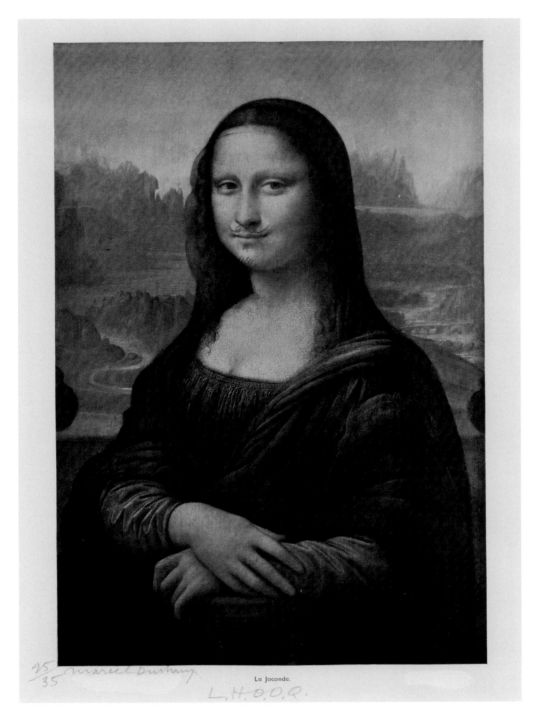

L.H.O.O.Q., 1964 after 1919 original
Pencil and gouache on a reproduction of the
Mona Lisa, ed. 25/35
11 7/8 x 9 1/16 in.

Produced for the book by Pierre de Massot,
Marcel Duchamp, propos et souvenirs.

Marcel Duchamp
French, 1887–1968

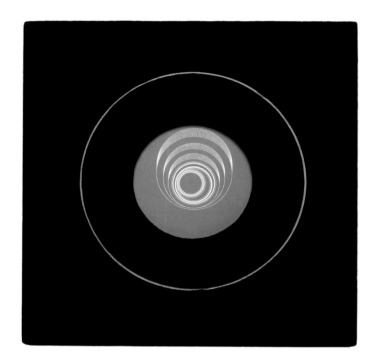

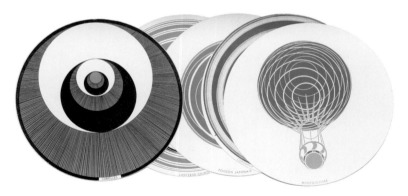

Rotoreliefs (Optical Disks), 1965
Wooden box covered in velvet with motor and
aluminum disk
14 3/4 x 14 3/4 x 5 in.

Set of six cardboard disks, printed by offset
lithography on both sides
Each 7 7/8 in. (diameter)
To be viewed at 33 1/3 rpm

Edition Galerie Schwarz, Milan, ed. 88/150
Four editions were produced between 1935 and 1965

The Rotoreliefs are an extension of the rotating spiral disks in Duchamp's 1926 film *Anémic cinéma*. They
appear in the Duchamp sequence of Hans Richter's 1947 film *Dreams That Money Can Buy*, and also in
Jean Cocteau's 1930 film *The Blood of a Poet*.

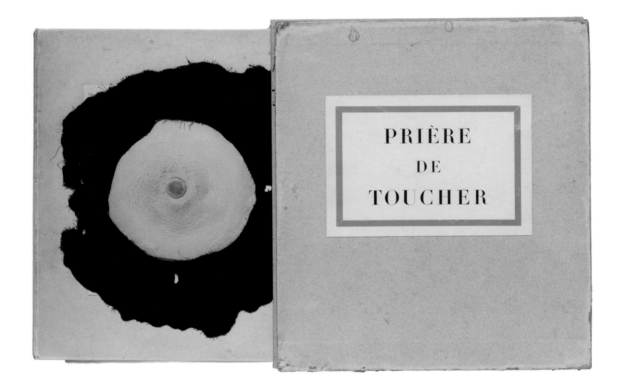

Prière de toucher (Please Touch), 1947
Hand-colored foam rubber, black velvet,
and cardboard
9 1/2 x 8 1/2 x 1 1/2 in.

Cover for the catalogue of the exhibition
Le surréalisme en 1947

999 copies were prepared by
Marcel Duchamp and Enrico Donati.

Marcel Duchamp
French, 1887–1968

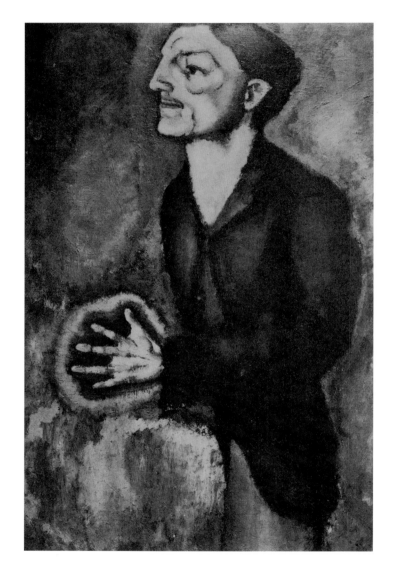

Épreuve inédite de "Boîte-en-valise"
(Unpublished proof from "Box in a Valise"),
1937 after 1910 original painting
Portrait of Dr. Dumouchel
Lithograph, artist's proof
8 1/2 x 5 1/2 in.

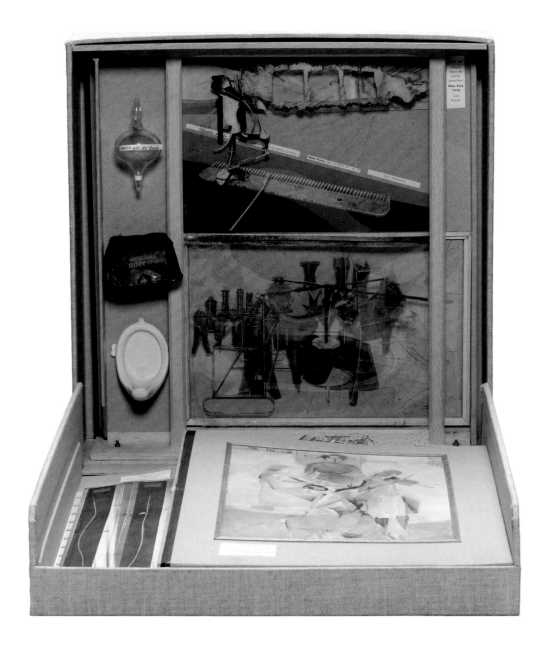

Boîte-en-valise – série C (Box in a Valise – Series C),
1958
Paperboard box and mixed media, ed. of 30
3 1/2 x 15 3/4 x 14 3/4 in.
Assembled by Il'ia Zdanevich
Contains 68 items

Miniature replicas and color reproductions of works by Duchamp, contained in a cloth-covered cardboard box, enclosed in a valise of leather, imitation leather, or cloth-covered wood. First published by Duchamp in 1941. Seven series (A-G) were produced between 1941 and 1968.

Marcel Duchamp
French, 1887–1968

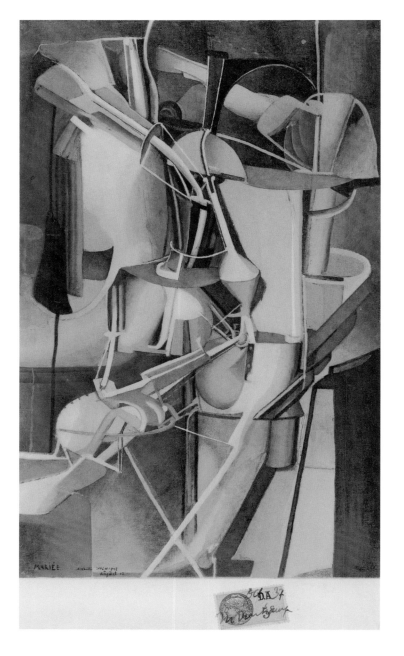

Mariée (Bride), 1937 after 1912 original painting
Collotype with pochoir
13 3/8 x 7 3/4 in.

When Duchamp had the reproductions of *Bride* produced for *Box in a Valise*, he also chose a limited, unknown number of prints for his friends, to which he added a 5-centime stamp and his signature.

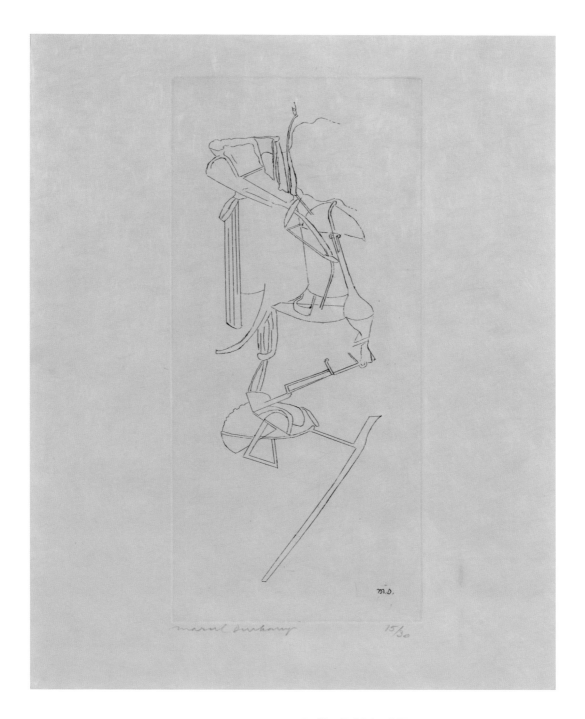

Mariée (Bride), 1965
Etching, ed. 15/30
12 3/4 x 10 in.

Marcel Duchamp
French, 1887–1968

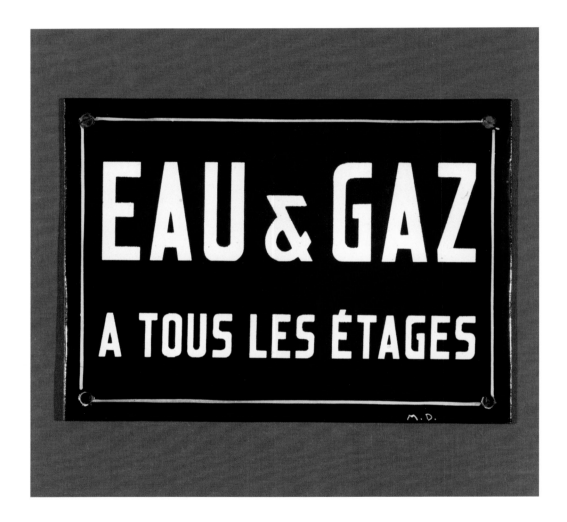

Eau & gaz à tous les étages
(Water & Gas on Every Floor), 1958
Enamel, edition of 21
5 7/8 x 7 7/8 in.

The plaque is attached to the lid of the box
containing the special edition of Robert Lebel's
Sur Marcel Duchamp.

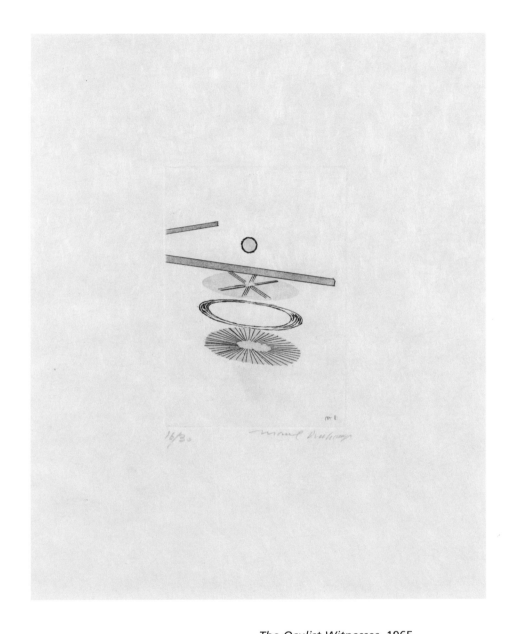

The Oculist Witnesses, 1965
Etching and aquatint, ed. 16/30
13 1/4 x 11 in.

Max Ernst
German, 1891–1976

Untitled
Oil pastel
16 x 13 in.

Max Ernst
German, 1891–1976

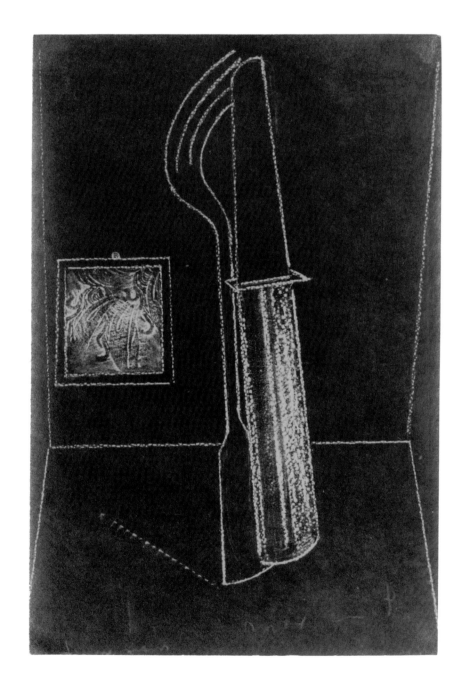

Max Ernst and
Man Ray (Emmanuel Radnitzky)
American, 1890–1976
Mr. Knife/Miss Fork, 1931
Negative print of an original frottage by Ernst on
photographic paper, printed by Man Ray and signed
by Ernst in the image
6 3/4 x 4 1/4 in.

Max Ernst
German, 1891–1976

Orage (Storm), 1946
Oil on board
8 1/2 x 6 3/4 in.

Max Ernst
German, 1891–1976

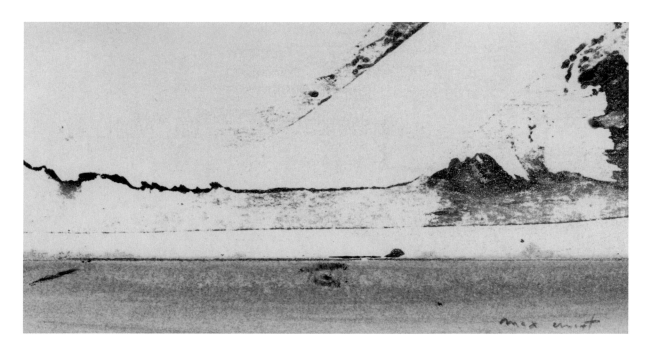

Paysage (microbe (Landscape (microbe))), 1964
Tempera
3 1/4 x 6 in.

Reinhold Ewald
German, 1890–1974

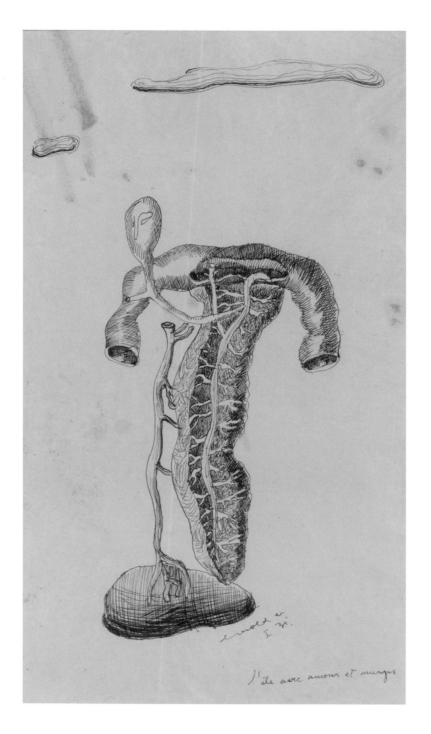

L'ile [sic] *avec amour et nuages
(Island with Love and Clouds)*
Ink
11 1/4 x 6 3/4 in.

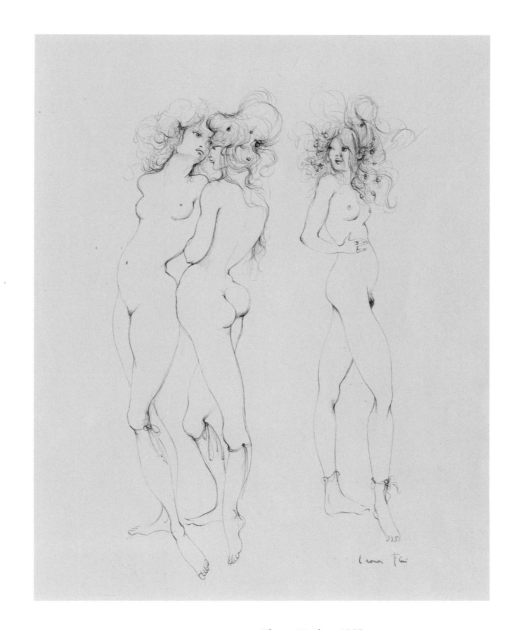

Three Nudes, 1933
Ink
14 1/2 x 12 in.

Natalya Goncharova
Russian, 1881–1962

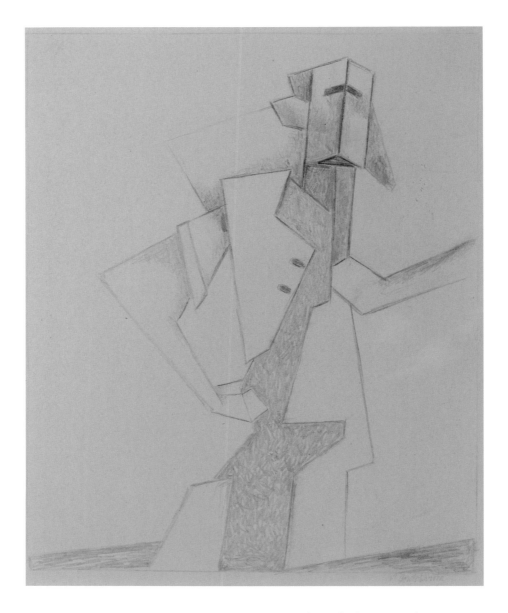

Figure cubiste (Cubist Figure)
Pencil
14 1/4 x 11 in.

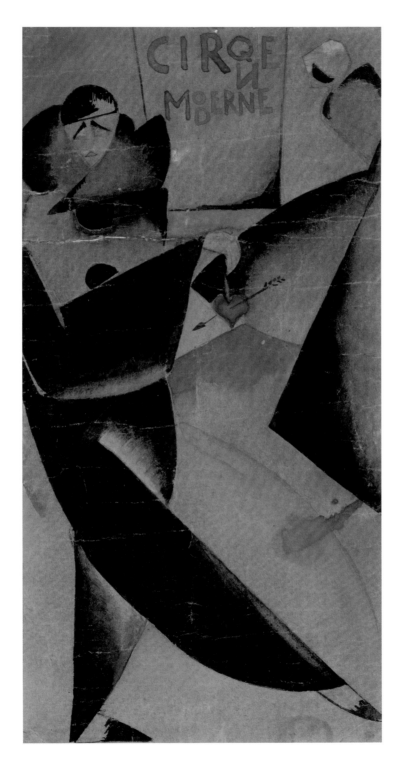

Le cirque (The Circus), ca. 1919–1920
Gouache
11 1/8 x 6 in.

George Grosz

German, 1893–1959

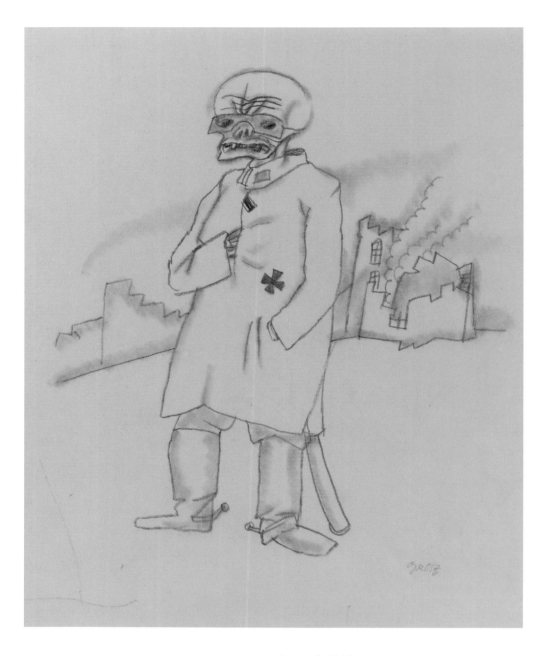

General, 1916
Pencil
7 7/8 x 7 1/4 in.

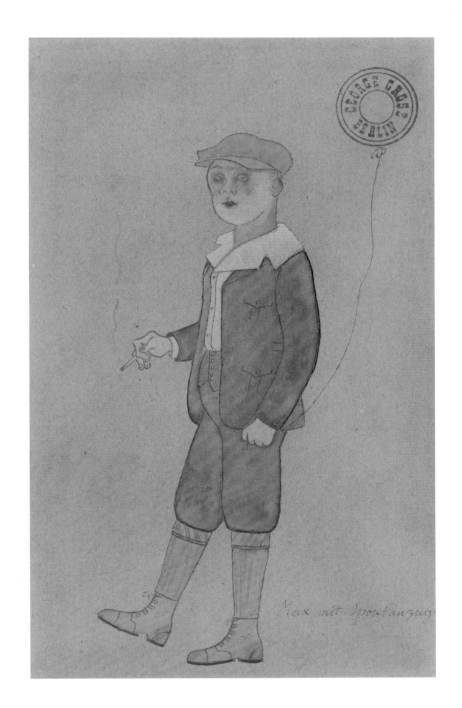

Max mit Sportanzug (Max in Sports Coat), 1919
Pencil, pastel, and watercolor
13 3/4 x 9 1/4 in.

George Grosz
German, 1893–1959

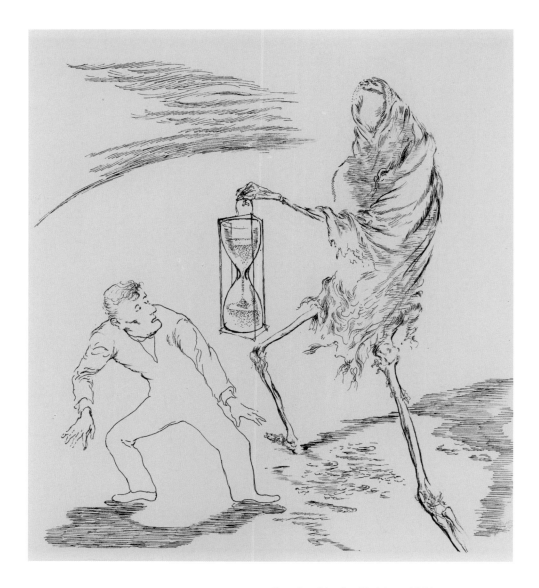

Forgive Me for Sighing, 1941
Ink
22 1/2 x 19 in.

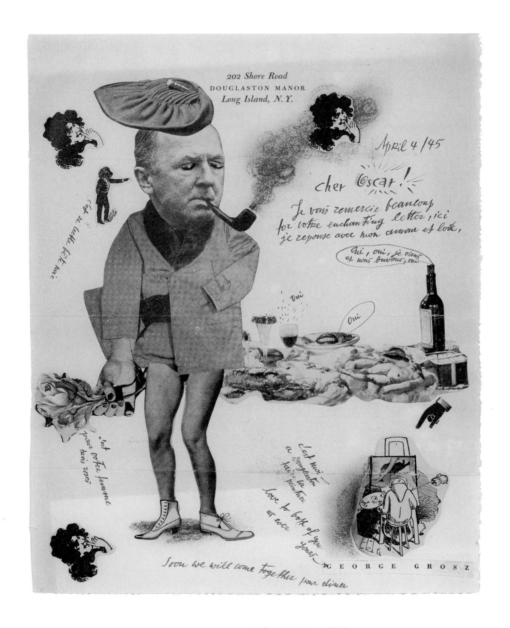

The Letter, 1945
Ink, watercolor, and collage
10 3/4 x 8 1/4 in.

Hannah Höch
German, 1889–1978

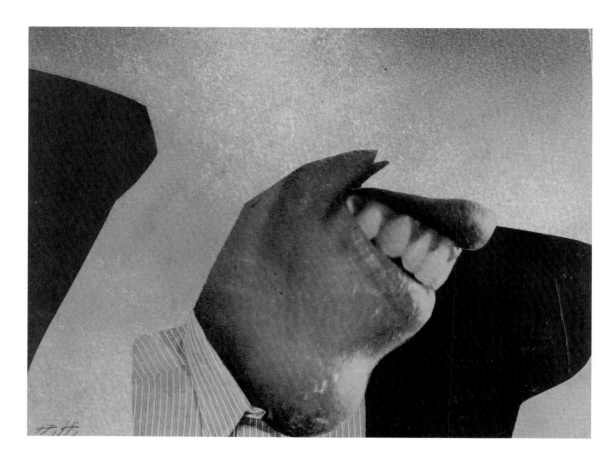

Und Schatten (And Shadows), ca. 1925
Collage on board
5 1/2 x 7 1/8 in.

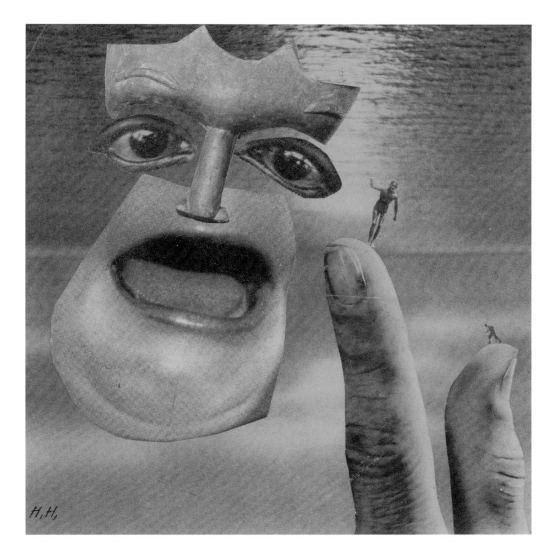

Gesicht und Hand (Face and Hand), 1947
Collage
8 3/4 x 8 3/8 in.

Georges Hugnet

French, 1906–1974

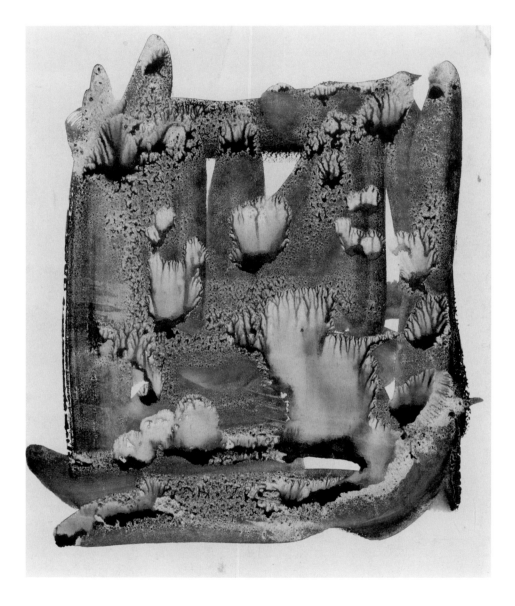

Décalcomanie, 1936
Black gouache decalcomania
12 3/4 x 9 7/8 in.

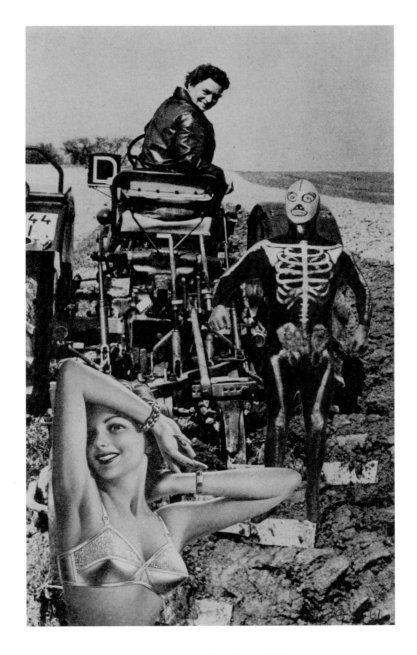

Untitled, 1961
Collage
9 1/4 x 6 1/4 in.

Valentine Hugo
French, 1887–1968

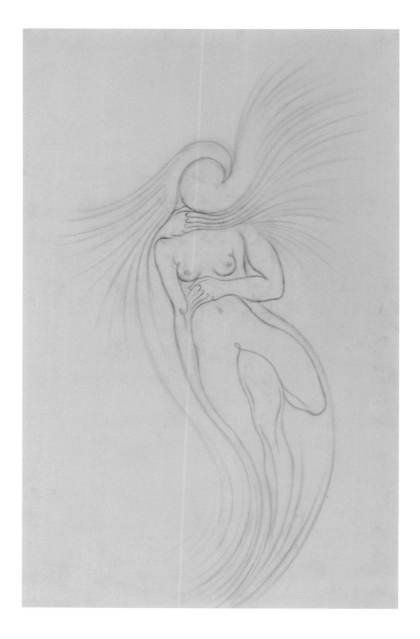

Femme-onde (Wave Woman)
Pencil
19 1/2 x 13 in.

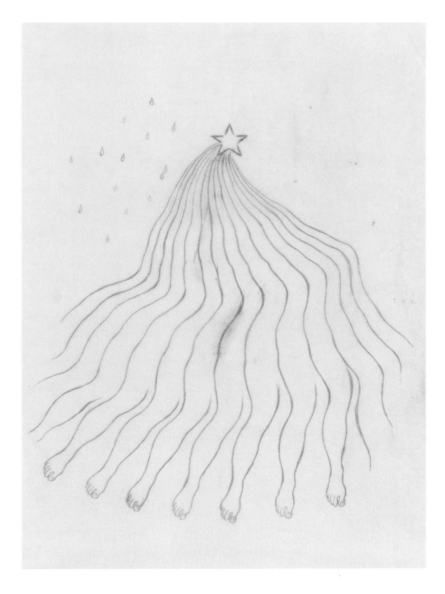

Stars and Legs
Pencil
18 1/4 x 13 1/2 in.

Wassily Kandinsky
Russian, 1886–1944

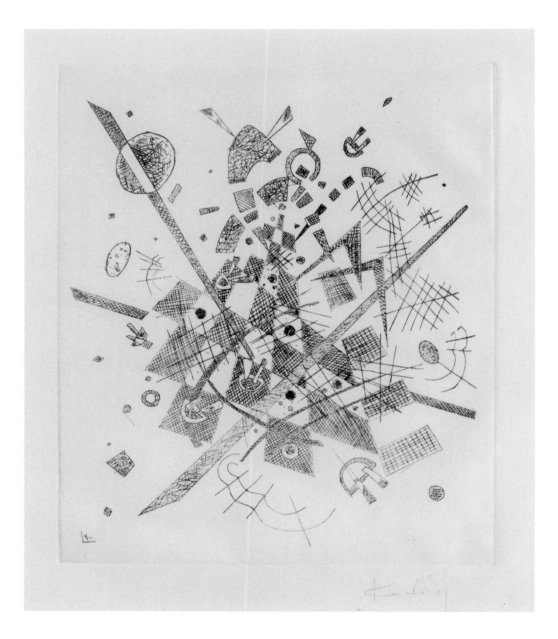

Kleine Welten (Small Worlds), 1922
Drypoint
13 x 11 in.

Wassily Kandinsky
Russian, 1886–1944

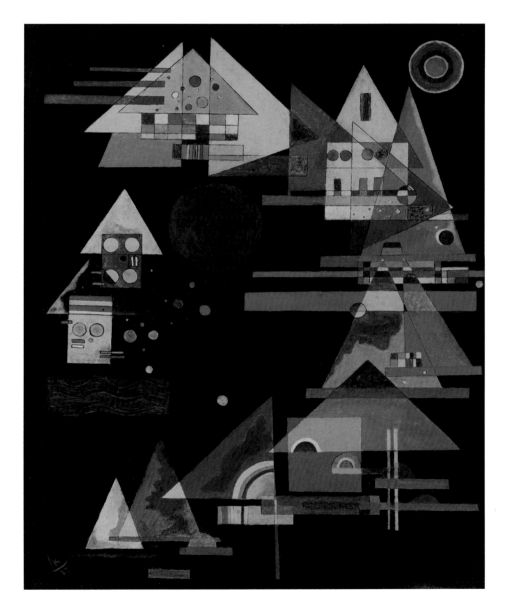

Spitzen im Bogen (Pointed Arcs), 1927
Oil on board
19 3/4 x 15 3/4 in.

Leon Kelly

American, 1901-1982

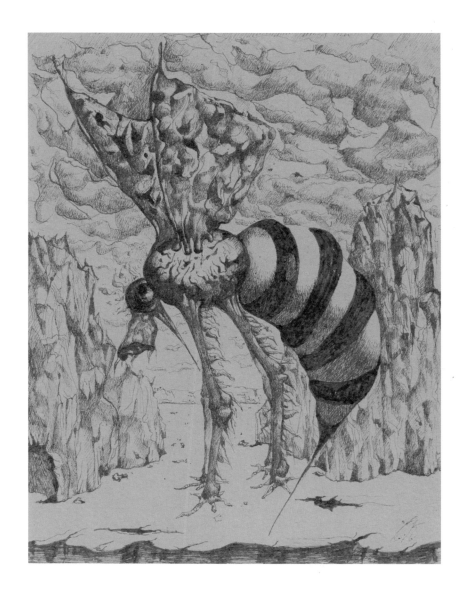

Mosquito on Orange Mountain, 1943
Ink
6 3/4 x 5 in.

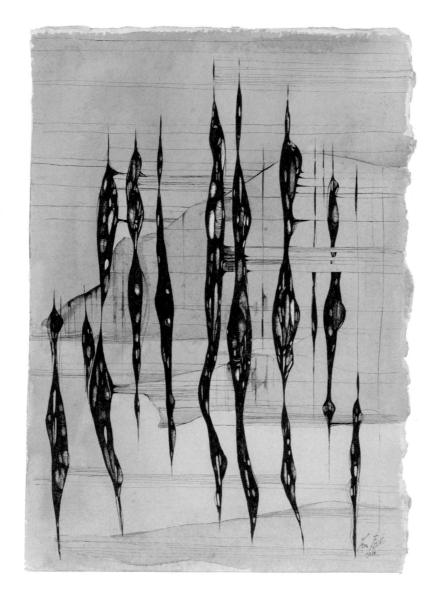

Celestial Mirage, 1945
Ink and watercolor
13 1/2 x 9 1/4 in.

Leon Kelly
American, 1901–1982

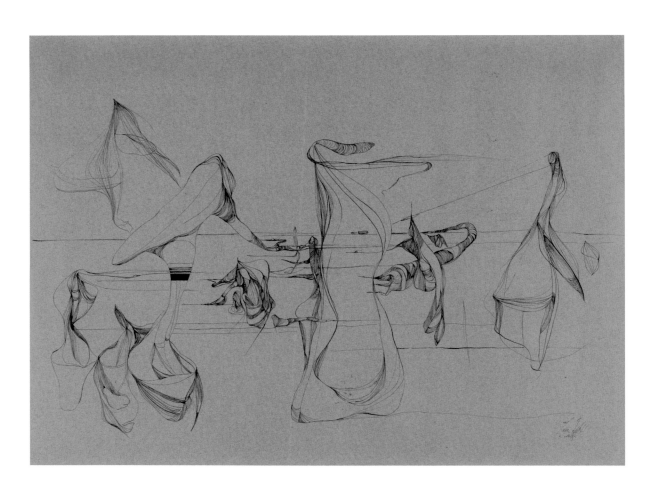

Plateau of Silence, 1945
Ink
15 1/2 x 19 in.

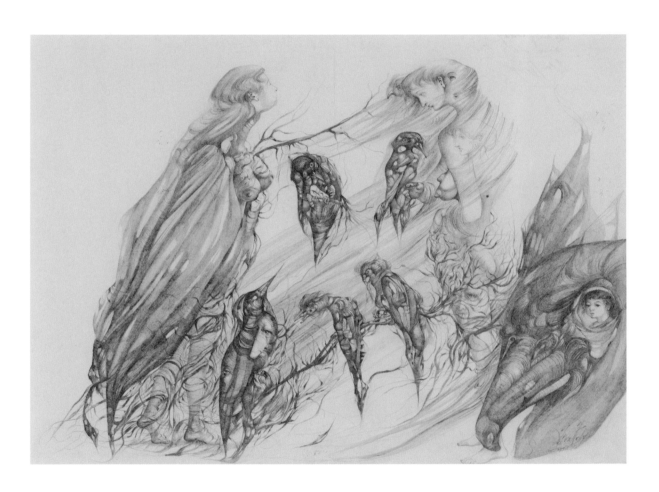

The Love of Chastity, 1945
Pencil
9 3/4 x 12 3/4 in.

Ivan Vasilievich Klyun
Russian, 1873–1943

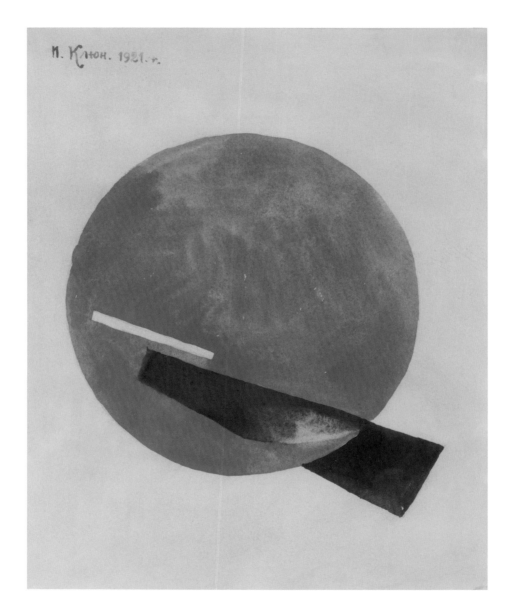

Untitled, 1921
Gouache
10 3/4 x 8 1/2 in.

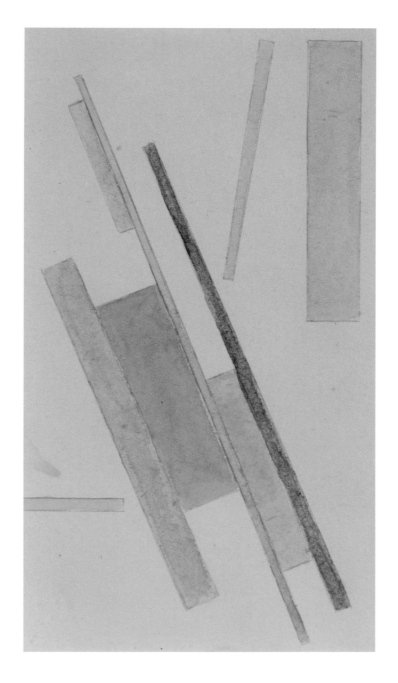

Suprématisme, ca. 1922
Watercolor
7 3/8 x 4 5/8 in.

Frantisek Kupka
Czech, 1871–1957

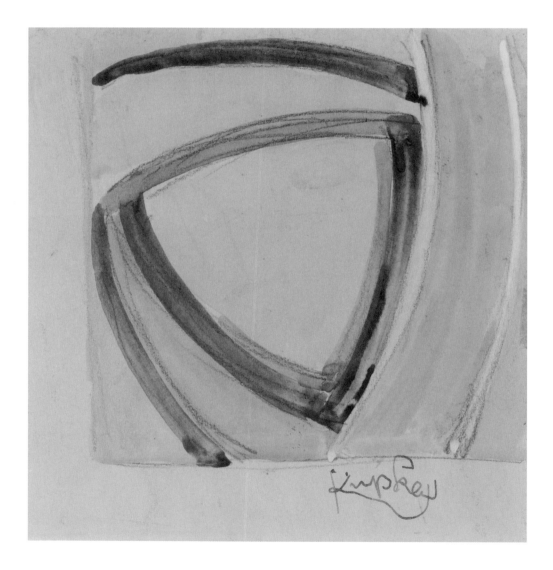

Composition
Pencil and watercolor
4 3/4 x 4 7/8 in.

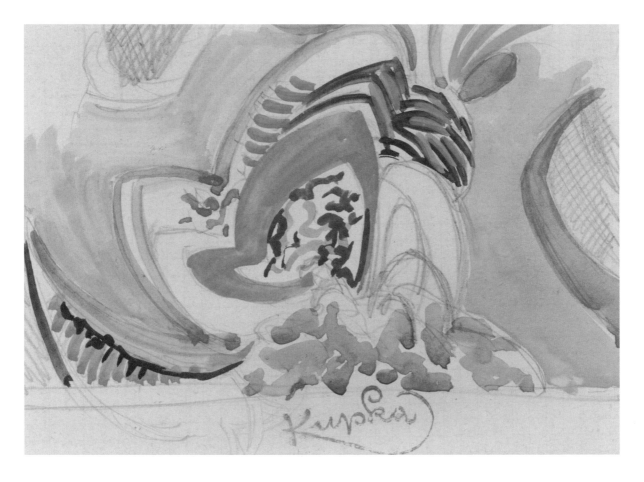

Composition
Watercolor
4 x 5 3/4 in.

El Lissitzky
Russian, 1890–1941

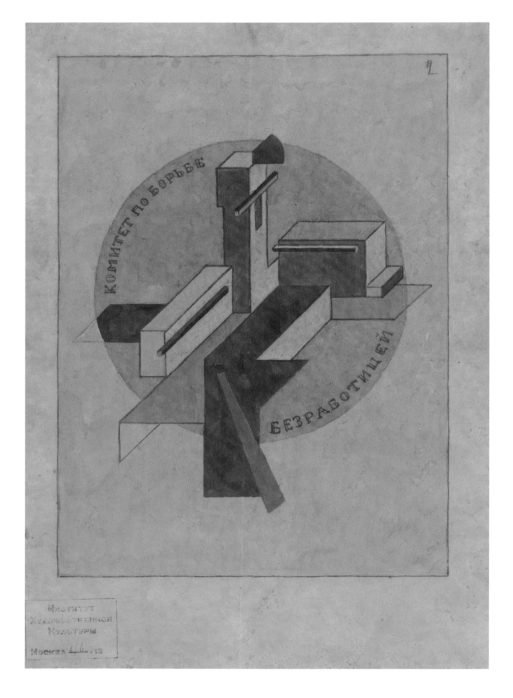

Projet d'affiche agitprop: comité de lutte contre le chômage (Sketch for Agitational Propaganda Poster: Committee for the Fight Against Unemployment)
Gouache on copying paper
15 x 11 in.

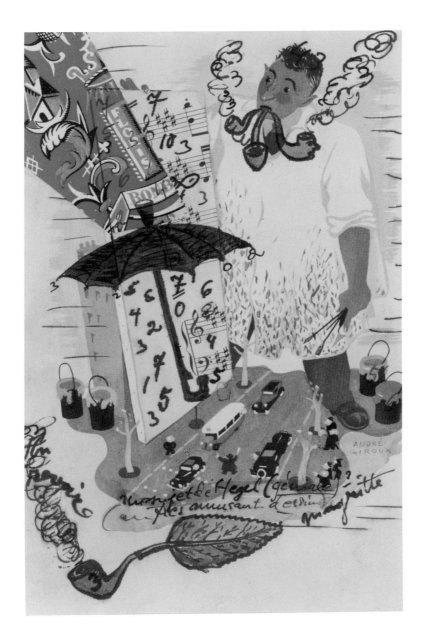

Un sujet de Hegel (A Subject by Hegel)
Ink and collage
9 1/4 x 7 in.

René Magritte
Belgian, 1898-1967

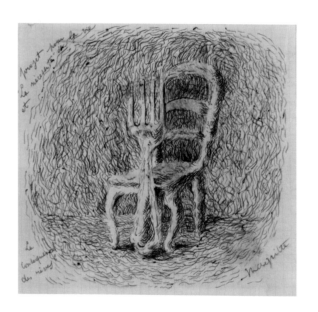 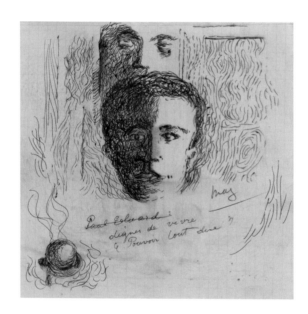

Projet pour "Les nécessités de la vie et la conséquence des rêves" (Sketch for "The Necessities of Life and the Consequence of Dreams"), 1945–1946
Ink on both sides of the sheet
7 x 7 in. each

René Magritte
Belgian, 1898–1967

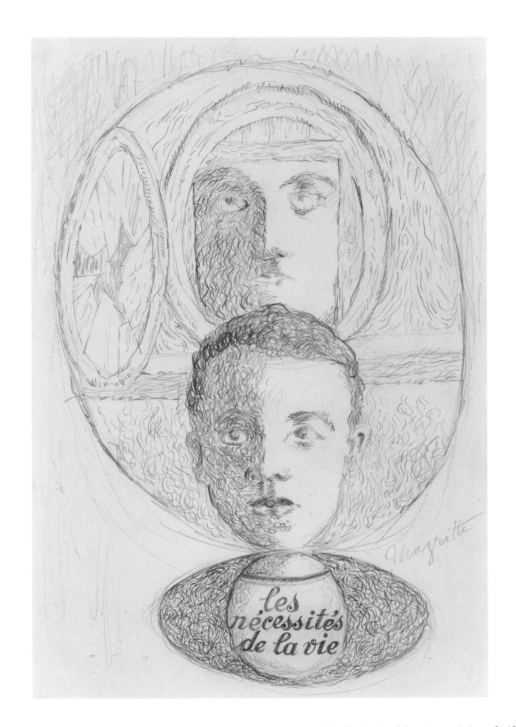

Les nécessités de la vie (The Necessities of Life),
1945–1946
Pencil and ink
10 1/2 x 7 in.

Portrait of Paul Eluard created for the 1946
republication of Eluard's work *Les nécessités
de la vie et les conséquences des rêves.*

Kazimir Malevich
Russian, 1878–1935

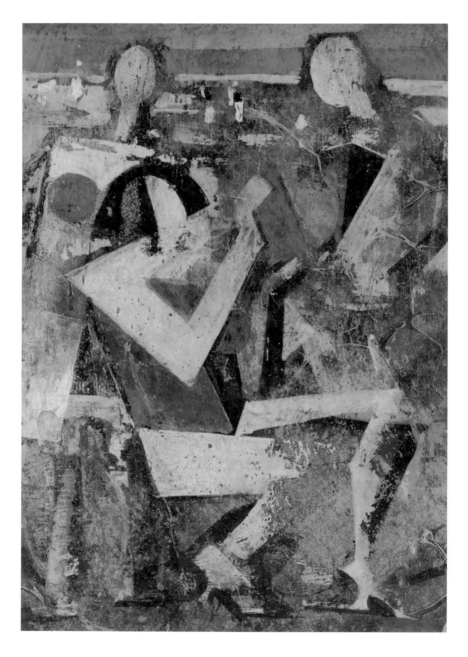

Untitled
Oil and watercolor on board
5 x 3 1/4 in.

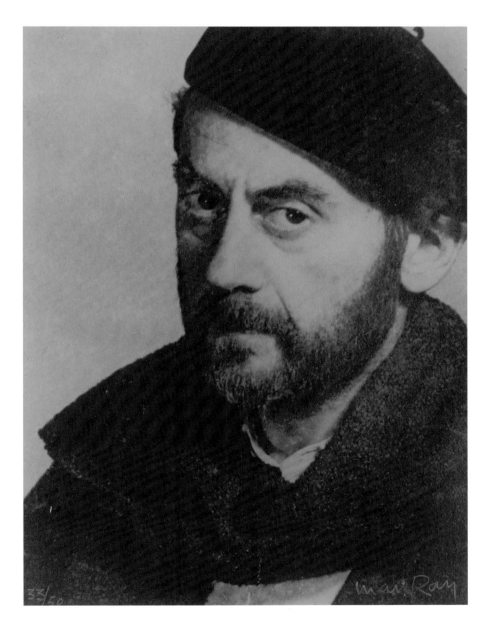

Self-Portrait with Beret, 1946
Gelatin silver print, ed. 33/50
10 1/4 x 7 1/4 in.

Man Ray
(Emmanuel Radnitzky)
American, 1890–1976

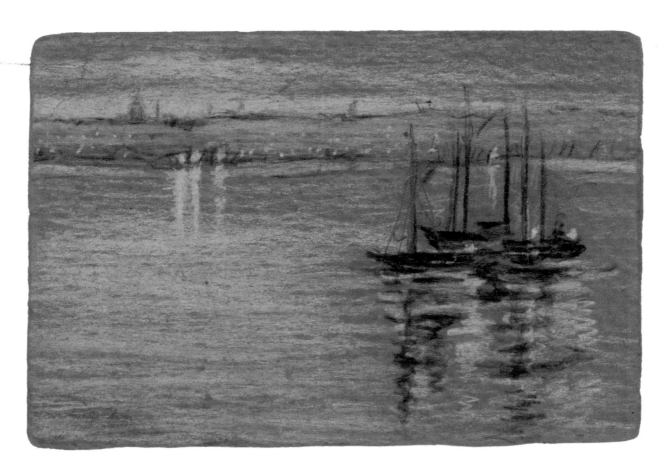

Sailboats at Sunset, 1910
Pastel
3 1/2 x 4 7/8 in.

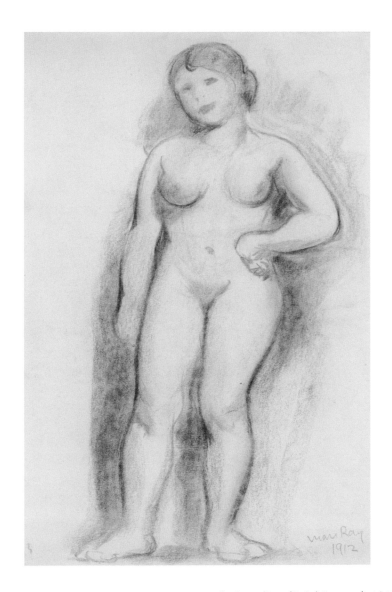

Nude Standing (Ariel Durant), 1912
Pencil
18 1/2 x 12 in.

Man Ray

(Emmanuel Radnitzky)
American, 1890–1976

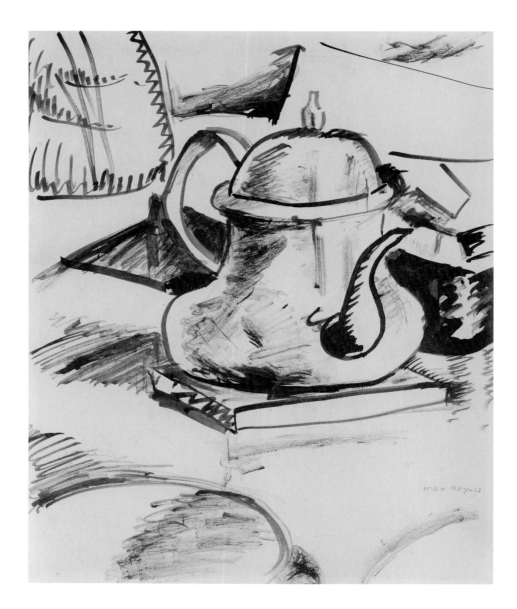

Teapot, 1913
India ink
10 x 8 in.

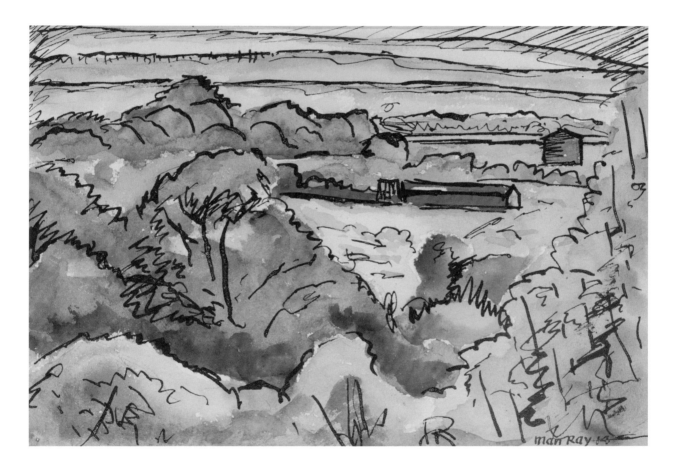

Landscape, 1914
Ink and watercolor
6 1/2 x 8 1/4 in.

Man Ray
(Emmanuel Radnitzky)
American, 1890-1976

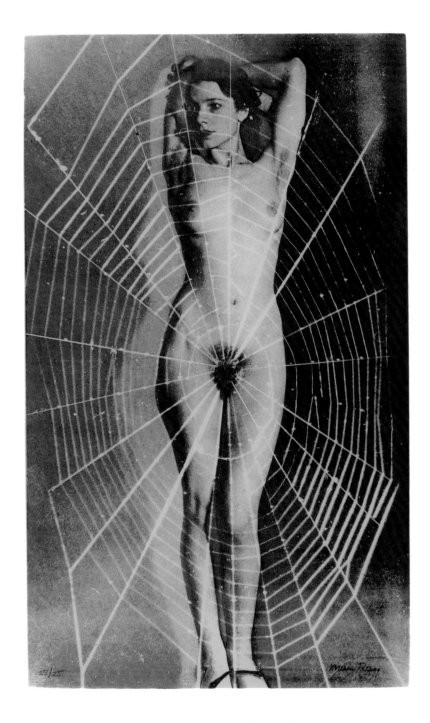

Nue bleue (Blue Nude), after 1929 original
Serigraph, ed. 23/25
23 1/4 x 13 in.

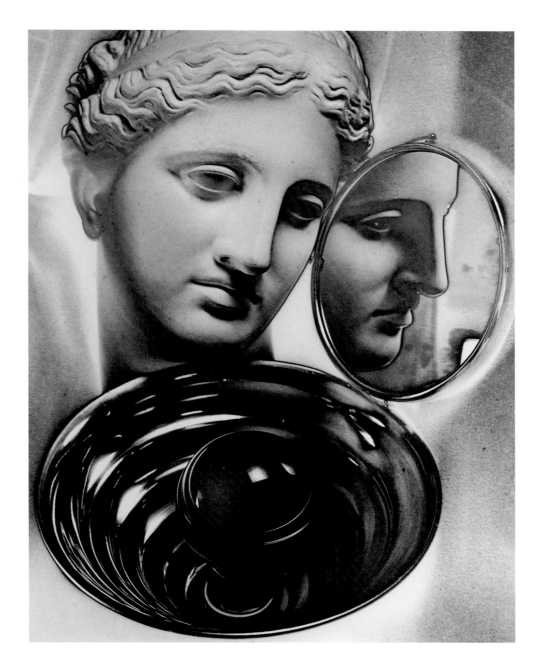

Venus with Surgical Lamp, ca. 1932
Rayograph
11 7/8 x 9 1/8 in.

Man Ray
(Emmanuel Radnitzky)
American, 1890–1976

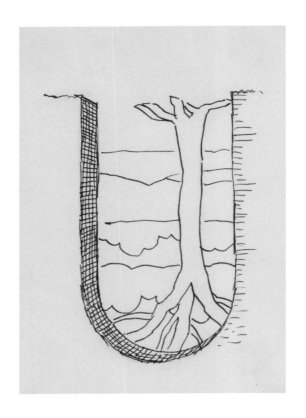

O, 1947
Ink
5 3/4 x 4 in.

U
Ink
5 5/8 x 4 in.

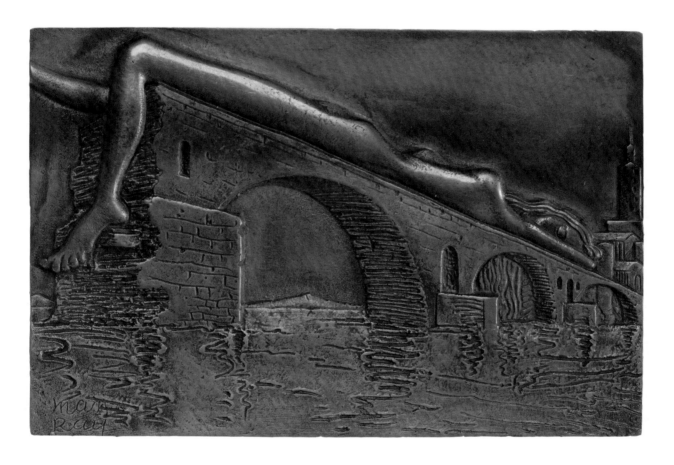

Le point brisé (The Broken Point), 1972
Bronze, ed. 20/500
8 3/4 x 10 3/4 x 5/8 in.

Man Ray

(Emmanuel Radnitzky)
American, 1890–1976

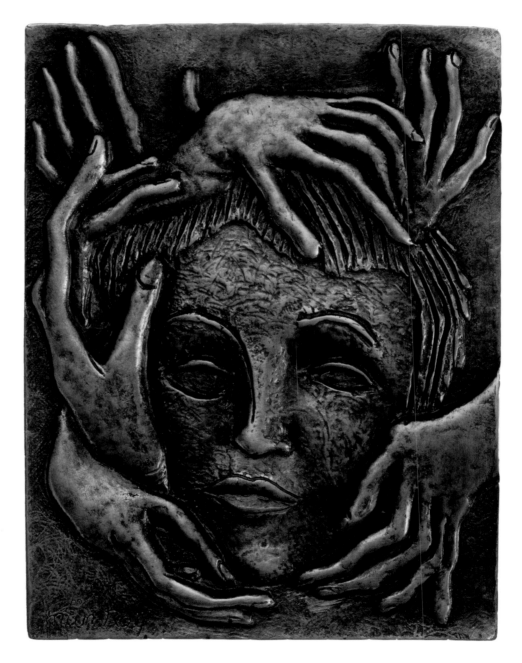

Tête aux mains (Head with Hands)
Bronze, multiple
11 x 9 x 1/2 in.

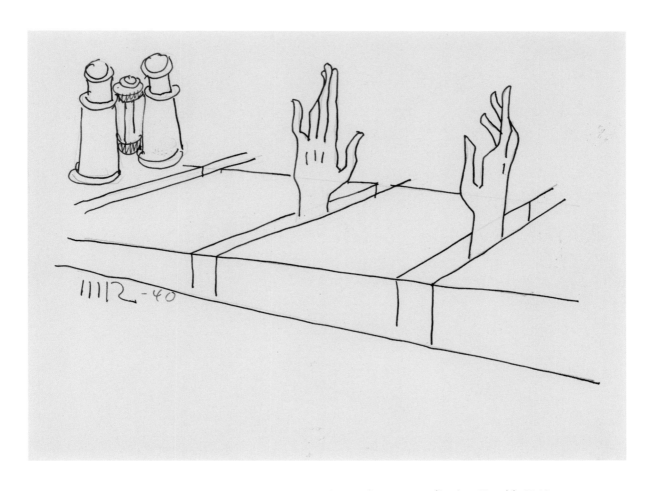

Les mains voyants (Seeing Hands), 1940
Pencil and ink
12 x 14 in.

Man Ray
(Emmanuel Radnitzky)
American, 1890–1976

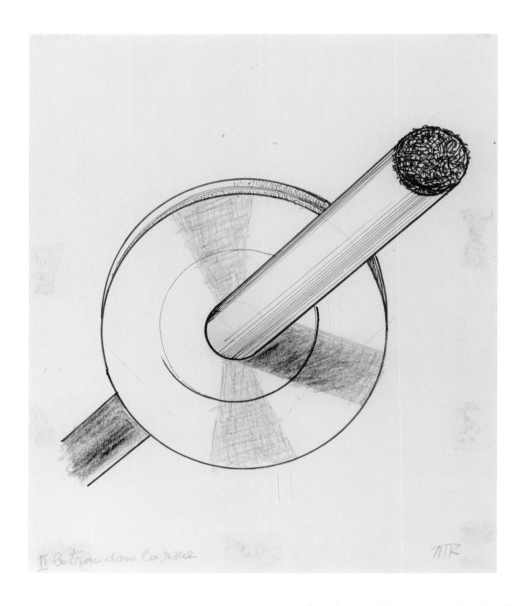

Le trou dans la roue (The Hole in the Wheel)
Pencil and ink
14 x 12 in.

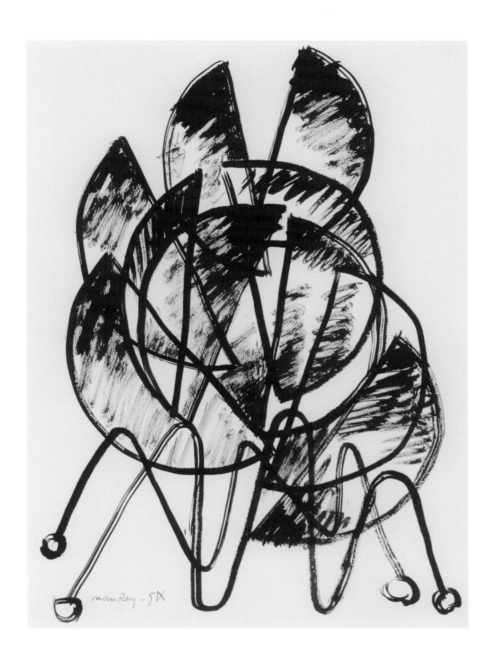

Untitled, 1954
Ink
12 x 10 1/2 in.

Man Ray
(Emmanuel Radnitzky)
American, 1890–1976

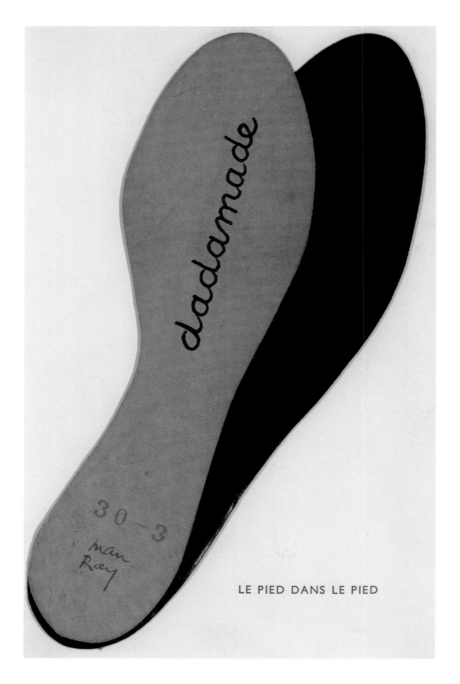

LE PIED DANS LE PIED

Le pied dans le pied
(The Foot within the Foot), 1957
Leather shoe soles and ink, ed. 3/30
9 1/4 x 5 7/8 in.

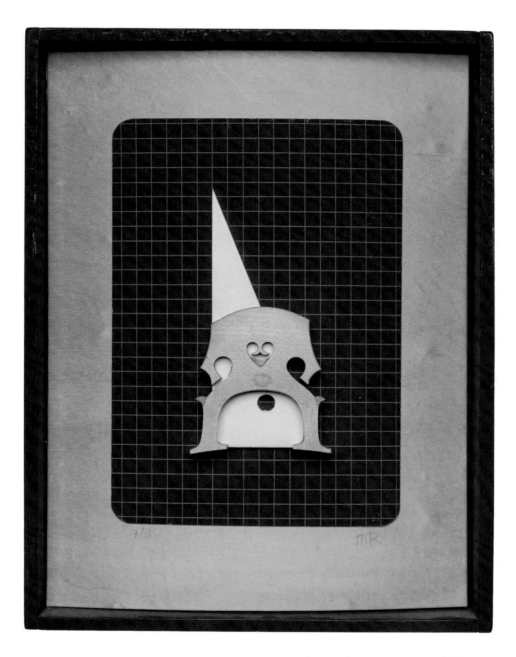

La Jurassienne (Native Woman of the Jura),
1945–1966
Wood, ed. 7/9
16 x 12 x 2 in.

Man Ray
(Emmanuel Radnitzky)
American, 1890–1976

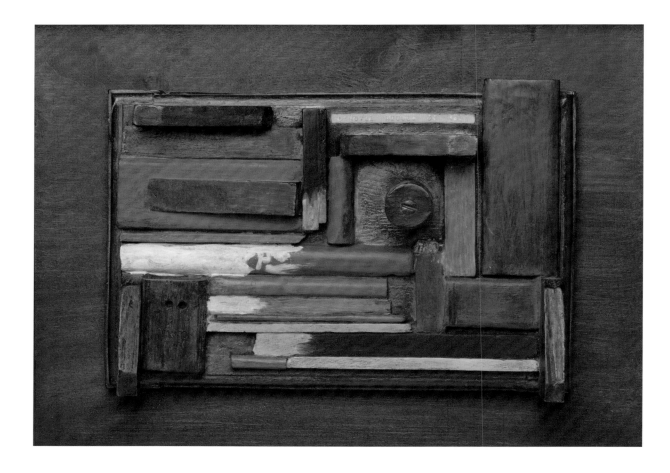

L'hôtel meublé (Furnished Hotel), 1921–1969
Wood and bronze, multiple
10 1/2 x 14 3/4 x 3 1/4 in.

Man Ray
(Emmanuel Radnitzky)
American, 1890–1976

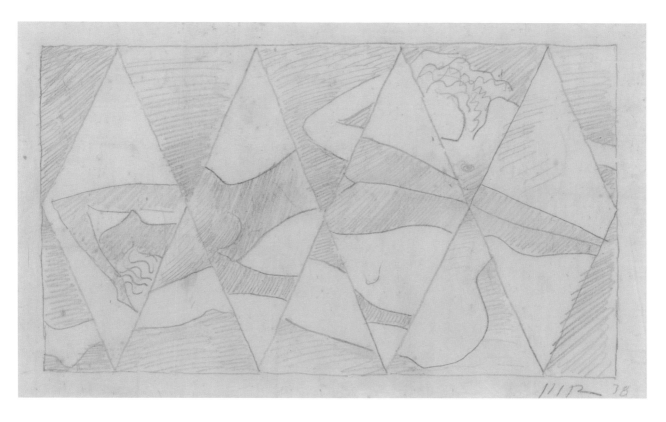

Two Nudes, 1938
Pencil
7 1/2 x 11 3/4 in.

Man Ray
(Emmanuel Radnitzky)
American, 1890–1976

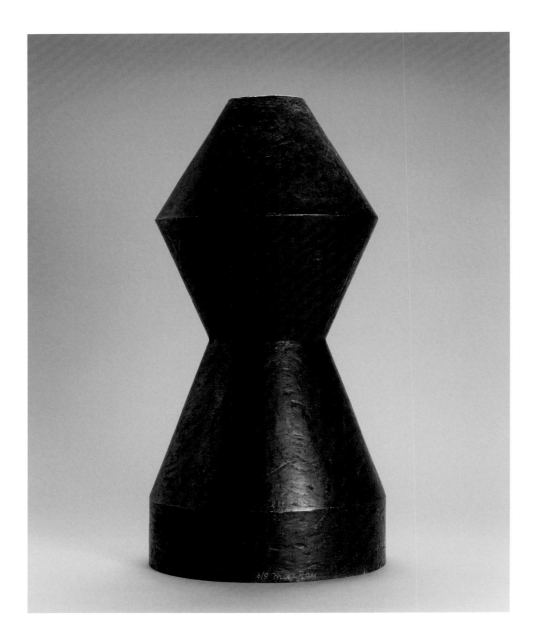

Turning Torso, 1946
Bronze, ed. 6/9
22 x 10 1/2 in. (diameter)

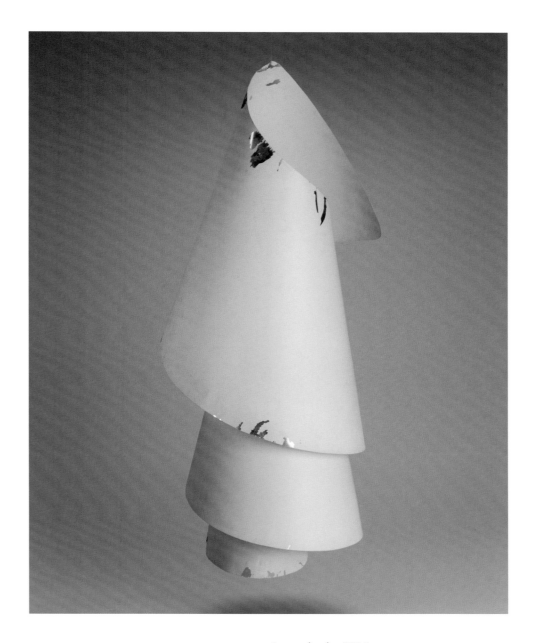

Lampshade, 1954
Painted aluminum
60 1/8 x 25 in.

Artist's later version of his 1921 aluminum replica
of his lost 1919–1920 original, which was a found
broken paper lampshade on a stand.

Man Ray

(Emmanuel Radnitzky)
American, 1890-1976

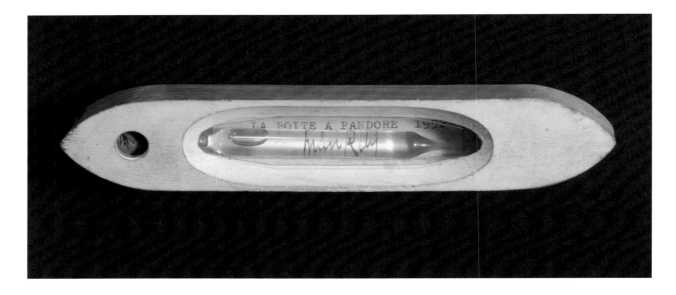

La boîte à Pandore (Pandora's Box), 1952–1973
Mixed media, multiple
1 1/4 x 6 1/2 x 1 in.

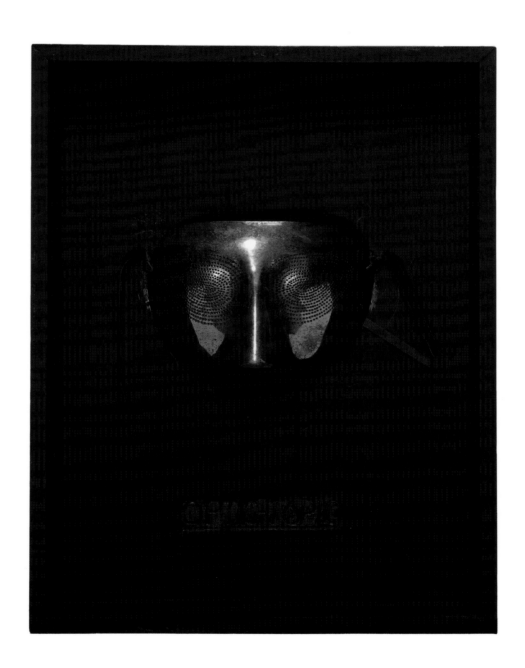

Optic Topic, ca. 1974
Brass masque mounted on wooden panel,
ed. 21/100
14 3/4 x 11 1/4 x 3 in.

Man Ray
(Emmanuel Radnitzky)
American, 1890–1976

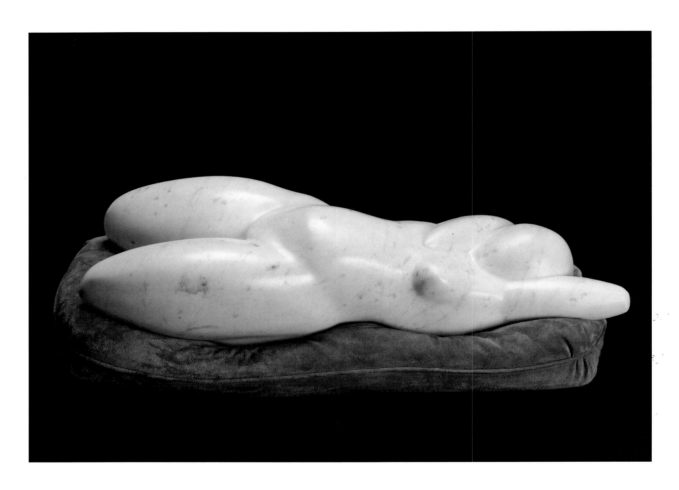

Herma(phrodite), ca. 1919–1971
Marble, ed. 6/8
25 x 9 x 8 in.

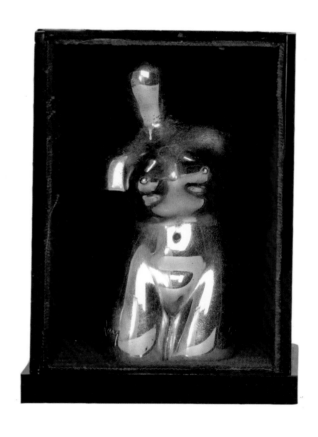 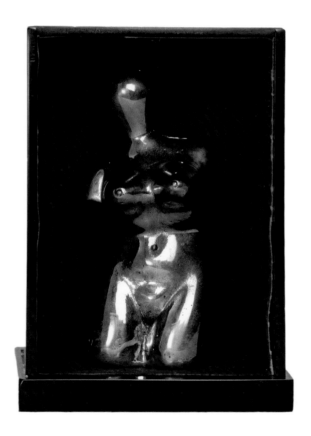

La vierge apprivoisée (The Tamed Virgin)
Silver, multiple
3 3/4 x 1 3/4 x 1 in.

La vierge apprivoisée (The Tamed Virgin)
Bronze, multiple
3 3/4 x 1 3/4 x 1 in.

Man Ray

(Emmanuel Radnitzky)
American, 1890–1976

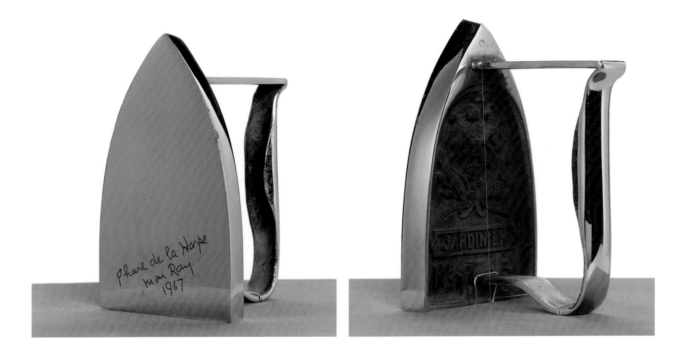

Phare de la harpe (Beacon of the Harp), 1967
Chrome-plated iron, edition of 15
5 3/4 x 3 1/2 x 3 7/8 in.

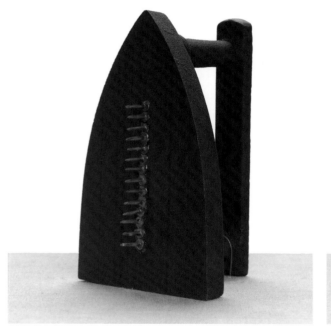 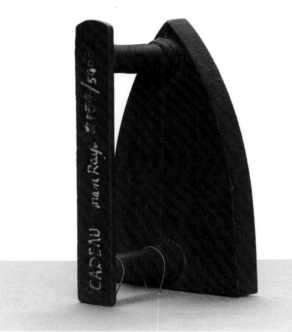

Cadeau (Gift), ca. 1963 after the 1921 original
Iron and nails, ed. 2159/5000
7 x 3 3/4 x 5 in.

Man Ray

(Emmanuel Radnitzky)
American, 1890–1976

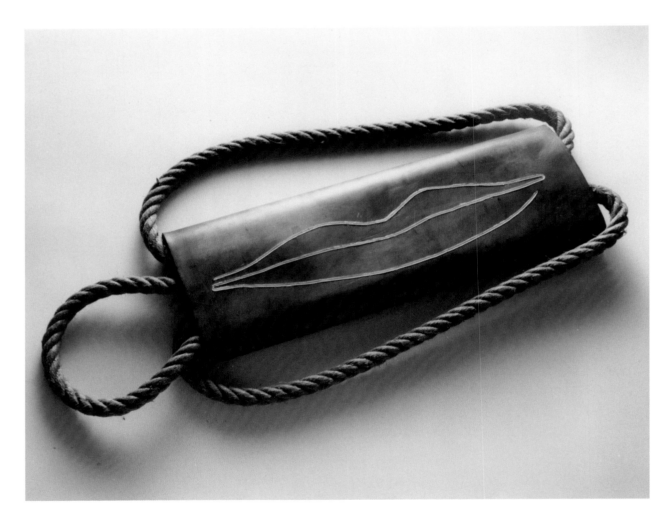

The Lovers, 1973 after the 1933 original
Lead, paint, and rope, ed. 4/8
16 x 28 1/2 x 1 1/2 in.

Man Ray
(Emmanuel Radnitzky)
American, 1890–1976

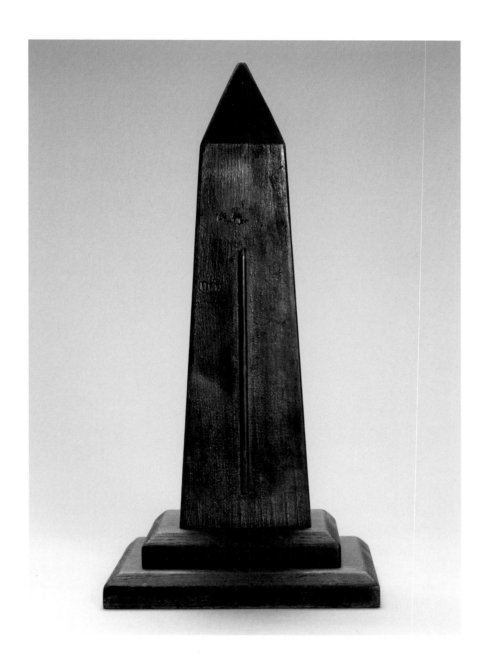

Proverb, 1973 after the 1944 original
Patinated silver and wood, ed. of 9
One of 3 artist's proofs
13 x 6 x 6 in.

André Masson
French, 1896–1987

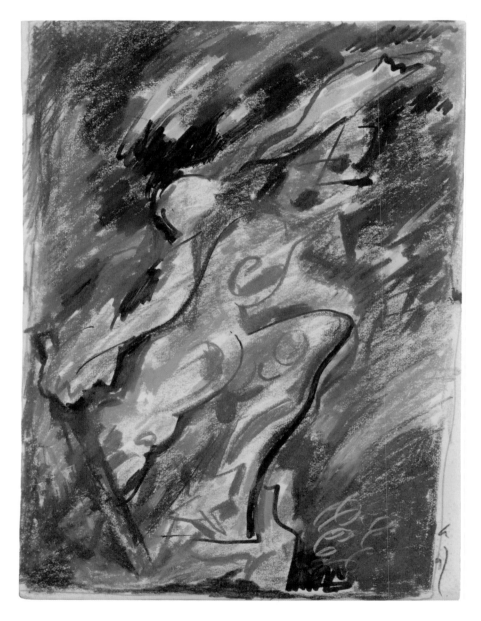

Untitled, ca. 1965
Oil pastel, felt-tip pen, and pencil on
paper adhered to canvas
16 1/2 x 13 1/2 in.

André Masson
French, 1896–1987

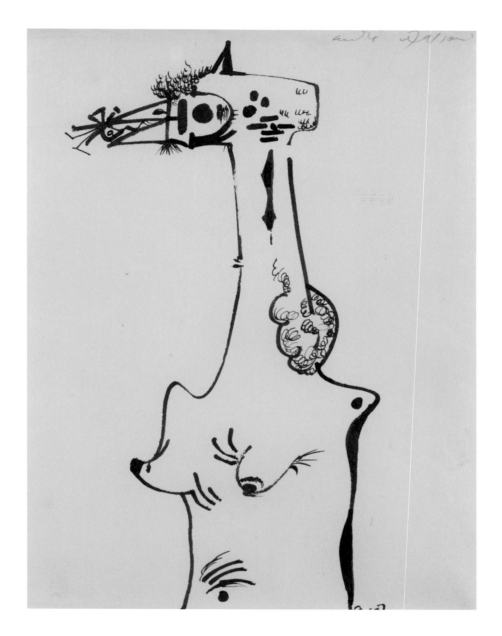

Femme (Woman), ca. 1940–1950
Ink
10 5/8 x 8 1/8 in.

Jean Metzinger

French, 1883–1956

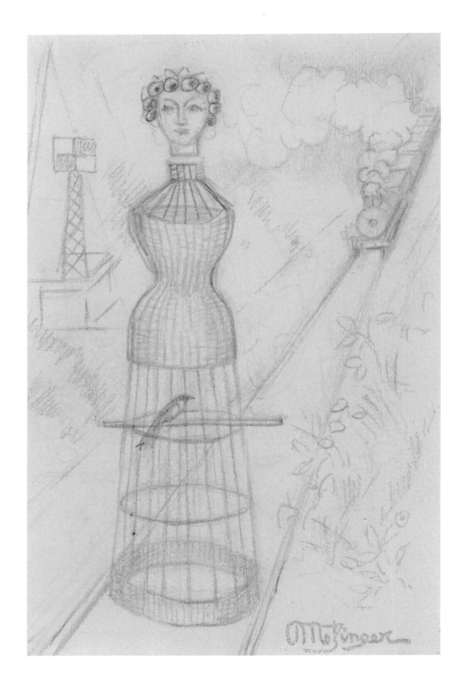

L'arrivée du train (The Arrival of the Train)
Pencil
6 7/8 x 4 1/2 in.

Jean Metzinger
French, 1883–1956

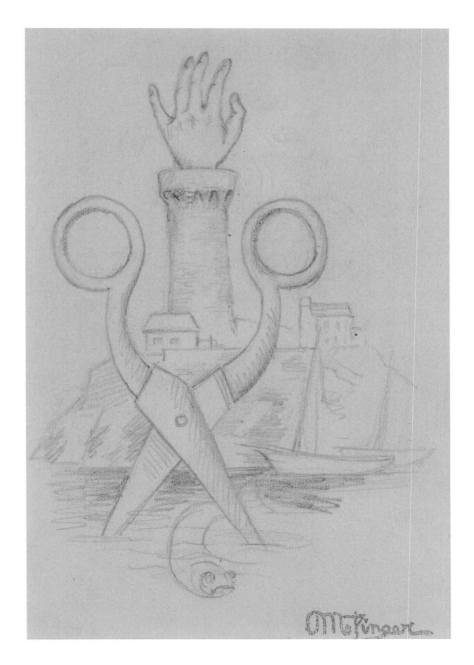

*Composition surréaliste aux ciseaux et bateaux
(Surrealist Composition with Scissors and Boats)*
Pencil
6 3/4 x 4 1/2 in.

Cas(parus Bernardus) Oorthuys

Dutch, 1908–1975

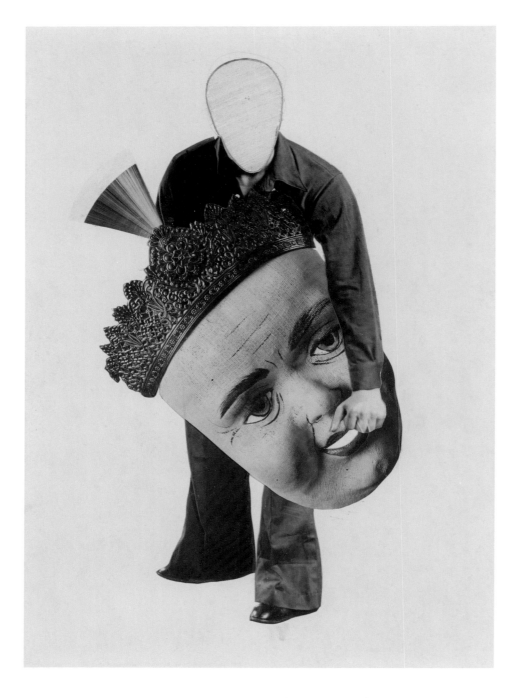

Faceless Figure with Mask, 1935
Gelatin silver print collage
10 1/2 x 9 1/4 in.

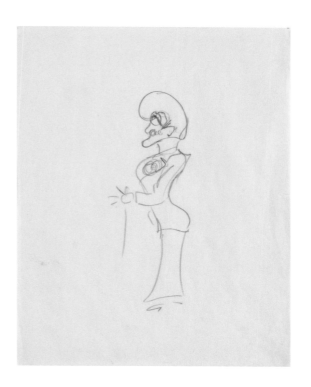

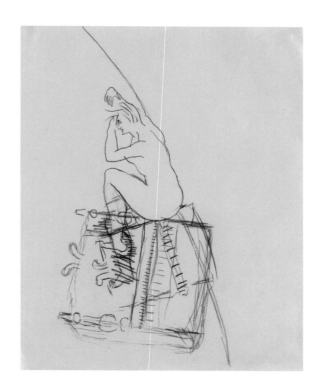

Femme (Woman)
Charcoal
10 1/4 x 8 1/4 in.

Femme assise (Seated Woman), 1938–1941
Charcoal
10 1/2 x 8 1/4 in.

Francis Picabia
French, 1879–1953

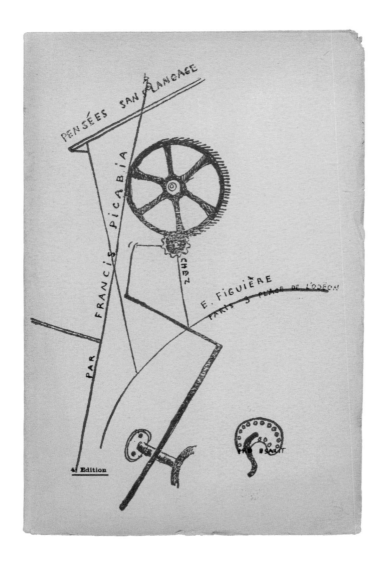

Pensées sans langage
(Thoughts without Language), 1919
Poem by Francis Picabia with a foreword by Udnie
Paper-bound book, cover illustrated by the author
7 3/8 x 4 3/4 x 3/8 in.

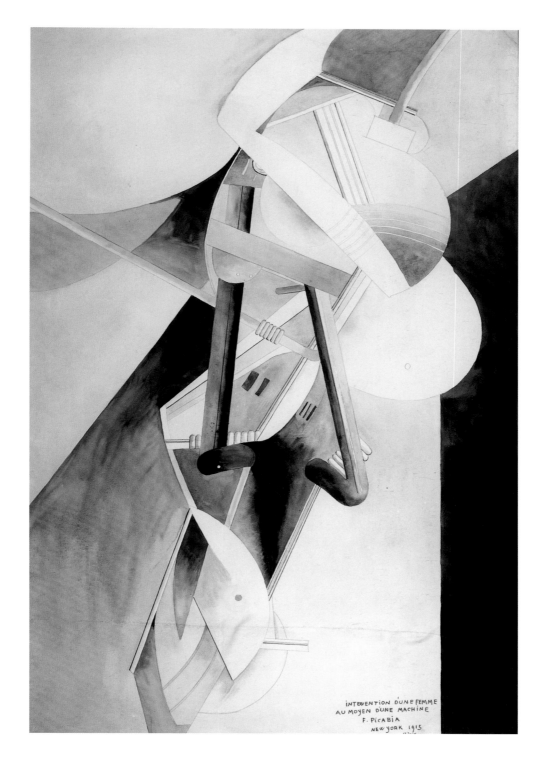

*Intervention d'une femme au moyen d'une machine
(Intervention of a Woman by Means of a Machine)*,
1915
Pencil and gouache
29 7/8 x 20 in.

Liubov Sergeevna Popova
Russian, 1889-1924

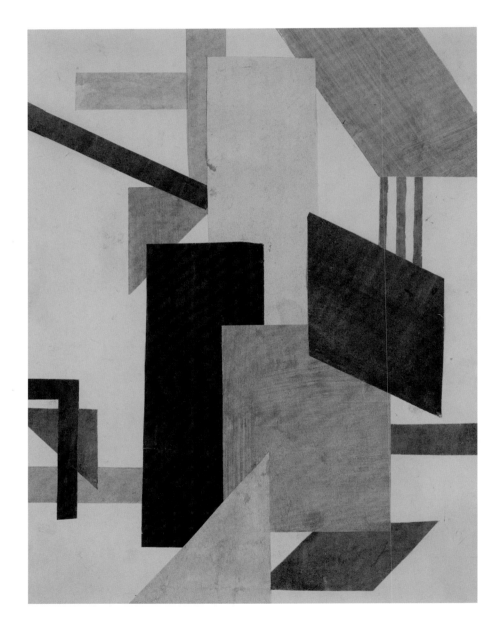

Dynamic Composition, 1917–1919
Watercolor and collage
14 1/2 x 11 1/4 in.

Maria Potocka
Polish, 1899–1963

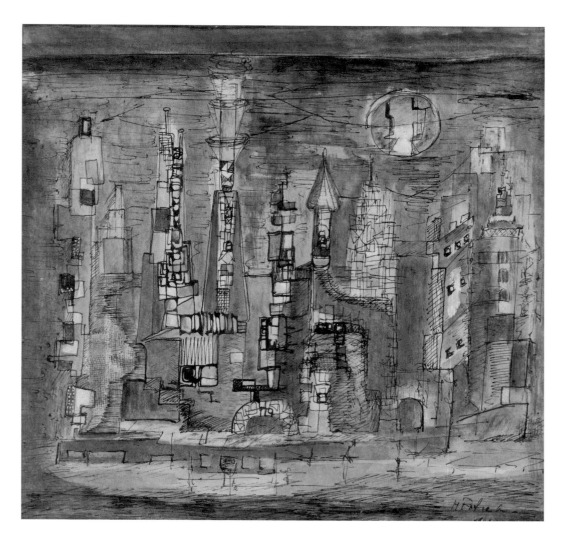

Night City
Ink and watercolor on board
7 3/4 x 7 3/4 in.

Hilla Rebay

American, 1890–1967

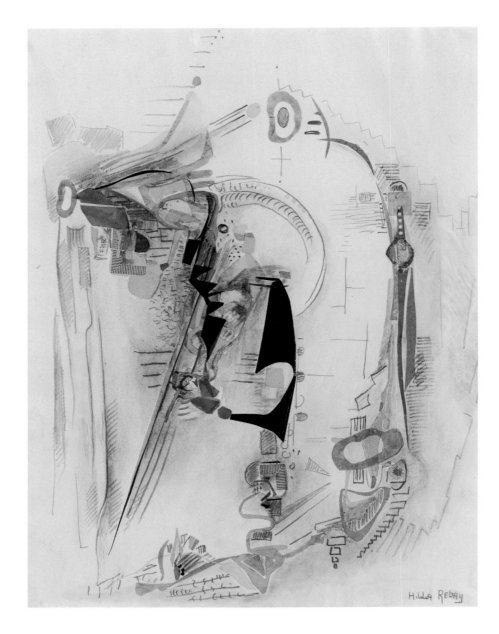

Centered Composition
Pencil, colored pencil, watercolor, and collage
11 3/4 x 9 1/8 in.

Alexander Rodtchenko
Russian, 1891–1956

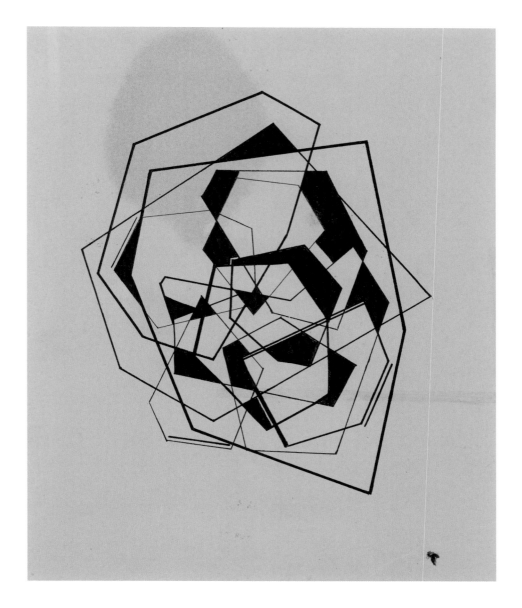

Untitled
Ink
8 1/4 x 9 3/4 in.

Franz Roh
German, 1890–1965

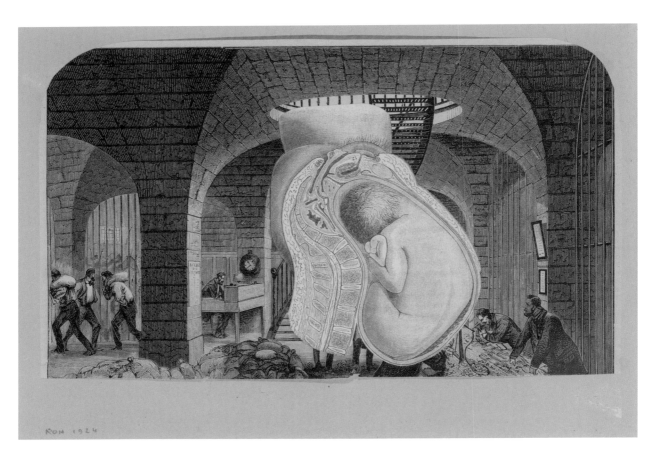

*Eine Kommission lässt die Übermenschen Ausbrüten
(Commission for Breeding Superhumans)*, 1924
Collage
7 x 9 3/4 in.

Franz Roh
German, 1890–1965

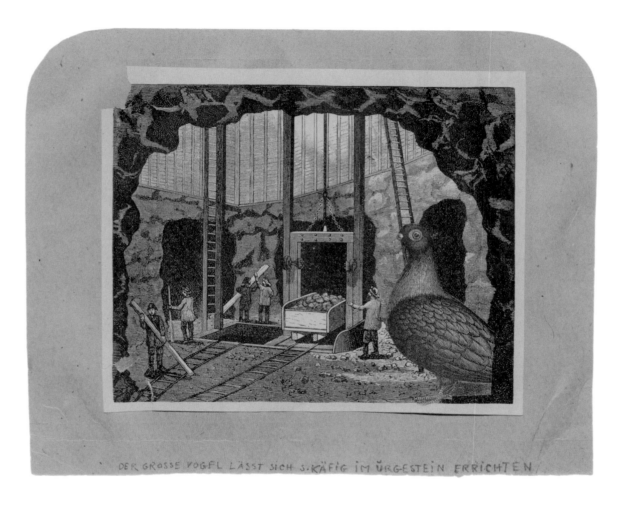

*Der Grosse Vogel lässt sich s. Käfig im Urgestein errichten
(The Big Bird Has Its Cage Built in the Bedrock)*, ca. 1925
Collage
5 3/4 x 7 in.

Franz Roh

German, 1890–1965

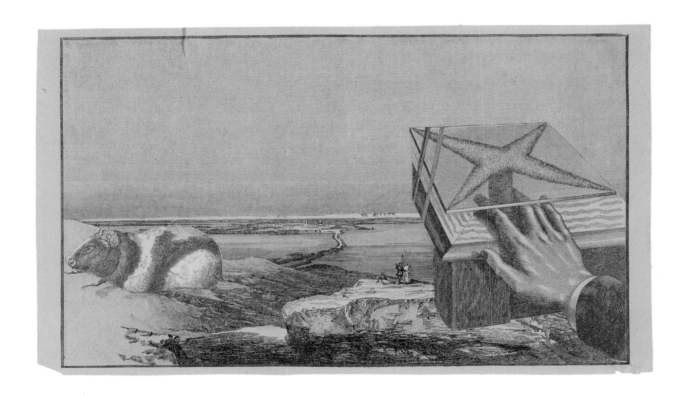

Friedliche Bestrebungen (Peaceful Endeavors), ca. 1925
Collage
4 3/4 x 7 3/4 in.

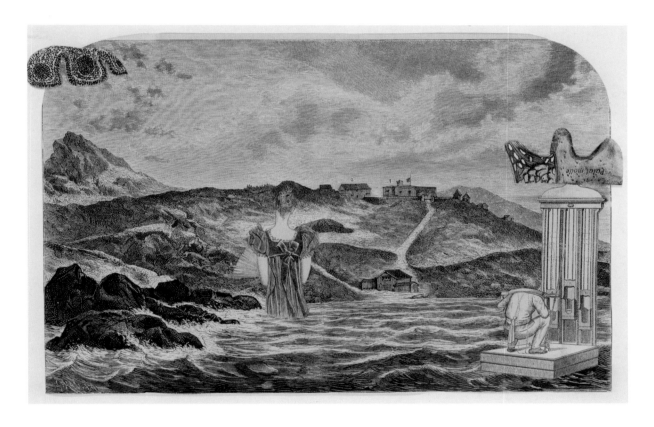

Vix, ca. 1925
Collage
6 1/4 x 10 in.

Pierre Roy
French, 1880-1950

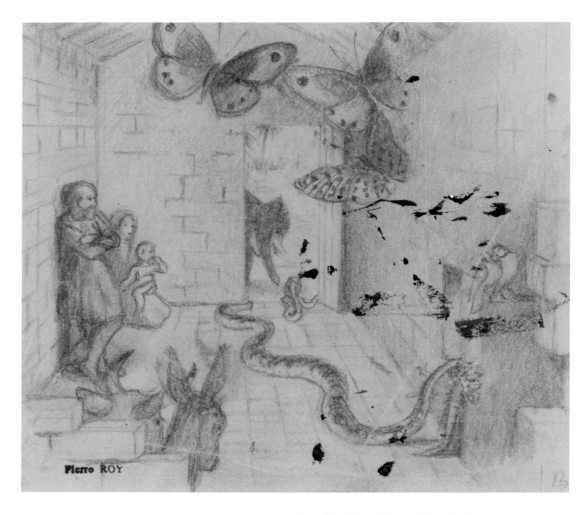

Boeuf et l'âne (Ox and Donkey)
Mixed media and pencil
4 3/4 x 6 1/2 in.

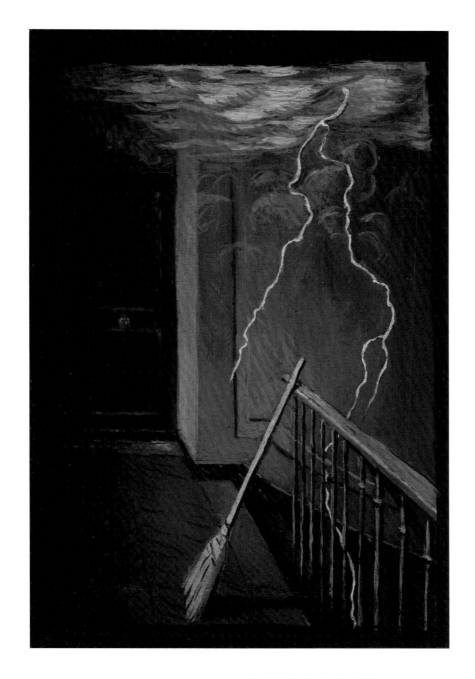

L'éclair (Lightning), 1922
Oil on canvas
13 x 9 in.

Kay Sage
American, 1898–1963

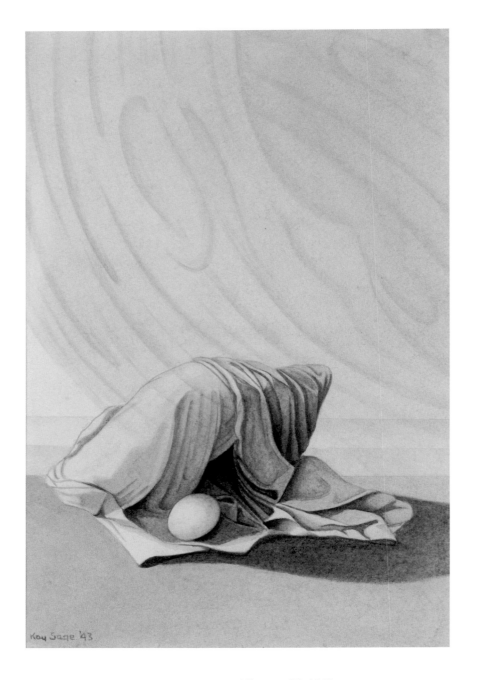

Minutes #8, 1943
Pencil
9 1/2 x 6 3/8 in.

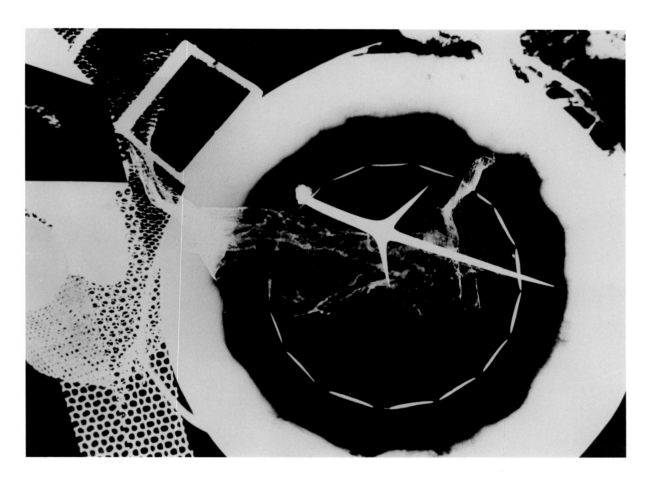

Schadographie, 1932
Schadogram
9 1/4 x 7 1/4 in.

Morton Livingston Schamberg

American, 1881–1918

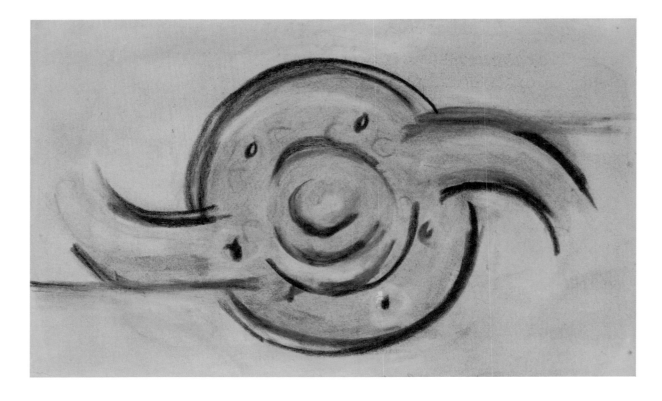

Composition, 1916
Pastel
4 1/4 x 5 3/4 in.

Morton Livingston Schamberg
American, 1881–1918

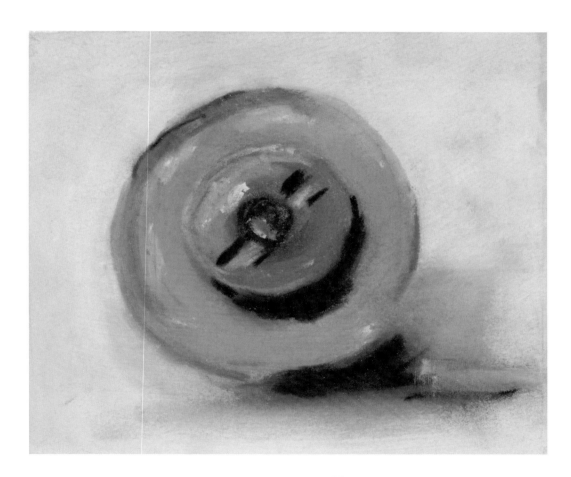

Composition, 1916
Pastel
5 x 5 7/8 in.

Kurt Schwitters
German, 1887-1948

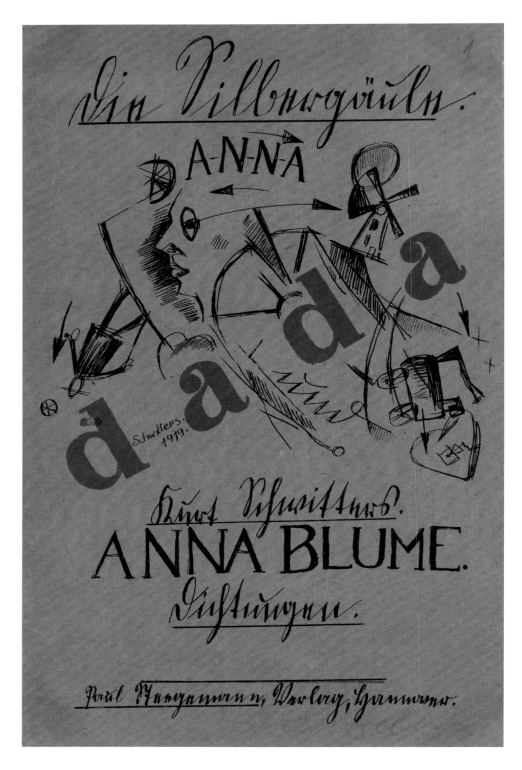

Anna Blume. Dichtungen
Cover of the illustrated book *Anna Blume. Dichtungen (Anna Blume. Poems)* by Kurt Schwitters, original edition, published by Paul Steegemann, Hannover, 1919
Ink and watercolor
8 3/4 x 5 1/8 in.

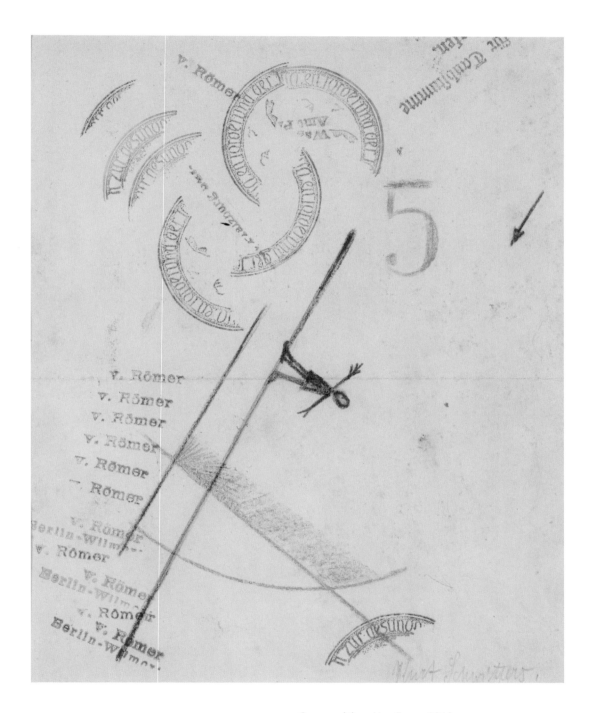

Composition No. 5, ca. 1919
Colored pencil, ink, and ink stamps
8 x 6 1/2 in.

Kurt Schwitters
German, 1887–1948

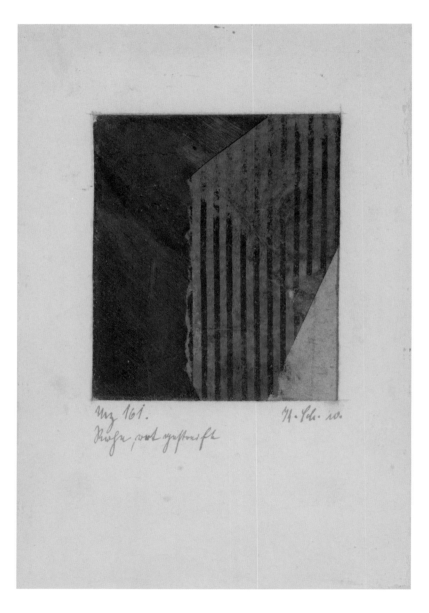

Mz 161 Ruhe, rot gestreift
(Mz 161, Silence, Red Stripes), 1920
Collage
3 1/4 x 2 3/4 in.

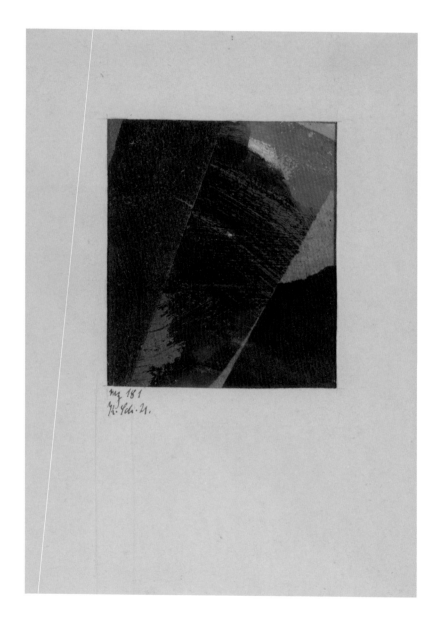

Mz 181, 1921
Collage
3 3/8 x 2 7/8 in.

Kurt Schwitters

German, 1887–1948

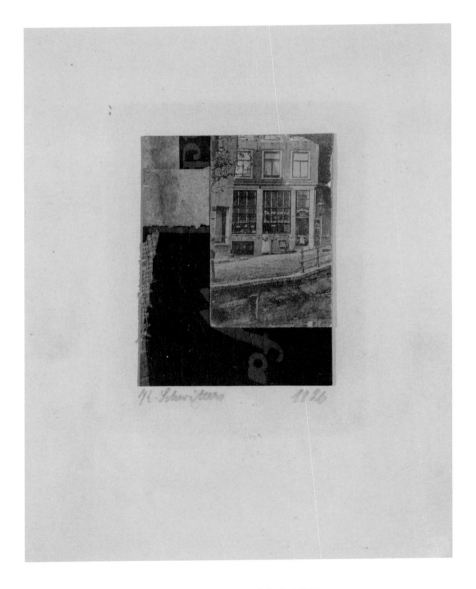

Untitled, 1926
Collage
3 x 2 1/4 in.

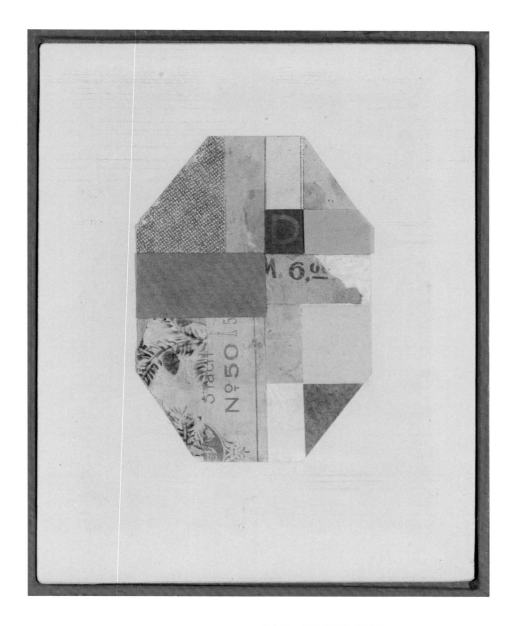

D6 No. 50, 1923–1926
Collage
4 1/8 x 2 3/4 in.

Kurt Schwitters

German, 1887–1948

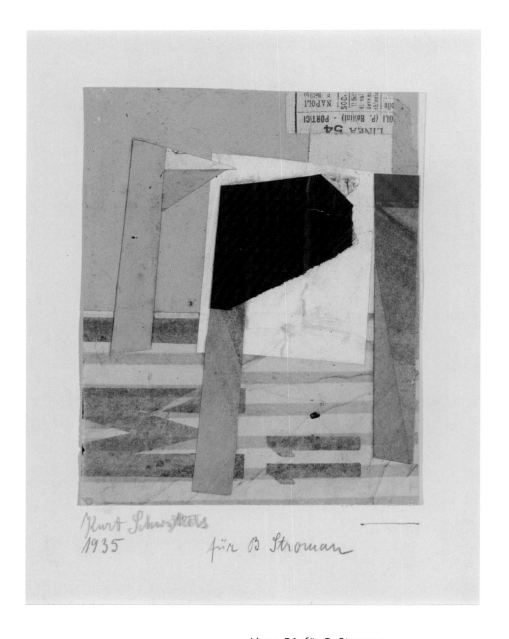

Linea 54, für B. Stroman
(Linea 54, for B. Stroman), 1935
Collage
5 1/4 x 4 1/8 in.

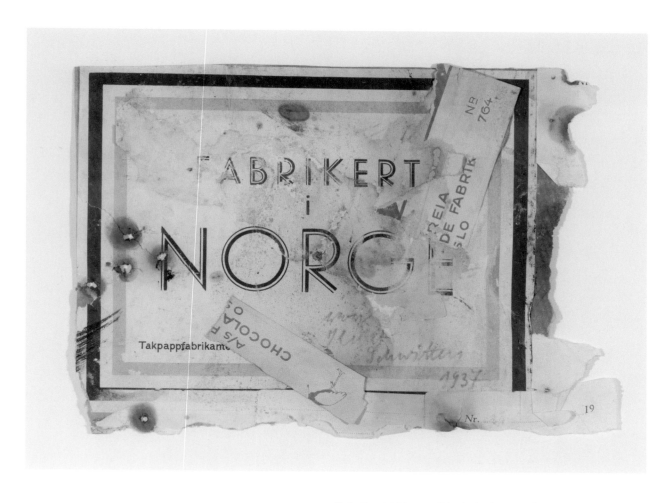

Fabrikert i Norge (Made in Norway), 1937
Collage
5 1/2 x 7 3/4 in.

Kurt Schwitters
German, 1887–1948

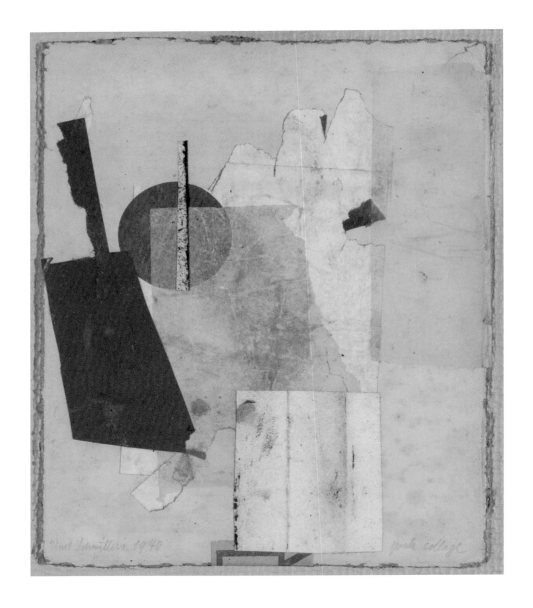

Pink Collage, 1940
Watercolor and collage
10 5/8 x 8 3/4 in.

Kurt Schwitters
German, 1887–1948

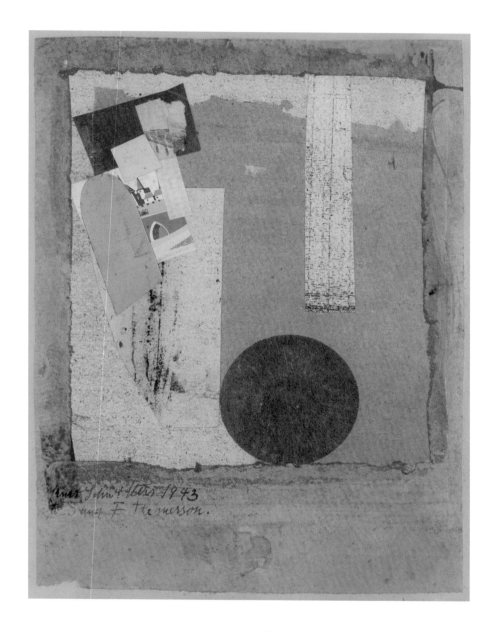

Collage, 1943
Collage
9 x 6 3/4 in.

Kurt Schwitters
German, 1887–1948

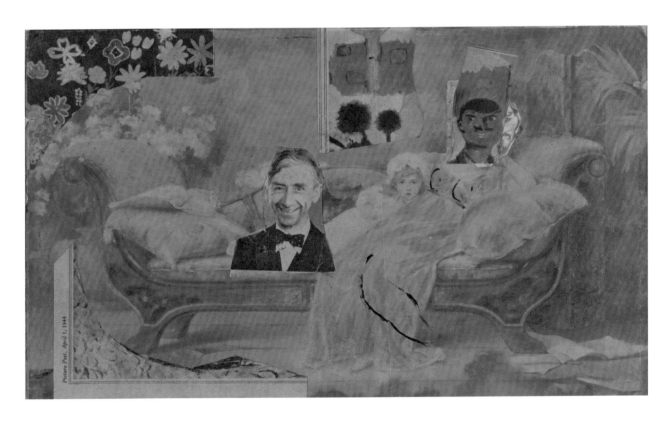

Homage to Sir Herbert Read, 1944
Collage
7 x 10 1/4 in.

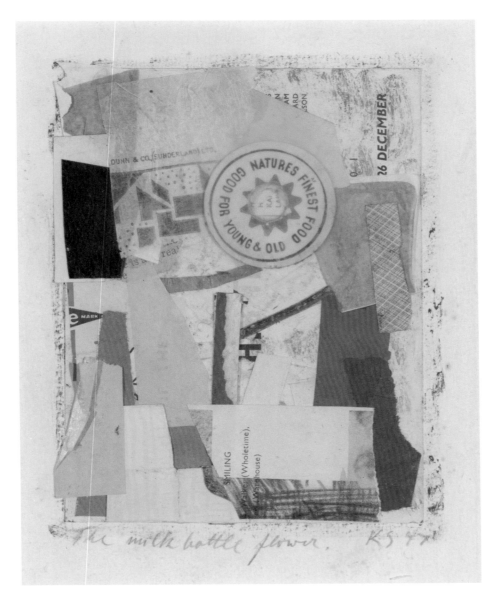

The Milkbottle Flower, 1947
Collage
9 3/4 x 11 1/2 in.

Kurt Schwitters
German, 1887–1948

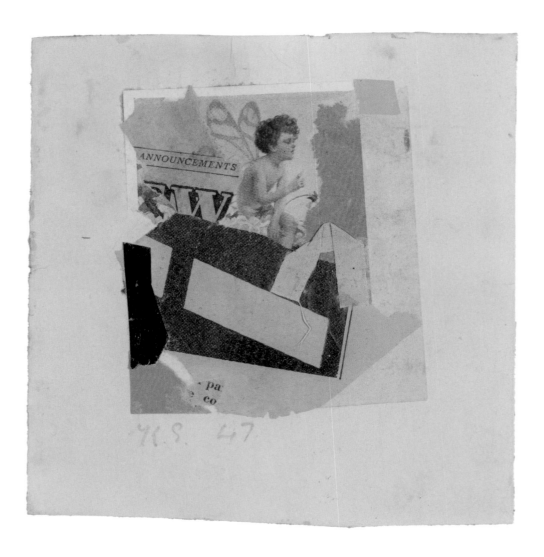

Announcements, 1947
Collage on cardboard
4 x 3 in.

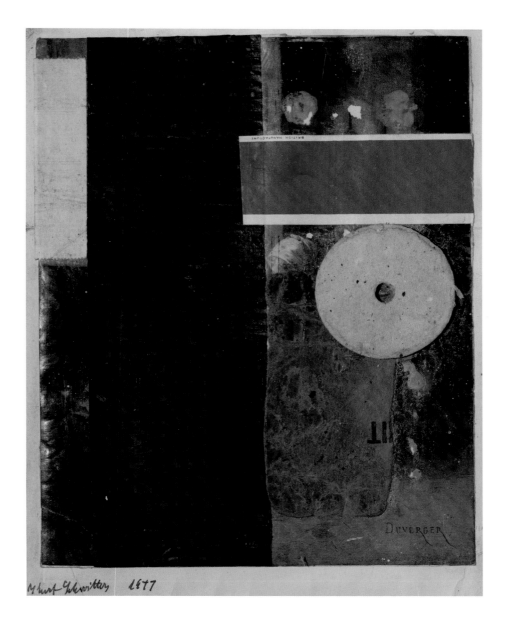

Duverger, 1947
Collage
11 1/4 x 8 1/2 in.

Kurt Seligmann

Swiss, 1900–1962

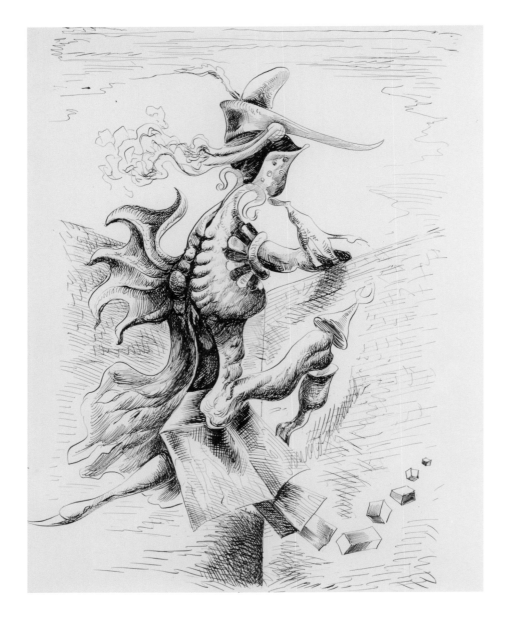

Personnage surréaliste (Surrealist Character),
ca. 1945
Sketch of an illustration for a book by
Georges Hugnet
Ink
23 5/8 x 18 1/8 in.

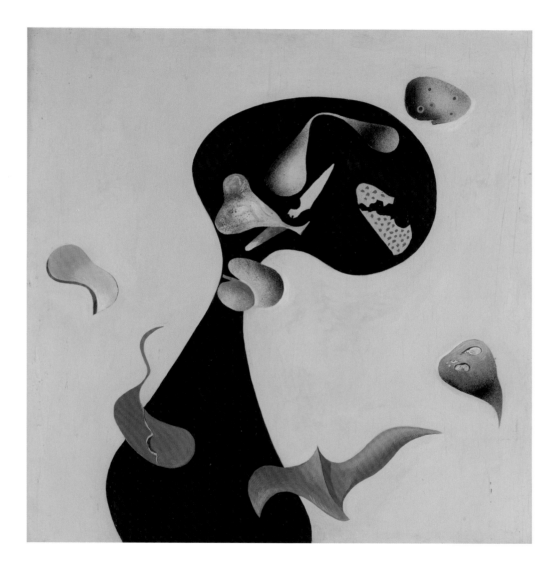

Bust of a Man, 1933
Oil on panel
36 1/4 x 34 3/4 in.

Kurt Seligmann
Swiss, 1900–1962

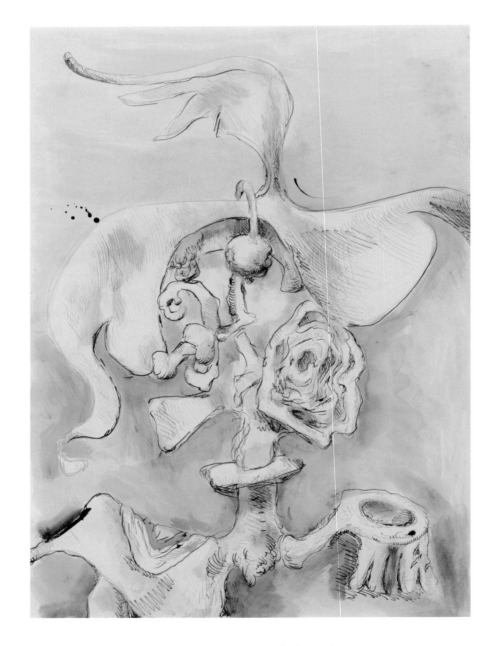

Untitled, ca. 1945
Ink
20 1/2 x 15 1/4 in.

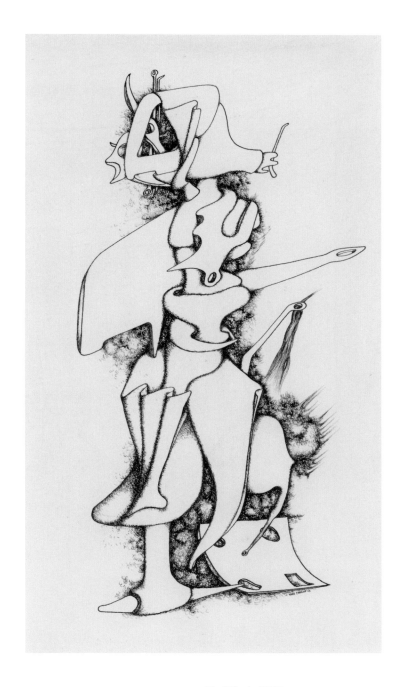

Untitled, 1943
Cover for *Poems for Painters* by
Charles Henri Ford, 1945
Ink
15 x 9 1/4 in.

Yves Tanguy
French, 1900–1955

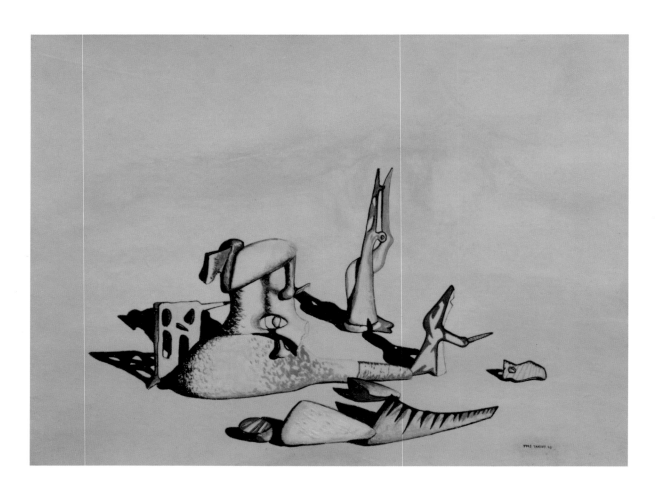

Untitled, 1943
Oil on canvas
9 1/4 x 11 3/4 in.

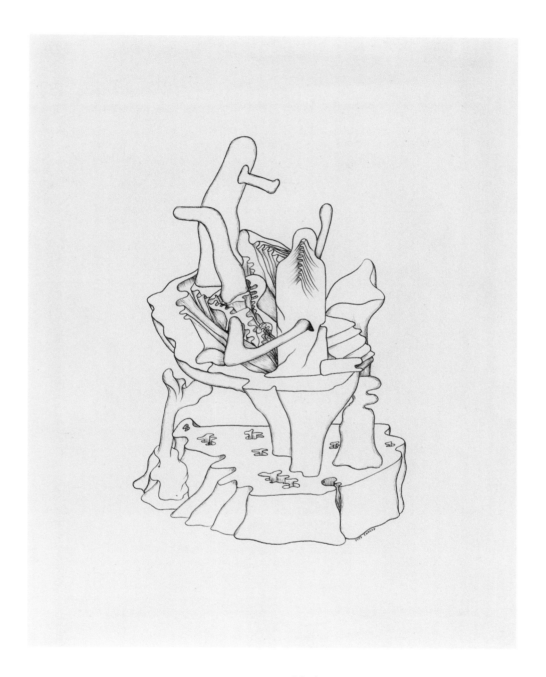

Untitled, ca. 1945
Ink
11 1/2 x 9 1/2 in.

Yves Tanguy
French, 1900-1955

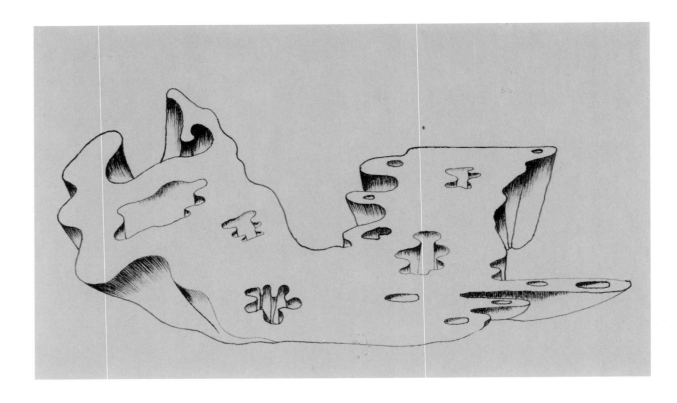

Untitled, ca. 1945
Ink
4 1/2 x 6 3/4 in.

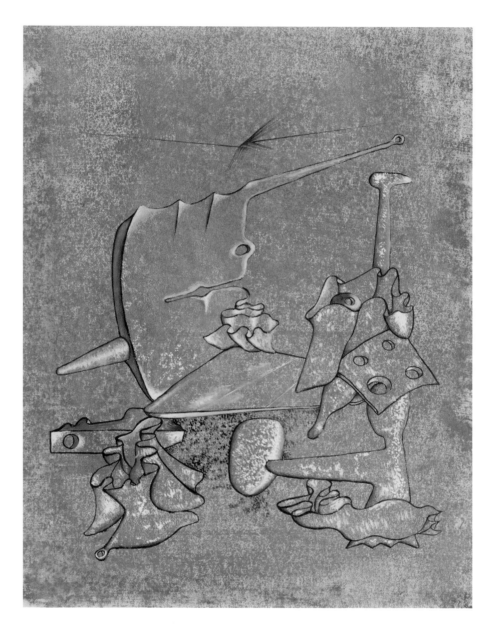

Untitled, 1946
Gouache
11 x 8 1/2 in.

Dorothea Tanning
American, born 1910

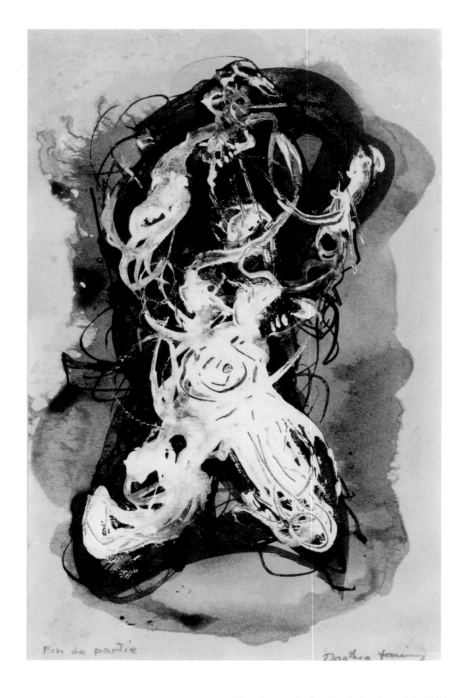

Fin de partie (End of the Match), 1962
Gouache and watercolor
7 1/8 x 4 1/2 in.

Pavel Tchelitchew
American, 1898–1957

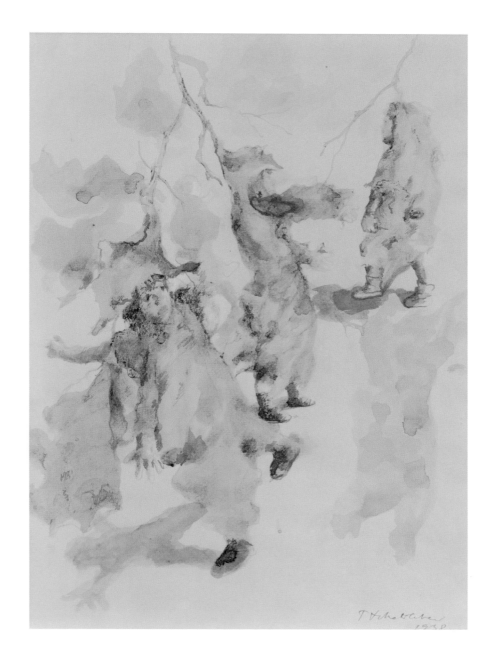

Study for Hide and Seek, 1938
Ink
18 1/2 x 13 1/2 in.

Toyen

(Marie Cermínová)
Czech, 1902–1980

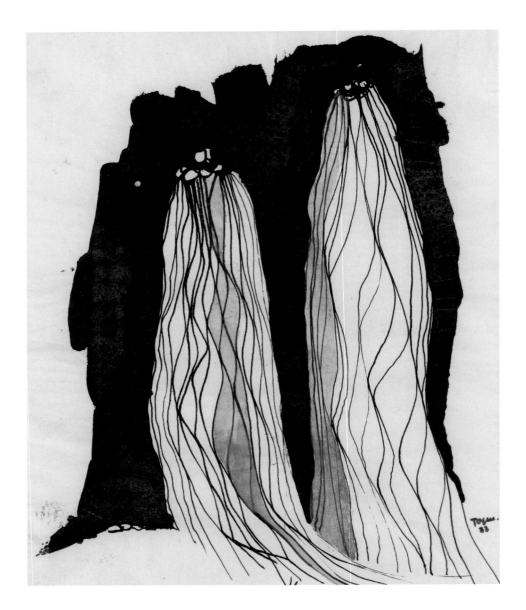

Composition surréaliste, 1933
Ink and watercolor
10 x 8 1/4 in.

Wols
(Alfred Otto Wolfgang Schulze)
German, 1913–1951

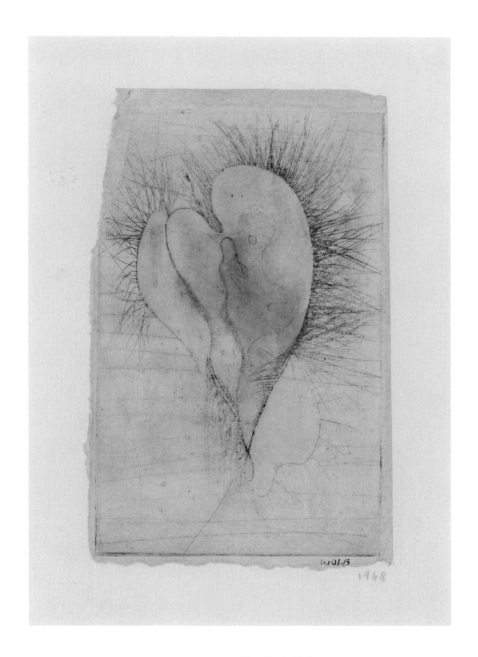

Untitled, 1948
Colored etching
5 1/2 x 3 1/4 in.

Il'ia Mikhailovich Zdanevich
Russian, 1894–1975

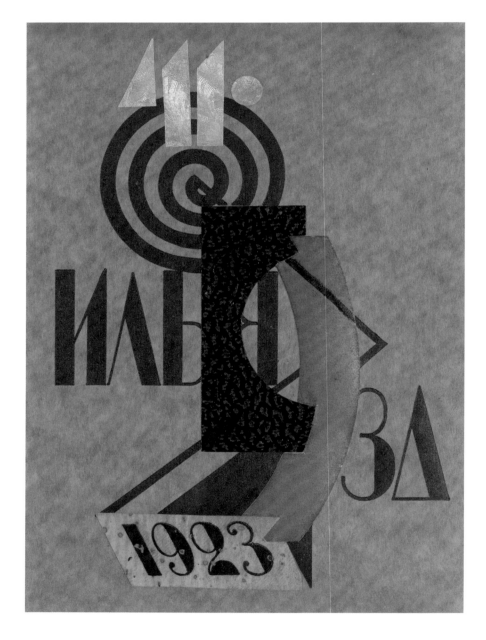

Ledentu le Phare (41 degrees), Paris, 1923
Collage and typographical designs
7 5/8 x 5 3/4 in.

Willi Baumeister
German, 1889–1955
Apoll (Apollo), 1922
Lithograph
14 3/4 x 9 in.

Paul Delvaux
French, 1897–1994
Profile
Etching, ed. 16/35
8 1/4 x 6 1/2 in.

Marcel Duchamp
French, 1887–1968
Self-Portrait in Profile,
1959
Relief print, impression
J of 17 impressions
numbered A-Q
18 1/4 x 15 in.

Alberto Giacometti
Swiss, 1901–1966
Diego Giacometti
Swiss, 1902–1985
Albatross, ca. 1928
Plaster and resin,
artist's proof I/III
18 x 65 x 1 3/4 in.

Natalya Goncharova
Russian, 1881–1962
*Branche fleurie
(Flowery Branch)*
Watercolor
10 1/2 x 6 1/2 in.

*Nuages et matière
(Clouds and Matter)*
Watercolor
10 1/2 x 6 3/4 in.

George Grosz
German, 1893–1959
Sea Anatomy, 1958
Collage
18 1/4 x 14 in.

Auguste Herbin
French, 1882–1960
Composition cubiste,
1918
Ink
7 x 5 in.

Jacques Herold
Romanian, 1910–1987
Untitled, 1941
Ink
8 1/2 x 6 1/2 in.

Hannah Höch
German, 1889–1978
Mother and Child
Ink and watercolor
8 1/4 x 6 1/4 in.

Composition, 1925
Ink and watercolor
3 3/4 x 6 1/2 in.

Abstraction, 1938
Pencil and India ink
9 1/4 x 8 1/2 in.

Adolf Hoffmeister
Czech, 1902–1973
Hommage à Max Ernst,
1934
Collage
20 1/8 x 14 1/4 in.

Georges Hugnet
French, 1906–1974
Untitled, 1961
Collage
5 3/8 x 10 1/2 in.

Marcel Jean
French, 1900–1993
Untitled, ca. 1935
Monotype
13 1/2 x 10 1/2 in.

Ivan Vasilievich Klyun
Russian, 1873–1943
*Composition cubiste ou
hommage à Picasso
(Cubist Composition or
Homage to Picasso)*
Watercolor
8 x 6 1/4 in.

Suprématisme, 1918
Pencil
4 3/4 x 3 3/4 in.

Nina Kogan
Russian, 1887–1942
Composition, ca. 1921
Pencil, India ink, and
watercolor
6 1/2 x 3 1/8 in.

Frantisek Kupka
Czech, 1871–1957
Composition
Watercolor
6 1/2 x 4 1/2 in.

*Composition lyrique
(Lyrical Composition)*
Pencil and watercolor
10 1/4 x 6 in.

Man Ray
(Emmanuel Radnitzky)
American, 1890–1976
*Revolving Doors VI:
Decanter*, 1916–1942
Pencil, ink, and gouache
14 1/4 x 10 3/4 in.

Fisherman's Idol, 1937
after 1927 original
Bronze and marble,
ed. 216/1000
8 x 1 5/8 x 1 5/8 in.

The Lover's Object, 1969
Gelatin silver print
8 x 10 in.

Hans Richter
German, 1888–1976
*Spiegel-Zurück
(Mirror Reflection)*
Pencil and crayon
9 3/4 x 4 1/4 in.

Kurt Schwitters
German, 1887–1948
*Ohne Titel (Prosit
Neujahr!) (No Title
[Happy New Year!])*,
ca. 1907
Ink and gouache on
postcard
3 1/2 x 5 3/4 in.

Untitled, 1922
Collage
5 1/2 x 4 3/8 in.

Kurt Seligmann
Swiss, 1900–1962
*Katherine Dreier at the
Fancy Dress Ball*
Ink
19 1/2 x 18 1/4 in.

Yves Tanguy
French, 1900–1955
Composition surréaliste,
1943
Ink
11 1/2 x 10 1/2 in.

Untitled, ca. 1945
Etching and aquatint
with hand coloring,
ed. 2/5
3 5/8 x 2 5/8 in.

Dorothea Tanning
American, born 1910
*Le soir à Saragossa
(Evening at Zaragoza)*,
1965
Oil on canvas
7 1/4 x 5 1/2 in.

Recommended Reading

Ades, Dawn. *Dada and Surrealism Reviewed*. London: Arts Council of Great Britain, 1978.

———. *Dalí* [exh. cat., Philadelphia Museum of Art]. New York: Rizzoli, 2004.

Ades, Dawn, Neil Cox, and David Hopkins. *Marcel Duchamp*. London: Thames and Hudson, 1999.

Agee, William C. *Morton Livingston Schamberg: The Machine Pastels* [exh. cat., Salander-O'Reilly Galleries, Inc.]. New York: Salander-O'Reilly Galleries, 1986.

Bailly, Jean-Christophe. *Kurt Schwitters*. Trans. Jean-François Poirier. Paris: Hazan Editions, 1997.

Barr, Jr., Alfred H., ed. *Fantastic Art, Dada, Surrealism*. New York: Museum of Modern Art and Simon & Schuster, 1947.

Baur, John I. H. *George Grosz* [exh. cat., Whitney Museum of American Art]. New York: Macmillan, 1954.

Bernheim, Cathy. *Valentine Hugo*. Paris: Presses de la Renaissance, 1990.

Berry-Hill Galleries, Inc. *Leon Kelly: American Surrealist* [exh. cat., Berry-Hill Galleries]. New York: Berry-Hill Galleries, Inc., 1999.

Bonk, Ecke, ed. *Marcel Duchamp: The Box in a Valise: De ou par MARCEL DUCHAMP ou RROSE SELAVY*. Trans. David Britt. New York: Rizzoli, 1989.

Boswell, Peter, et al. *The Photomontages of Hannah Höch* [exh. cat., Walker Art Center]. Minneapolis: Walker Art Center, 1996.

Bowlt, John, and Matthew Drutt, eds. *Amazons of the Avant-Garde* [exh. cat., Deutsche Guggenheim Berlin]. New York: Solomon R. Guggenheim Foundation, 1999.

Buckley, Harry E. *Guillaume Apollinaire as an Art Critic*. Ann Arbor: UMI Research Press, 1981.

Burns-Gamard, Elizabeth. *Merzbau: The Cathedral of Erotic Misery*. New York: Princeton Architectural Press, 2000.

Camfield, William A. *Francis Picabia* [exh. cat., Solomon R. Guggenheim Museum]. New York: Solomon R. Guggenheim Museum, 1970.

_____. *Francis Picabia: His Art, Life, and Times*. Princeton, NJ: Princeton University Press, 1979.

_____. *Marcel Duchamp: Fountain* [exh. cat., The Menil Collection]. Houston: The Menil Collection, 1989.

_____. *Max Ernst: Dada and the Dawn of Surrealism* [exh. cat., The Menil Collection]. Houston: The Menil Collection, 1993.

Chadwick, Whitney. *Women Artists and the Surrealist Movement*. Boston: Little, Brown, 1985.

———, ed. Essays by Dawn Ades, et al. *Mirror Images: Women, Surrealism, and Self-Representation*. Cambridge: The MIT Press, 1998.

Chanzit, Gwen Finkel. *Herbert Bayer and Modernist Design in America*. Ann Arbor: UMI Research Press, 1987.

Cohen, Arthur A. *Herbert Bayer: The Complete Work*. Cambridge: The MIT Press, 1984.

Davidson, Susan, et al. *Victor Brauner: Surrealist Hieroglyphs*. Houston: The Menil Collection, 2001.

Dervaux, Isabelle, ed. *Surrealism USA* [exh. cat., National Academy Museum, New York]. Ostfildern, Germany: Hatje Cantz, 2004.

D'Harnoncourt, Anne, and Kynaston McShine, eds. *Marcel Duchamp* [exh. cat., Museum of Modern Art]. New York: Museum of Modern Art, 1973.

Dickerman, Leah, ed. *Dada* [exh. cat., National Gallery of Art, Washington, and others]. Washington, DC: National Gallery of Art, 2005.

Dickerman, Leah, and Matthew S. Witkovsky, eds. *The Dada Seminars*. Washington DC: National Gallery of Art, 2005.

Dietrich, Dorothea. *The Collages of Kurt Schwitters: Tradition and Innovation*. New York: Cambridge University Press, 1993.

Duncan, Michael, ed. *Pawel Tchelitchew: The Landscape of the Body* [exh. cat., Katonah Museum of Art]. Katonah, NY: Katonah Museum of Art, 1998.

Duve, Thierry de, ed. *The Definitively Unfinished Marcel Duchamp*. Cambridge: The MIT Press, 1991.

———. *Pictorial Nominalism: On Marcel Duchamp's Passage from Painting to the Readymade*. Trans. Dana Polan. Minneapolis: University of Minnesota Press, 1991.

L'Ecotais, Emmanuelle de, and Alain Sayag, eds. *Man Ray: Photography and Its Double* [exh. cat., Musée national d'art moderne, Centre Georges Pompidou]. London: Gingko Press, 1998.

Elderfield, John. *Kurt Schwitters*. London: Thames and Hudson, 1985.

Elliot, David, ed. *Rodchenko and the Arts of Revolutionary Russia*. New York: Pantheon Books, 1979.

Fauchereau, Serge. *Kupka*. New York: Rizzoli, 1999.

Flavell, Mary Kay. *George Grosz, a Biography*. New Haven: Yale University Press, 1988.

Foresta, Merry, et al. *Perpetual Motif: The Art of Man Ray* [exh. cat., National Museum of American Art, Smithsonian Institution Washington DC]. New York: Abbeville Press, 1988.

Foster, Stephen C., ed. *Crisis and the Arts: The History of Dada*. 10 vols. New York: G. K. Hall and Co., 1997–2005.

———, ed. *Hans Richter: Activism, Modernism, and the Avant-Garde*. Cambridge: The MIT Press, 1998.

Grohmann, Will. *Willi Baumeister: Life and Work*. Trans. Robert Allen. New York: Harry. N. Abrams, 1966.

Hammacher, Abraham. *Magritte*. New York: Harry N. Abrams, 1974.

Haskell, Barbara. *Burgoyne Diller* [exh. cat., Whitney Museum of American Art]. New York: Whitney Museum of American Art, 1990.

Heiting, Manfred, ed. *Man Ray: 1890–1976*. New York: Taschen, 2000.

Henderson, Linda D., *Duchamp in Context: Science and Technology in the* Large Glass *and Related Works*. Princeton, NJ: Princeton University Press, 1998.

Hoek, Els, ed. *Theo van Doesburg, oeuvre catalogue.* Utrecht and Otterlo, The Netherlands: Centraal Museum Utrecht, 2000.

Hopkins, David. *Marcel Duchamp and Max Ernst: The Bride Shared.* Oxford: Claredon Press, 1998.

Hubert, Renée Riese. *Magnifying Mirrors: Women, Surrealism, and Partnership.* Lincoln: University of Nebraska Press, 1994.

Hulten, Pontus, ed. *Marcel Duchamp, Work and Life.* Cambridge: The MIT Press, 1993.

Iles, Chrissie. *Marcel Duchamp – Man Ray: 50 Years of Alchemy.* New York: Sean Kelly Gallery, 2004.

Jones, Amelia. *Postmodernism and the En-Gendering of Marcel Duchamp.* New York: Cambridge University Press, 1993.

Joselit, David. *Infinite Regress: Marcel Duchamp, 1910–1941.* Cambridge: The MIT Press, 1998.

Judovitz, Dalía. *Unpacking Duchamp: Art in Transit.* Berkeley: University of California Press, 1995.

Kirstein, Lincoln. *Tchelitchev.* Santa Fe: Twelvetrees Press, 1994.

Krauss, Rosalind E. *The Optical Unconscious.* Cambridge: The MIT Press, 1993.

Krauss, Rosalind E. and Jane Livingston. *L'amour fou: Photography and Surrealism* [exh. cat., Corcoran Gallery of Art, Washington, DC]. New York: Abbeville Press, 1985.

Kosinski, Dorothy, ed. *Painting the Universe: Frantisek Kupka, Pioneer in Abstraction* [exh. cat., Dallas Museum of Art, et al.]. Ostfildern, Germany: Hatje Cantz Publishers, 1997.

Kuenzli, Rudolf E., ed. *New York Dada.* New York: Willis, Locker, & Owens, 1986.

Kuenzli, Rudolf E. and Francis M. Naumann, eds. *Marcel Duchamp: Artist of the Century.* Cambridge: The MIT Press, 1989.

LaFountain, Marc. *Dalí and Postmodernism: This is Not an Essence.* Albany: State University of New York Press, 1997.

Lavin, Maud. *Cut with the Kitchen Knife: The Weimar Photographs of Hannah Höch.* New Haven: Yale University Press, 1993.

Lebel, Robert. *Marcel Duchamp.* Trans. George Heard Hamilton. New York: Grove Press, 1959.

Legge, Elizabeth M. *Max Ernst: The Psychoanalytic Sources.* Ann Arbor: UMI Research Press, 1989.

Lewis, Beth Irwin. *George Grosz: Art and Politics in the Weimar Republic.* Princeton, NJ: Princeton University Press, 1991.

Lichtenstein, Therese. *Behind Closed Doors: The Art of Hans Bellmer.* New York: International Center of Photography, 2001.

Lukach, Joan. *Hilla Rebay: In Search of the Spirit in Art.* New York: G. Braziller, 1983.

Lust, Herbert C. *Hans Bellmer.* New York: Isidore Ducasse Fine Arts, 1990.

Maur, Karin von, ed. *Yves Tanguy and Surrealism.* Trans. John Brownjohn and John Southard. Ostfildern, Germany: Hatje Cantz, 2001.

McCloskey, Barbara. *George Grosz and the Communist Party: Art and Radicalism in Crisis.* Princeton, NJ: Princeton University Press, 1997.

Mehring, Christine. *Wols Photographs* [exh. cat., Busch-Reisinger Museum]. Cambridge: Busch-Reisinger Museum, 1999.

Molesworth, Helen, ed. *Part Object, Part Sculpture* [exh. cat., Wexner Center for the Arts, Ohio]. University Park: Pennsylvania State University Press, 2005.

Moorhouse, Paul. *Dalí.* San Diego: Thunder Bay Press, 1998.

Moser, Joann. *Jean Metzinger in Retrospect* [exh. cat., University of Iowa Museum of Art]. Iowa City: University of Iowa Museum of Art, 1985.

Mundy, Jennifer, ed. *Surrealism: Desire Unbound* [exh. cat., Tate Modern]. Princeton, NJ: Princeton University Press, 2001.

Museum Jean Tinguely. *Kurt Schwitters: Merz—A Total Vision of the World* [exh. cat., Museum Jean Tinguely, Basel]. Wabern, Germany: Benteli, 2004.

Naumann, Francis M. *Conversion to Modernism: The Early Works of Man Ray* [exh. cat., Montclair Art Museum]. New Brunswick: Rutgers University Press, 2003.

———. *Making Mischief: Dada Invades New York* [exh. cat., Whitney Museum of American Art]. New York: H. N. Abrams, 1996.

———. *Man Ray in America. Paintings, Drawings, Sculpture, and Photographs* [exh. cat., Francis M. Naumann Fine Art]. New York: Francis M. Naumann Fine Art, 2001.

———. *Man Ray: The New York Years, 1913–1921* [exh. cat., Zabriskie Gallery]. New York: Zabriskie Gallery, 1988.

———. *Marcel Duchamp: The Art of Making Art in the Age of Mechanical Reproduction.* Ghent: Ludion Press, 1999.

Naumann, Francis M. and Hector Obalk, eds. *Affectionately, Marcel: The Selected Correspondence of Marcel Duchamp.* Trans. Jill Taylor. Ghent: Ludion Press, 2000.

Neff, Terry Ann, ed. *In the Mind's Eye: Dada and Surrealism* [exh. cat., Museum of Contemporary Art, Chicago]. New York: Abbeville Press, 1985.

Nisbet, Peter, ed. *El Lissitzky, 1890–1941* [exh. cat., Sprengel Museum, Hannover, and Staatliche Galerie Moritzburg, Halle]. Cambridge: Harvard University Art Museums, 1987.

Onslow-Ford, Gordon. *Yves Tanguy and Automatism.* Inverness, CA: Bishop Pine Press, 1983.

Orchard, Karin, and Isabel Schulz, eds. *Kurt Schwitters. Catalogue raisonné.* 2 vols. Ostfildern, Germany: Hatje Cantz, 2003.

Perloff, Nancy, and Brian Reed, eds. *Situating El Lissitzky: Vitebsk, Berlin, Moscow.* Los Angeles: Getty Research Institute, 2003.

Phelps, Julia, ed. *German Art in the Twentieth Century.* Trans. Catherine Hutter. Greenwich: New York Graphic Society, 1968.

Pierre, Arnauld. *Frank Kupka in White and Black.* Liverpool: Liverpool University Press, 1998.

Radford, Robert. *Dalí.* London: Phaidon Press, 1997.

Rathke, Ewald. *Wols: Drawings and Watercolours* [exh. cat., Goethe Institute]. Trans. Anthony Vivis. London: Goethe Institute, 1985.

Rubin, William, and Carolyn Lanchner. *André Masson* [exh. cat., Museum of Modern Art]. New York: Museum of Modern Art, 1976.

Sarabianov, Dmitri, and Natalia Adaskina. *Popova.* Trans. Marian Schwartz. New York: Harry N. Abrams, 1990.

Sawelson-Gorse, Naomi, ed. *Women in Dada: Essays on Sex, Gender, and Identity.* Cambridge: The MIT Press, 1998.

Schaffner, Ingrid, and Colin Westerbeck. *Accommodations of Desire: Surrealist Works on Paper Collected by Julien Levy* [exh. cat., Curatorial Assistance Traveling Exhibitions, Pasadena, California]. Pasadena: Curatorial Assistance, Inc., 2004.

Schmalenbach, Werner. *Kurt Schwitters.* New York: Harry N. Abrams, 1970.

AMANDA FOODY

QUEEN OF VOLTS

inkyard PRESS

ISBN-13: 978-1-335-14586-4

Queen of Volts

Inkyard Press
22 Adelaide St. West, 40th Floor
Toronto, Ontario M5H 4E3, Canada
www.InkyardPress.com

Printed in U.S.A.

To Mom, for showing me the magic of books

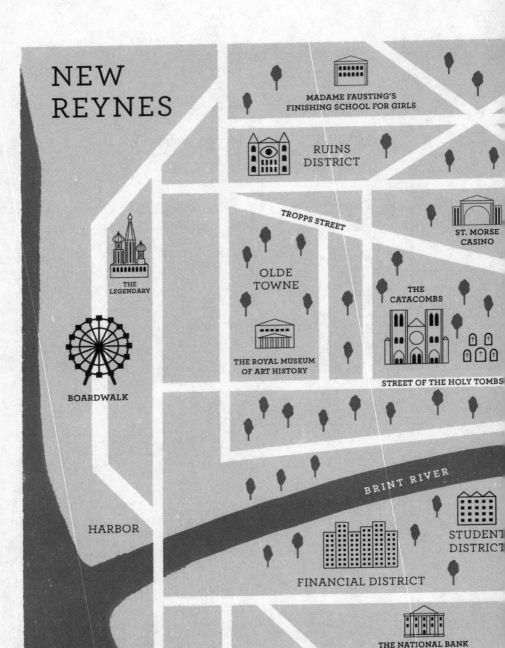

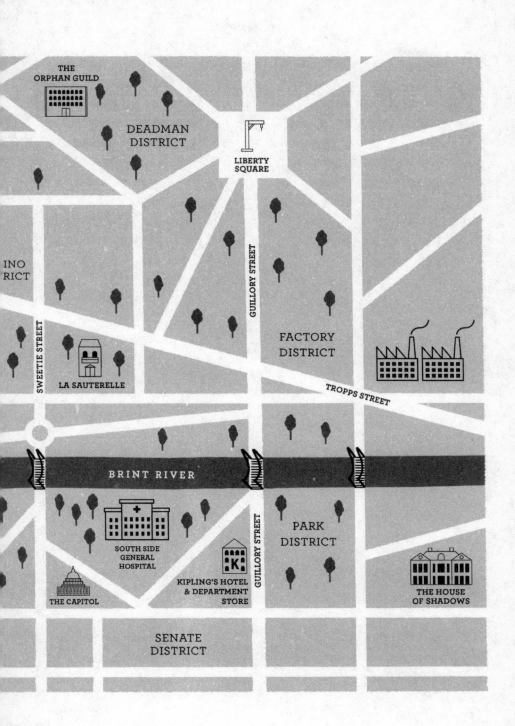

STRENGTH

"Some cities respect their history.
New Reynes burned it."

Séance. "The Revolution Racket."
Her Forgotten Histories
17 Aug YOR 19

HARVEY

It was early morning when Harvey Gabbiano dug the grave.

Harvey didn't like the cemeteries in the Deadman District, precisely because they *were* cemeteries. Most people didn't know it, but there was a difference between a cemetery and a graveyard—graveyards were connected to a church. But the only place to find devotion in this neighborhood was at the bottom of a bottle.

This cemetery was a bleak, soulless plot of land, made bleaker by the drizzle that had soaked through Harvey's clothes. Rusted industrial plaques marked each of the graves. There were no flowers anywhere, not even weeds, and the unkept grass grew patchy and brown.

"It would've been easier if you'd burned it," Bryce told him. He'd watched Harvey work all morning, but not once had he offered to help...or even to share his umbrella. Bryce didn't see the point in helping with tasks he disapproved of, even if this task was important to Harvey.

"It's holier to bury him," Harvey repeated yet again. Even

though Harvey was Faithful, he wouldn't have gone to all this trouble had the deceased not been wearing a Creed of his own. He didn't know many others who practiced the Faith anymore—it had been banned for so long now. "You don't have to stay."

"I'm staying. You're funny, you and those superstitions of yours. I could use a laugh."

Harvey didn't know how Bryce could find humor in the situation. The November weather was cold. The cemetery was irreverent and depressing. The dead had not deserved to die.

But Bryce had come with him, and so, no matter the circumstances, Harvey couldn't help but feel a little bit pleased.

"I'm not doing this to be funny," Harvey responded, forcing his voice into a grumble. He pressed his bulky leather boot against the step of the shovel. The mud he lifted glinted with green shards of broken bottles.

"My mistake," Bryce said dryly. "You're doing this to be decent."

Harvey absolutely was doing it to be decent. To be *good*. Because Harvey might not have been the person who killed this man or any of the other hundred who'd perished two nights ago at the party in St. Morse Casino, but as long as he remained hopelessly in love with Bryce Balfour, he would always have blood on his hands.

It was hard not to glance at his friend as he worked. Harvey hated to look at him. But he didn't need to—he had long ago memorized every agonizing detail of his face, his figure, his posture. Bryce could be absent and still be Harvey's distraction.

Harvey hated himself for it.

The body made a *thump* when he pushed it into the hole.

Harvey straightened, his back aching from the exertion, his fingers blistered even through his gloves. The hours of rain had made the dried blood on the body and clothes run again, and the flattened brown grass it had been lying on moments be-

fore was now flooded with red. Harvey watched as the puddles washed the blood away, and he murmured a silent prayer that the rain would do the same for his immortal soul.

"Harvey," Bryce said sharply.

Harvey's gaze shot toward him, and he flinched. Bryce hadn't worn his brown-colored contacts since that night at St. Morse, when he revealed himself to be a malison, someone with the talent to create curses known as shades, a talent the world feared but hadn't believed to truly exist. And despite always knowing what Bryce was, Harvey wasn't used to this adjustment.

Bryce's malison scarlet eyes were a reminder of how low Harvey had fallen.

But Harvey's gaze didn't stop there—of course it didn't. It traveled across Bryce's face, down concave cheekbones and lips chapped from kissing someone who wasn't him. Down bony shoulders and a tall, skinny frame, over threadbare clothes and a black wool coat that draped shapelessly over him. Harvey lingered on the places *he* had kissed, on slender fingers and narrow hips and the smooth pale skin between. Those memories haunted him.

Bryce didn't pay Harvey's staring any attention. He never did. His concentration was focused on the card in his hand. He ran his thumb over its foiled gold back.

It was a Shadow Card, one of the cursed cards the Phoenix Club used to play the Shadow Game. Except it wasn't. Shadow Cards were silver. This one belonged to a different game, one Bryce and his girlfriend, Rebecca, had devised themselves, one they had set in motion at St. Morse two nights prior. Harvey had helped them deliver golden cards to every designated "player" across New Reynes, and now all that remained was to wait for the star player to make a move.

"They're here. I can feel it," Bryce said hoarsely, squeezing the card so hard it bent.

By "they," he meant the Bargainer. The City of Sin treated

all of its legends with a hallowed reverence, and this one was the oldest, most famous of them all: the wandering Devil who would bargain for anything. Bryce had been obsessed with the tale for a year, ever since Rebecca had fallen sick. Despite every effort—ethical or otherwise—Rebecca wasn't improving, and Bryce had convinced himself that her last hope for a cure was the Bargainer's power. It was why he'd murdered all those people at St. Morse—a desperate, ruthless attempt for the Bargainer's attention.

I'll sell my soul, if that's what it takes, Bryce had once confided in Harvey, back when his smiles weren't so much like sneers, when he looked more like the boy Harvey used to love—the kinder version of himself, the one Harvey couldn't manage to let go of. Though Harvey had never voiced his opinion, Bryce had lost his soul the moment he'd formulated this despicable plan.

They all had.

Harvey tried to ignore Bryce's words. In the legend, the Bargainer approached people of their own choosing. The only way to summon them directly was through chaos.

Surely Bryce wouldn't attempt such evil, Harvey had once told himself.

But he had, and since that night at St. Morse, all of New Reynes seemed ablaze. The Scarhands, the largest gang in the seedy North Side, had crumbled, their lord executed. Séance, the notorious assassin of Chancellor Malcolm Semper, had been unmasked as both the last surviving Mizer and, to the city's shock, a seventeen-year-old girl from finishing school. Mafia donna Vianca Augustine had been shot dead, and her son had won his election. Luckluster Casino had burned, and the Torren Family empire along with it.

Thanks to Bryce, the City of Sin was in a state worse than chaos—it was in hell.

And now the Devil had returned home.

Even though Harvey was an accomplice in Bryce's plans, the thought of all that had transpired—and all that was still left to unfold—filled him with dread. He tried to focus on the shovel and the dirt and the grave, on this *one good thing*, but his sins weighed heavy on his soul.

"Harvey," Bryce snapped again. He never tolerated being ignored.

Harvey sighed. "How can you be certain the Bargainer *is* in New Reynes now?"

"I told you. I can feel it."

At that moment, the rain began to fall harder, shifting from a drizzle into a downpour. Harvey's brown corkscrew curls stuck against his fair skin, and he wiped the water from his eyes.

"Why haven't they come to me yet?" Bryce rasped, his hands trembling while he clutched his umbrella. "I'm the one who summoned them. I deserve my bargain."

"The legends never mentioned whether the Bargainer was prompt," Harvey pointed out. He dumped another pile of mud into the hole.

Bryce's lips formed a thin line. He trudged over to the grave. The body was now entirely covered with earth, but the plot was only half-filled. "That's good enough. We should go back."

"You can go. I'll finish," Harvey told him.

Bryce nodded and fiddled with his card anxiously. It was moments like these, when he looked so young and vulnerable, that made Harvey weak. Because even if Bryce Balfour had lost his soul, Harvey still kindled a hope that it could be found. That *he* could be the one to find it.

"Never mind," Harvey murmured. "I'll go with you."

Harvey heaved his shovel over his shoulder, said a final prayer for Jac Mardlin and his unfinished, unmarked grave, and followed his friend home.

II

THE MAGICIAN

"Call the Faith's superstitions fear-mongering,
if that's what you like. But don't pretend they aren't true."

Shade. "Liberty, Equality, and Faith."
The Treasonist's Tribunal
26 Feb YOR 8

LOLA

Lola Sanguick strode down the Street of the Holy Tombs carrying a leather briefcase crammed full of newspapers. Dark circles sagged beneath her eyes, a souvenir from sleepless nights spent with her ear tethered to the radio. For the past week, everyone in her life had boarded themselves indoors. They'd chattered and drank and mourned and cried, but no one—*no one*—had stopped their noise to pay attention to the omens really gathering in the City of Sin.

Sometimes Lola felt she was the only one who did.

The Street of the Holy Tombs was the unsettling heart of Olde Town, a historic North Side neighborhood of spindly streets and church towers casting it in perpetual skin-creeping shadow. The superstitions of New Reynes thrived here: the haunted tinkling of Faith bells, the wrought iron gates and gothic spires reaching teeth-like toward the sky. As though this street was designed to coerce a frightened prayer from even the lips of nonbelievers.

A tinny bell chimed as Lola shook away her goosebumps and opened the door to an office.

Despite the welcome mat by the door, the place must not have received many visitors. Dust clung to every surface, and the air smelled stale, all of the windows boarded, curtains drawn. Lola would've thought it abandoned, if not for the woman hunched over her work.

The woman was fair and middle-aged, with a waist-length braid of brown hair and a massive wooden Creed dangling from her neck—a Faith symbol that resembled a *T* with a circle at its base. When she blinked, Lola noticed black tattoos of eyes inked on the back of her eyelids, as though, even with her eyes closed, she could always see.

Lola had never met the woman before, and a shiver crept up her spine at the woman's cold, fixed stare.

"Why are you here?" the woman asked, by way of a greeting.

Because no one else will listen, Lola thought bitterly.

Lola didn't tell her that, in case that made her sound paranoid. More than anything, Lola hated being called paranoid, and it was that word—spoken groggily that very morning by her half-asleep girlfriend when Lola tried to explain her worries—that had prompted Lola to yank her briefcase out from the secret nook in the closet and storm her way here.

Lola liked to consider herself clever for the way she noticed details others overlooked. Like when she'd spotted bloodied handkerchiefs buried at the bottom of her family's waste bins, and her father had succumbed to pneumonia less than a week later. Like when her eldest brother had stopped buying more paper for his typewriter, and the month afterward, Lola had discovered he'd been expelled from university. Or when her other brother's mood swings and rages turned to silence, and then he'd abandoned their family altogether.

There were warning signs now, too, but her friends roman-

ticized the city's tragic legends too much to understand where their story was truly heading.

Twenty-six years after the tryannical ruling class had been slaughtered, a Mizer had been discovered alive.

A Mizer in known partnership with an orb-maker, both of whose ancestors had governed the world side by side.

Partners who'd assassinated the man who'd started the Revolution.

Partners who'd committed countless other crimes against the Republic, and who kept company of the seediest sort.

And meanwhile, an election even the public regarded as corrupt. A massacre committed by a malison who possessed the very talent the Mizer kings had once vilified. And the victims—so many, too many—dead.

A reckoning was coming for the City of Sin—and if not revolution, if not war, then it would bring violence all the same. Lola wasn't paranoid for heeding its warning signs; she was merely clever enough to pay attention.

But there were still mysteries left unsolved, which was why Lola had wandered so deep into Olde Town for answers. Her friends dismissed her concerns now, but they might need these answers, once the reckoning arrived. They would need every weapon they could find.

Rather than telling the woman why she was here, Lola decided it would be better to show her. Lola slammed her briefcase atop her desk and unlatched it. She pulled out stacks of newspapers and clippings. Many came from *The Crimes & The Times*, including editorials comparing the most recent turmoil in New Reynes to the so-called Great Street War nineteen years ago, the golden age of North Side crime. Others dated *from* the Great Street War, historic pieces which Lola had stolen from the National Library. Scattered through were copies of *Her Forgotten Histories*, the very newspaper printed in this

office. Lola's simple and neat handwriting wove between the indents and margins of everything in violently red ink.

"How…" the woman started, and Lola braced herself for that word she hated "…diligent."

"Yes, well, I have lots of questions," Lola said, somewhat flustered, somewhat proud. "And I think you're the only one who can answer them."

"Why me?" asked Zula, knotting her brow.

Because Zula Slyk wasn't just the publisher of *Her Forgotten Histories*, the only newspaper Lola had come to trust; she was the last surviving member of the Pseudonyms, a group of anonymous journalists who'd once dug up the secrets so damning that even the City of Sin had tried to keep them buried.

"Because you were Lourdes Alfero's friend," Lola answered. Enne's adoptive mother used to write for Zula's newspaper. "And I'm her daugther's."

That answer must have sufficed because Zula leaned forward and parsed through Lola's feeble collection of discarded history.

"What do you already know?" Zula asked her. Her words had a grave quality to them, like a physician asking how far her symptoms had progressed.

"I know…" A lump caught in Lola's throat. Zula might have spent her days surrounded by empty desks, suspicious of visitors, her frown and worry lines etching deeper into her face, but Lola had never wanted to impress anyone as much as she did her.

She would not call Lola paranoid.

Lola frantically flipped through the clippings until she came upon a page torn from a book, and her finger trembled as she jabbed a highlighted name. "Enne's real blood name is Scordata, and I discovered that before the Revolution, the Scordatas were a lesser noble family here, in Reynes. And I know the name comes from her father, that he was the Mizer who passed down her blood talent."

Lola was a blood gazer, someone with the ability to read another person's talents and discern from which parent they had inherited them. Talents were a tricky business: every person was born with two. The stronger was called the blood talent, and the weaker was dubbed the split talent. Their abilities ranged from simple skills like music—Lola's own split talent—to powers crudely described as magic.

Parents only passed down their blood talents, but it was random, which parent gave the child the stronger or weaker one. Lola had been the only powerful blood gazer of her siblings.

But she wasn't just powerful—she was good, relying on thorough research to supply whatever information her talent could not. Otherwise Lola wouldn't have deduced as much about Enne's lineage as she'd managed. She just needed to prove herself to Zula.

"So I know a lot, but I still have questions," Lola continued, attempting to sound confident. "The whole Scordata family was supposedly killed at least nine years before Enne was born. So who was her father? Some kind of bastard?" This was the only conclusion Lola had come up with, but the Mizers had been meticulous about records and registering talents. It wasn't likely.

"A lucky find," Zula told her flatly, "but a dead end. You won't find anything thinking like this."

Lola's pale, freckled cheeks grew warm. "I also know her mother was Gabrielle Dondelair." During the time of the Great Street War, Gabrielle had been a famous criminal and Mizer sympathizer, and she'd gotten herself killed for it.

"Well, you clearly know everything. So you don't need me."

Zula measured every bit as unpleasant as Enne had described her. Lola squeezed the fragile papers so hard they ripped.

"I do need you," she said desperately. "I need to know the answers. How did Enne's father survive the Revolution? How did Enne end up in the hands of an underground journalist, to be raised hundreds of miles from New Reynes in secret? Why

would Lourdes Alfero ever send Enne back to the same city she'd kept her from? To an orb-maker, when that association looks so...damning? I feel like I've been circling the answers for months, but I can't seem to—"

"Get out," Zula snapped, closing her eyes so her tattooed ones could seem to glare at Lola instead.

Lola's confidence tore even easier than the papers. "I—I just want—"

"No, you don't. You don't want this."

Truthfully, Lola Sanguick had never wanted any of it. She hadn't wanted to work for the Orphan Guild, but the criminal temp agency had offered a flimsy means to find her last surviving brother when nothing else did. She hadn't wanted to pledge her allegiance to Enne with a shard of glass pressed against her throat. She hadn't wanted to find herself at the center of a new street war, of a tragic legend, one all of her friends seemed so willing to die for.

Well, she wasn't going to let them.

Lola pulled a card out of her pocket and threw it on the desk. The illustration of the Hermit stared warily at the both of them.

Zula's face went ashen. She glanced—imperceptibly—at the stack of papers beside her, and Lola wondered if another card like hers lay hidden beneath, one also with gold foil on its back instead of silver. Zula knew many of the city's secrets; maybe she was a player, too.

Lola pressed further. "Whatever this game is, whatever Bryce Balfour is—" because despite the claims of Bryce's display of power at St. Morse, Lola still struggled to believe in malisons "—it's not about whether I want it. I'm already in it."

Zula's gaze swept over her with a look almost like pity. Lola tried not to feel self-conscious. If she'd wanted to inspire confidence, she should've dressed the part. Instead, Lola's houndstooth trousers were wrinkled and gaped at the ankle, and her crimson hair had grown out at the root, letting her natural,

lighter red peek through. The dark under-eye circles. The deranged annotations and clippings she'd waved about. Lola hadn't even raised a gun the night it all happened at St. Morse, but she still looked like collateral damage.

Finally, Zula spoke. "I was with Lourdes Alfero not long after she received that same card, the Hermit, when it'd meant a warning from the Shadow Game. But this card is gold. It's clearly meant for something else." Zula's expression softened for the first time. "You remind me of her, though. Quiet. Stubborn. The three of us are the sort meant to tell the story, once all the violence is over."

If that were true, then Lourdes Alfero would still be here, and Zula wouldn't be the last Pseudonym left alive.

"I don't have answers for you," Zula told her, "so you might as well—"

"I want to work for you," Lola blurted. "Teach me. Let me prove that you can trust me."

Zula shook her head. "It has little to do with trust. I know the answers you seek, but I've been forbidden from speaking the truth. That was the bargain he made."

Lola's mind whirled with Zula's words. Someone had made a deal to hide the truth? Only the Bargainer was capable of sealing away such information, so that the words couldn't even be uttered. This only confirmed Lola's instinct that the truth was valuable and that she needed to find it. No matter what.

"I don't care. Let me stay," Lola urged.

Zula gathered Lola's papers and slid them back into the briefcase. "You don't want to work here. I'm afraid the paper won't be open much longer, anyway. With Vianca Augustine and Worner Prescott dead, what dregs remain of the monarchist party will likely dissolve. And Chancellor Fenice will see to it that they do, I'm sure."

"But I do want to," Lola countered.

Zula's eyes flashed. "They're all dead. Every one of them but me. Is that what you want to be a part of?"

Lola had no desire to die, but she *was* growing desperate. These secrets didn't feel like pieces of history that she could ignore. They felt *important*. Lola might not have wanted any part of this, but Enne was still Lola's best friend. And now that the world had learned that the famous criminal called Séance was really a Mizer, they would only see Enne as a threat. Maybe unraveling the mysteries of Enne's past could help change that.

"No, I don't have a death wish," answered Lola. "But I'd like to finish what the Pseudonyms started."

Zula snorted. "Don't insult my friends' memories. None of this is what they wanted."

Jac Mardlin's face came to Lola's mind, his ridiculous fake glasses and dimples. The thought of him left a raw and aching wound in her heart, as though one of the knives from her own collection had been plunged into it. Even if his death had been an accident, Jac had died a legend. He'd gotten exactly what he'd wanted. And Lola would never, ever understand how she was supposed to find peace in that.

Lola opened her mouth to apologize for bothering Zula, to return to her girlfriend, Tock, likely still in bed and waiting for her, but then Zula handed Lola back her card.

"Are you prepared to die for this?" Zula asked her, her voice heavy with wariness, her frail hands quaking from stretching out her arm. Lola realized Zula didn't use cruelty to wound— she used it to warn away anyone left who dared to tread too close. And so she locked herself alone in her office, writing and watching and waiting for the day the leader of the Republic came to take her work and then her head.

"I am," Lola answered, and she was horrified to discover it wasn't a lie. Maybe that made her no better than her friends,

but unlike them, Lola wouldn't throw her life away to become a legend—she'd die to make sure the legends were finished.

"Then come back to me when you find this one answer," Zula said, clicking Lola's briefcase decidedly closed. "You can be my protégée, little Lourdes, when you learn Lourdes Alfero's true name."

ENNE

Enne Scordata had died four times that afternoon.

First, from a knife jabbed between the ribs. Then another in her side. A pistol fired at her temple. An arm around her neck, tightening and twisting until it snapped.

"You're hesitating," Grace Watson hissed, crouching beside Enne as she sputtered, Enne's cheek pressed against the faux fur carpet of a spare classroom at Madame Fausting's Finishing School for Girls. A slaughter of girls did live here, but they were far from students.

"I'm not." Enne rolled onto her back, chest heaving, as Roy Pritchard backed away from her, an apologetic look on his face for knocking her to the floor. He shouldn't be sorry, Enne thought. She was the one making mistakes, and since the world had learned the one secret Enne had desperately tried to keep hidden, she could no longer afford to.

"Actually, you *are* hesitating," Roy told her. "If you're going to disarm a—"

QUEEN OF VOLTS

"I'm the instructor. You don't get to speak," Grace snapped at him.

Roy glowered, and he looked handsome even when annoyed. Two months ago, his perfect jawline and poreless, fair skin had made him the poster boy of the whiteboots...until Captain Jamison Hector tried to have him killed for threatening to expose the truth behind a cover-up. Now Roy remained a ward of the Spirits, something between a prisoner and an ally. At least, Enne liked to think of him as an ally. Since the events at St. Morse, she had precious few of them.

Which was why, even aching and dripping in sweat, Enne stood and readied her stance. "Again," she ordered.

In the corner of the room, Lola Sanguick scowled, setting down today's copy of *The Crimes & The Times* on her lap. Twin photographs of Enne and the late Queen Marcelline grimaced on the front page, above an article uselessly attempting to draw conclusions about Enne's ancestry from the matching light tone of their skin and chestnut hair. Any comparison between them failed there, as Enne's delicate features bore little resemblance to the queen's stern countenance.

Even so, the article frightened Enne. Already the public was forcing connections between her and a woman they'd executed.

"If an army of whiteboots arrives to escort you to the gallows," Lola said morbidly, "it won't matter if you know a dozen ways to disarm a single assailant."

"Again," Enne repeated, ignoring her.

Roy shot a glance at Grace for permission, who nodded and backed away. Then he sighed and grabbed his capped knife from the carpet.

The dull glint of metal made tremors shoot down Enne's spine, and a memory rose to her mind, unbidden, unwanted. The gleam of her revolver as she trained it at Jac in St. Morse Casino. The sound it made when it fired. The moment he took his last staggered breath.

29

Don't worry, he'd told her. *I've beaten worse.*

Roy lunged, his knife aimed at Enne's abdomen, and, distracted, Enne reacted a moment too late. Before she could disarm him, he slammed his shoulder into her stomach. She landed painfully on her back, the breath knocked out of her.

Grace loomed over her, her expression unimpressed. The dozens of sharpened Creeds around her neck clinked as she crossed her arms. Grace wore them even though she wasn't Faithful—she just liked desecrated, frightening things. Enne cringed, looking at them. Jac had worn a Creed. Unlike Grace's, though, his had meant more to him than decoration.

"I trained you better than this," Grace said. Even if Grace worked as the third and a counter in Enne's gang, the Spirits, she'd never lost her daunting assassin air. Or maybe the intimidation came from her other choices of clothes; Grace donned black lacy corsets the way a soldier would opt for a bulletproof vest.

Enne fought to catch her breath. "Roy is fourteen inches taller than—"

"It's the same-sized coffin," Grace told her fiercely.

Enne scowled as she climbed to her feet. Her body ached—not just from the sparring, but from lack of sleep. Each night, she lay awake in bed, alone, her mind a nightmarish reel replaying all of the events of the past week. It felt as though the dust and the horror of what happened had settled, and now it coated her, smothering her. She sweated through her bedsheets each time she relived Jac's death and how powerless she'd felt as Vianca Augustine's omerta forced her to pull the trigger. She buried her face in her pillow each time she heard the phantom echoes of Jonas Maccabees, the lord of the Scarhands, outing her as a Mizer with his dying breath.

During the Revolution twenty-six years ago, the tyrannical Mizer ruling class hadn't just been overthrown—they'd been exterminated. It didn't matter that Enne had never been called

a queen, that she hadn't even known the truth of her talents until five months ago; her existence was supposed to be impossible. And to the so-called wigheads who now governed the Republic, her existence was a threat.

Enne didn't feel like much of a threat to anyone, crying in the solace of her room, falling apart when she needed to be making herself stronger. Not just for her own sake, but for the sake of everyone she cared about, whom she'd damn by mere association should they all be apprehended.

As Enne readied her stance again, Lola stood up and stalked between her and Roy. "Enough," Lola huffed. "What good is this doing?"

"I can't just wait around and do nothing," Enne said shakily.

"I'd argue that sparring away your problems *is* doing nothing," replied Lola flatly. "We could talk about this. Just because the world has labeled you as dangerous doesn't mean you have to rise to the mucking occasion."

Enne nearly laughed. She'd never been given much say in her identity. At home in Bellamy, due to the powers of Lourdes's protection talents shielding her from the rest of the world, Enne had wandered through life overlooked and discarded, a font of wilted ambitions without the sunlight to flower. In New Reynes, Vianca Augustine had taken advantage of Enne's cluelessness and molded her into Séance. Enne had never considered her identity as a Mizer to be any different.

Maybe she could reject it. She'd ease the public's concerns about her talent by fashioning herself into the very picture of innocence. She already knew what that looked like—a lost schoolgirl wearing pointed-toe heels and pearls, trembling with nerves as she stared up at the smoggy, menacing City of Sin skyline, a tourist guidebook clutched in her hand.

It would be easy. Despite all that had happened, that naïve girl did not seem so distant from who she was now.

Enne's emotions threatened to overwhelm her. This was her

true skill—bursting into tears at a moment's notice. What a terrifying threat she posed, indeed.

"I don't want this," she choked out, forcing the tears back.

Lola's expression softened.

"But how do I…"

Before Enne could finish, someone knocked on the door. It was Charlotte, one of the other counters in Enne's disorganized gang of financially minded girls. And behind her, Mansi Balay. Mansi had been Levi's card-dealing protégée, until she defected to the Irons and joined the Scarhands. Her black bobbed hair looked greasy and unwashed, and the bags under her eyes made her appear many years older than fourteen.

Enne stiffened. The location of the Spirits' hideout was a secret. "How did you find this place?" she asked Mansi, quickly purging any tremor from her voice.

"You think Jonas didn't know where your hideout is?" Mansi asked.

Of course the Scar Lord had known. Enne recalled his office crammed with filing cabinets, each folder inside representing a different citizen in New Reynes. Jonas had prided himself on knowing everything.

Enne took a seat in one of the armchairs in the classroom's corner and nodded for Mansi to join her. Mansi peered around the decorations with confusion—beaded pillows, discarded bottles of nail polish, and every shade of pastel. It all hardly suited a gangster headquarters, but Enne had never needed to prove herself to the Spirits, her friends. Now, wearing a petal pink leotard left over from her stint in the St. Morse acrobatics troupe, with her face blotchy and sweaty from exertion, her purple irises exposed, Enne felt like she was supposed to look like someone different. Someone she didn't know—might never know—how to be.

A lady never betrays her emotions. So went Lourdes's rules about

etiquette—or, so Enne had also learned, the rules of the North Side's streets. Enne forced her face into neutrality.

"I wasn't Jonas's second, or his third, or anyone important," Mansi started. "But I was the only one who knew who you were." When Enne had first arrived in New Reynes, lost except for the task Lourdes had given her to find a man named Levi Glaisyer, she'd met Mansi, and so Mansi had known pieces of Enne's truth from the start.

"Until Jonas told the whole city," Enne said darkly. For a brief moment, Enne had seen Jonas as something near to a friend, and even if he'd revealed her secrets in a desperate attempt to lighten his execution sentence, his betrayal still stung.

Mansi shifted nervously in her seat, seeming to realize she was a suspicious stranger surrounded by Enne's cohorts—some of whom included a muscled grunt of a man and a nightmarish cleaver of a girl. "Before he was executed, Jonas sent a message to me that he wanted me to give to you."

"Was it a knife in the back tied with a bow?" Grace sneered. When Enne caught her eye in warning, Grace crossed her arms. "What? He didn't have to sell you out. His fate was already sealed." She picked at her black nail polish. "I'm glad he hanged."

"So compassionate," Roy muttered.

"You're doing it again," Grace said, knotting her brow—but a smile played on her lips.

"What?"

"The speaking thing. Pretty boys should be seen and not heard."

While Roy rubbed his temples, Enne cleared her throat and turned back to Mansi. "Let's hear this message."

The Scarhand reached into her pocket and retrieved a torn and stained piece of cloth, which Enne realized with mild disgust had likely once been a shred of Jonas's undershirt that he'd

been wearing in his cell. Enne took it and unfolded it, revealing crude words written in what resembled smeared dirt or blood.

Ivory is dead.

Grace scoffed, peering from over Enne's shoulder. "You're saying *Pup* killed her?" Ivory was the notorious lord of New Reynes' fourth gang: the Doves, a cloistered group of trained assassins. At St. Morse one week ago, Levi had shot Ivory in a confrontation between him, her underlings, and Jonas. But Levi had never described the wound as appearing fatal.

"The Doves are the ones who turned Jonas into the white-boots," Enne said. "So Jonas was with them. He could've witnessed Ivory die."

"But what does this mean for us if she's dead?" Roy asked.

Enne wanted to ask the same question. Two months ago, the four gangs and the Orphan Guild had consolidated their power to control the North Side, forcing the whiteboots and wigheads to remain south of the Brint River. But since then, the North Side had fallen. Militia patrolled the streets, automatics slung over their shoulders, demanding identification papers and enforcing curfew. There was no hope of reclaiming their stronghold now, with two of the gangs lacking lords.

She wished she could consult with Levi, who had always been a lifeline for her in New Reynes. But since Enne had been forced to shoot Jac, Levi could barely look at her. Just like she could barely look at herself.

Still, a decision needed to be made.

"I need to speak to my associates in private," she told the Scarhand. Then Enne slipped out into the hallway, Lola, Grace, and Roy following behind her.

"It doesn't matter about Ivory," Lola said quickly. "You don't need to help the Scarhands. You don't need to do *anything*."

"The world is all speculating about whether Enne wants to

overthrow the government, and you suggest just letting them?" Grace shot back, shaking her head. "No. Enne needs to make a statement."

Grace's words left Enne dizzy. Only several months prior, Enne's chief concern had been graduating from finishing school.

"But what kind of statement?" Enne asked numbly.

"About what kind of Mizer you are," Grace replied matter-of-factly. "Are you one of the shatz tyrants who behead their subjects over high tea?"

Enne frowned. "I should hope not."

"Are you a saintly princess? Someone pious who wouldn't *dream* of committing treason?"

"Well," Enne said, her throat constricting as she thought of how she'd been credited with the previous Chancellor's assassination, "it's a little late for that."

"The city isn't going to wait for you to decide," Grace pressed.

Enne closed her eyes. Another image of the party at St. Morse returned to her, of the hundred people Bryce Balfour had murdered in the ballroom. She could still hear the screams. "It's just..." She shuddered. "It's only been a week."

"Every day is another paper," Grace pointed out.

"For the record," said Roy, clearing his throat, "I don't think you're a tyrant, Enne."

"Wow, do your heartfelt compliments come with flowers?" Grace snapped.

"*Enough.*" Lola seethed. She put both her hands on Enne's shoulders. "Enne, you can go back inside, and you can tell Mansi to leave, regardless of what she really wants. And we can figure out what your talent is going to mean for all of us. There's too much to figure out, too much we still don't know. It's unwise to act just yet."

Enne nodded, Lola's words helping to wind her composure

back together. She smoothed out the loose hairs from her ballerina's bun and walked back inside the classroom.

Before she could speak, Mansi cut in. "Whatever you're gonna say, wait. Ever since the North Side has been on lockdown, the Scarhands have been struggling. There's nearly two hundred of us, but our lord was executed, and our second died in the battle at St. Morse. We're broke. Half of us are injured, and…" Mansi swallowed. "When the gangs controlled the North Side, before the lockdown, we were doing well. And with Ivory gone, we think there's a way to get that back."

Curious, Enne prodded, "What do you mean?"

"The Doves are without a lord now, too," Mansi said. "The Scarhands all agreed. We want the North Side united again. And if you take the Doves, it could be united under one lord."

Enne's balance veered, and she clutched the back of one of the upholstered armchairs to steady herself. "That's…quite a proposition." Behind her, Lola frowned deeply. "What about the Irons?"

"You and Levi work together, don'tcha?" Mansi asked, her brows knitted.

"We do," Enne said, unsure whether or not that was now a lie. She hoped not. "But you could have approached him."

"But he's not *you*," she answered.

Enne had been too preoccupied with worrying that her talent was a threat to consider that it was also an opportunity. It didn't matter if she only dressed in gowns made of frills and cotton candy; the Mizer talent could offer her power, if she wanted to take it.

Her gaze flickered to her friends, attempting to gauge their reactions. Lola shook her head vigorously, while Grace grinned. Roy had sheepishly stuffed his hands into his pockets.

Enne reached forward and took both of Mansi's hands. Mansi had long fingers, good for card tricks, with nails bitten raw and brown skin crisscrossed in her gang's signature scars.

"The Scarhands would all swear to me?" Enne asked her.

"We would," Mansi responded, her posture perking up. "Gladly."

Lola let out an exasperated groan. "You can't—to go from nine of us to—"

"If we unite the North Side, we'll have leverage. We could negotiate for our pardons. Besides..." Enne gazed out the window, at the sprawling, abandoned grounds of Madame Fausting's. It looked so desolate in the chilled, dying breaths of autumn, the unkept campus betraying no signs of the girls secretly residing there. "It's a big school."

Enne saw the answers clearly now. Even if she could return to the girl she used to be, that girl had also been weak. And facing monsters like Vianca Augustine, Sedric Torren, and Bryce Balfour had taught Enne an invaluable lesson: the City of Sin would always prey on weakness.

She would not, like Lola suggested, diminish herself so that the wigheads would dismiss her. She wouldn't leave her fate in the hands of those who'd prefer her dead regardless. She'd had so little control of her life until now, and she would not willingly relinquish it again.

"If you surround yourself with more criminals," Lola warned, "you'll be playing right into the narrative the Chancellor wants you to. You know that, right?"

Enne knew the risks, but there was no future that didn't pose its dangers.

"You told me to figure out what my talent means," Enne said. "I have. We'll take the Doves. We'll unite the North Side. We'll force the Chancellor to negotiate with us, not make our choices for us."

"That's my girl," Grace said, smirking and elbowing Lola in the side. Lola scowled in response.

Enne handed Roy the practice knife once more. She readied her stance. "Again," she ordered, hyperaware of Mansi's eyes on

her. Mansi might've already agreed to convince the others to follow her, but Enne didn't want the Scarhands' desperation—she wanted their respect.

Roy shot a wary glance at Grace. "I don't think—"

"Again," Enne repeated.

He sighed and raised the blade.

Enne still saw Jac Mardlin in the glint of the metal, and perhaps she always would.

But Enne hadn't killed him—Vianca had.

Even though the donna was dead, dozens of other enemies remained. And if Enne hesitated again, any one of her friends would die next.

She delivered a swift punch to Roy's wrist, snatched the knife, and held it to his throat.

"I win," Enne breathed.

LEVI

Levi Glaisyer awoke late and hungover. An empty bottle of whiskey stood on his end table, resting overtop an envelope he'd torn open last night deep into his drinking hours, the time of day after business had ended—the business of keeping his remaining friends alive. So was his new routine. The moment the Iron Lord was no longer needed, he retreated to his bedroom in the renovated Royal Art Museum and dowsed himself like a flame snuffing out.

He clung to one of the wrought iron bars of his bed frame and pulled himself into a sitting position. His head spun like a roulette wheel.

"You got sick last night," Tock Ridley told him. She perched on the edge of his desk, wearing her usual military-grade combat boots. She was Levi's age, eighteen, with light brown skin, a curvy build, and black hair chopped short and uneven. "You can't let the rest of the Irons see you like that."

Levi didn't answer and squinted at the peeks of light shining through his curtains.

"Are you listening to me?" she hissed.

He staggered as he rose from the bed, and he looked down to realize he still wore the same clothes from yesterday. They smelled like vomit.

"You're still drunk."

"It's only been one week." One week since St. Morse. One week since his best friend had died. And because Jac's body had ended up in the hands of Harvey Gabbiano and Bryce Balfour, enemies far too dangerous to approach, Levi hadn't even gotten to say a proper goodbye.

"That doesn't give you permission to drink yourself to death." Tock threw open the drawers of Levi's dresser and rooted around for fresh clothes. "It doesn't give you permission to fall apart when there are still people depending on you."

Levi's anger kindled in his stomach with the residual alcohol. He'd heard a speech like this from her before. "No one has been working harder than me to keep the Irons safe, and—"

"I'm not accusing you of not caring." Tock thrust the clothes into his arms, crinkling her nose as she got a whiff of him. "I'm accusing you of not thinking. There's no turning off, Levi. You don't stop being lord the second your door is closed. You don't get to poison yourself with whiskey and leave the rest of us to hang."

She grabbed the envelope off the end table, sending the liquor bottle on it crashing to the floor and shattering. The noise ricocheted painfully around his skull, and Levi cursed.

He reached for the envelope, but he lost his balance and toppled back onto his bed. He remembered opening the letter but not reading it. It'd come late last night by private messenger, long after business hours.

Tock ripped out the contents. "Levi," she read hotly. He suspected she'd raised her voice to purposefully summon a head-

ache. "This should come as no surprise—Chancellor Fenice wishes to meet with you, Erienne Scordata, and Bryce Balfour."

Levi's stomach turned. He hadn't just been expecting this—he'd been *dreading* this. Like him, the City of Sin had been in a state of shock since the events at St. Morse. But the crimes of that night demanded punishment...and their reckoning was coming.

"'This is not a threat or a trap,'" Tock continued, as though the writer had predicted Levi's thoughts. "'Fenice only wishes to discuss peace, and I would not have agreed to send you this message if I didn't believe her. A similar message is being sent to Bryce, and I'd hoped you would communicate with Séance on our behalf. You're all to come to the Capitol tomorrow at 10 a.m. Come discreetly and separately. I cannot convey my sincerity enough that I hope you will attend. Best regards, Senator Harrison Augustine.'" Tock scoffed. "I see he's already signing as *Senator*. He doesn't waste time, does he?"

The remnants of Levi's anger dissipated, instead replaced by guilt. He'd never received such an important letter in his life, but he forgot opening it. His enemies wouldn't wait to attack until he'd sobered up.

He closed his eyes and leaned into Tock's side. "I'm not trying to poison myself."

"I know you're not," she said softly. She reached to his end table and handed him a full glass of water, one she'd likely given him last night and that he'd ignored. "I'm not your nurse. I'm your third."

Levi sucked in his breath. Now that Jac was gone, Tock was rightfully his second. Any other gangster would've immediately claimed the title—much like Harrison had swiftly claimed his. But Tock wasn't just his third; she was also his friend. And she knew what the words meant to him. That Jac's story wouldn't be written over.

"I'm sorry," he told her. His hand trembled as he sipped the water.

"I know that, too. We're all sorry." She tapped the letter. "So what are you going to do about this? Can Harrison be trusted?"

Levi had once considered Harrison Augustine, Vianca's estranged son, an ally. And maybe he still was. Even if he'd orchestrated the assassination of his political opponent—an assassination he'd originally asked *Levi* to perform, last time they'd spoken alone—Harrison had still killed his mother, freeing Levi, Enne, and Bryce from her unbreakable omerta. Harrison could've sold Levi out on a number of occasions... Levi had no reason to believe Harrison would turn on him now.

"I think so," Levi answered. "But it's Fenice I'm not sure about." Josephine Fenice became Chancellor five months ago, after the death of Malcolm Semper, and Levi doubted the newly appointed chief of state would want the first year of her term in office soiled by scandalously consorting with criminals.

"*She* could be planning a trap," Tock said.

"Harrison isn't naïve."

"The Scar Lord was just executed six days ago. What makes you, Enne, and Bryce any different from him?"

"The last surviving Mizer. An orb-maker. A malison. Given the history of our talents, I'd say there's more political nuance to this than just our criminal records." The government liked to pretend that the brutality of the Revolution was over; they wouldn't execute the three of them—not so quickly, not outright. But it was still a gamble.

After deliberating another moment, he said, "We'll go."

Tock pursed her lips, clearly swallowing down her characteristic urge to put up a fight. "You'll have to tell Enne."

Levi's resolve collapsed. He'd used to feel like he and Enne were partners, that they could face the city side by side and always emerge victorious. But Enne had killed his friend, and so Enne was the last person he wanted to see right now.

"It's only been a week," Levi whispered for the second time, his gaze darting back to the splattered puddle of whiskey.

Tock put a hand on his shoulder and bent to his eye level. "You got one of the things you wanted—you're a legend. And legends die at Liberty Square, not at the bottom of a bottle."

"Are those words meant to encourage me?" Levi asked. Not that long ago, they would have. Levi had been prepared to pay the ultimate price for glory, but he'd been wrong about what that was. And he could never take it back.

"They're meant to sober you." Tock patted his back, and he winced. Muck, his whole body ached. "I'll go call the Spirits."

Enne arrived at the museum dressed in a simple wool coat and a tea-length skirt. The Irons paused their games of Tropps and poker to ogle her—not because she looked like a South Sider, but because she hadn't worn her mask or colored contacts. For so long, half of Séance's notoriety had been the mystery of the girl hidden behind the black satin blindfold, but no one had expected her to be a seventeen year-old girl. And even more shatz, a Mizer, with the violet eyes to prove it.

It didn't matter what Enne wore. It didn't matter that several delicate, clever-looking girls in the Spirits flanked her on either side, each wearing matching dainty white gloves. All of the Mizers were dead. No one—especially not Levi—could look at Enne without seeing the blood of history in her wake.

It was unnerving. But it was also impressive.

Levi tried not to think of how he must look in comparison. His pinstriped shirt wrinkled from being wadded in his dresser. His brown complexion ashen and sleep-deprived. A cut on his chin from where he'd nicked himself shaving, from pulling himself together in a haphazard, bone-tired rush.

As Enne approached where he stood at the foot of the stairs, he stiffened. The last time they'd seen each other, Jonas had died. And before that, Jac. Death would always haunt the space

between them, and any of Levi's other desires for her felt buried beside all those he had lost.

"How are you?" she asked, and Levi's gaze dropped from the tenderness in her eyes to her side, to the outline of the gun tucked within her coat.

I love you, she'd told Levi, only minutes before she'd killed his best friend.

"Let's talk in private," Levi managed.

Enne bit her lip and followed him upstairs, motioning for Tock, Lola, and Grace to follow. They wandered into one of the many abandoned galleries of the museum and shut the door behind them.

"On the phone, Tock mentioned a letter," Enne started. "A letter from Harrison?"

Levi handed it to her and stared out the window while she read it out loud. The museum overlooked an untamed park at the edge of Olde Town, one of the two neighborhoods in the North Side that were the Irons' claim. Olde Town was the haunting shadow of New Reynes, full of crooked alleys, barred windows, and barbed wire. Ever since he'd come to the city when he was twelve, he'd called it home. It might've been decrepit and broken, but it was still far better than his last one.

"We can't trust this," Enne said after finishing.

"I think we can," Levi said.

"Bryce murdered over one hundred people at St. Morse—you think this is about compromise?" Grace shook her head. "This is a trap. You three go there, and both you and Bryce are dead."

"Levi knows Harrison," Tock pointed out.

"And I know a ruse when I see one," Enne snapped. "We're not going. What leverage do we have to negotiate for pardons right now?"

"And if I go alone?" Levi asked flatly.

A curtain of silence fell over the room. He couldn't help

but notice the way each of them stood: Levi and Tock on one side, Enne and Grace on the other, and Lola watching them all warily in between. Harrison should never have assumed Levi and Enne were partners—they were two separate pieces on a chessboard. Since Enne's reckless actions at Jonas's execution, which they'd barely escaped with their lives, he wasn't even sure they were on the same side.

"Walking into a death trap is your own prerogative," Grace growled.

But beside her, Enne's already somber expression had darkened. "You'd do that?" It wasn't a question—it was an accusation.

"You aren't just a criminal—you're a Mizer," Levi replied. "Killing you has political ramifications. And Bryce, however shatz he might be, has a talent the world didn't believe existed. And I'm an orb-maker, the grandson of one executed for it. The world isn't desensitized to murder or havoc like it was during the Revolution. Since the Chancellor can't just kill us, her only choice is to speak to us."

Enne advanced toward him. Levi had a talent for reading auras, but it was only his split talent—and so he could only sense the auras of those he knew well. Hers was purple, and it whirled around her, uneasy torrents like a rising storm. Levi studied that rather than her lips. He focused on the smells of espresso and rain and not the phantom scent of his friend's blood.

Maybe he was still a little drunk.

"Do you think I wanted Jac dead?" she asked, and Levi flinched at her words. "That it was my idea?"

Vianca's omerta hadn't instructed Enne to kill Jac—only to break Levi's heart. And just two months ago, Enne had orchestrated a riot to stage the assassination of a man she hated, all while lying and manipulating Levi behind his back. Even if she hadn't gone through with that particular plot, there was something dark in her, something he hadn't seen when she'd

arrived in New Reynes wearing pearls and white lace and the look of someone lost.

"No," Levi answered coolly. "But that idea came from somewhere, and I think you don't want to admit that."

Enne cringed but didn't back down. "No, *you* just don't want to admit it came from Vianca. Because the only reason Vianca gave me that order was because you betrayed her. *Your* decision. Not mine."

Enne moved to jab her finger into his chest, and he caught her wrist before she could. He thrust her away, as though her very touch burned him. It did in more ways than one. "I betrayed her to save both of us. I did *everything* to save both of us."

"Then stop hating me," she demanded, her voice catching.

Levi didn't think he hated her, but he couldn't bring himself to deny it. She'd hurt him on more than one occasion, and so the saying went: fool him twice...

He wouldn't be played again. Like Tock had told him this morning, he didn't get to grieve or drink or break. And forgiving Enne seemed like the same as breaking.

Because until the moment he'd begun to hate her, he'd loved her. And he could never go back to that.

"I'll go to this meeting," Enne told him, "if you swear to look me in the eyes again."

Levi saw pain on her face—some he knew he had caused—but he was beyond the point of doing anything about that. "I don't make promises anymore."

"Then give me something. You know I don't want to do this, but I'll go. For you." She reached for him, then lowered her hand, seeming to think better of it. She glanced over her shoulder, and Levi realized with a start that he'd forgotten their audience. "Give me something."

Levi didn't know if he had anything left to give her, but he would do whatever it took to protect the Irons, and with militia still patrolling the North Side, negotiating peace with the

Chancellor was the best way he knew how. He couldn't do that without Enne.

And so he held out his hand to shake.

Enne stared at it, her lips a thin line. It was the gesture of acquaintances, of business, of formality. It wasn't the gesture of two people who had faced the Shadow Game together and survived. Whose wanted posters had shared the front page of every newspaper in the city. Who had once kissed each other as though the world would end in the morning.

But it was something.

She shook his hand, her eyes glistening, then left the room without a word.

SOPHIA

Sophia Torren knew a bad idea when she saw one.

"Is this it?" the cab driver asked, peering at her through the rearview mirror. They had parked at the edge of a manicured lawn belonging to a large estate. The lights in the windows glowed, dim halos on each sill, but dark curtains obscured any movement inside. The bare-branched trees on the grounds swayed in the wind, casting briary shadows over the house's gray stone, but even so—the house didn't look as haunted as the legends claimed.

"I guess so," Sophia told him, because even if it wasn't, she couldn't turn back now. She'd held her breath the entire drive, and now, light-headed and queasy, she needed some air.

She reached forward and handed the cabbie a glass sphere that sparkled with volts. The driver emptied twenty-three of them into his meter as payment, handed the orb back to her, and drummed his fingers nervously against the steering wheel as Sophia muttered a goodbye and stumbled onto the sidewalk.

QUEEN OF VOLTS

The nighttime November wind made her shiver, and she wrapped her trench coat tighter around herself and glanced back at the New Reynes skyline glittering several miles behind her like a gaudy faux jewel. This address Harrison Augustine had given her led to the edge of the city limits, somewhere east beyond the Park District of the South Side. The House of Shadows belonged to one of the oldest, most sinister legends of New Reynes, of curses traded like trinkets, of brutal games of life and death. But the cabbie had found the address on a standard map.

Not much of a legend at all.

As the mystique faded, reality settled over her. She was really standing here, in front of the House of Shadows, alone, in the middle of the night, ready to confront the person who had taken so much from her. A person even the City of Sin called "the Devil."

All it had taken was a terrible bargain and a cab ride.

Sophia cursed herself for her fragile bravado. She cursed the boy she loved for dying and breaking her heart and making it soft and brittle in the first place.

She hoped this was still a bad idea. She'd dressed for one.

Sophia reached into her pocket and pulled out a pair of dice, black and heavy—the way fate *should* feel. She crouched down by the mouth of the driveway, feeling childish and unbalanced in her stiletto heels. She rolled the dice against the pavement.

A five and a one.

Sophia had a tricky blood talent for manipulating her luck. Performing good deeds sowed good fortune, whereas bad deeds reaped disaster. The rules were fickle as far as powers went; she'd be a lot better off if she had a flimsy conscience, so her self-perceived sins counted fewer in number. But that was the tactic her older siblings, Delia and Charles, had chosen, and she would never regret being different from them.

She'd only been using the dice to measure her luck for a few

days, but already she'd grown familiar with their nuances, the sort her old coin had lacked. Matching high or low numbers were straightforward—her luck was on the rise, or in decline, respectively. Such a split meant that the night would offer as much success as it would misfortune.

Sophia smiled and popped a piece of Tiggy's Saltwater Taffy in her mouth. Years ago, a boy had given her a box of the candy as a gift, the first person she'd met in New Reynes when she came back after making the greatest mistake of her life. The mistake that had defined her every action since.

Green like your eyes, he'd told her. She'd always prided herself on her bright green eyes—another characteristic that differentiated her from the rest of her family.

The sentiment of the gift had been sweeter than the flavor, because Tiggy's were really green like absinthe. But Sophia had been scared and alone and desperately in need of compliments, to please somebody, and so she'd acquired a taste. Now she craved the taffy for its chewiness, the way it stuck to the back of her teeth, the almost glow-in-the-dark stain it left on her fingertips. It was unpalatable but came in pretty packaging, much like she did.

Music whispered through the night as Sophia tread to the door. She'd worn a satin, skin-clinging dress—red, like the signature color of her family's casino...and the fire of when she'd burned it.

After her partner had decided to get himself murdered a week ago, wearing black might've been more appropriate. But red had always meant something to Sophia—identity and purpose. And purpose mattered to her just as much now as ever.

She'd once vowed to destroy her family's empire, and she'd succeeded, but she'd sacrificed a piece of herself to see it happen.

Now it was finally time to get that piece back.

Sophia took a deep breath and slid her key into the front door of the House of Shadows. To her surprise, the door was

already open, and she frowned. She'd sacrificed something for this key, too.

A woman greeted her as she stepped inside. She wore sequined suspenders and sharp brass rings all the way up her knuckles. Judging from her muscular build, Sophia guessed with a pang of grief that she possessed a strength talent, much like Sophia's old partner.

"Oh, you must be with the other two," said the bouncer.

Sophia had just stepped foot into a place half the city didn't believe existed. A place steeped in ghosts and secrets and legends. She'd expected worse than trouble—she'd expected ruin. And she'd even welcomed it.

She hadn't expected it to be so easy. It felt like a trick.

"E-excuse me?" Sophia stammered.

"They're in the other room." The bouncer nodded past an archway, and Sophia, dazed, followed her directions deeper into the house. The dim lights made her stumble as her eyes adjusted, and she was surprised to find it so empty, and—though decorated luxuriously—laid out much like the parlor of a normal home.

Surprise seemed the theme of the night.

She spotted the "two" the woman had mentioned, arguing in the corner beside a grand piano. Several more silhouettes moved in the next room, from which the pair had clearly escaped to speak in private.

"I can't *believe* you followed me here," the first girl snarled. Both girls were fair, blonde, and doe-eyed, but the first one's skin was smattered with freckles, and she wore her hair up in a high ponytail, so tight it was a wonder she could make any facial expression.

"What was I supposed to do?" The second girl crossed her arms. Her black dress was high-necked and conservative. It looked appropriate for a wake, though even from a distance

Sophia could tell it was designer. "You can't just *say* you still love me and not expect me to make some grand gesture."

"You paid a detective to stalk me, Poppy."

"You were gone."

"It's been one week."

"It hasn't just been *one week*, as if it's been an ordinary one!" Poppy's voice rose. "My father is dead! My friend is some sort of crime lord! And then you show up and tell me you're shatz about me and you leave just as fast…"

Poppy's voice trailed off as she spotted Sophia gaping at them from the corner. Sophia froze. She hadn't meant to eavesdrop, but she realized she recognized the second girl—Poppy Prescott, the daughter of Worner Prescott, the monarchist candidate who'd lost the senatorial election to Harrison Augustine. And who'd recently been shot in the head.

Sophia had glimpsed Poppy from afar last week, while Jonas had been executed for Prescott's murder. To the best of her knowledge, Poppy was a ballerina and a socialite—not anyone Sophia had expected to encounter in the House of Shadows.

"Ignore my friend," the first girl told her through gritted teeth. "She's gotten herself lost."

Sophia wondered if she'd gotten herself lost, too. She nervously clutched the dice in her pocket, just to have something to hold.

"It's fine," she muttered, stepping behind them through the archway.

She entered a billiards room—large, with a bar on one end and a collection of couches to the side. Several smartly dressed people sat in clusters, whispering at high top tables over cocktails or setting up a cue for pool. It all felt quiet and somber.

Sophia hovered awkwardly. She'd been expecting the rumors she'd heard from her cousin Sedric, about exclusive parties where guests could sample any vice: the touch of an alluring dancer; the taste of liquors and delicacies once reserved only

for kings; the thrill of watching the desperate gamble for their lives. Instead she found upholstered furniture and middle-aged businessmen in tweed suits.

What if Harrison Augustine had tricked her? What if this was the wrong place? The thought nearly made her anxious enough to throw up on the floral carpet.

"They're closed for business tonight," a woman told Sophia to her left.

Sophia glanced at the bar, where the bartender still served drinks. It didn't look closed. "Who is 'they'?"

The woman furrowed her eyebrows. "Don't you know where you are?"

Before Sophia could answer, before she could flash a tell-me-more, taffy-sweet smile, she felt a hand on her shoulder. She jolted and turned to find Poppy behind her.

"We do," Poppy answered for her, then steered Sophia away. Sophia felt both the woman's and the other blonde girl's eyes on them as they sat at the edge of an empty couch.

"It's some sort of social club, right?" Poppy asked under her breath, peering around the room. "A very boring social club?"

"I don't really know you…" Sophia said.

"I just want to know what this place is," said Poppy seriously. "And you're pretty. I trust pretty people. The others here all look sort of dead, don't they?"

Now that Poppy mentioned it, Sophia did notice something strange about everyone's skin—all a little bit gray-toned, no matter their shades. And sort of waxy, like they'd melt beside a candle flame.

Sophia didn't have time to help a girl who clearly didn't belong here—not when she'd come for answers. So she gave Poppy a tight-lipped smile and said, "You should really go back to your girlfriend. She's glaring at you."

"Delaney isn't my girlfriend," Poppy said dismissively, despite the exchange Sophia had overheard barely minutes earlier.

"And don't tell anyone you saw me here with her. As if that's what I need right now—more paparazzi."

Sophia only half paid attention, her gaze scanning the room for someone else to speak with. She wasn't used to having to approach someone—typically, people approached *her*. And how was she supposed to go up to someone and ask, *Do you know where I can find the Bargainer? I sold a part of myself, and I want to get it back.*

Years ago, Sophia had sold her split talent and any memory of it to the Bargainer in exchange for hiding her identity from her family. At the time, it had felt a fair price in order to infiltrate the Torren empire and bring it down.

Since then, she'd always felt broken, like a shard of a person. And now that Jac was gone and her family finished, Sophia had no partner or purpose to ground her. She felt like driftwood washed up on the litter-clogged New Reynes shore.

"I'm sorry," Sophia murmured. "Excuse me." She stood and left Poppy pouting and alone on the couch, instead walking toward a group of two men and a woman hunched over today's copy of *The Crimes & The Times*. Sophia spotted a photograph of Enne on the cover, but it took her several moments to recognize Queen Marcelline in the portrait beside it—she'd never seen the woman depicted with her head.

The group looked up at her, their skin gray and dull in the dim lights. "They're not open for business," they told her, repeating the words of the woman from earlier.

"Who is 'they'?" Sophia asked again.

One of the men furrowed his eyebrows. "Do you have a key to this place?"

"Of course she does," the woman snapped. "Without a key or an invitation, she couldn't have walked through the front door." She narrowed her eyes at Sophia. "Did you steal yours?"

Sophia's heart pounded. She'd thought it strange that the door to such a place would be unlocked, but clearly it hadn't

been—there was some other power over this place. A curse. A shade.

But that only meant she had come to the right place, after all.

Her confidence rose, and she managed one of her sweetest of smiles. "I didn't steal it," Sophia told them.

"Then who gave theirs to a teenage girl?"

Sophia's lips twitched in annoyance. "Harrison Augustine," she answered, smugly taking in their surprised expressions. As of last week, Harrison was one of the most powerful politicians in the Republic.

"How exhausting," the man drawled.

Someone grabbed Sophia's arm, pulling her back. It was the freckly girl from earlier, the one with the too-tight ponytail—Delaney. She looked far less demure and doe-eyed up close. Her baby blue nails dug sharply into Sophia's skin.

"Harrison sent you here?" Delaney hissed. "Did he ask you to spy on me?"

"He didn't send me here. He just gave me a key." Sophia squirmed out of the girl's clutch. She didn't want to talk about Harrison—that would mean dwelling on the deal she'd made: entrance into the House of Shadows in exchange for his omerta. Her most desperate bad idea. Especially when she'd yet to find a trace of who she was looking for. "I thought...I..."

"You thought what?" Delaney snapped. She had a haughtiness to her voice that matched her preppy hairstyle. Both Delaney and Poppy reeked of South Side, like trust funds and noxiously floral perfume.

"I thought I might find the Bargainer here. Or learn at least where she is."

Delaney scoffed. "You think everyone would be sitting around like this if we knew that? Look at this place. The party's over."

The Bargainer was a powerful malison, someone with the talent to make shades—much the way a Mizer made volts. According to legend, the malisons of the Republic dwelled here

in the House of Shadows. But by the tense, stifled air of this place at the mention of her name, the Bargainer was not welcome here.

Which meant Sophia had traded the omerta for nothing.

Her lips trembled, but she would not cry. Not in public. Not while wearing expensive mascara.

Poppy squeezed in between them, saving Sophia from having to respond. She grabbed both of their hands, as if the three of them really had come here together. Sophia was so numb that she let Poppy drag her back to the front door, even as the two girls bickered the whole way.

Sophia had become worse than driftwood—she was sinking. She flinched as she walked into the darkness of outside, memories of her twisted older brother prowling in the back of her mind. She wrenched her hand away from Poppy's. A touch was all it had taken for Charles's split talent to give pain, and it would take more than a few days after his death for Sophia to forget the fears he'd instilled in her.

"So this is what you've been gone for?" Poppy demanded from her not-girlfriend. "Who even are those people? What is this place?"

Delaney sighed. "It doesn't matter—I already got what I came for. Let's just go home."

"What did you come for?" Poppy asked sharply.

Sophia knew she should leave them and return to Jac's apartment, where she'd been sleeping since she'd burned Luckluster Casino without him. But she hadn't made a plan for getting home—truthfully, she didn't want to go back there, anyway. She'd been finding Jac's cigarettes tucked into places where he didn't think she'd look.

"I received a gift the other day," Delaney said carefully. "And I wanted to know what it was. Turns out it didn't come from here."

Her words returned Sophia to the present. "What kind of

gift?" For Delaney to come here for answers, the gift must have been a Shadow Card, an invitation to the Shadow Game. After all, it was played here, in this building. Sophia herself had received a card last week, but the color of it was wrong. She didn't know what game it belonged to.

Sophia slid hers out of her pocket and held it up. The Wheel of Fortune—depicted with what resembled a roulette wheel and black clouds like factory smog in the background. An appropriate choice for a Torren blood talent.

Delaney's brown eyes widened, and she pushed Sophia's hand away while shooting a frantic glance at Poppy, in case the other girl had seen. Then Delaney let out a shaky laugh. "It's nothing—"

"Oh, one of those?" Poppy opened her Maxirello purse and whipped out a Shadow Card of her own, its gold foil matching the delicate rings on each of her fingers. The Star. The woman in it with long blond hair even looked like Poppy. "I found this a week ago. What is it for?"

Sophia's thoughts jumbled together as she tried to process what this meant. After the massacre and battle at St. Morse, a number of people she knew had found these gold-foiled cards: Levi Glaisyer, Enne Scordata, Tock Ridley, Lola Sanguick, Grace Watson, Roy Pritchard, Harrison Augustine.

Jac Mardlin, not that he'd been able to collect his.

Sophia hadn't dwelled on what the cards meant, as she'd been too busy trying not to dwell on anything. Not on how she'd impulsively entered into a dangerous contract with a dangerous man. Not on how burning Luckluster Casino hadn't felt half as satisfying as she'd thought it would, that she could hate her family but still feel wretched and guilty for betraying them, her own blood. Not on how Jac was really gone— gone as in not waiting for her back in his apartment, gone as in never coming back.

If Poppy and Delaney also had Shadow Cards, whatever game this entailed was bigger than Sophia had thought. But

she couldn't dwell on it. Dwelling meant drifting, sinking, drowning.

No. She needed to focus on finding the Bargainer and stealing her memories back. That goal was the only life raft she had.

At Poppy's brandished Shadow Card, the color drained out of Delaney's face, and it took her several moments to gather herself. "Th-the card is nothing. It's not important. Come on. We can walk home."

But while Delaney stalked off across the lawn, Poppy lingered behind.

"She thinks I'm fragile," Poppy told Sophia, "but I only followed her because I think she's the one who's breaking." Those were surprising words from someone whose father had just been murdered. But maybe Poppy wasn't dwelling on it yet, like Sophia.

Then she handed Sophia a business card to a ballet company.

"We both dance here. Come find us. I can play along with her tonight, but I'd like some real answers. And maybe a friend." She gave Sophia a weak smile, then left to follow Delaney.

Sophia pursed her lips. She wasn't looking for friends. And she'd made up her mind not to dwell on the game.

She walked down the street until she reached the first crossroads, and then—feet aching in her heels, the high of chasing legends now replaced with a bone-deep fatigue—she waited.

No one came.

All out of bad ideas, Sophia went home, where she found another cigarette taped beneath the nightstand drawer.

HARVEY

Rebecca Janus lay in bed coughing up blood, and Harvey tried very hard to feel sorry.

Bryce doted on her, inspecting her sweat-soiled bandages and offering her water. Rebecca's long blond hair was greasy from not showering, and wine-colored splotches had blossomed like bruises across her skin from her cursed illness. There was no cure for it. After all, it wasn't natural. A vile sickness for a vile heart, Harvey figured.

"I don't know why you bothered," Rebecca told Harvey, who lingered awkwardly over her sickbed. Rebecca's eyes were fixed on the golden card he fiddled with—Strength. It'd belonged to Jac Mardlin. Five days since the burial, and Harvey couldn't shake the image of Jac's Creed from his head.

The three of them were in the abandoned and historic Royal Prison, in a cell refurbished into a bedroom. Bryce's and Rebecca's bedroom. Harvey had chosen his in the corner of the

building farthest from this one. The walls of this place were very thin. "If I felt better, I would've burned the body myself."

"I'm sure you would have," Harvey said dryly. Then he gave her the biggest smile he could muster.

Rebecca flinched away from him. "Don't you dare try to use your talent on me."

Harvey was careful with his smiles. He was a Chainer, someone with a talent to bind those in debt to them to a certain place. His father had made a fortune operating a drug den on Chain Street where, day and night, Lullaby and Rapture addicts lived. Too lulled or buzzed to work and without means to pay back their debt, they could never leave. It was a slaughterhouse, except the deaths were slow, and the cattle was human.

Chainers also had an affinity for making people trust them. Harvey knew how his smiles made a stranger relax their shoulders, how his words made people lean in closer. Bryce had assured him a number of times that he knew Harvey couldn't help this ability, but Harvey could, and he knew the truth—Bryce would rather accuse his friend of manipulating him than admit he was still charmed.

Now neither Bryce nor Rebecca trusted any of his smiles, whether they were loaded or not. In fact, Rebecca treated Harvey's very happiness like a threat.

"I'm only trying to be sympathetic," Harvey lied, replacing his smile with false hurt. "Is there something I could get you?"

"A new set of lungs," Rebecca croaked.

Harvey wished it was a joke.

"So soon?" Bryce squeezed her hand. "It's barely been a few weeks."

"Yes, well, I *am* dying," Rebecca said, making Bryce wince.

Since last summer, Rebecca and Bryce had been hiring skin stitchers to deliver new organs to replace her decaying ones. Ever since her illness had started one year ago, it was spreading throughout her bloodstream, infecting her organs one by

one. At this point, Harvey imagined half of Rebecca's insides to look rotten and shriveled, like pickled pieces of fruit. He didn't know where the skin stitchers obtained the body parts, but they were always fresh.

"Don't say that," Bryce pleaded. "Your wound will heal, and then you'll feel better."

"But I'll still be sick," Rebecca said. She let out a dramatic, bloody cough. "And soon I'll be dead."

So we can hope, Harvey thought. He should feel guilty for such cruelty—it was certainly a sin—but lately, hating Rebecca was the only thing in his life he didn't feel guilty about.

It wasn't that Rebecca was a girl—Harvey might've been bitter, but he wasn't an asshole. And it wasn't the general idea of Bryce loving someone other than him—even if, admittedly, that did hurt. It was that Rebecca wasn't *good*. She was a liar, a killer. Nearly every piece of her life she had stolen from somebody else. Most egregiously, she had changed Bryce, twisted him, wrapped him around her blood-stained finger as an accessory in her own ambitions. And Harvey could never forgive that.

She, like Bryce, belonged locked away in the House of Shadows. Rebecca's split talent came from a shade-making family, those who specialized in making curses with malisons, much the way an orb-maker made volts with a Mizer.

Except Rebecca had made a grave error. Determined to free Bryce from Vianca Augustine's omerta, they had crafted a shade to murder her but spare his life. But shade-making came with rules. Shades were bound in metal, the way volts were bound in glass. Yet Rebecca had believed that she could increase its strength by binding it to herself, to her own body and flesh. The same way the Bargainer did, according to the stories. And, at the time, it was the most powerful shade that Bryce and Rebecca had ever created.

But Rebecca was not the Bargainer, and as shade-making

was only Rebecca's split talent, it was too weak for a task so grand. Not only had the curse failed, but now it was killing her slowly, corroding one organ at a time.

And that was how Bryce's obsession with the city's oldest legend had begun.

"I'll find the supplies," Bryce told her hastily. "But that's not why I'm here." He reached into his too-large cardigan and pulled out a letter. The envelope looked embossed and official. "Chancellor Fenice wants to meet. Me and the orb-maker and the Mizer." He let out a weird, strangled laugh. "It's begun."

Once every doctor and mystic in New Reynes had declared Rebecca incurable, Bryce had fixated on one final, desperate option: the oldest legend of the City of Sin, the Bargainer. In the stories, the Bargainer could make a deal with you for anything—even your own soul. And due to strange workings in the House of Shadows that Harvey didn't understand, the only way to summon the Bargainer to New Reynes was through chaos.

And so Harvey Gabbiano—pushed aside, still waiting, still hoping—had become complicit.

He'd said nothing when Bryce broke into Lourdes Alfero's bank account and stole all her volts—and one of the strange black orbs that belonged to a pair. They were used in the Shadow Game, and—so Bryce was convinced, due to months of untangling rumors—they held the life energy of the last surviving Mizer. A souvenir from when the birth mother had played for her own child's life.

Harvey had said nothing when Bryce wrote that letter to Lourdes's adopted child, his target, pretending to be Lourdes, luring whoever they were to New Reynes.

Nothing when Bryce arranged Lourdes's capture and demise, ensuring the Mizer was without protection.

Nothing when Bryce used his malison talent to bind the Mizer to the orb-maker, a royal pair.

Nothing when he bought so many stolen body parts.

When he and Rebecca planned their deadly game and enlisted Harvey in it.

When Bryce killed over a hundred people at St. Morse.

Harvey knew his own role in it all made him as sinful as Bryce, but he couldn't leave. Not when there was a chance that Bryce could still be saved. That things could return to the way they were before Rebecca, before Vianca.

"You can't honestly be considering *going* to that meeting, can you?" Harvey accused Bryce. He didn't care how expensive the Chancellor's card stock was: it was basically a pretty warrant for Bryce's execution.

"There are twenty-two players in our game," Bryce answered. "They need to know the rules."

"You won't come out of that meeting alive," Harvey snapped.

"But I will, if the expected company arrives."

Harvey sucked in his breath, and he reached for the Creed around his neck. Even after all this time, some part of him hadn't believed the legends of the Bargainer were true.

It'd been easier before the Mizer and the orb-maker had names, before he knew them, before he'd befriended Enne and consoled her in the hallway at St. Morse and buried Levi's best friend.

Why do you need them? Harvey had once asked Bryce as he'd clutched a stolen deck of Shadow Cards from the House of Shadows. As he stared at the Emperor and Empress artwork. As he planned his ultimate game.

An expensive bargain will demand an expensive price, Bryce had answered.

Harvey's stomach still lurched at the memory. Enne and Levi weren't the notorious couple of a North Side legend. Bryce and Rebecca were, and Enne and Levi were bait.

As Bryce continued reassuring Rebecca, as he rubbed his hand through her greasy curls and kissed her trembling knuckles, Harvey staggered out the room. He leaned against the ce-

ment walls of the hallway to support himself. He squeezed his Creed in one hand, and his own golden Shadow Card in the other: the Fool.

I thought the price of losing your game was death, Harvey had said to Bryce the day Bryce had given him that card. *You'd make me play?* Harvey would do anything for Bryce, but he wouldn't risk his life for *her*. For *this*.

If it was your *lover dying tragically after trying to save you, I'd risk my life, too*, Bryce had told him with that excited glimmer in his eyes whenever he spoke about romance. He loved happy endings. No—he was obsessed with them.

When Harvey pictured such a lover, he could only see Bryce. But he didn't recognize the boy from his memories anymore, and he didn't recognize himself, either.

"I need to warn Enne and Levi," Harvey murmured to himself, squeezing his Shadow Card so hard it bent. He'd sworn such noble things before, but now it was different. Now the Bargainer was finally in New Reynes.

Bryce emerged from his bedroom, dark shadows beneath his unholy red eyes. He reached for Harvey's hand, and Harvey froze at the touch. He swallowed down his desire with his vomit.

"I need to ask you something," Bryce said.

"What?" Harvey asked sharply, certain his betrayal was obvious in his expression.

"It's the game. The players all have their cards, but I haven't set the game in motion yet—not really. They still don't know their targets. I'm going to explain the rules at the meeting with Fenice so they can tell the other players. That is, if the Bargainer doesn't come to me before then. And it's just that…"

"You already know who the targets are," Harvey finished, growing sicker. Harvey didn't understand all the rules of Bryce's game, but he knew this much: every player had a target. "So who is yours?" Whoever they were, they wouldn't live to see

December. Bryce had already killed so many to make this heinous plan work—what, then, was one more life?

Unless Harvey stopped the game. He could do more than warn the other players—he could stop all this *now*. Every time Harvey had stood complicit, Bryce had built a list of debts. Harvey could Chain Bryce to this prison where he rightfully belonged. He could trap Bryce and free himself. He *should*.

Bryce held up his Shadow Card. Red words were scrawled across the gold foiled back.

THE FOOL

Harvey stiffened and squeezed his card tighter.

"You told me the targets were random," Harvey rasped.

"They are. The shade devised them all. I guess you could call that fate." Bryce gave him an isn't-it-romantic smile, but no, it really wasn't. Not to Harvey.

"But you're the malison. Rebecca is the shade-maker," Harvey sputtered. "I don't understand how your target being *me* could be random—"

"I promise I didn't have a hand in this—or her. You'd understand if you ever wanted to learn how my talent actually works."

It was true; Harvey had never wanted to know. According to everything Harvey had been taught, malisons and shade-makers were unholy, a crime against the Faith. Harvey had avoided the subject whenever Bryce brought it up. The boy he loved was more than his talent—no, he wasn't his talent.

But maybe it'd been a mistake to think that way. Harvey might need to understand Bryce's talent better if he decided to stop him.

"You know what happens if we don't collect our target's card," Bryce whispered, averting Harvey's eyes.

"We die," Harvey answered flatly. If he didn't give Bryce his card, then Bryce would perish in his own game. It wouldn't happen now, but it would when the game finished, once an-

other player had collected a string of five cards. It could take days. It could take months.

"You know the game's rules. If you hand over your card to me willingly, your life is bound to mine. Which means that if I die, so do you," Bryce said, his voice cracking. "I didn't—"

"And my target?" Harvey asked.

"Judgment," Bryce answered. Harvey didn't recognize that card—between the three of them, Harvey had only delivered Enne's and Levi's. "But I swear that I never planned it this way. I would never... I want you to know that you can say no. I made you play this game, but I won't make you die for it. For me."

Harvey's mouth tasted grossly of chemicals, of the noxious smells of Rebecca's room. "You've explained this all to me a thousand times. Twenty-two players. A string of five cards. But I still don't think I understand it. I don't understand how this will convince the Bargainer to find you and cure Rebecca. How all this death will get you what you want."

Bryce hesitated, and Harvey wondered fearfully if Bryce didn't trust him with the whole of it. And he shouldn't, considering how Harvey was contemplating betraying him.

Then Bryce asked grimly, "Do you want to understand?"

Harvey's knees quaked a bit. Whatever the reason Bryce thought the game would bring the Bargainer to him, it must've been terrible for Bryce to sound so grave like that. And even with all the sinful acts Harvey had seen, Harvey had *done*, he didn't really want to know. Harvey's life philosophy was simple: if he closed his eyes, then he couldn't see the blood on his hands.

That was the terrible truth of it; if it came down to his conscience or to his wicked heart, Harvey would choose his heart, every time. Harvey had loved better boys than Bryce Balfour, but he'd never loved any of them more. And maybe Harvey had listened to too many of Bryce's sappy radio shows, but no

matter how bleak their story got, Harvey still hoped that they would have their happy ending.

He didn't want Bryce's secrets. Not if they could ruin that.

"I guess I don't want to know," Harvey murmured.

Then he handed Bryce his Shadow Card, his own feculent, rotten heart pounding furiously.

Complicit.

Complicit.

Complicit.

Bryce clutched it with a trembling hand, then he threw his arms around Harvey. He leaned into him like a man who had gone days—months—without rest. Harvey knew the feeling well.

"Thank you," he whispered, and Harvey smiled his most charming smile.

III

THE WORLD

"A cause, even one as noble as democracy,
cannot be deemed righteous if sins were committed
to bring it to fruition. Everything has a price,
but you cannot pay for goodness in blood."

Ventriloquist. "On Princess Honaire."
Her Forgotten Histories
18 Jul YOR 2

LEVI

Levi's gaze skimmed over the murky waters of the Brint River as he and Tock crossed a bridge into the South Side. Up close, the white marble of the Senate District actually looked gray, like a stain unable to be scrubbed clean at the bottom of a porcelain ashtray. For the first time in over a week, Levi wasn't drunk or hungover—but he didn't feel good.

"Am I making a mistake going to this meeting?" he asked softly, reassuring himself by tracing the outline of his pistol in his jacket pocket.

"You told me you weren't," Tock said from the driver's seat of his white Amberlite. Her voice sounded like a warning, a reminder that the others had put their trust in Levi, even if he didn't feel he still deserved it.

Levi tried to swallow down the rest of his unease, but it felt lodged in his throat like a wad of paper, the receipt for the incalculable price of his foolhardy dreams.

They pulled up to the Capitol building, and Levi shuddered as

he looked up at its cold stone steps, each etched with the names and death dates of revolutionaries. It served as a monument to the fall of the Mizer kings and the end of tyranny. But instead of garnering his respect, Levi was struck with the phantom scent of sea as he opened the car door. Not like the ocean of New Reynes that smelled of grime and port-city smoke—though the body of water was technically one and the same—but the memory of the ocean beside his childhood home. It was a sharper, cleaner smell, and it sliced through him like a blade.

Orb-makers ruled beside the Mizers, and so they died beside the Mizers, Levi's father had once sneered at him. *You are spared only until you remind them who you are.*

Jonas might have outed Enne, but he had reminded the world exactly who Levi was, too.

Levi squinted at the ornate gilded laurels on the roof over the portico, as though expecting to see his grandfather's head, blood-crusted and speared on a pike.

A line of guards watched him as he stepped onto the curb, and for the first time, Levi did not know who he really was, how he should behave. Everything in his life was a performance, but if he had, in fact, come here to die today, then would he die a gangster or a king?

He was starting to regret his and Enne's decision to heed the letter's advice and arrive separately. It might've been safer, but right now nothing felt safe. And despite everything, he did feel stronger with her at his side.

Beside the guards, Harrison Augustine stood, his brown hair slicked back like in his campaign poster. He wore a navy suit that matched the patch covering his right eye. His other eye was a vibrant green, like his mother's. And even though Levi did believe Harrison was good in ways Vianca hadn't been, like her, a cunning brand of coldness hardened all of his expressions.

"I didn't know if you'd come," Harrison said, grasping Levi's hand to shake.

"Was I wrong to trust you?" Levi asked. He peeked over his shoulder—still not spotting either Enne's or Bryce's cars. Enne would be here soon, but who was to say Bryce would arrive at all?

"At times like these, you're wrong to trust anyone," Harrison told him, his voice sounding deeply tired. "But let's try to fix these times, why don't we?"

Harrison walked toward the Capitol's side door, and Levi turned to Tock one last time.

She must have seen the nervousness on his face because she said, "If you die here, I swear on Vianca Augustine's grave I'll tell everyone the truth about you."

Levi was in too serious of a mood to joke, so he only managed to raise an eyebrow when he responded, "And what is that?"

"That you're an ugly crier. That you can't hold your liquor. That you..." Her voice trailed off, like she, too, found her words cheap when these could be the last thing she said to him. "Just don't die," she added weakly.

"I never seem to," he answered. Then he followed Harrison up the steps, hyperaware that the bearer of each name he passed would have preferred him and his family dead.

"I heard about Jac," Harrison said slowly. Harrison had been working with Sophia and Jac to undermine the Torrens, so of course he knew. Still, Levi had forgotten that for a moment, and it jarred him to hear Jac's name in a place otherwise so out of context. "I'm sorry. Especially for any part I played in it, when my mother found out we'd been working together."

Levi nodded numbly, unsure how he was supposed to respond. Harrison was only being kind, Levi knew. But somehow this, too, felt like a performance.

"Thanks," he managed, when he probably should've absolved Harrison of any misplaced guilt. After all, Levi was the

one who should've considered the risks of working with him and betraying Vianca.

At that, Harrison led Levi inside to a hallway as pristinely white as the exterior.

The Chancellor waited for them at the end of it.

Josephine Fenice was an older woman, and—according to the rumors about the Phoenix Club's immortality talent—she was far older than any person should rightfully be. All the warmth in her fair skin had seeped out like a wilted flower, making the otherwise unassuming pink lipstick she wore appear vibrant and wrong.

As a revolutionary herself, Josephine should've hated Levi and his orb-making talent. As Chancellor, she should despise him for his crimes against the Republic.

But instead, as he approached, the only emotion that crossed her face was relief.

"Thank you for coming," she said hoarsely. "The others should be here soon."

Levi nodded, and the three of them waited in an awkward silence. In the vast and empty stone chamber, the sound of the Chancellor's tapping foot echoed, and her anxious air quelled Levi's own nerves. The Chancellor didn't seem to want *his* head—only his help.

The opportunist in him realized he could make a request in this meeting. He could ask for a pardon for himself and the other gangs of the North Side. He could ask for volts. He could even ask for his father to be returned to his home in Caroko, from where he'd been forbidden since the Revolution.

Levi had always sought greatness, had always been so certain where his story led, but for the first time in his life, he wasn't sure. He had been one of the richest people in the North Side. He had been a legend. But standing here, dressed in his best and gaudiest suit paid for by the fortune of his infamy, Levi realized it didn't quite fit like it once had. The fabric constricted

at his shoulders, skimmed at his ankles when it should have covered them.

He didn't know what he'd request. He didn't know what he wanted.

The side door swung open, and Bryce Balfour walked inside. It seemed odd to see the young man alone, without the chaperone of either his girlfriend or Harvey Gabbiano. He was tall and skinny, the sort of skinny that made his clothes hang on him and his cheeks look sunken. His scarlet eyes burned even from across the room, and his aura, black and noxious, spread throughout the air like ink seeping through water.

Levi had been so concerned about the Chancellor that he hadn't dwelled on how it would feel to face Bryce again, so he was unprepared for the fear that flooded him. He was suddenly in the St. Morse ballroom, Vianca Augustine's blood dripping down the edge of the stage, screams piercing from all around, bodies collapsing across the floor with every spin of Bryce's cursed roulette wheel. He had the same urge as when he thought of the Shadow Game, when he thought of his father: *run, run.*

Even after Fenice's voice wrenched him back to reality, Levi's hands still trembled.

"Mr. Balfour," Fenice greeted him, as though Bryce had not senselessly murdered one hundred people with a talent previously only mentioned in Faith lore. As though she really had summoned him here to talk, not to hang. "Thank you for joining us."

"Where is the Empress?" Bryce asked. Levi realized he was referring to Enne by the golden Shadow Card he'd given her.

"We won't be discussing games today," said Harrison flatly. "What you've done—you don't even understand—"

"I probably understand what I've done better than you do," Bryce told him. His gaze turned to Fenice. "But I'm sure you understand perfectly."

Fenice paled; Levi was surprised someone so lifeless could even do so. "Careful. I've only agreed to this discussion because—"

"Because you're desperate," Bryce said venomously, and Fenice didn't even flinch at his words. Levi, on the other hand, didn't like where this conversation was going, didn't like how he felt like the one here with the least understanding of what they were talking about. If anyone should've commanded the power in the room, it was the Chancellor, so where did Bryce get away with speaking like that? Was it the threat of his blood talent...or something else?

Bryce licked his lips. "So, shall we begin?"

"We're still waiting on Enne," Levi said, his voice noticeably, awkwardly quiet. He would feel better once Enne was here, once he wasn't so outnumbered.

"She's already late," Bryce pointed out.

Levi checked his watch and bit his lip. She *was* late. This was likely the most important meeting of their entire lives, and she might've only reluctantly agreed to go, but it wasn't like Enne to be careless.

But after several more minutes of standing in silence, Harrison sighed. "We'd better assume now that she's not coming."

"No," Levi blurted. "She'll be here—"

"Will she?" said Harrison, shaking his head.

Fenice took a shaky breath. "Then I suppose we have no choice but to proceed without her." She opened the door to a conference room and led the others inside, and Levi followed with a dreadful anger in his stomach. He and Enne had shaken hands in their agreement to come here. It had seemed cheap at the time, when so much more had once passed between them. But he'd thought it meant something.

Harrison was right—Levi had been wrong to trust anyone. Once again, Enne had betrayed him and played him for a fool.

But it was worse than that. She'd claimed it was too dan-

gerous. Which meant, in her mind, she'd left him to die. Even the word *fury* felt inadequate to describe the way his stomach twisted.

"Well," Bryce said, rubbing his hands together as they each sat down. All of his actions, no matter how trivial, made Levi's pulse spike. Bryce was a human jump scare. "If you could all just reach into your pockets, then—"

"I said no games," Fenice snapped.

Bryce gave her a pointed look. "You'll have your turn after I have mine."

Harrison shot the Chancellor a warning glance, as though he felt as alarmed by Bryce as Levi did. Then Harrison reached into his pocket and retrieved a golden Shadow Card. Levi had seen him clutching one at St. Morse the other night, same as him, but now he glimpsed the Lovers on the face. It was rather appropriate, if not depressing—Vianca had killed Harrison's girlfriend during the Great Street War nineteen years ago, which was part of the reason Harrison had ultimately killed *her*.

On the golden side, red words were scrawled across the foil, in an ink that looked like blood.

THE SUN.

Levi reached into his own pocket for the Emperor and found a word also scribbled across its back. *STRENGTH.* A chill crept across his neck. That word hadn't been there before, but no one had touched his card but him, not since he'd received it. That meant this wasn't a trick; this was another piece of Bryce's power. His talent went beyond anything Levi understood.

His eyes flickered to the door again, his thoughts spiraling. St. Morse. The Shadow Game. His father. *Run. Run. Run.* The only reason he didn't was because his fear had frozen him in his seat.

Josephine shakily slid her hand into her purse and retrieved her own card, the World. *THE LOVERS* was written across it.

"What does this mean?" Harrison asked.

"It's simple, isn't it?" Bryce told them smugly. "These are your targets. These are the rules to my game."

ENNE

Enne would've felt worse about lying to Levi if she hadn't thought he was making a horrendous mistake. This was not the time for negotiations, when they had nothing to exchange with the Chancellor for their safety. And as much as she wanted to stop him—and protect him—she couldn't. The moment he had looked at her like she was a stranger, he'd made it clear that they were not in this war together. And so while he met with the Chancellor, likely with a hundred whiteboots aiming guns at his heart, he could make his move.

And she would make hers.

Grace snapped her fingers in front of Enne's face. "Séance, come in? Stop staring off into the distance, looking lovesick. You need to focus."

Enne resented being described so pathetically, even if it was true. "But how is it possible that none of the Scarhands know where the Doves' hideout is?" She bit her lip. "The longer we

wait to approach the Doves, the more time they'll have to re-group since Ivory's death."

Early that morning, behind the closed door of the head-mistress's office, Enne, Lola, Grace, Roy, and Mansi met to hash out how they'd possibly live up to the Scarhands' ambitions that two gangs of forgers, counters, and weapon salesmen would overthrow the most secretive, formidable assassins in the city.

"I don't know what to tell you," said Grace, perched on the edge of Enne's desk and clutching a stale cup of coffee. "The Scarhands worked for Jonas, but they weren't Jonas."

"And not even the whiteboots know?" Enne asked Roy. He'd assumed his usual position, crossing his arms and glow-ering out the window at the finishing school's barren, waste-littered grounds, as though he was frequently reminded that the company he kept was not the law-abiding sort.

"You think Captain Hector would leave the Doves in peace if he did?" Roy answered.

Enne turned to Lola across from her. She looked tired, her pallid green eyes rimmed with red, and her broad, bony shoul-ders hunched as she straddled her backward chair. Her har-monica was poised beside her lips, though she'd yet to play it.

"Don't look at me," Lola muttered. "I still think this is a muck idea."

"But you say that about all my ideas," grumbled Enne.

"Because I'm the one who prioritizes self-preservation." Lola sighed. "Plus, you made me lie to my girlfriend about the Chancellor's meeting."

"I know, and I'm sorry about that," Enne told her. "But we can do this. We have more than enough people and weapons, thanks to the Scarhands. This is our chance—maybe our only chance." When no one echoed her poor muster of confidence, she looked to Mansi. "After Jonas, who was the next best per-son in the Scarhands to ask for information? There must have been someone."

"Like I said yesterday, our second died in the battle outside St. Morse." When Enne mumbled something unladylike under her breath, Mansi stiffened and continued. "But we still have Jonas's records! For the most part… The important ones. The ones he tried to hide before he died."

Jonas had kept meticulous records on every person in New Reynes, and if he'd salvaged any of them before the whiteboots had raided their hideout, then he might've saved the ones she needed.

"And didn't Levi say something about Jac being attacked by a Dove two weeks ago?" Roy asked.

Levi had mentioned that the night after St. Morse, which they'd spent in the Irons' reclaimed museum, exhausted, wounded, shell-shocked, listening to the radio report the horror they'd just lived through. Simply dwelling on it for a moment made Enne's chest feel tight. Even if she'd uncovered a path forward, her composure still felt teetering at the edge of a wall, behind which she'd carefully quarantined every fear, every anxiety, every mistake.

Don't worry. I've beaten worse.

"That means there might be a trail," Enne said, her voice cracking slightly. She cleared her throat. "Maybe we can find this Dove. They could tell us where the hideout is."

"It's not like they'd just linger around Luckluster," Roy said. "Plus, Luckluster is literally rubble now."

"It didn't happen at Luckluster," Lola recalled. "It happened at a tavern Jac and Sophia worked at. Liver Shot."

Roy furrowed his eyebrows. "Even so. Why would the suspect hang around? Wouldn't they have returned to the Doves?"

"Ivory doesn't exactly take kindly to failure," answered Grace. "They might not have anywhere else to go. We could ask around. Maybe we can track them down."

Enne grasped at this tendril of hope and clung to it. She

stood up and declared, "Then it's decided. Lola and I will go to search Jonas's files, and—"

Grace put a hand on her shoulder and pushed her back down. "Easy, Séance. There are six more Spirits and over one hundred other Scarhands here right now. We can't *all* leave, you least of all."

Enne frowned. She didn't like delegating tasks to her friends that she could easily handle herself. *She* should be the one parsing through Jonas's files—she'd seen them before.

But Grace was right. When news returned, someone needed to be here waiting for it. Someone needed to lead and make the next decision.

"Fine," Enne breathed. "Grace, you and Roy can go to Liver Shot and play detectives—"

"It's not playing," Roy mumbled. "I *am* a detective—"

"Lola," Enne continued, "you can look through Jonas's files."

"Why do I have to be partnered with the whiteboot?" Grace asked, glaring at the dregs of her coffee. "I'll take Lola. Make Roy go play librarian."

"Because Lola is better with research. And because you're going after a *Dove*, and Lola isn't any good at fighting," Enne told her. "No offense, Lola."

"Too late," she said flatly.

Grace sulked as she and Roy made for the door. "I'm not your partner," she snapped at him.

He smirked. "If you say so."

Lola rolled her eyes and followed them out, the tune of her harmonica drifting down the hallway with her.

When the others had left, Enne—a good bit soured—led Mansi to the main classroom in the finishing school, where the rest of the Spirits passed the time. Them and their thirteen cats, each of whom were named after dead street lords of North Side history. The girls lounged on pink fur throw blan-

kets and plush carpet. The cats lounged everywhere other than
their actual beds.

Charlotte looked up from behind her copy of *The Guil-
lory Street Gossip*, a South Side tabloid. This edition featured a
glamorous photograph of a severe-looking blonde girl named
Delaney Dawson, whom Enne recognized as the ballet rival of
Poppy Prescott, Enne's old friend.

"Can I borrow that?" Enne asked her, desperate for some
way to pass the time.

Charlotte handed it to her—its pages were sticky with melted
chocolate. Feeling exceptionally useless, Enne collapsed on
the couch and ignored the Scarhands peering at her from the
hallway. She wished she could do *something*. A lord would. A
Mizer would.

Instead, she flipped through the tabloid until she found a
photo of Poppy, and she sighed, wondering what her friend
must think of her now.

Grace and Roy returned before Lola did, a boy in tow. He
was bleach-pale, freckly, and badly beaten up—one of his eye-
lids engorged and swollen as though it might burst. Yellow
bruises covered his arms, some fresh, some not. He was al-
most nauseating to look at, like something spit out of a North
Side gutter. Several of the girls—even Marcy, who normally
blushed at the concept of any boy—covered their noses at his
odor as Grace and Roy dropped him in a heap on their rug.

His hair was white, the way the Doves wore it.

He coughed a bit and looked around wildly, like a captive
animal. He gawked first at the cats, with the same bewilder-
ment as many of the Scarhands who'd visited their home. He
then searched the faces of the girls until his dull green eyes
found Enne's.

He spit on the rug.

"Well, that's contaminated now," Charlotte muttered, and Marcy elbowed her in the stomach.

Grace shot Roy a smug look. "Go on, say it. Say that I was right."

"We found him not far from Liver Shot," Roy explained with little mirth. "One of the workers said he'd been loitering. He wasn't even hiding. It was like he wanted to be found."

"They'll take me back," the boy barked. His voice was nasal-y and tinny. "They keep trying to get rid of me, but I'm still alive, aren't I? They'll take me back."

"What's your name?" Enne asked.

He said nothing, only straightened into a kneeling position and grimaced at the floor.

Enne frowned at Grace. "You should've called me before bringing him here." Not only would this compromise the finishing school, Enne felt inclined to agree with Charlotte, who was currently scowling and spritzing perfume into the air.

"Of course I brought him here." Grace reached into her bag and pulled out a few items: a gun, several empty orbs, and—of all things—a flute. "Look at him. He's Lola's brother."

His gaze snapped to Grace at her words. "You're wrong," he snarled. "I'm no one's brother."

But suddenly Enne wasn't so sure. Lola had a split music talent— it made sense that her brother would carry a flute. And he looked like her, especially the Lola Enne had known when they'd first met, with dyed white hair. Freckles dusted the boy's fair skin, and he was tall, big-boned and skinny like a blunt instrument. Their eyes matched, as did their small noses, their pink ears. He looked the right age, too—maybe only a few years older than herself.

"Lola has a brother?" Charlotte asked, her brows knitted.

"Only Grace and I knew," responded Enne. "Has Lola called yet?" Enne asked. Beside her, Marcy shook her head.

"I'm telling you, I don't have a sister," the boy said. Barely after rasping the words out, he stood and broke for the door.

Roy grabbed him by the shoulder and wrestled him back down. The boy let out a wounded, pathetic cry, then bit into Roy's arm.

Charlotte cringed. "That'll get infected."

Enne hoped the boy was right, for Lola's sake. This boy looked rabid and desperate, and thanks to Grace's questionable judgment, they would be forced to keep him here much the way they'd once imprisoned Roy. Enne had enough to worry about without letting the Spirits house any more dangerous strays.

"Do you know where the Doves live?" Enne asked him.

"I'm not telling you anything," the boy snapped.

"You said you want them to take you back," she said, cringing as she examined his many injuries. "Did they do this to you?" She brushed her finger over his swollen eye, but he turned away.

"I'm going back. They'll welcome me back."

"Why did they make you leave?" she asked.

"Because I learned... I..." He bit down on his lip, as though trying to prevent himself from speaking. His face scrunched up like even his own thoughts hurt.

"Lola will be able to tell us the truth, when she gets back," Enne said.

The boy winced but said nothing. It only confirmed Enne's suspicions, but she took no pleasure in that.

"Or you and I can strike up a deal," she added, thinking quickly. If the boy hadn't contacted the Doves since he'd been sent to attack Jac and Sophia, then he didn't know that Ivory was dead. "I know Ivory. I can convince her to take you back. But I can't speak to her unless I know where to find her."

"Ivory would never listen to *you*," he hissed.

"I now control the largest gang on the North Side," she told him, using Lourdes's old rules to lace her voice with confidence. "I think she will."

He narrowed his eyes. "What do you even want from her?"

"What does anyone want from her?" Enne asked. "I want somebody dead."

She didn't—not anymore. She'd once craved the death of the Phoenix Club as retribution for her mother's murder, but all she really craved now was a sense of security. She didn't want to lose anyone else.

The boy stilled under Roy's arms, as though Enne's choice of words had relaxed him. Enne had heard rumors of the Doves resembling a cult more than a gang, and truly, the boy did look deranged. It would be all the better for him when there were no Doves to return to.

"Their hideout in the sewers. You can enter through an abandoned Mole station—Pinochle. In the Deadman District," he said quietly. "Go in through the tunnels."

Enne rarely ventured into the Deadman District; she wasn't familiar with that station. But even if it would be helpful to drag the boy with them for extra guidance, it wouldn't be smart. He looked as stable as a homemade pipe bomb.

"Roy, could you take him upstairs?" Enne asked. "Now that we have what we need, the rest of the Spirits can keep an eye on him while we go. And Charlotte, I'd like to be the one to tell Lola. So don't let her know about the Dove until I come back."

The boy screamed as Roy picked him up. "No!" he shouted. "Take me with you! You have to! I'm not a traitor!"

Shuddering, Enne tuned out his cries and turned to Grace. "Let's go."

IV

DEATH

"What is buried is not always dead."

Séance. "Semper Orders Thousands of
Mizer-Era Records Destroyed."
The Journey of Reynes
12 Mar YOR 6

LOLA

In the Factory District, the Brint River reeked of manufac-
turing waste, a putrid funk of chemicals and slop that was cer-
tainly unsafe to breathe. Her Scarhand guide had led her to a
block of row houses wedged between two industrial complexes,
less than a mile from where she'd been born. But despite her
years spent here, Lola had forgotten the smell. She'd forgot-
ten the front lawns with gravel instead of grass, the churning
of hydrolics in the distance, the litter, the graffiti—all of it.
How depressing that the happiest years of her life were spent
in such a muckhole.

Lola might've traveled here at Enne's request to study Jonas's
files, but that didn't mean she supported Enne's delusions of
uniting the North Side under one lord. Enne had claimed Levi's
decision to meet with Fenice was dangerous, yet she'd race off
to challenge the most notorious killers in the city. It was ab-
surd, hypocritical. And Lola rarely—if ever—sided with Pup.

But Lola hadn't only agreed to the errand for Enne's sake.

You can be my protégée, little Lourdes, when you learn Lourdes Alfero's true name.

Zula Slyk's words from yesterday had planted a parasitic seed in Lola, sprouting roots that burrowed into her curiosity and demanded to be fed. Zula was a bitter old woman, all of her associates and friends dead from a war long over. For all Lola knew, her test was a lie, meant to send Lola scrambling for answers she'd never find.

But Lola couldn't stop thinking about it.

Lourdes had supposedly been a Protector—someone whose talent provided an extra layer of defense to the secrets of those they'd sworn loyalty to. Based on Enne's descriptions of her childhood, Lourdes's talent did match that of the Alfero family. But when Lola, Enne, and the Iron boys had visited the National Library last summer, Lourdes's name had been missing from the Alfero family archives.

And if there was anywhere Lola could unearth Lourdes's true name, it was in Scavenger's files.

Her Scarhand guide unlocked the front door of the duplex, and they walked inside what Lola imagined had been Jonas's personal home. The furnishings were sparse. Stacks of *The Crimes & The Times* were piled on the coffee table, many of their articles cut out, words highlighted or crossed or underlined. Similar clippings coated the walls.

It looked like the work of a madman, but Lola admired the dedication. Maybe she wasn't the only one in New Reynes who paid attention.

"Down there," the Scarhand told her, pointing to a cellar door.

It creaked when Lola opened it. She swallowed and descended into the darkness. The Scarhand didn't follow after her.

Once Lola switched on the lone dangling lightbulb, she saw that the basement looked even worse than the upstairs. Folders were heaped in piles both on and around the sole desk. Many

of the towers had spilled over, leaving papers strewn carelessly across the floor. Lola stepped around them carefully so not to damage them. These documents were valuable, more valuable to her than anything else in New Reynes. A thrill pulsed in her fingertips. She felt like an archeologist, uncovering ruins left behind for her to find.

She started with the closest pile. Each folder represented a citizen of New Reynes, but the handwriting of their names on the tabs was scratchy and hard to read, slowing her process. Occasionally, she passed over names she recognized—celebrities in the South Side, business owners, politicians. But after the first pile, then the second, then the third, she didn't come across any name that mattered.

Time ticked by. Enne, she knew, would be growing impatient, but this kind of work couldn't be rushed.

But still, as several hours passed, frustration snapped in her like a muscle pulled taut. Jonas hadn't only saved his important files—he'd saved them *all*, a symptom of his obsession with his work. But Lola shared in that affliction, and if it had been her, she wouldn't store all of her files together, a disorganized, chaotic mess. She would hide the ones that mattered somewhere else.

She wrenched open the drawers of Jonas's desk, feeling past the loose, empty orbs and food wrappers for…something. Anything. To her satisfaction, she found a false back in one of them, and she carefully pushed down the flap to reveal a bronze key.

Lola raced upstairs, clutching it in her fist. She was breathless, her heart juddering. Muck, she was actually having fun. "Do you know where Jonas kept a safe?" she asked the Scarhand eagerly.

The young woman shrugged. "I didn't know him that well."

Jonas had been second and then lord of the largest gang in New Reynes, yet no one had known him.

Lola sighed. First Lourdes, now Jonas. Following in the footsteps of tragic figures didn't likely lead anywhere good.

But after tearing apart the living room, kitchen cabinets, and pantry—Jonas had as terrible taste in snacks as he did wall decor—she found the safe in the same way she'd found the key, by asking herself: If it was her, where would she hide it?

She spotted it in an empty spare bedroom, tucked behind the radiator. It measured no larger than a shoebox, one of those portable safes—perfect for someone like a Scarhand, a gang that, for years, had never kept a permanent headquarters. This was something Jonas could take everywhere with him. Knowing him, he could probably fit it beneath his pillow.

Lola unlocked it and knelt on the floor, pulling out a handful of folders belonging to the people Jonas had deemed the players of this city: Josephine Fenice, Erienne Salta, Levi Glaisyer, Charles Torren, Aldrich Owain, and more. Lola was both relieved and strangely offended to find herself not among them.

But there were three files that made her heart clench.

The first belonged to Jac Mardlin, the person who told her he'd never wanted to be a player. Or maybe she had told him that, and he hadn't corrected her. Either way, it hurt that she'd been so willfully wrong, that she hadn't *seen* when seeing and listening and observing were exactly what she prided herself for. Maybe he rested happily knowing that he'd gotten his legend. But even if Lola had always known—much as Zula had said— that she would be the one to tell these tragic stories when all of this was over, she'd never wanted to be telling his.

Still, she flipped through Jac's file, curious. Hospital records, wanted posters, financial logs from his old debts to his One-Way House. It was too much, too personal. Overwhelmed, Lola snapped the folder closed, and resentment spewed up her throat. Lola didn't even like boys, but they still found a way to break her heart.

"Fuck you," she whispered, but she didn't mean it.

The next file belonged to Lourdes Alfero.

And the last belonged to Ivory.

Lola took a deep breath and collected herself. Her own de-
sires itched to open Lourdes's folder and examine its secrets, but
hours had passed since she'd left the finishing school.

And so Lola opened Ivory's folder first, one that was—more
than any of the others in the safe—clearly the most worn. Sweat
and coffee and inky fingerprints stained the corners of the doc-
uments, their edges curled and brown. Notes in Jonas's scratchy
handwriting filled every margin in pigeon scrawl. The papers
even smelled like Jonas—the acrid stench of something dead,
a characteristic of his talent to swipe volts off of corpses. They
also smelled like beef jerky.

The folder was confusing and irrationally organized, with
other folders wedged inside it and papers that seemingly be-
longed somewhere else. There was some kind of entry writ-
ten by Reymond Kitamura, Jonas's predecessor as Scar Lord,
who had once been a Dove. There was Jonas's own file tucked
inside, double-labeled with his own name and then another—
and Lola guessed the name Maccabees had always been an
alias. There was a file of a girl, a dead girl, who shared Jonas's
true blood name.

And then there was the file of Rebecca Janus, Bryce's girl-
friend who helped him manage the Orphan Guild. Lola knew
her the way she knew the flu—miserable, stomach-curdling,
something she'd never like to meet again. But as Lola's gaze
swept over the mess of it all, she kept returning to this one
folder. Despite her two years of work for the Orphan Guild,
Lola had never known Rebecca's blood name.

If Lola had been anyone other than a devotee of research, she
might not have uncovered the truth hidden among the mayhem
of Jonas's paperwork. Ivory's file clearly represented the heart
of Jonas's obsession for scavenging secrets. There were so many

documents and photographs to parse through, it was exactly the sort of conspiracy Lola could see someone going shatz over.

"Janus," Lola said, rolling the name over her tongue. The Janus family had a shape-changing talent. They could adopt or transfer three faces the way an Augustine possessed three omertas.

She read through Reymond Kitamura's letters to an old business partner, describing his confrontation with Ivory when she'd taken her dagger and given him his nickname Eight Fingers, back when he'd been a Dove. She'd been acting differently for months. She didn't remember things, important things. As though she had suddenly become a different person.

There were documents and notes from the murder of the dead girl—Jonas's sister, Lola realized. No wonder Ivory was his obsession; whatever mystery lurked within all this was personal. When his sister's body had been exhumed for further evidence, there had been two corpses found within the casket—each one with an identical face. Jonas's sister's face. But she hadn't had a twin.

Can a Janus alter someone else's face? Jonas's notes asked.

No better way to hide a body.

In the meeting at the Catacombs, it was like Ivory knew Bryce well.

Lola cupped her hand to her mouth as she started to piece it together. She counted on her fingers. The first face: her own. The second face: the one she'd stolen from Ivory. The third face: Jonas's sister's face, which she gave to Ivory's body.

Ivory is dead, Jonas had written to Enne. The words were truth, but they'd all interpreted them wrong.

Ivory was dead, and she had been dead for a long time.

Rebecca wore her face now.

Lola raced down the stairs, her stomach in knots. "I need to get to a payphone," she told the Scarhand breathlessly. Then she grabbed her by the wrist and dragged her outside into the stench. If Enne had already found the location of the Dove

hideout, then she wasn't about to conquer a fallen kingdom—she would find its queen alive and waiting for her.

Lola's hands shook so much that she could barely dial the number. She called the finishing school.

"Hello?" she asked, her voice trembling.

"'Lo?" someone answered. Lola's heart sank—it was Marcy, not Enne.

"Is Enne there? Put her on—"

"She's gone. She, Grace, Roy, and some of the Scarhands all left. They went to the Pinochle Mole station."

Lola cursed, clutching Jonas's safe to her chest like a life raft. Enne had been right earlier; Lola was no fighter—her collection of knives were just for show. The only blood she'd ever drawn had been for a talent reading. If anyone would get hurt in a showdown with the Doves, then it would be her.

"Muck," Lola groaned, dropping the phone, running toward danger, anyway.

LEVI

"Please," the Chancellor growled at Bryce, the sharpness of her voice snapping like static in the still air of the conference room. "I didn't call this meeting to bend to you and your psychotic, terror-inducing games. I called this meeting because it's clear that you don't understand what kind of legends you're playing with. And—as much as I am loathe to do it—I find myself in a position of having to explain myself to you. And I hope that when you understand, you will end your foolishness and agree to help me. Both of you."

At those last words, her dark gaze shifted from the malison to Levi, and Levi stiffened. It took more than nerve for Josephine Fenice to ever look *him* in the eyes and ask for his help. The last time he had shared a table with her, Enne had been playing for his life.

And so he reminded her, "You tried to kill me. Why would I help you now?"

He expected apologies, crooked words, and empty smiles like any politician. He *deserved* them.

Instead, she asked, "Have you ever heard of the Bargainer?"

It was a ridiculous question—everyone in New Reynes knew the story, the oldest legend of all of the North Side's trove of tales. Though Levi still barely understood one mucking thing about Bryce's talent, Levi did know this much: every heinous act Bryce had committed at St. Morse was in hopes of summoning the Bargainer, and—according to Sophia Torren—the Bargainer was more than a hushed story whispered in Casino District alleys.

But Levi also didn't know if Bryce had truly succeeded. The smug look in Bryce's scarlet eyes and the stricken paleness of Fenice told him they both thought he had.

"Of course they know the legend," said Harrison with an awkward chuckle. He leaned back in his seat and smiled like he was forcing himself to do so. The others didn't bother to follow suit.

"So you might know the story, but you don't know the truth," the Chancellor said darkly. "The Bargainer is not a legend—they're a real person, who resembles a young woman. She is a malison by blood talent, and a shade-maker by split talent. A powerful and potent combination, one that allows her to rely on no one."

Levi frowned, trying to keep up. "How would you know that?"

"Because I've met her," the Chancellor said gravely. "And because everything I've done since has been to stop her from returning to this city."

Bryce grinned widely. "But you failed."

She shot him a seething look. "You have no idea the sacrifices that have been made. The deaths, all so that—"

"I am a malison. I lived in the House of Shadows, where my

family helped to *create* the Shadow Game," Bryce shot back. "I think I know enough."

"Well, I'd certainly like to be enlightened," Levi growled.

Fenice assessed him, her steely gaze now fixed, not on his face, but on his hair, as though the black dye didn't fully conceal his coppery orb-maker roots.

You are spared only until you remind them who you are.

In all his years here, Levi had never once been made to feel like he didn't belong in New Reynes. The Republic's capital drew people from all across the world, tourists and newcomers with features in such variety that Levi's brown skin and tight curls never stuck out much. And with his sleazy pin-striped suits, sidewalk card tricks, and roguish smile, Levi looked so quintessential City of Sin that he'd had them all fooled—himself included. But so it turned out, he couldn't wash out the Revolution's toll on his life with soap in a pub's bathroom sink.

If Levi had ever realized this before, he'd dismissed it, ignored it. And so Levi didn't know how to react to the Chancellor's stare. He didn't know how to be Levi the dead nobleman's grandson when he'd spent so long being Levi the Iron Lord.

Run, his father whispered. Levi didn't, but he did look away.

"The Mizers were powerful. They were *kings*, and they kept those they trusted close to them while everyone else suffered on the fringes," Fenice needlessly explained to him. As if Levi needed an education on his family's origins and demise. "And so how do you think they fell?"

"The people grew fed up with their tyranny?" Levi guessed. Even if he was supposed to side with his family, he couldn't deny the wrongs the Mizers had committed.

"Yes, but that doesn't explain how the revolutionaries managed it," Bryce answered for the Chancellor. "The Mizers fell because of a bargain."

Levi tensed and glanced to Fenice. He knew enough about

cards to know the look of someone caught. Bryce spoke the truth.

"The night before Malcolm Semper was to be executed for treason against the kings, he made a bargain," Bryce continued. "He asked for the Mizers to fall, but the Bargainer—who also had been wronged, as malisons long have been by the Faith— asked for a pledge far worse in return. She didn't just want the Mizers usurped. She wanted every single Mizer dead. At the time, Semper had only been fighting for one kingdom, for this one city. And so the Bargainer held all of Reynes hostage. She would free him and light the Revolution's spark, and he would see the world burn—and if he failed, then she would return to this city and destroy it, his home."

After all the years of spinning his story as though he'd come from nothing, Levi didn't expect his anger to rise like it did. His family had been ruined, not for the righteousness of a Revolution, but from the bargain of a man too cowardly to face his execution.

Levi had put a bullet in the same man's head.

And the weight of that story—his *true* story—was not lost on him.

"Why would she do that?" Levi snarled. "Why would destroying New Reynes give her any satisfaction? Why bring about more violence?"

"Don't you listen to the stories?" Bryce asked. "The Bargainer thrives on chaos. She grows more powerful with every deal she makes. And this city was all that Semper cared about."

The Chancellor slammed her frail fist on the table. "If you know the true history, why would you ever summon her here?"

"Because I don't give a muck about New Reynes, and I never have," Bryce answered flatly.

"Well, it's unfortunate for you that the three of us *do* care about this city," Harrison said, and Levi considered disagreeing. Harrison and Fenice were politicians, working for a govern-

ment that had robbed his family of everything they had. But Levi *did* care about this city. And after losing so much of what he cared about, he was still willing to fight for this.

Harrison reached into his jacket and retrieved another Shadow Card, this one silver. Levi's already jittery heart sped up at the sight of it. It was another legend, the Fool, the invitation to the Shadow Game. Only months before, the memory of that card and that night had haunted him, but he'd thought he'd gotten over that. Instead, he realized, he'd been burying all his traumas in the same spot, and after the pain and fear of the last few days, they'd all been unearthed together, like the bones of the dead after a torrential rain.

Meanwhile, Bryce laughed. "You don't get it, do you? The era of the Shadow Game is over. The only game we're playing now is mine." He reached out to touch the card, and all three of the others held their breaths. The Shadow Cards had divination properties—touching it should force the recipient into a vision. But Bryce didn't even blink as he grabbed it and tossed it over his shoulder like lint on his too-large shirt.

Run, Levi's father repeated, louder this time. He jolted out of his chair and stood, the eyes of the room all fixed on him in surprise. He froze, embarrassed, knowing he looked shatz. So, in order to make his action seem like it'd meant something, he grabbed his gun from his pocket and aimed it at Bryce's head.

"Let's just do this the easy way," Levi said, voice catching as he clicked off the safety.

Bryce raised his eyebrows. "Don't you remember what happened at St. Morse? You can't kill the Gamemaster by cheating." At the casino, Enne's bullet had whizzed right through Bryce as though tearing through smoke. But still, Levi didn't lower his gun. He suspected the weight of it was all that kept him standing.

"Listen to him, Levi," Harrison said sharply. "The Shadow Game isn't what you think it is."

"It's a card game where the invited player always dies," Levi rasped. "You forget that I've witnessed it firsthand."

Bryce cocked a sly grin. "You still don't know the whole picture. When Semper realized that he'd failed—there was still at least one Mizer left alive after the Revolution—he knew he had to find a way to stop the Bargainer from returning and razing the city. So he consulted with other malisons, and he and the rest of the Phoenix Club created the Shadow Game. That's what it really is—a curse. With every death, the shade of the game grows stronger. It's what keeps the Bargainer out of New Reynes, like a barrier."

There's a price to keep the devil away, Levi recalled Bryce saying at St. Morse, which Levi had written off as the words of a lunatic.

It was still too much to believe. "How do you know all this?" Levi demanded.

"I told you. I'm from the House of Shadows—all the remaining malison families live there, selling shades, ensuring the Shadow Game continues on. I just left a long time ago."

From the grim way he said it, Levi guessed Bryce had also run away from home. Vianca Augustine had definitely had a type.

"The game was devised so that every player bets their lives," Fenice said. "It's why only those with the immortality talent play for the Phoenix Club—our lives cannot simply run out. The Club was formed for a noble purpose."

Levi didn't like this version of history. He'd preferred when the Phoenix Club was a group of sadistic South Siders replacing executions with card games. It was still mucked up, of course, but it was also layered and messy and complicated, just like the Revolution had been.

"The Shadow Game is finished," said Bryce. "The shade that held it together is broken. I replaced it with mine. But don't worry—I'm not thick. The Bargainer is a player, too, bound by

the rules the same as you. Until the game ends, no player will be allowed to leave New Reynes—and therefore, for now, the Bargainer will be forced to keep the city standing."

"And what is this game?" Harrison asked tightly.

Bryce stood up, paying no mind to the gun Levi still pointed at his temple. "Like I said, every person has been matched up with a target. You cannot simply steal your target's card—it must be given willingly or taken by force. No sneaking. No tricks. And once you give away your card, you cannot take it back."

Taken by force, Levi reflected, probably meant death. The gun wobbled in his grip.

"How does the game end?" Harrison asked. Levi had muck idea how he kept his voice so level, how he kept his composure as slick as his receding, greased-back hair. He'd been there at St. Morse. He'd seen it. And that night was only the grisly prelude to Bryce's real plans.

"Once someone has collected a string of five cards—and done so properly. By collecting their target's target, and so forth. There will be no cheating."

"You realize you've set up a murder spree," Levi growled. He lowered his gun to Bryce's heart. It would feel good to shoot him, even if it did nothing.

Harrison held up his hand to Levi and shook his head slightly, as if to tell him, *Don't*. Levi didn't take orders from Harrison— still, he dropped his hands. But he didn't sit down. His legs felt leaden, and he was sweating through his suit.

"If we cooperated," Harrison asked Bryce coolly, "why wouldn't we just hand our cards over to each other to end the game without bloodshed?"

Bryce licked his lips. "Because there's a caveat. If the game ends and you're not in possession of your target's card, then you die. But also, once you give away your card, you rest your

fate entirely in the other person's hands. If they die during the game, so will you."

Fenice's eyes flickered to Harrison's card—her own target. Harrison averted her gaze and quickly slid it into his pocket.

Levi's heart hammered. The game could be finished in days, or it could take years. And it seemed there was no way to end it without at least some of the players dead.

All of his friends had a card.

They would work together, he decided. If there were twenty-two players, one for every trump card, then they would work together in order to survive. Maybe Enne had stood him up because she'd thought this meeting was a mistake, so it was up to Levi to explain these rules to their friends. Like everything else in his life, it was his responsibility to make sure the people he cared about survived.

He stared at the name of his target. *Strength.* He didn't know who that card belonged to, but he *would* kill for it, if he had to.

As Bryce finished his speech and stood to leave, Levi spoke up, "I don't get it. How does this game get you what you want? How will this get you your bargain?"

Bryce gave him an ugly smile and answered, "It will get me everything." And then he left, and despite his three enemies in this room, no one bothered to chase after him. What good would it do? Maybe the other players were vulnerable, but as the Gamemaster, he'd made himself invincible.

The Chancellor's hands shook as she pushed herself to her feet. "Don't be fooled—the only true threat is the Bargainer, who still wants to see this city gone. Never let Bryce distract you from that."

Harrison gave a funny noise from the back of his throat and ignored her. He instead looked at Levi with an expression that resembled—dare Levi say it—concern. Levi self-consciously wiped the sweat off his brow.

"Are you all right?" Harrison asked him.

"I'm fine," Levi grunted.

"Do you need a ride home?"

It was such a pleasant, absurd question that Levi gaped. "Am I your ally now? Or am I still a wanted criminal?"

"A discussion I'm happy to have," Harrison said smoothly, ever a politician.

It was a conversation Levi wanted to have as well, but his list of requests would have to wait. He needed to speak with his friends before any decisions were made.

"My driver and I have a meeting place," Levi responded, then he muttered a terse goodbye and left the room. He strode down the hallway and out the door, where he took a deep, gulping breath of fresh air. It still tasted of dread. He'd hoped this meeting would make him stop looking over his shoulder, make him feel in control, but instead, he ducked past every passerby. He felt dizzy, foreign, exposed. The businessman who strolled past with a cup of coffee thought he was a Mizer sympathizer. The man carrying his toddler thought he was a dangerous criminal. The stranger who accidentally bumped into his shoulder was another player in Bryce's game, and Levi her target.

Panicked, Levi slipped down a nearby alley—he'd take a detour in his walk back to Tock. The morning sun gleamed brightly, though the harsh shadows cast the alley in muted darkness. Still, he made out the silhouette of a girl at the alley's mouth. She looked barely older than Levi, though she had a harsh, serious face, with thin eyebrows and thinner lips and a sharp part in her light brown hair.

She resembled an ordinary girl, was dressed like an ordinary girl. But even though Levi couldn't see her aura, he sensed something *wrong* about her. She watched him—a young man—approach her alone in an alley, yet she did not move. And a scar traced a circle around her neck, faded to the white of new, pale skin.

Levi didn't realize until he grew closer where she stood—at a crossroads.

Levi had listened to legends his entire life. He'd wanted to *be* one. But now the hairs on his arms stood on end. The shadows each stretched an inch too far.

A jolt went through him as he passed her. He felt her eyes on him.

"An orb-maker." Her voice was an eerie murmur, but still he heard it, even as he put distance between them. He heard it like her lips grazed his ear, and he nearly leaped out of his skin. "Is there something you want? Someone you desire? Someone you miss?"

Run.

Levi finally listened. He broke into a sprint, and he didn't stop until he reached Tock waiting in his Amberlite and jumped into the passenger seat. He kept his gaze fixed out the window as they drove back to the North Side, but the Bargainer didn't follow him.

ENNE

Enne did not feel like herself as she descended into the abandoned Mole station.

Even if Enne had agreed to carry out the Scarhands' plan, she hadn't considered what it would mean to face danger so soon after St. Morse. She didn't feel weepy or afraid—she felt disoriented, as though she was watching herself from outside her body. She did not recognize this place, the acrid stench of piss, the cigarette butts and street cart wrappers littered on the concrete steps. Other than Grace and Roy, she did not recognize any of the gangsters flanked at her sides.

She did not recognize her white-gloved hands as they clutched the revolver at her hip.

But she did recognize the gun. *That* gun.

It was too late to turn back, and so she crept deeper onto the subway platform. Her heart thundered wildly, but she was too numb to feel it.

"The Doves should be down to fewer than ten people,"

Grace said. If they could trust Lola's brother, the Doves lurked in a sewer connected to this tunnel—strange for those named after birds to dwell underground. "If they're smart, they won't put up a fight."

"The Doves aren't a gang—they're a cult," Roy breathed. "What makes you think they'll surrender quietly?"

Enne had not come here intending brutality. Even assassins who lived in a gutter could see the value of Enne's proposition, of joining her and uniting the North Side under *one* lord.

"They'll capitulate," Enne told them. If the deranged state of Lola's brother was any indication, the Doves needed saving.

"And if they don't," Grace added, "we have enough numbers to make them."

"And Scythe?" Roy pressed.

Ivory might've been dead, but her second wasn't. Enne had only encountered Scythe on one occasion, at the first meeting that Levi had called between the lords, and she remembered him as cold, intimidating, and patronizing—she doubted he would agree to their terms. The thought of facing him broke through her daze and made her nerves feel tauter than a tightrope. Maybe violence was certain, then. But that was one man, one fight.

Her hands squeezed the revolver tighter.

True to what Lola's brother had described, the group approached a grate in the wall, large and circular, with metal bars wide enough to squeeze past. A connection point between the city's labyrinth of Mole tunnels and sewers. A rivulet of piss and who knew what else pooled across the floor, and pigeon and seagull feathers floated at its surface. Somewhere in the darkness, rats scurried along the tunnel's edges.

Enne crinkled her nose. "I guess we found it."

The stench intensified as they crept through the bars and into the next tunnel. She wished she'd brought perfume to dab beneath her nose—the odor's taste coated her tongue, waxy

and feculent. She, Grace, and Roy approached a canal of waste and exchanged a revolted look.

"How can anyone live in a place like this?" Enne choked.

A voice answered her, high-pitched and breathy, echoing down the tunnels.

"They can't."

Roy jolted and—if not for Grace hurriedly grabbing his coat collar—nearly fell over the ledge into the sewer. He pointed his gun down the tunnel toward the noise. "Who said that?" he demanded, his whiteboot voice full of authority.

The darkness obscured all but a few feet in front of them. The many Scarhands behind Enne had clambered through the entrance to crowd around the canal's edge, all of them pressed shoulder to shoulder, back-to-back. Enne stiffened at each touch—the very sensation of it felt wrong; her body felt wrong.

"Who's there?" Enne called out.

"Here," Grace said, and she flicked on a flashlight and shined it down the cement walls, but they were alone.

"Where's Laila?" a nervous voice asked behind them. Enne and Grace whipped around, Grace beaming the flashlight into the squinting eyes of an anxious Scarhand. The young man shoved the flashlight away and scanned the faces around him. "She's missing."

Beside him, a girl's eyes widened. "So is Mina. She was just here a moment ago."

A trap, Enne thought frantically, raising the revolver.

"Everyone stand together," Roy called out, and the group huddled even closer, making Enne's nerves wind up even tighter. She could feel someone's breath hot and damp against her neck.

Someone screamed behind her. "Linus! Linus is gone! He was right here—"

"Shut up," Enne snapped. "If you shout, we can't hear—"

"Gianni's gone, too!"

Quiet fell, and with Grace wildly waving the flashlight in every direction, no one should have been able to sneak on them without detection. But something sinister and heavy hung in the putrid air, a sense of dread Enne couldn't shake. She'd made a mistake coming here.

"Everyone out!" Enne gasped. "Back to the Mole tunnels."

The group pushed and shoved their way back through the bars. It wasn't until they scrambled through that they realized their group of thirty had been reduced to eighteen.

"Time to go," Roy croaked.

"We can't just abandon those Scarhands," Grace hissed.

"Yes, we can," muttered a Scarhand behind Enne. And with that, another five of them took off sprinting down the tunnel toward the exit, leaving the few who remained alone in the near darkness.

Enne wanted to run, too, but she didn't like the idea of turning her back to whatever lurked in these tunnels. So she stood, frozen, her revolver white-knuckled in two trembling hands. *The gun. The gun.* She tried her best to wrestle those thoughts away, but they were still there, if only a whisper. She shouldn't have come here. It was dangerous. She hadn't been sleeping. She kept seeing Jac—

Footsteps thudded, growing closer—and fast.

Enne reacted even faster. She fired.

Bang!

Someone let out a loud, hissing curse, and Enne realized with a heart-lurching jolt that she had shot in the direction of the subway's exit, where the five Scarhands had fled.

But it wasn't a Scarhand.

Grace pointed the flashlight behind them, and Enne saw red. Red hair, red blood.

Then Lola was there, upright but swaying, her face contorted in pain and her hand clutching her right ear. Crimson pooled down her neck, her scarf, her sleeves.

Enne snapped back into focus all at once, her out-of-body sensation broken. *Her* hands. *Her* gun. *Her* bullet. The revolver fell from her hands and clacked against the cement floor. Dizzy, she squeezed her eyes shut, but she still saw Lola, and she still saw Jac.

"Why the fuck would you shoot?" Grace asked hotly.

Roy, meanwhile, hurried to Lola's side. "Let me see— I know first aid— I—"

"Don't," Lola snapped as Roy tried to tug her hands away to examine the wound. "I'm fine. I think. I just—I came here to tell you that—"

"Coming here was a mistake," someone else answered from deeper in the tunnel's gut.

Enne froze. She recognized that voice, but it didn't make sense. That woman was dead.

As Grace swung the flashlight forward, a figure came into view. The woman staggered as she walked, but if anything, the weakness only added to her terrifying air. She wore a white dress that hung on her similar to a hospital gown, with bandages around her limbs trailing behind her as she strode closer, their ends damp from the puddles on the floor. She was fair, with white hair that made her look far older than her likely forty years.

Ivory coughed violently, and each sound made every person who watched her shudder.

Everyone except Grace. "She's weak," Grace grunted. "I can take her."

"Don't even dare," Roy said, with a tone like he really would fight her if she tried.

Enne's thoughts train-wrecked. Ivory was *alive*. Did that mean Jonas had betrayed them, even from beyond the grave? Or had he made an error? Enne looked down to where her gun had fallen, knowing she should reach for it, but the mere sight of it made her limbs freeze in panic.

She'd shot at Lola.

She'd killed Jac.

As Ivory came closer, Enne saw the stains down her shirt and along her sleeves—blood. They looked too fresh to be from the gunshot wound Levi had given her a few days ago, these splatters crimson and slick.

"Rebecca is Ivory," Lola rasped.

"What do you mean?" asked Grace.

A delirious memory crossed Enne's mind—of Rebecca blocking Enne's and Lola's exit from the Orphan Guild, of the coughing and blood smeared across her lips. But that didn't make sense. The woman in front of her clearly was *not* Rebecca.

"Did you really think we lived in this filth?" Ivory asked, letting out a cackling, condescending laugh—exactly like Rebecca would.

"The Dove set us up," Roy breathed.

Grace cursed. "I knew it was too easy to find him. I told you—"

"Don't blame me," Roy said. "I didn't even want to do this in the first place."

Blame me, Enne wanted to speak but couldn't.

"Leave," Ivory ordered them. "Leave with the few friends you have left."

Enne looked behind her—now only four other Scarhands remained, trembling with wide eyes. The twenty others who hadn't run... They couldn't truly be dead, could they?

Bang!

This time, it was Roy who fired. The sound of it made Enne's knees weak, and she put a hand against the wall to steady herself. She wanted to see if Lola was all right, but couldn't bring herself to look at her after what she'd done.

The bullet struck Ivory in the chest so hard she fell backward. Enne and the others stared, horrified, as Ivory propped herself on her elbows and let out a howling laugh.

"She has on a vest," Grace said.

"Or she's another demon like Bryce," Roy said weakly.

Grace scoffed. "You're a muck detective, you know that?"

Then, Grace's flashlight burned out, plunging them into almost total darkness. Enne dimly made out Grace's silhouette as she cursed and shook the contraption. The only sound was the rattle of the battery.

A strong hand grabbed Enne by the shoulders and threw her back. She winced as she collided with the wall and as something hard found its way to her throat. A staff, of some sort.

A blade gleamed on its end—a scythe.

"What did you expect when you came here?" Scythe snarled at her.

Enne choked and tried to kick him, but he pressed the staff harder against her neck. He might've been many decades past his prime, but he was far from feeble. "What did you do to the others?" she demanded.

"We evened out the numbers," Scythe said. "That's only fair, isn't it?"

"Let them go," she growled. The Doves might've been assassins, but even they wouldn't outright murder so many people. *Would they?*

Scythe laughed. "Pathetic words for someone who snuck in here looking for, what, power? The North Side doesn't want a queen." The staff slid across Enne's neck as Scythe brought the blade closer. The metal licked her cheek. "Any last words?"

"Let them go, Scythe," Ivory ordered, her voice weak. Enne heard her faltering footsteps as the Dove Lord approached, her ragged breathing as she reached Scythe's side. "You can't kill her."

Why not? Enne wanted to ask but knew better than to speak.

Ivory picked something up off the ground—Grace's flashlight. She shook it, and the light flickered on. When she shined it around the tunnel, Enne realized that the Doves held all of

her friends and the four remaining Scarhands captive. A gun to the temple. A rope around the throat. A knife in the side.

They all stood frozen, their petrified gazes fixed on Enne.

Enne had been so focused on appearing like a proper leader that she'd acted rashly. The only place she'd led her friends was to their deaths.

Ivory peered at them all. Blood dribbled down her lips, and she swayed as she made her way to Grace, as though drunk.

"Don't touch her," Enne and Roy snapped at the same time. Grace, however, didn't speak—only glared.

Ivory ignored them, then dug into Grace's pocket and pulled out something golden and shiny—the Shadow Card from Bryce's game. Grace's card was the High Priestess—perhaps morbidly appropriate for a girl who wore so much Faith jewelry.

However, the card didn't look as it did before. A red word was scrawled across the foil, as though written in blood.

THE MOON.

"Let me take this, or I'll kill you," Ivory told her flatly.

Grace lifted her chin, pressed against the blade of the Dove who held her, and said nothing.

Ivory sighed. "Let me take this, or I'll kill him." She nodded at Roy, who stiffened and looked to Grace warily. "There's no need to kill either of you. Not if you say yes."

Why would Ivory spare Grace all for a card? Why even ask for it, rather than just take it? Enne recalled Bryce's words at St. Morse about the game that he'd concocted, and even if Enne knew not to underestimate Bryce's power, she hadn't considered since that night what the game meant. If Lola was right and Ivory *was* Rebecca, then she undoubtedly knew the rules to this game. She knew the stakes—and they didn't.

Roy must've been thinking the same thing because he blurted, "Don't give it to her."

"Thickhead," Grace muttered under her breath. She met Ivory's gaze. "Go ahead. Take it."

Ivory smiled and snatched the card. "Scythe, Rope, Saber, check their pockets."

The Doves ruffled through Roy's and Lola's clothes while Scythe did the same to Enne. They each pulled out all of their golden Shadow Cards. Enne realized that hers, too, looked different. The red letters on the back read *THE EMPEROR*.

Levi's card, she remembered. Even if she didn't know what it meant, nerves quaked inside her. Whatever the answer was, it wasn't good.

On Roy's card—Justice—the words read *THE HANGED MAN*, and on Lola's—the Hermit—it read *THE CHARIOT.*

"Are any of theirs yours?" Ivory asked Scythe.

He shook his head. "I'm after Temperance."

They're hunting particular cards, Enne realized.

Ivory cocked her head to the side. "Then we're done here. Kill the others."

Before Enne could blink, the four Doves who guarded the Scarhands slayed them. A bullet rang out, followed by several screams, the sound of bodies falling to the floor and splashing in the waste.

Blood seeped down the train tracks, and Enne swallowed down a mouthful of vomit.

It didn't matter whose idea this was; this was her decision, her mistake. And unlike Jac's death, this time she had no one to blame except herself.

"Now you know," Ivory said coolly, letting out another frail cough. "You're far from a queen."

"And you're Rebecca, aren't you?" Enne asked, her voice even weaker than the assassin's.

Ivory's eyes flashed. The Dove Lord had a very poor poker face. "*Leave.* Before I change my mind."

Scythe lowered his staff, freeing Enne from its grip, and the other Doves did the same for Roy, Grace, and Lola. Enne

gasped and clutched at her neck, tears blurring her vision as she made eye contact with her friends. As she forced the image of the bodies from her mind.

They ran.

V

THE HANGED MAN

"Over two hundred witnesses confirmed what many have dismissed as impossible. Yesterday, at Veil's execution, when Chancellor Semper went to remove the black gauze covering Veil's face—a look that has become synonymous with Veil's image—he couldn't. It was as though the gauze had fused to him like a second skin."

Jester. "The Mystery Remains."
The Antiquist
16 July YOR 8

SOPHIA

Harrison Augustine greeted her in his luxurious top-floor suite at the Kipling's Hotel. Unlike the last time they'd met, he wore a cleanly pressed suit—not a bathrobe—and he smelled like Gershton-brand cologne instead of alcohol.

Sophia didn't want to admit that things as simple as class and hygiene could intimidate her, especially when she'd arrived in opulence to match—a scarlet wool coat and heels so tall even Harrison couldn't look her in the eyes. But last time Sophia had seen Harrison, even after taking Harrison's omerta, she'd felt that she had the upper hand. After all, he'd been half-drunk, and Sophia had had it all: the ruby-painted smile, the tricks, the element of surprise—everything it took to be what Sophia Torren considered bulletproof.

But she felt small now, despite her stilettos, painfully aware that this time, she had not chosen to come here—she'd been summoned. Because she was so mucking *good* at fixating on things. On razing her Family's empire. On hunting down the

Bargainer. And she never stopped to consider what would happen after all her bad ideas had come to pass.

"Thank you for joining us," Harrison said smoothly, swinging open his door to reveal two others in his sitting room. Delaney stood by the coffee table, her arms crossed, her blond ponytail so tight it practically gave her a facelift. A fair boy with curly hair huddled on the couch's edge. He looked a year or two older than Sophia, and he seemed so nauseous that his skin nearly looked taffy green.

"Is it a complex?" Sophia asked Harrison, cocking an eyebrow. "Why you only spend time with people half your age." Her voice still oozed confidence and condescension, which she greatly preferred to vulnerability.

Harrison quirked an eyebrow, matching hers. "Apparently." He smirked, and his amusement only made her trust him less. If there was anything Sophia could depend on as certainty in this world, it was men and their fragile egos.

Smoothing down her curly, waist-length black hair, Sophia took a seat on the divan beside Harrison's other two guests. A pitcher of fresh-squeezed orange juice rested on the coffee table amid silver platters of pastries and fruit—the expensive South Side sort, where the honeydew had been sliced into roses and the glaze on the pastries gleamed so brightly Sophia could see her own reflection in a croquembouche. Delaney hadn't touched the spread, while the boy with the curly hair clutched a plate of food to his chest and nibbled on it, his empty gaze fixed on the floor, like he wasn't even tasting what he ate.

"Earlier this morning," Harrison started, sitting as well, "I met with the Chancellor, Levi Glaisyer, and Bryce Balfour. I'd been so nervous that I'd forgotten to eat, and so I ordered brunch. Hope you've all come hungry."

The three of them stared at him blankly. *We're his three omertas*, Sophia realized. When Jac had described the vileness of

Vianca Augustine, he'd never mentioned the woman liked her conferences catered.

"So you found out what these mean?" Delaney asked, brandishing a gold Shadow Card, much like the one Sophia had. It was the Moon, with *THE TOWER* inscribed on the back in a smudgy scrawl a shade darker than Torren red.

"I have," Harrison answered, "but I thought it would be better to ask Harvey, here. As you may or may not know, I'd intended to kill my mother after my inauguration, not before it."

He talked of matricide with a buttery soft tone, without even a smidge of guilt. It both fascinated and unnerved Sophia, whose family was as wretched as his, but who still thought of Luckluster Casino with a pinch of shame.

"But Harvey made a deal with me," Harrison continued. "Kill my mother before she killed Bryce. So you see, it's thanks to Harvey here that Bryce was saved and we've all been enlisted in this game. And a little thanks to me, who shouldn't have taken pity on either of them."

Sophia reexamined the boy with the curly hair—Harvey. There was something greasy about him, a gleam like oil between his fingers, a cunning slickness to his expression even as he paled. A Chainer, she recognized instantly. As a Torren, she knew his sort well. Well enough never to trust them. Even if Harvey *had* willingly accepted Harrison's omerta in exchange for saving his friend.

"Well, Harvey?" Harrison asked. "How does it feel to have helped engineer this mess?"

Harvey cleared his throat. "Well, I…I didn't mean…" He looked no one in the eyes. "I just wanted to save him."

"Does he even know that you did?" Harrison asked coolly. "About the deal you made with me?"

Harvey pushed his half-finished plate back onto the coffee table. "No."

There was a weight to his voice that Sophia recognized—

Harvey and Bryce were more than friends, or, at least, they felt so to Harvey. And like Harrison, Sophia struggled to pity him, even if Harvey obviously deserved it. If Harrison had killed his mother only minutes earlier, then Jac would still be alive. Then they could all still have their murder, their boys, and their happily-ever-afters.

"So what is this game?" Delaney pressed.

"There are twenty-two players," Harvey murmured, almost too quietly to hear.

"Speak up," Delaney snapped.

Harvey repeated himself, stumbling over his words. "Every player has a target. That's what the red word means, on the back. Whoever has that card is the one you're after." He explained how to obtain a target's card, either by killing them or convincing them to relinquish it. And the caveat of how surrendering your card tied your life to the survival of whomever you gave your card to.

"Who are all the players?" Harrison asked, and Harvey numbly listed them off. Bryce, Rebecca, and him, of course. Enne and Levi—the royal pair. The seconds of every gang: Scythe, Lola Sanguick, and Tock Ridley. Grace Watson and Roy Pritchard. Harrison and the Chancellor. The whiteboot captain, the publisher of *The Crimes & The Times*, a nightclub owner, an ex-Pseudonym, and the manager of the House of Shadows. Prima ballerinas Poppy Prescott and Delaney Dawson. Sophia Torren. The Bargainer.

Before Sophia could mull over his words—specifically the last one—Harvey added, "And Jac Mardlin." He pulled a card out of his pocket and laid it on the table. "I, um, wasn't able to deliver his card."

Sophia nearly laughed at the name of it—Strength. Jac *was* the strongest person she had ever met, and he'd survived her sadistic brother only to die from bad luck, from being in the wrong place at the wrong time, from running inside St. Morse

in the midst of danger convinced that he could save everyone just because he'd saved *her*.

Sophia hadn't meant to let him save her.

It was a quiet, nagging thought—trivial in comparison to how much she hurt, how much she missed him.

It should have been Sophia who killed her brother.

Destroying her Family's empire had always been her mission, not Jac's. And she knew Jac had sacrificed for it. He'd nearly broken his friendship with Levi. He'd nearly died, on more than one occasion. And it was over now, anyway, so why should Sophia care who had pushed Charles over that bannister? At least Jac had gotten his legend.

She clutched the upholstered armrest of Harrison's divan, all of her false confidence from earlier smearing like day-old makeup. Because she *wasn't* bulletproof. It had only been eight days since Jac died, and she was still looking at the apartment door, accidentally wondering what time he'd get home. She was totally alone, without a single real lead on the Bargainer, bound to a man she feared and a game that could kill her. She couldn't tell if she had no idea what she was doing or if she was being purposefully, inanely self-destructive. And muck, she wished she had someone to tell her.

While Sophia blinked back tears, Harrison flipped over Jac's card, revealing his target: *DEATH*. Sophia didn't know who that belonged to.

"I know who needs this card," Harrison murmured, tucking it into his pocket before Sophia could even think to ask for it to keep for herself. "I'll make sure that he gets it."

"If Bryce created this game, then why can't we just kill him?" Sophia asked, making Harvey—if possible—stiffen more.

"You can't destroy a shade by killing the malison," Delaney explained matter-of-factly. "I should know—I'm a split shade-maker."

"You told me you've never helped make a shade before," Harrison said.

"Doesn't mean I don't know how it works," Delaney said tightly. "It's no wonder Rebecca's dying, trying to make curses this big."

And it was no wonder Delaney knew her way around the House of Shadows, being who she was. The thought made Sophia feel even more foolish about venturing there on her own. Delaney probably thought her as silly as she did Poppy.

"I thought you all kept to the House of Shadows," Harvey said. There was an obvious disdain in how he said "you all," which struck Sophia as deeply ironic, that he could spurn malisons and shade-makers when he seemed hopelessly, unforgivably in love with one.

Delaney rolled her eyes. "And I thought you kept to Chain Street."

"Where is *your* card?" Harrison asked Harvey.

Something nervous crossed Harvey's face, but it was quickly replaced by a smile. And not any smile—the brightest, most alluring smile Sophia had ever seen, the sort of thing she wanted to bottle up and drink. She trusted wounded men even less than she did confident ones, but she now knew that Harvey—certainly—had her best interests at heart.

"Interesting," Harrison said. His voice was distant, as though behind a closed door. "Your talent doesn't seem to work on me, probably from the omerta."

"I can't always control it," Harvey said. *His* voice sounded close—and sweet as lemonade.

"Yes, you can," Harrison told him. "So stop it."

Harvey made a choking sound, and the spell vanished, like a splash of cold water to the face. Sophia blinked as the allure faded. She'd never experienced the talent of a Chainer before.

But the Augustine talent was far worse.

Harvey's dark eyes watered as he lifted a hand to his throat.

He opened his mouth to speak, to scream, but no air squeezed out. Delaney looked away, her lips pursed in plain disgust, but Sophia forced herself to watch as Harvey's face reddened, as saliva dribbled down to his shirt collar. This was the mistake she'd made, just to make a terrible decision since Jac wasn't here to stop her. Just to break more until she could finally make it hurt.

It did hurt, to watch him struggle.

Then Harrison released the omerta, and Harvey gasped, sagging limply against Sophia's shoulder. She jerked away from him—his body was feverishly warm. Then, hands trembling, she unwrapped a piece of taffy and popped it in her mouth. She wondered if Harvey regretted his bargain with Harrison, too.

"Where is your card?" Harrison asked again, sharply.

"I...gave the Fool..." Harvey huffed. "To Bryce. I was his target."

Delaney rolled her eyes, eerily composed. Harrison might have her under his omerta, but she didn't seem like the type of girl who made mistakes. So how did she end up in the same situation as the rest of them?

"If killing Bryce won't stop the game, then we need to focus on the biggest threat," Harrison said. "We have no idea what disaster it could mean for New Reynes now that the Bargainer has come home."

"But what can we do about the Bargainer?" Delaney asked. "Can they even *be* killed?"

"If there's an answer to that question, there's only one place to find it," Harrison said. He gave Delaney a knowing look. "I know you hate going back."

"I loathe it," she corrected.

"And you want to find the Bargainer yourself, don't you?" Harrison asked Sophia.

Sophia opened her mouth to respond—it was such a simple question. Of course she did. But she'd spoken of her deal with the Bargainer to only two people in the whole world, to Jac,

and to Harrison, right after she'd accepted his omerta. But if she explained to two other strangers that she'd given away a precious piece of herself, then all the effort she'd put into her heels and her clothes wouldn't matter. She'd look pathetic.

Harrison seemed to sense Sophia's discomfort, so he turned back to Delaney and said, "The two of you will go together, then. Tear apart the House of Shadows if you must. If there's a way to kill the Bargainer, then we need to know it."

Sophia didn't look at him, but she could feel Harrison's eye on her. It looked like hers—bright green and knowing, like he saw through her and her expertly applied composure. She felt small again, and she hated it.

But he'd given her a gift: another opportunity to return to the House of Shadows, to unearth whatever secrets lived there about the Bargainer. Just because Sophia had failed the first time didn't mean she couldn't succeed in the end. Despite Harrison, despite Bryce's game, she would find a way to get her memories back.

"Meanwhile, I would put it past no one to kill another player as a means to save themselves or to end this game," Harrison continued, "and as I am not like my mother, I consider it a priority to see the four of us survive together."

Harrison threw his card in the center. The Lovers. His target: *THE SUN*.

"Who are your targets?" he asked them.

Sophia turned her card over. *THE STAR*.

Delaney jolted. "That's Poppy's card."

Something troubled crossed Harrison's expression, but he quickly erased it. "We'll figure it out."

But still, Delaney glanced at Sophia suspiciously. A piece of hair slipped from her bun.

"My target is Judgment," Harvey said quietly. "I don't know whose card that is."

"The Sun, the Star, Judgment, the Tower," Harrison listed

off. "We should start with my target. As you know, if I die, you all die—that is how the omerta works, and there are no more Augustines left to kill me the way I killed my mother so that you all can be spared. Thankfully, I am Fenice's target, and I don't think she's desperate enough to lay a hand on me just yet. The best the four of us can do for each other is secure mine."

It seemed cowardly, but even Sophia couldn't begrudge Harrison's logic.

"But who owns that card?" Delaney asked.

"I have an idea," Harrison replied softly. "Unfortunately, I don't think she'll be easily convinced. I don't think she'll be convinced at all."

In the silence and exchanged glances that fell, Sophia finally did pity Harvey.

He shifted under the weight of their stares. "What do you mean?"

"You're complicit in this," Harrison told him. "The girls have already been given their task. I will be contacting my other friends, trying to uncover a feasible way to end the game. And so this errand will be your responsibility—yours alone. You'll tell Bryce none of this."

The realization seemed to dawn on Harvey, and—stricken—he grasped at his Creed. It reminded Sophia of the one Jac wore, but unlike Harvey's, Jac's had actually stood for something. Conviction.

"You want me to kill your target," Harvey rasped. "The Sun."

Harrison cast him, not a pitying look, but an appraising one. "This is your game, after all. I want you to play."

LOLA

Lola had escaped death by an inch.

Death at the hand of her closest friend.

From what she could distinguish from her reflection in a murky Tropps Street window, her right ear was gone, blown off, with nothing remaining but ripples of raw, uneven flesh and a crusted sheath of dried blood. She could still hear through it, but the sound was muted. So for the entire journey back to Madame Fausting's, she'd hung back at the group's right, where she could still listen when Enne offered her an apology, when Grace or Roy turned to ask if she was all right.

But no one spoke. No one even looked at her.

They opened the front door of the finishing school to find a sea of expectant faces waiting for the oh-so-impressive Mizer's entourage. The Scarhands' clothes were so dirt-crusted they each looked like cockroaches invading the Spirits' gag-worthy pastel and doily-themed parlor. Everyone's chatter promptly

died as the four of them staggered inside, reeking of sewer, each of their clothes speckled—or in Lola's case, drenched—in blood.

Enne froze at the edge of the crowd, swaying as though off-balance. Lola realized with a start that the Scarhands who'd fled past her in the Mole tunnels had never returned, either. She guessed grimly that the Doves had intercepted them.

"Where's Mina?" a Scarhand asked, their voice hitched.

"Where's Henning?"

"Linus? Danielle?"

"Were we supposed to meet them somewhere else?"

Out of the corner of her eye, Lola saw Grace and Roy exchange a nervous glance. But Lola was too furious to consider how greatly the Spirits were outnumbered, or how livid the Scarhands would be after learning that every one of their associates who Enne had brought with her was dead.

One more inch. That was all it would've taken, and Enne would've killed another of her friends.

"Well, Enne?" Lola spat out. "What happened?"

But Enne still didn't look at her. Instead she brushed past a concerned Charlotte and made toward the stairwell.

"Wait," Charlotte said, reaching for Enne's hand. Enne swatted her away and climbed up the stairs. "If you don't say something… If you don't offer something…" Charlotte glanced warily at the other Spirits huddled at the opposite side of the room from the Scarhands, the division between the two gangs as distinct as the dirt stains on the carpet.

But realizing what Charlotte meant only made Lola twice as angry. Enne had imagined herself a queen, and her decision had put all of them in danger—not once, but twice. And now she could face a revolution of her own.

"Where is he?" Enne growled, ignoring Charlotte's words.

"He's upstairs…" Marcy answered, her gaze flicking—strangely—to Lola. "But—"

"I want to speak with him."

Lola had no idea who they were talking about, but once Enne reached the top of the stairs, Lola cursed under her breath and started after her.

"Lola," Roy said, "why don't you let me take a look at your—"

"I'm fine," she grumbled, even though she wasn't. But someone needed to talk to Enne and make her see sense, and that someone was usually her.

Upstairs, Enne stormed down the dormitory hallway to the final door on the right, one of the Spirits' empty bedrooms.

"Enne!" Lola called after her fiercely. She ran to catch up, the side of her head throbbing. "Enne, what the muck was that? There are over a *hundred* Scarhands, and they're each about as friendly as bone saws. You have to explain."

Enne's knuckles whitened on the doorknob. "We were given false information," she growled.

Lola had been so focused on what she'd learned about Ivory that she hadn't thought about how Enne and the others had happened upon the Mole station in the first place. "So did Grace and Roy find the Dove who went after Jac?" she guessed.

"They did," Enne said darkly.

Lola didn't like the grave look on Enne's face—it didn't suit the girl who went to finishing school and danced ballet and owned a wardrobe with every revolting shade of pink. This was the face of the girl who'd once held the shard of a wine bottle to Lola's throat.

"What is it?" Lola asked uneasily.

"I'm sorry about…" Enne swallowed. "I don't know why I fired. I…" She looked down at the gun in her pocket like it didn't belong to her, as though it had betrayed her and fired on its own accord. "Why don't you go first?" Enne suggested, so quietly Lola could only hear her from her left ear.

Lola thought back to the pitiful way Charlotte had looked at her, to the way Enne was looking at her now. And she knew.

She knew even before she opened the door and saw her brother handcuffed to the bedpost.

His gaze whipped to her as she entered, and of all the injured Scarhands downstairs and Lola with her gaping, bloody ear, he looked by far the worst in the building. Bruised and scarred and swollen, his freckled skin was dappled in every shade between green and purple. His white hair was long and disheveled, falling unevenly into his eyes and sticking against his neck.

"Justin," she breathed.

He crossed his arms and looked away. "I don't know you," he said, all whiney, so like him and his tantrums.

Last time they'd spoken to each other, they'd fought. Back then, it'd been a year since their eldest brother had died—it had only been the three of them for a long time—and Lola had accused Justin of being a useless muckhead who needed to get his act together because he was all she had left. In turn, he'd accused her of being a know-it-all bitch who had only him in her life because everyone else thought she was as annoying as hell. Lola had shared this memory with Tock, who'd assured her that her brother was wrong, but what he'd said still haunted her. That was the problem with loving someone. Once you let someone into your heart, they could take a sledgehammer to it.

And so, stewing on all this, Lola snapped at him, "You look like roadkill."

"No, I don't," he countered like a child.

She stormed closer to him, even though stomping so strongly made her head ache. "I've been looking for you. For over *three years*. Did it ever even occur to you to come back?"

"No, because you'd say this muck to me," he grumbled.

"What? Acknowledge that you abandoned me? That I missed—"

"Making it seem like I did something wrong, but I didn't. I *never have*. You always treated me like I was weak, and it made me weak. But I'm strong now, and—"

"*I* made you weak? I was your fourteen-year-old sister." Lola wanted to grab the bedposts and shake them. She couldn't believe that after all this time, Justin still talked like this. Like the entire world was out to get him, and all his problems were his younger sister's fault.

"The Doves were the only ones who realized how strong I was—"

"Justin, you are handcuffed to a bed with a lavender duvet. You look like a half-exterminated human termite. You…" Lola ran out of words, suddenly overwhelmed. Her terrible, ungrateful brother was alive. Her closest friend had nearly spilled her brains into a puddle of sewer. Her right ear was *gone*, which meant she was hurt in a permanent way, in a way that hadn't even begun to sink in yet.

Enne hovered in the doorway, glaring at Justin. The blood on her clothes looked all the more gruesome in the crimson glare of the setting sun through the window.

"You lied to us," Enne hissed at him. "You set us up."

Justin licked his lips and smiled. "How many died? I'd like to know."

Lola cringed hearing her brother say that, like somehow his words reflected on her. And, like she'd done countless times in the past, she was going to apologize for him.

Until Enne took out her revolver and trained it on her brother's head.

ENNE

"What are you *doing*?" Lola asked, her mouth gaped in horror.

Enne clenched her teeth as she switched off the safety. They might've fled the Mole station, but her mind had not left, not really. She still felt the blade of the scythe licking her cheek, still trembled from the panic of realizing she'd fired at Lola, of watching all those Scarhands die right in front of her.

"He tricked us," Enne told Lola, her voice quivering.

Lola lunged between Enne and the Dove, and the sudden movement made Enne's heart lurch. Made the gunmetal feel hot enough to burn. "You can't kill him. He's not—he's not well."

Voices rose from downstairs—shouts, amplified by the corridor's lofted ceiling and linoleum floors. Grace and Roy must've explained what had happened to the Scarhands. That their friends weren't coming back.

"You told us Ivory was dead!" someone accused.

"How come it's only the Spirits who were left alive?" demanded someone else.

"Do you hear that?" Enne choked at Lola. "There's over a hundred of them and nine of us. If someone doesn't pay for this, there will be mutiny." And an insidious voice inside her warned that it would be her. She was the Mizer.

"We can escape," Lola said quickly. "We'll go to Tock and Levi. The Irons will—"

"How are we going to escape?" Enne asked hotly.

Lola opened her mouth to speak, but nothing came out. No matter how clever Lola thought she was, she didn't have an answer.

Footsteps clamored up the stairs. The Scarhands were coming for this room, coming for her.

"Give me a way out," Enne demanded, tears welling in her eyes.

Lola's eyes widened, and she looked nothing like the blood gazer Enne had first met in June, with a collection of knives and tangled, killer-bleached hair. She looked frazzled. She grabbed at Enne's shoulders and dug bitten-down fingernails into Enne's skin. Behind her, the Dove watched them with a proud, twisted smile.

"He's my brother," Lola begged.

"Am not," the Dove shot back, making Lola wince. He smiled wider at Enne as her hand shook. "Kill me—I was expecting this. You're Séance. You're a Mizer. I knew you would."

"You don't know what you're saying," Lola snapped at him.

Several Scarhands appeared in the doorway. Enne looked for Mansi, but she didn't recognize any of these gangsters, with hair that looked cut by a switchblade. One even had profanity tattooed over his lips.

"We're looking for some answers, missy," one of them sneered. If he'd called her that to purposefully make her feel small, it was working.

But she would not show them that. "I have them," Enne told them. "Right here."

Avoiding Lola's gaze, Enne unlocked Justin's handcuffs. Then she hoisted him up by the mud-crusted hood of his coat and dragged him, flailing and moaning, toward the door.

The Scarhands moved to let her pass, but one asked, "Who's the Dove?"

Her best friend's brother.

"The one responsible," answered Enne, swallowing down her guilt.

She'd made it a few steps into the hallway before she felt a blade in her side. The tip of it pressed through the fabric of her sweater, and she froze. She should've known blaming the Dove wouldn't be enough. Enne was the one who'd listened to him. Enne was the one at fault.

But it wasn't a Scarhand's knife. It was a scalpel.

"Don't do it," Lola rasped. "Please. Don't."

Enne dropped the Dove, who collapsed and knocked his head on the floor. He laughed as he watched them, clutching his abdomen like their demises were just so mucking *funny*. He didn't even attempt to scramble to his feet and run, not with the Scarhands flanking him at either side.

Lola watched him incredulously, tears spilling out of her bloodshot eyes.

"Put the scalpel down, Lola," Enne told her carefully.

"You can't kill him."

This boy might've been Lola's brother, but Enne remembered the stories Lola had told her about their relationship. The idea of everything Lola had put herself through to find him made Enne furious. Working at the Orphan Guild, even when she'd hated her bosses. Bleaching her hair, no matter the danger it put her in. The Spirits had been more of a family to Lola than this boy ever had.

The Scarhands around them made no move to help Enne. Instead, they assessed her, and Enne knew she was not living up to their expectations, not of a lord, not of a Mizer. They

already had a reason to hate her. They already had enough reason to use her—her bounty had tripled since Jonas's execution. Enne needed to make a show of strength, otherwise they'd take advantage of her weakness.

"I'm sorry, Lola," Enne murmured, quiet enough so that the Scarhands couldn't hear. "But this isn't about you. He set us—"

"It *should* be about me. I'm your second, aren't I?"

"So what am I supposed to do, then?" snapped Enne. "It's because of him that thirty people are dead. What if one of those people had been Roy? Grace? What if one had been *you*?"

Something in Lola snapped at those words, and Enne didn't guess what it was until Lola snarled, "You nearly made sure of that without his help."

Enne's balance teetered. Her memories flashed on a reel, images and sounds and emotions twining together. Footsteps. Running closer. Her heart—pounding.

Bang!

The sound of Lola groaning. The sound of Jac falling.

Enne felt more of herself unravel. The gazes of the observing Scarhands seemed to render her transparent, exposed. "I–it was dark. The Doves—"

"Were ahead of you, not behind you," Lola gritted out. "You've spent the past ten days making us watch Roy beat you to a pulp, just to prove to everyone you can take a hit. *You* are the reason those people are dead. If you'd been thinking straight, you wouldn't have fallen for Justin's trick from the start."

Enne's emotions switched from desperation to anger. Not just from the traumatized picture of Enne that Lola was painting to the Scarhands, but from Lola's own obsessive need to be right. She wasn't. "You don't know what it's like," she fumed.

"To what?" Lola asked.

"To be cast as the villain, no matter what choices you make." Enne remembered the first time she'd met Lola. Enne might've

been the one to win their fight, but Lola was the one who'd started it. "You were the first one to teach me that."

Lola's expression hardened at the memory. "And you weren't supposed to be like the other lords. You told me you never wanted this."

Enne seethed. "What part of this do you think I want?" She had not asked for her talent. She had not asked for this responsibility, to be the one always ensuring she and her friends stayed alive.

"If you don't want this," Lola told her, "then stop it. This isn't the only way you have to play."

Enne's rage felt white-hot. Lola pretended to understand, but Lola had never willingly put her life on the line for someone else, or been forced to hurt the people she cared about. She had no idea what it meant to play.

"Put. The scalpel. *Down*," Enne grunted.

"Or what?" Lola baited. "You'll shoot me?"

Lola jerked her head to the side, as though offering Enne the ear she had left, and Enne truly felt one breath away from falling apart. So she did the only thing she could to end this before the Scarhands did for her—she moved. Swiftly, she brought down the handle of the gun on Lola's wrist. The knife dropped and hit the floor with a clatter. Just like Grace had taught her: a hand to the shoulder, a knee in the side, and Enne twisted Lola's arm behind her back.

Then, when the Dove lunged hungrily for the scalpel, Enne kicked it away—it screeched as it slid down the hallway. One of the Scarhands hurriedly grabbed it.

"I'm sorry," Enne breathed. Then she shoved Lola aside and hoisted the Dove up a second time. She hauled him toward the stairs, the group of Scarhands trailing behind her.

"Is it true?" the one with the tattoo asked, looking at her with greater respect. "This Dove set us all up?"

Enne nodded. "And I'm going to make sure he pays for it."

She stopped at the edge of the stairs, studying the angry crowd that awaited her below.

Most of the Scarhands who'd stayed behind today weren't fighters—they were counterfeiters, salespeople, bookkeepers—and the grunts remaining were injured from St. Morse. But the sheer size of the Scarhands' numbers had forced the Spirits shoulder to shoulder in the parlor's corner, and Enne swallowed, watching Marcy hold one of the cats protectively, listening to Roy argue with a nearby Scarhand.

"It was a trap," Roy snarled. "And it was dark. I couldn't see—"

"Henning had a speed talent. He couldn't have—"

Enne cleared her throat as she descended the stairs. It took her three attempts until the tumult of the room quieted. Everyone's eyes turned to her, and she took a deep breath. She still felt dazed from the shock of what had happened, but the danger hadn't passed yet. No matter her well-being, no matter the pressure, every one of her next moves had to be perfect.

"This boy tricked us," Enne said, pushing the Dove down the last few steps so he fell in a pathetic heap on the floor. "He wasn't hiding from the Doves—he wanted to be found. And he gave us information that led us straight into an ambush."

One of the Scarhands in the front spit on his face.

But the one beside him didn't look appeased.

"*Him?*" she asked incredulously. "He's a mess. Why would you believe anything he told you?"

"Because we didn't think the Doves were capable of such a trick. The message Jonas sent me said Ivory was dead."

This earned gasps of surprise, and Enne decided against explaining what Jonas had truly meant. Better to have the Scarhands believe that their brilliant lord would've made the same mistake as she had. Better to have them believe that Enne wasn't to blame.

Beside her, Lola squeezed past Enne and shoved her way to

the front door. Enne wanted to apologize, but she was in an impossible position. And for as many times as Lola had criticized Enne's miscalculations, Lola had never offered her solutions, either.

Enne pressed her revolver against the Dove's temple.

"The price of these crimes is execution," Enne spoke. "Is there anyone who objects to this?"

The crowd in the foyer remained silent, and some of the fury in the room dissipated. For the first time since she'd left the sewers, Enne felt a small ounce of control.

But before she could pull the trigger, someone—a boy—said, "I do."

Enne froze and looked up. She'd turned away as Lola left, so she hadn't seen Levi enter. Enne swallowed a wave of nausea as Levi's gaze wandered to the Scarhands—she hadn't told him about her deal with Mansi. He glanced out the window, where Lola undoubtedly had run off in tears, and then he stared at the soiled brown in Enne's boots from the sewers, at the flecks of blood on her clothes.

That idea came from somewhere, and I think you don't want to admit that, Levi had told her only yesterday about how she'd killed Jac, and shame seeped into Enne's stomach. She was confirming everything he'd accused her of.

"You don't..." Enne started but her voice caught in her throat. *Understand.*

"If you can all wait for your blood," Levi said coolly, "I need a moment to speak to Séance in private."

He'd used her street name, not her real name, even if it wasn't a secret anymore. Every time they saw each other, their relationship broke a little more, a crack spreading farther across a pane of glass. And she'd certainly shattered her friendship with Lola completely.

The gun in her hand—*that* gun—suddenly hurt too much to

hold, and Enne shoved it in her pocket, out of sight. It burned there, too.

"A moment," Enne murmured in agreement, nodding at Grace to take her place watching over the Dove.

As associates, it would've been logical to lead Levi to her office, where she did business. But she definitely wasn't thinking straight, because she instead led him upstairs toward her bedroom. She'd gone there seeking comfort—not from him, but from the familiarity and safety of her own space.

As soon as she stepped through the threshold, she realized her error. Her cheeks burned, but it was too late to take it back.

Once she closed the door, Levi demanded, "What the muck was that down there? And why weren't you at the meeting?"

"You don't know what happened earlier," Enne said quickly. "You only walked in on—"

"A public execution, by the looks of it." His gaze found the specks of blood smattered across her coat, and his expression eased from shock to concern. "Tell me what happened."

If Enne explained how she'd purposefully stood up his meeting with the Chancellor, he'd be furious. Jac's death had left behind a wound in Levi that had not even begun to heal, but it had left one in her, too. It was taking from her, piece by piece. Her closest friend was gone. Her sense of security, gone. If even a strand of her and Levi's partnership remained intact, she needed to cling to it like a lifeline.

And so she picked apart the lies, the pain, the shock, and she tried to make him understand. She told him about the note from Jonas, about her deal with Mansi. How she'd thought that the Chancellor's invitation had been the trap, but really, the trap had been Ivory's—Rebecca's. Her anger released some of its heat with each word, but opening up wasn't soothing—it *hurt*. Like pressing repeatedly on a bruise.

By the end, Levi was sitting on the edge of her bed, his fingers steepled. Even wrung out and exhausted, Enne couldn't

bring herself to sit beside him, to fully relax. She wanted to hear Levi's thoughts, but the longer they spoke, the more restless the Scarhands would grow.

"Enne..." Levi began carefully. "You're scared, and I get that—I'm scared, too. But even though the Chancellor has every reason to distrust a Mizer and an orb-maker, right now all of her worries are centered on Bryce. The longer he remains the true enemy, the less we'll seem a threat in comparison."

"What are you suggesting?" Enne asked uncertainly.

"I'm saying that you don't need to command the whole North Side to seem strong. Our strategy needs to be seeming—"

"Weak," Enne finished flatly. "Which is another way of saying vulnerable."

"We have an opportunity to make an ally of the Chancellor, not an enemy."

"The Chancellor is one of the people who murdered Lourdes, Levi. Who orchestrated the Revolution and helped kill *every single Mizer*."

"The world discovered that you're a Mizer a week ago, but the world has known my family's history my entire life." Levi stood up and rested both of his hands on Enne's shoulders. "And you know how my family survived? By being small. By keeping their heads down."

His words were so contrary to everything Enne had experienced that she could barely process them, barely recognize the person in front of her.

"A few months ago, all you wanted was to rule the North Side," Enne reminded him.

"That's because I thought I could escape who I am by pretending to be someone else, but after today, at this meeting..." He shuddered, and he reached down for Enne's hands. Her breath hitched at his touch, and she didn't trust herself to move, not even to squeeze, in case he pulled away. "Who are we right now? We're the Mizer and an orb-maker. We're Séance and

Pup. The people who killed the Chancellor, the people responsible for nearly destroying the North Side. But we have an opportunity now to rewrite the narrative. Vianca is gone. We can claim that she was pulling all the strings. We can help the Chancellor end Bryce's game before more blood gets spilled."

If Levi got to rewrite himself as someone else, why couldn't Enne? Because she couldn't live like this, shooting instinctively, not sleeping, hearing Jac's last words in every moment of quiet. It was no surprise she'd made a mistake. She would make more mistakes. But too many people depended on her. Too many people saw something in her that she wasn't. And she'd do anything for a way out.

Maybe Enne *could* agree to this, no matter what her gut told her. Her gut was the reason she'd made such a mess of things, anyway.

Before Enne could respond, Levi let go of her and retrieved his golden Shadow Card from his pocket. He turned it over in the space between them. The word *STRENGTH* was now scrawled across the back in red, and Enne immediately recognized it and stiffened.

"If we collect a string of five cards, we can end the game," Levi told her. "This is my target. Do you know whose card this is?"

Enne closed her eyes as a fresh tide of guilt flooded over her.

"It's Jac's," she whispered. Harvey Gabbiano probably had the card now—he was the one who'd taken Jac's body away from the casino.

Levi faltered, but his voice was still soft when he asked, "And who is your target?"

She fumbled for her own card and showed it to him. "It's you."

He took a hurried step back, and Enne's heart clenched. There had been a time when Levi wouldn't have hesitated— he would've given her his card. They'd been more than part-

ners; they'd been in this game together, win or lose, and that was exactly what surrendering their cards meant.

"The way the cards work, if I give mine to you, my life is tied to yours," Levi told her carefully.

"So you're saying you don't trust me," Enne murmured, trying to ignore how badly the realization hurt.

"I'm saying that I need a promise from you. That we'll work with the Chancellor and Harrison. I think Harrison sees me as an ally, but I can't broker any sort of deal for us if we're not really in this together. And I know you. You shoot first, you think after—"

"Wait, what is that supposed to mean?" Enne asked, immediately thinking of Lola, of Jac.

"That's not what I meant. I meant that...you're good at fighting your way out of trouble. The Shadow Game, Revolution Bridge, St. Morse... If we were cornered with guns aimed at us from all sides, I'd trust you with my life. But that isn't what this is. This is politics. And if I'm going to trust you, I'm asking you to trust me."

It would've been easier to relent. Enne wanted his arms around her again. She wanted all the burden of her identity off her shoulders. But she couldn't stop herself from snapping, "It's not you I don't trust. It's the woman who's already tried to kill both of us. You think playing weak will make her forget who we are?"

When he didn't respond, Enne closed the distance between them again. She wrapped her arms around his waist and pressed against him, a touch that felt so familiar, so safe. But Levi was a statue beneath her, so she continued, her voice wobbling.

"I made a mistake. I know that. But we can't change hundreds of years of history. We will *always* be the enemy."

"Don't pretend like you know more about the Revolution than me. This has been my history long before it was *ever* yours." Levi clenched his hands into fists and broke away from

her, as though he couldn't bear to touch her. "You can't help it. You always attack first."

No, Enne had always *been* attacked first. By Vianca. By Sedric. By Lola.

"What I can't help," Enne snapped, "is trying everything I can to survive. For *all* of us to survive."

"And you're the reason we've survived before," Levi said coolly. "But you're also the reason Jac is dead."

Enne froze as though she'd been struck. It *felt* as though she had. If she couldn't convince her best friend or the boy she loved that she wasn't the villain, then she couldn't convince anyone.

"Say you don't hate me," Enne murmured.

"What?" he bit back.

"Say it. Say you don't hate me."

Instead, without a word, Levi swept past her out the door.

Enne followed after him, so startled and hurt that she tripped over herself as she raced down the hallway. Levi stopped at the top of the stairs, looking down on the Spirits and Scarhands below.

"The Dove will not be dying today," Levi declared, and Enne would've yanked him away if he had not purposefully placed himself in the center of the spotlight. At the uproar that immediately followed, Levi raised his voice. "I know what the past few months have been like—the arrests, the curfews. I understand that fighting feels like our only option right now, but it isn't. Because what I'm offering you will put everything from the past few months behind us. Each of you will receive a formal pardon from the wigheads—no more hiding, no more bounties."

Shocked whispers broke out downstairs, and Enne had to grasp the bannister to steady herself. Levi was dissolving everything Enne and the Scarhands had agreed upon. Everything Enne had engineered to keep herself and her friends safe.

"How do you know that?" Mansi asked him, her arms crossed.

"Because I'm going to convince the wigheads that the North Side deserves a second chance," Levi answered.

"So we just, what, forget the fact that our friends are dead?" Mansi shot back. "This Dove deserves to pay for that." Her words felt more loaded than from this one exchange, and Enne remembered Chez Phillips, another of one of Mansi's old friends. But Levi had never paid for that, either.

The reminder only infuriated Enne more. If she was terrible, then so was Levi. Painting her as a villain didn't make him a hero.

"I know that," Levi told Mansi awkwardly, "and I'm sorry for what happened. But this Dove isn't the one who murdered your friends—that was Ivory."

The Spirits were watching Enne with wide, startled expressions, and the Scarhands still looked unconvinced. It made Enne hopeful—it wasn't working. Levi wasn't going to convince them. But before she could step in with a new idea, he added, "I don't know you all, and I didn't know Scavenger well, either. But I knew Eight Fingers. And that's why I want to help you. I'm going to give each of you volts."

The mood of the audience changed instantaneously, their gazes flickering between Levi and her. Even Mansi, who had once heard similar empty promises from Levi, regarded Enne with a look of newfound possibilities.

Enne grabbed Levi tightly by the arm. "What are you doing?" she asked hoarsely. "If you wanted the Chancellor to forget that we're a Mizer and an orb-maker, than the last thing we should be doing is making volts."

"I don't plan on abusing our power," Levi grumbled. "I'm only rectifying the situation that you've created. Harrison will understand when you explain it to him when we next meet. When you help us find a way to end Bryce's game."

Enne paused. This was not a truce, but Levi was offering her a way out. Except despite Levi's confidence, Enne didn't trust Harrison—she didn't trust anyone related to Vianca. Just because Enne had made a mistake didn't mean that Levi wasn't making one, too.

"I'll start working with you *if* you get the pardon," Enne told him. "For the North Side, for the gangs, and for me."

Levi stared at her intently, then nodded. "I will."

"You know, you didn't have to betray me to get what you wanted," she said shakily. "I hope it was worth it."

He shook his head. "You betrayed me first when you lied about the meeting."

Then it made them even, but it didn't feel resolved. Standing at his side, Enne didn't know what ached worse—how much she resented him or how much she missed him.

The Scarhands and Spirits around them dispersed, leaving Enne, Levi, and the Dove at the foot of the stairs. The Dove lay on his back, glaring at them like they'd denied him the execution he'd craved.

"She's not my sister," the Dove spat at them. "Not anymore."

"Don't be a fool—the Doves cast you out to die, not because it's honorable, but because you weren't worth keeping," Levi told him. "So stand up and look grateful. Now we all get to live to play another day."

THE SUN

"Every person and every place has a worst version
of themselves. That's what I believe Veil meant when
he asked if a city built on sin is worth saving—he meant
that this is ours."

Faithless. "Unveiled: The Mystery Remains."
Her Forgotten Histories
13 Sept YOR 8

LEVI

"Levi?" Harrison Augustine purred into the phone, which made Levi jolt. He sounded remarkably like his mother. "Are you ready to meet?"

"I am," Levi answered. He hunched at his desk in his bedroom, his chair facing the glare of the morning sun through the window. The oak and sassafras trees that normally blocked his view had shed their foliage, and the art museum—once feeling so secluded from the rest of Olde Town—now felt exposed in the face of winter. Levi didn't like that, and he stared outside most nights, watching nervously for any whiteboots, unable to sleep since he'd stopped the drinking. "But this time, I'd like to suggest the place to meet."

He gave Harrison the address.

"Why there?" Harrison asked.

"It's a property of mine," Levi told him smoothly.

"You're eighteen. You don't own property." When Levi

didn't respond, Harrison grunted, "I can hear you rolling your eyes."

"I'm not." He was. "It's a recent acquisition." It wasn't—but it would be.

"Where did you get the volts?" Harrison asked.

Levi cleared his throat. "See you in an hour—"

"Levi—wait—don't—"

Levi hung up and cracked his neck, attempting to rank his next thickheaded move on a scale of all the thickheaded moves he'd ever pulled.

There was nowhere in New Reynes he could travel where the ghosts of the Revolution wouldn't haunt him—not even this museum, once a symbol of culture and now picked apart like a scavenged animal, the Irons left with only the carcass to claim as home.

He knew more about the Revolution in Caroko, of course. He'd read those stories in the lines worried around his parents' eyes rather than words in a history book. But he still knew the tales of how the streets of the Ruins District had once run red. How every small victory over the course of the bloody uprisings only made the populace hunger for more. How a series of harsh winters had left the city low on firewood, so they could no longer burn the bodies. How they reeked.

It terrified him, the kind of fire he and Enne were playing with.

But keeping their heads down didn't mean he'd just sit here and wait for himself to burn.

Levi pulled a glossy business card out of his pocket and dialed a number he hadn't used in months.

"This is Fitz Oliver," came a snappy voice. Fitz was a real estate mogul who had offered Levi a deal last August that Levi had been forced to turn down. But if Levi was going to make volts—the one thing he'd told himself he'd never do—to save the Scarhands, then he would save the Irons, too.

"'Lo, this is Levi Glaisyer."

"Levi," Fitz said, clearly pleased at the call. "I didn't think I'd hear from you again. What can I do for you?"

"That casino you tried to sell me—is the property still available?"

"I'm afraid it's been bought," Fitz answered.

But Levi wasn't so easily put down. "How much?"

"It's…it's not available anymore," Fitz stammered.

"How much?" Levi repeated.

"I can't go back on my contracts. It's not good for business."

"How much?"

He heard the exact moment Fitz relented, a throaty sigh that scratched through the receiver. "They'd sell for one hundred thousand." It was forty thousand more than the original offer.

"I'll take it," Levi told him. After they finished hashing out the details, Levi hung up. He had just closed the biggest business deal of his life, the sort he and Jac used to fantasize about when they were thirteen, when life was lived in the late hours after a Saturday night shift.

I'll feel like that again, Levi told himself. *I'll feel it when I see it.*

Since September, the casino's construction site had neared even closer to completion. It still smelled of lumber, but the electricity worked, and the insulation along the ceiling was no longer exposed.

This place is mine, Levi thought. *Exactly like Jac and I pictured it.*

Stepping inside, Levi waited for the fantasy to wash over him. And he couldn't figure out why it didn't.

"I'm not sure this place suits you," Harrison said from the atrium. He stared up at the casino's opulent black-and-white aesthetic with a similar expression as Levi—he'd once pictured himself owning such a place, too.

"I'm not sure, either," Levi admitted. He tugged on his too-short jacket sleeves.

"Then why buy it?"

Levi considered telling Harrison the practical reason—that the Irons, like the Scarhands, needed to start over. But instead, he shared the real reason. "Because it completes the story, the card dealer who buys himself a casino."

Maybe that was why the fantasy didn't work. Levi didn't feel like just a card dealer anymore, but he couldn't tell if that was because the Chancellor no longer looked at him like one, or if he'd begun to think of himself differently. He didn't have control over whether the world regarded him as a criminal or an orb-maker, and he didn't want to let go of part of his identity just because a different one was thrust upon him.

But if this casino wasn't the culmination of his story, then what was?

He led Harrison into the cards room, already furnished from the months Fitz Oliver had used it as a showroom. Levi sat Harrison at a Tropps table like the sort he'd dealt at in St. Morse, and Harrison ran his fingers across black felt with admiration.

"I've already spoken to the Chancellor and other representatives in the Senate. Even if I haven't been formally sworn in yet, I have sway," Harrison began. "They'll pardon you and your associates, and we'll end the state of emergency in the North Side. We can call all the violence the Second Street War—make it sound noble. Make it sound *over*."

Even though Harrison had mentioned the possibility before, Levi didn't realize that ending the chaos of the last few months would be so simple. After the losses they'd all suffered at St. Morse, after the months of curfews and patrols, the North Side needed this pardon, not because they needed forgiveness, but because they needed peace.

Then Levi remembered his conversation with Enne, and the demand she'd given him.

"You'll pardon *me*," Levi repeated carefully. "But what about Enne?"

"That's what we have to talk about." Harrison pursed his lips. "I take it she told you to negotiate on her behalf?"

"That's one way of putting it," Levi mumbled, trying not to reveal to Harrison how furious he was with her. Regardless of how they behaved toward each other, Levi still thought they should appear a united front. "Enne doesn't trust you, and she's being careful. She doesn't want to have a conversation or show herself until there's been a public pardon."

Harrison let out a tired laugh. "Then she's going to be disappointed." He laid his black leather briefcase on the card table and opened it. Levi expected him to reach for the pens and notepad, but instead he slid out a copy of *The Crimes & The Times*. He handed it to Levi.

"I already read today's paper," Levi told him.

Harrison tapped the date on the top corner—November 20. "This is tomorrow's. Take a look."

Levi begrudgingly examined it. Opinion pieces crowded the headlines and continued for several pages more. He'd never known the city's main news source to provide so much space for public forum, especially when the First Party had Aldrich Owain, the paper's owner and editor-in-chief, in its pockets.

She already assassinated one Chancellor—no doubt Fenice is next, one letter wrote.

It doesn't matter to me that she's a Mizer, said another. *What matters is that she's a criminal.*

My wife didn't die fighting for the Revolution so another Mizer could threaten our nation.

Chills spread across Levi's arms as he read the words, each one a message of fear. *The Crimes & The Times* had been reporting about Enne for over a week, but this was worse. New Reynes could afford a second Great Street War, but it could not afford a second Revolution.

Maybe Levi had judged Enne's behavior yesterday too harshly. It wasn't that she was being cruel—she was *terrified,*

terrified enough to consider putting a bullet in someone's head if it meant ensuring her own safety for even one day more.

"Are these opinions legitimate?" Levi asked sharply.

"Does it matter?" Harrison asked.

It didn't, Levi agreed. Hysteria could be manufactured. "If this prints, it'll be her death sentence." If not by Liberty Square, then by mob.

Pardon or no, his father's voice whispered in his mind, *it's your death sentence, too.*

"I tried to explain that to Owain, but Owain is paranoid right now—he's another recipient of one of Bryce's cards," Harrison told him.

Levi sighed and rubbed his temples. Levi liked to consider himself the best card player in New Reynes, but this game was far bigger than any he'd played before. Bryce, the Bargainer, the Mizer...they were pieces on a chessboard, none of them on the same side.

Except him and Harrison, maybe.

"I told Enne I'd get her a pardon," Levi breathed.

"You need to consider how this looks," Harrison said. This time when he reached into his briefcase, he grabbed a travel-sized bottle of whiskey. "It isn't even just that Enne is a Mizer. It's that she's also the most famous criminal in the city. It's far too late to brand her as a lost seventeen-year-old when she's spent the past five months making herself appear the opposite."

"So why am I any different?" Levi asked.

Harrison paused, then offered him a snarky sort of smile. "Well, maybe it *is* just that she's a Mizer." He swallowed the whiskey in one swig.

Levi put his head in his hands. Enne had been right—without anything to negotiate, the city wouldn't grant her a pardon. And though Levi didn't approve of any of the measures she'd taken, he'd undermined all of her plans by offering to pay off the Scar-hands. He hadn't helped her—he'd made things worse.

"What can we do to convince Owain not to run this?" Levi asked desperately.

"Volts maybe. Since you've bought this casino, I assume you're in no shortage of those." Harrison cast Levi a knowing look, one tinged with what looked like almost fatherly disapproval. "I'm sure I don't need to tell you to be careful."

"You don't. But thanks, Pop," Levi replied sarcastically.

Harrison squinted, as though affronted to be accused of being old enough to be anyone's father. "I can't help that I've taken an interest in you. We're similar. We both come from different sorts of nobility. And after I left, I think my mother always thought of you as my replacement."

Levi considered correcting him. A two bedroom home under nearly constant governmental surveillance was a far cry from coming from nobility. But Levi had spent years spinning the story that he'd come from nothing, and he could no longer pretend that that was true.

His guilt worsened. The only person who knew how trapped he felt was Enne, and he'd been cruel to her, all for struggling with the same legacy he was.

He needed to make it up to her. He needed to fix this.

"My father always told me that the Mizers were kings not because they made volts, but because they knew how to use them," Levi said. "What if I can give Owain something better than a bribe? How about a story? He can interview Enne."

"Enne will agree to that?" asked Harrison, eyebrows raised.

"I'll convince her to." Even if it meant apologizing.

"Owain will agree to that offer, I think," Harrison said. "Then he won't run these opinion pieces—for now. But that isn't enough to get Enne the pardon."

"But there's another way to spin Enne's story. The Senate knows how omertas work. We could play off everything that happened over the past two months as your mother's doing— then Enne wouldn't be held responsible."

Harrison drummed his fingers against the table. "It's a clever idea. But I can't promise anything until the story runs and we can see how the public reacts to it. That's all going to take a few days."

Levi swallowed. Enne wouldn't be happy at the idea of working with Owain—he was a member of the Phoenix Club, and thus one of the parties responsible for murdering Lourdes and nearly killing them. But if she wanted that pardon, she'd have to put her years of finishing school to use. She'd have to be on her best behavior.

"I like the idea of the two of us working together," Harrison told him, which was good, because Levi liked it, too. "And that's why I also want to talk to you about Bryce's game."

Harrison reached into his pocket and slid Levi a gold Shadow Card. Levi froze as he stared at it. Strength.

"How did you get this?" Levi asked hoarsely, unsure if he actually wanted to touch it.

"I have an arrangement with Harvey Gabbiano."

At first, Levi couldn't put it together. A politician and…a Chainer? Bryce's partner in the Orphan Guild? But then it dawned on him, the way Augustines used the term *arrangements*.

Harrison had once told Levi that he didn't use his talent, but clearly he'd been lying. Levi straightened, putting space between him and the politician. It had only taken a shake of the hand for Vianca to ensnare him with her omerta, and Levi would die before he fell victim to another.

Seeing Levi's expression, Harrison cleared his throat. "In the interest of transparency, all three of my omertas are filled. And I'd like to see them stay that way. I won't have their blood on my conscience."

If Reymond, Levi's old mentor, was still alive, he could tell Levi whether or not Harrison was lying. A useful, tricky talent. Levi grimaced at the thought of him and all the people he'd lost.

You don't get to be powerful in New Reynes by only being good,

Levi thought. After all, Levi had plenty of guilt on his own conscience. But this still felt personal and ugly in a way he didn't like. He'd wanted to trust Harrison, but maybe he couldn't trust anyone. What a miserable thought.

"Could Harvey kill Bryce?" Levi asked quietly.

Harrison frowned. "If *I'm* a muck person, then clearly so are you. I don't ask people to kill the people they love."

"Fine," Levi said, irritated. He was only being pragmatic. Harvey knew Bryce's weaknesses better than any of them did. Maybe there was a loophole to Bryce's protection as Gamemaster.

"Besides, I've been informed that killing Bryce wouldn't be enough to end the game, anyway."

"But is it even possible to win this game?" If any player who hadn't collected their target's card by the end of the game would die, then that had to include those who volunteered away their card to secure the string of five. By definition, they wouldn't end the game with their target's card if they'd given them all away to the game's victor, which meant there was no way to approach this game without some of the players dying.

Harrison murmured, "I'm working on an answer to that."

He stood to leave, and Levi followed him to the door. It opened directly onto the boardwalk, facing the grayish-green sea. It looked more like the same sea behind his parents' home than it ever had.

"Be careful," Harrison told him, then shot Levi a look daring him to make a joke about it. "And buy some new suits—ones that actually fit you and don't have pinstripes. You're playing politics now. Time to belong in the South Side."

HARVEY

Harvey used to come to the Street of the Holy Tombs as a child, to the church now called the Catacombs. Once a month, his parents dressed him and his four siblings in their best clothes and dragged them into the Mole, entering in the chaotic bustle of a Tropps Street station and exiting at Olde Town's eerie quiet. It was always darker in this neighborhood, always seeming an hour closer to sundown.

There are ghosts here, his older sister used to whisper. She smelled like chamomile—they all did, living on Chain Street. Like Lullaby. *The quiet keeps them asleep.*

Their mother would hush them. His sister's stories weren't true, not like the Faith's stories were. But they still left goosebumps prickling across Harvey's skin, so they must've had their own sort of power, holy or not.

Harvey knocked on the door, piercing the silence. The sign on it read *Her Forgotten Histories*, and faintly, he made out a Faith symbol scratched into the windowpane. The eye from

the Story of Omens, an icon meant to ward away harm. It did nothing to stop Harvey from knocking a second time, an acidic mixture of guilt and bile brewing in his stomach at what he'd been sent here to do.

The door swung open, revealing a fair-skinned older woman with a weary look in her eyes and a collection of Creed necklaces around her neck. They reminded Harvey of his mother.

"I, um…" His voice died in his throat, in the same place where he could feel the omerta tightening around his neck, sealing off his air. Tears blurred his vision as he choked out, "I'm here for good deeds. Good deeds to cleanse a dirtied soul."

Those were Faith words, contrition words. As a child, whenever he or his siblings did something wrong, his mother would drag him to a neighbor's house, where they would knock on the door, humiliated and humbled, and offer to perform a favor to make up for their troublemaking.

What Harvey didn't understand as a child was that, in his family, no favors were free.

Zula Slyk's weary eyes narrowed. "You're a little old for these errands, aren't you?"

"I've still got a lot to make up for," Harvey managed. Something painful shot through his chest, but he couldn't tell if it was the omerta or his own guilt. He tried to imagine his parents' reactions to hearing him twist the Faith in such a way.

They would've been proud, he thought sickly.

Zula's expression softened, and she opened the door. "I have a broken faucet."

Harvey followed her inside what appeared to be a newspaper office, with worn gray carpet, a press, and several empty desks. On a weekday afternoon, an office like this one should have been busy with people at work, but Zula was alone, just as Harrison had promised she'd be. It made Harvey wonder how she'd ended up that way, if anyone would mourn her after he left.

She led him upstairs to a cramped apartment treated more

like a storage unit than a home. The clutter had layers—stacks and piles, the sort of dishevelment that could be measured in years of accumulation. Much of it paper.

Easy to burn.

Sweat trickled down Harvey's neck as she led him to the bathroom. "It hasn't worked in years," she said, then she turned the gunked-up handles to show him. No water poured out. "I've been using the one in the kitchen."

Harvey stared at Zula, at the woman he'd been ordered to kill, if only because he felt he ought to. The sweater she wore hung on her, its elbows patched. Her nails had been bitten down, the skin around them uneven and scabbed. She didn't take care of herself, just like she didn't take care of her home. So how had such a recluse received one of Bryce's cards?

"Years is a long time," he said quietly.

She gave him a harsh look. "Just fix the faucet—*I* don't need fixing." She reached into the hall closet and pulled out a toolbox, then set it on the lid of the toilet. "You can fix my kitchen radiator next, if it makes you feel that much better." Then she left him to his work.

Harvey crouched on the bathroom floor, and his hands shook as he opened the cabinet beneath the sink. He didn't know if it was better or worse that she'd left him alone. He would've only felt sorrier if she'd spoken to him, if he'd gotten to know her. But when alone, his thoughts drifted.

To Bryce, always to Bryce.

Stories are tools, Harvey, Bryce had told him four years ago, not long after they'd first met. Harvey remembered, even then, how much he'd been drawn to him. How the red of Bryce's eyes made him more curious than horrified, and how that in turn made him shameful. He'd just broken up with Reymond Kitamura then—by all accounts, not a nice boy, either. But the unholiness of Bryce's talent seemed worse. *Not every Faith-*

ful believes every story. You don't have to choose to believe the ones about malisons.

But it wasn't so simple, choosing what to believe and what to ignore.

Harvey was quite good at fixing things, over his years of good deeds. He laid down on his back, his head beneath the sink, and gazed up at the rusted pipes. He liked working with his hands. It was honest work, not the sort he did with his smile.

Working with his hands could usually distract him, but not today. He trembled with each twist of the wrench—it might as well have been the twist of a knife into Zula's side. Nausea coiled in his stomach, but when he paused to steady himself, the omerta's grasp tightened around his neck, forcing him on.

If I hadn't made that deal with Harrison, Bryce would have died, Harvey reminded himself. *Vianca would have killed him before Harrison killed her.*

His mother had always told him that evil collected evil. If Harvey hadn't loved Bryce, he would never have made that deal, and he wouldn't be tricking an old woman into her own murder now. He wouldn't be standing complicit as Bryce waged war on the whole city.

He should've let Bryce die.

Harvey dropped the wrench, letting it clatter to the grimy floor tiles. *I won't do this.*

The omerta answered. Harvey didn't resist it—in fact, he welcomed it, even as the pressure pushed at the corners of his lungs and it felt like his chest was collapsing, his ribs folding down like an accordion.

The pain was a relief. After all, Harvey liked fixing things— he was good at it. But for years now, Bryce had only seen Harvey not as a friend, not a lover, but a tool, and Harvey didn't know how to change that. He had no *strength* to change that.

But if he died here, he wouldn't need to—it would simply stop. The omerta would even do it for him. It wouldn't be as

easy as falling asleep and never waking up, but at least his death would not be his responsibility.

Fifty seconds of suffocating passed. Tears and fog blurred Harvey's vision, and a pain shot from the top of his spine and over his skull. It pounded behind his eyes, like they'd burst from their sockets.

Still, he waited. He didn't have the breath to sob.

Then, suddenly, the omerta lifted its hold. Shocked, Harvey sat up abruptly, knocking his head painfully on the sink, and leaned over, gasping. He vomited into the toilet.

"No," he whispered shakily, his cheek pressed against the toilet seat. He wiped the tears from his eyes. "Please."

Bryce had told him how omertas worked, how he'd felt Vianca's chokehold until he did what she ordered, or how his body sometimes acted of its own accord. But it was as if this omerta *knew* what Harvey planned. Like it wouldn't let him do this, not until he finished what he'd been sent here to do.

Harvey finally let out a sob. He'd been complicit for so long, but this task he couldn't do. He couldn't murder someone.

But his hand reached for the wrench.

He tried to yank it back, but his muscles didn't listen. He was the omerta's puppet, and so it wouldn't let him abandon his assignment. He had no control over his life or his actions. He had never felt so helpless.

But then a cold acceptance settled over Harvey. After he finished, he would be free. The omerta wouldn't control him, wouldn't stop him. And even if it wasn't easy, if it *was* painful, he would take that control back, in the most final way he knew how.

It made sense, in its own awful way. Once Harvey killed Zula, he didn't deserve to live, anyway.

When he finished fixing the sink, he ran the water and washed the taste of vomit from his mouth. He reached into his heavy winter coat and pulled out the canister of gasoline he'd

bought after leaving Harrison's this morning. His nose crinkled as he poured it over Zula's squalor—he hated the smell.

He made his way downstairs to find Zula at her desk, her shawl wrapped tightly around her bony shoulders. She looked up at him.

"It works?" she asked.

Harvey nodded.

"Well, that's good."

"Why have you waited so long to fix it?" he asked.

"I've lived to see a lot of things, but my friends haven't all lived to see them with me. You learn a thing or two about trust from that." She eyed him shrewdly. "Not many people practice the deeds anymore. Your parents raised you right."

"They did," agreed Harvey, a knot in his throat. He retrieved the second canister from his coat and poured the gasoline in a puddle on the floor.

Zula stood up, her eyes wide. "What are you doing?"

"It's okay," Harvey told her, his voice unnaturally level. "I'm staying, too."

He struck a match and dropped it into the flames.

Fire erupted beside him across the floor, and Zula clapped a hand to her mouth, stifling a scream. Harvey approached her, smiling his Chainer smile. Her shoulders relaxed a little.

"Your card," he said, holding out his hand. Bryce's power over it ensured that the card couldn't be destroyed, not even with fire, but Harvey would still leave it somewhere easy for Harrison to find amid the rubble.

Zula watched him, subdued as though transfixed, and removed the card from her desk drawer. The Sun.

Harvey took it and slid it under the crack in her front door.

With his back turned, his smile gone, Zula snapped out of her trance. She placed a hand on Harvey's shoulder and whipped him around with surprising force. The flames behind her grew, smoke filling the air and making her cough.

"A Chainer?" she snapped. "Why do this? I have no enemies on Chain Street." She spoke as though she wasn't surprised to find herself approaching her own murder, however. Like she'd been expecting it.

"Someone else," Harvey said, because the omerta prevented him from revealing Harrison.

Zula staggered back from him and lunged for the door. But she couldn't wrench it open.

"You know how my talent works," Harvey said softly.

She ignored him and tried a window, ripping aside the moth-eaten curtains and attempting to push it up with a low groan. It didn't budge.

Zula whipped back around, seeming to finally realize that she had no means to escape. "You don't have to do this."

"Actually," Harvey said darkly, the omerta tightening like his own Creed around his neck, "I do."

She went to her desk next, rummaging around her disordered drawers. For a weapon, Harvey guessed. Before she could, Harvey took out his own pistol and trained it on her.

"Stop," he warned.

She froze, her eyes narrowed. "If you've come to kill me," she seethed, "why not just shoot me, then?"

"It's supposed to look like an accident."

The smoke burned in the back of Harvey's throat. The room was stiflingly hot, and fear raged in him worse than the flames. He could leave at any moment, if he wanted to. But he had decided. He would do this.

Zula took an uneasy step closer to him.

"Stop," Harvey repeated, sharper this time.

Rather than reach for him, Zula closed her eyes. There were black tattoos inked on her eyelids, another matching pair of eyes. "I can see the shade on you—the game. But it clings to you more than it does to me."

Goosebumps broke out across Harvey's skin. All of Bryce's sins clung to Harvey, as though he owned them, too.

"You will never get what you seek," Zula told him ominously. "And you will never escape it, either."

Harvey didn't—couldn't—respond. His eyes watered from her words as much as the smoke. She was wrong. There *was* a way to escape it.

He clutched the Creed around his neck. "I'm sorry."

Zula let out a sharp laugh. "How can you be? You don't know me. I make sure that no one does." She turned away. "I'm going to my bed. I'd rather die there."

And she left Harvey standing in the office alone.

He positioned himself deep into the room, far from the flames that had begun to climb up the walls. He didn't want to burn—he only wanted to pass out from the smoke. It would be an uncomfortable but painless way to die. The pistol would be quicker, he knew, but Harvey had just buried a gunshot victim. It felt wrong to die like that, too.

He sank to the carpet and hugged his knees to his chest, taking deep gulps even as they burned their way down his throat. Each breath, no matter how unpleasant, lifted a weight off his shoulders. He was no longer complicit. He was free. He was gone.

The thought of dying distracted him from the thought of murder. Soon, he forgot Zula was upstairs at all. All he dwelled on was his own end, and for the next five minutes, as the blackness in the air began to seep into his mind, he tried not to think about Bryce at all.

He still did.

But it was all right, Harvey told himself. He would never have found a way to fix it.

He couldn't help but think of him, but Harvey wasn't helpless.

Not anymore.

★ ★ ★

He woke on his back, his shirt ridden up, cold cobblestones digging into his spine and bare skin. He coughed weakly, each quake sending a jolt of pain through him. Soot covered his fingers, and his vision still seemed stained with it.

Someone—a man, Harvey thought—kneeled beside him, long, dark hair damp with sweat. A bright, golden light glowed behind him, like the painting of a martyr, and it took Harvey a few delirious, dreadful moments to realize that the glow wasn't the sunset; it was the *Her Forgotten Histories* office burning to the ground.

Without him.

"What?" he rasped. "How—" He tried to sit up, but the man's hands pushed him down.

"Just breathe. You nearly died. When I found you, you—"

"You *saved* me?" Harvey asked, his voice hoarse and furious. He rubbed at his eyes until he made out the young man above him. He looked about his own age. He wore an oversize black shirt that hung on his tall, slender frame, exposing the dark brown skin of his shoulder and chest. He was extremely attractive, and for a moment, Harvey wondered if he was, in fact, dying and suffering from some sort of fever dream.

The handsome young man sat back and brushed aside his hair, revealing a tattoo of a pair of dice beneath his jaw. He sighed. "I saw the smoke from the Catacombs—I-I work there. And I...I can't believe I ran in there. I didn't even think. I didn't..." He paused and looked to Harvey. "Are you...are you all right?"

Harvey wanted to answer *No, I'm supposed to be dead*, but his thoughts gave him nothing but shame. He should be grateful, but he was not. He should be relieved, but he was not. The moment he had tried to regain control in his life, it had been stolen from him.

Thankfully, Harvey was saved from answering honestly, as

the words that came out of his mouth were not his own. "The card," the omerta said for him. "What happened to the card?"

While Handsome gaped, Harvey shakily got to his feet and stepped toward the flames. Other residents of the Street of the Holy Tombs had gathered to gawk and gossip, coats or robes wrapped tightly around themselves in the evening chill. Harvey made for the door.

"Wait!" Handsome called after him, scrambling to his feet.

But Harvey was running. Smoke seeped out of the door, and the heat felt like a curtain, like being submerged.

"Is someone else inside?" Handsome asked worriedly.

"No," the omerta lied, as Harvey bent down to pick up the gold card, undisturbed on the porch. He numbly stepped back down the steps, joining the young man on the street.

Handsome's brown eyes widened as he stared at the card. "What is that?" he asked.

Harvey shook his head. "Thanks for...for saving me." Even if he didn't mean it. "But I—"

"I have one, too," Handsome said. He reached into his pocket and pulled out another card, Judgment.

Not only did his savior have a card, but he was Harvey's own target.

LOLA

The dread came as soon as she smelled the smoke.

Lola raced down the Street of the Holy Tombs, her heart pounding painfully, like the broken thing was killing her rather than keeping her alive.

Several fire engines clogged the street. Residents lingered, shivering and whispering to each other while wearing mismatched bathrobes and winter boots. Though the flames had died down to smoldering cinders, this block still looked brighter than those around it. The collapse of the ruined building had cleaved a gaping hole in Olde Town's towers and spires, offering an unusual glimpse into the sunset sky. Lola squinted into the smoggy light, panic eating her from inside out.

"Excuse me?" Lola asked someone standing nearby. "What happened here? The woman who lived there, is she all right?"

The person's face softened in pity. "She died, poor thing. Never left that place, did she?"

Lola's mouth hung agape as she treaded toward the rubble,

making her tongue taste coated in smoke. Ash billowed in the wind at her shoes.

It wasn't fair. She'd done what Zula had asked. She'd learned Lourdes Alfero's true name. But it was too late, and now there was so much Lola would never learn. Secrets that she knew, deep within herself, were terribly important.

"Muck," Lola muttered to herself, tears spilling from her eyes. She was losing everyone in her life in the span of days. First Jac. Then Enne, the moment she'd pulled the gun on her brother, who barely seemed like her brother anymore.

A voice inside of her told her it was her fault.

You misjudged them, it said. *Just like you misjudged your brothers.*

She recalled the cruel, feral look on Justin's face when he claimed not even to know her.

Tock will go next, and you still won't see it coming.

Lola trembled as she turned around, wiping her tears away on her coat sleeve. She jolted to find she was facing a girl.

"A blood gazer," the girl said, cocking her head to the side. She was strange looking, her features sunken and thin, as though age had touched her bones but not her skin. Her light brown hair was bobbed and tucked beneath a wool hat, and her wide-set eyes shone a dull crimson. "Is there something you want? Someone you miss?"

Lola looked down to the cobblestones where they stood—a crossroads.

The Bargainer.

Lola staggered back and dropped her briefcase. It snapped open, and her and Jonas's collections of papers fluttered loosely in the ashy wind. The photograph of a younger Lourdes Alfero stared up at them, then known as Clarissa Reid. Clarissa Semper Reid.

The Bargainer bent down to pick them up, and Lola shuddered at the image of the greatest legend of New Reynes kneeling at her feet.

The Bargainer handed her the papers, and Lola accepted them numbly. "There must be something you want," she spoke again, her tone soothing.

Lola glanced back at the rubble of the building behind her, feeling a terrible sense of loss. She still heard the menacing click of Enne's gun against her brother's temple, the nasal sound of his voice as he goaded her to shoot. She remembered the look in Levi's eyes when he'd told her Jac was dead. And the sight of the body falling from St. Morse's roof, the heart-wrenching moment when she'd thought it was Tock.

But deeper, buried beneath the loss, Lola felt fury. She had been wrong about so many people, but she wasn't wrong about herself. She didn't want this. Enne, Jac, Levi—they all wanted to be players, but she did not.

But the card in her pocket left her no choice.

"I want to know the story, all of it," Lola said. "I want to know who Enne's father was, how he survived the Revolution and if he's still alive. I want to know how Lourdes ended up with Enne. I want to know about the Shadow Game, the House of Shadows. I want to know everything from the past so that we all can stop dying for it."

The Bargainer laughed. "A noble request. It won't even take power to fulfill—after all, I was there. I know all the answers you seek."

She held out her hand.

Lola hesitated, her heart pounded furiously. "What is the price?"

"The price is the last thing you have left. It's a fair price. If you want to devote yourself to this cause, you must be devoted wholeheartedly. And your heart is torn."

The image of Enne filled Lola's mind. Her friend. Her lord. She knew such a deal did not make them enemies, but it didn't make them friends, either. There could come a time when they

found themselves on opposite sides of this battle, and a torn heart was a dangerous one.

"Fine," Lola murmured, before she could change her mind. She shook the Bargainer's hand.

More memories filled Lola's mind, but in reverse. She felt the edge of a broken wine bottle against her throat, Enne wielding it with steady hands. She watched the nods of the Scarhands and Spirits as they sentenced her brother to death. She heard the confidence in Jac's voice when she imagined him telling her that he'd gotten the legend he always wanted.

The wounds—some old, some fresh—bled again, until Lola could feel the pain of all her betrayals and misjudgments like cuts across her skin.

The last memory was Tock muttering about Lola being paranoid but still smiling in her sleep when Lola kissed her good-bye. Lola hated that word, and so this memory hurt, but it hadn't scarred. And so she didn't notice when the Bargainer's power drew it from her, when claws dug itself into Lola's mind and cleaved that whole person out—the last thing she had left.

When Lola let go of the Bargainer's hand, a darkness shrouded her consciousness, the hollow parts where not just one memory, but many, had been removed. She didn't know what they were, but they must have been comforting because without them, she felt wounded and angry and paranoid and nothing else.

The Bargainer licked her lips, as though finishing a good meal. "Do you remember what you gave up?"

Lola frowned. "Whatever it was, it wasn't as important as what you'll tell me. And you'll tell me—"

"Everything," the Bargainer said, nodding. She placed a hand on Lola's shoulder and led her away from the ruins of the fire. "Maybe you can even tell me what this card means."

She flashed Lola the Devil card, clutching it between two man-

icured white fingernails. On the back read *THE HERMIT*—
Lola's own card.

I'm her target, Lola thought with despair. If the legends about
the Bargainer were true, then she wouldn't hesitate to kill her.
After all, Lola had just given up the last thing she had left—
what other value did she have?

But even if Lola Sanguick had resented them for it, if there
was one thing she had learned from her friends, it was how
to play.

Lola slung her arm over the Bargainer's shoulder, making
the girl jolt and shoot her a surprised, dangerous look. The sort
from someone who didn't have anyone else, either.

"It means that you and I are going to be friends," Lola said.

HARVEY

After delivering Zula Slyk's card to Harrison, Harvey Gabbiano, murderer, returned to the Orphan Guild in need of a shower. He stripped off his clothes, still reeking of smoke and gasoline, and threw them in a waste bin. Then he stood in the prison's communal bathroom and watched as the soot-blackened water ran off him and circled the rusted drain, and he cried.

I'm not okay, he thought. *I haven't been okay in a long time.*

The despair had crept over him slowly, too slowly for him to recognize it for what it was, and now its tendrils had hooked around him and encased themselves over his skin. He felt heavy with it, buried in it. Though it wasn't the first time he'd had thoughts about ending his life, he'd never tried before. And he had a terrified feeling that, since it didn't work this time, it would never work. He would always be trapped. He would never find a way out.

He wanted to sink into bed for the rest of the night, if not the week—for as long as he could until Harrison Augustine

summoned him again. Just the thought of that made his hands tremble as he dried himself off.

Harvey had become a monster, not because he was cruel or ruthless—but because he was weak. And that only made him hate himself more.

Despite how sweet the idea of bed sounded, he didn't want to be alone right now, so he walked to the other end of the Royal Prison. He found Bryce in his office, hunched over the Orphan Guild's ledger. Harvey didn't know how Bryce could focus on everyday tasks when the world was crumbling around them. But then again, Bryce was probably elated right now—he was getting everything he wanted.

"I need to talk to you," Harvey told him softly, making Bryce nod and motion to the seat in front of him. Harvey took it, but he looked out the window rather than at his friend. It had started to flurry—early this time of year for snow. At first, he only wanted to ask for developments on the game and on the Bargainer, but he was floundering under the weight of his secrets. He took a deep breath, only to cough from inhaling so much smoke earlier. "I have…"

Harvey's voice caught like a stopper had been shoved down his throat. He felt suddenly thickheaded. It had been so many years since Harvey had learned of Bryce's omerta that he'd forgotten that Bryce had been unable to say the word, had been unable to tell anyone.

But Harvey needed to. He needed to tell someone.

"What?" Bryce said, furrowing his dark brows.

"Give me a paper. And something to write with," Harvey told him.

Bryce slid him the ledger, and Harvey's hand quivered as he accepted the ballpoint pen. *I have*, Harvey started, but once he tried to write "Harrison Augustine's omerta," his arm froze, letting ink bleed a splotch into the paper.

"Are you all right, Harvey?" Bryce asked uncertainly.

"No," Harvey gritted. He threw down the pen and dug his nails into his armrests. Bryce knew how omertas worked. Harvey would make him understand. "I have..." Harvey choked, his eyes watering. "I have..."

Bryce's already pale face drained to a sickly shade of white. "No... No, that can't be possible. She's dead."

It was no surprise to Harvey that Vianca still haunted Bryce, and Harvey shook his head.

"The night at St. Morse, Vianca was going to kill you. You knew—she told you, and you told me. I had to do something." *But maybe I shouldn't have.* "He was going to wait to kill her, but then you would've been dead. I convinced him not to wait."

He'd been kind about it, too, Harvey recalled. Harrison had comforted Harvey when he'd stumbled in, shaken, and nearly weeped at the thought of his friend gone. Harrison's interest in Harvey's talent, his offer to ensure Bryce's survival, had relieved Harvey. Thank everything he was useful. Thank everything he could save him. Harvey had sagged his shoulders, sighed out all of his fear, and agreed gladly.

Bryce closed his eyes, like he'd rather not look at his friend. "You should never have done that."

"You would've *died*," Harvey said, arguing against the very thought he'd had himself.

"But you know what it was like for me having Vianca's o-omerta." Bryce still stumbled over the word, as though a habit. "You were there for all of it." Bryce's voice rose, making Harvey tremble and hug his arms around himself. He hated to be yelled at, and he was vulnerable right now—without any armor, without any strength. "Rebecca is *dying* because of how hard I tried to escape Vianca, and you just volunteered for this?"

"Do you want me to apologize for saving you?" Harvey choked.

"Muck, Harvey." Bryce stood up and slammed his fist on the table, and for a wild, panicked moment, Harvey thought

Bryce might reach across and strike him. Instead, Bryce collapsed into his seat, like a paper doll folding into itself. "I don't know how to be grateful when I wish you hadn't done this."

Minutes passed, and Harvey's dark thoughts circled a shameful drain of their own.

As a child, Harvey had thought the Gabbiano talent was charm, and he'd liked it. His smile was infectious. It made strangers grin back, happy to perform favors, happy to do whatever he asked.

With that smile and those curls, his mother had once said, kissing him on both cheeks, *how could anyone say no?*

It wasn't until he grew older that he realized the insidious truth about his family, how they twisted their smiles, twisted the Faith.

And so he'd left. That might've made him alone, but at least he wasn't complicit.

Leaving Bryce should've been easy, since Harvey had done the same before. But now Harvey knew what alone felt like. He knew how it hurt to betray people you loved, how it hurt for them to hate you.

That was why it'd been easier to stay in the *Her Forgotten Histories* office when it burned. Because he knew how it would feel to do otherwise, and because he was not okay. He would never be okay.

"How much did you tell Harrison?" Bryce asked him. When Harvey couldn't bring himself to respond, Bryce said, flatly, "Everything. You told him everything."

Harvey swallowed and nodded.

"Harrison, Pup, Fenice, the Mizer…they're all working against me. You and Rebecca—you're the only ones I've been able to count on. But how can I trust you when you work for him?"

Panic clawed up Harvey's throat, making his own saliva taste sour. He shouldn't have confided in Bryce. Shouldn't have taken

Harrison's omerta. Shouldn't have. Shouldn't have. Shouldn't have. He wished desperately that life came with a do-over. Maybe if he'd never met Bryce—but no, then he would've been truly alone.

"O-of course you can trust me," Harvey sputtered. "I'd do anything—"

"I know," Bryce murmured, pain etched into the lines on his face. "And I'm sorry. I'm so sorry—it isn't fair. But I can't let you stay here, if you're tied to him. I can't keep you close to me. You must understand. I've been working on this game for—"

"You're making me leave?" Harvey asked, standing up, his fists clenched at his sides. Maybe he did have some strength left.

"I don't want to. This is obviously the last thing that I want—"

"You can't! I work here! I *live* here!"

When Bryce didn't respond, only sunk lower into his seat, Harvey felt his weeks of despair writhe inside of him, a beast unsheathing its claws and baring its teeth. His rage made his own vision red.

Harvey held out his hand. "Give me back my card."

Bryce's mouth dropped open. "You can't be serious."

Harvey stalked forward and grabbed a fistful of Bryce's shirt, lifting him up so he could glare at him eye to eye. "I want it back."

"I—I can't," Bryce stuttered. "Once you surrender your card, it's irreversible. Your card belongs to me." Bryce placed his hand on Harvey's shoulder, and the touch still made Harvey tremble, even after years. He couldn't tell if Bryce did it out of instinct or if he'd meant it. But then Bryce's hand slid up his neck and to his cheek, and Harvey didn't remember the last time someone had been so gentle with him. "I do miss you. But Rebecca…"

With Rebecca, it'd been different. The malison and the

shade-maker. *That* was the sort of fated story Bryce wanted, made all the more romantic now that Bryce got to save her.

When Harvey had made his deal with Harrison, he'd been thinking he was saving *him*.

"Don't," Harvey said, tearing Bryce's fingers away from him. Then, feeling even worse than when he'd entered, Harvey stormed out of the prison. Each time he thought his life couldn't get worse, it did. He felt foolish and asinine for ever hoping for something different. The very idea of improvement seemed insurmountable.

He didn't know where to go. Enne and Levi wouldn't trust him—nor should they. Harrison, as twisted as considering it was, might've taken him in, but Harvey couldn't bring himself to ask. He would also never go back to Chain Street.

He could find somewhere dangerous. He could try again. But even giving up took a great deal out of him, and he didn't have the courage to act so impulsively twice in the same day. Harvey was not that type of person. He considered and imagined and planned. And those things took time.

Which left one person. One person, who was barely more than a stranger.

Thirty minutes later, well past ten o'clock, Harvey knocked on the door to the Catacombs, carrying a bag of necessities he had bought at a convenience store, his curls damp from the falling snow.

The door swung open, revealing the young man who had saved Harvey. He carried a violin bow in one hand and a glass of water cupped beneath his arm.

"It's you," Handsome said, his eyes widening. "What are you doing here? Are you okay?"

Harvey's cheeks flushed with embarrassment, but he managed, "I'm not okay, and I was wondering if…if I could stay here."

Handsome nodded. "Of course, um…"

"Harvey," he said.

"My name is Narinder."

Harvey smiled—not one of his Chainer smiles—but a genuine one, of relief and gratitude. Yet even without his talent's trickery, Narinder smiled back and swung open the door for Harvey to come out of the snow.

TEMPERANCE

"The only winner in history is the one who
gets to tell the story, once the story is finished."

Séance. "Monarchist Candidates Purged from
Ballots across Republic."
The Antiquist
11 June YOR 13

LEVI

That night, Levi dreamed of the hallway—same as he had every night for the past several months. He came to on a checkboard-style floor, and he pushed himself to sitting, examining the endless stretch of black and white doors in either direction, the edges of his vision and the details of the ceiling swathed in a blur-like mist. A familiar, inexplicable feeling tugged at his chest, urging him to find a particular door.

Levi climbed to his feet. Though he was well-accustomed to this place, it still unnerved him. This was a dream he couldn't escape, a dream he and Enne shared. And despite having faced devastating memories or vivid nightmares behind these doors, Levi still felt compelled to search for the one he needed. Although he couldn't explain how, he knew that was the reason he was here.

He approached a white door.

He turned the brass knob and entered a dining room. Levi had never been here before, but he knew exactly where it was

because he recognized the plates—the delicate geometric design circled the porcelain in a vibrant blue. His mother had kept a shard of one, tucked secretly into a kitchen cloth, hidden away like all of the Glaisyers' most precious things.

This was his family's home, before the Revolution. In Caroko.

It was magnificent. The stone floors gleamed, a golden dust sprinkled beneath the polish, making Levi feel like he stood upon stars. The woodwork around the windows—painted a rich orange—was so intricate he could have stared at the designs for hours. The ceilings, too, were an artistic masterpiece, each tile similar yet completely unique, a lattice of paint and metalwork, its beauty surpassing anything his mother had tried to describe.

Levi was stepping into his parents' stories, and he itched to explore more. In the next room, he found paintings of people who looked like him—they shared the same strong set to their brows, the same warm hue of brown skin, the same orb-maker colors in their curls. This was the place where his parents got married. This was the Glaisyer estate passed down through generations. This was his history.

It thrilled Levi, but the more he explored, it also depressed him. Because even if he could see so much of himself here, it wasn't a perfect fit. He couldn't simply walk among the past and feel like he belonged. He had never been to this home. He had never met most of the people who'd lived here. Like his pinstripe suits, this place fit only in the category of nearly and not quite.

Levi was approaching the grand foyer when he heard it. Shouts. The clamor of shattering glass. And though he couldn't see the black haze yet, he could already smell burning. He knew his parents' stories well enough to know what such a noise meant—the rebels were coming.

And so, in a moment of instinct, Levi did exactly what his

parents had done. He reached for the closest thing he could find—a teal porcelain spoon—tucked it in his pocket, and he ran.

That morning, Levi grabbed the orb-making supplies from the trunk of his Amberlite and hoisted them over his shoulder, ignoring the trembling of his hands or the stirring of memories in old, forgotten places of himself—places he'd prefer to leave behind.

Enne climbed out of the passenger seat and staggered over a mound of dirty, half-melted slush. "Where are we?" she asked. Like everything in the Ruins District, the manor in front of them was held together by little more than crumbling stone and the loose threads of history. Since he'd spoken to Harrison yesterday, Levi had guessed that if he explored the abandoned estates, he'd come across an orb-maker's home eventually—and with it...

"It's a workshop," Levi answered grimly.

The pair didn't speak as they wandered the house's paths. Weeds had crawled out of the cobblestones, and the broken remnants of windows and lawn sculptures littered the grass. A fountain full of grime and rainwater sat in what must have once been impressive gardens. There was something especially eerie about the way it had been left—the destruction of the Revolution untouched, as though the horrors from that era lingered, as well.

Do you know what they did to the orb-makers in Reynes? his father had taunted him, when Levi had first developed an interest in the city. *They killed them all.*

The workshop door, already hanging on its hinges, broke open easily. Levi stepped inside, dropping his bags of coal, tools, lighter fluid, and sand to the dust-coated floor.

First, Levi stripped down to his undershirt, exposing the tattoos on the underside of each of his forearms: a spade and

an A. Next he scraped the refuse collected in the ancient furnace. While he worked, Levi was aware of Enne's eyes on him. It was strange to sense her aura in a workshop and not his father's, the warm espresso scent instead of perfumes and smoke.

But that didn't make it more welcome. Enne watched from a stool in the farthest corner of the room, her arms crossed and the violet of her aura twisting in nervous torrents.

"You still haven't told me how your meeting with Harrison went," she said.

"I'm trying to concentrate," Levi grunted, and he was—mostly. After he finished shoveling coals into the furnace and lit the fire, he tried to remember his father's instructions. It didn't make sense that his emotions from those memories still felt raw when the lessons themselves seemed clouded. To make matters worse, Levi had never extracted volts from a Mizer before. He'd always used old volts to activate new orbs.

"So Harrison didn't agree to the pardons," Enne said flatly.

"I never said that."

"Well, you haven't said anything."

It would take thirty minutes for the furnace to grow hot enough, then another ten minutes to melt the sand. This unfortunately meant that Levi had nothing to do, and so he fiddled with his rows of punty pipes, trying to make himself look busy while he waited. He didn't want to look at Enne—she saw through his poker face better than anyone.

"Harrison negotiated with Owain yesterday," Levi told her. "But Owain is printing the story tomorrow: the state of emergency in the North Side is finished. No more patrols. No more curfew."

"And the gangs?" she pressed.

"Every gangster in the North Side—except the Doves—will receive a pardon. Including me. Including you, if—"

"They agreed?" Enne asked, her shoulders sagging in relief,

making her suddenly look much smaller perched upon her stool. She let out a shaky, disbelieving laugh. "What did you say?"

After the way she had looked at him the last time they'd seen each other, Levi was taken aback by how good it felt to see her smile. The thought confused him. He had not forgiven her, but it was hard to separate the two versions of Enne in his mind: the girl he had loved and the girl who had killed his best friend.

But it didn't matter. He knew that once he told her about the interview he'd promised to Owain, she'd be furious—probably enough to storm out of here, and Levi needed the volts. For the Scarhands. For Fitz Oliver.

"I blamed it on Vianca," Levi told her.

Enne's smile faltered. "That makes sense," she murmured. Vianca was the one who'd ordered Enne to save Levi the night of the Shadow Game, a stunt that led to Sedric Torren's and Malcolm Semper's deaths. Vianca was the one who'd commanded Enne to organize the Spirits into a real gang. Vianca lurked behind so many of their crimes, and so blaming her shouldn't feel like a lie.

But they'd only ever saved each other because they wanted to.

"Levi," Enne started. She clutched a romance novel in her lap, and she stared at the page she'd dog-eared rather than at him. "I'm sorry for standing up your meeting. I'm sorry that you had to intervene with the Scarhands. Ever since what happened at St. Morse…" Levi noted that she didn't use Jac's name, and he was glad for it. He didn't want to hear it spoken, either. Especially not by her. "I haven't felt well. I didn't asked to be a criminal, and I definitely didn't ask to be a Mizer." She dragged her gaze up to him. "It's just a lot of responsibility. And there's a lot I wish I could take back."

Now you've done it, Levi scolded himself. He should've told Enne immediately that he'd failed. He'd gotten everyone else's pardon except for hers, and even if he'd found a chance to earn

it, it was a gamble. Maybe she was right; maybe for her, more than anyone, the world would only see her as a villain.

And now she was looking at him like he'd erased the past week and a half entirely. He was transported right back to St. Morse, before the world had fallen to hell, when they'd danced together and he'd told her that he loved her. The memory burned in him.

Levi wished he could take it back, too.

"I don't hate you," Levi murmured, remembering her question from yesterday. He wondered if it would be simpler if he did.

Then he cowardly turned away, returning to the orbs and prolonging his farce only a little while longer. He'd bought the highest quality orb-making sand he could find—it was sturdy, quick to melt, and quicker to cool. After he had blown the glass into shape and created a dozen orbs cooling on the rows of hot punty pipes, he cleared his throat.

"You can come over now," he told Enne.

She slipped the book into her purse and treaded over, her gaze running over his workstation. She sat in the dust-covered chair in front of him and rolled up her sleeves past her elbows, exposing the skin where many deposited volts into their blood to make them harder to steal. Levi tenderly pressed his finger against her vein.

"Do you know what you're doing?" Enne asked him, not unkindly.

Levi rolled up her sleeve a few inches higher. "The Revolution was seven years before we were born. Of course I don't."

"Will this take a while? It's hard to breathe in here." She wiped away some of the sweat accumulating above her brow and lips. He shouldn't notice those things, not when he was still angry with her. But he did.

"Don't swoon on me," he muttered, unable to resist the joke.

She frowned at him, but it was crooked, like she was trying to keep from smiling.

Levi couldn't keep staring at her and second-guessing himself if he was going to get this job done. So he tuned her out and focused instead on her veins in the crook of her arm, tracing them down from elbow to fingertip, searching for the energy in her blood that he'd only ever felt in glass. It felt strange to touch her like this, sterile in comparison to the other ways they'd touched before. He made sure to orient himself to put as much distance between their legs as possible, even when they sat face-to-face.

He *did* feel the energy, a pulse fainter and faster than Enne's own. He coaxed it out from her arm the same way he'd draw volts from orbs, like tugging on a thread until the spool unraveled. Strands of white light slipped out of her skin and coiled around his fingers.

Enne sucked in her breath. "That doesn't look like volts."

It didn't. Volts looked like electricity, and though these strands glowed, they were limp instead of jagged.

And within moments, they disappeared, dispersing in the air.

Levi cursed under his breath. "We'll try again."

Enne peeled a sweaty strand of brown hair off her cheek and nodded. "Fine."

"I'm sorry—I know it's uncomfortable in here."

She met his eyes, making chills prick out across his skin. "I don't mind."

Their conversation was not helping his focus, nor was the storm of his own thoughts. He could still hear his father as though he lurked over Levi's shoulder, mocking his technique. He could still picture Jac the day he died, healthier and more sure of himself than Levi had seen him in a long time.

This time, when Levi coaxed the threads from Enne's arm, he drew them lower, his touch grazing down her wrist, her palm, her fingertips. Her skin prickled beneath him.

The threads spilled out of Enne's fingers and coiled around his own, more solid than the last ones. Enne's aura cradled them. Levi had always been able to sense auras in volts because of his split talent, but this was the first time doing so didn't bother him. Unlike the other Mizers before her, Enne's aura was not stained with the same sort of tragedy.

When Levi looked up, he realized that tears had streaked trails down Enne's cheeks.

"Are you crying?" he asked, worried he'd done something wrong.

She smiled awkwardly and rubbed the tears away with the back of her free hand. "I don't mean to cry at everything, but I was just thinking that with my pardon, I don't have to be anybody. I don't have to be a street lord or a Mizer or anything I don't want to be."

In Levi's opinion, Enne was an accomplished street lord—better than him, even, though his pride prevented him from admitting that out loud. Even if confronting the Doves had been a mistake, Levi had once run the Irons into ruin.

"What would you want to be?" Levi asked with surprise.

"I don't know yet. I guess I have to figure that out," she said cheerily. "What about you? Will you keep calling yourself the Iron Lord?"

Levi hesitated to answer and prolong this conversation. It would only make it worse when he told her the truth about her pardon.

"I don't know what I want," he answered slowly.

"You *always* know what you want," she said, smirking.

Levi reached for one of the cooled orbs from the pipes, forcing himself not to look at her, at the flush blooming across her neck and cheek, at where her hand lay outstretched, as though waiting for him to grasp it. He didn't reach for it.

No, he didn't always know what he wanted.

"Maybe I'll be someone different, too," Levi answered fi-

nally. "I think I only dreamed of being a street lord and latched onto Reymond because I desperately wanted to be someone else. It was just another way of running away from my family. But it's hard." He swallowed, thinking of how anxious he'd felt the past few days—especially as he left the meeting with Fenice, how it felt like the whole city was watching him. "I still feel like I need to run."

"I think we might always feel like that, a little," Enne said quietly. "I think that's why it's so easy to make mistakes."

She watched him pointedly, and Levi knew she was asking for his forgiveness. For what happened with the Doves and Lola's brother. Maybe also for Jac.

Levi avoided her eyes and reached for one of the cooled orbs from the pipes, then he gently eased the energy into it. They writhed and bent as they approached the glass, transforming from threads into sparks, transforming from energy into volts.

It wasn't until he stared at the volts in the orb that he realized he'd succeeded.

His father had told him that he didn't deserve this legacy. That it was noble and holy, and that Levi had replaced kings with street lords and Faith with legends. But now he'd achieved what his father would likely never do again. And he had done it beautifully.

"How much is there?" Enne murmured, staring at the row of glowing orbs.

Levi pressed a volt reader to each of them, tallying up their spoils. "A *lot*," he answered. Enough for the down payment on the casino. Enough for so much left over.

But now that they had finished, he couldn't put off the truth any longer.

"There's a catch, to your pardon," Levi said carefully. "The wigheads would like you to sit for an interview with Aldrich Owain at *The Crimes & The Times*. They'd like to get to know you better before they do anything final."

Enne stiffened. "Why didn't you tell me earlier?" She glanced around the table, at the volts around them, her expression darkening to accusatory. "You need the voltage, don't you?"

Levi stared at the dying embers in the furnace. "It's for the Irons. And the Scarhands."

"You're unbelievable," she spat. "You realize what the interview really means, right? They're waiting to gauge public opinion. About whether or not they'll end up killing me."

"Which they *won't* if we play our cards right. We'll blame it on Vianca. Besides, you're just a seventeen-year-old girl. If you come across like that during the—"

"What exactly does it mean to 'come across like that'?" Enne demanded.

"I'm just saying, we don't want them to cast you as a threat."

Enne's face was already flushed from the heat of the workshop, but now she went scarlet.

"As I'm sure you haven't forgotten," she fumed, "Aldrich Owain is part of the Phoenix Club. He killed Lourdes. He tried to kill the two of us."

"I haven't forgotten," Levi said hoarsely, knowing she'd say that. He still had nightmares about the Shadow Game. "The interview is scheduled tomorrow morning at the paper's office in the South Side."

"And I don't have a choice, do I?" Enne snapped.

"Not if you want the pardon." Levi took a risky step closer to her, but she only used their closeness to jab a finger into his chest. "I'm sorry I—"

"You're not as clever as you think you are. You acted like you were saving me from myself when you stole the Scarhands from me. But last time you were in charge of the North Side, the North Side fell. It's why the Scarhands approached me first, and not you. It's why I should never have trusted you in the first place."

Her words struck him in all Levi's most vulnerable places,

where he blamed himself for so many failures. Now he knew that Enne blamed him, too.

"I'll be at *The Crimes & The Times* tomorrow, waiting for you," Levi mumbled. "Whether or not the interview works, it's worth a try."

"But is it worth the risk?" Enne shot back, grabbing her coat and storming toward the door. Before she left, she turned to him one last time. "The world has never given me any choice in this, but I never thought that you'd be one to take it away from me, too."

LOLA

"Do you believe there's such a thing as bad blood?" the Bargainer asked Lola as the two girls drove through the crowded streets of the Casino District on a workday morning, the slush along the curbs littered with cigarette butts and muddied party streamers. The Bargainer white-knuckled the edge of the passenger door, her pale face tinted a putrid shade of green, and Lola didn't know whether to be proud or affronted that even the greatest legend of New Reynes was no match for her driving.

"I don't," Lola answered. Just because her family had all gone rotten didn't mean she would—or so she hoped. "And I don't want to talk about this. Grace told me that Justin is still alive." And so Lola was going to pick him up, before Enne changed her mind and murdered him, after all.

"I wasn't talking about your brother," the Bargainer said.

Despite Lola's deal the day before, she had spent much of the last night explaining to her companion the rules of Bryce's game, describing as much as she knew about the other play-

ers, making herself useful so the Bargainer would keep her alive. But Lola knew the girl wasn't thick. The only reason she hadn't asked Lola which card she owned was because she'd already guessed.

"I thought you wanted to know all this," the Bargainer goaded. "You traded something precious for it."

"I do, but I...I'm driving—"

"No, you just think I'm going to kill you once the bargain is fulfilled."

Lola nearly swerved off Tropps Street. "That's not true," she lied.

"I'm not going to kill you because you're going to give your card to me. You'll give it to me because you need a friend just as much as I do." Clearly Lola's empty bravado had made an impression on her. But ultimately, those words weren't true. Lola had been alone long before she'd met Enne, and she could manage fine now.

"Fine, then," Lola said. "Tell me."

"I'll tell you, but it's more fun if you try to guess. I think you will, after a while," she said.

Lola had enough on her mind imagining what she'd say to Enne when she faced her, when she took her brother and left and didn't look back. Enne couldn't force her to stay—not even with the oath—but that didn't mean Lola could avoid a confrontation.

"This isn't a game—"

"Isn't it, though?" the Bargainer said. She shot Lola a wry smile, but it quickly fell when Lola skidded around a corner. She clutched at her stomach. "Maybe you're the one trying to kill me."

The idea of it was so absurd that Lola snorted. "*Can* you die?"

Then the Bargainer leaned out the window and vomited, and Lola figured the answer was yes.

She parked at the curb. "Thanks for not getting sick in my car."

The girl leaned back in her seat, her eyes closed and her lips pursed. "Arabella. You can call me Arabella."

Lola might have made a deal with the Devil, but that didn't mean she wanted to be on a first name basis. "Did you take that name?" According to legends, names were a common thing to bargain away—names, memories, talents.

Arabella opened one eye—the red of it made Lola shiver. "Maybe. Maybe I even took this face." When Lola grimaced, Arabella added, "I know the way the legends describe me, like I'm so old I witnessed the Casino District being built. But I'm not ancient. And I go by *she*." Then Arabella opened the passenger door and stumbled out, wrapping her peacoat tighter around herself. "We're walking the rest of the way."

Lola didn't argue. Madame Fausting's was only a mile away now, at most.

As they set off, Arabella said, "The Duke of Raddington's bastard child—he was Enne's father."

Lola had enough of a passion for history to know the title the Duke of Raddington was bestowed on the spouse of the crown princess, daughter of the queen of Reynes. Like all royalty, he was a Mizer, and he died by hanging in Liberty Square, a week after his wife.

"I believe his mother kept her son hidden to avoid scandal," Arabella explained. "So Enne's father would've been around thirteen when the Revolution began."

Which would've made him only a couple years older than Lola when Enne was born.

"Is he still alive?" Lola asked breathlessly.

"No. He died a long time ago, after he tricked me. He made a bargain that no one who'd known him would be able to speak the truth of who he was." Lola recalled Zula cryptically telling her that she couldn't divulge the past. Now Lola knew the

reason—Zula literally couldn't. "Your bargain has overridden that one, at least between the two of us." Arabella grinned. "So maybe it's me who finally won, in the end. *You* didn't know him. Finally someone can spill his secrets."

"And his name?"

"I told you—I'm making you guess. It's more fun that way." When Lola frowned, Arabella added, "It's more fun *for me*. It's been eighteen years since he tricked me—I like to celebrate my victories."

"So how old are you, then?" Arabella didn't look older than twenty. "If you're not 'ancient.'"

"This isn't about me."

Lola rolled her eyes. "Fine. I know that Enne's mother was Gabrielle Dondelair, who was executed for giving birth to a Mizer, among other crimes. I know she played for Enne's life during the Shadow Game, that she won and tried to flee—but only Enne escaped."

Arabella nodded. "I'm surprised you managed to dig that up, even as a blood gazer. Here's what you don't know. Gabrielle's brother wasn't the good sort—he fell into some trouble and dragged her down with him."

"Trouble?" Lola asked.

"Kidnapping. Enne's father—being the last surviving Mizer—was very paranoid. He wanted a Protector, someone with a talent for keeping his secrets better hidden. And so he hired Gabrielle's brother to kidnap the only Protector who could offer him even more—Malcolm Semper's daughter. He knew Semper couldn't make a move against him once Clarissa had sworn her protection to him—otherwise she'd be forced to defend him. Clarissa was Lourdes's real name. Semper's daughter. But you already knew that."

Lola had, but she hadn't read anything about a kidnapping in Jonas's file about Lourdes. Semper must have kept the entire affair a secret.

"But how did he convince Lourdes to swear her protection to him?" Lola asked.

"Gunpoint."

Lola shivered. Maybe there *was* such a thing as bad blood—she'd sworn Enne her street oath nearly the same way.

"So that's how Gabrielle met Enne's father," Lola said. Not very romantic. "How did Lourdes end up with Enne, then?"

Arabella shrugged. "I don't think she ever hated Gabrielle, the way she hated *him*. But she must not have really hated him, to become a monarchist herself. For her own father to kill her in the game he devised to use against *me*..."

Every moment Lola forgot who she was speaking with, the gravity of her situation returned to her. Everything that had gone wrong in Lola's life had happened because she'd surrounded herself with players, but Arabella was the most dangerous player of all, and—against all sense—Lola kept forgetting that.

They reached the grounds of Madame Fausting's, and nerves knotted in Lola's stomach.

"From what you told me about this place, I probably shouldn't go in," Arabella said.

"Because you'll get recognized?"

"Because I'm quite allergic to cats."

Lola laughed, some of the tension rolling off her shoulders. "Fine, but one more question. I want something to distract me..." *from facing all my friends.* "What did her father look like?"

"I wouldn't know. I never saw his face."

Lola frowned and pondered that as she made her way to the entrance. How could Arabella have made a bargain with him without seeing him?

She knocked on the door, and Grace answered. It was still early—the Spirits often slept in late—and so Grace squinted into the morning light as if it offended her. Then she took in the image of Lola.

She punched Lola in the arm. "I was worried about you after you hung up! I thought you'd gone to Tock's, but she's here—she came looking for you—"

"Is Enne awake?" Lola asked.

"She left already with Levi."

Lola stepped inside the empty foyer, relief washing over her like a cold drink that she'd get to avoid Enne. "I'm just here for my brother."

Grace locked eyes with her, and she had the sort of predatory stare—smudged eyeliner and cold gaze—that made Lola want to reach for her scalpel, even though Grace could outmatch her without a weapon of her own.

"I don't think she would have done it," Grace said darkly. "Enne was just making a show. She wouldn't have killed your brother."

"If you think that, then maybe I know Enne better than you," Lola answered. Grace hadn't been enlisted in this operation under duress—she'd been bribed with frilly South Side party invitations.

Grace opened her mouth to argue but seemed to think better of it. At least with words, Lola was the one with the upper hand.

"I'll take you to him," Grace told her. "Tock is with him. He likes her—won't shut up about her, actually. I tried to get Roy to take the last watch, in the lucky case the Dove managed to kill him, but he kept insisting on her."

Lola nodded disinterestedly, not sure who Grace was talking about. She didn't bother asking. She only wanted to leave before Enne returned.

Grace opened the spare bedroom in the dormitory hallway. Justin looked no cleaner than yesterday, his freckled skin splotched with dirt and his hair matted from grease. His hands were handcuffed behind his back, but he didn't seem to mind, lounging on the bed and in the midst of a conversation with a heavy girl at the other side of the room, with light brown

skin, short-cropped hair, and combat boots that laced up to her knees. She was pretty, but she had a crooked sort of smile that matched the Iron tattoos on her arms.

To Lola's shock, the girl jolted up and threw her arms around her. She might as well have been hugging a steel rod for the way Lola froze. "Where the *muck* have you been?" the girl growled, then stood on her tiptoes and kissed Lola on the lips.

Lola peeled herself out of the girl's embrace, face burning. She'd never kissed anyone before, and of all the things she'd braced herself for today, kissing had not been one of them.

"Your girlfriend is awesome," Justin said. "She can blow things up!"

Lola didn't respond, on the off chance she'd misheard or misunderstood everything that was happening in the room. Instead, she turned to Grace. "Where is the key to his cuffs?"

The girl—Tock, Lola figured her name was—grabbed Lola by the wrist and spun her around. "I came right here when I heard what happened. You can leave with me—Levi will let you stay with the Irons. Both of you..." She shot a glance at Justin. "Well, I'll make him, anyway."

Lola let out a delirious laugh. "Why would I stay with Pup?"

"Well, where *are* we going, then?" Justin asked impatiently.

"I..." Lola suddenly trusted everyone in this room a lot less. It might be better if Enne didn't know where they were staying, and Grace would undoubtedly report everything back to her. "It doesn't matter. Justin, will the Doves—"

"My name is Silence," he said seriously.

Grace groaned. "No one cares about your cult name. That's not even a weapon. Aren't all Doves named after weapons?"

"Tock said you were an assassin, but I don't believe it." Justin scoffed. "You're a counter. You're not—"

"You're lucky you're leaving today," Grace growled, "otherwise you could've counted yourself dead."

Lola rubbed her temples. There was a lot to process in the

last twenty-four hours, and her head felt foggy. "How about we leave the handcuffs on? Then we'll—"

"Let me come with you," Tock told her, more urgently.

"Yes!" Justin said. "Let her come with us."

Lola cursed and yanked Justin up by his arm. He reeked of body odor. "Stop trying to help us—you've all helped me *so much* since the other day." Lola glared at Grace. Then to Tock: "And I don't even know you. You're...you're obviously very confused."

Something dark crossed Tock's face, and she exchanged a look with Grace that Lola knew well. It was the same look Lola had once given Justin when their older brother started spinning lies that stopped making sense. The same look that all the Spirits and Scarhands had when they'd dragged Justin, thrashing, across the floor. Like Lola was shatz.

She didn't want to believe in bad blood.

"We're leaving," Lola muttered, then she pulled her brother out of the room.

The girls shouted after her, but she kept moving, focusing on Arabella's final clue to drown out everything else that didn't make sense. Lola didn't stop until she'd hauled Justin all the way to the edge of the grounds, where Arabella stood waiting for them.

"Enne's father is Veil, isn't he?" Lola panted. "That's why you said bad blood—because he was the most notorious street lord in history. And you wouldn't have seen his face because he kept it covered. Probably to hide his purple eyes."

Arabella grinned. "Well done."

Something icy and wet touched Lola's nose, and she stared up at the bleak sky of the Ruins District—it had begun to snow again. She let go of her brother and fought to catch her breath, taking in the cold truth of it all, and decided whatever price she had paid for this knowledge had been worth it. Because

Enne's father had nearly burned New Reynes to the ground, and Lola wouldn't let herself or her brother get caught in the flames when her friend did so a second time.

ENNE

Enne stood at the center of a hallway stretching endlessly in either direction, the alternating doors and floor tiles a dizzying checkerboard of black and white. She knew this place enough to know it was a dream—a repeated dream, one she and Levi somehow shared. She knew this feeling, too. The tug in her stomach, urging her forward. The need to find a particular door.

When she entered the closest black one, she stood on the grounds of Madame Fausting's Finishing School, only it was not the school she recognized. Its white stone walls and bay windows were polished. Tulips sprouted in the neatly manicured gardens, with lawn statues of ducks and rabbits in the flower beds. Girls passed on the sidewalks—girls who, in many ways, reminded Enne of herself, even if their hoops skirts and ornately decorated hats were old-fashioned. They looked nothing like the girls who lived there now.

I'm in the Royal District, Enne realized, the name of this

neighborhood before it had fallen into ruin. Enne grimaced as she strode across the cobbled roads, remembering stories of how they'd once flooded with blood.

Bells tolled, and they didn't sound like the church bells of Olde Town—but she heard those, too, muted in the distance. The skyline of New Reynes looked so different. Though the factory smog still smothered the clouds, the skyscrapers of the Financial District were gone. The South Side did not yet exist.

Enne couldn't help her curiosity; she started north, in the direction of the palace. Even from here, she could spot its turrets, constructed of a striking red stone when so much of Reynes was bleakly white. The homes she passed were magnificent. They belonged to the kind of old money that Enne had never seen on the South Side. This was a time when families valued themselves as much on their lineage as they did their voltage.

Enne heard screams once she approached the palace square.

A man thrashed, his arms bound behind him to a pole. Two others stood over him. The first wore the vestments of a priest, though Enne had never seen a cassock with such intricate embroidery, even on the Street of the Holy Tombs. The other dressed like a layperson—though a wealthy one—and raised a gleaming knife into the air as the prisoner cowered beneath them.

A small crowd gathered to observe, and Enne felt a sickening reminder of Jonas's execution in Liberty Square. She squeezed her eyes shut, certain the layman was about to bleed the man out, and she winced at the prisoner's screams. But when she finally peeled her eyes open, she realized the man was not dead. The noble instead had dipped his fingers in the blood and smeared it over his own eyes.

A blood gazer, Enne realized, feeling a pang of guilt as she thought of Lola.

The blood gazer turned to the priest and whispered something to him. The priest shook his head gravely and announced, "This

man is found guilty of possessing talents of an abominable nature, and his sentence—by order of Queen Marcelline—is death."

Enne hadn't heard what talent the blood gazer declared, but whispers spread through the onlookers around her. "Demon," they growled. Several spit on the ground. Others grasped the Creeds around their necks.

But from here, Enne could see that the man's eyes did not match the red of Bryce's. She wondered with disgust how many talents the queen deemed worthy of capital offense. From what Enne knew of history, the answer was anyone the Mizers deemed a threat to their power. It was why they'd crafted the Faith in the first place. The Mizer talent paled in comparison to those who could ensnare a victim with a smile, who possessed the strength or speed to outmatch any foe, who knew a lie the moment it left someone's lips. And so the Mizers had spun stories to instill fear, and on that fear, they'd built their thrones.

A woman tore through the spectators, her shrieks quelling into sobs. An officer of some sort—he wore a violet uniform instead of white—seized the woman by her shoulders and shoved her away.

Enne walked closer, compelled to help even though she knew she wandered these dreams a ghost. She reached instinctively into her pocket for her gun, the weapon that always made her feel in control, but as soon as she grabbed it, a shiver coursed through her. *That* gun.

Enne watched helplessly as the woman was led away, her screams muffled by the officer's hand gripped around her mouth. *Help her*, Enne urged herself, but she was frozen, petrified from the gun, petrified from this history she wanted no part in.

The dream slowly bled away, color seeping from the palace into a crimson puddle at Enne's feet, and the only vision that remained was that moment in between bullets, when Jac had been down but still alive, when Enne hadn't been in control at all.

★ ★ ★

Enne awoke barely an hour into her sleep on sweat-dampened sheets, the moon splashing hazy light across her floorboards. Shaken and overheated, she threw off her comforter and held her face in her hands, willing herself not to cry. She had finally slept after so long without it, but even her dreams reminded her that she was in danger.

She collected herself enough to sit at her vanity, where she examined her violet eyes in the heart-shaped mirror. She barely recognized her own face.

"They fear you," Enne whispered. "They'll never give you your pardon. Not even if you stop fighting."

Enne cleared away the mess on the vanity's surface: blush palettes and lipsticks, her revolver and spare bullets. She packed all the weapons into drawers. Her gun had once made her feel powerful, but now she could not look at it without seeing her mistakes, without seeing Jac.

Lifting a hairbrush, Enne was surprised to find items she had been without for a long time: her tokens. She miserably studied the possessions that used to bring her old self so much comfort. The queen's token had been a gift from Lourdes, a curious trinket from a bygone era. The king's token was stranger—it burned with an unnatural warmth, and in the cameo of the king's face, his eye glowed eerily purple. A mystery Enne had never solved.

Enne missed the girl who had cherished these, who'd reached for strength from within instead of reaching for her gun. But Enne didn't know if she could be that girl anymore. The City of Sin was a game, and you couldn't win if you played nice.

But since Lola left, Enne also realized that her hardships weren't one she needed to endured alone. And so she crept into the hallway to Grace's room, her tokens clutched in her fist.

Grace looked up as Enne eased open the door. Her makeup, normally washed off by this time at night, looked pristine. She'd

straightened up the usual clutter of her living space, replacing the tangle of metal necklaces on her nightstand with a candle. It smelled oddly pleasant, like vanilla.

"Oh," Grace said, her voice high-pitched. "It's you."

"Were you expecting someone else?" Enne asked, eyebrows furrowed.

"What? Of course not." Grace blew out her candle and switched on her lamp instead. "What is it?"

Enne sat on the edge of Grace's bed. "It's about tomorrow, about the newspaper interview."

"I thought you weren't going to go," Grace said. "And you shouldn't. You'd be giving Owain all the power to describe you in *his* words. It reeks of a setup."

"But what if I'm making a mistake?" Enne asked quietly, hugging her knees to her chest. "I've been pretty superb at making them lately."

Grace squeezed Enne's shoulder. "When you wanted to murder Owain to avenge Lourdes, I was the one who talked you out of it. But when we came back from the Mole station, after all the Scarhands had been killed..." Grace fiddled with a strand of her cleanly washed black hair. "I didn't stop you then. Or help you. I should've, but I was shaken." Grace's voice trembled on the last word, and Enne realized with a start that she'd never seen Grace look so sensitive before. "I think we all were."

"It's not your job to make me a good person," Enne grumbled.

"I'm your friend. If I think you're going to muck up, I'm going to tell you. Just like you'd do the same for me."

Enne let out a hollow laugh. "Like you'd need it."

"What do you mean?" Grace asked.

"You're the steadiest, strongest person I know." Enne gestured to Grace's bedroom, as though to submit Grace's black drapes and garlands of pigeon bones and barbed wire as evidence in her case. "You've never once looked vulnerable. You

face every problem head-on. It's why I've always admired you so much."

"That's absurd. Take that back. No one is allowed to admire me." After a moment's pause, Grace added, "You don't even know the person I was before, when I worked for the Orphan Guild."

"I remember meeting you pretty well," Enne said. Even amid the crooks of the Orphan Guild, Grace had stood out, devouring a romance novel and dressed for a funeral she'd likely caused.

"Right, but I got to be a different person, once I met you." Grace met Enne's gaze seriously. "I had a reputation for taking any job, no matter how terrible. At first, it was because I needed to—I needed the volts to leave the One-Way House. And by the time the Orphan Guild bought my contract, it was too late. That's who I was. Until you offered me a way out."

Enne didn't realize that Grace had grown up in a One-Way House, the city's cruel indentured worker schemes disguised as orphanages. From the moment you arrived, your living expenses accumulated a debt, and no matter how many jobs you accepted, escape was nearly impossible. Jac had been raised in one, too.

It was no wonder Grace never took jobs as a counter. All her life, every breath she took had a price.

"I didn't know that," Enne said softly. "And I'm glad you told me."

Grace reddened. "I'm just saying, once people think they know you, it's hard to change that. It won't matter if you go to the interview dressed up as a worker on Sweetie Street. Or with your face all bandaged up, like a second coming of Veil. They've already made up their mind about you. It will take a lot to change that."

Enne flipped the tokens over and over in her palm, biting her lip. "I don't know—Levi seems to think we can pin every-

thing on Vianca. That I can pretend to be some silly, seventeen-year-old girl."

"Silly, seventeen-year-old girls fare pretty well in Sadie Knightley's romance novels, you know," Grace pointed out.

Enne's life was far less pretty than the swoons and courting of the books from their favorite novelist. But as a lifetime devotee of the romance genre, Grace's words gave her an idea.

"I think I know a way to convince the public to change their minds about me. To love me, even," Enne murmured. "Even the City of Sin loves a romantic story."

It took Grace several seconds to decipher what Enne meant. Her eyes widened. "You can't be serious."

But she was. Enne had tried the gangster approach—it hadn't worked. She was done putting her friends in danger or latching on to someone else's idea of who she was. She'd put away her gun. It was time to trust herself.

"If the city loved me, the Chancellor couldn't execute me. It would be politically unwise," Enne explained. "And that would still put me in a position of power. I could negotiate for my pardon."

"*If* you can convince New Reynes," Grace said carefully. "Last time I saw you and Pup together, you were at each other's throats—and not in a sexy way."

Enne frowned, wondering exactly which Sadie Knightley novel contained such a scene. Then she picked up Grace's vanilla candle and smirked. "I should hope that's not what I'm interrupting tonight. If I didn't know better, I might think your heart is not as ruthless as you'd like everyone to—"

"I have no heart," Grace snapped, glancing frantically at the door and back again. "*Anyway*, will Levi even agree to such a plan? He used to be the *Iron Lord*." Grace rolled her eyes at the nickname. "Will he be happy with you painting him as a lovesick romantic?"

After Levi had played her so easily at the workshop, Enne

saw nothing wrong with playing him. "I won't give him much choice in the matter."

Grace whistled and grinned wickedly. "Well, you *are* going to give *The Crimes & The Times* something to write about."

SOPHIA

"*This* is more what I expected," Poppy said, wobbling as her stiletto heels sunk into the lawn of the House of Shadows with each step. She wore only a beaded dress—no coat—and it glimmered as she giggled and motioned the two other girls to follow her through the dark.

"I can't believe you invited her," Delaney grumbled as she and Sophia lagged behind. Delaney, as usual, wore a stiff, conservative dress and a tight ponytail. Only this time she'd gotten festive and added a baby blue ribbon.

"She worries about you," Sophia told her, even if Sophia's reasons had been far more selfish than that: she'd invited Poppy because Poppy was her target.

"That's not your business. *Neither* of you should even be here. I don't care what history you have with the Bargainer—you're in over your head, and you'll only make this job harder to get done." Delaney sighed, her breath fogging in the chill air. "I can't save both of you. You better keep that in mind."

Then she started after Poppy.

Sophia was hardly offended—she barely knew either of the two girls. Of course they would protect each other before her. What stung was the acknowledgment that she was utterly on her own. Especially because it was true.

She stumbled as she followed them to the front door—walking was tricky in her skin-tight, scarlet number—where the same bouncer from last week loomed in the threshold. "You three are back."

They must have looked quite the trio—Poppy and Delaney, dressed like the two flavors of cotton candy; and Sophia like she came with a warning label.

"We are," Poppy said cheerily.

The guard let them pass, and Sophia gaped at the difference mere days had made to the House of Shadows. It had come alive, candles aglow on barstools and fireplace mantels, crowds clustered in its maze of rooms, dancing or smoking from embellished cigarette holders or drinking out of heavy goblets. There was an element of exclusivity to this party. The guests followed a dress code of dark, muted colors—making Sophia stand out like a bloodstain. Silver glinted everywhere, in cards tucked into jacket pockets and jewelry dangling on slender wrists. Many moved between the others, not as strangers, but as familiar faces, friends.

Sophia searched them for the details she remembered about the Bargainer: fair skin, light brown hair, sunken eyes and haggard features. But she recognized no one. She knew that the Bargainer was unlikely to return to the House of Shadows, whose occupants conceived the very power that had barred her from New Reynes for twenty-six years, but the crowds still made Sophia feel adrift. Everyone looked like some version of a rich South Side party brat—some version of Delaney and Poppy, really. This had been her best chance, but it seemed hopeless Sophia would find a trail to the Bargainer here.

"I hate these people," Delaney groaned, shrugging off her coat and slipping it over one of the dozens of racks. "Harrison knows I didn't want to come back."

Sophia was tempted to ask more about Delaney's history with this place, but Delaney had a grimace like she was deeply annoyed. Or maybe she always looked like that.

"Who are these people?" Sophia asked instead.

"Delinquents, mainly," Delaney answered flatly.

"They dress pretty spiffy for delinquents," said Sophia.

Poppy rolled her eyes. "She only hates them because they kicked her out."

Delaney's cheeks reddened. "That's ridiculous. And *wrong*. I left on purpose." Then she nodded for Sophia to walk ahead. "You're tall. You go first."

Sophia didn't argue, only because her words made it sound like they'd stick together at this party, after all. Delaney's hand on her shoulder pushed Sophia through the crowd, past the parlor and into the billiards room Sophia remembered from the first time they'd visited. The faces inside were far less ashen than before—sweaty and red cheeked, mouthing the words to a song Sophia dimly recognized from the radio. Even amid the Friday night glamor, it still felt more mundane than she had expected. Unless the music was merely overpowering the whisper of legends. Unless the secrets of this place were buried beneath discarded heaps of designer coats or sunken to the bottom of top-shelf liquor bottles.

Delaney steered her to a black velvet curtain behind the bar.

"What's back there?" Sophia asked.

"You know in a museum how you exit through the gift shop?" Delaney asked cryptically. "Just don't touch anything."

Then she pushed them both through the curtain.

It looked like a smaller version of Kipling's Department Store, if all of their merchandise only came in metal.

The girls passed a table of broaches, belt buckles, and eye-

glasses, then a display of wristwatches and a rack of gowns embellished with sleeves like chain mail. Artwork of metalcraft was hung on every available wall space, price tags dangling below each frame. The gazes of the employees followed them as they passed, and chills crept up Sophia's spine when she noticed many of their eyes were red.

"Shades are cast on metal," Delaney said, as though sensing Sophia's confusion. "Like how volts are stored in glass."

"So these are *curses*?" Poppy asked. "For *sale*?"

"Like I said, don't touch anything. Let me go talk to Creighton. He's the manager and part of Bryce's game."

Delaney walked to the corner, toward the room's largest piece of artwork—a rendering of Tropps Street at night, paint smudged across the metal buildings of the Factory District like a flaking layer of rust.

Sophia and Poppy glanced at each other and nervously tread toward the jewelry displays in the room's center. Sophia bent over the glass, inspecting the dark, glittering diamonds, many filled with impurities that looked like clouds of black smoke or dust fragments trapped within stone.

"Are you looking for something specific?" one of the shopkeepers asked—a malison, judging from the red of his eyes. The color reminded Sophia so much of the Bargainer that she had to force herself not to stare. He gestured to the rings. "Is there something you'd wish to forget? Perhaps you need a little glamour—courage? Stamina? Cunning?"

There were a lot of things that Sophia wished to forget, but she had already forgotten too much about herself to sacrifice another broken piece.

Poppy, however, leaned in closer. "How does it work? Do you make a deal or—"

"No deals," he snapped. "We don't want your talents—what would we do with them? We only accept volts."

Sophia didn't realize that the Bargainer kept the talents of

those she dealt with. Did she have many talents, then? Dozens? Hundreds? Even if Sophia's split talent counted as only one in her collection, it soothed Sophia to know it still existed, that maybe she could get more than just her memories back.

Sophia dug her dice out from her pocket and rolled them across the counter, making a loud clatter. A three and a five. Those were good odds. There was no point in stalling, then.

"Speaking of deals," she spoke confidently, "we'd like to know how to kill the Bargainer. Are you the right person to ask or—"

"Clearly," he growled, Sophia's good odds apparently not good enough, "neither of you belong here—"

"We'll take this one," Poppy said, pointing to a small ring in the display. Sophia squinted at the inscription underneath: *Tell me.*

Delaney had instructed them not to touch anything, and even if Delaney acted like her brassiere was perpetually digging into her ribs, Sophia had to agree with her here—they shouldn't mess with curses. But when Sophia shot Poppy a warning look, Poppy smiled wide, purposefully ignoring her.

The shopkeeper looked Poppy over shrewdly. "Nine hundred volts."

Sophia whistled, but Poppy didn't even blink. She took off her sparkly bracelet and handed it to him.

"I told you—volts only—"

"It's Maxirello."

He rolled his eyes and removed the ring. "Fine. Take it. Leave."

Poppy slid it onto her pinky finger, grinning wickedly. She winked at Sophia. "Sometimes you need to make your own luck."

"Delaney said not to buy anything," Sophia said carefully.

Poppy rolled her eyes. "Tell me—how did Delaney meet Harrison?"

A strange sensation filled Sophia's stomach, something warm and syrupy, like a cordial.

"I don't know," Sophia answered automatically, her voice a little slurred even when her head felt clear.

Poppy frowned at the ring. "Doesn't it work?" Before Sophia could respond, Poppy opened her purse and pulled out her Shadow Card, the same one Sophia had seen before: the Star. Except this time, red writing stretched across the back. *THE EMPRESS.* "Who does the Empress belong to?"

"Enne," Sophia answered automatically. "You can't keep—"

"Do you think she'd give me her card, if I asked?"

Sophia couldn't stop herself from speaking. "No. But—"

"Do you know whose target I am?"

"Mine. But you can't—"

"Did you only tell me Delaney was coming here tonight so you'd have a chance to make me surrender my card?"

"Yes," Sophia answered, even as she tried her best not to. Then she bit down on her bottom lip, hard. A flush of shame made her face feel hot.

Instead of backing away from her, Poppy's face brightened. "Well *this* is the best purchase I've ever made. And that bracelet wasn't even Maxirello—it was a knockoff." Poppy covered her mouth with her hand. "Looks like it has a few side effects. I didn't mean to say that."

Sophia didn't like the idea of this ring. She hid her secrets like Jac hid his cigarettes, places no one would think to look. For instance, no one would expect the girl who'd destroyed her family's empire to miss them, to miss calling herself a Torren, to miss being someone's daughter or cousin or sister, no matter how terrible they'd been. Maybe she just hated the feeling of being alone.

"I get it if you don't trust me," Sophia said, "but I've messed with shades before. And it's why I'm warning you—you shouldn't, either."

Poppy glanced at Delaney, who was in a heated argument with the other store clerk. Then Poppy linked arms with Sophia and pulled her back into the party.

Once they were safely from Delaney's sights, Poppy narrowed her eyes. "You don't have to talk to me like she does."

Considering Delaney and Poppy were dating—or something, as Sophia had never been sure—she doubted she could've sounded like Delaney in that moment.

"And how is that?" she asked.

"Like I'm about to break. Because I'm not."

Sophia had not forgotten that Poppy's father was recently killed, but she hadn't grasped until this moment that Worner Prescott had died the same night as Jac.

"That must be nice," Sophia said flatly, "because after my boyfriend died at St. Morse, I made a deal with Harrison and offered him…" Her voice broke before she could speak the word, but she continued on. "So it must be nice, you know, that you're not self-destructively buying shades right now. That you're not breaking."

Poppy's eyes widened. "I—I'm sorry. I didn't know."

A server passed them carrying a tray of drinks that looked bubbly and dangerous. Poppy plucked one off and cradled it between them, like a shared conspiracy.

"It's just been so public," Poppy murmured into the cocktail. "Dad and I knew that everything was going to change after the election—we were prepared for it. For *something*. And all the reporters, all the people who knew him, have been swarming around me for days. It still feels like the election, like some giant fake publicity stunt."

"That's sort of how I feel, too," Sophia murmured. "My boyfriend and I achieved this big, nearly unattainable goal. I knew everything would be different afterward. And…" She was talking quietly, likely too quietly for Poppy to hear over

the music. Which was probably for the best—Sophia never did feelings well. "Well, everything *is* different."

Poppy must have heard her after all because she gave Sophia a small, understanding smile. Sophia had never had many female friends, and she didn't think this was how she was supposed to make them—squeezed shoulder to shoulder in illicit parties at illicit places, where neither of them belonged, paying no attention to the music or dancing and instead talking about the stuff that hurt.

"Are you going to kill me and take my card?" Poppy asked seriously.

Sophia gaped—so much for friends. "*No.* I was never planning that." At least Poppy knew she was telling the truth because she was still wearing the cursed ring.

"What *were* you planning on doing, then?"

"I'm not much of a planner."

Poppy snorted, then she took a long sip of the cocktail and gagged. "What *is* this?" she asked, disgusted.

"It's a Snake Eyes."

"It needs sugar." She set it on a nearby bookshelf, which was probably also for the best, as Sophia would otherwise have downed it in one gulp—bitter or not. Sophia resisted any leftover urge by popping a piece of taffy in her mouth. "For the record, buying a cursed ring is not my kind of self-destructive. I totally would have bought this, anyway."

Sophia was having a difficult time figuring Poppy out. "Why?"

"So I get to feel dangerous, too."

Now *that* was a sentiment Sophia understood. And precarious or not, the ring did have its uses.

"Come on," Sophia said eagerly. "Let Delaney make small talk with the shopkeepers. You and I are going to get what we came here for."

It wasn't hard to approach people—when Poppy fluttered

her eyelashes or Sophia twisted a dark curl around her finger, anyone happily welcomed them to their circle. Each of their smiles faded when Poppy asked her question, even as the responses poured from their lips like backwashed cocktail.

I don't know anything about the Bargainer.

That's just a story.

I don't think they can be killed.

Their investigation led them through a maze of rooms and floors of the house. To dining rooms with tables piled high with expensive hors d'oeuvres that Sophia had no taste for. To an empty room upstairs, with a large black table clearly meant to play cards—which Sophia and Poppy had quickly fled. Even downstairs, to a strange hallway running beneath the building, full of alternating black and white doors and flickering, industrial lights.

"This isn't working," Sophia grunted as the ninth group shut them out. She had the urge to kick something—and given her black leather platform boots, she'd certainly worn the shoes for it. Sophia had accepted Harrison's omerta in exchange for a place that seemed to know no more about the Bargainer than she did. Just another deal that she couldn't take back.

"I hate this." Poppy seethed, stomping her foot. "The Bargainer probably has hundreds of talents—she could win the game easily, if they wanted. So are we all just going to die in it?"

"Probably," Sophia answered automatically.

Poppy's blue eyes widened, then she slipped the ring off and handed it to her. "Maybe I prefer the pretty lies."

Then a scream cut through the party.

The music screeched to a halt, and the guests quieted, confused. The shriek died out, but soon everyone pushed toward the other room to find the source of the commotion, whispering with more excitement than fear. Sophia and Poppy were wedged between shoulders and elbows. They spilled into the

billiards den and into the shades shop. A crowd gathered around the back corner, beneath a painting of the Capitol.

"Oh, that's *horrible*," someone whispered.

"What is it? I can't see!" another asked.

"There's so much blood."

Even on her tiptoes, Sophia couldn't glimpse over the heads. So she shoved her way to the crowd's front, stomping on toes in her boots, until she stumbled into a puddle of red.

A man's body lay crumpled on the floor.

His head lay beside it.

Delaney shakily stood over the body. She gazed into the crowd with a terrified, empty expression—as though uncertain where she was—until she laid eyes on Sophia. She lunged forward and grabbed Sophia's wrist, smearing blood on it.

"I found him like this," she whimpered. When she looked at the red on her hands, she heaved. "And I just looked for his card. It isn't on him."

"Who is it?" Sophia asked. She didn't recognize the man, and she hadn't seen so much blood since Charles's death, impaled on the Luckluster bannister. The sight of it all was making that night rush back to her in painful bursts. *Jac.* She hated how he was nowhere except during the times she hurt.

"It's Creighton, the manager," Delaney choked out. "He was another player. And he was the only one I thought might know how to kill the Bargainer."

At that moment, Poppy had managed to squeeze to the front of the onlookers. She froze in sight of the gory display, and her whole body recoiled. She clasped her hand to her mouth, ghostly white, and she ugly cried over the stranger as though she knew him. Sophia guessed that Poppy had been near her father when he'd been shot, and no matter what the girl had told her, Poppy was definitely broken.

Delaney moved, but she was also in shock, and so Sophia

reached Poppy first. She grabbed her by her narrow shoulders and twisted her around.

Sophia shushed her. "You don't have to look."

"Muck," Poppy wailed, her head buried in Sophia's shoulder. "I'm the girl who something terrible happened to. That's... that's who I am now."

Sophia stroked her blond hair. "I think we're both those girls, then," she whispered hoarsely.

Delaney squeezed Poppy's shoulder. Her gaze looked someplace else.

"Did the Bargainer do this?" Sophia asked her.

"I doubt they would use a blade." The comment forced Sophia to look back at the corpse, exactly where the head had been severed. The arterial artery still sputtered out onto the carpet.

"Then we're leaving," Sophia said forcefully. "There's nothing to find here,"

Probably because there was nothing to find at all.

LOLA

Lola did not approve of cabarets.

The Sauterelle was as loud as it was dirty, with a sugarcoated stickiness to the floor from spilled cocktails and its stage lights blurred in the clouds of cigar fumes. Even the private table Arabella had paid for had crude words scratched into its top and lemon wedges and cherry stems crammed in between the booth cushions.

Lola scowled and stirred her drink with the straw. It was a Dead Cat Bounce, the snooty, South Side equivalent of a Gambler's Ruin—only you ordered it when you had hit a losing streak, not a winning one. *Cheer up*, urged the whiskey, *it can't get worse than rock bottom*. Lola disagreed.

"You don't like it?" Arabella asked. Lola didn't hear her at first—she was sitting to Lola's right and this place was mucking loud—so she had to ask her to repeat herself.

"I'm not in the mood," Lola grumbled, which was the truth, but only part of it. Lola didn't handle liquor well, and—call

her shatz—she didn't think it wise to lose her wits around the most notorious legend of New Reynes.

Besides, someone needed to look after her brother.

Justin scowled even deeper than she did. He somehow looked worse now that he'd bathed, all his bruises and scars more obvious without the grime. Now twenty, he resembled their older brother so much it hurt for Lola to look at him.

"I'll take it," he offered eagerly, reaching for Lola's drink.

She slapped his hand—the one handcuffed to hers. "No, you won't."

He leaned back and pouted, and Lola considered reminding him for the dozenth time that the Doves had sent him to die. He didn't care, though. They were his purpose, his family, and she was just the person who made him "weak."

So rather than look at him, she studied Arabella, who twirled her long necklace of black pearls around her finger, her gaze fixed on the vedette on stage. Even if Lola didn't trust Arabella, she had somehow stopped fearing her. Which was ludicrous, since Lola was Arabella's target.

Arabella smiled and turned to Justin. "Do you want to get out of these handcuffs?" she asked him.

His eyes flickered to Lola, then back to the door. He nodded.

"Wait," Lola breathed. "Don't—"

But Arabella had already slid the key into the lock. The cuffs clicked, and Justin wrenched his hand free and stood up and stalked off without so much as looking at them.

Lola jumped to her feet, but Arabella grabbed her wrist. "Don't worry. I Chained him—he can't leave the cabaret, for that favor. I wanted to talk just the two of us. It's temporary—I'll free him after."

Lola swallowed and slid into the booth, still casting a nervous look to her brother. "He'll go to the bar, then. I don't want him drinking. It wouldn't be good for him."

"Consider it done," Arabella told her smoothly. Then Ara-

bella reached forward and took Lola's cocktail. She took a sip and scrunched her nose. "That's a bitter, pretentious drink."

"I'm a bitter, pretentious person," Lola muttered.

"I know. I read the papers in your briefcase."

Lola's eyes widened. "Those are…"

"Private?" Arabella smirked. "You don't even write about yourself. You write about everyone else but yourself."

"If I wrote about myself, there'd be nothing to write about," Lola scoffed. "And in this city, that's a good thing."

"None of your friends seem to think that."

"What friends?" she said flatly.

The Bargainer rolled her eyes. "Sometimes, when I wear this face, I feel younger—like this face is how old I really am. And then I spend time with someone this age and remember I'm not."

Across the cabaret, Justin shouted profanities as he attempted and failed to reach the bar, prevented by an invisible force. He looked shatz, pounding on the Chained barrier, on seemingly nothing. The dancers around him cleared a wide berth.

Lola sighed. "Maybe I don't write my own story because it's mucking depressing."

She flushed as soon as she spoke—she didn't talk like that, not to anyone, least of all to Arabella.

Arabella had donned glass contacts for their excursion, and even with the crimson of her eyes masked by black, she had a very pointed stare.

"Yesterday, I told you everything you wanted to know about Veil and Lourdes and the Great Street War," Arabella said gravely, though her voice made everything sound grave. "But tonight I want to talk to you about the Revolution."

"What do you mean?" Lola asked apprehensively. These weren't secrets Lola had asked for; Arabella was under no ob-ligation to tell her anything else. And though Lola was grate-

ful to have someone by her side, especially someone with volts, Arabella was under no obligation to stay with her, either.

Arabella swallowed, and Lola realized with a start that the Bargainer was nervous. That *Lola* made her nervous. "Having read your files," Arabella spoke, "I can tell you're a good judge of people. I want to tell you more. And then I want your help."

Lola's apprehension doubled. She hadn't been a good judge of anyone lately. "I don't think—"

But Arabella had no interest in Lola's unease; she launched into her story.

It started much the way Lola's own tale had—with misfortune.

"I don't think you can imagine what it was like, when the Mizers reigned, when the Faith was public doctrine and not superstition. I grew up in hiding. I knew so many who…" Arabella took a shaky breath. "Malison and shade-maker are the Mizer and orb-maker counterpart. The Mizers feared us because we were the only ones strong enough to take away all the power that they'd built for themselves."

Arabella closed her eyes, as though reliving the memories. Anger coursed through her features—a muscle clenching her her jaw, her wispy brows knitting together.

She continued. "And so I, born a malison and a shade-maker, became what the Mizers always feared most."

A shiver shot down Lola's spine. The Bargainer wasn't simply trusting her with the Revolution's story; she was trusting her with *her* story. Arabella held nothing back as she recounted how her legend began—not her deceits, not her cruelty. She left countless victims in her wake all to ensure she never became one herself. And not once did her voice betray any regret.

"I bargained with Semper for his freedom on one condition— that when he led his rebellion, he wouldn't stop short after Reynes," Arabella explained. "Because even though I'm from here, what use was it to me to stop at this one kingdom? I knew

worldwide revolution would risk countless people's lives, and so I needed to know that the world would truly change for it. So I made him promise that, once it was all over, every last Mizer would be dead. The kings. The nobles. Even the children."

Lola hadn't lived through the Revolution, but even so, it sickened her to learn the corruption behind it. In their three days together, in rescue missions and cheap cabarets, Lola had let herself forget who Arabella truly was, but Lola saw her clearly now.

Arabella was a monster.

"You're quiet," Arabella said softly.

"I—I want to know why you're telling me this," Lola stammered, then she grabbed the Dead Cat Bounce and sipped only to feel something cold wash down her throat.

"I told. I want your help."

Arabella took something out of her pocket and slid it across the table. A prayer card. Lola gaped at the photograph of Enne, clearly taken from her finishing school's yearbook. She lifted the card to stare at it closer, because even if she knew those pearls, knew that face, Lola barely recognized the sorry sort of smile of the girl in the portrait, so different from the Enne whom Lola knew now.

Even so, Enne's image forced a surge of anger in Lola's stomach. She unconsciously reached her hand to the wound on the side of her head, and it throbbed as her fingers grazed the bandage.

"You know why I like you, Lola?" Arabella asked.

Lola faltered, unaware that the person often dubbed as "the Devil" had actually grown fond of her. "Um, why?"

"Because you understand the power of legends."

Of course Lola did. She'd lost her brothers to the stories of these streets. She'd bargained for the truth of one herself.

Arabella tapped the prayer card. "So consider that. And tell me Enne's real story."

"She's..." Lola swallowed, knowing how carefully she'd need to choose her words. Even if Lola had never been so furious with Enne, Enne—the last surviving Mizer—was all that stood between Arabella and her post-Revolution vision for the world. And Lola didn't want to see Enne dead. "She used to go to finishing school. She's a dancer. She likes, I don't know...sugar."

"You're more descriptive in your files," Arabella said flatly. "I know you can do better."

She could, but Lola didn't know what Arabella was after—the satisfaction of her curiosity, or justification for whatever she planned to do next.

"If you've read my files, then you already know it all, anyway," Lola said uneasily.

"But I want to hear it from you, not from some papers. Tell me how you met."

Lola's hands shook, and she hid them beneath the table. "We met last June," she relented. "I was working as a blood gazer for the Orphan Guild—"

"The business that the malison runs, the one everyone is talking about?" asked Arabella, frowning. "You keep quite the company for someone who prides themselves on not being a person worth writing about."

Lola scowled. "Coincidence. But anyway, Enne and I got into a fight when I realized she was a Mizer. She made me swear a street oath to her, and that's how we became friends." Arabella snorted, but Lola ignored her and continued. "She's snooty. Not very dependable. Whenever it comes time to make a decision, she makes it alone because..." She thought of Enne's gloomy expression in the prayer card. "I think that's what her life was always like before New Reynes—alone."

Lola stopped, knowing that if she told Arabella the whole truth, it would damn Enne. How could it not? Vianca Augustine's cruelty aside, Enne was far from innocent.

"You hate her, don't you?" Though there was a lilt at the

end of her sentence, Lola didn't get the sense that Arabella had meant it as a question.

Lola's mouth went dry, and unintentionally, she stole a glance at her brother, who now sulked by the stage. The musicians played a jazzy number, a song Lola actually knew, had played along to herself on her harmonica. But hearing it now, Lola couldn't remember why she'd liked it.

"I think I hate myself," Lola said, sighing, "for not guessing that she would betray me. Everyone always does."

Then Lola's eyes widened. She was forgetting herself, forgetting the weight of this conversation, and so she quickly steered it away from Enne. "But what about Bryce? He's looking for you. He wants his bargain."

Arabella laughed. "He's a fool if he thinks that the flimsy shade of this game will be enough to kill me. He thinks he's holding my life hostage, that I'd crawl to him and offer a bargain to end the game." She grinned mischievously. "Maybe I'd rather play it. Maybe I've already made my move."

"Is that what this conversation is?" Lola asked, her skin crawling. She felt thickheaded now for not realizing it earlier. "Your honesty is a weird way to make me trust you so that I'll give you my card." The joke was on Arabella—Lola knew better now than to trust anyone.

The Bargainer frowned. "I'm not after your card, Lola."

"I suppose killing me would be easier."

Arabella coughed, and once she started, it took her several moments to stop. A rattling sound came from her chest with each tremor, and she grabbed the edge of the table to steady herself.

"Are you sick?" Lola asked her.

Arabella waved her hand dismissively. "I've put this body through a lot." Arabella grabbed Lola's drink and grimaced when she realized it was empty. "But killing is never easy, no

matter what the legends say of me. I haven't worn my real face since the Revolution ended because I can't bear to look at it."

That meant even the so-called Devil was capable of guilt.

"Before their executions, I appeared to the Mizers—each and every one. And I offered them a choice—their talent or their lives. They all clung to their power, even in death." Arabella traced the edge of the prayer card with her finger. "Does that sound like your friend?"

Now Lola understood the conversation, the help Arabella wanted. She was asking Lola to decide Enne's fate for her.

"You don't need to think like this," Lola told her. "You can leave Enne be. You can put your past behind you."

"Those are some optimistic, naïve words for a bitter, pretentious person," Arabella said snidely. "But I can't. And what keeps me up at night isn't that what I did was awful—it was. But it's because I'm afraid that the world is better because of what I did. And so I can't trust myself. It's why you should decide what to do about the last Mizer, instead of me."

Lola stiffened. Even if Lola understood anger, Arabella's reasoning for what she'd done was objectively horrifying; there was absolutely no justification for it. And Lola had always wanted to believe that the truth of stories was more powerful than the lies of legends.

But glancing again at the prayer card, Lola was no longer sure. That prayer card didn't exist a few weeks ago. Regardless of Enne's own actions, the world was changing because of her.

And Enne was far from innocent.

"I—I don't want to decide," Lola stammered. "It shouldn't be my responsibility."

Arabella pointed to the scar on her neck, a white line that traced across her throat. "Being passive is a decision, too. It's what the world decided before I made them choose otherwise."

Lola squeezed her eyes shut. Arabella was putting her in an impossible position.

"Fine," Arabella amended. "Forget about Enne. I meant it when I said I trust your judgment, and you're the only one who knows my story. So what do you judge of me?"

Out of the corner of her eyes, Lola glimpsed the others in the cabaret drinking and dancing and laughing, and though Lola had never truly lived or wanted to live in their world, she envied them. Their brothers weren't dead or feral shells of their old selves. Their lives weren't the poker chips of someone else's game.

Lola didn't want to incite Arabella's wrath, but she was angry and frustrated. If Arabella genuinely wanted Lola's opinion, then Lola would give it to her.

"What you did, what you made Semper do…it was terrible. The legends are right to call you a monster," Lola told her hotly. If this verdict bothered Arabella, she didn't show it, and that gave Lola the courage to continue. "And Enne can't help what people print on prayer cards or everything that happened before she was born. At least give her a chance to change the story."

Arabella furrowed her brows. "But after everything you told me, will she?" When Lola didn't answer, she pressed, "*Can* she?"

Lola did have an answer, but it scared her. So she turned away from the Bargainer, focusing instead on the band now onstage. "I've made up my mind. Now let me enjoy the cabaret."

HARVEY

"This is the worst job I've ever had," Harvey grumbled as he struggled with a wine cork, his shoes soaking in the reeking puddle that was the floor behind the Catacombs bar—a floor that had once belonged to a holy place.

"If I'm taking in strays, I still expect them to pay rent," Narinder said. He had the uncanny ability to make all his words sound charming, even ones Harvey would rather not hear. "There's a book of cocktail recipes behind you for reference. And measure the shots before you pour—the customers don't need you to flip bottles or put on a show. That's what I'm for."

Harvey yanked at the bottle opener so hard the cork split in two. He cursed and searched the drawers for a knife, aware of the impatient eyes of the two customers at the edge of the bar. At ten o'clock, the nightclub was still mostly empty. But it was a Friday night and the curfew in the North Side had just been lifted—likely, the whole city would soon show up.

Watching Harvey struggle with the knife, Narinder set down

the crate of freshly washed martini classes and pushed him aside. With the bottle opener, Narinder twisted and popped out the broken cork in one expert, fluid motion. He poured two glasses and slid them to the waiting customers, then went back to restocking.

"Consult the book. Memorize the recipe for a Snake Eyes. And don't use your talent to sell people drinks," Narinder told him. "If you do, you're out. This isn't Chain Street."

Harvey reddened. If Narinder knew he was a Chainer, why had he allowed Harvey to stay in one of the spare rooms of the rectory last night? Most weren't so accommodating.

"I…" Harvey closed his mouth—he was gaping. "I wouldn't."

Then Narinder's expression softened into a crooked smile. "You're welcome to do it for the fries, though. Everyone forgets we sell food, and they're quite good. We season them with my mother's recipe."

Then Narinder walked off to speak to the musicians. This place was far better managed than the Orphan Guild, which Harvey suspected was crumbling without him—or, at least, he hoped it was.

Harvey didn't usually mind crowds; in fact, he liked them. He enjoyed wandering through them, adrift but never lost, appraising each person he passed for the qualities the Orphan Guild admired. Even if he didn't use the favors he collected in such places as this, he could charm with a smile, a pat on the shoulder, a shake of the hand—beguiling whoever would collect the most handsome finder's fee. *A poacher*, many had called him. Harvey preferred to think of himself as the face of opportunity.

Tonight, however, he was catering to the crowds, stumbling over his soaked loafers while trying to find the extra lemons, sweating under the glares of impatient guests drumming their fingers against the bar and waiting for their orders. Harvey had always liked cocktails better as props than for their taste,

so when the book's recipes called for a "splash" or a "pinch," he had no idea if the result was palatable. And as the night progressed, his tip machine remained bleakly low.

As the hours passed, he snuck glances at Narinder, who seemed to move through the crowds much as Harvey could. He was everywhere. On the stage, playing music loud enough to make the bones on the church walls rattle and Harvey's ribs tremor. In the booths, laughing with attendees whom he seemed to all know by name. Behind the bar with him, picking up Harvey's slack or replacing a draft keg when the old one kicked out. He made the work look effortless while Harvey spilled grenadine down his shirt.

Once the night ended, Harvey felt exhausted from inside out. His lager-wet socks squished with every step. His stench was one hundred proof. And he'd been, more times than he could count, berated or publicly humiliated.

Narinder slapped him on the back as Harvey slumped over a barstool. "There's still cleanup to do. The bar needs to be wiped down, the lemons and cherries and limes tossed, the floor mopped, the glasses restocked—"

"It's five in the morning," Harvey said groggily.

Narinder shrugged. "I assumed when you asked if you could sleep here, you knew you wouldn't be getting much sleep."

While Harvey worked to unclog a wad of soggy bar napkins from the floor drain, Narinder examined the tip meter.

"You're not very good at this," Narinder said matter-of-factly.

"I don't normally need to be good at things," Harvey grumbled. "I smile, and people do things for me." The thought reminded him of Zula, of her unkempt house and cool acceptance at her own end. He swallowed down the sick feeling in his stomach. "But I don't do that anymore."

Narinder nodded seriously, in a way that gave Harvey a

warm, nervous feeling in his stomach. Like he believed him, even when Harvey wasn't sure he believed himself.

The staff cleaned for over an hour, trickling out around the time the dawn seeped through the stained glass. Harvey stood beneath the largest window, examining the scarlet and golden light, and tried to reconstruct the Catacombs from memory, from when it had been a church instead of a club. Muscles aching and feet sore, Harvey felt more cleansed than he had in a church in years. He felt like he could sleep—really sleep.

But before he did, he passed through the kitchens and into the back room where Narinder hunched over his ledger. It reminded him of how Bryce had done the same yesterday when they'd spoken. Well, it did and it didn't.

"I..." Harvey started. "I just want to thank you for letting me stay and work here."

"And for saving your life?" Narinder asked, not looking at him.

Harvey's mouth went dry. "Yes. Of course," he said, even though he hadn't wanted to be saved.

But he *was* thankful. In the moments where he forgot what he'd done, what he'd let Bryce do for so long, he was thankful. That just wasn't the same as being better. He wasn't sure better was even an option at this point.

Narinder closed the book and stood up. "You hungry? I'm starving."

Harvey wasn't hungry, but he wouldn't turn down an invitation from the person who'd shown him charity. "Sure."

He thought Narinder meant to eat the leftover fries in the kitchen, but then Narinder slipped on his coat, and they left the club. The morning overcast sky played tricks on Harvey's mind, nudging him to wake up when all he wanted was to sleep.

The Street of the Holy Tombs looked different than even a few days earlier. The Faith symbols, once discretely hung on porch beams or resting on windowsills, were now prominently

displayed. There were symbols Harvey recognized from the Stories of Omens, Protection, or Martyrs. One shop had rested a sign on its steps advertising Creeds 3 for 20V. A church had flung open its doors and set up a stand outside, giving away prayer cards with the faces of Queen Marcelline and the rest of the executed royal family.

Narinder eyed the Creed around Harvey's own neck. "What do you think of this?" he asked, nodding at the church. "Is this because there's a Mizer left alive…or a malison?"

"Both, I imagine," Harvey said quietly. Even if he wore a Creed, he didn't like drawing attention to his faith. It had been discouraged—in many places, outlawed—after the Revolution. Most historians believed that the Mizers had engineered the Faith to proliferate lore about their own talents. And even though some of the Faith's stories brought Harvey comfort, he also understood they'd also been used to hurt. He tucked his Creed beneath his shirt.

"I wasn't raised with the Faith. My family were revolutionaries," Narinder said. "And it never bothered me, living on this street. I only bought the church for my club because the real estate was cheap. But someone shoved those prayer cards underneath our door this morning. Maybe it's just because of that woman who died in the fire on Thursday, but I don't know how I'm supposed to feel about it."

Harvey bit his lip. He knew, rationally, that he couldn't bear responsibility for all the Faithful, just like he couldn't for all Chainers, but that hardly stopped him from bearing their guilt.

The pair turned off the Street of the Holy Tombs and walked north until they reached the westernmost part of Tropps Street.

They stopped outside of a row of casinos, where a lone street stand remained from the night before. An extremely sullen-looking woman slouched in a fold out chair beside it, her arms crossed. Half her table already seemed packed away.

"Harvey, this is Amara. Amara is kind enough to always wait

for me to close up each night," Narinder said. "Half the time, she's the sole person making sure I'm fed."

"I don't know why I do," she grumbled. "You come later and later, ever since you bought that club of yours."

"This is the same woman who, for half my life, told me to grow up and get a job," he said, rolling his eyes.

She smirked. "Yet I'm still taking care of you, and you're very ungrateful. Just go sit."

Narinder and Harvey sat at the edge of the slushy curb while Amara cooked, watching the early crowd shuffle bleary-eyed out of cafés or make their ways to the Mole station.

"My mother used to own a food cart next to Amara," Narinder explained. "She'd cook and play music to entertain her customers. And her food was good—better than Amara's, but I can't let her hear me say that."

"That sounds nice," Harvey said, because it did. His parents still lived on Chain Street.

As they waited for their meals, Harvey wondered why Narinder had brought him here. His relationship with Amara was clearly personal, but Harvey and the musician hardly knew each other. It was the Chainer in him, Harvey knew, but he didn't know why a stranger would ever spend time with him if not to manipulate him.

Amara brought them their food, a shrimp and noodle dish served on paper plates with a side of sliced bread. Even if it was standard New Reynes fare, it smelled good, like butter and paprika and onion, and Harvey ate it so fast he hardly stopped for breath.

Harvey was so busy using the bread to soak up the last of the sauce that he didn't notice Narinder had pulled out his Shadow Card.

"Explain to me what this means," Narinder told him.

Harvey did—the targets, the other players, all of it. He spoke matter-of-factly because, of course, this was why Narinder had

brought him here. To gain something. And Harvey, who knew a thing or two about debts, knew that he was not Narinder's friend—but he did owe him this.

Narinder didn't interrupt him, his gaze fixed blankly at the casino and corner store across the street. Then, once Harvey had finished, he asked, "So who's coming after me? Whose target am I?"

It would've been easy to lie—or even easier to smile.

But instead, Harvey answered, "Me."

Rather than snapping at him, or running, or anything else that was rational, Narinder's shoulders relaxed. "And my target?" He flashed Harvey the back of his card—the World.

"The Chancellor," he said.

Narinder set his plate down and put his head in his hands. "Muck," he muttered.

Harvey resisted the urge to pat his shoulder or speak words of comfort. After all, Harvey had let this happen. He'd let Bryce do this.

It was moments like these when he wasn't so grateful for Narinder saving him. He suddenly clutched at his stomach, the butter and seafood not sitting as well as he'd thought. The good sort of exhaustion from earlier had disappeared, and he knew when he finally did make it to his bed, he likely wouldn't sleep at all.

"Why me?" Narinder asked. "I'm not a player. I'm not a criminal. I play music and make people drinks. I don't pull stunts. I take my life seriously, unlike...well, unlike people I used to know."

Harvey didn't have a good answer. Bryce and Rebecca had chosen the players—not him. "You did run into a burning building to save me," he pointed out. "I'd call that a stunt."

Narinder laughed bitterly. "Or a mistake."

The cold ocean wind seemed to tear right through Harvey's coat. He grabbed his plate and stood up. The Catacombs had

been a bad idea. He'd find a hostel, but he didn't have volts—he'd left them all at the Orphan Guild. Which meant he'd have to swindle a night with a smile, and suddenly, that seemed too high a price to pay.

Narinder grabbed Harvey's coat sleeve, making him drop the metal fork on the sidewalk with a clatter. "Wait. I didn't mean that. I just meant..." He sighed. "I really don't want this. I don't want to die. And my cousin... Muck, she must have a card, too."

No, he *had* meant it. Just because Harvey was being honest now didn't mean everyone was.

"Well, I'm not going to kill you, so there's that," Harvey told him. He grabbed Narinder's empty plate and threw out both of them.

Narinder stood up and hovered over him. "But where is your card? Did someone take it?"

"Not exactly."

"So you put your life in someone else's hands, and you still don't have anywhere to go?" Narinder asked.

It must've been the fatigue, because Harvey had to take a shaky breath to stop himself from crying. His misery had layers to it, and Narinder had peeled back the deepest one.

Speaking was dangerous, speaking meant potentially breaking, but Harvey knew if he shook his head, Narinder would feel obligated. "I don't need..." His voice cracked.

"You do," Narinder told him, waving a quick goodbye to Amara and tugging him back down into Olde Town. He sighed when he unlocked the doors of the Catacombs, like maybe he was just as tired as Harvey was. The sound of it reminded him of Bryce.

Well, it did and it didn't.

VIII

THE HIEROPHANT

"What will we tell our children who weren't alive
to witness what we did? Will you tell them what
terrible things you've done? Will anyone?"

Shade. "The Last Mizer Is Dead."
The Treasonist's Tribunal
7 Jan YOR 4

ENNE

The office of *The Crimes & The Times* was located in a historic building in the Financial District, famous for its unusual architecture, with a sloping roof and exposed piping. Enne scowled at the paperboy outside, waving copies of today's edition at passersby. A photograph of Levi dressed in a smart, navy suit dominated the front page with a headline *Young Reformed Criminal Negotiates Pardon for the North Side*. She'd bought him that suit, if she remembered correctly.

"Funny," Enne muttered from the passenger seat of her Houssen. "*I* haven't been pardoned."

"The North Side isn't on lockdown anymore," Roy said from the backseat. "That must count for—"

"Did you even see the ruckus on Tropps Street this morning?" Grace cut in. "They're almost ready to throw a parade in Pup's honor, as if the lockdown wasn't *his* fault to begin with."

It was true—the drive through the Casino District to reach the South Side had been chaotic. To celebrate the lifting of

the curfew, people had begun a twenty-four-hour party that spilled out into the middle of traffic. There had been shouting, dancing, and an overwhelming amount of litter. Enne had felt on edge just driving by it, reading the article in the backseat.

Talks between Levi Glaisyer, future Representative Augustine, and the Chancellor amounted to an end on the state of emergency in the North Side...

Glaisyer promises to continue working to help the North Side get back on its feet...

Our sources confirmed that Séance was not involved in these negotiations...

Everyone was getting exactly what they wanted, but meanwhile, Enne's life was still on the line.

As if on cue, Levi appeared in the doorway of the office building, wearing yet another suit Enne had bought him. When she tried to decide why that bothered her, the only thing she could come up with was that it looked good on him.

"If your plan doesn't work," Grace whispered, "there's still option two. He's clumsy. A wrist lock would easily—"

Levi opened Enne's door. "Thank you for coming," he told her, sounding sincere.

Even if there were no reporters to glimpse them yet, the show began right here. Enne flashed her best finishing school smile and took his offered hand to help her out. She stood up on the sidewalk, straightening out the wrinkles of her blush-pink blouse.

"Thanks," she said. Then she reached into her purse and made a show of fiddling with her two tokens, a show of appearing anxious. She looked up at the building with wide eyes.

"If I'm going to do this like you want," she murmured, "I was wondering if you could do me a favor."

Levi narrowed his eyes briefly, then switched his expression to his usual smirk of a smile. "What might that be?"

"Could you sit next to me, during the interview?" she asked. "I'm nervous."

He hesitated. "It's supposed to be a feature on *you*. I'm not sure—"

"I'd just feel more at ease if you were beside me. If I felt like..." She swallowed. "We were in this together."

His face softened. "I'll mention it to Owain."

Enne came very close to feeling sorry. But really, she fumed. Grace had dug up the most feminine outfit from her wardrobe, one with an obscene amount of pastel and lace and frills. She felt like a caricature of herself. *Do I look like a missy enough for your plan?* Enne wanted to ask Levi snidely.

"Congratulations," Enne told him pleasantly. "On the pardon. The whole North Side is in love with you now."

She'd clearly gone too far with her niceties, because a muscle in Levi's jaw twitched, like he knew she was plotting something. "Not all of it," he muttered, averting her gaze and motioning for her to follow him inside.

She did, her heels clicking on the lobby's polished marble tiles. The elevator brought them to the eighth floor, opening to a grand waiting room with crystal on every end table and frames of prizewinning photography on the walls.

A knot twisted in Enne's stomach, and she tensed from her toes to her shoulders. Her very survival could rest on this interview, and the reporter questioning her would be one of her mother's killers.

A man greeted them beside the front desk, a man Enne recognized instantly as Aldrich Owain. His skin did not match the Chancellor's dull gray, probably because of the suspicious line of makeup along his jawline. He was skinny, with little hair

and shrewd, dark eyes, and the brass chain of a pocket watch dangled from the vest of his three-piece suit.

Enne had once tried to kill him, but he didn't know that.

He'd also once tried to kill her, and he definitely remembered that.

"Mr. Glaisyer," he spoke, grasping Levi's hand as though they were old friends. "I'm sure you know the article ran this morning. The portrait looks good, eh?"

Levi beamed, and his slick North Side grin looked far more genuine in this change of scenery. But before he could speak, Enne looped her hands around his arm and cooed, "I thought it looked marvelous."

Owain studied how Enne leaned into Levi with obvious interest, and Enne didn't bother to pull away. Levi's smile went tighter.

"Yes, well…" Levi cleared his throat. "Like I told you before, I'm happy we could arrange this." He slipped his arm out of Enne's grasp and pushed her forward by the small of her back. "Though she needs no introduction, this is Erienne Scordata."

Enne nearly tripped at the sound of her true name spoken so casually.

This time, Owain's gaze drifted to Enne's eyes, rimmed with lavender shadow. "Of course," he said. His palms were damp when he shook Enne's hand, so maybe all the lace and frills hadn't worked the way she'd hoped. "I appreciate you agreeing to this. I imagine it must've taken a lot of convincing."

Enne didn't know what he meant by that, but Levi saved her from having to answer that by cutting in. "I was hoping to suggest something we didn't discuss earlier. Would it be possible for me to sit in on the interview, as well? I know you'd like some photographs, but even if I could sit beside her—"

Owain bellowed out a laugh. "Looking for more limelight, are you? She *is* a pretty thing to sit beside." But he didn't look

at Enne like she was pretty. He looked at her bare neck like he'd like to see a noose around it.

Flushing, Enne was beginning to rethink her decision not to murder this man. She batted her eyelashes. "Actually, I have a bit of stage fright." As though she were not a trained performer.

"I suppose there's no harm. Come on, come on." Owain led them to a studio, where photographers had put together a full set—bright lights, a leather armchair, and a deep purple backdrop. While the assistants went to replace the armchair with a love seat, Levi dragged Enne to the room's corner.

"What are you doing?" Levi whispered.

"Am I doing anything?" she asked innocently.

"Don't do that to me. I know you."

"You told me to play a ditsy seventeen-year-old girl." She gestured to her outfit and twirled. "Don't I look the part?"

Levi pursed his lips, clearly wanting to argue. But before he could, a makeup artist fluttered over their shoulders like a hummingbird, brandishing a compact with brown powder to conceal a blemish on Levi's chin. Enne wondered how a previous version of Levi—the one of barroom cologne and cheap card tricks—would react to see himself now.

Ten minutes later, the pair of them were ushered into the mauve love seat, and Enne made sure to sit a few inches closer to Levi than was strictly professional.

Owain pulled up a stool in front of them, a notepad on his lap.

"Erienne, we've heard—"

"Enne," she told him sweetly. "Please call me Enne."

"Enne," he amended, eyebrows raised. "As you must know, the city is overwhelmed with curiosity about you—where you've come from, who you are. We'd love for you to shed some light on this. To tell us about yourself."

She pressed a hand to her cheek as though to hide her face. "Oh, I'm t-terrible at talking about myself, and this is all a bit

surreal for me. I didn't even know I was wrong about my talents until a few months ago."

"Yes, when you attended the Bellamy Finishing School of Fine Arts, your name was registered as Erienne Salta, wasn't it? Did you ever suspect that you weren't a dancer?"

"I…" Her pearl necklace suddenly felt like it was choking her. She swallowed. "I didn't."

"And so what was it that brought a young lady like yourself across the ocean to the City of Sin?"

"My mother—the person who raised me, that is, not my birth mother—hadn't returned from a vacation here. I simply wanted to make sure she was all right. I found out shortly afterward that she had passed away." Enne's lip trembled a bit, which was not a show, but she made sure to reach for Levi's hand as though seeking his support. If Levi was surprised, he didn't betray it to the cameras. "I've been quite a bit lost since then."

Owain raised his eyebrows. "Is that how you ended up assassinating the Chancellor? You got 'lost'?"

Enne's hope wilted like a flower. She and Grace had practiced for this, but even then, Grace's words had not been so harsh.

"I'm sure you're familiar with how the Augustine talent works, sir," Enne said as meekly as she could manage. "She was a known monarchist, and she ordered me to…" Enne shuddered and squeezed Levi's hand tighter. "I can't bear to think about it, honestly."

"Hmm," Owain said, his lips a thin line. As someone present in the Shadow Game, Owain knew better, but his associates certainly didn't. The makeup artist, hovering behind the cameramen, let out a low, pitying sigh. Maybe Enne's show was working, after all.

"If it were not for Levi, I don't know how I would have gotten through the past few months, fulfilling all of Vianca's orders as Séance, that despicable character she fashioned for me." Enne scooted another few inches closer to Levi.

Levi cast her a sharp look. *What are you doing?* His warning gaze seemed to ask, but Enne ignored him.

"What exactly is your relationship to Mr. Glaisyer?" asked the reporter standing next to Owain, a younger man wearing a dapper burgundy suit and clearly eager for a story.

Enne let out a girlish giggle. "Why, I thought that must have been obvious."

She threw her arms around Levi's shoulders, his yelp of surprise muffled as Enne pressed her lips against his.

It was an awkward kiss—Enne leaning so far across the love seat, the embarrassment or fury or mixture of both making Levi's skin hot to the touch, the blinding bursts of the cameras. But Enne made sure to prolong it, made sure the photographers had their shot for tomorrow's front page. Her hand not already grasped in Levi's played with the corners of his cravat. She felt Levi grunt in displeasure against her mouth, but she kissed that away, too. No matter how much they might've loathed each other, this kiss was going to save them.

Except she didn't loathe him. It had been so long since she'd breathed in the familiar scent of him—like amber and smoke—that she felt desperate for it. Her heart leaped in potent, undeniable want, making her squeeze his necktie a little too desperately, making her interlace his fingers with hers...

Until she realized his touch wasn't simply warm from a flush—it *burned*. He'd used his talent to jolt her off, and she sprung back from the twinge of pain. Ignoring the anger simmering in his gaze, Enne quickly flashed a sheepish grin to the crew at their lovestruck display.

"We're courting!" she announced giddily, as though her life were truly a Sadie Knightley novel. She hoped it was. The protagonists always survived at the end.

"A Mizer and an orb-maker?" Owain responded, aghast. "Surely you see the historical irony in—"

"If you could just smile for the cameras...we could use an-

other shot," the reporter interrupted next to him, motioning for Enne to move closer to Levi. "Maybe put an arm around the lady?"

Levi paused, and for a brief moment, Enne feared he'd spoil her farce, labeling her as the manipulative performer the Republic feared she was. But he must've realized the danger in that because he reluctantly wrapped his arm around Enne's shoulders. The cameras flashed.

"No one is going to believe this," Levi hissed in her ear.

In response, Enne glanced at him, laughed, and wiped some of her pink lipstick off his chin.

"This is going to sell a lot of papers," the young man said gleefully, oblivious to the frustration flushing across Owain's face as he elbowed him in the side. "The board is going to love this, sir."

Enne leaned into Levi's chest and smiled wider. She didn't play much cards, but she believed the phrase was "forcing one's hand."

An hour later, the heart-eyed couple remerged onto the bustling streets of the Financial District. Outside *The Crimes & The Times* office, a street vendor sold bouquets of roses and carnations, and Enne was surprised to find the labels for each color no different from those on the North Side—white for friend, pink for lover, and red for mistress. She supposed the city loved a good romance no matter which side of the Brint you lived on.

"Is there green for liar?" Levi said lowly as they passed the display, finally tearing his hand from Enne's. "Or perhaps purple for traitor?"

"It's a good plan, Levi," Enne said coolly. "And it worked."

"I'm not saying it's not a good plan, but you could've consulted me before we made a spectacle worthy of Sweetie Street."

"Just like you consulted me when you paid off the Scarhands?" she countered. "Besides, it's a good thing I had a plan

of my own. You heard the questions Owain was asking. If he'd gotten what he'd wanted, tomorrow's paper would be printed with my death sentence."

Levi frowned and stared at the rose petals littering the sidewalk, and Enne knew the only reason he didn't have a snarky response was because he knew she was right.

"Besides," Enne murmured, softening her tone, "it's not like we haven't kissed each other before."

"You're right," he said darkly. "And it's not like we haven't betrayed each other, either."

SOPHIA

"We have a lot in common, I think," Harrison Augustine told Sophia as they waited in the restaurant in the Kipling's Hotel. "Our families being what they were."

"I don't want to talk about my family," Sophia grumbled, ignoring the bread basket or the waiter filling her glass with water. She hadn't had much of an appetite lately—either that or she'd eat too much at once and feel bloated and uncomfortable for hours, as though her body had completely forgotten how to take care of itself. If she grabbed the butter knife beside her and plunged it into her hand, she wouldn't be surprised if her blood ran out taffy green.

"Well, I think it's important we get to know each other," Harrison said, and Sophia restrained herself from barking out a laugh. They were hardly friends. "I don't think you know how long we could be waiting."

"Will Delaney and Harvey really take that long?" Sophia asked. Their table was set for four.

"That isn't what I meant, and Harvey isn't coming. I saw him earlier, and I decided he needed space." After murdering Zula Slyk, Harvey probably needed therapy, not space, but Sophia didn't bother voicing this. They were trapped in a game of life and death. None of them were getting what they needed. "What I meant is that this game might not end for months. Years, even."

Years. Sophia couldn't even contemplate her future into next week.

"Three players have already died," she pointed out.

"But it will take five cards to end the game. We still have a long way to go."

"Unless the Bargainer gets bored. I'm sure she could win fast, if she tried." Why she hadn't tried yet, Sophia had no idea.

He raised an eyebrow. "Are you always this grim? You can manipulate your own luck—that must count for something."

She considered snapping at him. *No, I'm not always this grim. But my boyfriend was just murdered, and that's been a damper on my month.* But, thinking better of it, she instead murmured, "I'm not sure all the good deeds in the world could change these odds."

"Remind me not to bring you to parties." Then Harrison's expression softened. "We have something else in common. The people we loved were both murdered by my mother."

"What? Are we supposed to bond over that?" Sophia growled.

"The Families are gone. We're all that's left. It feels like a place to start."

"I'm not your trauma friend. I'm your..." She couldn't say the word, not even to him. "We can start and end at that. As far as I'm concerned, you're exactly like your mother."

He bristled. "That isn't true."

"Then why use your talent at all?" She stared him down,

and he looked away. She wasn't surprised. Those designer suits he bought didn't come with a backbone.

"The same reason you aren't fun at parties," he said softly. "Trust issues."

Delaney and Poppy appeared behind her and took seats at the table. Their hair was wet—they'd come freshly showered from rehearsal, Sophia guessed. She wondered what it was like to have such a pretty, glamorous life outside of the game. She had nothing to do except dwell on it. And sleep. And bicker with Harrison Augustine over a restaurant table, apparently.

The mood changed instantly, as though they'd been dowsed with Brint water. Sophia thought first to blame it on the circumstances—they were meeting because the House of Shadows had failed to provide them any answers about how to kill the Bargainer.

Then she realized it was Poppy, the daughter of Harrison's electoral opponent. The man who, according to Levi's stories the night after St. Morse, Harrison had had killed.

Poppy looked good, far better than Sophia did, after her breakdown last night over a beheaded corpse. She'd brought a notebook, and the ring she'd purchased at the House of Shadows glimmered on her finger as she flipped open its pages. Her eyes were fixed on Harrison.

"'Lo," Harrison said politely, but not warmly. "I wasn't expecting you to join us, Miss Prescott."

"Neither was I," Delaney muttered.

"I'm a player in this game, too," she said haughtily. "Or is there a specific reason why my being here makes you uncomfortable?"

Sophia's heart clenched. Poppy hadn't come here to help them—she'd come to interrogate Harrison about the death of her father. Likely that was the reason Poppy had bought that cursed ring in the first place.

But he answered, "Not at all. I'm merely surprised, but happy to have the extra help."

His words were smooth—not slurred. Why hadn't he been compelled to speak the truth because of the ring? The only jewelry Harrison wore was the emerald Augustine ring on his fourth finger. But he was familiar with the House of Shadows. Perhaps he carried protection in his pockets.

Maybe he did have trust issues. Or maybe he just had a lot to hide.

Poppy's eyes flickered to Sophia's, and Sophia was surprised to realize that she already knew that look. Sophia reached under the table and squeezed Poppy's hand, wondering when she'd begun to care about Poppy so suddenly, so fiercely. But Sophia had come to realize that she was the type of girl who some respected but few liked—like a shot of something bitter and strong. And she'd always clung to those who'd been willing to tolerate the burn.

Poppy collected herself with all the poise of a politician's daughter. She deftly changed the subject. "I brought notes."

She showed them a whole page spread in her notebook. It listed several names of the players in Bryce's game, with a chart filled in with a few known targets. It was cleanly organized and easy to read, though she'd written it all in glittery gel pen.

"It's not complete, but I thought it would be useful," Poppy told them. "From what I understand, even if players were to volunteer their cards to reach a string of five, those players would die at the game's end because they wouldn't be in possession of their target's cards—"

"Exactly," Harrison agreed. "And do you know anyone noble enough to volunteer?"

"Well, I wanted to see if there was a string of five that…" Poppy bit her lip for a moment's pause, then forced out, "Five people who'd we'd be willing to see dead."

Delaney made a strangled noise. "*That's* why you've been making that chart?"

"Don't look at me like that," Poppy shot back. "There are some despicable people in this game."

Her gaze fell on Harrison.

Harrison pursed his lips, as though irritated when he should've felt uncomfortable, or better yet—guilty. "That would be fortunate for us indeed," Harrison said in a low voice. "May I?" He nodded at her notebook, and she slid it to him. He pulled a ballpoint pen from his blazer's pocket and wrote in a few extra names. Then he returned it to her. "Now you have a larger chart. You tell me who you'd be willing to sentence to death."

Poppy straightened and tucked a stray blond hair behind her ear. "Well, Scythe and Ivory—or whatever her real name is—are killers. Bryce is the one who started this game. Zula Slyk, Creighton Holt, and…" she glanced nervously at Sophia "…Jac Mardlin are already dead."

"So I learned when Harvey gave me Zula's card, Zula's target was Sophia," Harrison said, pulling out the Sun and laying it faceup on the table. "So I'm afraid that path is a dead end."

Vianca would've had no qualms sacrificing her omertas, Sophia knew. So maybe that did make Harrison better than his mother, if only marginally. Not that his morals should matter to her.

But they *were* similar, as he'd said. Sophia wondered if she was terrible for missing her family, if she was allowed to miss people who'd committed such heinous crimes. But Harrison still wore his Augustine ring, and he'd destroyed his family's empire just like she had. If he was even a little bit good, then she could be good, too.

"You said Creighton was beheaded," Harrison continued. "That sounds like the work of Scythe. Creighton was probably his target. We could start there, but we don't know Scythe's

card. Process of elimination will only get us so far. And Bryce already has Harvey's card, and like I said, even if Bryce *could* be killed, I'd like to see the four of—" he nodded at Poppy "—the *five* of us safe."

"So even if we did fill in this entire chart," Sophia said, "there's no string of five players that we'd be willing to see dead."

"Then what do we do?" Delaney asked.

"We wait," Harrison answered. "There are nineteen players left. Not everyone has made their first move."

Delaney scowled as she looked out the window to the view of the Financial District. "By 'wait,' you mean wait for people to die who we'd rather not kill ourselves. That's real honorable of us."

Poppy scoffed. "You really expected honor from him?"

Harrison folded his hands neatly across the table and leaned closer to Delaney. "*You're* the one from the House of Shadows. *You're* the one who knows more about shades than any of us. So tell us—what are our other options?"

Delaney swallowed. "I don't have any."

"Then we stick to the original plan. We learn more about the Bargainer's weaknesses. If we have her, we have negotiating power with Bryce." Harrison glanced at Poppy's notebook. This time, he did not ask permission. He flipped to a new page and wrote a new list of names. "These are people I've heard have made deals with the Bargainer. Maybe we can get insight about her weaknesses there. Maybe if we collect enough pieces, we'll be able to discern the whole picture."

The list wasn't a lead—it was a last resort. And the idea of meeting with others like herself didn't sound comforting. Only the most desperate made a deal with the Bargainer, and Sophia felt just as desperate now as she had before. To get her memories back. To keep the players who mattered to her safe.

"Then I guess this is all we have," Delaney said quietly, sounding defeated.

"With my inauguration approaching," Harrison said, averting Poppy's steely gaze, "I won't have a chance to meet for some weeks, but I hope that gives you time to find answers. If they can be found."

"Fine, then." Poppy stood up. "I'm not hungry. Let's just leave." She walked to the exit and motioned for the other girls to follow. Delaney did, but Sophia lingered, only for a moment.

"You have cursed pieces from the House of Shadows, too, don't you?" Sophia asked Harrison.

"Of course," he said coolly. "I keep myself protected."

"Because you had Worner Prescott assassinated?" she said.

He met her stare with an intensity that matched her own. But it was the first time his facade of ease looked anything other than impeccable. "You should be careful when playing with shades. But you already know that, don't you?"

Sophia didn't have enough luck to beat Bryce's game, but she certainly had enough to pick Harrison's pockets. She'd done it before—when they'd first met, when she'd stolen his Lovers card for the sake of impressive theatrics. Without his protection and with Poppy's ring, he would have to speak the truth. She could know if he was good or corrupt once and for all.

But it shouldn't matter to her, she decided. Harrison had already used his omertas, and just because his every other action wasn't despicable didn't mean he could be redeemed.

"Have fun at your inauguration," Sophia said flatly.

She left just as the waiter approached, asking Harrison if he would be dining alone.

ENNE

Enne perched on a bench in the Park District and tried not to dwell on her dream last night, but an embarrassed flush seemed to have permanently stained her neck and cheeks. She shivered, hugging her wool coat closer to herself, but it had nothing to do with the cold.

"'Lo," came a voice behind her, and Enne yelped and whipped around. Levi glowered, but not at her—rather, at the deck of cards in his hands. He shuffled through them, once, twice, several times, as though preparing to deal a game of Tropps rather than take a stroll with her.

Enne peeked over her shoulder for any reporters lurking among the paths and trees. Charlotte had tipped *The Guillory Street Gossip* off earlier that Enne and Levi would be meeting for a "date" in a public park, but thankfully, they had yet to arrive and photograph Levi, acting sullen and looking anywhere but at her.

"This doesn't have to be long," Enne told him.

When he finally did meet her eyes, he glared. "Then we might as well get it over with."

Enne reached into her pocket and clutched her tokens for support. She would *not* apologize for using any means necessary to secure her pardon. Especially when her plan was no more precarious for him than touring parks and sampling cafés.

Enne stood up, her kitten heels sinking into the soft mud of the path, and hooked her arm around Levi's. He silently slipped his cards away and led her through the manicured lawns of brittle winter grass and empty flower beds. Enne should have realized that even the South Side would appear bleak this time of year—Bellamy had been far more temperate.

"We should probably make conversation," Enne said lightly. "It looks rather strange for us not to be talking, don't you think?"

"I wouldn't know. I wasn't given a script for what is and isn't expected when you're pretending to be—what's the absurd word you used? Courting."

"Please keep your voice down," Enne hissed, casting furtive glances over her shoulder. "And would you have even agreed to this plan, had I suggested it beforehand?"

"No, because my feelings about it aside, I don't think it will work."

Enne disagreed. The article *The Crimes & The Times* had printed three days ago was exactly as she'd hoped. It'd painted her as Vianca's blameless doll, and she'd looked as pretty as a doll, too, smiling or kissing in every photograph. Surely Levi, who knew every legend of New Reynes by heart, recognized the power of a good story.

But she didn't want to bicker with him, worsening his mood and only making him hate her more. She might not have consulted him in this plan, but she'd prefer he didn't hate her at all.

"And what are those feelings?" Enne asked delicately.

"That I've been reduced to a prop," Levi snapped. "That

my personal life has been sensationalized for public consumption. That we're supposed to stroll around and smile and make small talk when I'd rather be anywhere in the city than with you right now."

Enne cringed, knowing she deserved every word. But she wouldn't have needed to resort to such measures if Levi had managed to negotiate her pardon, as he'd promised. They'd both failed their original plans. Certainly she could be forgiven for her last resort.

When she thought back to their kiss at *The Crimes & The Times* office, she chided herself for ever hoping that Levi felt any echo of their old feelings for each other in it. The ache of disappointment made her lips wobble slightly, but she would not cry—not here. This was her mess, and she did not deserve to use tears to make him feel worse.

Plus, it would spoil her plans if she cried here.

"Maybe we can talk about something else," Enne offered, her steady voice betraying none of her hurt. "How are the Irons? How is Tock?"

Levi's shoulders relaxed. "The Irons are fine—back to work, with their bounties and the curfew lifted. I haven't seen much of Tock. She keeps to her room."

"So Lola hasn't contacted her?" Enne asked.

"It would seem not, after you almost killed her brother," he answered tightly, and Enne felt another blow of guilt. How could Levi ever resent being here? She'd gifted him such a perfect opportunity to make her feel despicable, and she, too, had no choice but to smile through it.

As if beckoned by her thoughts, a camera flashed behind them, and Enne felt Levi's grip around her arm tighten.

"Make me laugh," Enne whispered.

"What? You can't make yourself laugh?"

After cursing under her breath, Enne forced out a burst of

giggles, leaning her head into Levi's shoulder. She'd nearly pulled it off, too, until the reporter appeared behind them.

"Sorry to interrupt," she said quickly, in the kind of tone that made it clear she wasn't sorry at all, "but our readers would love a few words from you. Levi, were you the one who chose this spot? Very romantic."

Levi knew as much about the parks of the South Side as he did physics or neurosurgery, and it showed when he answered, thickly, "Sure."

"I might have suggested it," Enne cut in hurriedly, grinning and tugging him closer. "But if you don't mind, we're trying to make an appointment at a café…"

"We are?" Levi muttered under his breath.

The reporter frowned but backed away. "My apologies. I wouldn't want to make you late."

Once the reporter was safely out of earshot, Levi leaned down and snarled into Enne's ear, "I was told this was just a walk."

"Sorry—it was just an excuse. I didn't think she'd hover like that."

"Well, now we have to go."

"It's just a coffee." The weather was so blustery that Enne would actually relish a hot drink.

"I only drink coffee when I'm hungover."

Enne rolled her eyes. "You know, I don't know why I picked you for this charade, either. You have all the charm of a rush-hour Mole station."

He scoffed and looked away. "That's not true. I can be very charming."

Enne, unfortunately, knew that he could, which made his pitiful performance of the boyfriend all the more frustrating. But such thoughts made her mind steer back to her dream, of the version of Levi she'd encountered behind so many doors of the hallway last night. *That* version hadn't been half so angry

with her. Truly, the scandalous corners of her subconscious mind embarrassed even her.

"What?" Levi asked, raising his eyebrows, and Enne felt certain he spotted a telltale blush on her cheeks. "No retort?"

Any of Enne's own charm and wit had vanished in her fluster. "It's just that, the better the show we perform, the sooner we might be able to finish this whole ordeal."

At this, they reached the park's edge, where it intersected with Poplar Street. The roads of the South Side were all named after trees or flowers, similar to how those of the North Side had been matched to card games. Enne admired the lacy curtains in all of the apartment windows and the smartly dressed bellhops outside each of the buildings.

To Enne's surprise, Levi must have been motivated by her words because he pulled her into a candy store on the corner, its displays of chocolates and cream puffs far more elegant than any she'd seen in Tiggy's Saltwater Taffy. The air inside smelled devilishly sweet, and Enne watched, transfixed, as the employees stirred vats of simmering chocolate or spun green and orange sugar into candy floss.

"I'm going to look at this," Levi grumbled, snatching a box of chocolates from a nearby shelf, "as an investment in my political future—and my state of mind."

"Oh, you must stop," Enne said flatly. "Or I might swoon."

This earned her a small crack of a smile. He waved the box. "That's what the sugar is for."

The man at the checkout counter, dressed in a candy-striped apron of pink and yellow, widened his eyes as they approached, seeming to recognize them. His hands trembled as he took the box.

He's afraid of us, Enne realized, startled—even over two weeks since Jonas had exposed her identity, she wasn't used to her unmasked face being so instantly recognizable. But she stuck with her plan, forcing a sweet smile and grabbing Levi's hand.

The man's suspicion didn't seem to fade, however. He scribbled down the receipt and thrust both it and the box of chocolates into Levi's hands, and Levi and Enne slinked out of the store.

"As far as investments go," Enne sighed, "that could have gone better."

"There were two street lords who fell in love with each other before, you know," Levi told her. "Inamorata and Iris. They were credited with multiple bank robberies and at least seven deaths. It's why, even if you weren't a Mizer, there's no way this plan will get you your pardon."

Enne knew about Inamorata and Iris, as the Spirits had two cats who were their namesakes, but she mourned that Sadie Knightley had not prepared her for the reality of romances in the City of Sin.

"Well," Enne said, refusing to be put off, "that's just one man. The café will be better."

The café, at first, did seem better. The pair had claimed a private booth in the corner, far from the window and the threat of any gaping passersby. The reporter who'd followed them in the park had been joined by two others, perhaps from *The Kiss & Tell*, and the three of them not-so-subtly found a table facing Enne and Levi's direction. They scratched furiously in their notebooks as Enne took Levi's hand.

"At least these taste good," Levi said, unwrapping one of the chocolates and popping it into his mouth. "But they don't taste worth ten volts."

Enne nodded, distracted by the feeling of his hand in hers. Though the café was far warmer than outside, the flush had never truly left her cheeks.

Then someone approached their table. It wasn't a waiter, but an elderly man wearing an old-fashioned top hat accessorized with a violet ribbon. And—so Enne didn't notice until he reached into his coat—a wooden Creed around his neck.

"Miss," he said, placing some sort of postcard on the table. "I was wondering if you could sign this. It might bless it, so my wife thinks."

Enne furrowed her eyebrows, unsure what he could possibly mean. Then she turned over the card and stared at her photo from the Bellamy Finishing School of Fine Arts. In the picture, she wore the school's uniform of a crisp white blouse and baby blue sweater, and Enne had fashioned her hair into her usual ballerina bun, much the same as she did now.

Except beneath the photo were verses she didn't recognize. Before she could read them closely, Levi grabbed the card from her and thrust it back to the man.

"We're not Faithful," he told him tightly, and Enne realized with shock that it must have been a prayer card. A prayer card of *her*, as though she was some sort of saint.

"But…" The man tried to hand it back to Enne, but she shook her head. Behind him, she noticed the reporters writing even more furiously than they had before. Her heart sank. "But how could you not? It is the way of—"

"We mean no disrespect," Enne murmured, "but please leave."

The man gaped, and for a moment, Enne worried he would cause a scene. Then he stormed away to his table at the other end of the café.

"I'm surprised there's any Faithful in the South Side," Levi said quietly. "But they've been more public than they used to be. Lately Olde Town is busier than I've ever seen it."

"Well, hopefully the reporters print how I want no part of it," Enne said, shuddering. "This day was supposed to be meaningless—just walking in a park. Now it will probably turn into an exposé on my bizarre religious following."

Levi grimaced. "I could've told you that this wouldn't be easy."

"Yes," she snapped. "I'm sure you could have. You would've

told me that this was a huge mistake, then you wouldn't have given me any other option."

"Don't turn this around on me," he said, letting go of her hand. "I don't know how to fix this. I'm just doing what I was told. Showing up at the park. Smiling for the camera."

But Enne didn't believe that. Levi always knew how to put on a show—Enne had seen him work shifts at St. Morse, where he'd earned prestige through sleights of hand and card tricks. The only possible reason he couldn't now was because he wasn't performing for the reporters, holding Enne's hand and smiling when the only words they exchanged were insults. He was performing for *her*. He was pretending every touch and moment meant nothing, when they meant just as much to him as they did to Enne.

Or maybe that was merely wishful thinking. The glare on Levi's face was very convincing.

She could find out for sure, if only to put her hopes to rest once and for all.

"Then kiss me," Enne snapped. "Make the reporters forget about the man and his prayer card. Make the clerk at the candy store look at tomorrow's tabloids and realize whatever he'd been thinking was all in his head."

Levi stiffened. "Right now? Here?"

"Do you have a better idea?" Enne asked, knowing he wouldn't. Offering an idea would make him seem like a willing participant, and he would never give her that satisfaction.

He sighed. "Fine." He drew Enne toward him by the edges of her coat, and Enne tried to count the passing seconds once their lips met.

One.

Two.

But her heart sped up. She felt the eyes of the reporters behind her, heard the click of a camera, and it became hard to focus on the kiss even if she wanted to.

Four?

One of Levi's hands found her waist, but she couldn't guess if the move was calculated or thoughtless. She rested her hand on his right knee, where it would still be in frame.

Seven?

With his other hand, his fingers ran through Enne's hair, pushing the falling pieces back. But that couldn't have been thoughtless—he'd exposed more of her face to the camera.

Nine?

Finally, he pulled away, his expression unreadable, and Enne was left with no better knowledge of his feelings than earlier.

"Charmed now?" he asked softly, and Enne would've scowled if not for the audience.

She said nothing, feeling terribly foolish, and she unwrapped a chocolate just to have anything to claim her attention other than him. Levi might've hoodwinked the reporters, but Enne knew him better, and so now she had her answer—that kiss had meant nothing to him. And the biggest fool was herself for ever imagining otherwise.

IX

THE STAR

"Before her death, Havoc's final request
was to sign her own tombstone."

Nostalgia. "Havoc Apprehended."
Her Forgotten Histories
15 Jul YOR 8

SOPHIA

Delaney owned a powder blue car.

"Well, get in," she told Sophia as she climbed into the driver's seat. It had been over a month since they'd last seen each other, and though Sophia had little to fill her time except for naps, Poppy and Delaney had kept putting off their meeting to rehearse for their upcoming show. Only with Harrison's inauguration tomorrow, they could no longer procrastinate.

"Neither of you own anything less conspicuous?" Sophia asked, eyeing the car nervously and chewing on a wad of taffy.

Poppy was reapplying her blush in the side view mirror. "Oh, if anyone is going to stick out on the South Side, it's you."

Sophia glanced down at her tall scarlet boots and licked her matching lipstick. She smirked. "This is my day outfit."

"You look like you floss your teeth with the souls of men," Poppy told her. "I mean, you look great. But I'm not sure the problem is my girlfriend's car."

Delaney flushed at the word *girlfriend*, though Sophia hadn't

realized they were anything else. "Is calling me that how you try to make me forgive you for crashing our meeting with Harrison?" Delaney asked Poppy.

She grinned slyly. "It could be."

Sophia rolled her eyes. She liked the two girls, especially Poppy, but she didn't fancy the idea of spending the day tagging along with their off-and-on bickering and flirting. She could be sleeping. And all the fresh air was giving her a headache.

"Maybe it would be better if we split the list," Sophia suggested. The list of names Harrison had given them was long, anyway. Sophia hadn't realized so many others in New Reynes had made a deal with the Bargainer. "You both can take the South Side. I'll take the North Side."

"Delaney will dump me back at home if you don't come along," Poppy told her. "So you've been vetoed. You're coming."

Sophia reluctantly slid into the beige leather backseat.

"I wouldn't dump you back at home," Delaney teased. "I'd dump you back at the theater. You butchered the choreography. The papers will start talking."

"About how I'm grieving the death of my father? They might." When Delaney winced, Poppy added, "This is why you should let me come. I need a distraction."

It was one of those jokes that Sophia expected was true, and that didn't make it funny—it made it depressing. Still, Sophia laughed, anyway. Her voice sounded raucous and hollow.

As Delaney started the engine, Poppy twisted around and told Sophia, "The gossip columns still think we're rivals."

"We *are* still rivals," Delaney said, her grin returning.

"If you say so." Poppy leaned over and kissed her on the cheek.

Sophia crossed her arms in the backseat, fixing her gaze out of the putrid happiness in the car. Even in the winter, the South Side was a smear of pastels, like flowers petals crushed

on parchment. It was nothing like where she'd met the Bar-
gainer, a dirt crossroads in the sort of town that had three tav-
erns but not a post office, a thousand miles from New Reynes.
It almost made Sophia forget what they were doing. The dirty
laundry around here was designer dresses and imported silk.

They parked in a garage in the Financial District. The sky-
scrapers reminded Sophia of dominoes, white stone like every
building in the City of Sin, squeezed next to each other as
though one tip was all it would take for them to fall.

Inside one such skyscraper, Delaney asked the reception desk
for a man named Samuel Travis. The attendant looked the three
girls over and furrowed his eyebrows.

"Mr. Travis prefers that you don't call on him at work," he
told them gruffly, his eyes falling mostly on Sophia's boots.
"His wife—"

Delaney turned pinker than a glass of rosé, and Sophia let
out a strangled laugh.

"Tell him Poppy Prescott is here," Poppy said, flashing the
man a polite smile.

His eyes widened. "Oh, my mistake. My apologies, Miss
Prescott. I'll ring him now." He scampered away so fast he
nearly tripped over his own oxfords.

"I can't *believe* he thought we were call girls," Delaney grum-
bled. She tucked a loose strand of hair back into her coifed
ponytail.

"I told you that you'd stick out, Sophia," Poppy said.

"Oh right, let me just pull out the spare white lace outfit I
keep in my purse," Sophia muttered sarcastically, trying not
to feel self-conscious. She always fit in on the North Side. But
maybe that was because she still dressed like a Torren.

A few minutes later, a man emerged from the elevators,
wearing a light gray three-piece suit and berry-colored loaf-
ers. He stared at Poppy in confusion.

"Miss Prescott? My deepest condolences. But I'm...surprised to see you here. I don't believe we've ever met."

"We have some questions for you about the Bargainer," Poppy told him, sparing him no pleasantries, which Sophia admired her for.

His already pale skin turned alabaster. "I—I don't know what you're—"

"Just come with us," Sophia told him darkly. "It's just questions."

It turned out that Sophia's call girl clothes doubled as a threat, because he took one look at her and nodded stiffly. They relocated to a café, and thanks to Poppy's ring, he told them everything.

"I was on a business trip," he explained. "I thought...I thought I was about to be fired. My wife and I weren't doing well. She would've left me. At least, I was sure of it." He stumbled over his words, his fingers trembling around the steaming cup of coffee in his hands. "I bargained for a promotion. She took my blood talent—I'm a counter."

"How do you get by at your job without it?" Delaney asked.

"Well, once you get promoted enough, you don't do the grunt work like you used to. I can still..." He swallowed. "It's just numbers. It's just a job. But I used to see the world in numbers. They made sense to me. They grounded me. It's hard not to look in the mirror and ask myself who I am now. I'm not good at anything. I'm still married, though. I guess that...I guess that counts for something."

A realization made Sophia's stomach turn as she looked at him.

He's not like me, she thought. Sophia had been desperate, sure, but she'd sought to destroy when this man had wanted to heal.

It was the same with the next contact, a fortune-teller who catered to wealthy older women in the Park District. Her daughter had been sick. She'd bargained away a kidney.

Another woman, trying to find an old love she'd lost touch with during the Revolution. She'd given up the memory of her friend to learn that her lover was dead.

There was a pattern to what the Bargainer wanted: talents, memories, and body parts. By the time night had fallen, when Delaney suggested moving on to the North Side, Sophia felt sick. She lay down in the back of the car, breathing deeply and clutching her dice.

"Are you all right?" Poppy asked. "Should we pause for something to eat?"

"Just take me home," Sophia told them numbly.

The day's conversations replayed in a reel in her mind. In their own ways, all the contacts had shared the same story: fear. They'd been so terrified of losing something or someone that they'd sacrificed something else.

Sophia was different. Sophia had *wanted*. And maybe that meant she didn't deserve to get her split talent back. Maybe she deserved to be broken.

Unfortunately, the girls didn't take her home. They took her to a glamorous cocktail lounge in the South Side's Park District, one supposedly haunted by the gossipy paparazzi from *The Kiss & Tell*.

"I want to be seen out and about," Poppy explained. "I want everyone to think I'm fine."

"But you're not fine," Sophia said matter-of-factly, making Poppy shoot her an annoyed glance. Sophia hadn't meant to be rude, but the performance of it all seemed a waste to her. And she just wanted to sleep.

"Then they can see me and Delaney together," Poppy said. "It'll be good for our show. We're co-starring opposite each other, you know."

Poppy and Delaney's luxurious world of fame was alien to Sophia. In the North Side, celebrity was obtained through fear, not adoration. And as she'd suspected, stepping into the ritzy

lounge as Poppy dragged her through the revolving door, she once again stuck out like a bloodstain on white linen.

Like a Torren.

She liked her clothes—she always had. But maybe she was performing, too. For all the sleeping she'd done, it wasn't the rest she craved. It was the moment of waking, that blissful haze when the past few months hadn't happened.

Sometimes, it was that Jac was still alive. That he was lying beside her, fine.

Others, it was that she'd never met Jac. That she'd never burned Luckluster Casino. That Sophia, who was missing an essential piece of herself, still had a family to define her. To make her almost whole.

She clung to those moments every time she dressed. The boots and the lipstick made her feel like the girl she'd always been, but now it all felt useless. What did it matter? She was no one anymore.

At least Poppy got her wish. No sooner were they seated in a corner booth did Sophia jolt from the flash of a nearby camera. Poppy and Delaney expertly ignored it and ordered lemonades— Poppy wasn't in the mood to drink, and Delaney didn't like the taste of liquor. The server didn't ask Sophia her order and merely brought out the same.

"What I don't understand is the body parts," Poppy whispered. "What could the Bargainer want with them? I feel nauseous just thinking about it."

"She must be sick," Delaney said. "Just like Rebecca is sick."

"What do you mean?" asked Sophia.

"As a shade-maker, you're not supposed to cast shades on yourself. Like how an orb-maker transfers volts into glass rather than putting them straight into their skin. Shade-making and orb-making aren't regular talents. They'll keep changing the energy. They'll corrupt it. It's why you have to first use metal or glass," Delaney explained. "It's how Rebecca got sick. And

the Bargainer keeps the talents and whatever anyone gives up for herself. She has to be casting the shades directly on herself. I…I probably should have considered it before."

"So the Bargainer is dying, too?" Sophia asked.

"She might not be *dying*," Delaney answered. "There are talents for healing. She clearly has one, judging from what that woman told us about her sick daughter. I can't imagine the talent would cure her, though. It would just constantly heal her."

"If that's true," Sophia said, "then Bryce must've realized it. And if the Bargainer can't even cure herself, how can she cure Rebecca?"

"Oh, I'm sure she still can," replied Delaney. "Some powers don't work well on yourself. It doesn't mean Bryce won't get what he wants."

"We were supposed to find a way to kill her," Poppy said grimly. "Just because she's sick doesn't mean she *will* die. Or even *can* die. We still don't know."

"I guess not, but we did learn something," Delaney pointed out. "The Bargainer casts the shades on herself, which means, if she does die, those shades will be broken."

"You mean, if she dies, I could get my split talent and memories back?" Sophia asked, sitting up. She'd always thought she'd need to make another bargain for them.

"You might. It's definitely possible."

The thought filled Sophia with hope, and she hated herself for it. What about the woman who had bargained for her daughter's health? What would happen to her?

My happy ending is someone else's tragedy, Sophia thought numbly.

It was dangerous to think this way, her father had once told her. A conscience was the enemy of a Torren. Guilt could twist her luck, and Sophia had always been the soft one of her siblings. The weak one. It was why Jac had killed Charles, and not her.

Every wrong she did would return to her. And killing the Bargainer? The Bargainer had touched so many lives, for better and for worse. Sophia would help some people—she'd give the financier his talent back, others their health back. But she'd be damning people, too. The suffering would outweigh the good, both in the world and in her own heart.

If your luck falls too low, you'll die, her father warned. Even his voice in her mind sounded distant—she remembered him so little. *I've seen it happen. It's why I've raised you the way I have. You have to be stronger than that. Because if it happens, the only person you'll have to blame is yourself.*

The server returned with their trio of lemonades, dragging Sophia away from her morbid thoughts.

"Can I ask you something?" Poppy asked Sophia. Sophia's gaze flickered to Poppy's hands, and she was surprised to find Poppy had removed her cursed ring.

"I guess," Sophia said, sipping the sweet drink.

"Why did you give your split talent to the Bargainer?"

Sophia nearly choked. The question shouldn't have surprised her, but it still felt strange for others to know the secret that she'd kept so close for years. She hadn't told anyone until Jac.

"My family were monsters," Sophia explained, picking at her already chipped red nail polish. "I knew I needed an advantage in order to end their business, once and for all. And so I asked the Bargainer for them to stop recognizing me. For them to look at me and see a face different from my own." Sophia still couldn't bring herself to look at the girls. Her cheeks burned. And after a moment's silence, she blurted, "I don't regret it. It worked. But I'd still like my split talent and memories back."

Poppy rested her hand on hers. "I think what you did was brave."

Sophia had never thought of herself as brave. She'd thought of herself as burdened. "I knew the evils they'd done better than anyone. That made them my responsibility."

There was another flash of a camera, and Sophia tried to imagine what the headline would claim tomorrow. If the two ballerinas wanted press, they should've come here alone, otherwise they looked like they'd dragged along a corrupting influence. Based on the most recent headlines of the past few weeks, featuring photographs of Enne and Levi every time they touched shoulders or held hands or kissed, Sophia knew the gossip columns would happily run such a story.

Poppy turned to Delaney. "And you. Why did you make a deal with Harrison?"

Sophia liked Poppy, and she was pretty sure Poppy liked her, too. But it was obvious what Poppy was doing. She hadn't been interested in Sophia's truth; she'd only wanted Delaney's.

Rather than snapping, like she had many times before, Delaney only sighed. "Does it matter?"

"Why you agreed to do the bidding of the man who had my father killed? Yes, it does matter to me," Poppy told her fiercely.

Delaney winced. "I hadn't known then that he..." She swallowed. "As you know, I'm a split shade-maker, but my blood talent is dancing—from my mother. Most of the malisons and shade-makers of the city live in the House of Shadows. It's where they hid before the Revolution, and it's where they upkeep the shades of the city now. But my mom had no intention of raising me there. And so they cast a shade on me as a baby, so I would be forced to return once a week. So they could watch me. It was the same for Rebecca, a distant cousin of mine."

Sophia had never disliked Delaney, but she'd never understood her, either. Delaney's pastel everything, her too-tight ponytail, her unwavering confidence. She and Sophia were clearly different sorts of people. But now Sophia could see through Delaney's pristine facade. Especially for someone who grew up in the spotlight, her perfection was a veil to hide her secrets beneath. If Delaney looked as though she had every aspect of

her life together, no one would look too closely for the loose threads—especially dangerous ones.

"Bryce probably helped Rebecca remove her shade," Delaney said. "And after the near collapse of the Shadow Game when Levi and Séance escaped it, I no longer wanted to be tied to the House of Shadows. So I asked Harrison to negotiate for mine to be lifted."

Poor Delaney, Sophia thought miserably. Even from knowing Poppy barely a week, Sophia could tell from the girl's heart-eyed expression that all would be forgiven. And after their lemonade date was over, they would make up for whatever previous falling-out they'd had, more in love than ever. Friends shouldn't get irritated by other friends' happiness, but still, Sophia was. She was irritated sick.

And so, while the girls whispered among themselves, their fingers interlaced and heads bent close together, Sophia turned away and rolled her dice along the velvet cushions of the booth.

Snake eyes. A lucky roll, in most games. But not for her.

Killing the Bargainer could kill me, she realized.

Sophia wished acutely that she hadn't joined the girls for this outing—not just to the cocktail lounge, but the entire day. It would've been better if she'd never known about the mother who'd saved her daughter, about all the people they'd hurt if they managed to end the Bargainer's life. In this case, ignorance was the key to a clean conscience.

Because she couldn't simply back down. Harrison wouldn't let her.

Maybe Sophia could explain to him. Maybe they really were alike, and he was a good man, after all.

But Sophia had not known many good men in her life. The one she had, she only kept now for moments at a time. And then he was gone.

LEVI

Levi parked his Amberlite in front of Madame Fausting's, where a row of girls peered at him through the smears of dirt on the windows. Levi had only visited for the first time six weeks prior, and with the Scarhands long since cleared out, paid, and back to their squalors in Scrap Market, the Spirits watched Levi as though they had never encountered a boy before.

Levi knocked on the door, feeling awkwardly on display in his rented South Side tuxedo, its lapel embossed with a brocade of silver geometric designs. He loosened his necktie.

Grace cracked open the door, and a tabby cat attempted to squeeze his head through the opening. Grace cursed and moved it away.

"Come in, hurry up," she snapped at him, and Levi shimmied himself inside, nearly tripping over the three other cats huddled by the entrance. No sooner did he collect his balance than Grace slapped a newspaper into his chest. "It's been a month of this. You need to do better to earn Enne her pardon."

Levi looked at the photo of himself and Enne three nights ago at a glamorous restaurant in the Casino District. Though they clasped hands across the table, their expressions were downcast, which made sense, as they rarely spoke a single word to each other on their staged outings.

But even so, the headline read "The North Side's Favorite Couple Samples Ritzy New Restaurant." Their performances hadn't been as miserable as Grace made them seem. In fact, as much as Levi hated Enne's plan, he'd call it a success. She didn't have her pardon yet, but she hadn't been arrested yet, either.

"Are you our publicist now?" he asked Grace coolly.

"Clearly someone needs to be, otherwise you'll be doing this forever," she responded, and Levi—bitter or not—respected her sentiment. He had his casino's construction to manage. He didn't have time to keep up this charade.

Then Grace gestured to the gown she wore, made of a green taffeta so dark it looked black. "I'm even dragging the white-boot with me tonight. You know, so it looks official."

"Right," Roy said, smirking behind her. On the corner of his mouth, Levi spotted a smudge of dark lipstick in a shade that matched Grace's.

"I wanted to be the publicist," whined one of the Spirits watching from the window. Levi didn't know the names of all of Enne's associates, but based on the copy of *The Kiss & Tell* she carried and Enne's descriptions, he guessed this was Charlotte. "Did you even bring a corsage?" she asked Levi.

"It's an inauguration, not a debutante ball," Levi answered flatly.

Charlotte stomped her foot. "Oh, you're no *fun.*"

Levi failed to see the fun in their performance. When he'd told Enne that he struggled to see them together after what happened to Jac, he'd meant it. But now they were carrying on in every establishment of the North and South Sides, kissing whenever they glimpsed the flash of a camera, buying one an-

other boxes of Tiggy's Taffy or jewelry or flowers to flaunt how much they adored one another. Levi had regifted most of those presents to the Irons, and he'd stopped reading newspapers.

"Oh good, we match," Enne said, emerging at the top of the stairs. "That's convenient."

Enne's dress was loose-fit and modern, its lavender satin material draping over her like a slip of lingerie. It jangled with beads, embroidered in ornate geometric designs that complemented Levi's choice of tux. She'd worn her hair down, which she rarely did, curled in neat, precise cascades that caught the light like ocean waves.

"What?" Enne asked him once she reached the ground level. She grabbed her coat from the rack behind him.

Levi realized he'd been staring. He loosened his necktie again. "We should leave," he said gruffly. "We don't want to be late."

It was worse in the car, when Levi should've been distracted by the road. Enne's violet aura wafted through the small space, clinging to her bare shoulders. Even though all their recent kisses tasted sour, the scent of her aura reminded him of more pleasant flavors, like espresso sweetened with cream, and he suddenly found himself craving a drink.

It's just the dreams, he told himself, because he'd dreamed of her every night, even when he fell asleep hating her. He dreamed of her in every salacious, scandalous way, as though his own subconscious was betraying him, contorting his heart in whichever way could be both a pleasure and a pain. Levi shook his head and focused on reaching their destination.

They had purposefully avoided the official inauguration ceremony. No matter how harmless their charade seemed, neither Levi nor Enne wanted to hover behind Harrison and other elected officials being sworn into office with their hands resting over the Republic's constitution, like the ghosts of the regime before them.

The ball afterward took place at Kipling's Hotel, and Levi

drummed his fingers against the dashboard as they waited in a line of traffic outside its revolving front doors.

"You smell weird," Grace said to Roy in the backseat. "Are you wearing cologne?"

"Is that a problem?" he asked her.

"No, it smells g—" Grace seemed to catch herself, as though she'd spoken something wrong. "Actually, maybe it's better that we pretend we don't know each other tonight. I'll be an unrepentant criminal. You can be a..."

"A whiteboot?" Roy finished for her, smirking. "You know, I'm not sure it's fun if the roles we play are who we *really*—"

Grace slapped him hard on the arm, and he winced.

"It's just us, you know," Enne said, sounding bored. "You two don't have to pretend like you're not together. I don't know why you do that, anyway."

"She thinks I'm too upstanding," Roy told them, rolling his eyes. "That I'll ruin her reputation."

Grace crossed her arms. "Maybe you should try pickpocketing someone tonight. Or, I don't know, jaywalking—"

"But that's illegal," Roy replied, aghast.

"All things considered," Levi said flatly, "they're better at pretending than we are."

He hadn't meant to sober the mood in the car, but the others fell silent. Enne, in particular, fixed her gaze out the passenger window. He wondered if he'd hurt her, but he felt more frustration than guilt. After being dubbed the "North Side's favorite couple," he couldn't begrudge Enne the success of her plan, but this was exactly why he didn't like it. Because they weren't supposed to care, but now he couldn't stop thinking about kissing her in that dress.

Ten minutes later, a valet approached their car, and the show began.

Levi opened the passenger door and took Enne's gloved hand.

She waved at the tabloid reporters behind the roped barrier, linking her arm around his.

When Levi didn't wave as well, Enne hissed, "Remember, the Chancellor will be here tonight. This performance is our most important one."

The word *performance* summoned more fury in him than it should've. He pulled her tighter toward him and gave the reporters a polite wave, trying to determine who he was angrier with: Enne, for staging a relationship after he'd made it clear he didn't want one; or himself, for letting old memories sweeten the taste of new, bitter ones.

They entered through the lobby, and Levi cringed as he took in the decor. During the Revolution, a famous noble had been stabbed to death in his bathtub on the top floor, earning the combined hotel and department store a morbid reputation. They capitalized on that in their design, each of their centerpieces crimson, a red carpet trailing down the stairs like a dripping pool of blood.

The formality of the affair reminded Levi of the last party he'd attended: St. Morse.

"Certainly they could have chosen a different venue," Enne said grimly, mirroring his own thoughts.

While they waited in line for the coat check, Grace pulled the four of them in a huddle. "Remember," she said, keeping her voice low. "Several dances. At least one kiss. And hold your piss if you must—you're both to stay glued to one another all night. I want it to look like you can't get enough of each other."

"But what if—" Levi started.

"No buts. Just pretend to be happy."

After they'd checked their coats, Enne and Levi entered the ballroom, decorated elaborately in the colors of the Republic's flag. Though the guests numbered far fewer than the event at St. Morse, Levi recognized many faces as the same. Perhaps those not in attendance had been, like Levi, uneager to attend

another party so soon. Even with whiteboots stationed along the walls, prepared on the off chance Bryce Balfour decided to make an encore, Levi felt similarly in these crowds as he had after the meeting with the Chancellor.

It will only take one mistake, his father's voice warned, *and they will change their minds about your pardon.*

Levi had to believe that wasn't true. He'd ended the state of emergency in the North Side. He'd legitimized the Irons when he'd bought the casino. But he couldn't shake the urge, ever-present in the darkest corners of his mind, to run.

Arm in arm, he and Enne headed toward the bar and tables of set hors d'oeuvres and desserts. Enne arranged a plate of cookies while Levi ordered them drinks: a Snake Eyes for him, and a Hotsy Totsy for her.

"No Gambler's Ruin?" Enne asked him. "I thought that was your drink of choice."

"It's a drink for winning streaks, and I have felt far from lucky lately," he answered darkly. "Besides, I don't really intend to drink. I need all my wits about me."

"I don't know. I wouldn't mind something to relax." She nodded over Levi's shoulder, and he turned to spot Chancellor Fenice in a circle of politicians, many of whom donned their signature powdered wigs even outside of the Senate chambers. They hovered at the edge of the dance floor, and after a moment of staring, Levi watched their gazes turn to them.

Enne grabbed Levi's hand. He didn't know if it was for support or part of the show.

Before he could decide which he'd like it to be, Enne stood on her tiptoes and kissed him on the cheek, and he scowled and whipped toward her.

"Can't you...I don't know...warn me?" he snapped.

"Levi," Enne said sharply.

"No, I'm tired of feeling like a prop. It's been a month. If the City of Sin isn't going to pardon you after me buying you

chocolate, or a paddleboat on the Brint, or a five-course dinner, then they're not going to—"

"*Levi,*" Enne repeated, and someone cleared their throat behind him.

When he turned, the Chancellor stood directly in front of him. She smiled coldly, and Levi instantly sobered. "Mr. Glaisyer, Miss Scordata. Trouble in paradise?" Her gaze focused on Enne. "So nice of you to actually join us this time. I must say, it gives a much better impression."

"You'll forgive me if I'm wary of your invitations," Enne said tightly.

"So you left your beau to face the potential danger of my meeting alone, while he expected you to join him?" Fenice shook her head. "Your act is completely transparent."

The bartender handed Levi their drinks, and despite his earlier words, Levi couldn't resist the urge to take a long, desperate gulp.

"I have no idea what you're insinuating," Enne said lightly, snaking her hand around his waist. Levi forced himself to smile. "We've never been happier."

"So you've also been completely disregarding the game that Bryce created?" Fenice's eyes roamed over the crowd in the room, as though the Devil lurked amid the glints of diamonds and silken waistcoats.

"Not disregarding. We're just..." Enne squeezed Levi tighter and smiled. "Distracted."

Before the Chancellor could respond, Enne tugged on Levi's side.

"If you'll excuse us," Enne said, "we only came here to dance." Then she steered Levi to the opposite end of the ballroom, nearly making him spill the drinks he carried on the guests they passed.

"What was that, Levi?" Enne demanded, snatching her

Hotsy Totsy out of his hands. "I know you're angry with me, but you can't do that. Not here."

"I didn't know Fenice was right behind us," he grumbled.

The couple beside them brushed against Levi's shoulder, making him tense. He didn't like standing among such heavy crowds, surrounded by strangers who might *not* consider them their favorite North Side couple. Who might wish them harm, wish them dead. He'd learned from Enne that a person could conceal a number of weapons beneath their skirt.

"It doesn't matter if there was no one behind us. I know *you* already have your pardon, but I don't." Enne downed her Hotsy Totsy in one gulp. "Maybe I should've known better than to ask a favor from you when you have nothing to gain from it."

"Funny," he said coolly, "I don't recall you asking."

"Is that what I need to do? Should I get down on my knees and beg? Please, pretend you actually care about me so that the city doesn't decide to execute me?"

Her words—a little too loud, even in chatter and music of the ballroom—made Levi grab her by the wrist and wrench her down a nearby hallway to the kitchens. They ducked into the closest pantry, where they could speak freely without the threat of eavesdroppers.

Enne set her empty glass on a shelf beside jars of breakfast preserves, then propped her hands on her hips. "Oh perfect, now we can spend the whole party in here, and no reporter will see us," she snapped.

"We'll go back out," he said. "Just give me a moment of space."

He needed to untangle his thoughts, which would be easier to do without her here. One kiss, Grace had instructed, but Levi did not feel ready for it. Not with the crowds. Not with Enne looking like that. Not with less than two months passed since Enne had drilled two bullets into his best friend.

"We've barely been here for fifteen minutes," Enne shot back.

"I asked you for space, real space, after what happened," Levi said, his voice rising. "And so let me have this one mucking minute. And then I'll go back out there and play doting boy-friend again."

"What part of that performance was doting boyfriend?" Enne shook her head in exasperation, making her carefully pinned curls slide from their barrettes. "All I'm asking is for you to reciprocate. For you to act for one second like you don't hate the thought of touching me."

Levi didn't hate the thought of touching her—far from it. The threat of one kiss was that he wasn't sure he could only kiss her once.

"You want me to reciprocate?" he growled, taking a step closer to her.

"You're the Iron Lord, aren't you? The master of shows," she said as though goading him with a dare. "Maybe I should have asked Grace or Roy to gallivant with me across New Reynes."

"Maybe you should have," he bit out.

"Because they actually care about me?"

"Because they aren't in love with you!" he shouted.

Enne opened her mouth to say something, but it only hung agape. She watched him deliriously, and Levi realized he'd spoken in present tense.

"Muck," he cursed, then he strode toward her and kissed her so fiercely even the scandalous tabloid reporters would hesitate to snap their cameras. He wound his fingers through her hair, cradling her head with one hand and waist with the other, pulling her toward him. The espresso flavor of her aura left traces on her lips, and after all evening craving the taste of her, he finally let himself drink deeply.

At first, Enne gasped, then she drew him closer, pressing against him so tightly he barely had the space to breathe. So long as he did not stop kissing her, he didn't think he needed to.

"Tell me when it's enough," he murmured.

When she didn't respond, didn't let go, he steered her by her hips against the pantry's back wall. Levi had not forgotten who he was. He knew how to put on a show, but this was not that. And with every new touch—his mouth against her neck, his fingers tracing her hem up her thigh, the straps of her dress slipping until the lace of her camisole was exposed—he wanted to prove to her that when it came to what he felt for her, every performance would fall short.

"Tell me when you're satisfied."

Enne said nothing, which was good, because Levi wasn't, either. He wouldn't be until he purged the taste of cheap taffy and chocolate from his lips. He wouldn't be until she gasped his name, with no one to hear it but him.

A bright light flashed, making Enne freeze in shock beneath him. Levi sprung off of her and whipped around, facing a small flock of reporters. His mouth went dry. Had they followed them here?

Another flash. Levi squinted, dizzy, and wrapped his arm around Enne to shield her from the people crowding into the cramped space. Enne stumbled as she wrenched down her dress.

"Don't— We didn't— Move out of our way," Levi grunted at the paparazzi, his throat tight each time another stranger bumped into him. He regretted ever coming to this mucking ball.

Once they'd freed themselves, they staggered back into the ballroom to Grace and Roy, who slow danced to a jazzy ballad, not bickering for once.

"I'm done. We're leaving," Levi growled, pushing past them to the exit.

Enne hurried to keep up, her cheeks still flushed scarlet. "Did you hint to those reporters to follow us?" she asked.

Levi nearly choked. How could she possibly think that? He hadn't been pretending at all.

Had she?

Hating himself for his own thickheadedness, Levi fumbled in his pocket for an orb and thrust it into Enne's hand. "For a cab," he snarled, as though this had really been a cheap date. And then he fled without a goodbye.

X

THE HIGH PRIESTESS

"Regardless of what this city claims,
not everything is worth the gamble."

Royalist. "The Empires of Vianca Augustine
and Garth Torren."
The Journey of Reynes
19 Nov YOR 21

LOLA

"Are you sure this girl is the same as the one you told me about?" Arabella asked, smirking and peering over Lola's shoulder at her copy of *The Crimes & The Times*. A photograph of Enne and Levi at Harrison Augustine's inauguration dominated the front page, and they were not depicted congratulating the new representative. Lola scowled and slammed the paper down, the image seeming to burn itself permanently into her vision. "All she does is go to cafés and parties with this orb-maker."

"Their relationship is a farce," Lola snapped. "Last I saw them, they were barely speaking."

"I'm not sure *this*—" Arabella tapped the photograph "—counts as speaking."

Lola ignored her and sipped her coffee, and the kitchen table wobbled as she lifted her mug. Arabella had found this Factory District apartment several weeks ago, and Lola hadn't yet grown accustomed to its smells and its racket. The radiators clacked and clattered day and night. The cigarette smoke from

the tenants downstairs seeped from their floorboards. The walls rumbled each time the Mole passed outside their windows. She never got any sleep.

Arabella slid into the chair across from Lola, her eyebrows raised. "Did you lie to me?"

"What?" Lola asked, confused.

"In November, when we went to the Sauterelle and I asked you about Enne. Did you lie to me?" Arabella's voice was cool, not accusing, but shivers still shot up Lola's spine. "Because you assured me that Enne wasn't a danger, but..." Arabella cocked her head to the side. "Were you in love with her?"

"What? Muck, no," Lola said. Lola didn't even believe in such things. And even when it came to attraction, girls like Enne weren't her type.

"Then explain to me why you do this every morning. You just sit here and glare at your newspapers. You glare at *Enne* in the newspapers."

Lola grimaced. She made her sound pathetic.

"It's just that I haven't seen her in over a month, but I *see* her everywhere," Lola answered. "Whenever the paperboy waves the newest editions of *The Crimes & The Times*. Every time I run to the corner store and there's the stacks of *The Kiss & Tell* resting on the checkout counter. It's exhausting. She's convinced the whole world that all she cares about are roses and chocolates. And all I can think when I look at them is that she was once managing hundreds of thousands of illegal volts in the North Side. How she's killed people! That she's Veil's daughter."

And more, how Enne had hurt *her*. Even if Lola's wound had healed, her hearing would never be the same. She still counted herself lucky that Justin was even alive.

Arabella's expression grew solemn. "I recall you *wanting* to know about her father. Do you wish I hadn't told you?"

"No," Lola grumbled, "but I'm starting to think I need to tell Enne."

It was unfair to keep the truth of Enne's father hidden from her, but the idea of facing her old friend made Lola's insides curdle.

"Then why don't you?" Arabella asked. "You can do with the information what you'd like. Veil's shade has no effect on you."

"I would rather not see her, is all," Lola grunted, staring nonetheless at the newspaper.

Arabella snapped her fingers in front of Lola's face, forcing Lola to look at her. "I know what you're doing to yourself. She hurt you, and you're letting your wounds fester."

Lola's face heated as though beneath a spotlight. "She nearly killed my brother."

"And your brother left you," Arabella droned. "I know your stories. But for all you care about him, you can't even look at Justin now. You're angrier at him than you were a month ago. You let it build up. Just like you have with Enne."

At that, music carried in from the next room, loud and wailing. Justin played his flute in his bedroom at all hours of the day, and for someone with a musical blood talent, he knew exactly how to make his melodies sound cacophonous. The haunting minor notes and mismatched harmonies grated on Lola's one ear, and she cursed, knowing he only did it to annoy her.

But she never stormed into his room to stop him. She couldn't face him, either. It wasn't like he considered her his sister, anyway.

Arabella watched Lola expectantly, waiting for her to respond. But Lola never had the words when it came to herself. She preferred to be the one doing the listening or the consoling, like during her conversations with Jac. Jac had been battling his inner demons, but if he'd ever looked closely at Lola, he would've realized she was battling the whole world, all the time.

When Lola said nothing, Arabella snapped, "You know, I've really thought about what you said—that I am a monster. I think about it all the time."

Lola's throat seized up. Because she knew where this conversation was headed. Arabella was going to leave her, just like everyone had. And Lola didn't have anyone else.

"I was too harsh," Lola said quickly. "The Mizers were terrible, and they hurt you and the malisons more than anyone. And you've never been anything but kind to me."

Arabella frowned. "Now you *are* lying. When I asked you to make a decision about Enne, I thought it was the right one. Because you were her friend. You know her. And I didn't trust myself." She glared at Lola. "But when I look at you, sometimes I *do* see myself. You're paranoid. You scour these papers every day waiting for her to mess up, just like you wait for the whole world to mess up. That way it'll validate how miserable you are."

"Then if you can't stand me," Lola said, seething, "why are you still here?"

Arabella sighed. "Listen to yourself. You *are* paranoid."

Lola flinched as though she'd been slapped. Something hot simmered in her stomach—the burn of an infected wound, swelling and swelling, never healing.

"Fine!" Lola shouted, standing. She bumped her side into the table, and it teetered, spilling what remained of her coffee on the newspaper. "I'll go tell her about Veil."

Lola cringed as she knocked on the door of the art museum. An Iron answered it, a boy with shaggy black hair and a four and a diamond tattoo on either arm.

"Oh, you must be here to see Tock," he said. "I can go get—"

"No, no," Lola choked out, flushing at the memory of the strange girl who'd kissed her. "I'm here to see Levi. Send him out."

She was being a coward, she knew. Enne had a right to be told this information before her maybe-ex-boyfriend. But when

Lola had stormed out of her apartment building and slipped on her lopsided earmuffs, she'd decided that even if Enne deserved to know the truth, Lola didn't deserve being the one who had to tell her. Regardless of what Arabella thought.

Levi emerged on the front stoop, and Lola suddenly realized she rarely—if ever—spoke to Levi alone. He looked more tired and terrible than usual, and Lola hoped that was just his choice in tacky, pinstriped shirts. She didn't have it in her to comfort any more broken boys who didn't take her advice, anyway.

"Lola?" he said, frowning. "Are you here to see Tock?"

"No," she grunted. "I'm here to talk to you."

Levi's gaze fell to her right earmuff, and Lola instinctively turned her face away to hide the scar that grazed her cheekbone. "How are you? I haven't seen you in a while."

"I'm feeling like I want to go for a walk. Get your coat."

Before he could question her, she started off down the path along the museum grounds. He hurriedly grabbed his coat and followed, and Lola kept to his right side so it'd be easier to hear.

Lola had no idea how to make small talk with Levi, so she skipped it altogether. "I've come upon some information," she started nervously. "In the National Library—I found some archives—just had to dig *really* hard and—"

"Yes, all right," Levi said impatiently. Clearly the inauguration last night had put him in a sour mood. "What is it?"

"Veil was Enne's father," Lola blurted.

Levi stopped walking; they'd reached the cobblestone sidewalk along the Street of the Holy Tombs, and for several moments, the only sound was the unnerving clinking of Faith wind chimes on porches in the distance. The charms numbered more than Lola remembered from when she'd last been here, and she realized they were probably believed to ward away bad omens and malisons. Bryce's rise to infamy was changing the world just as much as Enne's was.

"Veil as in the street lord Veil?" Levi asked tightly. "From the Great Street War?"

Lola rolled her eyes. "Yes, that Veil. Who else would I have meant?"

"But Veil wasn't a Mizer."

"No one knew what Veil's talents were." Even after being publicly executed, Veil was still famously a mystery.

"But the Great Street War ended before Enne was born," Levi argued. "Veil would've been long dead."

"Not that long," Lola said. "Only a couple months, at most."

He sighed deeply, and Lola wondered if maybe, even if she hadn't deserved to tell Enne, Levi didn't deserve this, either. He'd gone through a lot these past few weeks, and though he and Lola had never been close, she felt guilty for not considering the position she was putting him in. She'd only wanted to escape the apartment, to stop Arabella from pretending like she really *saw* her. Because she didn't, and the idea that Lola could have anything in common with someone who'd committed such heinous crimes made her nauseous.

"So you're sure," Levi said, staring at her intently.

"Positive," she answered.

"Well, I've never known you to be wrong." Levi shuddered and kept walking. This time, Lola followed, surprised by his compliment. "Does Enne know?"

"No. I haven't told her."

"Why not?"

Lola reddened and looked away. "Because I'd rather not talk to her."

Across the street, the bells of a church rang. Lola couldn't remember that church ever holding services before. She couldn't remember the city feeling so superstitious before. It made her think of Arabella's confession last month, how she wondered if her sins had left the world a better place.

Maybe Lola had been too quick in her decision to spare

Enne. When the responsibility was this great, she didn't know if it was better to be good or to be smart.

Lola had always prided herself on being smart.

"So you've decided *I* ought to tell her?" Levi grumbled.

"Is that a problem?" asked Lola.

He grimaced. The expression reminded her of Jac. "We haven't been talking much, lately."

Lola smirked. "That in love with each other, are you?"

His countenance went darker, and he reached into his pocket for a deck of cards. He shuffled them as they walked, and they slid effortlessly through his fingers even with his gaze fixed elsewhere.

Levi whispered something that Lola couldn't make out. "What?" she asked. "I can't hear you." Lola knew she should consider herself lucky that the bullet had only struck her ear when it could've struck her skull, but muck, every time she asked someone to repeat themselves, she grew a little bit angrier.

"No one can know about this," Levi hissed louder. "Even though the warrant for Enne's arrest was revoked, her criminal record hasn't been…not yet. Besides, who her parents were doesn't matter."

"What do you mean it doesn't matter?" Lola retorted. "Enne's father was the most notorious street lord in New Reynes' history. That mucking matters." Even if Enne hadn't known it, the day she stepped foot in the City of Sin, she'd been coming home.

"Whatever the papers would claim, Enne isn't like Veil."

Lola snorted. "It's nice that you think that. I've lost an ear to her. And I nearly lost a brother."

Levi stopped walking again, this time to glare at her. "Where have you *been*, Lola?" he growled. "You're gone for over a month, only to show up with…research? Is that all you've done in your absence? Dig up evidence on Enne to get her hanged?"

Lola sucked in her breath. Now that Arabella pointed it out

to her, Lola couldn't stop noticing it—the heat boiling inside of her, the anger, the hurt. She could taste the rancid steam of it on her tongue.

Maybe Arabella was right; maybe Lola was paranoid. Lola hated to think that she resented Enne for the same reasons that Justin resented her, and she wondered if such traits could be inherited. Lola already checked her tissues for blood every time she sneezed or coughed, in case she perished the same way as her father. Surely anger could be passed on the same way.

Not that she'd reveal those fears to Levi.

"I was looking for truth," she said defensively. "I can't help it that the truth is incriminating."

"Enne is better since what happened with your brother. If you'd talk to her, you'd know that."

Maybe Lola had interpreted the articles in the gossip magazines all wrong. Maybe Levi was grumpy—not because he was staging kisses with the girl who'd killed his best friend—but because they were interrupted.

Well, good for them. They got their happily-ever-after, and Lola got what? A brother she couldn't even bring herself to speak to? A monster for a companion, who'd dumped the weight of this whole terrible mucking world on Lola's shoulders?

Lola pursed her lips. "Well, it was hard for Enne to fall lower."

"You don't know what it's been like since Jac died," Levi snapped.

"Jac was my friend, too." Lola fumed. "And you don't see me accidentally shooting people in my grief."

Levi must've carried his share of anger, too, she realized, because he had a very loaded scowl. "Then why tell me what you did, if not to threaten me? To threaten both of us?"

Lola knew this information might burden Levi, but she'd never thought he'd see it like *that*. Jonas had used information

as a weapon, but the only weapons Lola carried were knives, even if she could barely wield them. After all, information had never protected her. Information had never cured her father or saved her brothers. And despite all the heartache Lola had suffered, she liked that she didn't use her weapons. It made her better than her friends, better than her brothers. It made her appear unarmed if she got wounded in their cross fire.

But Levi looked at her now like she was no better than anyone. Like she was a player.

Lola brushed past him, knocking into his shoulder and sending his deck of cards spilling onto the cobblestones. The jack of diamonds fell faceup at her feet.

"Goodbye, Levi," she growled, strutting away, her face burning.

She didn't look around until she'd walked several paces, and she felt a pang of guilt as Levi tore the jack of diamonds in half.

LEVI

It was Levi's turn to sit at the edge of Tock's bed.

The box springs creaked underneath him, and Tock jolted. She blinked open her dark eyes warily. "You could've knocked," she grunted, burying her face back into her pillow. Her short black hair looked a mess—there was a tangle the size of a ping-pong ball at the base of her neck.

"I did knock," Levi told her. "Multiple times." When Tock didn't respond, Levi pressed, "I need you to get out of bed. I need to talk to you."

In his hands, he clutched this morning's copy of *The Kiss & Tell*, a magazine he did not typically subscribe to. But an Iron had shown it to him this morning, giggling hysterically at the compromising picture of Enne and Levi on the cover. The edition had passed through every hand in the museum faster than a queen of spades in Tropps.

Did you hint to those reporters to follow us? Enne had asked him.

Her words still made Levi want to set every last copy of today's *Kiss & Tell* on fire.

"Or, consider this," Tock replied, "you could be miserable with me. There's plenty of room in the bed. I'll sleep on this side—you can have that one."

Levi could smell Tock's breath from here, so he'd truly rather not. "It's Enne. Have you seen this front page—"

Tock grumbled something unintelligible.

"I can't understand you," he snapped.

She turned her head to the side, glaring at him. "I *said*—it's always about Enne."

He grimaced. "That isn't true." He'd also planned on telling Tock about Lola's visit, but he was still working out how to do so without revealing the details of their conversation. Even if he trusted Tock more than anyone, the first person he'd tell about Veil was Enne.

"Fine. Then it's always about *you*. What about me? What about *my* anguish?" Tock pounded her fist on the pillow beside her, and it exploded with a loud *boom!*, sending down feathers fluttering through the air, and scaring Levi so much he toppled onto the floor.

He clamored to his feet, blowing a feather out of his eyes. He hadn't known Tock could be so dramatic, but he supposed he had little room to talk. "Fine," he muttered. "Let's discuss you first."

Tock rolled over and sat up, sniffling. She wore a long-sleeved set of black silk pajamas with green piping along the edges. She'd been wearing the same pair the last time Levi had spoken to her, as well as the day before that.

Her room also looked untouched. As expected of Tock, it was decorated bombastically, with every piece of pawnshop curiosity or Casino District trash Tock had found inexplicably "chic" or "charming." These included a shelf of milivolt-sale books, encompassing all obscure topics from birdwatching to

pre-Revolution cookbooks to bad poetry written by university students. There was a poster of an advertisement for a men's luxury clothing store, and another construction sign from the last time the city had filled in a pothole. She also owned a collection of strange religious items, like a brass chalice and a mobile of prayer beads, which she'd brought with her when she'd moved out of the Catacombs.

"My girlfriend *forgot* who I am," Tock said woefully. "Have you ever heard of something so tragic to happen to *anyone*?"

Levi could, but he bit his tongue. "Are you sure Lola hasn't just been...pretending?" Based on her behavior earlier, Lola hadn't just cut out Enne from her life—she'd cut out everyone. "Did you do something—"

Tock shoved him. "No, thickhead. We aren't constantly at one another's throats. We aren't a *straight couple*."

Levi was tempted to laugh and point out that no relationship he'd been a part of was a straight couple, but then he realized the weight of Tock's accusation. "You're saying that Lola genuinely forgot who you are. You're saying..."

"That she made a deal with the Bargainer, yes," Tock said.

Levi didn't pretend to be Lola's closest friend, but he wouldn't have guessed this of her. When he'd passed by the Bargainer after his meeting on the South Side, he'd been terrified. Maybe it was the hints of his split talent for sensing auras, but the Bargainer had felt...evil. It was the most inane way—but also the *only* way—to describe her presence, the sound of her voice following him like a breath against his neck.

"Why didn't you say anything sooner?" Levi asked sharply.

"Because I thought I was making it up," Tock replied, "and that she'd come back. And then I was just...scared. I was scared I pushed her into it, even though I don't remember doing anything wrong."

"Lola was here earlier," Levi said quietly. "Well, she didn't come in, but—"

"*What?* You didn't wake me?" Tock shot up to a sitting position, her eyes as round as poker chips. "What did she want?"

"She wanted to talk to me."

"You? Why you?"

Levi sighed and considered his words carefully. "She wanted to know how Enne was doing, but that's it. She didn't say anything about the Bargainer."

Tock groaned and leaned her head back into her pillows.

"Do you know what Lola would've wanted?" Levi asked. "What would have been worth a bargain to her?"

Tock rested her forehead against her knees. "No, it's like I said. I keep wondering, but I can't...I can't come up with anything." Her voice cracked. "We loved each other. There was nothing worth more than us."

Levi sighed, then he did climb into the bed beside her. He leaned back against the headboard, his legs stretched out, trying but failing to relax. "I'm sorry."

"I'm so angry," she whispered.

"We could find out where she's staying," he offered. "Then you could see her."

"What good would it do if she doesn't even *know who I am*? You should've seen her face when I kissed her. It was like..." Tock let out a low laugh. "She probably thought she'd never been kissed before. She thinks she's still a—"

"Whatever you're about to say, I promise you Lola probably wouldn't want *me* to hear it," Levi said, feeling his face heat.

"Lola did always think you were a thickhead," Tock said, snorting.

He cleared his throat. It felt morbid to talk about Lola this way, like she was dead. He'd been angry with her when they spoke earlier, but now he thought he might need to consider their conversation differently. Lola was clearly not herself.

"Well, if I get a do-over with her, maybe—" he started.

"She definitely only forgot *me*. She still thinks you're a thick-head."

While Tock began fiddling with the knot in her hair, Levi wondered if he should share Tock's suspicions about Lola with Enne, if she'd want to know, if Levi should even be the one to tell her. He couldn't fathom the thought of facing Enne, now that he'd put everything he felt out in the open and instead been accused of pretending.

But he had a great deal to tell her.

Tock sighed. "You can tell me about your romantic woes now. I just wanted it to be clear that mine are worse. And that I'm suffering."

"It's noted, and you know that I *am* sorry, right? You're my..." He caught himself. He was about to say *best friend*, and then a wave of guilt washed over him.

"Maybe you need some time to lie down, too," she told him, stretching out her legs and patting them. Levi laughed softly and lay on his back, his head on her thighs. Her pajamas were likely unsanitary at this point, but he was too tired to care. "You're doing better than I thought you would be, considering where you were only two months ago."

"I'm not any better," he said truthfully, "I'm just sober."

"Do you want to be?"

"Muck, no." He reached into his pocket and pulled out his deck of cards, so he could have something to fiddle with. "Most nights, I dream about my family and the Revolution, and I can't stop hearing my father's voice, warning me that I've made myself a target. That Enne and I are next. I never wanted to be an orb-maker. I thought using my talent would make me feel like him."

"And did it?" Tock asked softly.

"No, but I'm still on edge. I can't even go near the Casino District—they've been partying nonstop since the curfew

ended. It's so crowded. I keep thinking that they're all watching me, that they all want me dead."

"I think that's normal."

"Normal?" he echoed. "What part of that sounds normal?"

"I meant for someone who keeps finding themselves in life-or-death situations, I think it's normal to always feel like you're in one."

Levi supposed that made sense. "Meanwhile, Enne has me putting on this charade where we act like we're in love and flaunt it everywhere. She thinks that will make the city love her, but..." He reached over and grabbed the magazine from where it lay on the duvet. "Just look at this."

Tock whistled. "Am I old enough to read this?"

Levi covered his face in his hands. "How did I go from being the man who negotiated the end of the state of emergency to...to..."

"I don't recall you feeling so torn up when this same magazine named you one of the most eligible persons of the North Side."

"This is different, and you know it," he shot back. When he tried to shuffle the deck of cards, they accidentally spilled all across his shirt. "And what's worse is that Enne thought I staged the whole thing. But—"

"But you didn't." Tock squeezed his shoulder supportively. "I thought you didn't still have feelings for her after what happened to Jac."

"I didn't—I mean, I don't know. I couldn't just make those feelings disappear, even if I was angry. But I can't stop thinking about how Enne didn't think it was staged before the reporters showed up, that she kissed me back. And that means we could go back to how we used to be. Ever since Bryce's game began, I feel like I'm playing against her, not with her. It was never like that before."

"And that's what you want?" Tock pursed her lips. "To have her back?"

Levi hadn't been well when he'd kissed her. He'd been stressed and in need of an outlet. Or maybe it had been that he missed her, that she'd always been the person he leaned against. Habit.

He thought again about Lola's revelation. Though he struggled to process that Enne was the daughter of the man Levi had once idolized, it didn't change the way he felt. If anything, it made him more afraid. One more reason for the Republic to turn on them.

"I don't know if I want her back," he groaned. "But I don't think I can keep up this performance."

"It doesn't sound like you'll have to," Tock said, pointing at lines from the article that followed the photograph. "'The City of Sin's favorite couple caught in a passionate tryst.' 'A scandal of royal proportions sends the city swooning.' 'Enne Scordata has just been crowned New Reynes' most interesting sweetheart.' Enne's plan seems like it's working exactly as she hoped it would. If you called Harrison now, I bet you could get her that pardon."

Levi's heart swelled. Tock was right. He could end this, right now.

"You didn't answer my question," she said. "Do you want her back?"

Did you hint to those reporters to follow us?

The question had only been a simple mistake on Enne's part, but the words still haunted him. It was like Enne couldn't even sense the desire he'd put into that kiss. Like she couldn't realize how much the past few weeks of staging a relationship had hurt him.

Levi tossed the tabloid aside. He didn't want this. He didn't want to feel cheap. He didn't want to feel scared every moment of every day.

"I don't," Levi answered.

Tock nodded seriously. "Then I'll support you."

Despite all the terrible things that had happened to him, Levi still counted himself lucky he had Tock through it all. He didn't know where he'd be without her.

"You can be my best friend without being a replacement," he murmured, feeling a bit sheepish as soon as he said it.

She shoved him off her lap. "Gross."

He smirked and sat up. "If anyone is gross right now, it's you. You smell like a Tropps Street pisshole."

Tock sniffed her armpit and grimaced. "Well, you've worn worse cologne."

He shook his head and walked to the phone in the room's corner, set atop the bookcase. He dialed the number for the direct line to Harrison's office.

"'Lo, Pop," Levi said.

"I told you to stop calling me that," Harrison growled. "And I missed you at the inauguration ball. I thought it was because you were busy with your casino. But this morning I got to read the real reason why."

Levi buried his embarrassment behind his poker face, even if Harrison wasn't present to see it. "Good, then you've read the article. Is it enough for Fenice?"

"Is it all real? Because Enne's friends might confront you afterward, and you'll have to start carrying shades on your person because it wouldn't be the first time you've been caught." His voice drawled.

"Are you drunk?" Levi asked incredulously. It was three o'clock.

"Yes, but unlike all of you—I'm legal." While Levi rolled his eyes, Harrison added, "But I'm glad you called. Because I think you're right. I think we have a pardon to negotiate."

Levi let out what should've been one of the biggest sighs of his life. Except it wasn't. He was relieved—he knew how much

Enne needed this. And he'd told Tock he'd made up his mind, and he wasn't going to change it.

But even the right decisions had a way of leaving him disappointed.

ENNE

Enne nervously rolled and unrolled the most recent edition of *The Kiss & Tell* in her hands while Grace drove. If any of her old instructors from finishing school glimpsed her photo on the front page, they would faint. Even with Levi blocking much of the cameras' views and the magazine censoring certain details due to her age, you could still see a glimpse of her camisole, a trace of her thigh. Every time Enne looked at it, she blushed deeper.

"Cheer up," Grace told her, smacking her shoulder. "The City of Sin loves scandal, and now they love you."

"I feel humiliated," Enne snapped. "Levi could have... He could have at least *told* me what he'd planned before he made me look like a harlot in front of the whole world."

What made it worse was that she hadn't realized it was a show at all. She'd been all too happy to kiss him back. Who knew where she would've taken the encounter had they never been interrupted at all. She'd already been dreaming of such things.

No matter which black door Enne opened as she roamed the hallway in her sleep, she always found Levi. Smiling—though she rarely saw him smile anymore. Kissing her—in St. Morse, in her bedroom, in the workshop. It was as though whatever strange power lurked within the hallway was urging her back to him. Enne often woke covered in sweat.

"What's more important—your decency or your life?" Grace asked.

No sooner had Grace finished her question than she parked the motorcar in front of the Capitol. Enne stared out the window at its white stone steps, each engraved with the name of a different fallen revolutionary. The building was a monument to the perils of her legacy, yet she'd been summoned inside to a private audience: her, the Chancellor, Harrison Augustine, and Levi. And unlike last time Fenice had extended such an invitation, Enne had public support. It might not have come in the way she'd first expected it, but she wielded it all the same.

"Come in with me," Enne blurted at Grace.

Grace knitted her eyebrows. "I wasn't invited."

"I don't care—I'd like you there," Enne urged, grasping her white-gloved hand. "I thought you were our publicist."

Grace smirked and looked down at her scanty outfit. How Grace could bear to expose so much skin in this winter chill, Enne had no idea. "If that's what you want, but I won't promise to behave."

Enne walked outside, relieved to have someone to face these steps and this building beside her. Then the two girls linked arms and strode up to where a line of servicemen waited for them by the side door.

"The others are already inside," one told her gruffly. His eyes fell to Enne's legs, and Enne flushed, realizing immediately what filthy thoughts were going through his mind. She didn't care if Levi's plan had worked—if they'd waited long

enough, their performance might've played itself out, anyway, *chastely*. When she saw Levi, she'd strangle him.

Except when she did see Levi, standing inside next to Harrison Augustine, his hands tucked sheepishly in his pockets, Enne flushed so deeply she must have looked cherry red. He might've played her like a fool, but she couldn't erase the details of that encounter from her memory. Like how the low rasp of his breath felt against her ear. How his hands had reached places higher on her thigh than she'd ever been touched before.

"Keep looking like that," Harrison Augustine told her, giving her a thumbs-up, "and you'll do great."

Enne pressed her hands to her cheeks; they were feverishly hot, exactly as an innocent schoolgirl should react to such a scandal.

"I see you've brought your..." Harrison took in Grace uneasily "...muscle."

"Chaperone," Grace cooed, her fingers twisting around her sharpened Creed necklaces.

Levi scowled. "Come on. Let's just get this over with." He motioned for them to follow him into a conference room, plainly decorated except for the Republic's flag on the wall and a framed portrait of Malcolm Semper beside it.

At the table, the Chancellor's wizened gray-toned fingers tapped against the glossy cover of *The Kiss & Tell*.

"I'm sure you two are proud of yourselves," Fenice said gravely. "All day, my office and those of Senators have been fielding calls from this dreadful publication's readers, advocating for your political plights."

Enne was far from proud, but Fenice's words did succeed in raising her spirits. "Then it sounds like we'll all be able to reach an understanding."

"A pardon for your status as a Mizer," Fenice responded flatly. "A pardon for the assassination of our first Chancellor. A pardon for your criminal activities with the gangs of the North

Side. A pardon for the death of Sedric Torren. I'm to erase all your offenses, as though your actions have not cost my administration hours of stress and paperwork. Have not destabilized the confidence this government has worked so hard to achieve since the Revolution."

"Can you hold someone accountable for the wrongs committed under an omerta?" Enne asked sweetly. "It seems to me, apart from my talent, the culprit is Vianca Augustine. And she has already answered for her crimes."

"Yes, so you and Levi have both claimed," the Chancellor intoned. "My concern is that, even after I pardon you, what is to prevent you from engaging in such corrupt activities again? It's to my understanding that you continue to reside with the gang you were apparently forced to form. That you and a number of other criminals attempted a skirmish two months ago with a rival gang, costing multiple lives."

Enne hadn't realized the Chancellor knew so much about the Spirits. She stiffened.

"As one of those so-called criminals," Grace said, clearing her throat, "I can assure you that Enne has changed since she's been courting Levi. They're both quite...reformed."

Enne kicked her under the table. She was hardly some helpless woman who only needed a man's strong hands to guide her.

"Though I'm sure your word is...inscrutable," the Chancellor said dryly, eyeing Grace's display of cleavage. She reached into the folder in front of her and slipped out a packet of papers. "You'll understand that your criminal organization will have to disband immediately, and that our contract is contingent on a number of conditions should we agree to proceed."

"Can I see it?" Enne asked, taking it nervously from the Chancellor's hands.

Prohibited from any public practice or acknowledgment of the Faith.

Prohibited from voicing public opinion on matters of politics, including but not limited to candidates for election, legislation, political parties...

Enne scanned through the lengthy list of demands—three pages long, single-spaced—until she paused on one in particular.

Prohibited from continuing a relationship of any kind—romantic or otherwise—with Levi Glaisyer.

"You can't be serious," Enne growled. "What? I'm never supposed to speak to Levi again?"

"It's curious that you voice a concern over that contingency first," the Chancellor spoke, "when your public courtship is so obviously fictitious."

"Let me see that," Levi said, tearing the paper from Enne's hands. His eyes widened as he read it. "You can't do this. You can't—"

"*You* are an orb-maker, and *you* are a Mizer. There are too many implications. The Senate and I cannot allow it to continue."

Enne had moments ago considered the thought of strangling Levi, but now she met his eyes across the table, his own horrified expression mirroring her own. He had been the first person she'd met in New Reynes. Her friend. Her confidant. Her partner.

"The p-public supports us," Levi managed shakily. "This will infuriate them."

"Which is why you're going to stage a falling-out. A display as loud and indecent and public as the two of you have now become so known for."

Harrison cleared his throat. "Surely, this contract can be negotiated—"

"Do not let your own past cloud your judgment, Harrison," the Chancellor snapped. "Every one of these stipulations was written with the safety of the Republic in mind."

A well of emotions spouted in Enne, and she grasped the edge of the conference table to steady herself. She'd thought she'd entered this meeting from a position of power, but she felt helpless. And as much as she loathed the spread on *The Kiss & Tell*, she'd be far more humiliated to burst into tears in front of Fenice.

Grace, seeming to sense her distress, grabbed Enne by the hand. "We need a moment to discuss this, if you don't mind." With her other hand, she grabbed a fistful of Levi's collar and wrenched him up. "You, too, Pup."

Enne took deep, calming breaths as they walked into the hallway and closed the door behind them. The servicemen still watched, and so the three made sure to lower their voices to a whisper.

"You can't sign this," Grace said. "It's not even just about Pup. There are so many demands that you're bound to make a mistake eventually, even by accident. This is just an excuse to catch you slipping up later."

"Then what do you propose we do?" Levi hissed, his arms crossed. "We've been trying to negotiate for months for this offer, and now we have it. And we might not get another."

Enne's mouth fell open. "Are you honestly considering this?"

"I don't like it," he said quickly. "But it could be easier for us. What if, say, new information about you were to come to light and—"

"Easier?" she gritted out, loud enough for the servicemen to overhear.

"A lot has happened over the past few months. It's messy. And besides, it means ensuring your safety." Levi opened his mouth like he wanted to add something else, but then his eyes flickered to the guards watching them, and he swallowed.

"You heard what Grace said. This is its own prison sentence!" Enne wadded the contract in her fist.

"All I'm saying is that if you *can* negotiate, our relationship shouldn't be your first priority." Levi bit his lip, and Enne hated how that only reminded her of kissing him. "They want access to your bank accounts and purchases for the rest of your life. They've forbidden you from a single show of political demonstration, even to be caught in traffic behind one—"

"Is that what you'd prefer, then?" Enne demanded. "That we never see each other again?"

He peeked over his shoulder at the servicemen, then he put a hand on Enne's shoulder and tried to steer her a few steps back. She swatted him away. He did *not* get to touch her.

"Of course not," he whispered, "but if it means that you're safer for never seeing me again, then how could I say no?"

But Enne couldn't believe his words. *Messy,* she repeated in her mind furiously. That was how he saw this contract: a way out.

"Well, if that's what you want," she snapped, then she turned on her heels and marched back inside. She threw up her hands. "Fine!" she barked, making the Chancellor and Harrison startle. "Give me a pen. I'll sign it." She threw the crumpled contract onto the table and collapsed into her chair.

"Wait," Grace cut in, just as Enne accepted Fenice's offered pen. "We want to negotiate."

"I told you that the relationship is not up for discussion," Fenice said.

"That's not the adjustment I'd propose," Grace responded. "The Mizers used to control and mint all the volts of their kingdoms, but the Mizers are gone, and now we have the technology to do so ourselves. It—"

"Please get to your point," Fenice said coolly.

Grace ground her teeth. "These stipulations do nothing to ensure that Enne has a role in modern society. She is not just

a relic of a bygone era. She's a person, with a talent that could still be of use. So I propose that you give Enne a position of some power at the National Bank. And that you eliminate the clause about Enne disbanding her gang—many of our associates are counters, all with Enne's interests at heart. So legitimize us. Let us work together in the treasury."

The Chancellor's gaze shifted to Enne, and Enne molded her expression into something unreadable. Grace hadn't discussed any of this with her, but her logic was sound. Such a role would stop Enne's existence from seeming archaic. And it would mean, even if she didn't have Levi, she would still have the Spirits. And that mattered to her.

Fenice took a moment to consider, then she took the pen from Enne's hand and scratched out the offending clauses. She wrote Grace's request at the bottom as a final stipulation.

"Very well," Fenice ceded. "We will grant you and your… associates a department within the National Bank—"

"With actual authority and function," Grace growled.

"Yes, a department with responsibility. And you will, in turn, agree to our other demands."

Beside Fenice, Harrison crossed his arms and scowled, but he said nothing.

Enne forced herself to meet Levi's eyes one last time. If she'd known that those few minutes in the pantry at the Kipling's Hotel would be their last true moments alone together, she would have slapped him for all the heartache he'd put her through. Or she would have kissed him harder.

Her safety and pardon were no trivial matters, but the two of them had always been in danger, every moment they'd spent together in New Reynes. To so thoughtlessly throw her away now felt like the ultimate wound, one she knew would leave a permanent scar.

Enne looked away, accepted the pen, and signed.

"Then it's decided," Fenice declared. "After this disgust-

ing article, it seems appropriate to give the news some time to settle. And then, in one month's time, you will both stage your falling-out, and the Republic will return to the stability it once had."

Enne did not cry. Not after signing the contract, not when she and Levi shared a terse goodbye, not in the entire car ride home when Grace cursed Levi to the ends of the Deadman District and back. Crying had always been a release, but Enne could think of no means to ease this pain. After months living out a story so deeply intertwined, her and Levi's story was over for good.

HARVEY

Harvey was not well at the Catacombs, but he was better. He should've been proud of his progress, but instead it only scared him. In the nightclub, his life felt alien, like it wasn't his own. And he feared that the second he stepped outside its bone-plastered walls, the worst of his illness would return to him, a veil lifted.

And so, even if it was one of his precious few nights off, Harvey didn't trust himself to leave. He parked himself in a stool by the bar, sipping a Snake Eyes, and watched the night unfold around him.

By now he knew the other staff, but they were too busy with their work to entertain him. He considered scoping the crowds for some other boy looking for company, but he kept stealing glances at Narinder instead, who never afforded himself a single moment's rest, let alone an entire night off. Even when Narinder occasionally hopped off the stage to dance with the club's patrons, he did it to make them feel singled

out, special. He wouldn't have time if Harvey asked Narinder to dance with *him*.

Oh well. At least Harvey was comfortable. At least he was better.

Or he was—until Rebecca Janus walked inside.

Harvey nearly spilled his drink when he spotted her. She looked well. Her illness was nothing a face of makeup and a fresh pair of kidneys couldn't fix, at least for a night. Her calculating light eyes scanned the room until they fell on him, sitting hunched and cross-legged on his barstool, wearing an expression as though he'd been caught doing something he shouldn't have. He didn't know what that wrongful act was. Being almost happy, maybe.

She started toward him. Even while wearing her own face, she commanded a bit of Ivory's intimidating presence, a trick she'd mastered over the years of donning her skin like a costume. The dancers gave her a wide berth.

"Let's talk someplace else," Rebecca told him, without even a simple hello.

Harvey was still reeling at encountering her here. She wore a black shift dress, which was very fashionable for someone who paid no attention to the passing trends—she'd tried hard to blend in tonight. The only hint of illness she hadn't concealed with makeup was her lips. They were chapped, but with the color drained out of them, like the ridges of worms.

"I'd rather not," he said stiffly.

"We're going to talk," she pressed.

"I—I know that," he stammered, because there had never been use in denying Rebecca anything. Not even from him. "But I'd like to talk here."

Rebecca pursed her wormy lips but slid into the stool next to him. When the bartender—Orphie, his name was—asked for her drink, she only requested water, no ice.

"Have you been reading the papers?" she asked.

"Not if I can help it," he responded truthfully.

"Enne now operates a department at the National Bank. Owain didn't give the announcement much—only a few inches on the third page. Harrison Augustine kept it all hush-hush. But she works there now."

Rebecca had a grave expression on her face that Harvey didn't understand. He swirled his straw around his drink. "And that's...bad...?"

"Do Enne and Levi know?" she asked him sharply. "Does Harrison know?"

Harvey was tempted to say, *Well, I don't even know.* Because he didn't. Whatever she was referring to, it was a piece of Bryce's plan that he hadn't shared with Harvey. And even this better version of Harvey didn't want to admit that.

"I doubt it," he said smoothly.

She rolled her eyes. "Why do you feel the need to do that?"

"Do what?"

"Lie. Really, your insecurities are unbecoming."

Harvey's face burned. He was completely transparent.

"If Bryce didn't tell you, it was probably because he didn't want Harrison to find out, which is for the best." Rebecca drummed her fingers against the bar—her nails were broken down too low to make a noise. "Which means my coming all the way out here was a waste of time."

"You could've asked Bryce before finding me," Harvey pointed out.

"Bryce is...touchy when it comes to you."

Harvey was pleased to hear that. He shouldn't be—but he was.

"How did you know where I was?" Harvey asked her. He hadn't told Bryce where he was staying.

"Someone from the Orphan Guild saw you here," she answered. "Well, since I *am* here, is there anything you could tell

me about Harrison? What are they all planning? What have they guessed?"

Harrison had forbidden Harvey from revealing that information, but even so, Harvey snapped back, "I can't tell *you* anything."

She sighed like he was the most irritating thing in the world. This was one of the many reasons he didn't like Rebecca, because she made him feel like he *was*. "Why do you hate me, Harvey? Are you still that lovesick?"

Harvey hated that word. He *was* sick—that much was certain and his sickness hadn't started with Bryce. It had started with his parents: the horror of how they tricked people with their talent, the anxiety of leaving, the ache of severing himself from his past so unconditionally.

And then there *had* been Bryce, the boy who convinced him he was more than just a Chainer, and who Harvey believed was more than just a malison. Bryce was the first person Harvey lived with after his family, in a crummy apartment in the Deadman District. Eventually, Bryce had convinced him to start the Orphan Guild because they both needed the volts, because that was how it felt to live in the City of Sin—like you needed to dream something, to start something. That was when their friendship had changed. When Bryce had confessed he'd liked boys the same way he liked girls, when he'd kissed Harvey, when Harvey realized he never wanted him to stop.

"I assumed whether or not I hate you was obvious," Harvey told her.

"Well, it's not," Rebecca said flatly.

"You and Bryce created a shade that's going to get a lot of people killed. You already *have* gotten a lot of people killed. Bryce never would have done something like that before he met you." Harvey looked her dead in the eyes and said, "You're the reason he's terrible."

Rebecca snorted, not appearing an ounce offended by Har-

vey's years of pent-up fury. He didn't like that, either; it made him feel insignificant. "You've deluded yourself. I haven't changed Bryce at all. You just remember your past all rose-colored."

"I don't remember Bryce killing anyone," Harvey said darkly.

"Bryce has always been ambitious. You just didn't realize how far he'd be willing to go to see those ambitions realized."

There was a chance Rebecca was right, which only made Harvey hate her more.

"I'm ambitious," Harvey blurted, and he immediately realized how pathetic and ridiculous that sounded. He wished Rebecca hadn't caught him so unprepared. He wasn't drunk, but this was his second Snake Eyes.

"You want to know a secret?" Rebecca asked. Before he could respond, she leaned over and took a sip of his drink. She shouldn't have done that—her liver didn't need the extra stress—but Rebecca had always treated herself like she was indestructible. Even now.

"Sure," Harvey answered nervously.

"I've never hated you, specifically. But I hate the way you look at me. You've started to look at Bryce that way, too, even if you don't mean to. Like you've got the Faith all over you. You're the reason I've spent my whole life scared. Well, not *you*. People like you."

Harvey struggled to imagine Rebecca scared of anything. "You're the lord of the Doves. At least, you pretend to be. I've spent my whole life scared of *you*."

"No, you haven't. You've avoided certain neighborhoods, sure. You've shivered at the thought of killers the same way you might a bedtime story. But the Mizers convinced the world to hate people with talents like mine. You've been afraid of meeting someone with white hair. I've been afraid of anyone, everyone. Because there's no marker to indicate whether or not they'd want to hurt me." Rebecca sighed, again like Har-

vey was the most irritating thing in the world. Only this time, he actually felt guilty about it. "Why do you think I poisoned Ivory? Why wouldn't I have wanted the chance to become the most feared, most powerful woman of the North Side?"

Harvey knew the history of the Faith, but that didn't mean his beliefs were easy to shake. Especially when there was so much about the Faith he liked, that had once brought him comfort. He hated the idea that something that had healed him could hurt someone else.

"I'm sorry," he muttered, surprising even himself.

"And I'm grateful you saved Bryce's life. How could I ever hate you for that?"

Harvey would probably never like Rebecca, but this conversation did feel like a sort of truce. It was more of a thanks than Bryce had ever given him.

"What were you talking about? About the National Bank?" he asked. "Why is that important?"

"Don't bother," replied Rebecca. "Even if it weren't for the omerta, I'm not sure I trust you're on our side."

Instinctively, Harvey was about to open his mouth to tell her that he was, but he instead took a long gulp of his drink. No matter what his heart told him, he wouldn't continue to be complicit.

"I thought so," she said, but she didn't sound angry. If anything, she sounded smug. Maybe she and Bryce had fought about this before. Harvey hoped they had. "I should go. I'll let you get back to…drinking alone."

"I'm not alone," Harvey told her reflexively. If he motioned to Narinder, Narinder would come—even if that meant Harvey was a bother. Harvey definitely didn't want to be, but he didn't think Narinder was the sort to think like that.

"Those insecurities, Harvey," Rebecca said, standing up and smirking, and Harvey couldn't help but feel that Rebecca

Janus did hate him, a little. "Have a good night," she said, and then she left.

Harvey never ordered another drink, but he did sit there until the club closed, watching the bustle of it all, wondering what other secrets his best friend had kept from him.

XI

THE LOVERS

"Count your blessings.
You'll owe for them soon."

Jester. "Seeing Silver."
Her Forgotten Histories
27 Feb YOR 16

ENNE

"I thought they would give us influence in the currency sup-ply," Grace growled for the dozenth time since the Spirits had moved into their new, respectable South Side positions at the National Bank one month ago.

Beside her, Charlotte rolled her eyes. "Right. You thought they would hand the very mechanics of inflation over to a group of eight teenage girls."

Shortly after Enne's meeting with the Chancellor, the Spirits had been granted a dusty, unused office space on the National Bank's fourth floor. Her friends dressed more conservatively than Enne had ever seen them—their blouses buttoned up to their necks, the fabrics in every titillating shade of gray. They hunched in each of their cubicles, deeply focused on their work despite Enne, Grace, and Charlotte bickering in the room's corner. In order to make the formal atmosphere of the build-ing more like home, the Spirits had laid out a white, shaggy fur rug over the dull brown carpet, and they'd decorated the

walls with the glossy advertisements from *The Kiss & Tell* with their favorite fashion or cosmetic brands. The air of the office smelled strongly of perfume samples, and it was quiet except for the clicking of typewriters or the scratching of pencils into ledgers.

"Well, they could've given us something better than *auditing*," Grace said, seething. With that, she whacked a cup of red pens off of a nearby desk, making Marcy startle so much that she spilled her coffee.

"I don't like it any more than you do," Charlotte muttered. "This place is freezing. And Marcy keeps marking up all of my spreadsheets because my typewriter's ink was too faint or because I drew a line without a ruler. I know we're all supposed to be reformed now, but is it a breach of contract to murder her?"

Marcy turned to glare at her. "Do you even review your own work?"

"*Yes!* Yes I *do!*"

Enne sighed and rubbed her temples. "I don't even know what you're all doing. Roy and I just sit in my office all day reading romance or detective novels."

"Yes, and feeling sorry for yourselves," Charlotte said dismissively.

Enne frowned. She felt she had a right to be sorry for herself. Apart from a brief telephone call reminding her that their planned "breakup" was approaching within the week, she and Levi hadn't spoken. *And* it'd been her birthday. She wondered if murdering him counted as breach of contract, too.

"Don't you have to go back to work?" Marcy quipped, looking at Grace expectantly over her glasses. "Weren't you just complaining about some notes payable that didn't balance out?"

Grace scowled and stormed back to her office. Hearing her kick the wall angrily, Roy peeked his head out of Enne's office.

"What's going on?" he asked.

"Don't ask me," Enne grumbled, fiddling with her pearl

necklace. "I'm just here for show. Like an ornament." Not that Enne wasn't grateful for Grace's plan, which provided the Spirits with a steady income and gave Enne a role that suited modern society, but she desperately wished she could be of real use. When she'd attempted to audit a pack of receivable statements that Marcy had given her, she'd made so many errors that it'd taken Marcy more time to correct them than if Marcy had performed the first review herself.

"That makes two of us," Roy said, sauntering into Grace's office with Enne following close behind.

"My eyes feel like sandpaper from looking at these papers so long," Grace complained, squeezing eye drops into them. They watered, making her rings of makeup smear.

"Maybe you should take a break," Roy said gently.

"I just did, but it doesn't help. I keep going in circles. Something isn't making sense."

"What do you mean?" Enne asked, leaning over Grace's shoulder to look at her papers.

"So the National Bank—the actual bank part, not the treasury—owns the mortgages to most of the construction projects on the boardwalk," Grace explained. "And there are a few companies who've acquired multiple properties. But some of these...I'm struggling to trace their voltage back to their accounts. These records *list* account numbers, but once I start looking those numbers up, it's like the accounts don't even exist."

"Maybe we're missing some paperwork," Enne suggested.

"We aren't. All our papers are numbered, and none of them are missing. I checked. Twice." Grace dragged her black fingernails down the pages. "See? There's this company. Brint Water Holding Company. They actually filed an insurance claim recently because one of their properties burned down, but they own a bunch. Then there's Gregorist & Sons, Inc. And Tropps Street Realty. Really, there're only five or six companies that

seem to own almost the entire boardwalk. In fact, that casino Levi bought was originally purchased by Tropps Street Realty."

Enne scowled at the mention of Levi's name, and Grace shot her an apologetic look.

"Oops," Grace said. "Too soon? Sorry."

Of course, this only made Enne scowl deeper.

"Then we look up all these companies' contact information," Roy said, steering them back to the matter at hand. "We hunt down their accounts."

Grace sighed and ran a hand through her black hair. "Sure, I guess." She thrust a handful of papers into Roy's hands. "Call them. Maybe these numbers are wrong or something."

After Roy left to claim a spare cubicle, Grace rested her head against the conference table.

"I could help," Enne said stiffly, feeling left out.

"You could fetch me more coffee," Grace grumbled.

Enne's lip quivered. "I thought this job was a good idea—all your ideas are good ideas. But maybe we shouldn't have signed that contract so quickly. If we'd negotiated more, maybe we could've—"

"Gotten you your boyfriend back?" Grace finished, looking up and raising her eyebrows. "I love you, and so I mean this in the kindest, gentlest way possible. Pup dumped you in writing, in a contract where your own life is at stake. Muck him."

Enne was inclined to agree with her, but even so, she couldn't stop replaying Levi's words over in her mind—he hadn't explicitly and enthusiastically *agreed*. And their last kiss...

"Besides," Grace continued, "we never celebrated your birthday. We could take all the Spirits to a Casino District cabaret and find you a new beau. Or just party all night because men are the worst."

Enne peeked outside at Roy, already diligently turning the dial of a desk phone. "I don't know. Your man seems just fine."

Enne expected Grace to curse and deny it like she usually

did, but instead she shrugged and returned to her papers. "Yeah, I guess he is." A smile played on her lips.

For the next twenty minutes, Enne bitterly returned to her romance novel.

This is what you wanted, she reminded herself. *You wanted to be inconsequential, and so that's what you are.*

Maybe celebrating like Grace had suggested would help. But the reason she'd avoided a party in the first place wasn't because she was miserable about Levi, but because it was her first birthday since Lourdes had died. And even if most days she was fine—missing her, but fine—some days, every breath she took felt like a knife in her side.

Twenty minutes later, Roy returned with the papers Grace had given him, Charlotte at his side. "You're gonna want to hear this," he declared. "The phone numbers listed for these companies are different. But when I called at first, I didn't get through—the line was busy. But Charlotte did. And I didn't manage to speak to anyone until her call finished."

"And I listened in," Charlotte continued. "We spoke to the same woman."

"If we traced all these numbers, I'd bet a kilovolt they go to the same location," Roy said.

"You're saying all these companies are actually the same?" Enne asked. "But why?"

"Because someone is trying to cover their tracks," Grace said, licking her lips and leaning forward. She had that glimmer in her eyes she always got when she'd found a new puzzle. Sometimes, Enne found Grace more intimidating like this than when she brandished a blade.

"Why? Because they own a lot of properties?" Enne asked.

Charlotte furrowed her eyebrows. "When were the properties acquired, Grace?"

Grace flipped through her papers. "All within a few months

of each other, beginning in February of last year. So twelve months ago. Is that significant?"

Charlotte sighed. "I guess not."

"The boardwalk is on the North Side, right?" Enne asked, and the three others nodded. "If someone is covering their tracks, that means they're likely illegitimate. And on the North Side, that probably means—"

"No gangsters of the North Side ever had that kind of voltage," Grace interrupted. "We didn't even when we ran the stock market."

But the more Enne thought about it, the more underhanded it seemed. When she'd arrived in New Reynes, the North Side had been neatly divided. The Factory District had been Scarhand territory. The Deadman District belonged to the Doves. And the Irons had claimed Olde Town and the Casino District. The only reason Enne had been able to take hold of the Ruins District was because no one lived there, no one wanted it.

Which meant, to anyone grappling for more power in the City of Sin, the boardwalk represented an opportunity.

"If you spoke to someone, then the properties hadn't belonged to Reymond," Enne said, thinking out loud. "Or Jonas. This operation is ongoing."

"I don't think that's—" Roy started, but Enne cut him off.

"It doesn't sound like the Doves. That's not their style."

Her mind raced, trying to pluck a name out of her memory, someone with a vested interest in building an empire. She immediately though of Bryce's game and the twenty-two people he'd deemed the players of this city. Aldrich Owain, Jamison Hector, Harrison Augustine... There were plenty of those in the South Side whom Enne didn't trust. There was Bryce and Rebecca, she supposed, but she'd visited the Orphan Guild on more than one occasion—she doubted they had that kind of

voltage. And there was the Bargainer, who'd been forbidden from New Reynes for two and a half decades. But Enne couldn't decipher anyone's motives. She couldn't find her answer.

"It's probably some wealthy South Sider trying to cover fraud," Charlotte said flatly.

"Could it be...?" Roy glanced at Enne nervously. "Levi? He does own a casino there."

"These were bought months ago. He didn't have the volts," Enne said. "I think we should investigate."

"And tell the Chancellor what, exactly? That you went running the moment something smelled gangster?" Grace shook her head. "Absolutely not."

Then the door to their conference room swung open, and Marcy stood there, a dark coffee stain down the front of her blouse, clutching a notepad. Her already large eyes went wider. "You're not g-going to believe this," she sputtered. "*Three* of the properties we own the mortgages to on the boardwalk caught fire last night. They burned to the ground—all of them." Marcy slapped her notepad on the table and slid it toward Grace. But Enne snatched it first.

"Brint Water Holding Company," Enne read. "And Tropps Street Realty." She glanced at the others smugly. "Still think this is just simple fraud?"

Grace pursed her lips, then she leaned back in defeat. "If it is, it's really bad fraud."

"Someone has been quietly buying all these properties," Enne said. "And someone *else* knows about it. It's sabotage."

"Which we should worry about because...?" Roy looked between her and Grace in confusion.

Because if whoever was involved *were* players in Bryce's game, then that meant they were a threat.

And because Enne desperately needed something to do.

"Because this is the City of Sin, and whatever my contract says, we don't have any choice but to play." Enne forced a shrug,

trying not to seem as eager as she felt. "Besides, so I've been reminded, Levi and I are staging a breakup. And what makes a more romantic date than the opening of the boardwalk?"

LEVI

Over a month had passed since Levi had last seen Enne, but the moment he saw her approaching from across the pier, he knew he'd made the right call in letting Enne sign that contract.

She'd dressed conservatively, as befit her new position as overseer of a department in the National Bank. A long coat draped over her matching two-piece jacket and skirt, cinching tightly at her waist, and her hair—though normally tied up—had been swept into an elegant and elaborate knot at the base of her head. She looked utterly unrecognizable to the wanted poster that had once haunted New Reynes' streets, but Levi was struck with the resemblance to the girl he'd first met, lost amid Olde Town's turrets and spires.

She could be that girl again—she could lead whatever life she wanted, even if that meant Levi would no longer have a place in it.

"You look in good health," Enne greeted him tersely. An icy February wind tore across the waterfront. Grand open-

ing or not, this was a miserable day to explore the boardwalk. The city could've waited until summer, but nothing was more New Reynes than instant gratification. "I hope you're ready for this. Half the reporters from *The Kiss & Tell, The Crimes & The Times,* and *The Guillory Street Gossip* are here, flocking and pecking around like seagulls. We'd better be careful—we wouldn't want this to get *messy*."

Enne's words wounded him, even if he tried not to show it. Because Levi had a second, selfish reason for agreeing to the contract, and that was how much she hurt him. Not just in the past, but all the time. She hurt to look at. She hurt to listen to. She hurt to fantasize about every night they'd been apart. Because despite everything, he was still in love with her, and his desire and pain and grief were so intertwined that his heart could no longer tell them apart.

For appearances' sake should any reporter be watching, Enne looped her arm around Levi's with the steely tightness of a prison guard.

"You're going to take me on a walk," she declared, and so he did.

The boardwalk, its construction at last complete, was divided into three piers, like the letter *E*, and each one of varied in degrees of family friendliness. They passed Levi's casino along the main drag, its black-and-white facade glossy as though dipped in candy lacquer, gleaming in the afternoon sunlight. It loomed over the buildings around it, large as a landmark.

In a loopy, drunken-like script, the words *The Legendary* were inscribed over the awning. Levi felt the name was appropriate, given how he and Jac had once dreamed of owning such a place. He hoped his friend would've been proud of it.

Before Levi could take the lead, Enne tugged him in the direction of the second pier, home to gambling houses and taverns—an oceanic extension of Tropps Street.

"Why are we going there?" Levi asked. "The reporters are all on the first pier." The first pier, even from a distance, imposed on the skyline—a ferris wheel stretching up like a roulette table into the city smog.

"Perhaps I need to take a turn before I'm ready to perform," she snapped.

"Fenice won't like if it appears we have actual time in private."

"Ah, yes, the *Chancellor*, whose concerns I value more than all of my relationships."

Levi gritted his teeth. After they'd lost so many friends, how could she casually dismiss her own survival?

He needed to tell her about her father. Then maybe she'd understand why signing that pardon had been so urgent, but before he could respond, Enne halted. Levi didn't know why—with hours to go until sundown, none of the establishments on the second pier had opened their doors—until he spotted a smudge of black on the gray-toned landscape: the ruins of a building. The structure's wooden frame had collapsed inward, its beams jutting out like an inverted rib cage, its remains ashy and charred. The flames must've been impressive to be so destructive; it was lucky the fire had not taken out half the boardwalk with it...

Lucky enough to be staged.

"Please tell me this wasn't your doing," Levi hissed. Arson definitely counted as a breach of contract.

"Of course not," Enne said, her voice distracted as she inspected the soot.

If she hadn't caused this fire, Levi wondered what she was looking for. This must've been the real reason she'd led him here—he doubted she needed any preparation to publicly chew him out, at this point. If anything, she'd probably been looking forward to it.

Rather than fight, he decided to play along. "For the fire to burn only one building yet leave the rest of the pier untouched, I'd guess this was the work of someone's talent. What kind of business was it?"

"A gambling den, and it's not the only building that burned." Enne pointed down the pier, to the second site of a devastating fire. Then she nodded to the third pier, where Levi counted three gaping holes in its line of white buildings. Like a smile missing teeth. "Was it you?"

His mouth dropped open. "Me? Why would it be me?"

"You have a talent that involves fire."

He snapped his fingers, igniting a spark that hovered above the tips, then quickly blew out from the blustery sea wind. "Yes, tricks. I'm no fire-maker. I can't control it. Isolate it." He glanced around the rubble with a heavy frown. "And whoever did do it knew how to cover their tracks. You won't find any evidence here." When Enne only furrowed her brows and didn't respond, he grunted, "We're going to the first pier. We're getting this over with."

She didn't argue as Levi took the lead, grasping her hand and tugging her oh-so-romantically in the direction of the scents of cotton candy and saltwater taffy. Gone were the enterprises catering to all manners of vice, replaced by rides, games, and workers in summery, out-of-season costumes. An artist had painted beachy animals along the wooden planks below their feet—turtles, crabs, and seagulls. Sometimes Levi forgot there even were kids in the City of Sin. Then he remembered he'd been one, when he'd arrived. He hadn't felt like it.

As Enne had warned, a flurry of photographers flocked them as they approached. Considering this was supposedly the scene of their breakup, Levi made sure to don a sour expression. It wasn't difficult.

"How are you adjusting to your new role in the National

Bank?" one reporter asked Enne. "It must be dreadful to spend so much time apart. You've hardly been out together for a month."

"A month? Has it really been so long?" Enne asked, smiling widely while she squeezed Levi's hand in a death grip.

"How did you two spend your birthday? Did he get you any gifts?"

"We wanted to do something more private. I cooked," Enne answered.

Levi knew full well that Enne's culinary prowess began and ended at sweets. He almost laughed when he imagined such a night, swallowing down whatever burnt meal she'd served him and glaring at each other over the table.

"Now, if you'll excuse us, I'd like to ride the ferris wheel," Enne said sweetly, pulling Levi away.

"That death trap?" Levi asked, his mouth going dry as he peered up to its top. "You sure bumper cars wouldn't make more sense?"

"I have no fear of heights," Enne said simply, then strode toward the ride. She was punishing him, but the joke would be on her if they both fell to their deaths. He cursed under his breath and stalked after her.

Despite the frigid weather, because the attractions were so new, the pair were forced to wait in a long line for the ride. Levi hadn't been in a crowd like this since the inauguration ball, and even if it was mostly comprised of parents and children, standing there made his heart pound.

We have our pardons now, Levi assured himself logically. But his father's voice was always louder, reminding him that it was better they were apart.

By the time they made it onto the ride, Levi was sweating despite the cold.

"Oh, it won't be that bad," Enne said, rolling her eyes. "It's no higher than your penthouse suite at St. Morse."

Hearing Enne's tone, the ride operator shot them a surprised look.

Levi glowered as their seat rose higher, as his stomach dropped lower. "So I guess it's showtime, then? Better make sure it's over-the-top. Our audience can't hear us from here, but they can certainly see us."

"Good, because I've rehearsed what I'd like to say to you, since it's the last time we get to speak," Enne said, and her words struck him more than they should have. He hadn't considered this outing through that lens—he would never speak to her again. "Firstly, you are a coward. If you'd never wanted to see me again, then you didn't have to use the Chancellor's contract to do so."

"Forgive me for prioritizing your survival," he said dryly. "And I don't recall forcing you to sign that contract."

She crossed her arms. "You made it clear what you wanted— just like you have for months. That you can't stand the sight of me. That every moment of our romance has been an irritation, a—"

"I don't like performing," Levi said flatly.

"All you *do* is perform, Levi! Isn't that what you've been doing since we last saw each other? Buying decorations for the casino you don't even want?"

He flinched—he'd never told Enne his feelings about the Legendary. "How do you know that?"

"Because I know you. Because I loved you," she said fiercely, and Levi noted that she had not fallen victim to his same mistake—she'd clearly used past tense. She hugged her arms to herself. "It's not fair, what you've put me through since last November. I know you didn't agree to this romance, but you didn't need to toy with me the way you did at the ball. And

it's not fair that you've blamed me for Jac's death, when you played as much of a role in it as I did. If you—"

"Don't," Levi gritted out. "I don't want to talk about this."

"I don't care—I do. If you'd never made that deal with Harrison, you would've never betrayed Vianca, and she wouldn't have made me kill him. And I'll have to live with that forever. But you'd rather blame me than blame yourself."

Levi squeezed the cold metal of the edge of the compartment. "Vianca was a monster, and I spent three years working for her. Trapped. I don't regret helping Harrison and giving myself something to hope for. In my position, you would've done the same."

"And in mine, you would've done the same, too," Enne shot back. "I've killed Sedric Torren and two whiteboots—I haven't forgotten, even if I did it to survive. But you also killed Chez and Semper. If it'd been you, you would've had the thought, too."

Levi felt his normally expert poker face slipping. She was right. It wasn't fair for Levi to force his own guilt onto her. Like him, she'd been grieving these past few months. And she'd been afraid, too.

"I was not toying with you," he said quietly. "I had no idea the reporters had followed us into the kitchens that night."

Enne gaped. "But...but you never said—"

"I thought I'd made it clear, but you still couldn't see otherwise. Despite, as you said, knowing me so well." Levi swallowed and stared at the smoke-tinged skyline.

"I'm sorry," she murmured. "I didn't know."

Though silence descended for several minutes, Levi's thoughts were anything but quiet. His confidence from earlier felt muddled. Perhaps he'd made a mistake—a terrible mistake. Though Enne had only been in New Reynes for less than a year, he couldn't imagine his life without her.

But should he tell her that, he would only label himself as twice as selfish. This bargain had not been for volts or casinos or dreams—it had been for her very survival. He couldn't jeopardize that, even if they both wanted to.

As the ride neared the end of its circle, Levi knew he couldn't wait a moment longer. He needed to tell Enne about Veil.

"I love you," Enne cut in before he could speak, just as their compartment reached a stop. "And I'll never forgive you."

Any words he'd planned to say vanished from his mind, and he considered telling her a different sort of truth. *His* truth. That he loved her, too.

But instead, he said blandly, "You will." One day, many months or years from now, Enne would find someone else, a relationship that wasn't tainted by blood or omertas or betrayal. "But before you go, there's something I have to—"

But Enne was already storming off of the ride, clearly unwilling to sit beside him a moment longer. As he followed, she whipped toward him, the sea of reporters flooding around them both. Tears that he guessed were very real streamed down her cheeks. "You know, I don't think the truth changed anything. In fact, I think the truth is worse!" she shouted, several cameras flashing behind her with all the rage of crackling lightning. "You're still a coward."

"I'm sorry," he started, walking closer. But when he reached to grab her hand, he was met with a slap across his cheek. Performance or not, he winced. The cold made it sting.

"Don't apologize to me, not now," Enne told him, then she lowered her voice. "Because how could I ever know if you mean it?"

Then she fled, leaving Levi alone amid the hungry greed of these strangers, realizing he hadn't been able to tell her about her father. He watched her disappear down the pier with his thoughts in a web of knots.

You're safe now, his father whispered proudly, as though his father had ever praised him.

I made a mistake, whispered something else, muffled by his own fear.

The reporters pressed against him, ignoring all decency of personal space. His throat felt tight.

"Does this mean the end of your and Miss Scordata's relationship?"

"Which one of you do you feel is the guilty party?"

"Do you have anything to comment?"

Levi churned over his words, knowing he should say something with finality, to cement the display they'd just given. After all of this, now was not the time to hesitate.

A scream tore across the boardwalk, icy as the nautical wind.

Run, his father told him, but Levi ran toward danger, not away from it. The scream had clearly been female.

He shoved past the reporters, past taffy stands and cheap jewelry stores, until he found Enne behind the booth of a caricature artist. It was away from the crowds of boardwalk attendees, and he'd imagined she'd escaped here for a moment of solace.

A body lay at her feet.

At first, Levi didn't recognize it. He saw only a heavy overcoat draped across a corpse lying in a pool of blood. The fluid dripped in between the cracks of the boardwalk's wooden beams and left a metallic scent in the air.

The man's head lay several feet away, face-down. Levi realized, even without turning it over, that the gray, receding hairline belonged to Aldrich Owain. And the death bore the unmistakable mark of Scythe.

"This is Scythe's second kill," Levi said hoarsely. "His third card." It was the first act in Bryce's game that hadn't been merely to secure a player's safety...but to play to win. Levi had been so preoccupied with their pardons these past three months that he'd forgotten the threat of the golden Shadow

Cards. There was more to throw their lives in peril than a simple contract.

Enne looked up, her horrified expression mirroring his own, but she didn't have the chance to say anything before another camera flashed.

ENNE

In the cover of darkness, Enne freed a bobby pin from her hair and slipped it inside the gate's padlock. Though it had been some time since she'd honed her lock-picking skills, her fingers instinctively searched for the mechanisms. She pressed her ear against the cold metal until she heard the final, satisfying *click*.

She repeated the same procedure with the front door. The wind howled around her, tearing through the barren trees and rustling their branches. The freezing temperatures made her nose and lips sting, but she knew it wouldn't be prudent to wait until morning. In the quiet streets of Olde Town, night concealed her identity better than her old colored contacts ever could.

Once inside, she stripped off her heavy scarf and boots and crept upstairs, her pulse drumming against her every pressure point. The Empress card seemed to burn so hot in her pocket that her coat might as well have been letting out steam.

She paused in the hallway. Fractured moonlight spilled onto

the tiled floor from the grand window, offering a glimpse of Olde Town's jagged skyline and the South Side beyond it.

Enne's hand paused over the doorknob, wondering if her actions would damn them both. *Her* life she was willing to jeopardize, but his?

She shook her head. Their pardons were meaningless if Scythe beheaded one of them or their friends before dawn. Besides, Enne had no intention to stay long. She'd come only with a final request, one she wasn't sure Levi would fulfill. But she hadn't been able to ask it at the boardwalk, even in the privacy of their ferris wheel compartment. It was too dangerous. And it made tonight the last chance she had left.

Enne opened the door, wincing as it creaked. The blinds were drawn, so only a sliver of light sliced through the room as she slipped inside. She closed it carefully, not daring to draw a breath. She reached into her pocket and squeezed her tokens for support.

Despite her attempts at stealth, the bedside lamp switched on, making her squint and stumble back in surprise. Levi sat beside it on his desk chair, his elbows resting on his knees, his gun clutched in his hand.

Enne yelped back in shock. "What—what are you doing?" she breathed.

"Shouldn't I be asking you that?" Levi shot back, his voice heavy like lead. He didn't point his pistol at her, but he did tap it lightly. A threat. "I knew you'd come."

"You did?"

"Of course I did. I knew what you were thinking. That Scythe has already killed two players. Any one of us could be next. And even though I'm your target, I've never offered you my card. So you came to take it."

His words left a burn in her throat like she'd sipped a Gambler's Ruin. "Is that what the gun is for?" she demanded.

"Don't bluff. You have yours in your pocket."

Cowardly *and* thickheaded. Enne lifted her hand out from her coat and dropped the tokens she held. They clinked to the floor, piercing the tense quiet of the room. "It seems," she said icily, "that despite how well we both claim to know one another, we cannot always guess each other's mind."

Levi cursed and set his pistol on his nightstand. "I'm sorry. I don't know what I was thinking. I've been on edge ever since we found Owain."

"You thought I would shoot you?" Enne asked furiously. "After I was forced to shoot Jac, I can't even hold my own revolver, but you thought I'd steal here in the night and shoot you while you slept? What sort of monster do you take me for?"

He looked as though she'd slapped him again—this time for real. "You were right about everything you said this afternoon. I shouldn't have blamed you for Jac's death. I should've never made plans without you. I should've never acted as though we weren't..."

"Weren't what?" she prodded.

"Partners," he breathed. "But you know how it would look if someone saw you come here."

"Yes, which is why I was careful and why I won't loiter. I only came to ask you a question."

"Then ask me," he told her, his gaze intent.

"If your claim that you accepted the pardon for my own survival is true, if you love me but value my life more than us together, then you will give me your card. Because if this game continues, I'll be doomed without it. I know it, and so do you."

Levi sucked in his breath, then he reached into his pocket and pulled out the Emperor. But he didn't hand it to her.

"Is it because you don't trust me?" Enne asked softly. Relinquishing your card was putting your life in someone else's hands.

"No, no, it's not that," Levi muttered, so quietly that Enne had to tread closer. She removed her coat and rested it on his

bureau. "There's something that I never told you, about the pardon."

Enne's eyes widened. "What do you mean?"

"Before we met with the Chancellor, Lola came to visit me," Levi said. "She came upon some information concerning your lineage—she dug far deeper than *The Crimes & The Times* has ever managed."

"My...lineage?" Enne repeated. Of all the subjects they could've discussed tonight, this was not one she'd expected.

"Your father was Veil," he told her carefully. "He was the bastard son of a member of the royal family, hidden to avoid scandal before the Revolution, which is how he survived after. It's why Veil always kept his face covered—to hide his eyes."

Enne felt the truth spread through her like a wildfire. Her entire story, her entire identity seemed to slip from her grasp as her memories were cast in a harsher, grimmer perspective. She felt the illusion of a sea breeze sweep across the harbor as a girl clutching a guidebook took a weary step onto dry land—as though all of New Reynes had hitched its breath, remembering the child who'd been born there, the daughter of its most infamous crime lord, who had once brought the city to its knees. She imagined herself standing over Levi's shoulder during the Shadow Game, watching the moment her eyes shifted from brown to purple. She watched the crowd as Jonas hanged, at the same place where her father had hanged for being a criminal, and her grandfather before him for being a royal.

Enne wanted to speak, but she hadn't found the right words before Levi continued. "I supported you signing the contract because I was scared that, should this information come to light, there wouldn't be a contract. I was too nervous to fight it, when it seemed like your only chance at a pardon or happiness."

"Happiness?" Enne repeated deliriously. "What happiness is there for me, with a legacy of such destruction and evil?" She held her head in her hands. "What does this *make* me?"

"I didn't want to tell you because, well…" He watched her sadly. "I didn't want to hurt you."

She let out a snort. "It's a bit late for such concern."

"I know, and I'm sorry."

Enne leaned against the bureau to steady herself. The revelation that she was a Mizer had been difficult. It meant that Lourdes had lied to her, that Enne's own understanding of herself was built on fallacy. And it branded her with a history that she'd never wanted.

But this time, it felt different. There were no more shadowy alcoves in Enne's past, hiding her secrets. The light had finally been cast, and with it, Enne felt a sense of rightness. As a criminal, Enne hadn't merely survived on the streets of the City of Sin; she'd thrived, and now she knew why.

Enne let out a cry, not from sadness, but from triumph. Any guilt she had felt from being too much of a gangster or too much of a lady vanished. She could be both without contradiction. This had always been her story.

"I don't know what to say," Levi said softly. He opened his mouth to speak again, but for once, he must not have had anything clever to argue, because no sound came out. He looked utterly at a loss, and Levi Glaisyer did not wear hopelessness well. It sagged at his shoulders, bled a bruised violet beneath his eyes.

She laughed and wiped the tears from her cheeks. "Once again, you're interpreting me entirely wrong. I'm relieved."

"How can you possibly be relieved?" he asked. "You know what this means if Fenice finds out."

"I think for all the same reasons that you don't look at your casino with any pride," Enne answered. "It doesn't feel good to question who you are."

"And now that you know…" Levi eyed her warily. "Should I be concerned? I'm not sure Veil's actions should empower anyone. I should know—I'm the one who idolized him."

"I wouldn't say empower, exactly. But..." She shook her head. "I don't know what I want for myself, but this makes me think that...maybe one day I might."

He nodded, staring once again at the Emperor card in his hand. "If it weren't for Bryce's game trapping us here, I think I might leave."

"You'd leave New Reynes?" Enne asked incredulously.

"I don't know. Maybe not forever," he admitted. "But it'd be nice to see more of the world."

Enne's heart ached for him, for this freedom she couldn't give him. Bryce's game was impossible to win without the deaths of at least some of the people she cared about, and she hated to think what it would be like to live inside this curse forever, trapped in New Reynes and doomed to always look over her shoulder. Or worse, to suffer the loss of another friend.

But there had to be a way to win this. Enne and Levi had once played a different game that couldn't be won, and they'd emerged victorious.

The thought gave her an idea. "This game is a shade," Enne said, taking an excited step closer to him. "And shades can be broken."

His eyes widened. "Like the timer. The timer held together the Shadow Game. There's something that holds this game together, too."

"And whatever it is, that means we can destroy it," Enne finished.

Levi took a deep breath, an expression spreading across his face that Enne gradually recognized as hope. Hope, she realized, that *she* had given him.

He reached out and grasped her by the hand, tugging her until she stood over him. Enne fought the urge to jolt back at his touch, thinking of all the words and false embraces exchanged between them. Her heart had proven to snag on even the flimsiest of lines.

"I swear it," he spoke, startling her even more. "Oath by oath. Blood by blood." The words held no power here, the words of a gangster swearing to their lord. But then Levi reached forward and handed her his card. The Emperor. He gently lowered each of her fingers over it until she grasped it.

"Life by life," he breathed.

Enne had come here for this very card, but now her hand shook to touch it. It felt fragile, the same way their lives felt fragile. With this card, if Enne died, then Levi would, too. And pardon or not, there was no shortage of perils in this city.

His hand lingered over hers, and her stomach knotted as she looked him in the eyes, even in the dimness of the room. She felt a desire seed and sprout inside her, until it felt as though vines constricted the very breath from her chest. It was a hurt. It was a need. The cumulative force of so much time spent longing for him, dreaming of him, and loathing him made her struggle just to stand upright.

But she had made many mistakes where Levi was concerned, so all she murmured was, "Thank you."

He nodded, his gaze never straying from her own.

A silence followed, begging to be broken.

"Tell me what you want," Enne blurted out, without a degree of restraint. Her cheeks flushed, knowing her many attempts were unbecoming—or worse, pathetic—but if she was about to flee this museum before daybreak, for good, then she would leave nothing behind. "You know what I want."

Levi interlaced their fingers.

"There's no one I've risked my life for more," he told her seriously. "And nothing I wouldn't risk now if it meant I could be with you."

He tugged her closer to him, and it should have felt familiar, to sit on top of him, her legs straddling his waist, her chest pressed against his. But it didn't. It felt treacherous. After all the mistakes she'd made, she no longer trusted herself with power.

But she'd missed *this* power. How it felt to slide her hands against his stomach and feel him tense beneath her. How it felt to rest her head against the crook of his shoulder and feel him shudder. It was the sort of power that made her broken throne feel sturdy enough to support her. Whatever her mistakes, whatever her story, she would not fall.

Though Enne might've prolonged this control for longer, if only to relish it, Levi cradled her face in two hands and lifted her lips to his. It was a soft kiss, as though each feared the other might shatter. His touch only ever seemed to graze her, his fingers tracing up the curve of her waist or sleeve of her dress. She squeezed his shoulder only enough to hold herself upright. They had done terrible things to each other. They had made each other paper-thin.

But that was all right. Tonight, Enne wanted to feel herself shatter.

Moving faster now, she unbuttoned his shirt, and he shrugged it off and tossed it aside. His fingers clawed against her back as he unlaced her dress, and she slipped it off her shoulders and pressed herself against him, the fabric bunched against their stomachs, their skin warm and slick with sweat.

"Since, as you said, we cannot always guess each other's mind," Levi said, "tell me what *you* want."

Levi's breath was warm against her neck, but Enne still shivered.

In answer, she stood and stepped out of her dress. He watched as she unfastened her stockings and tugged them off, as though still unsure what she meant. Even in the weeks they'd been together, they hadn't slept together. It wasn't a question of morals—Enne had certainly abandoned her old finishing school's mind on such matters when she'd dubbed herself a Sinner. But it was because she hadn't been ready.

And despite the months apart, Enne felt different now. This wasn't giving herself to someone else, as though she was a bar-

gain of her own. She knew herself now, wholly and unflinchingly, and that wasn't something that could be lost.

"Could you unlace my corset?" she asked, her voice wavering slightly.

"Are you sure?" he asked.

"Yes," she responded, but that didn't mean she wasn't nervous. She turned her back to him and shuddered as she felt the contraption's tight binding release, little by little, until Levi discarded it on the floor. Then she worked up her nerve and pulled off her chemise so that she stood in nothing but a pair of thin silk shorts.

She turned, the only thing quelling her embarrassment as he looked at her was her own yearning to look at him. She led him onto the bed.

Levi kissed her everywhere, taking his time, as though he also felt there had been far too many nights squandered hating one another when they could have been doing *this*. But the wanting made Enne feel taut, like a finger pressed against a trigger without release, and there was one place he hadn't kissed.

When she asked him to, her words spilling out as her lips roamed his chest, he looked nervous. "I've never been with a girl before. I don't know what…" He cleared his throat. "Not that I'm not eager to learn."

"Don't worry," Enne answered, grinning. "I know myself. I can tell you what I like."

While Levi obliged, he raised his hand and interlaced his fingers with hers. She was glad for something to squeeze onto the moment she felt herself shatter.

Afterward, he moved on top of her. He breathed heavily. "Please tell me this is not the last time. Even if I have to march personally into the Chancellor's office and tear the contract into—"

"This is not the last time," Enne swore, though that didn't

mean she knew what their future held. Their relationship would transform from a public affair to a dark-held secret.

"Whatever happens," Levi spoke, "we will protect each other. We're in this together."

Enne kissed him fiercely so that his words would stain her own lips. She could taste herself on him, and she liked the taste of this secret.

She liked all of it, the weight of him on top of her, the ardent way he looked at her, the sound they both made when there was no closer for them to go.

After they finished and lay together for several minutes in the rightness of it, Enne reached over and grabbed their two discarded cards from the nightstand: the Emperor and the Empress. "Tell *me* there will be many times," she said softly, her mind returning to the gruesomeness of the earlier murder.

"I can't promise you that," Levi answered hoarsely.

"Promise me anyway."

He slipped his arms around her and held her tightly. "I promise."

Enne turned and buried her face against his chest. Two months ago, Vianca had instructed Enne to break his heart, but she could still hear it beat. She could feel her own, still rapid from lack of breath. And she wondered how many times it would take for their lives to stop feeling breakable.

XII

JUDGMENT

"The first casualty in the Revolution
wasn't a rebel—it was a bystander.
Remember that."

Ventriloquist. "Establishment Day."
The Treasonist's Tribunal
6 Nov YOR 3

HARVEY

Harvey had gotten good at washing dishes. He volunteered to do them every day because Narinder always kept his office door ajar, and Harvey could look in, from the sink. Narinder hummed while he worked—Harvey didn't even think he realized it. He tapped his pencil rhythmically against his ledger.

Harvey wished he had a talent like that. Music. Sometimes he felt like there were some talents in this world that suited good people.

Not his.

"Will it be busy tonight?" Harvey asked.

"Probably not," Narinder responded from his office. "It's a Wednesday."

But it'd been consistently busy, since curfew had been lifted. Narinder didn't like to talk about politics, Harvey had learned. He didn't listen to the radio, didn't subscribe to *The Crimes & The Times*. Even when the other musicians had discussed the

National Bank and whether or not the wigheads should've pardoned Séance, he never joined in.

When Harvey had explained the rules of Bryce's game to him, Narinder had asked, *Why me? I'm not a player.* Ever since then, it was as though he was performing. Keeping his head down, his nose in his ledgers, his hands busy with his violin. As if trying to prove the city had made a mistake.

It made Harvey feel bad for watching him like he did.

Complicit, his conscience whispered.

The phone rang in his office. "'Lo?" Narinder answered, while Harvey scrubbed the grease off a skillet. "Why are you calling me? Is it Tock? Is she all right?"

His voice was sharp, like a broken harp string. Harvey turned off the faucet to listen.

"It's been months," Narinder snapped. "I don't play host anymore. Or boyfriend."

Now Harvey was more than curious. He stopped scrubbing.

"I don't care. Call someplace else."

Narinder hung up and sighed deeply. Harvey stuck his head in and smiled. Not *smiled* smiled—he hadn't used his talent since he'd left the Guild, not even when Rebecca came in January— but he wanted to show support. "Who was that?" he asked, fighting to keep his voice nonchalant.

"Pup," Narinder answered. He rubbed his temples. "He wants to…" Then his voice trailed off, and he glanced at Harvey warily. Harvey didn't like that look. "Never mind."

"Never mind because it doesn't matter? Or never mind because you don't trust me?"

"It's about the game." Narinder dropped his gaze, and so Harvey realized it was the latter. Then Narinder stood up and brushed past Harvey, squeezing through the narrow kitchen. "Forget about it. I should get ready for tonight."

"Wait," Harvey said, following him. "If it's about the game, I want to hear it."

"Of course you do," Narinder muttered.

"What does that mean?"

"You want to make sure Bryce is all right."

Harvey stumbled hearing Narinder say Bryce's name. They'd never talked about him and Rebecca and the Guild, not explicitly.

"I—I'm not a spy, if that's what you think," Harvey stammered. "You can trust me. I owe you."

"It's not about debt."

Harvey winced, knowing that was a dig at his talent. He knew Narinder didn't tally every favor Harvey owed him, but Harvey couldn't help thinking that way.

Narinder strode across the empty dance floor, but Harvey didn't let him walk away. He grabbed him by the forearm and spun him around.

"Call Levi back," Harvey said firmly. "Whatever it is, I want to help." And he meant it.

Something Harvey didn't recognize flashed through Narinder's eyes. "So you're done, then? With him?"

"I haven't gone back, have I?"

"Say it, then. Say you're done with Bryce Balfour."

Harvey swallowed. Part of him was ready to say it. It hadn't been long, but he liked life here, in the Catacombs. He liked honest work. He liked Narinder's company.

But certain memories of Bryce had sunk themselves into him. It was why Harvey had stayed so long even after Bryce started seeing Rebecca, after everything went so wrong. There were some people who could carve their names into your soul. In a romantic story, the soul was a willow tree. In their story, it was a tombstone.

"I'm done with Bryce Balfour," Harvey said hoarsely. He hoped it wasn't a lie.

A muscle in Narinder's jaw twitched, and he turned around. "Fine. But I'm not calling Levi back."

"Why not?" Harvey demanded.

"Because I'm done hosting his little meetings. I'm not risking my life for him."

Harvey remembered how Levi had used the Catacombs for a gathering place before. Harvey had attended one of those meetings himself.

"Is it about him?" Harvey murmured nervously.

"No," Narinder snapped, then he added, quieter, "A little. But mostly not."

Harvey could guess what had happened between them—Narinder, in particular, had a reputation, though Harvey had never seen him keep late-night company since he started working here. Still, Harvey wanted to ask. But although he and Narinder might've been friends, it wasn't Harvey's place to pry.

"It sounded like it was about the game," Harvey said instead, "and you're a player, too."

"I never asked to be," he growled.

Narinder stopped walking, standing beneath the golden light of a stained glass window. Even if Harvey remembered when this club had been a church, he couldn't deny that Narinder belonged in this place. The light followed him, reflecting like embers across his dark skin. The walls, plastered with bones, echoed his voice more than anyone else's.

Maybe Narinder didn't mean to, but he looked important. He looked like someone worth knowing. He looked like a player.

"I promised myself when I bought this place that I wouldn't get mixed up in that," Narinder said fiercely. "The North Side got my uncle, my father. Tock always wanted it, and I couldn't stop her. I thought Pup was different, but he's not—none of them are. I don't want glory or whatever else this city is selling. I just want to live my life. And I'm not willing to put that on the line. Not for anybody."

Harvey realized what that look had been, now. When Har-

vey had said he was done with Bryce. He'd done what he never thought himself capable of doing, and even if he was still sick in many ways, he was better for his decision. But Narinder wasn't willing to do the same.

"I'm sorry, but you don't have a choice. Your problems won't disappear if you ignore them," Harvey told him. "So call Levi back. Tell him you'll do it."

The musician froze.

"I don't deserve this," he whispered.

Harvey's conscience tremored. "I know."

"And I...I'm scared."

"I'm scared, too," Harvey told him. "But if you don't call Levi back, I'll find him. I should..." He swallowed. Rebecca had been right to suspect Harvey. It'd taken Harvey years too long, but he was finally ready to betray his best friend. "I should be helping him."

Narinder bit his lip, and Harvey tried not to stare—even if staring at him was all he'd done lately. He wondered if Narinder ever stared back.

"Fine," Narinder breathed. "I'll talk to him."

ENNE

"How many people will come?" Enne asked, sliding into a chair at the head of the rickety table. Already the small private room above the Catacombs had run out of seats. Levi took the place beside her. Grace, Roy, and Tock across from them. Narinder and Harvey claimed the last chairs.

"I'm not sure, but Harrison mentioned *he'd* be here," Levi told her darkly, nodding at Harvey.

Enne didn't want to look at the Chainer. The last time they'd seen each other, Harvey had dragged Jac's body out of St. Morse. He looked better now, his curls freshly cut instead of wild, his posture not so slouched—but maybe that was because Enne had only ever seen him in the darkness of Bryce's shadow.

"I don't remember inviting you," Levi told Harvey gruffly. "In fact, I think you should leave."

"*I* invited him," Narinder answered tightly.

Harvey scanned the room as though counting the number of weapons in it. He swallowed. "I want to help," he rasped.

"Oh, I think you've helped enough," Levi grunted.

"Who is he?" Enne heard Roy lean over and whisper to Grace.

Grace sighed. "Sometimes I wonder if you're just meant for decoration." But even so, Enne spotted them interlacing their fingers beneath the table.

Levi gave Enne a pointed look. Enne didn't trust Harvey, either, but that didn't mean he wasn't useful. He knew more about Bryce and Rebecca than any of them, should he be willing to divulge their secrets. But her and Levi's partnership was still new and tenuous, and she didn't want to argue.

"You should leave," Enne told Harvey.

The hurt in Harvey's face shouldn't have cut her like it did. After all, how many afternoons had she and Lola spent at the Guild while Harvey had lied through his smiles? His grin was like a crocodile's, always bearing its teeth. She should know better.

Anger coursed across Narinder's face. "I wouldn't have agreed to this if—"

"Don't bother," Harvey mumbled, standing up, his expression grim. "I'll just—"

But as he turned around, he bumped into Harrison Augustine in the doorway. Dressed in a very non-South Side checkered suit and flanked by three girls, Harrison had never looked more like the heir to a criminal empire. He and Sophia Torren wore matching somber expressions, while the two other girls—arm in arm and smelling of department store perfume—clearly did not belong.

Enne's eyes widened as she recognized one of them: Poppy Prescott, her companion at all of Vianca's South Side parties, and whom she hadn't seen since November. In the Spirits' white gloves and without her contacts, shame snaked in Enne's stomach. Every interaction with Poppy had been a lie, and her old friend would obviously hate her for it.

But instead of glares, Poppy's face brightened when she saw Enne. She waved.

Harrison placed his hand protectively on Harvey's shoulder. "You can stay," he said, then he claimed Harvey's seat, leaving him and the three other newcomers to stand along the wall. Harrison's lips formed a thin line as he inspected the room—the cheap Faith memorabilia on the walls and the pitcher of cheaper beer at the table's center. "Well, I should've expected this when Levi said you were hosting such a meeting at a *nightclub.*"

"This is a respectable business," Narinder grumbled at the same time Levi smirked and said, "Right, Pop. Thanks for coming."

Harrison scowled. "So...is this everyone?"

Tock's gaze flickered to Enne's, and Enne stiffened, guessing the reason for the heat behind her gaze. She would've tried to contact Lola if she had any idea where she was, and judging from what Levi had told her, her second obviously didn't want to be found.

Enne cleared her throat. "Yes. There are eleven of us here. We make up half the players in the game."

"More than that," Sophia said quietly. "Now that four of the players are dead."

A somberness settled over the room. The music downstairs, though distant, pulsed faintly through the floor. It felt as though the City of Sin was out there, and them in here. Or maybe it was the other way around. New Reynes wasn't lights and cards and debauchery—it was the blurry line between friends and enemies, the smile of someone you used to know, the ghost of a victim gone, the dagger edge of a legend.

Enne took it upon herself to break the silence. "The death count will only rise if we don't do something about it."

"But there's no way to win the game," Poppy said, brandishing a pink notebook. "Not with all of us surviving."

Grace's eyes lit up at the appearance of a chart. "Can I see

that?" Grace asked eagerly, and Poppy handed it to her. Grace reached into her pocket and pulled out a pencil. The room waited as she scribbled in more names, the ones Poppy didn't know. "We can finish this chart. Most of it, at least. You," she barked at Delaney. "What's your name and card?"

CARD	OWNER	★TARGET★
The Star	Poppy	The Empress
The Empress	Enne	The Emperor
The Moon	Delaney	The Tower
The Tower	Scythe	Temperance
The Wheel of Fortune	Sophia	The Star
The Lovers	Harrison	The Sun
The Sun	Zula Slyk	The Wheel of Fortune
The Fool	Harvey	Judgement
Judgement	Narinder	Fenice
Strength	Jac	Death
The Magician	Bryce	The Fool
Temperance	Creighton	The Hierophant
THE EMPEROR	LEVI	STRENGTH
THE HANGED MAN	HECTOR	THE MAGICIAN
THE HIEROPHANT	OWAIN	
THE WORLD	FENICE	THE LOVERS
The High Priestess	Grace	The Moon
Justice	Roy	The Hanged Man
The Chariot	Tock	The Devil
The Hermit	Lola	The Chariot
The Devil	The Bargainer	
Death	Rebecca	The High Priestess

"Delaney Dawson. The Moon," she answered. Enne recognized her from tabloids—she was Poppy's rival and ex-girlfriend. Or, judging from Delaney's arm wrapped around Poppy's waist, maybe not as ex as she'd thought.

"You're my target," Grace told Delaney matter-of-factly, and Delaney stiffened, nervously regarding Grace's smudged

rings of eyeliner and black clothing. "Enne, you're Poppy's target."

Enne didn't know if she should cry or let out a sigh of relief. Poppy wouldn't hurt her, she didn't think. But could Enne really surrender her card to Poppy? Put her life in Poppy's hands? Poppy was the least North Side here.

"Harvey, what about you?" Grace asked.

His face reddened. "I was Bryce's target," he said. Enne noted his past tense. Harvey had already given Bryce his card. "Narinder is mine."

"Mine is the Chancellor," Narinder said darkly. Beside her, Levi stiffened.

Grace squinted at the chart. "Delaney, your target is Scythe, who has to be the Tower. And Bryce is Hector's target. And that means...Roy, you're Scythe's next target." Her voice wobbled a bit, and the room went silent. Thus far, Scythe was the only person playing to win. Playing for blood.

Roy stared at the table, seemingly determined not to acknowledge what she'd spoken. Not even when Grace reached across and squeezed his hand tightly. Then he leaned forward and poured himself a glass of the cheap beer. He passed servings around the table, not bothering to see whether or not each recipient declined. Enne stared grimly at their circle of untouched glasses.

Grace cleared her throat and continued. "That leaves Lola, Rebecca, the Bargainer—"

Enne struggled to envision all of the game's schematics— it was too complicated. "Why are we doing this?" she asked, so sharply Tock choked on the sip of beer she'd finally drank.

Grace tapped her pencil against the chart impatiently, the same way she might a statement of accounts at the bank. "If the game ends and we don't have our target's card, then we—"

"The game can't end without some of us dying, anyway," Enne snapped. "It's impossible. And even if we give each other

our respective cards—to give too many is a risk. If one of us dies, we could all drop like dominoes."

Harrison looked around the room thoughtfully, his finger swirling around the rim of his glass. "So who here has already given up their card?"

Levi, Harvey, and Grace raised their hands. The most vulnerable.

"And who here has their target's card?"

This time, Enne, Harrison, and Levi raised their hands.

"So we're the only three who will survive if the game ended tonight," Harrison said, sighing. Downstairs, the music seemed to grow louder, along with voices singing along to the lyrics. Enne wondered how Narinder could stand it, living his entire life serving a grand party. She'd be happier if she never attended a party again.

"This is why we can't win the game. It's impossible," Enne declared, clutching Levi's hand under the table. The group had finally reached the same impasse as Enne and Levi last night, which meant the reason the two of them had summoned everyone had arrived. "The only way for us all to survive is to break it."

"Break it?" Tock repeated, confused.

"You'd have to destroy the object the shade is cast on," Delaney explained, furrowing her eyebrows. "Bryce could've cast it on a coin and tossed it in the Brint, for all we know. We'll never manage it."

"That doesn't sound like Bryce," Harvey muttered, and the room's attention turned to him. He crossed his arms, as though trying to make himself small. "Bryce doesn't care about *things*. That's not him."

"That's how shades work," Delaney snapped.

"Well, wait," Levi cut in, looking at Harvey. "What do *you* think the game is bound to?"

"It's obvious, isn't it?" Harvey said darkly. He closed his eyes

and leaned his head back against the wall, almost like he was praying. "Who is the one person Bryce would want to keep alive during all of this? What does Bryce care about right now more than anyone?"

"Rebecca?" Poppy asked.

"What? No." Harvey shook his head. "She already corrupted a shade by binding it to herself, and she's dying from it. It can't be her."

"So you mean the Bargainer," Enne said, her eyes widening.

"You mean if we kill the Bargainer, we break the game?" Grace asked. She cracked her knuckles. "Then what are we waiting for?"

Sophia snorted. "Do you even know how? She has dozens of talents—maybe hundreds."

"But we think she's sick," Poppy said. "Sick like Rebecca."

"That doesn't change anything," Harrison said. "You remember what it was like to shoot at Bryce at St. Morse? How the bullet passed right through him?"

"That's only because he's the Gamemaster," Harvey said. "He's protected. You can think of killing him like cheating. It doesn't work. It isn't because he's a malison. It's because he's the malison who created this."

"That's a shame," Grace muttered, "because I'd like to kill him, too."

"Wait, wait," Delaney cut in, slamming her hands on the table and making Roy's glass spill all over his pants. "Oh—sorry. But Bryce couldn't have cast the shade on the Bargainer unless he owned something of hers. Or if he was connected to her in some way."

"That would've been easy, as they were once both connected to the House of Shadows," Harrison said. "Same as you."

Delaney flushed at his comment, and Enne realized that fact was a secret she hadn't wished shared. Saving her from em-

barrassment, Enne quickly interjected, "So are we saying this is possible?"

"We're saying she's someone who could be as fast as Chez Phillips, as strong as Jac, as smart as Grace—and who can make shades like Bryce and Rebecca. And who knows what other talents she has," Levi breathed. "That's what we're saying."

"It's eleven against one," Roy said.

"And I still wouldn't bet on those odds," Levi muttered.

Enne squeezed Levi's hand harder. "We don't have a choice," she said. Her words might've been bleak, but she didn't feel defeated—far from it. Whether or not Enne was close with every person in this room, they were capable and clever, and they were her allies. And if they were destined to lose this game, then they would all go down fighting.

"Do we even know how to find the Bargainer?" Harrison asked.

"I do," Tock murmured.

Tock had been silent for most of their conversation, and so the eyes in the room turned to her in surprise. She leaned back in her chair, her arms crossed.

"Would you care to elaborate?" Harrison asked flatly.

Tock gave him the snide look she reserved for all authority figures. "Lola. Lola was the last to see her."

Enne froze, and it was her turn to feel the burn of the spotlight. Everyone's faces shared the same pitying look, as though Enne were the victim of betrayal. When really, Enne was the one who'd betrayed Lola. It didn't matter that Enne had not felt herself, or that she'd been struggling to bear the responsibility for so many lives. What mattered was that Enne had hurt Lola, and Lola would likely never forgive her.

But the idea of Lola making a bargain? Lola had never wanted to be a player.

"How do you know that?" Enne asked weakly.

"She doesn't remember who I am," Tock answered.

"But she was just…" Grace frowned. "She was going through something. She—"

"You think I can't tell the difference between my girlfriend leaving me and forgetting me?" Tock snapped with the kind of fierceness that made even Grace back down. Or, at least, made Roy put his hand on Grace's shoulder to *hold* her down. "She sold it. She sold us."

"She was *our* friend, too—" Grace hissed at the same time Roy asked, "But sold for *what*?"

"No. No, it makes sense now. Why didn't I see it before?" Levi rapsed. He white-knuckled the edge of the table. "Last I saw her, she told me all this stuff about Enne that I don't know how she could've found out. So many records were destroyed. But she knew…"

Enne kicked him under the table, and Levi trailed off, seeming to remember himself.

"What did she know?" Harrison pressed.

Levi swallowed and glanced at Enne warily. "It's that… Well…"

Enne examined each of the faces around them. Even if these were her allies, and even if Harvey was bound under the power of Harrison's omerta, Enne didn't want to tell them the truth about her father, not until she determined what it meant for herself.

When Enne shook her head, Levi squeezed her hand again supportively, as if to remind her they were in this together.

"It doesn't matter," Levi said quickly. "What's important is that, when I spoke with Lola, it was like she'd found her information from the source. Like she'd bargained for it."

It was a lot to process, and Enne couldn't help but feel that she'd pushed Lola into this bargain. But even so, why bargain for Enne's story? A knot contorted in Enne's stomach when she considered the most logical answer: Lola wanted these secrets for revenge.

If Lola told the world, Enne might as well tear the Chancellor's contract and throw its scraps into the Brint.

But if Lola had wanted vengeance, then what was she waiting for?

Enne cleared her throat again. "I should talk to Lola. I'll—"

"I'll find her," Tock cut her off.

Narinder shot his cousin a pitying look. "But Tock... She doesn't even remember you. She'll remember Enne."

"Remember hating her, you mean?" Tock shot back.

Enne cringed but didn't correct her. She'd cost Lola her right ear. She'd nearly killed Lola's brother. And even if Enne didn't deserve her forgiveness, she couldn't help but want to find a way to make things right.

And maybe that meant letting Tock speak with her now.

"If Lola *is* with the Bargainer," Narinder continued, "then it'll be dangerous—"

"Have you been listening? This is *all* dangerous." Tock's expression hardened. "I'm going. Don't try to talk me out of it."

"Fine," Levi said quickly. "See what you can learn. *Everyone* see what you can learn. We can't afford to make mistakes. Some of our lives are tied together here."

When Tock stood up to leave, Levi grabbed her by the sleeve of her military jacket.

"Tock," he murmured, "just don't die."

Tock smiled weakly. "Don't worry about me."

She left, but while the others stood to follow, Enne remained numbly in her chair, trying to decide whether she'd made an enemy of her best friend.

"'Lo," someone said beside her, and Enne looked up to see Poppy. Enne smiled genuinely—she'd missed Poppy these past few months. "You must've always thought I was pretty silly, when this is your real world."

"I never thought that," Enne told her seriously.

"*I* would have."

"I didn't want to lie. It's just that—"

"You're a Mizer and were the most wanted criminal in the North Side?" Poppy smirked and tilted her head to the side. "I'll never understand why you wouldn't share that with *me*, the most glamorous prima ballerina in New Reynes. The only rough around my edges is a mink trim."

Enne laughed, then stood and hugged Poppy. The dancer squeezed back.

"I'm sorry about your father," Enne told her.

"He was in over his head," Poppy said softly. "I am, too. But I have smarter friends than he did."

"You're pretty smart yourself."

"I can't shoot like you, though. Where did you learn that? They don't teach that in Bellamy." Enne didn't shoot anymore, but they'd shared too many grim words tonight to burden Poppy with those details. When Enne nodded at Grace, Poppy grinned deviously. "Maybe I can convince her to teach me. I happen to know a few South Side bachelors…"

"I don't think she's on the prowl anymore," Enne said. They watched Grace and Roy bicker in the room's corner. Enne cringed, knowing they were discussing Lola.

"And you're *not* learning how to sharp shoot," Delaney grunted.

"Enne, this is Delaney, my overprotective girlfriend. Delaney, this is Enne, the—"

"Criminal you've been going to *tea parties* with? Yeah, I can't imagine why I'm overprotective." Delaney shook her head. "I don't know what we're doing here. That girl stormed out of here like she was off to kill the Bargainer herself, but—"

"That *girl* can level an entire building in less than a minute," Levi cut in from beside Enne.

Poppy clapped her hands together in delight. "I *knew* you had a North Side boy. You should've seen the way I squealed when I first saw your pictures in the papers. I was *right*."

Enne flushed. "It wasn't... I mean, at the time, I don't—"

"What Enne is trying to say," Levi said, straightening his tie, "is that she's far more North Side than I could ever aspire to be."

"Oh, I like him," Poppy said.

"Time to leave," Enne muttered, her cheeks heating. She pushed Levi toward the door. "You and I need to talk, anyway."

But before they could reach the exit, Harvey blocked their path.

"I..." He cleared his throat. "I just want to say that I'm glad to work with you. And I'm sorry for..." His voice trailed off, probably because none of them had time to list all the deeds Harvey Gabbiano needed to apologize for.

He held out his hand.

"I'm just sorry," he murmured.

Enne wasn't sure she forgave him, but he *had* been a help. And she was also impatient to talk to Levi. So she shook Harvey's feverishly warm hand, bid him a quick goodbye, and guided Levi into the hallway. Finally, they could have their privacy.

"You shouldn't have given me your card," she hissed. "If we don't manage to kill the Bargainer, what's stopping her from killing me like she killed all the other Mizers? What if—"

"Did it ever occur to you that if Lola is with the Bargainer, she's the one stopping the Bargainer from killing you?" Levi asked.

Enne stilled. "Tock said Lola hates me."

"Lola might've betrayed a few people here, but we all have, at some point or another. And we all want the same thing, ultimately—to survive this game. So we're going to need to learn to trust each other," he said. "Even Harvey. Because that's what it'll take to break this game. This is bigger than just us."

Enne reached into her pocket and clutched her tokens in her fist.

Levi slipped an arm around her waist. He dropped his voice

to a gentle whisper. "Tomorrow, I have something to show you. It's an after, I think. A life once this game is over."

"If we live to see it end," Enne said darkly.

He kissed the top of her head. "We will."

SOPHIA

Harrison offered to drive her home. Poppy and Delaney had stayed at the Catacombs—to dance of all things. Dancing felt like the last thing Sophia wanted to do right now.

A heavy energy hung in the motorcar, as if the air had thickened and she could feel New Reynes' pollution like a wax coating on her skin. The two of them should feel hopeful—even if they didn't know how to kill the Bargainer, they'd learned doing so would break the game. This hell could all be over, and soon.

But Sophia couldn't shake off her fear. The Bargainer had touched so many lives, and so long as Sophia listened to her fragile, self-destructive heart, her Torren talent was a double-edged sword.

"She's saved people," Sophia told Harrison, who sat beside her in the backseat of his private car. The words clawed their way out of her, and she felt like she was retching, breaking. She didn't like being vulnerable. Her own body rejected it, as

though weakness was cancerous. But she didn't want to dance with the girls, and she couldn't sit in Jac's apartment anymore, searching for hidden cigarettes that she could no longer find.

The problem with destroying her Family's empire was that now she had no family left.

"If we kill her, if all her shades break, then there are people who would be hurt," Sophia continued. "There are people who would die."

"This is a dangerous train of thought," Harrison said softly.

"All of my thoughts are dangerous lately." She took a breath, but she couldn't inhale fully, not in this air. Her heart pounded, each beat like a sledgehammer to her ribs. She cracked the window, but the cigar-fumed air of Tropps Street was no better. "Tell me I'm wrong."

"Did you imagine the Bargainer to be a monster?"

"I imagined her to be evil. The way she takes from people... What she did to Lola... It's a trick. It's terrible." Sophia squeezed her hand into a fist. "She should be gone. She shouldn't be allowed to do that."

"Then what's the problem?" he asked.

"The problem is that I can't stop thinking about the people we talked to," she growled. "And I'm scared it's going to kill me. Literally. Because I am the worst Torren at being a Torren, even if I'm the last one left standing."

Harrison gave her the exact look Sophia had been dreading. The kind of look that saw through her red lipstick and thigh-high boots, past the exterior of being intimidating or charming or whatever other people wanted her to be. He saw the grief on her, the sickness. He knew she wasn't taking care of herself, and her shame about it made her nauseous.

She hated this feeling. She hated asking for help even when she needed it.

Jac had felt different—she could see his sickness, too. But

even then, he'd dragged her secrets out of her, and she'd loved him and resented him for how much it had hurt.

"I spent five months in an attic with Leah Torren," Harrison murmured.

These were not the words Sophia was expecting. She'd braced herself for pity, for an obligated sense of comfort. Not for truth.

"Hostage situations have a way of making people get to know one another," Harrison said, with the kind of humor reserved only for the things that ached. "'The Torren curse,' she'd called her talent. The curse of only seeing the world in right and wrong, black or white, heads or tails."

Sophia didn't know much about her cousin. Leah had been Sedric's older sister, the heir to the Family, until she'd been poisoned. Sophia's father hadn't liked to talk about her. Sedric had barely known her. But Charles and Delia had. They'd never described her as anyone different from them, grown up with the conscience scorched out of them.

Maybe they'd been wrong.

"Your guilt makes you a good person," Harrison told Sophia. "But the world isn't black and white, and goodness can't be quantified."

"I *know* that," Sophia snapped. She didn't mean to snap—Harrison didn't deserve it—but it was reflexive. "Of course I tell myself that. It's not about it making sense. It's about the talent. It's inherently broken and mucked up. Sometimes I wish the Bargainer had taken the Torren talent instead, and all my memories with it. I'd be happy then."

"Then the Torren empire would still be alive, and Charles would be don," Harrison pointed out.

Sophia couldn't argue with his logic, as much as she hated it. She wished her mind could be so straightforward and rational.

"I think it's incredible, what you did. I didn't have the

strength to do that when I was your age, when I ran away," Harrison said.

"Jac was the one who did it," Sophia said bitterly.

"Had you not been there, Jac would've given me Delia's name, and I would've sponsored her as donna. Even though I held the same disdain for the Torrens as I did my family." Harrison let out a long sigh. "I'm scared I'm a pawn in all this. I think the last thing this world needs is a return to the time of monarchs, but the foundation of this government is corrupt. It's like a building infested with termites. It would take so little for it to collapse, and part of me thinks that it needs to."

"Another revolution?" Sophia asked, shocked.

He put his face in his hands. "Muck, I hope not. I can remember the Revolution. It was…" He shook his head. "I'm scared that if I try to change the world, there won't be any world left standing. I wasn't meant for this kind of responsibility."

Sophia never expected the man who held one of the highest offices in New Reynes—who'd *killed* for it—to call himself a pawn. To doubt. She didn't imagine Vianca Augustine had raised such a weak son.

But it was his weakness that made him better than Vianca. Not good, but…better.

"Why did you ever use your talent?" Sophia asked quietly. "You said 'trust issues,' but I have trust issues, and I don't try to control people."

Harrison looked away, and in the flashing lights of Tropps Street out the window, she could see his sickness, too. She could even smell it beneath his Maxirello cologne—like something necrotic.

"I loved Leah, and my mother killed her for it," Harrison told her. "I tried to stop her. Leah went into hiding for months, and I thought those months would cool my mother down. They only

made her worse. She *hated* the person I was when I came out of that attic. I'd gone in as a drunken, entitled university student, with my family's empire waiting for me. I'd left…traumatized. Broken. But also good. Well, not good, but better."

Sophia tried not to feel unnerved by how he'd echoed her own thoughts. "You didn't answer my question," she pressed. "After all of that, why would you want to be like her?"

"Because I wasn't like you. I wasn't the softhearted child born into a ruthless family. I was always ruthless," he murmured. "Even though I swore I'd never use my talent, when I did, it was so easy to tell myself that I'm an Augustine. That some talents are inherently rotten. That this is who I am, and there's no use fighting that.

"When we first met, I felt threatened, too. You talked about your family like they were your responsibility. And then when you willingly volunteered for the omerta, when I learned what you'd sacrificed to achieve what you did, I realized that I *am* a monster. No excuses. And I gave you the omerta anyway."

Sophia's sickness might be terrible, but it hurt no one but her. Harrison's wasn't like that. It made him fragile and brittle-boned, and people like that shouldn't have power over others. But that wasn't how the world worked.

"When I asked Harvey to kill Zula with his talent, I got a sick sort of pleasure in it," Harrison continued. "That Harvey could be a Chainer but not use his talent. It felt so…conceited. So I punished him for it."

"Because Harvey made you realize that your destiny is your responsibility," Sophia told him.

"Yeah." Harrison let out a shaky breath. "I could barely look at him tonight. And you… You're sitting here telling me that given the chance to save yourself, you feel guilt-ridden for all the people who you might damn."

"You're making me sound better than I am," Sophia said.

Because, ultimately, Sophia knew her faults better than anyone. She was fearful and manipulative and needy. Even when she tried so hard not to be.

"All those people in that room tonight," Harrison said. "Your friends. Think of them. That is who you'll be saving."

Calling everyone in that room her friend seemed like a stretch. Delaney and Poppy, sure, but the others? Up until tonight, their lives ran separate streets in the City of Sin.

But it did help her. She counted off each of their names: Delaney, Poppy, Enne, Levi, Tock, Grace, Roy, Narinder, Harvey, Harrison. She didn't know how to measure the worth of their lives versus all the others the Bargainer had touched, but they did matter. And they soothed the weight on her conscience.

And myself, she thought, mentally adding her own name to the list. She wanted to save herself, too, if she could. If the sole act of surviving in New Reynes didn't make her a selfish person.

"But what about the others?" Sophia asked. "It doesn't matter how important Bryce decided we all are—what about the people not in the game? Someone needs to worry about them."

Harrison twisted the Augustine ring around his finger. Then he slid it off and tucked it in his pocket.

"Let it be me," he said. "It's my job, isn't it? Let it be my responsibility."

A good man or a bad one? she'd kept asking herself. Because she couldn't, in clear conscience, entrust the fate of this city to the latter.

But he was right. He was neither good nor bad, and Sophia needed to stop seeing the world that way.

She reached into her own pocket and pulled out her dice. They'd vowed to kill the most powerful person in the world, and their chances undoubtedly would be bleak.

She rolled a one and a two.

She looked up. Harrison's head was turned out the window.

"Don't tell me the odds," he whispered. "If you don't mind, I'd rather not know."

made her worse. She *hated* the person I was when I came out of that attic. I'd gone in as a drunken, entitled university student, with my family's empire waiting for me. I'd left...traumatized. Broken. But also good. Well, not good, but better."

Sophia tried not to feel unnerved by how he'd echoed her own thoughts. "You didn't answer my question," she pressed. "After all of that, why would you want to be like her?"

"Because I wasn't like you. I wasn't the softhearted child born into a ruthless family. I was always ruthless," he murmured. "Even though I swore I'd never use my talent, when I did, it was so easy to tell myself that I'm an Augustine. That some talents are inherently rotten. That this is who I am, and there's no use fighting that.

"When we first met, I felt threatened, too. You talked about your family like they were your responsibility. And then when you willingly volunteered for the omerta, when I learned what you'd sacrificed to achieve what you did, I realized that I *am* a monster. No excuses. And I gave you the omerta anyway."

Sophia's sickness might be terrible, but it hurt no one but her. Harrison's wasn't like that. It made him fragile and brittle-boned, and people like that shouldn't have power over others. But that wasn't how the world worked.

"When I asked Harvey to kill Zula with his talent, I got a sick sort of pleasure in it," Harrison continued. "That Harvey could be a Chainer but not use his talent. It felt so...conceited. So I punished him for it."

"Because Harvey made you realize that your destiny is your responsibility," Sophia told him.

"Yeah." Harrison let out a shaky breath. "I could barely look at him tonight. And you... You're sitting here telling me that given the chance to save yourself, you feel guilt-ridden for all the people who you might damn."

"You're making me sound better than I am," Sophia said.

Because, ultimately, Sophia knew her faults better than anyone. She was fearful and manipulative and needy. Even when she tried so hard not to be.

"All those people in that room tonight," Harrison said. "Your friends. Think of them. That is who you'll be saving."

Calling everyone in that room her friend seemed like a stretch. Delaney and Poppy, sure, but the others? Up until tonight, their lives ran separate streets in the City of Sin.

But it did help her. She counted off each of their names: Delaney, Poppy, Enne, Levi, Tock, Grace, Roy, Narinder, Harvey, Harrison. She didn't know how to measure the worth of their lives versus all the others the Bargainer had touched, but they did matter. And they soothed the weight on her conscience.

And myself, she thought, mentally adding her own name to the list. She wanted to save herself, too, if she could. If the sole act of surviving in New Reynes didn't make her a selfish person.

"But what about the others?" Sophia asked. "It doesn't matter how important Bryce decided we all are—what about the people not in the game? Someone needs to worry about them."

Harrison twisted the Augustine ring around his finger. Then he slid it off and tucked it in his pocket.

"Let it be me," he said. "It's my job, isn't it? Let it be my responsibility."

A good man or a bad one? she'd kept asking herself. Because she couldn't, in clear conscience, entrust the fate of this city to the latter.

But he was right. He was neither good nor bad, and Sophia needed to stop seeing the world that way.

She reached into her own pocket and pulled out her dice. They'd vowed to kill the most powerful person in the world, and their chances undoubtedly would be bleak.

She rolled a one and a two.

QUEEN OF VOLTS

She looked up. Harrison's head was turned out the window. "Don't tell me the odds," he whispered. "If you don't mind, I'd rather not know."

THE CHARIOT

"On the day of the queen's execution,
Semper denied any request for a quote."

Shade. "Royal Family Condemned."
Her Forgotten Histories
30 April YOR 1

LOLA

Lola eased open the door to her brother's bedroom, though it had never *felt* like her brother's bedroom. The young man who lived in there was unrecognizable to her, from the scars she didn't know across his pale arms and shoulders to his white buzzed hair. The only part of this man who reminded her of Justin was his flute, and he played it now, sitting at the edge of the bed. Unlike his usual irritating cacophonies, the song had a dreamy quality to it, meant to lull you in and transport you somewhere else. Against all better judgment, it had lured Lola inside, and she shut the door behind her.

"Justin," she said, her voice hoarse and awkward. "We need to talk."

He lowered his flute and frowned. "I told you not to call me that."

"But Silence isn't your real name."

"It is. I swore to it. All Doves have one."

"Doves are named after weapons. You can't kill someone with silence."

He grunted and turned away. "You just don't understand."

After three months together, he sounded no less petulant and irritating. She hated that the person who could make her so furious could also break her heart. She hated that this was the hand she'd been dealt.

"I'm starting to understand why they got rid of you," she said, rolling her eyes. "But you and I still need to talk. You left me. You joined a gang and you left me."

He grumbled something unintelligible.

"What?" she asked.

"I said that *you're no better*. You're the second of the Spirits."

"That was an accident. I never wanted to join a gang. Not after what happened to Sam." Justin flinched at the sound of their older brother's name. "Besides, it doesn't matter. I'm not the second anymore."

Justin scoffed. "Of course it matters. It's why you have a card."

Lola didn't come in here to talk about herself. She didn't want to think about Enne or the look in Levi's eyes when she'd told him about Veil. She'd considered confessing to Arabella about what had happened, but Arabella had been gone a lot lately, disappearing for hours on end, returning reeking of smoke or seawater. And besides, she hadn't forgiven Arabella for calling her paranoid.

Justin wrenched his arm against the cuff binding his wrist to the bed knob. "I don't know what you want from me. I'm a prisoner here. You two can't keep me here forever."

"You're a danger to yourself," Lola told him coolly. "The fact that you even want to go back is—"

"I don't want to go back," he said, almost so quietly that she didn't hear.

Lola froze. "But you've always said—"

"But if I don't go back, they'll find me. That's the choice I've got. To go back or to die," he told her. "I don't want to, but that's the way it is." His gaze turned toward the window, to their view of a brick wall across an alley in the Factory District. "So you might as well let me go."

Letting Justin go back to the Doves was unthinkable. The Doves were powerful, but not as much as he'd been trained to think. Rebecca probably didn't even care about him, didn't even notice his absence.

"Well, I'm not," Lola told him.

He pursed his lips. "Then we've got nothing more to say to one another."

Lola's hands shook, and she managed to keep her voice level only because of the amount of times she'd rehearsed her words. "You abandoned me when I needed you. And I deserve an explanation."

Justin shrugged. "I just wanted to matter."

"You mattered to me," she told him.

He finally turned to look at her, but he didn't have the words to counter her. Maybe he'd been right. Maybe silence really could kill. Because the truth lingered in their quiet— Lola hadn't mattered enough to him. She had never mattered enough to anybody.

It really was that simple.

Blinking back tears, Lola stood up and left the room. She found Arabella waiting for her in the hallway.

"That bad, hmm?" Arabella asked.

Lola wiped her eyes. "It's nothing. I don't know why I bother."

"I think you should keep bothering," Arabella told her seriously. "I wish I had. And now all my friends are dead." Even after all this time, a bitterness still cut through Arabella's words. Like Lola, the world had not been fair to her, but she was still alive, still angry.

Arabella had warned Lola that she was becoming more like her, but suddenly, that no longer felt like a bad thing. It was time for Lola to stop pretending the world was anything but self-serving and cynical. Time for her to stop letting other people wield the power to hurt her.

She deserved her anger. She couldn't survive without it.

Before Lola could answer, Arabella said, "There's someone for you at the door."

A jolt of panic shot through her. "Is it Enne?"

Arabella shook her head, averting Lola's gaze and staring instead at the floor. "She had brown skin. Short hair. Boots. You know her?"

Lola scowled, remembering a girl who fit that description. She was that Iron. Jac's replacement. The one who'd kissed her. Why would she be looking for Lola now?

Once Arabella ducked off to another room, Lola wiped her eyes on her sleeve and answered it. She'd been right—it was the Iron girl. Dark circles ringed her eyes like she hadn't slept.

"What are you doing here?" Lola kept the door cracked.

The girl reached forward and yanked the door open wide. But rather than slip inside, she grabbed Lola by the wrist and tugged her out. Lola—uncoordinated to a fault—nearly fell on top of her as she stumbled over the threshold.

Lola gasped. "What do you think you're—"

"I want to start off saying that I haven't forgiven you," the girl snapped. "A-and I won't. But of everyone, I'm the best person for you to talk to, and someone obviously needs to talk to you."

Lola wasn't surprised to hear that Enne, Levi, and the others had been discussing her, but she *was* surprised by the girl's tone and gesture over Lola's whole body, as though they'd been discussing her well-being.

"I'm sorry. What exactly is your name again?" Lola asked.

"Tock Ridley," she gritted out. She looked angry enough to

shove Lola against the wall, and judging from her combat boots and leather jacket, Lola thought she actually might.

Lola took out one of her knives from her pocket—a scalpel.

Tock snorted and swatted it out of her hand. It clattered to the carpet of the hallway. "Don't bother. I know those are all for show."

"How do you know that?" Lola asked nervously.

"The same way I know where you keep them all," Tock said. "You were my girlfriend."

Lola let out a wild laugh. "You must be joking." Lola's romantic history was arguably the most tragic part of her life, which was impressive, really.

"Whatever bargain you made—did you really not give a single thought to what you bargained away?" Tock asked. "Or were we worth the price?"

Lola hadn't—she'd been a bit more preoccupied with the news Arabella had given her. But Lola should've considered the price she'd paid. Of course she should've.

Tock deserved some sort of explanation, but despite priding herself with being good with words, Lola had no idea what to say.

Instead she could only stand there, openmouthed, staring at the girl who had possibly once been her girlfriend. Tock was far too pretty for her. And confident. And…gangster.

Maybe this was a trick.

Lola stepped away until her back pressed against the door. "So Enne figured out I made a bargain?"

"*I* figured it out, thickhead," Tock growled, advancing forward. Lola squeezed the door handle in a white-knuckled grip.

"Why are you here?" Lola demanded.

"I'm here to ask you where she is," Tock said, jabbing her finger into Lola's chest. "You were the last to see her."

Lola didn't know Tock, but under no circumstances could

Tock learn that Arabella was in this apartment. Tock looked capable, but she was no match for Arabella.

Tock narrowed her eyes at Lola's expression. "Who's in there?" she asked.

The girl did know her well. "Just...just my brother."

Her face softened. "And does he talk now? Did he give you an explanation?"

Lola didn't like this. Someone in the world knew her, knew her secrets, and she didn't remember telling her any of them. Lola felt self-conscious in a thousand different ways.

"Look, I don't want to talk to you. Tell Enne—"

"Tell *Enne*?" Tock shouted. She threw her arms up. "You don't have anything to say to *me*?"

Lola swallowed. "I—I don't."

Tock put her head in her hands. "I don't get it! We were... Muck, out of everyone, if you'd asked me to put my volts somewhere, I would've put them on us." She looked up, her dark eyes wide with hurt and confusion. "And I thought I'd at least get some sort of explanation. But I don't know what I was thinking. You don't even remember!"

Lola winced. She'd said nearly the same words to her brother. And that made her as bad as him.

"I'm sorry," she whispered.

"Was it worth it? Did it change anything?" Tock grabbed a fistful of Lola's blazer. Lola let out a squeak.

Behind the door, a floorboard groaned.

Lola's eyes widened and met Tock's. Tock instantly let go of her jacket, as though grabbing it had only been for show. "I thought so," Tock murmured, and Lola heaved out a shaky breath. "I told them it should be me who came. I know you better than anyone."

Then she turned her hand and revealed something she'd been holding. Lola's card, the Hermit—its face pointed toward Lola. She must've taken it from Lola's jacket pocket when she'd

grabbed her. She turned it over curiously, staring at the target card in red scrawl: *THE CHARIOT.* Her expression darkened.

"Wait," Lola sputtered, "you can't—"

Lola tried to rip it from Tock's grasp, but Tock held it away from her. She squeezed it in her fist, then suddenly—*BOOM.* It exploded in her hand in a small blast of light and smoke. Its remnants fluttered to the carpet.

"You d–destroyed it!" Lola stammered. Though Lola had never offered it to Arabella, it meant that Arabella would never be able to collect her target's card. It meant she'd never survive the game.

"I did, and now the Bargainer is trapped, and her target's card is gone." Tock took a step closer to her, and Lola backed against the wall a second time. She reached into her pocket, and Lola stiffened, expecting some kind of weapon. Instead, she pulled out a second Shadow Card, and she thrust it into Lola's trembling hand. Lola turned it over to realize it was Tock's own target, the Chariot.

"You and me, we're surviving this game," Tock told her seriously. "I'll make sure of it."

Then she walked away and left Lola where she stood.

When Lola returned inside, shaken, she found Arabella in the living room. She sat at the edge of the couch, staring at the wall, completely idle. It unnerved Lola whenever she did that.

"Sh–she destroyed my card," Lola confessed, her heart hammering.

Arabella's brow furrowed. "But the cards can't be destroyed, not when they're part of the shade."

So Tock had tricked her. Lola should've expected such a tactic from an Iron. But even so, Lola struggled to summon any anger at her. After all, she'd given Lola her own card.

"Did *you* trick me?" Lola asked. "Did you steal my memories? Or did I give them up willingly?"

"I never trick anyone," Arabella told her seriously. "If any-

one feels they've been stolen from, it's only because they tricked themselves."

But if Lola had known, wouldn't Arabella have simply told her that? That she understood the price she'd been paying? Lola would prefer to know that her previous self had weighed the options and chosen wisely, that Tock hadn't been as precious to her as Tock seemed to believe. But maybe she had. Maybe there was someone out there who she *did* matter to.

And Lola had betrayed her.

"Shouldn't you be more worried?" Lola asked. "About the game?"

"I already told you—I've been making my moves. Bryce will end the game when he realizes he has nothing left to win, when he realizes whatever scenario he's planned for himself afterward won't come to fruition."

Lola scrunched her eyebrows. "You don't know Bryce like I do. He's stubborn. He's obsessive. If you back him into a corner, he'll only fight harder."

"Then I'll find a way to win it on my own."

"B–but…" Lola hugged her arms to herself. "You can't win without my card, and my target's card, and so on. But if I give them to you, then I'll die, once the game is over." And Tock would die, too.

But maybe Arabella didn't care. After all, Lola had never had a friend who hadn't betrayed her eventually.

"Do you trust me, Lola?" Arabella asked her darkly.

Lola had come close to, but after her conversation with Tock, she wasn't sure.

"I guess I don't trust anyone," Lola said softly, then she slinked back to her bedroom, ignoring her brother's music whispering through the walls. The sound of it made her heart clench. She didn't know why she bothered.

LEVI

In mid-February, the sea breeze spit icy water against the dunes, and the overcast skies smothered any hint of starlight. Levi had once considered the beaches a solace from the touristy, half-drunk city crowds. A place to reflect, should he ever take advantage of it. But its sense of solitude was gone, and like any place with natural beauty in New Reynes, it now felt bottled up, mass produced, and branded—a candy-coated replication of the Casino District. And though he'd been to the board-walk multiple times—twice with Enne and often to oversee the completion of the Legendary—the loss of its old tranquility felt more palpable at night, with the lights of its piers sending reds and greens and pinks dancing over the water. The once brackish air now smelled strongly of cigar smoke.

Regardless, Levi plastered on a kilovolt smile.

"Welcome to our ultimate venture!" Levi declared, and then to a chorus of oohs and aahs, he threw open the double doors to the Irons' new black-and-white palace. With its upstairs fi-

nally completed, it was every bit as grand as Levi described to the Irons—no, grander. Because since St. Morse lay abandoned and Luckluster lay ruined, its gaudiness was magnificent and unparalleled. The glossy floor tiles, like a checkerboard encased in glass. The intricate display of chess pieces, cards, and dice glued to the walls in a map of the city, the king's piece painted silver to mark the Legendary's spot. The mirrored panels along the ceiling, reflecting the dizzying decor as though the guests were stepping into a fun house.

The Irons flooded inside, their loafers slipping across the floors, whistling and laughing, waving at their reflections on the ceiling.

Enne, however, lingered behind with Levi, her coat wrapped tightly around herself, a scarf pulled over her head to conceal her hair and face. It was a risk for her, coming here together, but they had the cover of darkness, and it was important to Levi that Enne see this place.

"I didn't want to open it until the summer," Levi told her. "But it finished ahead of schedule. Seems a shame to let it sit, especially with the rest of the piers open."

There was more to it than that. With the way the game was going, Levi didn't know if he'd live to see summer. And if the worst came to pass, he wanted to leave the Irons with something that would endure. So little in New Reynes did.

He didn't need to explain his ulterior motives to Enne, though. She warily examined the glossy black front doors as though their epitaphs were etched on them.

"I know that look," he spoke. "What is it?"

"I can't stop thinking about Lola," Enne murmured. "About killing the Bargainer. About everything."

He wrapped his arm around her shoulder and held her close. "It'll be all right," he breathed. He was getting better at making empty promises. "There will be more times."

She smiled weakly. "I'm glad you bought this place, and I like the name. I think Jac would've liked it."

"I'm glad, too," Levi replied. Even if it didn't suit him anymore, maybe once the Irons were taken care of, Levi could use the casino's surplus profits to fund other projects, more meaningful ones than a gambling establishment. He could pay off the debts of other kids trapped in One-Way Houses. He could fund rehabilitation centers for those with addictions. Jac would like those things, too.

"So I finally get to glimpse it. This is the gaudiest, most outrageous place I've ever seen," came a voice from behind him. "And I'm not the least bit surprised you bought it."

Levi turned and cocked an eyebrow at Tock. "I didn't have a say in the design."

"Could've fooled me."

Tock liked to poke fun at him—she always had—but Levi knew her well enough to recognize that the look on her face was not normal. At least, it was not her new normal: unwashed bedsheets, twice as much mess as usual, going to bed early and rising late.

She looked good. More at ease than she had in weeks.

"Why do you look like that?" he asked her.

"Like what?" she responded, grinning and running a hand through her short black hair.

"Like you just watched me slip on a banana peel or wear my shirt inside out."

Tock beamed wider and held up a golden Shadow Card. Levi realized with a start that it wasn't hers—it was the Hermit. Lola's.

"How did you get that?" Enne breathed, her eyes wide.

"An Irons card trick. I swapped it out for a fake. Lola thinks I destroyed it," Tock explained. "Technically, it still belongs to Lola. But now that we have it… She's the Bargainer's target. And that makes this card bait. We don't need to find the Bargainer if she'll come to us."

397

Levi suddenly wished he'd been seated first for this news. He knew this game had to end as soon as possible, before anyone else lost their lives to it. But he hadn't prepared himself for how fast their plans could progress. He'd wanted him and Enne to have more time, before their times could run out. Now he realized how empty his promises to her truly were.

Tock and Enne looked at him expectantly. He remembered that he was the one who usually came up with the plans. Or he had been—he hadn't felt half so clever since he'd failed to get Enne her pardon. Even the realization that they could break the game had been her idea.

"If we bait her, we lose the element of surprise," Levi said blandly.

"It's a murder game," Enne pointed out. "There is no element of surprise."

At her words, he remembered how out in the open they stood, the whole boardwalk spread out behind them. While the Irons continued to explore, he hastily closed the casino doors and led Enne and Tock through hallways he didn't recognize. This casino was supposed to be his legacy, but he'd barely bothered to learn its floor plan.

They approached a series of conference rooms, the sort for meetings and corporate-sponsored events. They were plainer than the rest of the casino, the walls painted a neutral gray instead of the harsh stripes of black and white. And they still lacked furniture. Levi didn't care—he took a seat on the floor. Enne and Tock sat opposite him.

"So you think the Bargainer will come because she needs her target's card?" Enne asked. "But if so, why hadn't she just taken it before? She easily could have."

"Because she's working with Lola," Tock answered flatly.

"*What?*" Enne yelped.

"Are you sure?" Levi pressed.

Tock nodded. "There was someone else there at her apartment, and I don't think it was her brother."

Levi's head swam. He knew Lola had made a deal, but he'd never imagined the Bargainer had stayed with her. Did that make them allies? Friends?

Levi's heart squeezed painfully. He'd finally gotten an idea, but it was a repugnant one.

For so long, what had made the Bargainer a formidable enemy wasn't just her collection of talents—it was her mystery. Apart from Sophia's descriptions and the one instance when Levi had passed her, they knew nothing about her. Not her character. Not her name. She was an opponent with all strengths and no weaknesses.

Until now.

"The card won't be bait for the Bargainer," Levi said. "It will be bait for Lola. It's her card, after all. She needs it."

It took several moments for the others to follow his train of thought.

Enne's jaw clenched. "You can't do that to Lola. She's our *friend*, not a hostage—"

"You need to do it," Tock said quietly. Levi gaped at both of them. He'd expected opposite reactions. "It's the only way. Lola is her target—maybe her friend. If we use Lola to get to the Bargainer, we can kill her, and then we'll get Lola her memories back."

But do you want her *back?* Levi wanted to ask but didn't feel he had a right to. He didn't know Lola the same way Enne and Tock did. And as far as he could tell, Lola had betrayed them both.

But he knew that wasn't fair, that it was more complicated than that. Right now, eleven people stood on the same side, but eleven was a big number. They weren't all loyal to each other. They weren't all playing for the same reasons. It was what made their allegiance so delicate—at the first sign of

strain, it would snap, and they would all protect only the few they cared about most.

Tock was Levi's best friend, and if he asked her to, she'd play for him—he knew she would. Just like he would for her. But it was because she was his best friend that he wouldn't ask her to.

"Then what is *your* plan?" he asked Tock.

Tock leaned forward. "She doesn't know me anymore, not really. So it should be Enne."

Enne paled. "You want me to abduct her?"

"Just tell her to talk to you. Give her a reason to come." Tock gestured out the conference room doors. "This casino is ready to open any day—"

"Any day?" Levi cleared his throat. "Sure, the *building* is done, but the Irons aren't prepared. Maybe in a month. Or—"

"The Irons cheat their way through everything. They'll manage," Tock interrupted. "Just call it a pre-opening. Throw a party. That's the sort of thing we like to do, isn't it? Throw a party, and tell her to come. Tell *everyone* to come."

Levi met eyes with Enne. She looked as uncertain as he did.

"And then what?" Levi asked.

"It's your party," Tock told him. "You tell me."

A *party* was not the right word for an assassination—and likely, a failed one. The opening of this casino was supposed to be the culmination of Levi and Jac's story, but that moment would already become another piece of himself he'd sacrifice to the game, to the city—just like Jac himself had been. Another piece of solace sold away.

"Fine," he managed. "We'll do it here. It'll be the swankiest pre-opening you've ever seen."

HARVEY

Harvey was wiping down the bar when Levi called.

Narinder stepped out of the kitchen and motioned Harvey to follow him to his office. They both sat there, ears pressed to the receiver, knees grazing slightly, as Levi invited them to the pre-opening of his casino. He told them both to wear a tux and pack a gun.

"That thickhead," Narinder mumbled. "Just assumes I *have* a gun."

Harvey raised his eyebrows. "You own a business on the North Side and you don't?" When Narinder pursed his lips, unimpressed, Harvey smirked. "You're basically asking someone to rob you."

"Do *you* carry a gun?" Narinder asked.

Harvey patted a pocket in his jacket. "Always do. Habit."

"So why would I need one? I have you."

Harvey's cheeks warmed, even if he was the worst choice for

defender of the Catacombs. "I break at least one martini glass a night, and now you want me for security?"

"You're right. You're too easily flustered. Obviously." Narinder grinned, and Harvey—an expert on dangerous smiles—had yet to encounter a smile like his, that made him feel like his ribs had caved in with embarrassment. He was reminded of everything he knew about Narinder's reputation before he'd met him, all the ways he was experienced and charming in ways that Harvey was not.

While Harvey reddened and failed at producing a response, Narinder's expression turned serious. "I think we should talk, though. If Levi's plan *does* work—and they usually do, as far as I can tell—then we should discuss what happens after."

"After?" Harvey repeated, not following.

"Bryce is only safe because he's the Gamemaster," the musician said. "He's protected because of his talent."

Harvey didn't want to talk about Bryce, especially not with Narinder. It wasn't that Narinder wasn't understanding or kind—he always was—but because then Narinder would clearly see the truth about Harvey, that he was making a bad habit of falling for the people who took him in, like a stray puppy.

But Narinder wasn't finished. "So what will happen to Bryce once the game is over?"

A sick knot twisted in Harvey's stomach. As far as Bryce was concerned, the game was a failure. He'd been so sure it would draw out the Bargainer, but where was she? Crashing in an apartment with Lola Sanguick? The absurdity of it made Harvey want to laugh. Bryce had been so caught up in the legend that he hadn't considered the legend was human, and humans didn't always behave the way you wanted them to.

"You think the Chancellor will let him live?" Narinder pressed. "That Harrison Augustine will? That the girl with the eyeliner will?"

Harvey stood up and backed into the kitchen hallway. "So what am I supposed to do about it?"

"What do you want to do about it?"

"I don't want him to die," he croaked. "I've never wanted that." Maybe that made him too forgiving, but he didn't care.

"And I don't want to show up to a party *I* could die at," Narinder growled.

Harvey should've considered this before—the prospect of Bryce's demise. But only a handful of months had passed since the game began; in his mind, he still remembered it as a distant plan, the whispers of Bryce and Rebecca into the night, the false letters and white lies. He still remembered the boy Bryce used to be, before Rebecca, before Vianca. Before his own life spiraled out of his control.

Harvey had been so determined to please him that he'd never tried to stop him. Not just for those Bryce had hurt—but for Bryce himself, for the reckoning he would one day face for it. Because with the whole city against him, that reckoning would surely be great.

An insidious thought seeded in Harvey's mind, a bad idea disguised as something noble. It seeped through him like a sweet drink, all the alcohol smothered by the syrup.

But it wasn't noble, of course. If it had been, Harvey wouldn't feel the need to lie about it.

"I'm going to get one for you," Harvey told him, walking down the hallway.

Narinder stood and followed after him. "Get me what?"

"A gun."

"I don't *want* a gun."

Harvey didn't listen. He grabbed his coat slung over the bar and slipped it on.

Narinder grabbed his arm. "Wait. Listen to me. I don't want—"

"Some things are worth the risk," Harvey snapped at him.

He didn't mean to lash out, but he could think of no reason for Narinder to bring up Bryce's death except to cut him. "You're not better than the rest of us for not fighting when it's really just because you're so terrified of getting hurt."

Narinder recoiled and let him go. For once, it was the musician who was out of words. If he called out anything else while Harvey stalked out the door, Harvey didn't hear.

When Harvey had left home, he'd never once returned. He'd contemplated it dozens of times. He missed his siblings—his sister, especially. He missed the way he used to see the world when he lived there, through his rosy stained glass lens, when the worst thing he'd ever dreamed of doing was telling a lie.

Harvey was very good at lying now.

I am going to come back with a gun, he thought as he entered the ruined gate of the Orphan Guild's prison. Because regardless of his intentions or their argument earlier, he did care what Narinder thought of him. It was just that he cared about Bryce, too—enough to ask him if he had an escape plan if all his dreams went up in smoke.

Returning here felt how Harvey imagined going home would feel. Though only months had passed—not years—he could already see these hallways through a new perspective. It was disgusting here. It reeked of must, like the sweat from the summer months still clung to the cinder block walls. The Mizer kings who'd built the prison had not commissioned windows, and it felt like roaming a cave, its tunnels damp, its fixtures dilapidated and ancient. Harvey could almost imagine the drafts to be ghosts of revolutionaries. More memories than his haunted this place.

His feet led him to Bryce's office.

Bryce was not alone. A man Harvey didn't recognize sat across from him at the desk, but judging from his spiffy suit

and cherry red cravat, he was some kind of wealthy business-
man from the South Side.

Harvey could wait in the hallway, but already, his heart
leaped at seeing Bryce. For a brief, delirious moment, he for-
got why he'd come here. He nearly turned around.

But then the door opened, and Bryce stood there, his crim-
son eyes wide. Harvey froze as Bryce took him in, his gaze
sweeping over Harvey's clothes and face as though he, too, was
staring at a ghost.

"I…" Harvey started, but Bryce quieted him with a smile.
It was also a dangerous smile, but it didn't make him feel un-
done. It made him feel pieced together, fit neatly back into the
person he once had been.

Bryce swung open the door as Harvey gaped. He grabbed
Harvey by the wrist and led him in. "Sorry, Mr. Oliver. This
is my partner, Harvey Gabbiano."

Harvey felt dizzy as he shook Mr. Oliver's hand.

"Fitz, please," the man corrected.

"Fitz works in real estate," Bryce explained. "We were just
discussing a few…" He coughed awkwardly. "A few ventures."

Harvey nodded numbly and perched by his usual seat at the
window. He'd come prepared for anything—shouting, silence,
or even heartfelt declarations of regret. Business as usual, how-
ever, might've been more than he could stand.

He watched Bryce for the rest of the meeting. For some-
one whose plan was falling apart, he looked better than Har-
vey had seen him in a while. His usual under-eye circles had
lightened, and his pale skin had a bit of warmth. An intrusive
thought chided Harvey that Bryce was better off without him,
that Harvey had always been the jealous third wheel, a leech
who refused to find a life of his own.

Harvey restrained himself from patting down his curls.
Muck, he probably looked terrible.

When the meeting finished, Harvey mumbled a polite good-

bye to Fitz Oliver. Bryce, who would ordinarily walk clients out of the prison, closed the door behind Fitz and turned to Harvey.

"I didn't expect you to come back," Bryce said carefully.

"I'm not back," Harvey said quickly. "Well, I'm here now, but I'm not staying."

"Where are you staying? Are you all right?" Bryce ran his hand through his dark hair and slumped against his desk. "I've been so worried. I knew you didn't have anywhere else to go."

Part of Harvey wanted to lash back at that statement, but the other part of him—the winning part—simmered with guilt. Bryce had once taken him in when no one else would.

"I didn't mean to make you worry," Harvey mumbled.

"Of course I worried. You're my best friend."

Harvey felt his resolve withering, like a wilted flower. Because the rest of the world talked about Bryce like he was a monster, and when Harvey was there, with them, he could almost believe it. But he knew Bryce better than anyone, so he *should* know better. Bryce was not without a conscience. Not without a heart.

He had done this all to save someone, after all.

"I came here to warn you," Harvey managed, his voice high and hoarse. "The others are working together. They know how to break the game. And once they do..."

The red in Bryce's eyes seemed to darken. "Once they do, what?"

"They'll kill you," Harvey breathed.

Bryce drummed his fingers thoughtfully against the desk. That wasn't the reaction Harvey had expected upon learning the most powerful people in the city had turned against him. It was only Harvey's nerves that buzzed around the room like static. Bryce had an almost neutral energy. An eerie calm.

"How do you know this, Harvey?" Bryce asked, staring at him so intently Harvey unconsciously reached for his Creed.

Though Bryce had not moved, had not raised his voice, for the first time, Harvey felt a pinch of fear to be alone with his friend.

"I…" His forehead was damp, his mouth dry. "I heard…"

"Are you working with them?" Bryce straightened and stood up.

Harvey swallowed. There was no use hiding it—he had never been good at lying to *him*. "Are you surprised?"

"I am, but I shouldn't be," Bryce said softly. "You were always so good. I never should've asked you to help me. It wasn't fair. And now you're looking at me like that."

"Like what?" Harvey asked.

"Like I'm the villain."

Bryce walked closer, so close Harvey leaned back, his shoulder blades pressed against the cold of the window glass, his legs leaning against the heat of the radiator. There had been a time when they'd had no boundaries, when they'd been two outcasts who had found each other, a relationship far more intimate than friends. And while Harvey had been careful never to cross that line again, Bryce always did so thoughtlessly. The way he'd sometimes rest his hand on Harvey's shoulder. Or smooth a curl fallen out of place. Or stand too close. Harvey had hoarded those gestures, for thoughts alone and late at night, when he could pick at them like the skin around his fingernails, pick until they bled.

"Please don't look at me like that," Bryce murmured.

"You've killed people—voluntarily. How am I supposed to look at you at all?" Harvey asked, even if he could look nowhere but him.

Bryce's face fell. "I know. You know me better than anyone, and I…" He reached forward and cupped Harvey's cheek, a touch that even Harvey's self-doubt couldn't imagine to be thoughtless. His breath felt blocked in his chest. "I wish I could go back. I love her, but I don't love all of this. It wasn't like this when I loved you."

After spending weeks hating himself for being complicit, Harvey knew that wasn't what this moment was. He couldn't help who he loved, but he could help this. He could stop this. This wasn't one of Bryce's tragic romantic radio shows—this was toxic, and broken.

But it didn't use to be.

"I never wanted you to hate me," Bryce whispered. Bryce could've been tricking him, but the look in his eyes was so genuine that Harvey could see Bryce's old self in them.

"I don't hate you," Harvey answered truthfully.

Bryce pressed his forehead against Harvey's, and Harvey slipped an arm around Bryce's back. It was all familiar, reflexive. It felt natural even when Harvey wished it wouldn't. Like coming home.

"I'm scared," Bryce told him. "I thought the Bargainer would have offered me the deal—I thought she'd ask to end the game. I was so sure... I didn't think anyone else would have to die."

"Can *you* end the game, then?" Harvey asked.

Bryce shook his head. "Rebecca can. But she won't. She wants to keep waiting." Bryce found Harvey's hand and interlaced his fingers with his, and Harvey's knees nearly buckled, standing there, his broken pieces fusing together with every word and touch. All thoughts of Narinder fled. "But I'm scared about you. You helped, and that makes you implicated. Will they spare *you* when all of this is over?"

Harvey hadn't thought about it that way. He remembered the unease in the room at the Catacombs when they'd formulated their plan, how unwilling Levi and the others had been to trust him. It didn't matter what Harvey did to prove himself. He was complicit. Guilty.

Harvey sucked in his breath, suddenly dizzy, suddenly nauseous. He might've fallen over if not for Bryce's grip.

"Look at me," Bryce told him firmly, as though Harvey had been looking anywhere else, now and always. Bryce's lips

grazed his. "There's still a chance we could see this through. And when it's over, we can go back to the way things were. Just…"

And then Bryce started kissing him.

Harvey's mind swam with it all—the taste of him, the words, the memories. This was all a symptom of his self-destruction, he knew. Grasping at Bryce's collar, tracing his fingers down the crooks and slopes of his spine, biting at the edge of his lip the way he remembered Bryce liked it. Harvey wouldn't have done it had he not done it before, had he not dreamed of it, over and over again. With each fantasy, he'd dug himself a deeper hole, a grave wide enough for them both to lie in.

Growing more and more steady, Harvey backed Bryce to the edge of the desk, where Bryce could sit and be easier to kiss.

Complicit, Harvey's conscience whispered. His emotions raked through him, equal parts guilt and desire. He was almost reminded of when he'd killed Zula, how it felt to take back his control, how it felt to let himself die. *Complicit. Complicit.*

But he didn't stop. Not even if it felt like harming himself. Not even when Bryce's hands found their way to Harvey's belt.

His conscience no longer sounded like himself, anyway. Bryce's warning had given it a new voice—the voice of the ten others in the Catacombs who were not his allies, not his friends. He remembered the way they had looked at him, the enemy. Bryce was right. They would turn on Harvey the moment the game was finished, too.

But Harvey knew Levi's plan now—all of it. Which meant he knew exactly how to stop them.

Even better, if the Bargainer did show up at Levi's casino, then Harvey would be waiting for her. And he could make the bargain Bryce and Rebecca had wanted all along. He could finish this. Bryce would be able to free himself from Rebecca, and Harvey and Bryce would no longer be tied to New Reynes.

They could flee. They could start over somewhere else, safe, just the two of them—the way it used to be.

As Bryce knelt, Harvey saw something gold that had slipped to the floor, fallen from Bryce's pocket and peeking out below Harvey's discarded shirt. His distracted mind decided it was a wristwatch.

But when he returned to the Catacombs, leaving an Orphan Guild gun in the drawer of Narinder's office, he replayed the day over in his mind. And he realized it had been a card, Harvey's card. He hadn't seen it since he'd given it to Bryce right after the game started.

The Fool.

XIV

THE WHEEL OF FORTUNE

"Harrison Augustine murdered his political opponent,
and until anyone acknowledges it, I will keep
printing it until the day I die."

Memoria. "What Happened at St. Morse."
Her Forgotten Histories
18 Nov YOR 25

ENNE

"Are you sure you want to do this?" Poppy asked uneasily, eyeing the photos in *The Guillory Street Gossip* Enne had shown her.

"Of course she's sure," Grace snapped. "It's just hair."

Enne forced herself to smile, as though the confidence of her reflection in her vanity mirror could fool even herself. She resisted the urge to touch her hair. She'd sacrificed far more important things to the City of Sin than her appearance, but nothing had ever felt so…personal.

"If I'm recognized," Enne spoke, straining to keep her voice from quivering, "our whole plan could be ruined. Going to the Legendary satisfies breach of contract. And if the whiteboots are called—"

"You don't have to be there, Enne," Poppy told her gently.

The last time Enne had faced any real danger, she'd been a liability. But that had been months ago, and now Enne wouldn't make those same mistakes.

I am Veil's daughter, she told herself, and though the crime

lord had committed unfathomable cruelties, he'd also been brilliant, when the entire world had been against him. *I'm the daughter of Gabrielle Dondelair, who won the Shadow Game and set fire to the Capitol. I'm the daughter of Lourdes Alfero, one of the bravest people I've ever known.*

I'm the last surviving Mizer, and I will fight to stay alive, no matter what it takes.

These affirmations helped—words had always found a way to wind her back together. Enne didn't need her looks to remind her who she was and all she was capable of.

Even so, she sniffled with every snip, and her eyes teared at the smell of bleach.

Tonight, she wouldn't wear her ballerina bun, a habit from the life she'd once led. She wouldn't wear a dress trimmed with lace or pearls, even if she liked them. She wouldn't wear the black lipstick that she felt she'd earned after so many months surviving in the City of Sin. She would be anonymous. She would be no one.

And it hurt—for most of her life, she had felt like no one. She didn't want to return to that.

I am the last surviving Mizer, she continued to tell herself. By the time the makeover had finished, when Grace swiveled her chair around so Enne could examine her unfamiliar reflection, those words felt like all she had left.

LOLA

Lola reread the invitation several times while getting dressed. As she buttoned her shirt, cuffed her pant legs, and laced her loafers, she kept unconsciously reaching for it, as though to remind herself she had not fabricated the words.

I'm sorry. I'd like to start over. —Enne

The invitation was printed on expensive black card stock, Enne's elegant handwriting scribbled in the margins in metallic ink. The grand pre-opening of Levi's casino. Lola hadn't realized he'd even bought a casino. Despite Enne's note, something about the invitation itself felt distant, impersonal. It was no doubt the same card they'd sent to hundreds of others throughout the city. Like Lola was already someone they used to know.

"Can we talk?" Arabella asked quietly, hovering in the doorway.

Lola stiffened and tucked the invitation behind her. "Um…

sure." She followed Arabella into their sitting room. The walls rumbled from a passing Mole train, making the moth-eaten curtains jitter on their rods. Lola sat on the couch, the card squashed beneath her legs. Arabella paced, not meeting her eyes.

"I meant it when I told you that I don't lie to people," Arabella started, "but I do trick them. It's impossible not to. I can't read someone's thoughts, but I know you well enough now to know that, when you made your bargain with me, I don't think you meant to sacrifice what you did."

Lola straightened, her heart speeding up. "Do you mean Tock?"

"I told you that you would lose someone precious to you—the last person you had left," she said. "I don't think you realized who I meant."

So everything Tock had said had been...right. Arabella's confession might've hurt more if Lola understood *what* she'd lost, because even after speaking with Tock, she didn't. She couldn't imagine knowing that girl, with her Iron tattoos and leather combat boots. She couldn't imagine kissing her. She couldn't imagine telling anyone the secrets about herself that Tock had so clearly known. Whatever they'd been didn't feel precious—it felt alien.

"Well, that's depressing," Lola said flatly.

Arabella covered her mouth with her hand and took a deep, unsteady breath. "I'm alone in this city. Is it so hard to imagine that I wanted an ally?"

Of course she could. Lola had been desperate for one, too.

"I'm not mad at you," Lola told her.

Arabella raised her eyebrows. "You're not?"

"I don't know how to be. I don't know Tock."

Lola's words were meant to reassure Arabella, but her expression instead turned pained. "In the memories you gave up, you were different in them than the person you are now. This

is…" Arabella gestured to all of her. "This is the worst version of yourself."

Lola struggled to process the idea that Arabella knew pieces of her mind that she didn't. So, unsure how else to react, she barked out a laugh. "Gee, thanks."

"I mean it. You think everyone in your life has betrayed you, but that's not true. And I can't give you your memories back—that isn't how shades work. But I think I'm the closest thing you have to a friend now, so I promise you—I'm going to end this game, and the two of us are going to survive it."

Before Lola could decide whether to feel slighted or touched, Arabella sat beside her on the couch. She took Lola's hands in hers—her skin, like when they'd first shook hands, was warm with shades, close to burning.

"And so, in return, I want you to promise me that you won't accept this invitation." Arabella's gaze swept over Lola's formal clothes. "I know you're dressed for it, but—"

Lola jerked her hands back in surprise. "What? Why not?"

"I don't trust the Mizer," Arabella said coolly.

Lola understood—after all, Lola was still furious with Enne, too. Even if Enne wanted to start over, Lola didn't know if they ever could.

But since Tock had come here, a tick had burrowed into Lola's mind. Call it curiosity, call it paranoia, but even after Lola had sold a part of herself for the secrets of this city, she still sensed there was one more, a piece of this puzzle she'd missed.

And she worried that the girl she'd been before, the girl who'd loved Tock, wouldn't have overlooked it.

It was why she needed to face Enne. There was still a reckoning coming, and Lola wanted to have all the answers before she faced it.

Still, sensing an edge in Arabella's voice, Lola steered the conversation away from Enne.

"But I don't understand," Lola said. "How can you end the game without my card? You know that Tock—"

"I don't need it. It doesn't matter if I end the game without it—I've beaten a cursed sickness. I survived what was supposed to be my own execution. Bryce should've known that it will take more than this shade to kill me."

"Even so, I still don't understand how you think you'll win," Lola pressed.

Arabella grinned at her. "But it would be so much more fun if you guessed."

Lola racked her brain for what Arabella meant, but she couldn't find an answer. And she was tired of these games that dangled the lives of everyone she cared about in front of her. Because even though Lola should've felt relieved that Arabella knew a way to end the game and save them both, Lola couldn't help but think of her old friends.

If she and Arabella won, then they would lose.

"I'm going to the pre-opening," Lola told her seriously.

Arabella's eyes widened. "But what if it's a trap?"

"I don't think it is. I think you're being..." Lola caught herself before she said the word, knowing how it would make her sound.

"A monster," Arabella finished for her, gritting her teeth.

"What? That wasn't what I was going to—"

"Look, I can't help the things that happened to me," Arabella snapped. "I can't help the choices I made to survive."

Lola paused. She knew Arabella. She knew Arabella's anger. But even if Lola *was* the worst version of herself, she still valued cleverness, impartiality, truth—the same as she always had. And Arabella's truth hung plainly in her words.

"I don't know why it's *me* you're always trying to prove yourself to, but for what it's worth, if you were truly forced into the wrongs you've done, you wouldn't have called them choices," Lola said softly, and Arabella didn't respond, only squeezed her

hands into fists and looked away. "I'll be back but…I'm making a choice of my own."

Then she grabbed the invitation, her wallet, and her harmonica, and she walked out the door.

It was an outrageous venue, which didn't surprise Lola. Of course Levi would pick something revoltingly ostentatious. The slanting black-and-white stripes along the brick reminded Lola of a fun house, the flag streamers suited for a carnival. Lola waited at the edge of the crowd gathered outside, crinkling her nose at the reek of salt water, cigarettes, and bathroom cologne. She'd never liked beaches, but she still thought New Reynes had ruined a perfectly good one.

Lola wished the line weren't so long, forcing her to wait with her thoughts.

Maybe it'd been a mistake to leave Arabella after Arabella had made such a grand promise to her, but now all Lola could think about was that version of herself that Arabella remembered. In that version, Enne had still betrayed her. Her brothers had still abandoned her, lied to her. But somehow Lola had found a way to be happy.

If Lola was still that person, who would she have trusted: the monster so like herself, who treated Lola like a moral compass; or the girl who still loved her, even if Lola couldn't remember?

Someone tugged on her arm, jerking Lola out of her thoughts. She turned to face Enne, only Enne looked entirely different from the last time she'd seen her. She wore colored contacts again, and her hair—once spilling down her back—had been sliced to her chin and dyed a brassy sort of blond. Lola might not have recognized her had she known many people only tall enough to reach her shoulder.

"Lola," Enne breathed, then she threw her arms around her before Lola could object. She smelled faintly of bleach.

"'Lo," Lola mumbled. "You look…different."

Enne's smile wobbled. "I hate it, but at least I don't look like my wanted poster anymore, right?" Lola considered complimenting her on it, if only to make her feel better, but that would mean pretending that they were normal. And they weren't. "Am I allowed to ask you how you are? Where you're staying?"

Lola rolled her eyes. "You know where I'm staying. Tock told you."

"Yes, well..." Enne pursed her lips. "It's polite to make conversation."

Levi had told Lola that Enne was improved since they'd last seen one another, and she did sound like her old self. But Lola didn't think that was enough to forgive her. Lola didn't think any relationship initially forged by a weapon pressed against her throat deserved to be salvaged.

But maybe these were the thoughts of this *new* version of Lola. Lola cursed inwardly. How could she decide who to trust if she couldn't even trust herself?

"Come on," Enne said, linking Lola's arm with hers and leading her to the front of the line and past the casino's glossy double doors.

The inside was no less horrible than the outside—perhaps more so, with its overabundance of decorations, drapes dripping from the walls like licorice lacquer. Examining the guests around her, Lola realized she was underdressed, but she didn't have a suit in her current apartment, and she hadn't expected such an extravagant affair to take place on what was really just a two-mile slab of wood along the city's edge, whitewashed to hide the rot.

"Pretty impressive," Lola lied, also to make conversation.

"Grace and Roy are here, if you'd like to see them," Enne told her. She looked nervous, the way she fiddled with her necklace—a silver choker, not her usual pearls.

It might've been nice to see her old friends, but Lola had

needed to talk herself up just to speak to Enne. She wasn't ready for everyone. Not yet.

"Isn't there someplace here that's quiet?" Lola asked. "Where we can talk?" Even with Enne at her left side, it was difficult to hear.

Enne's shoulders relaxed. "Yes, of course. We can go upstairs."

They climbed up the grand staircase to the second floor, which was—in Lola's opinion—no quieter, with the music from downstairs echoing through the halls. But it was more private. Enne led her to a lounge at the hallway's end, and Lola sat awkwardly on a sofa, Enne beside her. She wondered if Tock was here. This was an Irons establishment, so she probably was.

"I'm sorry about everything," Enne told her. "I really am. After Jac died, I wasn't myself. The fact that I hurt you…" Her gaze flickered to the side of Lola's head, where her red hair fell flatter than it once had. "I don't know how I could ever make it up to you, but I'm so sorry. So, so sorry."

Her voice sounded sincere enough for Lola to believe her, and so Lola muttered, "Thanks." Lola's palms were sweating, so she wiped them on the edges of her blazer.

Maybe you can *trust her*, a voice whispered, one that was lighter and gentler than Lola's own. Perhaps that was the happier version of herself, reduced to merely a figment of her imagination.

"But there's something I wanted to ask you," Enne said softly.

Lola had been so focused on preparing her own speech that she hadn't expected that. "Sure."

"How did you find out that Veil was my father?"

Lola tried not to betray her surprise. Of course Levi had told her by now. "Old records," she bluffed, the same lie she'd fed Levi.

"But if there were records of a living Mizer, then that Mizer would've been killed, just like all the others," Enne said. Her

voice still sounded soft, but in her lap, she clenched and un-clenched her fist.

"It makes sense, doesn't it?" Lola continued, nervously. "Why Veil hid his face? Where he got his funding? Why the Great Street War was so violent—"

"I didn't say it didn't make sense," Enne said, coolly now, "I asked how you knew."

She knows about Arabella, Lola thought with panic. But of course she had to know—Tock told them. But that didn't mean she knew all of it, that Lola had lived with Arabella for the past three months, that Lola had defended Enne when Arabella had considered killing her.

That Arabella had warned Lola not to come here at all.

Lola scooted a few inches away from Enne. "I knew there were still questions about you that had gone unanswered—important questions. But you were too focused on being a street lord to ask them yourself."

"Then it should've been *me* to bargain for them," Enne snapped, and Lola realized that Enne hadn't invited Lola here to start over at all; she'd invited her here to confront her. "You could've bargained for anything, but you chose for answers about *my* life. Why wouldn't you bargain for one of yours?"

Enne's questions might not have been meant to hurt Lola, but they still did. Lola's life wasn't like Enne's. She hadn't been born the daughter of two wanted criminals—she'd been born insignificant. To the world. To her own family. There were no questions in Lola's life that she needed answers to. And though Lola did pride herself on a few things—her cleverness, her scrutiny—she wasn't Enne or Grace. She wasn't capable of protecting her friends with brute force. Levi had been right when he'd accused her of wielding secrets like weapons, because secrets were the only weapons Lola had.

Lola felt a pressure build behind her eyes, and she blinked back tears. She was fully armed now.

"Lourdes Alfero was never your mother's real name," Lola said scathingly, eager to finally be the one to deal a blow for a change. "It was Clarissa Semper Reid. She was Semper's daughter."

Enne stiffened, "That's not possible. Semper was the one who killed her."

"Semper was trying to save this city, and he couldn't, because Lourdes's talent was saving *you*."

The look of pain that crossed Enne's face was worse than if Lola had stabbed her with any of her knives, but Lola was surprised to find that she got no satisfaction from it. Tears finally leaked from Lola's eyes. Nothing and no one ever worked the way she wanted them to.

"I know that I'm the one who made mistakes, but I feel like I don't know you at all. You were never...cruel," Enne whispered, and though she didn't know it, there were no other words she could've spoken to take Lola so off guard.

Maybe Lola really was the worst version of herself, no matter what choices she made.

"I—I should go," Lola said, standing up. "This was a mistake."

But Enne moved faster, and for all Lola's cleverness and scrutiny, she didn't see it coming. In an instant, Enne swept Lola's feet from underneath her and bound her in a headlock, exactly as Lola had watched Enne do it a hundred times during Grace's lessons.

"Let me go," Lola snarled, but Enne's grip only tightened, her forearm digging into Lola's throat. With her other hand, Enne rummaged in her dress pockets.

"For what it's worth, I *am* sorry," Enne told her.

And then a lacy white handkerchief pressed against Lola's nose, and for as much as she tried to squirm away, only seconds passed before her consciousness faded completely.

LEVI

Levi stood in the lobby of his casino and waited for the Bargainer to arrive.

Other than Sophia, he was the only one who'd seen her before, and he hoped his descriptions from memory would suffice. He remembered her pale, almost translucent coloring, the way her face looked older and wearier than her skin betrayed, her limp light brown hair, eyes crimson red. Of course, she could look utterly different now—the legends claimed she possessed a face-changing talent, like Rebecca. The endless list of ways tonight could go wrong was making him sweat through his shirt.

"That guest with the mustache is getting belligerent again," Stella—one of the Irons—said beside him. "I told him to leave, but he won't. Should I ask James—"

"Yeah, sure," Levi told her, distracted.

She raised her eyebrows. "I wasn't sure you'd want to kick a guest out during, you know, the big pre-opening party."

The last thing on Levi's mind was good business practice.

"Just get him out. We want everything running..." His voice trailed off when he caught eyes with Enne across the room. Poppy and Delaney had transformed her for this event, her once chestnut hair cut to her chin and bleached into a shade of brassy blond, her eyes hidden behind green contacts, her makeup so heavy that she appeared an entirely different person...at least from far away.

Even Levi's gaze slipped over her slightly. But then she nodded, her determination so unmistakably *Enne* that he felt the same burn in his stomach. He liked her however she looked.

But he needed to focus. Her nod meant the others were also at the ready.

Levi felt as though he were setting up a game of chess. Poppy had taken Lola away to a location known only to her, him, and Enne. That left everyone else scattered across the Legendary, waiting for the Bargainer to make her move. They each waited in pairs: him and Enne in the lobby, Harrison and Sophia upstairs, Tock and Delaney in the back, Harvey and Narinder in the cardroom, Grace and Roy on the roof.

It won't work, his father whispered. They were playing an opponent with ten times as many cards in their hands, cards they could barely begin to guess.

Beside him, Stella muttered something irritated under her breath and stalked off.

"What's wrong?" Enne asked, appearing beside him and eyeing Stella as she disappeared into the cardroom. Her eyes were slightly bloodshot. "Did she see the Bargainer? Or—"

"No. Just some drunk," Levi grumbled, rubbing his temples. "Tonight was supposed to be...everything. Owning my own casino. Being free of Vianca."

Enne reached for his hand, then, seeming to remember where they were, jerked it back. It would do no good for their plans *or* the Legendary should she be recognized tonight. "I'm sorry we took this night from you for this. This should've been..."

She looked around the lobby sadly. "Well, for what it's worth, you did it. Your dream. I'm sorry you don't get to live it."

"I think my dream was inherently mucked up," Levi told her, sighing. "Even if all the other gangsters of the North Side were killed violently, I thought there was something romantic about dying that way. Turns out there's no way of dying that's romantic. Turns out tragedy is always tragic."

She smiled weakly. "Good thing this isn't a tragedy, then."

Oh, but we have all the makings of one, murmured the voice that was not his father's, but his alone.

"Lola will never forgive me," Enne murmured, then she sniffled.

Enne, he realized, had also sacrificed something precious tonight.

"I'm sorry," he told her, wishing they were in private so he could hold her. He hoped she had the chance to truly apologize to Lola, but even if Lola forgave them for kidnapping her, would she—should they manage it—forgive them for killing her friend? He didn't see a happy ending in this one.

Someone tapped his shoulder, and he whipped around to face another Iron, Hwan. At Levi's expectant expression, Hwan flushed and looked at his shoes.

"They're s-saying you should deal a game," Hwan stammered. "Or make a toast. You know, to thank people for coming out."

But Levi didn't think he could deal a game of Tropps, or raise a glass to anything other than surviving the night. He should've known the pre-opening would demand more from him. With Tock as occupied as he was, there was no one to oversee the casino on its very first night. If the event was a disaster, then this dream would be, too. Ruined before it had even begun.

"Just do it," Enne whispered to him.

"We're posted *here*—"

"We'll switch with Narinder and Harvey." She looked at him seriously. "You deserve this chance. Take it."

It was thickheaded and childish, and Levi preferred to think of himself as neither. If he was really going to be optimistic, then there would be other nights.

But it didn't feel that way. There was something unsettling in the air, sharp and metallic like unspilled blood.

"Don't you trust me?" Enne asked him.

More than anyone. They were in this together.

"Fine," he murmured, then he followed Hwan into the card-room.

Levi took a seat at the head of a card table and plastered on a smile, so practiced that it almost felt natural again. The others around him—all strangers—grinned back.

"So," he said smoothly, cracking his fingers, "I haven't gotten to baptize one of my own card tables yet."

"You mean take our volts yet," one player said, earning a chorus of good-natured laughter from the rest of the table.

"Ah yes, well, I hope I can live up to my own reputation." Levi reached for the deck of cards at the center of the black felt tabletop. Normally, he would make a show out of shuffling them, the way he used to at St. Morse. But he wasn't looking for tricks tonight. He shuffled, cut the cards, and went straight to dealing. "I'm a bit out of practice."

One of the men chuckled. "I don't think we're expected to believe that."

They were right to be skeptical. It'd only been eight months since Levi had left his position at St. Morse, and weeks since he'd last played with the Irons. He knew Tropps too well to forget it. He'd once played it at any hour of the morning or night. Drunk or sober. With friends or strangers. Sometimes he'd seemed to play it in his sleep.

This is my story, he thought. *This is who I am.*

It was so trivial, of course. Levi was far more than a card

game, than one skill, no matter how famous it had made him. But the legend that had moments ago felt claustrophobic now— for this one moment—felt like a familiar kind of comfort. As he flipped over each card, he didn't have to worry about the Bargainer, en route to the casino at this very moment. He didn't have to worry about the Chancellor, about Bryce Balfour, about how different it felt to gamble with lives instead of volts.

He won, just like how dreams were supposed to go.

Levi grinned and slid forward the pot of chips. Hwan slapped him on the back, and someone else thrust something cold in his hand. In the normalcy of it all, he stood up, a smile still spread across his face, his Gambler's Ruin raised high.

"Who would've thought this?" he asked, loud enough for the other tables around him to pause their games and stare. Levi climbed onto his chair and scanned the room for familiar faces. His spades—the dealers. The diamonds—bouncers, security. The clubs—managers. The hearts—performers. And Enne, who stood at the edge of the hall, nodding brightly for him to continue. He beamed. "If you had told me six years ago that I'd be trusted with my own casino, well, I wouldn't have bet on it."

At the smiles around the room, Levi's spirits rose further. His favorite part about putting on a show was when he forgot it *was* a show. When he could perform for no one but himself.

"I'm going to keep this short because I don't want to distract you from gambling away all your voltage," Levi said to a roomful of laughter. "Thank you for coming out to the beach in the freezing cold. Thank you to Luckluster and St. Morse for their absence and letting us open a new casino. Thank you to the fifty or so Irons here tonight, who were willing to quit more secure jobs at other dens to give this place a shot."

There were a lot more people to thank, Levi knew—one person, in particular, who deserved more gratitude than he could ever give. But these patrons hadn't come out to pay a

toast to the dead, and Levi hadn't begun his speech to put a damper on their night.

He didn't have to, though. As soon as Levi opened his mouth to add a last goodbye, a gunshot rang out from the hall.

Bang!

For a moment, the entire room froze, as though mistaking the noise for part of the show. Then, when Levi jumped down from his chair in shock, everyone lurched from their seats. Most screamed.

The Bargainer's here, Levi realized, frantically scanning the crowd for Enne. But when his gaze fell on her place by the door, Enne was gone.

SOPHIA

Sophia and Harrison had stationed themselves in the lounge of the upstairs hallway of the Legendary, each sitting stiffly on a set of black-and-white upholstered armchairs—Sophia clutching her dice, Harrison clutching his gun, and both tapping their legs restlessly.

"Stop it," Harrison grunted. "Stop fidgeting. You're making me nervous."

"*You're* fidgeting."

"Yeah. Because I'm nervous."

Sophia rolled her eyes, but she stopped moving her leg. She wanted to roll her dice, to see her chances of survival, but knowing her demise wouldn't make it any easier.

Plus, the night Jac had died, she'd rolled high. Her talent was meaningless if it only accounted for her, when she had so many people she cared about facing peril tonight: Poppy, Delaney, Harrison. Jac had always claimed Levi's plans were foolproof,

but Sophia didn't trust as easily as he had. And anyone who'd purchased a casino this tacky could not have good judgment.

Harrison took out his silver pocket watch and checked the time.

"You keep doing that," Sophia told him.

"It's what nervous people do."

"What are you waiting for?"

"It's just been a while, is all," Harrison muttered.

"You an expert on hostage situations?" she asked. He shot her a dark look, and she immediately realized her mistake. "Forget I said that."

Then Harrison did something she'd never seen him do. He lifted up his eye patch and rubbed both his eyes. The way nervous people did, she knew. But she couldn't help but stare at the rippled scars across his skin, at the hollow bulge where his eye had once been. It looked like a knife had dragged through his face from forehead to cheek, had cleaved his eye out like prying a nail out of drywall.

"How did you lose your eye?" Sophia knew it wasn't the sort of thing anyone was supposed to ask, but she did anyway.

"Veil sent it to my mother in a jewelry box," he told her, then hastily flipped his patch back down.

Sophia's stomach recoiled. How heinous.

"It would've been cleaner, but I fought back," Harrison continued, tapping at the end point of his scar, the part visible below the patch. "My mother and Garth Torren negotiated for our releases not long after that. My mother always prized our green eyes. Reminded her of royalty, how we all shared it, even if it doesn't have anything to do with our talent. Just runs in the…"

He cut off suddenly, as though he'd said something he shouldn't have, when all they were doing was talking to pass the time. To distract themselves from the fact that the Bargainer would arrive here any moment, probably looking for blood.

"You don't have to talk about her," Sophia murmured. "I know you have mommy issues."

He grimaced. "That's one way to put it."

The silence was awkward, so Sophia pulled a taffy out of her pocket and popped it in her mouth.

"You're going to rot your teeth, you know," he told her.

"I can't fidget, apparently, so I need something to do," Sophia growled. "Last time I saw the Bargainer, I sold her half of my identity, in case you've forgotten."

Which meant, if Levi's plan succeeded, if they really did manage to kill her, Sophia could get her memories back. Her split talent back. *Tonight.* The very thought of it made her dizzy, that the path she'd set herself on actually had a finish line.

"Can you really not guess what it will be?" Harrison asked. "You don't remember anything that—"

"My dad told me my mom basically dumped me on him when I was a baby." Sophia shrugged. "It suited his track record. Delia, Charles, and I were all half-siblings."

"But that's just what you remember. And what you remember could've been altered by the Bargainer."

"I know that," Sophia snapped. She didn't need him to remind her that her memories were not to be trusted, that she was a girl half-pasted together, a scrapbook of candy wrappers and casino ashes and the fears her older brother gave her.

Harrison, once again, checked his pocket watch.

"Is my emotional trauma distracting you?" she asked, frowning.

"I'm just checking the time."

"Guessing your time of death?" she joked, then shook her head. "Sorry. That was morbid. I'm trying not to be morbid."

"It's just late, is all," he said gruffly.

Sophia snorted. She'd spent the past several years managing gambling dens. If the sun hadn't risen yet, it was early.

"You have somewhere else to be?" she asked. "Your date didn't show?"

Harrison's lips formed a thin line. She must've hit some sort of nerve because he changed the subject. "I don't see the point of waiting up here. The Bargainer isn't going to climb through an upstairs window."

"Levi thought it was better if we were separate," she reminded him.

"You know that girl with the short hair? She blew up Revolution Bridge. We're all in this same casino—not that separate."

"You think Tock is going to blow up the building?"

"I'm just saying—we don't know what talents the Bargainer has, or what she could be capable of. If it's safer to split up, maybe we should've *actually* split up."

The Bargainer wouldn't risk that if there was a chance Lola could still be in the building, but Harrison's words still wormed themselves into Sophia's fragile composure. "If you're going to say things that make me nervous, I should at least get to fidget."

Unable to restrain herself any longer, Sophia tossed her pair of dice on the hideous black-and-white carpet. A four and a five.

She would've breathed out a sigh of relief, if she hadn't gotten the exact same roll the night Jac died. Now those numbers felt like an omen.

"Did your family ever talk about Leah?" Harrison asked suddenly, which surprised her.

"A little. Not much. She died around when I was born." Sophia hesitated, knowing that wasn't what Harrison wanted to hear. "Uncle Garth talked about her. Sedric, sometimes." But Sophia had avoided Sedric at every opportunity. Even as a teenager, he'd unnerved her. He'd looked at the whole world as though he owned it.

"When were you born?" Harrison asked.

Sophia furrowed her eyebrows. "January, Year 8." She'd turned nineteen three weeks ago.

He made a gruff noise.

"What?" she asked.

He stared at his pistol. "If we do kill the Bargainer tonight, if you *do* get your memories back...I've decided it would be a bigger mistake for me to keep quiet now, than it would for me to be wrong."

His voice had a serious quality—a politician quality—even as he fidgeted his leg. Sophia stopped fidgeting hers. She stilled entirely. Her gaze dragged up from the dice on the floor to his gaze, to his green eye that matched her own, realizing what his questions meant.

"Muck," she cursed, at the same time he blurted out, "It's not impossible that I'm your father."

Sophia jolted up. *"No.* You're not old enough to be my father. You're, like, barely over forty."

"I'm thirty-seven," he said flatly.

"I'm *not* an Augustine." Disgust boiled inside of her. Rewriting her memories of her true father didn't bother her. Demoting Delia and Charles from siblings to cousins, honestly, relieved her. But an omerta split talent? The same talent that had gotten Jac killed? Sophia couldn't stomach that. She couldn't *be* that.

Nostrils flaring, she whipped to face Harrison, who looked a shade of green to match his old Augustine ring. He didn't meet her eyes.

"You've thought this for a while, haven't you?" she demanded.

"Since after the election," he admitted. "I thought giving you the omerta would clear it up—you can't place an omerta on an Augustine. But..."

"But I might've bargained my talent away, and you might've placed an omerta on your own daughter," Sophia deadpanned.

He cringed. "I hope I'm wrong—"

"Yeah," she bit out. "I hope you're wrong, too."

"But in case I'm right, I didn't want you to find out by re-membering. I wanted a chance to...to do it right."

"Is this what you call right?" she snapped.

Before he could respond, footsteps thundered down the hall-way behind them. Sophia turned to see Grace and Roy sprint-ing toward them.

"The whiteboots are coming!" Grace shouted. "They've surrounded the building!"

Sophia turned to Harrison, the realization dawning on her. He *had* been waiting for someone—that someone just wasn't the Bargainer. "What did you do?" she gasped.

"The responsible thing," he answered wearily.

"Hector is coming?" Roy asked, his strangely perfect features sliding into a dark look of resolve. Sophia had always thought he resembled a marble statue more than a person, like he be-longed in a museum.

"Don't do that thing," Grace warned him.

"What thing?" Roy asked.

"The hero thing. *Your* thing."

"I'm going downstairs," he declared, pushing past, down the hallway. Grace cursed and ran after him.

"I'm going downstairs, too," Sophia said, only because she wanted to be anywhere but here, alone with Harrison during his impromptu confession hour. Unfortunately, as soon as she charged toward the stairs, Harrison followed.

"Leah went into hiding," Harrison told her, huffing as they ran. "I thought it was because of my mother, but maybe—"

"Please stop," she told him.

"You remind me of her."

"Gross."

He cursed as they reached the ground floor. Harvey and Narinder sat at the bottom of the steps, and they jolted up as Roy barreled past them.

"What the—" Narinder muttered.

"Where are you *going*?" Grace asked Roy, breathlessly stumbling down the final steps onto the checkered floor.

"I'm going to confront him."

"Why the muck would you do that?"

"He tried to have me killed," Roy said. "Now I can finally face him. I can ask him—"

"You want to *duel* him?" Grace lurched forward and grabbed at his tuxedo sleeves, but he wrenched her off. "Let *me* duel him, then. At least I'll win—"

"Let me go—"

But before either of them could march out the entrance, the doors swung open. A team of at least a dozen whiteboots entered, guns raised. As if summoned by the couple's bickering, Captain Hector stood at the front.

Roy and Grace lurched back, their arms raised. The other guests in the lobby froze, while Harrison strode confidently forward, his expression grim.

"You're making a scene," Harrison told him gruffly. "That isn't what we agreed—"

Bang!

Hector fired.

Harrison staggered back, his hand clutching his abdomen as blood bloomed across his white shirt. In his other hand, he dropped his pistol to the floor.

"No!" Sophia shouted, lunging toward him. But she didn't reach him in time.

His body dropped next.

XV

JUSTICE

"The driving force of New Reynes' history
arrived in a hearse."

Nostalgia. "The Busy Schedule of Liberty Square."
The Antiquist
10 May YOR 8

LEVI

After the sound of a gunshot, Levi's cardroom descended into chaos. Immediately, a patron collided with Levi's shoulder as they barreled past, sending Levi knocking into the Tropps table. He grabbed it, nails digging into the black felt, trying to steady himself as guests hurdled past toward the room's emergency exit. His heart had accelerated so fast that he thought he might be sick. Enne was gone, and from where he stood, he had no vantage point into the lobby.

This is what you planned, Levi reminded himself, trying to trust himself. But he hadn't anticipated the panic that gripped his chest, how he felt transported to that night at St. Morse. There had been havoc that night, too. The *click, click, click* of Bryce's cursed roulette wheel. The screams as each new victim fell.

Only minutes ago, Levi had felt in his element. Even among so many people, cardrooms were familiar—he felt no fear in his own kingdom.

But the pandemonium had changed that. Levi stood there for many heartbeats more, frozen, a paranoia seeping into his mind as his gaze flitted from guest to guest. It felt as though anyone could be the Bargainer, anyone could be the enemy.

Until someone shouting the word *whiteboots* snapped Levi out of his state, and he realized the intruder had not been the Bargainer at all. Captain Hector had driven a wedge through everything Levi had planned.

Then you'll come up with a new plan, he told himself, but now his confidence had shattered. He'd been too foolish to account for the unexpected, and once again, his friends were going to pay the price for it.

Run, his father whispered to him. *Run. Run.*

But even if their mission had been compromised, Levi couldn't leave his friends behind. He had no idea how many whiteboots had barged in and how many others waited outside. But if he trusted anything, it was the skill of his allies. Grace, Enne, Tock... They were all capable. They only needed an opportunity.

And so he did run, a plan forming in his mind.

While the guests and many of the Irons clamored out the emergency exit, Levi raced to the room's corner, to a set of grand windows sheathed with black velvet curtains. To make himself less noticeable, Levi kneeled, and he snapped his fingers below the fabric. Like flint, sparks ignited over his skin, followed by a small, steady flame.

After a few moments, the curtain caught, flames licking the bottom of its hem and gradually sweeping up.

This was a dangerous ploy—Levi hadn't been lying when he told Enne he didn't have the skill of a fire-making talent. He had no control over the flames. He could burn down half the boardwalk.

Regardless, he lunged for the next curtain and did the same, then the next, and the next. Before he finished the eight of

them, the fire had reached into the wood of the walls. Smoke swirled across the ceiling like storm clouds, its fumes making him choke.

I set fire to my own dream, Levi thought bitterly. But he didn't mourn the casino the same way he mourned the person he had been, because as he watched the flames claim the Legendary, he realized he didn't even care. He would find a better dream.

ENNE

Enne's heart lurched at the sound of the first gunshot, certain, at first, that she was the one to fire it.

She frantically looked down at her hands—empty. She hadn't hurt anyone. She hadn't even brought her revolver. After what she'd done to Lola, to Jac, it still hurt to hold it, and so she'd left it behind at the finishing school.

Now she wondered if that had been a mistake.

Already positioned near the archway to the lobby, a flood of guests swept around her, fleeing the source of the gunfire. No one noticed Enne—she was too small. An arm knocked her backward. A shoe stepped on the hem of her dress, sending her teetering off-balance. Screams reverberated throughout the Legendary, and Enne fought for space, fought for breath, as she tried to squeeze through the mayhem. She needed to see what had happened, who was hurt, who was dead.

Once she'd stumbled into the lobby, it took her several seconds to make out the person strolling confidently through the

guests careening for outside, a pistol in his outstretched hand. Though he and Enne had never met in person, she recognized him from photographs in *The Crimes & The Times*.

Captain Jamison Hector. With at least a dozen whiteboots behind him.

At first, Enne assumed that Hector must've been here for her. That despite their precautions, she'd been recognized. But Hector's eyes never once roamed the lobby in search of her, and Enne's gaze swept frantically across the havoc, searching for his target.

Then she spotted Roy, charging toward him.

"Don't!" Roy shouted, and Hector jerked in surprise, this time aiming the gun at Roy. Roy skidded to a halt, his arms raised.

I can't do anything, Enne thought helplessly. She'd packed a knife in her purse, but it would be little use against a squad of whiteboots.

A moment later, one of the guests cramming into the card-room barreled past her, and Enne collided with a column, shoulder to stone. She circled around the column, blocking herself from the whiteboots' view, trying desperately to make herself small so Hector wouldn't notice her.

As the last of the crowds dispersed, only a few people remained in the lobby. Narinder stood frozen at the foot of the stairs, his hands lifted in immediate surrender. Harvey sat below him in a matching pose. Grace stood exposed in the room's center, her gun trained on Hector. Sophia knelt beside Harrison, and Enne gasped when she saw the dark stain seeping out over his shirt.

Don't worry. I've beaten worse.

Enne's chest felt tight, painfully tight. She reached into her pocket, fingers fumbling for her tokens. The warmth of the metal did nothing to ease her panic. If not for the column's

support, she might've fallen. Because one of them was already hurt, the whole night careening toward disaster.

"Put your weapon down," Hector told Grace calmly, and Enne begged her silently to listen. "We have the building surrounded."

Behind him, the team of whiteboots advanced forward.

"You..." Harrison breathed heavily. "You could have...shot any of the guests. By mistake."

"Ah, but I don't make mistakes," Hector told him.

Harrison's one eye widened. As far as Enne knew, Harrison and Hector had always been on good terms. It was how Harrison had been able to arrange opportunities for Levi in the past, like when Tock destroyed Revolution Bridge. If Hector had betrayed Harrison, then he must've been answering to someone higher, which could only have been the Chancellor.

After all, Harrison was her target.

Harrison must've thought the same thing because he reached into his jacket.

"Keep your hands—" Hector started, moving his gun from Roy to Harrison.

"I'm just getting it. It's what you wanted, isn't it?" Harrison asked. He pulled two cards from his jacket. One slipped to the floor, and though Enne couldn't see what it was, she assumed it was Zula's. He held his card—the Lovers—between two trembling, blood-slick fingers. "Let Fenice—"

But Hector cut him off, gesturing to his men. "Evacuate everyone other than the targets." He never took his gun off Harrison, and Enne wondered if shooting him had not been enough. If the city's corruption was so terminal that he would murder the politician right here, in front of everyone.

As the whiteboots filed into the cardroom, Enne turned behind her, searching for Levi. But he was hidden among the crowds, and she couldn't bring herself to slip away to find him. She was paralyzed, her back glued to this pillar.

To her left, Hector stepped toward Harrison.

Roy lurched forward. "You can't do this, sir."

Hector turned his head at being called "sir." He squinted at Roy. "Pritchard? You're still alive?" He sounded more surprised than irritated, as though Roy had only ever amounted to a secondary thought.

"Yes, I'm still alive," Roy growled. "Despite you trying to have me killed for doing my job."

Grace cursed and backed closer to him, her gun still pointed at Hector. Enne should help her, she knew. If Levi could outwit a fight, then she could outmatch it. But she couldn't hold a gun anymore, couldn't even look at one without flinching. All she'd brought was the knife in her purse.

Hector scrutinized Roy. "If you and the girl don't lower your weapons this moment, the team will shoot you both."

Hector's disinterest clearly wasn't what Roy wanted from his old boss. His face contorted with righteous rage, but—per Grace's swift elbow in his side—they both did as instructed. Then Grace kicked their weapons across the floor. At the foot of the stairs, Narinder and Harvey did the same.

Gathering her courage, Enne took the knife out of her pocket and held it against her chest. It felt as though her very heart beat against its metal. Ever since the Shadow Game, Harrison had been the person keeping the noose from their necks. She needed to do something, but if she revealed herself, even with her attempted makeover, Hector might figure out who she was.

Before she could concoct a plan of action, she smelled burning, and she noticed a haze beginning to thicken the air. She gasped when she looked into the cardroom and saw smoke gathering at its ceiling, black and noxious.

"Fire!" one of the guest shouted. The remaining patrons, who'd confined themselves to the cardroom, sprinted into the lobby toward the set of double doors behind the whiteboots.

Once again, Enne was swallowed up amid the masses—and

this time thankful for it. With Hector and his men distracted, she dodged through the rush toward the hallway behind the grand staircase. No sooner did she get there than she spotted Delaney and Tock, urging her behind an open door.

"Did you start the fire?" Enne breathed as they yanked her into the supply closet.

Tock shook her head. "No—it wasn't me."

It was Levi, Enne realized, feeling a pang of anguish for him, setting fire to his own casino before it even finished its first night of business. She quickly shook the thought away. Better to grieve their dreams than grieve each other.

"We need to get out of here," Enne said.

"What about the Bargainer?" Delaney asked.

"She hasn't shown."

Down the hallway, Narinder and Harvey staggered toward them, seeming to also have escaped in the rush, and Enne had no doubts that Grace and Roy had managed the same. That meant that Sophia and Harrison remained in the lobby, and only Levi was unaccounted for. Enne knew it was for the best that Levi hadn't jumped into the already tenuous standoff, but she didn't like being separated.

"What happened out there?" Tock asked. "We heard some shots. Hector is—"

"Hector shot Harrison," Enne explained quickly. "And we need to move. We can't just stay here. The whiteboots will be—"

"Harrison was shot?" Delaney rasped, her eyes widening. "Then I have to go after him."

Enne cursed herself for not realizing it earlier. Harvey, Delaney, and Sophia were all Harrison's omertas. If he died, so did they.

"Then we go back," Enne said. "We get him out."

The smell of burning made her crinkle her nose. Smoke

snaked in through the hallway's mouth, making the hallway gray with haze. The fire was spreading—and fast.

Because Tock and Delaney were the only ones who still had their firearms, they led the group of five to the edge of the hallway.

"Do any of you know your way around this place?" Narinder hissed.

"No," Tock answered, and the rest of them shook their heads, as well. Not studying the casino's blueprints now seemed like an oversight in their planning, but they had never anticipated this.

Delaney peeked her head out into the lobby. She sucked in her breath. "Harrison looks badly hurt. Sophia is still with him."

"How many whiteboots?" Harvey whispered.

Delaney counted. "Fourteen."

Enne cursed. "What do we do, then?"

"If we separate them, I could take a few of them out," Tock suggested, squeezing her hands into fists.

"Yeah, but you'd take the building down with it," Narinder muttered.

"Enne, you're a good shot. Could you shoot Hector from here?" Tock asked.

Enne's heart seemed to stagger. Hector was close enough, but it wasn't the distance that made her doubt.

Thankfully, Harvey saved her from responding. "If you shoot Hector, the whiteboots might kill Harrison," Harvey squeaked.

"We could exchange hostages," Delaney suggested.

"We don't have a hostage," Tock said.

Delaney gave her a sly smile. "We've got the Mizer."

The four others turned to Enne. It was a desperate plan, and it would mean that all of the effort Enne had put into not being recognized would be meaningless. It would nullify her contract. She'd lose her pardon.

Worse, it would mean she'd be apprehended. Though the

whiteboots would hardly shoot her on sight—the Chancellor would want to execute Enne properly at Liberty Square—it was the most perilous sort of gamble. Could she trust her friends to save her?

But she couldn't shoot, couldn't fight. Giving herself up was the only useful thing she could manage.

"Fine," Enne said, her stomach churning. "It'll buy you time to get Harrison out."

"You should be the one to make the exchange," Delaney told Narinder.

"Why?" he asked, wide-eyed.

"Because you look the most frazzled."

Narinder frowned and tucked aside one of the long black hairs that had fallen from his braid. "I don't know what I'm doing! I... I..."

"He's right," Tock cut in. "It should be me. My talent is the only one good for—"

"Which is why you, me, and Delaney should be backup, in case something goes wrong. Narinder is the best option," Harvey said. He squeezed Narinder's shoulder while Tock offered him her gun. "You can do this."

Narinder looked at him, expression dark, and nodded. He grabbed the pistol.

"Sorry," he murmured, lifting it to Enne's head. Even without the threat, the feeling of having a gun pressed against her made her insides writhe.

"Just don't shoot me by mistake," she choked.

Narinder nodded, looking perhaps sicker than she did, and yanked her by her arm into the lobby. Hector and the thirteen other whiteboots turned with a start.

"Don't shoot!" Narinder shouted, dragging Enne closer.

Hector eyed them warily. "What are you doing?"

"I want to trade. Harrison for the Mizer."

"Harrison? What could he possibly be worth to you?" Hec-

tor asked, and Enne cursed. Narinder might've looked the part, but Hector was right—he had no connection to either her or the politician. This looked staged.

"If he dies, his omertas die, right?" Narinder asked, his voice hoarse. "I don't want to see that happen. I can't..." He swallowed and pressed his gun harder into Enne's cheek. She winced from the force of it. He played his part a little too well. "I can't let that happen."

Hector studied Enne, who hardly needed to act to appear terrified. She let her eyes dart across the room, to Sophia and Harrison on the floor, to the wide-open doors, to the corners, where—to her horror—another whiteboot already had Grace handcuffed and Roy on his knees behind her, his hands raised behind his head.

Hector's stare was calculating, his blue eyes all ice. "Take them both," he ordered.

Narinder stiffened. "I—I'll shoot her."

"You won't," he said calmly. He saw right through them.

In the cardroom, flames had climbed up the far wall, radiating a heat that pressed into the lobby like an oven. Narinder's hand was slick around Enne's arm as he shoved her away, as the whiteboots reached out to grab them.

In the commotion, a scream ran out, and Enne turned to see the man holding Grace crumple to the ground, clutching himself between the legs.

In an instant, Roy leaped to his feet. He reached underneath Grace's dress and pulled out another gun, one Enne didn't realize she'd kept hidden along her thigh.

He aimed and fired.

Hector grunted and dropped, dead before his face slammed against the stone floor.

Several other shots fired from around them, and the whiteboots fell, one by one. The first few came from behind the stairs, where Delaney stood, Harvey crouched behind her. Sev-

eral more had fired from the columns between Enne and the cardroom, where she at last spotted Levi, much of his hands and shirt covered in soot. Roy had shot the two men beside Hector.

But Enne's relief at finding Levi was short-lived. As she panted and looked around at the fallen bodies, at the sea of blood pooling across the floor, she counted those fallen and those who had shot them. Three from Delaney, two for Roy, five for Levi... She was no counter, but the math didn't add up.

"Over here," came a voice from one of the doorways.

Enne whipped around and spotted a girl standing there, barely a few years older than her. Everything about her was razor-thin—her hair, her features, her frame. And her eyes were red.

The Bargainer turned her gun away from the fallen white-boots and fixed it instead on Enne. "So where is Lola?"

XVI

THE DEVIL

"Forgiveness is not sought—it's built, stone by stone,
over whatever it is you've broken."

Martyr. "The Faithful Few."
The Treasonist's Tribunal
21 Mar YOR 13

HARVEY

Harvey's first thought at the Bargainer's appearance was confusion. After years of Bryce and Rebecca and him preparing for this moment, Harvey had begun to picture the Bargainer a certain way. And he'd never imagined she would remind him of Bryce. It had nothing to do with their features, not even the matching red of their eyes. It was their expressions. They shared something haunted. The look of someone who had done terrible things without repentance. The stain blood left behind even after you'd washed it off your hands.

"Muck," Delaney cursed beside him. It was her voice that brought him back, that reminded Harvey why he'd come to this pre-opening at all: not to kill the Bargainer, but to save her.

Narinder had risked his life tonight, and Harvey knew that part of that—even if only a small part—had been for him. But no matter their friendship, Narinder would never have come had he not had a card of his own, had he not had his own stake in this game.

It was Enne who answered the Bargainer first.

"Lola is safe," she told her, her voice surprisingly steady.

The Bargainer examined the bodies on the floor, at Harrison now passed out beside them. She glanced toward the cardroom, where dark smoke billowed like a fog. "That's more than can be said of you."

Levi turned his gun on her.

Harvey's heart hammered. Despite Hector's interruption, this had been their plan—to shoot to kill, to do whatever it took. Harvey couldn't let that happen. Once the Bargainer was dead and the game fell apart, Bryce would be next.

The Bargainer raised her eyebrows and aimed her own gun on Levi. "You want to make a deal, don't you? So I can bargain for Lola back?"

Levi hesitated. Harvey wasn't surprised—Levi was honorable like that. He didn't play dirty when it really counted.

Not like Harvey did.

Harvey slammed his elbow into Delaney's head, hard enough for her to slacken and crumple against him. He ripped the gun from her grip and let her slide to the floor.

"What are you—?" Tock started from across the room.

Harvey trained his gun on Levi. "Don't try anything."

"I *knew* you were a rat!" Grace shouted, still handcuffed on the floor.

Harvey ignored her. It was harder, however, to ignore the look that Narinder shot him: shock caving into hurt. Harvey had never wanted to cause him pain, but the world had given him an impossible choice.

Two against nine were abysmal odds, but both Harrison and Delaney were unconscious, Grace handcuffed, and Levi and Roy the only ones armed.

"What are you doing?" Levi growled, his own gun still pointed at the Bargainer.

"No one needs to die tonight," Harvey said carefully, his voice hoarse from the smoke.

"I'm sorry," Tock snarled, "but was this not all *your* plan from the start?"

He faltered, but only for a moment. Even if Harvey had realized that killing the Bargainer would break the game, he couldn't let them do it. Bryce had promised that they would go back to how they used to be, before Rebecca, before Vianca. But if the others destroyed the shade, then they would never let them. They'd *kill* them.

"Harvey," Enne warned from beside Narinder, "you're making a mistake."

But Harvey ignored her and steadied his hand. "We'll find another way to end the game. If you just *go* to Bryce," he told the Bargainer, "then no one has to die."

"Why should I make a deal with the person who started this?" the Bargainer asked. "Is he the one who has Lola?"

Before Harvey could answer, Levi fired. The bullet caught the Bargainer in the shoulder, tearing through her sweater and spilling blood down the wool. She didn't lurch back, didn't wince, not even from the force of impact. She glanced down at the wound with disinterest, as though someone had merely tapped her.

All too soon, the wound stopped bleeding. Harvey realized with a shudder that it had healed entirely, from a talent that didn't belong to her. It left nothing behind but a stain on the fabric.

Levi hissed out a long, muffled curse.

The Bargainer eyed each of them coolly. "Is that what this was, then? A trap?" She laughed softly. "Did you really think you all could kill me? After everyone who's tried? I am the only true legend of New Reynes, because legends cannot die."

If that was true, then Bryce's game had been for naught. The

Bargainer would never cure Rebecca. And Rebecca would die, the game would end, and Bryce would no longer be protected.

Splotches bloomed in Harvey's vision. No, that couldn't be true. Harvey could not have committed all these sins for nothing.

The Bargainer's eyes narrowed on Enne, assessing her new hair and contacts. "I told Lola not to trust you, but she came anyway. First her ear, then her brother, now this." The Bargainer shook her head. "And you think I'm the monster."

Enne froze, stricken.

"Is Lola here?" the Bargainer pressed.

"She's not," Enne managed. "But she—"

"Then I don't need to negotiate with anyone," the Bargainer said. In a blur, she stepped backward, toward the front doors. "And I don't need Bryce to end the game. Once you're all dead, I'm sure I'll have all the cards I need."

"You can't kill all of us," Grace growled.

She raised her eyebrows. "Can't I?" And then she lunged outside and slammed the doors closed. Harvey heard a lock click, but he couldn't be sure if he'd imagined it.

Why wouldn't she listen to him? How could she still not go to Bryce?

Roy charged forward and tried to follow after her, but the door didn't budge. "No!" he shouted, throwing his weight against it. "No. No, no, no! They're locked!" He swallowed and looked up around the Legendary. "They all might be."

Dread sank in Harvey's stomach like a stone, and his lungs tightened. This couldn't be right. This couldn't be happening. He didn't know what made it harder to breathe: his fear or the smoke.

The two other guns in the room turned on him.

"Give us one reason," Levi growled between gritted teeth, "why we shouldn't all kill you right now."

LEVI

Levi's hand shook as he pointed his gun at Harvey, his own anger igniting his vision red, the flames engulfing the cardroom casting a stifling heat across his skin.

"I..." Harvey's voice trailed off, as if even he couldn't conjure a reason he should stay alive. His gaze traveled back wildly between the locked doors and Levi's pistol. He was so distracted that he didn't notice Enne creep up behind him, rip the gun from his hand, and deliver a swift kick behind his knees. Harvey crumpled to the floor beside Delaney.

"If it weren't for you, we could have killed her," Levi growled. "This could be over! We could—"

"You shot her, and it did *nothing*," Enne told Levi.

"Are you suggesting it's my fault?" Levi had known that the Bargainer's talents would make killing her difficult, but he hadn't envisioned that she would treat a bullet as less threatening than a mosquito.

"I'm saying it's not just Harvey's."

"So…what? We let him go?" Levi didn't want to fight with Enne, but he'd never trusted Harvey. He'd included him as a favor to Narinder, and he only owed Narinder a favor for the way things had played out between them. But Narinder didn't know the North Side in the same way the rest of them did. Levi should never have trusted his judgment.

It felt thickheaded now. Harvey Gabbiano and his Chainer smile. Of course he'd betrayed them.

"We could use him as bait. Convince Bryce to call off the game," Enne suggested.

"That won't work," Harvey grunted below her. His eyes were closed, and he made no move to resist Enne's heel against his chest. He lay limp, like he'd already accepted his fate.

"Then why work for him?" she barked. "Why risk everything for someone who wouldn't do the same for you?"

Harvey turned his head to the side, swallowing hard. He had no answer.

Levi knew he could still be lying. But maybe it was the defeated, broken look on Harvey's face. Or maybe it was the pools of blood already soaking into the soles of his loafers. But Levi didn't want to kill him. Two hostages in one night was low, even for him, but that was what Bryce's game was, after all. It had diminished the value of a life to no more than a playing card. It had made friends into enemies of one another.

"You can all stand there arguing," Sophia snapped, "but Harrison needs to go to the hospital."

Levi whipped around to where Harrison lay, his head propped on Sophia's lap, unmoving except for the shaky rise and fall of his chest. "Does anyone have any medical knowledge?"

"I do," Roy said, running over. Something gold glinted in his pocket, and Levi realized that he had taken Hector's card—his target.

"Not that I don't care about the politician man," Grace

grunted, "but if we don't get out of here soon, we're *all* going to die."

She was right. Even if the flames wouldn't burn Levi because of his Glaisyer talent, he would be crushed when the building collapsed or by breathing in too much smoke. And judging from how the fire had climbed upward, swallowing the entire southern side of the casino, they didn't have much time.

"There has to be a way out," Enne said. "One of the other exits must be…"

Her gaze flickered to Levi, and a chill shot down his spine. There was something eerie about this moment. They had always thought the casino resembled the black-and-white hallway in their dreams, where they spent the nights roaming in search of a particular door. A nightmare made real.

"This isn't good," Roy breathed, exposing the bloody wound beneath Harrison's shirt and wincing. He tore off strips of fabric to make a bandage. "He won't last long."

"If he dies, so do the three of us," Sophia squeaked.

"Then we don't let him die," Levi said.

"Wow," Grace sneered, "thanks for that plan. I see why you're the mastermind. We can't even get out of here—"

"Of course we can," Tock said smugly. "I don't need a door."

"You could collapse the whole building," Levi pointed out.

"You have a better idea?" she shot back.

He didn't.

While Harvey stayed down, Enne shook Delaney awake by her shoulder. Delaney's eyes fluttered open, followed by a low groan. She rubbed the back of her head.

"Enne, help her walk," Levi said. "Tock, you go in front. Narinder, you and Roy can carry Harrison. I'll deal with Harvey. We need to get as far from the fire as possible, where the building is still the most durable. Tock can blow our way out."

They each nodded, and moved fast. Levi grabbed Harvey by the backs of his arms and yanked him up. They trudged be-

hind the group, both of their eyes bloodshot from the smoke. Harvey's skin was oddly feverish to the touch.

"You're the one who told us that the game's shade is tied together by the Bargainer," Levi told Harvey. "Is that even true? Did you set us up all for this?"

"If I'd lied, why would I have tried to stop you?" Harvey asked coolly. "I just didn't want anyone else to die."

"Bryce doesn't seem to share that agenda," Levi pointed out.

"He's not as terrible as you think."

"If someone is terrible to everyone but you, that doesn't make them secretly a good person."

They walked out of the lobby through a maze of back hallways, as far north as the casino would take them. Levi might have owned the Legendary, but he still didn't know it well enough to know where they were going. Another grim reminder of how little he'd invested into the dream that had once meant everything to him, the dream of the person who would gladly trade his life for a sliver of New Reynes' glory. But he no longer saw the glamour in chasing after a legend. Jac had managed it, and Levi was glad for him, but Levi had come to care more about the people—not the story—he would leave behind.

Because his story had always been a lie. He hadn't come from nothing. He was Levi Glaisyer, grandson of the right-hand orbmaker to the king of Caroko, son of two political prisoners who'd fled the bloodshed of the Revolution. He didn't want to build an empire out of poker chips and houses of cards—he wanted to build something that lasted. He wanted the unrest of the Revolution to finally end. He wanted to undo the corruption that lingered in the world. He wanted the legacy he'd been born for, not the one he'd conned himself into.

It had only taken setting his old dreams on fire to realize that.

"It looks like it, doesn't it?" Enne whispered ahead of him. At first, Levi didn't know what she meant until he recognized the eerie, grave quality to her voice.

"Like if I opened a door, I'd find a memory behind it," Levi said, grimacing.

"What are you both talking about?" Delaney asked.

"It's a…" Levi started, realizing immediately how shatz it would sound. Or maybe not, to a shade-maker. It was no less shatz than anything else that had happened to them recently. "Zula Slyk told us there is a shade that binds us both."

"You mean Bryce's game?" Delaney said.

"It's from before that," Enne explained. "It's in our dreams, ever since I got to New Reynes. I still see—"

"A second shade?" Delaney asked sharply. Her face, already pale, went whitewash. "Why would Bryce do that?"

Levi elbowed Harvey in the ribs as they walked. "Well, do you know what it is?"

Harvey pursed his lips, and Levi could see the uncertainty in his expression, weighing his loyalties. "I have no idea," he said finally.

"Nice try," Levi told him. He squeezed his wrists so tight Harvey winced. "But I am this close to locking you in one of these rooms, so you can burn the same way Zula did."

Harvey's expression darkened. "I'm telling the truth. I thought Bryce and Rebecca created that shade to lure the Mizer to New Reynes. To you. It shouldn't still exist."

"But that isn't how I met Levi," Enne said. "I found Levi because of a letter my mother sent. The shade doesn't have anything to do with it."

"Your mother didn't send you that letter," Harvey said softly.

Enne froze, making Harvey and Levi collide with her back. "What do you mean?" she whispered hoarsely.

But even if Levi shared her shock, he didn't need Harvey to answer. From the first day he and Enne met, it had struck Levi as bizarre that a woman he'd encountered in passing would send Enne to him. Now it all made sense.

"Why would Bryce have done that?" Levi growled at him.

Before Harvey could answer, Tock called out from the front of the group. "Stop walking! Stand back!"

Levi bumped into Harvey's back, who bumped into Enne.

"I don't understand what she's going to do," Roy hissed at Grace ahead of them.

"She's going to blow up the wall."

Roy's eyes widened. "*She's* the same girl who blew up Revolution Bridge? That's why I lost my job! I knew Hector was hiding... I can't believe—"

Levi didn't have time to brace himself. An explosion rumbled down the hallway, the noise ringing in his ears, ricocheting in his ribs, and blowing a cloud of dust over their heads. Levi wiped the debris off his face and looked ahead. True to her word, Tock had blown a hole through the wall. The blast had damaged the foundation of the boardwalk, spilling out onto the dunes.

"Muck," Tock breathed.

"What is it?" Levi asked.

"Whiteboots. A lot of them."

Of course, all the backup Hector had brought awaited them outside.

"I'll talk to them," Roy assured them. "Come on." He pushed Narinder forward, still carrying Harrison's body. They emerged first from the casino, stumbling on the dunes.

"Help!" he called. "I'm Sergeant Roy Pritchard, and we have a man injured! We need a paramedic."

They filed out, one by one. A crowd had formed around the building, a mixture of whiteboots and onlookers, many of them guests from the pre-opening. Though the paramedics did as instructed, the whiteboots quickly flooded them. They broke Levi's grasp on Harvey and jerked Levi back, locking his arms behind him.

"Roy?" someone asked incredulously. While the rest of them were rounded up, several whiteboots grinned and slapped Roy

on the back. "Where have you been? We thought you were dead! You—"

"The captain is dead," he said, making all of them quiet and their mouths hang open. "Who is in charge?"

"Sergeant Nicollo—"

"She's dead, too. Who's the highest ranking officer out here?"

"Captain Roxborough, from the Casino District's fifth precinct. But...the fire! We couldn't get into the building, and—"

"Let me speak to Roxborough. No reporters. And let these kids go. They've just been through an ordeal, and what matters right now is handling that fire." It must've been the authority in Roy's voice, because the other whiteboots nodded and released whomever they'd been carrying. They ran back into the crowd in search of the captain and fire department.

"Nice going," Levi told Roy.

Roy shot him a grin. "I wasn't publicly discharged. I might still have a few friends." Then he frowned. "But Hector shot Harrison on the Chancellor's orders. She might make an attempt on his life again."

Levi nodded in agreement. "Then we don't leave Harrison's side. We stay with him, and we think of our next move."

"And we contact Poppy," Delaney said. "She's still with Lola. And the Bargainer..." She paled.

Levi's head swam. There were so many people to account for, a thousand mistakes they could make. But he did know this—without Harrison, any chance of reclaiming peace with the Chancellor after this would vanish. And for now, with Harvey and Lola, they still had their two bargaining chips.

"Then we don't lose her. We don't lose *anyone*," he said. "Someone call Poppy. Tell her to meet us at South Side General Hospital."

LOLA

There were worse people to hold you captive than Poppy
Prescott.

"Do you want any?" Poppy asked, offering Lola a box of
macaron cookies, each flavored with a different type of flower.

"I'm not hungry," Lola grumbled, even though she was. She
was *starving*. But she was handcuffed to the door handle in the
passenger seat of a hideous and expensive pastel motorcar. She
wasn't going to accept finger food from her captor.

"It's not poisoned," Poppy said, waving the box in Lola's face.

Lola knocked it away with her free hand, spilling macarons
over the dashboard. "Get it away from me."

Poppy dropped the box on her lap and pursed her lips. "I'm
just trying to be polite."

"I'm a hostage."

"We used to be friends."

"We used to be acquaintances."

Poppy's expression darkened, a look that didn't suit someone

so bubbly and...pink. But Lola didn't feel sorry. It was hard to feel anything other than anger. Enne had tricked her. She'd drugged her. She'd kidnapped her. All to kill the only person Lola *did* have left in this city.

She leaned her head against the window. She considered pounding on it, shouting to the passersby in the South Side that she was a prisoner. But no one would see her in the darkness. She was anonymous and invisible.

Lourdes had been Veil's hostage, Lola knew. Veil had kidnapped her and forced her to swear her protection talent to him. Lola had spent the past few months questioning her own judgment, only to have her worst instincts proven right. She should've trusted Arabella from the start, and now Arabella would pay the price for that.

Not that Arabella was good, either. She'd betrayed Lola once, too.

Sometimes Lola felt like the only person in New Reynes without lies and blood on her hands.

Maybe it was time to change that.

"Where are you taking me?" Lola asked Poppy.

"To a friend's apartment. They're traveling. It'll be empty."

So Poppy planned to stay in the city. Probably in the South Side. If Lola could escape, she could phone her apartment. Pray that Justin answered. It would mean overpowering Poppy, who was a good deal more athletic than her. But Lola knew now she had more weapons at her disposal.

"Does it bother you to be working with the man who had your father killed?" Lola asked.

Poppy's knuckles whitened on the steering wheel. "You think I don't know?" She let out an unexpected, dry laugh. "I know more than anyone gives me credit for."

"You didn't know Enne was a street lord." Even if Enne could pass in high society, Lola and Grace had practically at-

tended those political parties with wanted posters taped to their backs. They were both as refined as broken beer bottles.

"There are worse sins than being naïve," Poppy said. "Better to be clueless than cruel."

"Are you accusing me of being cruel?"

"Was bringing up my father's murder meant as small talk?"

Lola grimaced. No matter how pretty or perfect Poppy was, Lola was the only victim here. "It's a fair question."

"My girlfriend is one of Harrison's omertas. It's not like I can retaliate," she said. "Besides, my father was a fool, happy to play Vianca Augustine's puppet, and that's why he died. It doesn't make what Harrison did any less terrible. But I can't afford to play with grievances or ideologies. Not until this game is finished."

Lola couldn't decide if Poppy was being remarkably mature or weak. But Lola's head still pounded from the lingering effects of the drug, and the metal cuff around her wrist was leaving a bruise, so she decided bitterly on the latter.

She'd told Zula Slyk that she wanted to be like her, the person to tell the story when the story was over.

Well, Zula was dead. Lourdes was dead. There was no one left to tell this story but Lola.

If the world learned that Enne was Veil's daughter, Enne's pardon would vanish. Any semblance of peace would vanish. Lola might not have been much of a player before, but even she knew that, when it came to finishing this story once and for all, she held the winning hand.

Her stomach rumbled. *Muck*, she was starving. While Poppy was focused on the road, she reached down and picked up a fallen macaron. But before she could stuff it in her mouth, Poppy slapped it out of her hand.

"Bitches don't get macarons," Poppy told her.

Lola let out a howl of shocked laughter. "Are you serious? I'm hungry."

Poppy straightened, as though trying to fit herself into the new role of gangster. "I could've put you in the trunk. I could *still* put you in the trunk."

"I'd like to see you try."

Lola reached down to pick up another macaron, and Poppy swerved the car. Lola smacked her head hard against the center console. She sat up. "What? You trying to kill us?"

"Just sit still until we get there," Poppy snapped.

So much for being remarkably mature. "Or what? You'll crash the car?"

"You know who suggested this entire affair?" Poppy asked.

"Enne?" Lola answered, rolling her eyes, then wincing. Her head ached.

"Tock."

That shouldn't have surprised Lola like it did. Tock had obviously guessed Arabella was in the apartment and told the others, which was how they'd gotten the idea to use Lola as bait. But she hadn't imagined Tock to have suggested kidnapping Lola.

And it shouldn't have stung like it did, either. Lola didn't know Tock. She shouldn't care what the girl thought of her. Now that they'd kidnapped her, she was done caring about her old friends.

"You sold Tock out for what? A history lesson?" Poppy goaded. "Was what you learned really so important?"

Lola had sold no one out. She'd been tricked. But she couldn't help that now. "What I learned changed everything."

"Should it have?"

When Enne was the last surviving Mizer, capable of throwing the entire Republic's tenuous political balance into turmoil, it did matter. Because Lola did understand the power of legends, and that kind of story was a loaded weapon.

The thought made her eyes flicker to Poppy's left side, at the gun holstered at her hip.

"Your father was a monarchist who almost won a Senate

seat," Lola chided, slowly leaning forward. "You don't think it matters?"

"I think other things matter more."

"Those are empty words. They don't mean anything."

"So that's your political philosophy? Kill the people with the power to change things? Explain to me how that makes you better than anyone else."

Lola eyed the street ahead. Poppy was preparing to turn. That was when she'd strike.

"Enne wouldn't change things for the better."

"You think so little of her?"

"She held a gun to my brother's head. She's literally the reason why I'm a hostage. Should I really think better of my captor?"

"You should think better of your friend."

The light turned green, and Poppy turned. Just as the car rounded the corner, Lola lunged forward, reaching over Poppy's lap. Poppy screamed and tried to push Lola off. The car swerved with a sickening lurch and a loud screech. Lola's fingers grazed the cool metal of the handle—

Crash!

Lola was knocked sideways, her side smacking against the shift handle with a loud and painful *crack*.

After a few moments of dizziness, she opened her eyes and slowly straightened, the movement excruciating. The car had collided with a light post, its hood crunched like an accordion, wrapped around the metal. Poppy had smacked her head on the steering wheel, and she now sat slumped in her seat, unconscious, blood trickling down her forehead.

"Muck," Lola muttered. She hadn't meant to crash the car. What if Poppy was dead?

Before she checked, she first reached over her lap and removed the pistol. She hated to touch one, but she couldn't chance Poppy using it against her. Then Lola—gritting her

teeth, she'd definitely broken a rib—reached into the backseat and grabbed Poppy's purse. She fished inside and found the key to her handcuffs.

Once she'd freed her wrist, she shook Poppy's shoulder. The heiress's eyes fluttered open, and she squinted at Lola. "What happened?" she asked.

Lola let out a sigh of relief.

Then she handcuffed Poppy to the steering wheel.

"What are you—" Poppy started.

"It's not that late. Someone will find you," Lola told her. "Try not to fall asleep. You probably have a concussion."

"Wait! Lola, don't—"

But Lola had already climbed out and slammed the door behind her.

She ran as fast as she could manage, clutching her side with one hand and the gun with the other. Every breath hurt, like the broken bone was digging into her lung. A balloon, ready to pop.

Taking in her surroundings, she realized she was in the southernmost part of the South Side, near the university campus. Poppy's traveling friend was probably a student.

Lola tossed the gun into a trash can and hobbled two blocks to the closest yellow phone booth. With relief, she realized that when Enne had stripped Lola of her scalpel after she'd drugged her, she'd left her orbs. Lola fed two volts into the machine and phoned her apartment.

It took three rings for her brother to answer. She'd almost thought he wouldn't.

"'Lo?" he said.

"Justin, it's me. I'm at the corner of Hellebore and Fifteenth. I need you to get me."

"I don't even know where the muck that is." He sounded groggy, like he'd been asleep.

"It's on the South Side," she growled. "Just use a map."

"You know I could be arrested for going out, right? With my hair?" Lola drummed her fingers against the window glass, frowning at her useless brother, a brother who didn't even want to help her. And muck, she was in so much pain. But she couldn't go to the hospital. She needed to save Arabella. She needed to stop Enne. "Are you hurt?"

That was the most considerate thing he'd said to her since they'd reunited. Lola's eyes widened in surprise. "A little," she admitted.

"Don't—don't move. I'm coming." He hung up.

Lola slumped to the ground of the phone booth. Maybe she wasn't as alone in this city as she'd first thought.

XVII

THE MOON

"'If the brutal task must fall to someone, then let it fall to us,'
he said, but when I asked him whether he was referring to
the Revolution, he answered, 'No. Of course, I am referring
to the game.'"

Ventriloquist. "An Interview with the Phoenix Club."
The Journey of Reynes
22 Dec YOR 7

SOPHIA

"You're not allowed to die," Sophia told Harrison from his hospital bedside at South Side General. She meant her words as his omerta, who would die if he did. She also meant her words as his maybe daughter, who wasn't emotionally prepared for Harrison to drop such a confession on her and then get himself killed.

The fluorescent lights of the room made Harrison appear already dead, though everyone else looked no better. Levi and Roy stood outside, speaking to the whiteboots who had seemingly only decided to follow Roy's lead because of Roy's expired officer badge, his authoritarian voice, and his über-respectable side-part haircut. Harvey sat in the room's corner under the watchful glares of Grace and Tock. Delaney and Narinder had taken to the seats along the wall, both slumped down and defeated.

The doctors claimed Harrison was going to be all right, that the emergency surgery had quickly removed the bullet and

patched up his abdomen. But Sophia would believe that when he woke up. When she rolled anything other than snake eyes.

Could Harrison really be her father? Harrison was, at best, a washed-up fraternity brother who'd never been held accountable for his actions and, at worst, a deplorable, corrupted politician. But Sophia no longer trusted her memories of the man who'd claimed to be her real father, who'd coddled her yet willfully ignored her complaints of Charles's cruelty. Harrison was neither a good or bad man, but he'd already consoled her better than her father ever had.

Sophia must've known the truth before she'd sold her split talent to the Bargainer. She must've known Harrison was her father, that Leah was her mother. So why hadn't she reached out to him? It didn't make sense. He'd been out there, all that time. Unless the Torrens had kept this from her, the way Enne's own history had been a secret.

Levi returned to the room, dark circles beneath his eyes. "The whiteboots and Harrison's own staff have posted guards all over the hospital. Roy told them there's been a threat on Harrison's life and not to release information to anyone, especially the press. Right now, the Chancellor and the Bargainer probably don't know where we are."

"They'll find out eventually," Narinder groaned. "I can't just sit here and wait for them to show up."

"We haven't heard from Poppy," Delaney choked out. "We called the dormitory, but no one is picking up. I..." She put her head in her hands. "I can't just sit here, either."

"Then our next step should be to go after Bryce," Enne said. Her eyes were more bloodshot than the others', irritated by the smoke and her cheap colored contacts. She'd removed them now, even if it exposed the violet underneath.

"I told you," Harvey said darkly, "Bryce won't negotiate. Not for me."

"I think he will," Narinder said sharply. "Otherwise, what's

changed? Why would you go back to him?" His voice was loaded with accusation, and Sophia realized that Narinder wasn't just upset that Harvey had tried to foil their plan: this was personal.

Harvey's face reddened. He had no answer. And Sophia had thought her own relationships were complicated.

"But we can't go to Bryce. Not yet," Delaney said. "Enne, you and Levi mentioned there was another shade. And that... that doesn't sound right."

"Another shade?" Sophia echoed, confused. "Other than the game?"

"Levi and I have the same dream," Enne explained. "A repeated dream, of a hallway with black and white doors."

Sophia furrowed her eyebrows. "That sounds like—"

"That sounds *shatz*," Grace growled.

"Any more shatz than the Bargainer?" Tock shot back. "Actually, yeah, it does."

"We know how it sounds," Levi growled. "But it's the truth. Zula Slyk said it was a shade."

"Well, if *Zula Slyk* said it's a shade..." Grace said mockingly while Enne glared at her.

"I don't know about this Zula Slyk lady," Sophia said, "but that sounds like a hallway in the House of Shadows."

The room quieted.

"What hallway?" Enne asked.

"You mean the one in the basement," Delaney said. "It's where most of the malisons in the House of Shadows live. It's all black and white. The doors, the tiles... With big columns and—"

"That's it," Enne breathed, exchanging a look with Levi. "That's exactly it."

"Poppy and I found it when we were there. I can take you back," Sophia offered.

"What good is touring the creepy dream hallway going to do?" Grace asked.

"In the dream, we're always looking for a particular door," Levi said. "Maybe we need to find the real one."

Grace threw up her hands. "Can't argue with that logic!"

"It does sound…" Narinder started, looking at his shoes sheepishly as though he didn't want to offend anyone. "It does sound ridiculous."

"What do *you* think?" Enne asked Delaney.

Delaney's expression was serious. But Delaney's expression was always serious. "I don't like it. Shades are supposed to disappear once they've served their purpose. If it was supposed to lead Enne to New Reynes, then why does this still exist? What does it mean?"

No one could answer that, of course. But from the uneasy glances shared around the room, Sophia expected no one *wanted* to. They'd had their fill of shades. If Levi and Enne had managed to ignore this one for so long, why stop now?

"We should go," Levi pressed. "We don't know our next move. This could show it to us."

"What happened to using the Chainer as bait?" Grace asked.

"If we find nothing, we'll come back," Enne assured her. "Sophia and Delaney can come with us. You all can stay here."

"I want to stay, in case we hear from Poppy," Delaney said. "Sophia knows the way. She can take you."

Sophia didn't want to leave Harrison, but it felt silly to say that out loud. As his omerta, Sophia had no reason to want to stay with him—she should hate him. And the thought of telling everyone what he'd told her left an embarrassed knot in her stomach. Sophia *knew* all the faces in the room, but she didn't want to lay all her hopes and doubts bare. She didn't want to be vulnerable.

"Fine," Sophia murmured. "Let's go."

★ ★ ★

It was a quiet cab ride to the House of Shadows.

The trio paid the driver and stepped out onto the lawn, each soot covered, scraped up, and weary. Enne and Levi studied the manor house as though they saw ghosts in every window, and Sophia supposed they did. Last time they'd come here, they'd barely escaped with their lives.

"The Phoenix Club..." Enne started hoarsely, but the words died in her throat.

"Seems mostly disbanded, now that Bryce replaced the Shadow Game with his one," Sophia told them. Her words did little to relax their shoulders. Enne reached out and squeezed Levi's hand.

It was such a small gesture to make Sophia's heart ache like it did. She missed Jac. So much. And it hurt to lead two people to what they hoped was their happy ending when hers had died not even four months prior.

"Come on," Sophia managed, then she swallowed and led them to the front door.

The party crowd was at its peak at this time on a weekend night, and after what had happened at the Legendary, Sophia was tremendously done with crowds. She felt overloaded, like one new sensation might break her down, and the House of Shadows' raucous laughter and jazzy music played at her nerves like a fiddle.

Then she felt a squeeze on her shoulder, and she turned to see Enne give her a slight smile. It grounded her enough for Sophia to push through the partygoers to the door that led downstairs. The stairs creaked with every step, and Enne and Levi both sucked in a breath when they reached the landing, when they took in the hallway stretched out in front of them.

"It's...it's just like it," Levi breathed. "Even the ceiling..."

Sophia looked up. The ceiling looked like an average ceiling to her, minus a few of the exposed pipes.

"The House isn't nearly this big from the outside," Enne said, gaping. "How do we know which door it is? We don't have hours, and there must be hundreds. I can't see the end."

Maybe this was all a waste and the two of them really were shatz. Because Sophia could see the end of the hallway just fine, along with its maybe twelve doors.

Levi traced his fingers over the frame of a white door, a clouded, almost dreamy look in his eyes. Nerves bundled in Sophia's throat.

"Are we looking at the same hallway?" she asked. "Because what you're describing...isn't real."

"What are you talking about?" Levi asked, dropping his hand.

"I'm saying I can see the end. Right there." Sophia walked ahead of them and slapped the cinderblock wall on the opposite end of the hallway. "Hear that? That's the end."

"I don't see it," Enne said, her voice hitched. "What does that mean? If we see something different than you?"

"It means we were probably right to come here," Levi answered. But as he reached for a doorknob, Sophia lunged forward and grabbed him by the hand.

"You heard what Delaney said. People *live* here. You could be about to barge into someone's sitting room! You can't..." Then she pulled her gaze away from his, to the ceiling. What had moments ago been water-stained tiles was now lofted vaults, grand, an eerie dreamlike mist clinging to them.

Sophia wrenched her hand away from Levi's skin. The vision above her returned to normal.

"What is it?" Levi asked.

"I—I saw it, when I touched you," Sophia said, fully aware that *her* words made her sound shatz.

But Enne didn't hesitate. She reached forward and squeezed Sophia's hand a second time.

Levi reached for the knob.

"What are we going to find behind there?" Sophia asked, now more nervous than she'd been before.

"I'm not sure," he answered. "But this door is one of mine."

He swung it open, and immediately, Sophia's heart gave a squeeze so painful, she thought she might pass out. Because it was hard to gaze at him, looking so much like Sophia remembered him, only his hair was blond—his natural color—instead of black. There was a bruise on his left cheek that she guessed had come from fighting, and he had the same emptiness in his eyes as when they'd first met, the gaze of someone adrift. Just like she was.

Levi didn't react like Sophia did. He'd probably seen Jac since it happened, in a dream like this one. Sophia wished she had. It was far better than finding his hidden cigarettes.

Jac was seated on a torn-up couch, in a building Sophia didn't recognize. It looked dirty and uninhabited.

"Where is this place?" Sophia asked.

"A house in Olde Town we used to squat at," Levi said softly.

Sophia knew the stories—Jac had told them to her.

She waited for something to happen. For Levi to enter, or maybe one of the other old Irons—Chez or Tommy or Mansi. But it was just Jac sitting there, drumming his fingers against his knee, waiting for someone who wasn't coming.

"I thought you said these doors held memories," Sophia whispered. "Or nightmares?"

"Well, it hurts, doesn't it?" Levi murmured.

It was agony, to stand here and watch. Because Sophia knew the moment she let go of Enne's hand, the illusion would disappear.

But truthfully, she didn't like to look at Jac this way. The way his shoulders slumped inward, as though trying to make his broad frame smaller. He looked skinnier. Greasier, like he wasn't taking care of himself.

The Jac she remembered was different. Healthier and more

assured. She knew that was how he'd prefer she remember him, too.

"Let's keep looking," Sophia said quietly. "It's not this door."

And, hand in hand, she pulled them away, letting Jac Mardlin disappear like a puff of cigarette smoke.

ENNE

Enne had liked it better when dreams kept to her sleeping hours, and there was something horrifying about walking this hallway that went beyond déjà vu. Here, her fears had substance. For months, Enne's nightmares had remained confined behind these doors, but standing here, she felt as though, this time, her nightmares might slither out to greet her.

"We need to keep going," Levi said, his voice tight.

Why? Enne almost asked him. They didn't know what this shade was, if Bryce had cast it or some other malison. It was a mystery to add to her already existing row of problems. Bryce's game. A potential execution, even when all of this was over. How many hurdles could they survive before their luck ran out?

She took a deep breath and squeezed Sophia's and Levi's hands tighter. "Let's try a black door." One of her doors. Fear lodged like a stone in her throat.

They approached the next one, and Enne's hand shook as

she turned the knob. The metal was solid and cold. Real, like her every nightmare was.

She eased it open, the hinges creaking. She recognized the surroundings instantly—it was Lourdes's office in Bellamy, the room Enne had been forbidden from entering all her childhood. But now the door was left ajar, and Lourdes leaned against her desk as though she'd been expecting her.

Enne's heart clenched. Was this her curse? To look upon Lourdes the way they had Jac, to feel the weight of all the words unspoken in the space between them? Enne didn't need a shade to remind her of the broken relationship between her and her mother. Of time and truth she would never get back.

But then Lourdes acknowledged her. "I'm sorry," she said softly. She averted Enne's gaze and shuffled through the papers on her desk—articles Lourdes had written as a Pseudonym, evidence of her double life. Lourdes had always presented as either female or neither gender, and though Lourdes's style remained subdued regardless, today she'd opted for feminine—a simple gray skirt and matching blouse, her long blond hair swept up in tight pins.

While Enne struggled to collect herself, Lourdes continued. "I regret so much, but more than anything, I regret preparing you for none of it."

She hadn't, but in the eight months since her death, Enne didn't want apologies, no matter how much Lourdes's decisions had hurt her. Enne missed her far more than she'd ever resented her.

Enne let go of the others' hands and sprang forward. She threw her arms around her mother and was relieved to find her solid and warm.

"Are you real?" Enne whispered, burying her face in Lourdes's neck.

"No," Lourdes answered, which was very like Lourdes, not

to sugarcoat. "But I am me. The way people remember me—including you."

Enne had an endless amount of questions she wished to ask, but she started with the one that hurt the most. "Why didn't you tell me who I was?"

"Because I'd hoped you'd never need to know."

Lourdes pulled away but kept her grip on Enne's shoulders. Tenderly, she touched the edges of Enne's short hair, and Enne was relieved her mother had so easily recognized her—not just from her hair, but in her expression and the way she carried herself, after all the horror she'd lived through. Enne wasn't sure she'd have recognized herself.

"But I deserved to know," Enne said hotly. "I worked...so hard trying to be someone I wasn't. You watched me struggle." Even though so much had transpired since Enne came to New Reynes, the scars Bellamy had left on her still felt fresh. Her feet were still calloused, still pink where her blisters had healed. From nights spent rehearsing instead of sleeping, clinging to a vision of herself that was based entirely on what others thought of her. Trying to be anything other than no one.

"I'd planned to tell you when I thought you were old enough," Lourdes murmured. "But you were already older than I was when I was roped into problems no one should have to face."

"When Veil kidnapped you and forced you to swear your protection to him," Enne said. "My father."

Lourdes nodded grimly. "He'd damned me. My talent... once I swear it, I can't act in my own interest—not if it hurts his. It meant I could never go home."

Enne shuddered. "That's despicable."

"I hated him, at first," Lourdes said. "But once I learned the truth about the Revolution, about the pact my father had made with the Bargainer, I realized I didn't have a home to go back to."

Enne knew that feeling all too well. She didn't think she'd ever return to Bellamy.

The thought of everything Lourdes must've gone through made her throat tighten. "You hadn't wanted this," Enne said hoarsely. "You hadn't wanted me."

Lourdes's face softened. "I could've traveled with you to the other end of the world and never returned. I didn't have to swear my protection to *you*. But I did. And I came back to New Reynes every chance I got to make this world better for you, in case it ever found out who you were."

Enne felt another hand on her shoulder, and she turned to see Levi, and Sophia behind him. She'd forgotten anyone else was in the room.

Lourdes's eyes settled on Levi. "I remember you. I gave you a recommendation to St. Morse." She frowned. "I owe you an apology, as well. I never imagined Vianca would use her talent on someone so young, a talent she can only bestow on only a precious few. I'm so very sorry. I know how it feels to be trapped."

"I–it's fine," Levi said awkwardly. He tugged on Enne's shoulder, meeting her eyes seriously. Enne remembered that they were here for more than a reunion.

"Are you the person I was meant to find?" Enne asked Lourdes.

Lourdes shook her head. "I'm afraid not. You should go find them."

But Enne still had a list of questions to ask Lourdes. She wanted to ask about Gabrielle Dondelair, her birth mother, what she'd been like. About Lourdes's childhood. About her many accomplishments in the City of Sin.

Tears spilled down Enne's cheeks, and she wiped them away on the back of her hand. "I love you," she told her.

Lourdes embraced her one last time. "I love you, too."

The room faded as Enne approached the door, the tendrils

of the illusion slipping away, like water between her fingers. When Enne glanced down, she saw pale threads of light, the same as she remembered from the Shadow Game. They reminded her of volts, the way they looked when Levi extracted them, wispy and soft, until they transformed into static in his hands. If these were the threads that held the shade together, then maybe Mizers and malisons weren't so different.

"Are you okay?" Levi asked once the door closed behind them, but Enne was distracted, still studying the threads. She looked up and sighted others strung around the hallway, tied between doorknobs, suspended from the ceiling, linking every piece of this place together. "Enne—"

"I'm fine," Enne said, her voice cracking. She wasn't—leftover tears still streaked down her face—but she didn't have time to fall apart. And there would be time, when all of this was over, when she could stop looking over her shoulder. Lourdes had fought for that for her, and Enne had to believe that her mother's sacrifice hadn't been for nothing. That everything Enne had done hadn't been for nothing.

One door, more than any of the others, was covered in threads. They slipped beneath it, looped around its hinges, disappeared within its keyhole, and circled the large metal knocker nailed to its center, one in the shape of an eye, its handle the lid. The door was black—her door—and Enne could feel something was different about it. An urgency seeped from it. The threads hummed, like the strings of a piano, each discordant with each other.

"Do you see that?" Enne asked them, pointing at the door ahead.

"Oh, is there more that I can't see here?" Sophia asked flatly. "Because I'm really loving this experience. I can literally feel my sanity slipping away."

"What do you see?" Levi asked Enne.

"I think that's it—the door we've been looking for," Enne murmured, inching forward. "The one with the eye."

"But what's behind it? Not to be crass, but I don't think I can stand seeing another dead person," Sophia said, shivering. "It could be one of my siblings."

"Or Vianca," Levi said darkly.

Enne didn't know why the shade would lead them to a monster they'd already faced before.

But she didn't doubt it *was* a monster. Just one of a different sort.

She held her breath and traced her fingers over the eye-shaped knocker. Its metal was eerily warm.

The knob turned of its own accord.

When the door creaked open, she recognized where they were instantly—Liberty Square, the site where Jonas had been hanged, along with dozens of street lords and Mizers before him. New Reynes' execution spot turned tourist destination. Except, at dusk, it was vacant, the overcast sky darkened by factory smog.

A lone figure sat at the edge of the platform. He—male, Enne guessed, judging from the broadness of his shoulders—was dressed entirely in black, from the patent leather of his boots to the gloves on his hands, to the black gauze wrapped around his face and neck, obscuring all skin beneath. He looked like the charred remains of a corpse, of something meant to be buried.

Levi sucked in a breath beside her. "Veil," he gasped.

The most notorious legend of the North Side. Enne's father.

"I thought he'd be taller," Levi said. "But then again, you got your shortness from somewhere."

Sophia gaped. "Are you suggesting…?"

Enne ignored them and strode toward the platform. She didn't care if this man was her blood. She wasn't like him. He'd taken so much from Lourdes. He'd committed crimes

she would've never considered. She might've had to fight to survive, but she'd never been malicious.

"Why are you the person we needed to find?" she asked him fiercely.

"I thought that would be obvious," he drawled.

Enne would prefer not to acknowledge their relationship. "Enlighten us."

"I'm the one who knows how to kill the Bargainer."

Enne had assumed the hallway had only brought her to this door because he was her father, and so her eyes widened. "So you can help us. There is a way."

"Of course." He had a smug voice, the sort from a person used to having to explain things, used to being clever.

But Enne was also used to being made to feel small. And no matter how grand Veil's legend, she was a legend of her own, equal in greatness but not in terror. She'd come so close to following his path, but looking at him now, sitting beneath the site of his own execution, she was glad she hadn't. She'd become something stronger, and it was because she'd learned to grow when people called her small.

"Take off the wrappings," Enne demanded. It was easy for him to have the upper hand if he could keep his mystery.

"Do you really want to see my face?" he asked, a hiss at the end of his words.

"I'm not afraid of what you look like."

He laughed mirthlessly. "I've heard the rumors that I'm scarred or hideous. I know you could handle that much, even though that isn't true. I'm wondering if you want to know how much you look like me." He paused. "I can tell you hate me."

"You stole Lourdes's life," she said.

"I lived through the Revolution, even if I was only a child at the time," he said. "I was the last Mizer left alive. I'm not proud of what I did to survive, but I'm not ashamed of it, either."

Enne couldn't imagine what it would be like to watch every-

one like you fall, but she did know how it felt to be the last of a dying legacy. It reminded her that, as much as she resented Veil for what he'd done, he was gone. Dead. The real enemies lived, and if Enne didn't stop them, either Bryce or the Bargainer could turn this world inside out.

"I think I can handle it," Enne told him, though glancing back, she wondered if Levi could, who openly gawked as Veil reached up to unravel the gauze, starting where he'd cinched it beneath his jaw.

Slowly, inch by inch, he unwound himself. He exposed fair skin, a clef jaw, a broad face—much like Enne's own. His features were angular where hers were softer, like her mother's, but she'd inherited his hair—dark brown and fine, though his was creased to his forehead, flattened and sweaty from the gauze. Their eyes, of course, matched in shade, though his were sunken and bloodshot from permanently squinting through dark fabric. He looked only a few years older than her, but tired, pale from never seeing sun, lines already etched into his skin from frowning. The sort of face that suited a wanted poster.

Enne was suddenly thankful for the changes Grace and Poppy had given her. She did not want to resemble this man.

He took a deep, gasping breath—it must've been hard to breathe through the wrappings. And he pushed his greasy hair out of his face.

"That feels…" His voice was hoarse, and as he leaned his head back, closed his eyes, Enne realized he was feeling the wind. "It feels good."

There was something tragic, watching him breathe freely on the very place where he died.

He met her eyes. "Satisfied?"

"I…" Enne crossed her arms. "Yes."

Veil slipped off his leather gloves. "I should hate myself for what I did to Lourdes, too. I owe a lot to her. Had I known about you, maybe I would've done things differently. Maybe

you wouldn't have needed her to protect you." He sighed. "I'd been so focused on saving myself, that by the time I realized what mattered more, it was too late."

"It *is* too late," Enne said, trying to keep her voice cold even if she was losing her resolve.

"You judge me harshly for someone who did the same to your friend," he told her, and Enne stiffened, realizing he meant Lola. "Did you know street oaths are meant to echo Protector talents, even if they're not as strong? That was the bargain Havoc made. The two of us created everything you know about the North Side." There was that smugness again.

Then there really was no difference between them. Enne faltered.

"Tell us how to kill the Bargainer," Levi said, speaking for the first time. "Help us end this."

"You have the answer with you," Veil answered. "It's in your pocket."

Enne frowned, reaching first for her gun—only to remember she hadn't brought it.

"Your other pocket," he told her.

Enne slipped her hand inside and pulled out her two tokens: the queen and the king. She realized immediately he was referring to the latter, the king's token, the one she'd found in the secret lockplace in Lourdes's bank account. Even now, the eye of the cameo glowed unnaturally purple, and the metal was warm.

"I tricked the Bargainer," he explained. "I told her she could take my talent, but instead, I sealed it inside that coin. That's the reason Lourdes never ran out of volts in that account—she had this."

"But how will this kill her?" Enne asked, confused.

"It's what she wants, isn't it?" Veil said. "Give it to a shade-maker, or an orb-maker. Warp what's in it to something deadly. Trick her just like I did."

"There's no guarantee that will work," Levi said.

Veil shrugged. "There's no guarantee anything will work. But this is what I knew. This is what I was supposed to tell you."

As he spoke, the smog above them began to part, giving way to the piping of the true hallway's ceiling in the House of Shadows. The gallows behind him dissipated, the stain on New Reynes's history washing away.

"I *am* sorry," Veil said, before disappearing himself.

The scene vanished, leaving Enne, Levi, and Sophia standing in the hallway, the shade of it gone, but all its nightmares remaining.

XVIII

THE HERMIT

"The line between justice and vengeance is a line of fire."

Martyr. "One-One-Six Dead."
Her Forgotten Histories
1 Oct YOR 10

LOLA

Lola shouldn't have been surprised when Justin showed, but she still was. Time and time again, Justin had made it clear that he'd willfully abandoned her for the Doves and he'd gladly do it again. But he'd come, wearing a flat cap to cover his hair.

"You're hurt," he breathed, nodding to her face. Lola reached up and lightly patted her cheek, feeling what she guessed was a bruise from where she'd smacked the shift stick in Poppy's motorcar.

"I'm fine," Lola said, grasping onto the handle in the phone booth and pulling herself to her feet. She sucked in her breath— her broken rib ached. "I wasn't sure if you'd really show."

His face fell, and Lola warily braced herself for another fight.

Instead, he said, "You deserve a better brother than me. I was so angry after Sam died, and I didn't know how to take care of you, or myself. When I found the Doves, they made me feel…competent, like I was really in control. It's laughable

now. When I found out Ivory had a secret, they…" He swallowed. "They discarded me. Like I was nothing."

At first, Lola didn't know what to say. Of all the betrayals she'd faced, Justin's had always hurt the most. But she'd never thought he'd apologize, and for as good as it felt to hear it, it also rattled her. It meant that she'd been wrong.

"You're not nothing," Lola told him. "Not to me." She'd done everything she could to get her brother back. Dyeing her hair Dove-white. Working with Bryce and Rebecca in the Guild.

It wasn't until she met Enne that—for a moment—she thought she'd found a new family, and she could finally relinquish the lost hope she'd been clinging to. And even if Justin was here now, Lola was glad she'd given up. She'd needed to let herself let go.

It was so dark out that it took Lola a few moments to realize that her brother was crying.

Lola shushed him and threw her arms around him, and even if her side ached, she let him bury his face in her shoulder, let him lean his weight against her.

He had come back. And he cared, no matter how fiercely he'd claimed he didn't.

"We need to find Arabella," Justin said, pulling away from her.

"She'd be with the others," Lola said, her voice tight. "That was the plan. To use me as bait. They were at Levi's casino. We can drive—"

"But the Legendary burned down," Justin answered.

"What?" Lola breathed. Her friends couldn't be dead. No, she would've felt it, the moment her street oath to Enne snapped.

Then she shook away her thoughts. It wasn't her old friends she should be worried for; it was Arabella. Who'd never wanted her to go to the Legendary in the first place. Who was the one person Lola had left.

One of the two people, Lola corrected herself, staring at her brother.

"I heard about it on the radio," Justin blurted. "They said there were deaths, but they weren't civilians. The fire took out half the boardwalk. And—"

"But we need to find them. If we find them, we find Arabella." Lola hugged her arms around herself. They could be anywhere in New Reynes.

No sooner had she asked her question than a whiteboot car roared past them, its red lights flashing and its siren blaring. Moments later, a second followed.

"We need to follow them," Lola said, pointing at the cars as they screeched and disappeared around the corner. Lola didn't play games, but if she had to bet, if there was trouble brewing in the City of Sin, then she would find her friends at the heart of it.

"On foot?" Justin asked.

Lola grinned, looking around the uppity street, at the expensive motorcars parked along the curb. She rubbed her hands together. "Oh, I can think of something better."

"When did you learn to hot-wire a car?" Justin asked, grasping at the door handle as the vehicle skidded around a turn.

"It's a bit late for brotherly concern," Lola pointed out.

Lola floored the gas pedal, delighting in the rev of the Houssen engine—likely a gift from a university student's rich father. It rode exactly like you'd expect an eight kilovolt car to ride: like a dream. They zoomed down Hedge Street, swerving across the lanes and out of the path of light posts, tailing the whiteboot car less than a block ahead of them.

"Where are they going?" Justin asked. "We're nearly at the Brint."

He was right—they were heading toward the North Side. But then the whiteboot car veered right, and Lola followed, her

tires screeching. It was hard driving these South Side streets—so smooth and well paved, without even a single pothole.

The whiteboot car slammed on its brakes at the mouth of the parking lot of South Side General Hospital, a tall building at the edge of the riverside. As it swerved, Lola nearly collided with its side. Justin screamed as they lurched to a stop, and Lola's chest smacked the steering wheel, knocking the breath out of her. But the Houssen had stopped—with inches to spare.

"Why'd he stop like that?" Justin demanded, sticking his head out the window to get a better look.

Lola's eyes watered from the pain in her side, and she shakily straightened, trying to see, too.

Then she spotted the figure standing at the intersection of the parking lot and street—at the crossroads.

Arabella.

"Park it for me, will you?" Lola told Justin. She opened her door.

"Wait—I can't drive—don't—"

"It's easy. And no one taught me, either."

Before he could protest further, Lola staggered out and closed the door behind her. "Arabella!" she called, crossing the street into grass along the curb.

Arabella lurched at the sound of her name. Then, spotting Lola, she ran to her side, so fast she reached her in moments. Lola nearly lost her balance when she felt Arabella's hands at her side, holding her upright.

"You thickhead," Arabella growled, seething. "You're hurt."

"I'll be all right," Lola assured her. "But—"

"I *told* you not to go. You could've been killed!"

Lola knew Arabella had been worried, but she was still taken aback by her harsh tone. She wasn't just concerned...she was furious. The lights from the sirens cast a glow over her eyes, her hair, her clothes—all of her was red.

"We're in the middle of the lot," Lola said, "let's talk some-

where else." The winter wind was brutal out in the open, and Lola's scarf and gloves had gotten lost amid the process of being drugged and carried to Poppy's car.

"Talk?" Arabella repeated. "I didn't come here to talk." Her gaze flickered to the hospital, and Lola realized from Arabella's murderous expression that Lola's friends were in there, right now. Which could only mean someone had gotten hurt.

It scared her, the danger her friends constantly threw themselves into. But it scared her just as much that she still cared. They'd betrayed her. They'd kidnapped her. But she couldn't stop thinking of Justin, the person she'd never thought would come back.

Maybe it changed nothing. Maybe it changed everything. There was nothing Lola could be certain of anymore.

"I know you're angry, but you can't hurt Enne," Lola murmured. "I know what Enne did, but—"

"*I'm* angry? Enne told you that she wanted to start over," Arabella shot back. "But where are you, Lola? Where are your friends? How many ears and ribs do you have to spare?"

Lola swallowed, failing to form a response. Every time she tried, a pressure built up in her throat, and she knew that whatever word she spoke would break into a sob. Because she suddenly felt pathetic. She was not okay—her abdomen ached with every breath—but she couldn't bring herself to admit it. Because her brother had only just come back, and he needed her shoulder to lean on.

When tears prickled at Lola's vision, Arabella took Lola's hand and led her down the block where they could slip into the cover of an alley. It was an escape from the wind but not from Arabella's fury.

"Aren't you going to say anything?" Arabella demanded.

"I…" Lola's voice caught, and she squeezed her eyes shut. Crying would only make her broken parts hurt worse.

"Arabella is my real name, you know," the Bargainer told her.

497

Lola was so surprised that she managed a hoarse, "What?"

"You're my friend. You know who I am. You know why I've done everything I've done. And I can't lose someone else. I can't…" She clenched and unclenched her fists. "What if Enne hurts someone else? What if the world goes back to the way it was? Then those consequences will be on you."

"On *me*?" Lola echoed, deeply overwhelmed. She couldn't bear the weight of the world. Not tonight.

Arabella narrowed her eyes. "No, no, you don't get to back down now, not after I've watched you scour every newspaper for months waiting for Enne to prove to the world that she's the monster you *know* she is." She took a step closer to Lola, blocking the glow from a nearby streetlight. The shadow Arabella cast seemed to stretch several feet too long, swallowing Lola in its darkness. "You've been wronged, Lola."

"I know that," Lola whispered.

"You're angry. You're as angry as I am."

Arabella reached forward and pressed her hand below Lola's shoulder, against her heart. Lola tried not to cringe. Arabella could undoubtedly feel her pulse racing in nerves, feel her chest staggering in swallowed sobs. It was such a simple touch, but now Arabella could tell how broken she was, inside and out.

"That makes the two of us the same," Arabella told her.

Lola couldn't deny this, but it still chilled her, to hear such words from the Devil's lips. She shivered, backing away from her until she pressed against the wall, until she could feel the cold of the brick even through her coat.

I've spent my whole life in someone else's cross fire, Lola thought. *But I can end the war now.*

But Lola couldn't bring herself to say the words Arabella so clearly wanted from her. Because despite how much Lola hurt, despite how her friends had used her, Lola still heard the same voice in the paranoid corners of her mind.

You are the worst version of yourself.

Lola knew this—not just from Arabella, but from Tock and Enne, people who had once cared for her. But in trying to piece together the girl she'd once been, Lola only had scraps of evidence, fleeting moments, foggy memories—an assortment as disorganized as Jonas's files.

She was clever, so her father had taught her.

She listened. Jac had shown her that.

She paid attention, Zula had complimented her.

Lola clung to these good qualities in case they were the only goodness she had left. Because Lola was also angry, and hurting, and paranoid—buckling under the pressure everyone had thrust upon her since she was a child. She'd always been the girl with a "good head on her shoulders," but that wasn't because she'd wanted to be. Who else would've cared for their father while he was ill? Who else would've paid the bills while her brothers chased their delusions of glory? It was all that responsibility and worrying that had made her paranoid in the first place.

Maybe there was no reckoning coming, and Lola had been paranoid for nothing. Or maybe reckonings weren't defined by the fire of a bullet or the thunder of an explosion. Maybe they were the moments when you decided who you truly were, and Lola, so obsessed with determining this for everyone around her, had been putting off her own moment, knowing that if she studied the whole of her life too closely, she'd only find hurt.

But she couldn't avoid it any longer. Because even though she was the worst version of herself, Lola refused to believe that any version of her resembled Arabella.

"I'm not like you," Lola told her quietly. "I am not a monster."

The Bargainer's features, distorted in the shadows' reach, gave way to rage. A rage Lola understood, but not one she wished to share anymore.

"I know what I've done, and I've tried to be better," Arabella deadpanned. "I *am* better."

"But you're not. You've done nothing to earn it."

"I've been nothing but good to you!" Arabella fumed. "I know that I tricked you, but I've tried to make up for it. I took you and your brother in. I've been your friend when you had no one else."

"I can forgive you for tricking me," Lola said, because she had, even though she hated not knowing herself. "But in the grand scheme of every sin you've committed, I'm not the one you need to redeem yourself to. I am your cop-out, and I'm tired of being your conscience."

Lola, as it turned out, did still have some anger left in her, because her voice rose.

"I'm a terrible judge of people," she went on, and for once, it didn't wound her pride to admit it. Because in all her research, she'd overlooked a vital truth—people changed, for better and for worse. Sometimes the ones you loved abandoned you. Sometimes they came back. "But I've figured out this. Your pain isn't enough to redeem you. Redemption is trying to heal the hurt you've caused. And I've never been the person you truly needed to redeem yourself to."

Arabella shook at Lola's words, and Lola realized that of any of the weapons she could've wielded tonight, she'd chosen the only one to make the Bargainer bleed.

"But you can still redeem yourself," Lola told her. "You're a malison *and* a shade-maker. Help Enne and the others end the game. Stop—"

"I will *never* help her," Arabella growled. "And I've already made my last move. The game will be finished before sunrise."

Lola's mouth went dry. Sunrise could only be a few hours away.

"You can't—"

"Why? Because it'll make me terrible? It'll make me a monster?" Arabella grinned ruthlessly. "If I'm the only one who

will move the hands of history for the better, then so be it. I'll be beyond redemption."

Lola eyed the mouth of the alley. Arabella stood between her and her exit.

Arabella laughed softly. "You'd try to run? You know I'm faster."

Lola was in no condition to fight, but still, she reached a hand into her pocket, seeking her scalpel but finding only her harmonica. She'd forgotten Poppy had removed it while Lola had been unconscious.

"I'm the only one who knows your true name," Lola rasped. A pitiful defense.

Arabella stepped back, offering Lola an escape route. She shook her head. "Yet you don't know me well, after all. I'm not going to kill you."

Arabella's words hung heavy in the air, waiting for Lola to claim her mistake—that Arabella couldn't be a monster.

Instead, Lola ran. Even though it hurt, she ran the best she could.

She didn't stop until she charged through the emergency entrance of the hospital. She entered a sterile white hallway, the fluorescent lights blinding compared to the night outside. She squinted and stumbled as her vision adjusted.

Then she skidded to a halt at the edge of a waiting room, locking eyes with exactly the people she'd hoped to find.

Tock sat on a chair, Poppy beside her. In the time Lola had waited for Justin, Poppy must've reunited with her friends. Her head was still bruised and blood-crusted, however, like she had yet to see a doctor. Lola felt a pang of guilt for leaving her in the first place, but it couldn't be helped now.

"Tock," Lola breathed.

"Lola," Tock said, stricken. She stood up.

Lola didn't know this girl, but maybe some part of her did, because her feet moved automatically toward her. Only min-

utes earlier, Lola had nearly made the worst decision of her life, a decision that would've made her a monster. And though Lola didn't expect Tock's understanding, she had a feeling that Tock would listen.

But Tock didn't respond, only continued to gape. It took Lola a moment to realize that Tock wasn't looking at her—she was looking behind her.

"Well, what do we have here?" someone asked—a man's voice. Something flashed in the corner of her vision, something sharp and metallic.

Lola whipped around to face Justin, his chin raised and his eyes wide as a tall man placed a scythe against his throat.

"The birdie who didn't come home," Scythe purred, in a voice that made Lola's blood turn to ice. In the man's other hand, he carried a machine gun. "Maybe you can help me find my next card."

XIX

THE TOWER

"We warned you this was coming. You live in the
City of Sin, but you did not guess the sleight of hand."

Jester. "The City with a Street Name."
Her Forgotten Histories
9 Oct YOR 12

SOPHIA

Harrison woke mere minutes after Sophia, Levi, and Enne had returned to the hospital and settled back into the harshly fluorescent room. While he slept, the doctors had removed Harrison's eye patch, revealing the rippled scar where a knife had dragged down his flesh. She'd caught Narinder staring at it more than once, clearly unsettled.

And the first thing Harrison did when he woke was lift his hand and gingerly feel his empty eye socket. He grimaced when he realized his patch was missing.

"Here," Sophia said, reaching to the nightstand and handing it to him.

Harrison blinked at her, then he looked down at his bandaged stomach, then at the dozens of whiteboots and members of Harrison's own service officers stationed out in the hallway.

"Muck," he said, sighing, as though he'd utterly forgotten that he'd been shot and rushed into surgery.

At his voice, one of the servicemen straightened and turned

to the others. "He's awake!" Several more of them poured into the room, Roy at the lead.

"How are you feeling, sir?" one asked.

"Can someone call the doctor?" spoke another.

"We have patrols all over the city who've been told the woman's description. It won't be long—"

"That's enough," Harrison rasped out, sitting up and wincing. He waved his hand weakly to shoo them out. "Thank you for—"

"You can call the doctor, but give him some space," Roy ordered. The others nodded and filed out of the room, with only Roy lingering behind. Outside the door, Sophia overheard a heated discussion between the officers and the hospital staff about keeping Harrison's identity secret and the hall private, and she squeezed the armrests of her chair beside Harrison's bedside. Even if they'd escaped the Legendary, the Bargainer was still at large. This night was far from over.

"Thanks," Harrison breathed to Roy.

"Grace, can you shut the door?" Roy asked.

Grace jolted behind them, as though surprised Roy was asking *her* to do something, rather than the other way around. Then she shook her head and did as requested.

Harrison let out what looked like a painful chuckle. "I don't even get a moment of rest before—"

"With all due respect, sir, we don't have time for that," Roy told him. "Actually, Grace, could you go get Enne and Levi? They're down the hall looking for Del—"

"Anything else you need me to fetch, Officer? Water? Cafeteria food?" Grace snapped, crossing her arms.

"Water would be great, yes," Roy said, smirking.

At first, Sophia suspected that Grace was tired and wrung out, like the rest of them, and that she was irritated because she'd prefer to continue napping in the corner. But then Grace threw her arms up angrily. "You know these whiteboot friends

of yours didn't go looking for you when you went missing, right? That they're not really your friends?"

Roy faltered awkwardly and shot a nervous look at the closed door. "I know that—"

"Chances are at least some of them knew about Hector's cover-up, so just because they're all smiles with you now doesn't mean—"

"You don't think I—"

"*We're* your friends. We're the ones who love you." She paused for a moment, seeming to realize what she'd said. Then she flushed and continued her onslaught, "And when tonight is over, you don't get to leave. You don't get to—"

"Grace," Roy cut in. "You're right. I know all that. I haven't let my guard down. And I don't plan on going anywhere."

"Good," she gritted out.

He beamed. "And I love you, too."

Grace flushed deeper and made a noise like a grunt. "You can't just... They don't..." Then she scowled. "I'm getting Enne and Levi. And the water." She opened the door and slammed it behind her.

Normally, Sophia would've laughed at such a demonstration, but it only reminded her that she had something to say, too. She knew, logically, that her words could wait. They weren't as important as security, as surviving this endlessly long, damned night. But after seeing Jac one last time in the House of Shadows, she was desperate to cling to the people she had left. She had Delaney and Poppy—friends she'd never expected but cared about dearly. She had, at least a little bit, the people in this room, though she knew some better than others.

But she didn't have family. And family was important to her. As a Torren, family was everything.

Harrison made a sorry excuse for a father. And the idea of being the product of two Families, of sharing blood with Charles and Delia as well as Vianca Augustine, scared her, like

monstrousness was coded in her, an entire identity valued in drugs and poker chips. Not to mention the omerta talent and how unspeakable that was, that Harrison could've cast it on his own daughter. That should she get her memories back, Sophia might share that power, too.

Harrison was flawed, and broken, and monstrous in at least a few ways. But he was reckoning with that, and the thought of it left Sophia with something she hadn't had in a long time—hope.

Harrison glanced at her like he wanted to say something about this, too, but Roy spoke up.

"Enne, Levi, and Sophia think they've found a lead on how to finish the Bargainer," Roy told Harrison. "How to break the game."

In the corner of the room, Harvey let out a strange, strangled noise. He'd been so quiet that everyone had seemingly forgotten he was present.

"Narinder, can you take him somewhere else?" Sophia asked.

Narinder pursed his lips but nodded. Wordlessly, he yanked Harvey up by his shoulder and guided him outside.

Sophia cleared her throat. "Enne happens to be in possession of a coin that used to belong to Veil, who turns out was also her dad. It apparently has Veil's talent locked inside—"

"It *what?*" Harrison croaked, grasping and squeezing his white sheets. The heart rate monitor beside him did a tiny whirl. Sophia put her hand on Harrison's shoulder and pressed him down before he could attempt to sit up.

"I know it sounds shatz," Sophia told Harrison calmly, "but there was this...vision of Veil in the House of Shadows. And he told us—"

"Shatz?" he repeated, still sounding strangled. "Veil is dead. I went to his execution. Believe me, I heard his neck snap."

Roy gave Sophia a wary look, but Sophia ignored him. Roy didn't know Harrison's history, but Sophia had expected

him to react this way. Veil was responsible for orchestrating the worst months of Harrison's life, which Harrison was reminded of every time he looked in the mirror. Even now, he unconsciously reached toward his eyepatch, as though the scar faintly throbbed.

"It's a shade," Sophia continued gently, "there was a shade on Enne and Levi, in addition to the one in the game. I know it doesn't make a lot of sense, but they think if they talk to Delaney, they might be able to..."

Before she could finish, the door swung open again, revealing someone Sophia had never seen before but instantly recognized. Her long neck, her beady eyes, her gray-toned skin were all exactly as she appeared in the newspapers. Josephine Fenice, the Chancellor of the Republic.

Two burly secret service men in suits flanked her either side. They each pointed a pistol around the room.

Sophia yelped and put her hands up, her heart rate spiking faster than even the beeping of Harrison's on the monitor. The Chancellor was the one who'd ordered Hector to kill Harrison. But she couldn't kill him now, could she? There'd be dozens of witnesses in the hospital. And Sophia couldn't lose the last chance at family she'd ever have.

"Madame Chancellor," Roy said, his voice a squeak, "you can't—"

"I hear Hector is dead," Fenice said coolly. She had an eerie monotone quality to her voice that suited her appearance.

"He was a friend of mine," Harrison said dryly, as though he could possibly mourn the man who'd shot him. But then again, Sophia mourned her siblings. Grief didn't play by the rules of should and should not. "You didn't have to do this. If you wanted my card—"

"It's about more than the game!" Fenice said, her cold exterior cracking. "You cannot surround yourselves with this city's

criminals and expect it not to have ramifications. The pardon of the Mizer was—"

"You'd execute an eighteen-year-old girl?" Harrison asked flatly.

"The Bargainer is back!" Fenice fumed. "All Malcolm wanted—all I wanted—was for the Revolution to end. But this violence…it has to end somewhere, Harrison."

"I believe we're in agreement there," he said.

"But we aren't," she snapped. "It hasn't been that long. I remember, you remember… All it would take is a push, and things could go back to exactly the way they were. Too many sacrifices were made for me to let this world fall back into tyranny. And if the price of that is more blood, then let history remember that I gladly paid it."

Sophia didn't pretend to understand the horrors of the Revolution—she hadn't been alive then, nor had any of her friends. But in her opinion, Fenice had acted ruthlessly enough to claim the title of tyrant herself.

"No one wants to go back in time," Harrison said. He lifted his hands, like he was trying to talk her down.

"You think any of us wanted *this*?" Fenice laughed mirthlessly. "You think we wanted all the Mizers dead? None of us were so terrible. But we didn't have a choice. Nor do I now…"

Just as she turned back to her two guards to give what Sophia imagined was a killing order, several people screamed from the hallway.

"Sir, put the man and the weapons down," someone barked.

"Don't take a step closer!"

"We have orders to shoot!"

There was the echoing of rapid gunfire, followed by more screams. Even with a wall between her and the commotion, Sophia instinctively ducked from her chair to the floor, so terrified she thought she might vomit. She'd thought she'd left the violence behind when she'd burned Luckluster.

Roy reacted first, lunging away from Harrison, but before he reached the door, a tall figure appeared at the threshold. The man wore a long, oversize wool coat that swept across the floor with the effect of a cloak. Pinned beneath him was a young man Sophia didn't recognize, with white Dove hair and a wild, frightened expression. The point of a scythe pressed against his neck, and in the tall man's other hand, he carried a machine gun.

Fenice's servicemen fumbled to point their guns away from Harrison to the man.

"Lower your weapons," one of the officers commanded pathetically.

To Sophia's shock, Scythe did—but only the gun. He switched on its safety and dropped it gracelessly to the floor, and it made a thump quieter than how heavy it looked.

The other officer took an uncertain step forward. "Your other weap—"

In a flash, Scythe shoved his hostage at the servicemen, and the hostage knocked into one and stumbled over a nearby chair. While he fell, Scythe swung his blade in a deadly, graceful arc, slicing through both of the officers' sides. Blood spurted from their abdomens, splashing onto the sterile white floor, and they collapsed, dead within seconds.

While Fenice screamed, Sophia looked out the door in horror to see other bodies of the other whiteboots littering the hallway, the faces of petrified nurses and doctors around them. Narinder and Harvey were nowhere to be found.

As Scythe straightened, his dark eyes circling the room, Sophia attempted to reach for her own gun in her bag. She wasn't a great shot—certainly no match for a Dove—but she couldn't just crouch there helplessly. But when she tried to reach for it, she found her arm wouldn't move. Something tight squeezed around her throat. The omerta.

She glanced wildly at Harrison, who gave an imperceptible shake of his head.

Fury coursed through her. There was no point in trying to protect her. If Scythe killed Harrison, then they'd *both* be dead.

Roy pointed his gun at Scythe's chest. "Stand down," he ordered, his hands shaking. "Stand down or I'll shoot."

Scythe opened his mouth and let out a long rasp for breath, as though trying and failing to speak. He raised his weapon.

"Officers!" Fenice called wildly, but no one in the hallway moved. There was no one *left* to move. Sophia's blood chilled. "Someone help!"

"I said stand down!" Roy shouted.

But Scythe didn't. His eyes watered, and his skin reddened from what appeared to be exertion, but he didn't listen. He wheezed as he took a step closer to Harrison.

Finally, Harrison sat up, his eye wide. "You have an omerta," Harrison said.

Scythe didn't nod or speak, but that was answer enough. That meant he wasn't killing of his own volition, not in this moment. He was someone else's puppet.

"An omerta?" Roy asked sharply. "Yours?"

"The Bargainer's," Sophia breathed, understanding washing over her. A single omerta—an Augustine split talent. What the Bargainer had taken from her two years ago.

Which meant she *was* an Augustine. She *was* Harrison's daughter.

"Mine," Sophia finished.

And she was so shocked by her own realization that she had forgotten something important: that Scythe, puppet or not, was still a player. And that meant he had a target.

It happened so fast, Sophia's senses seemed to take it in out of order. She heard it first—the whistle of the air, the wet slicing sound, the crack of bone, and the thump of a head hitting the floor. Then she saw the glint of steel and the blood—so much

blood—pour from the neck where it had been severed, same as the shade-maker from the House of Shadows. She smelled it last: iron. Then the vomit, as she bent over and threw up while the body tumbled to Scythe's feet, splashing crimson over the room.

Roy Pritchard was dead.

Sophia sat up, and her mind tilted, dizzy. Between the two servicemen and now Roy, she'd never seen so much blood— not since Charles died. For a moment, she stood where she once had, on the top of the stairwell at Luckluster Casino, staring down with Jac at Charles's body. So much death. She felt drenched in it.

Scythe reached down toward Roy's body. Sophia realized instantly he was reaching for Roy's Shadow Card. He'd already killed the shade-maker. Then he'd killed Owain. Now that he'd killed Roy, he'd have Roy's card. And Hector's.

Five cards to end the game, leaving everyone without their target's card—Grace, Harvey, Tock, Narinder, Poppy, Delaney, and herself—dead.

Harrison must've realized this, too, because he let go of the omerta on Sophia. And her luck must've been high, because when she grabbed her gun and shot—she hit. Scythe fell backward, his arm still outstretched over Roy's body. He slammed into the wall with a low grunt.

Sophia stood, her boots soaked in the blood coating the floor. She was vividly awake. She was delirious. She reached out, about to fall over, and Harrison grabbed her hand to steady her.

"No!" someone shouted from the hallway. Grace appeared at the door. She stood there, frozen. An anguish crossed her face that Sophia couldn't even imagine. After all, she'd lost Jac— but she'd never seen the body. She'd never seen *this*.

Grace put a hand over her mouth. "That's not... He told me he wouldn't..." she sputtered, almost too quiet to be heard.

She took a step back, as though she—someone who'd seen so much death herself—couldn't be close to this.

Scythe groaned as he leaned forward, breathing in gasping bursts and—once again—reaching for Roy. So distracted in her horror, Sophia almost didn't notice the Chancellor doing the same thing. But it wasn't Roy's Shadow Cards that Fenice grabbed—it was his gun.

She aimed it at Harrison, her hands and the metal dripping blood. "Now I can—"

Sophia only had a moment to make a decision. She couldn't roll the dice. Weigh the odds of killing the Chancellor versus killing Scythe. And so she squeezed her eyes shut, and she made her choice.

Bang!

The gun sprang back, the recoil so strong and unexpected that Sophia nearly lost her balance.

The Chancellor fell.

But Sophia hadn't damned them. The other Dove—Sophia had forgotten the hostage, in the chaos of it all—staggered to his feet. Before Scythe could snatch Roy's cards, the Dove picked up Scythe's own blade and leveled it at Scythe's neck.

Scythe let out a bitter laugh, blood dribbling onto his lips. "You'd kill me..." he started, wheezing "...without your namesake? Pathetic."

"Pathetic was giving my name to you in the first place," the Dove growled. "I'm taking mine back—and yours."

And he dragged it across Scythe's throat.

When it was all over, when their enemies and their friend were dead, when Sophia saw Luckluster red everywhere she looked, she slumped against Harrison's bedside. She suddenly thought she understood what the Chancellor had been talking about. They'd made history in this room. They'd soaked in it.

HARVEY

Harvey and Narinder crouched in the stairwell of South Side General Hospital, each panting, each stricken. They'd escaped the recovery floor shortly after Scythe arrived, but even so, Harvey had never seen so much blood. When he looked down, he noticed several speckles of crimson dusting his dress shirt. Nausea shook through him, and he squeezed the metal stair railing to ground himself.

"You don't get to vomit," Narinder snapped at him, sitting on the steps and hugging his knobby knees against his chest. "If anyone gets to be sick, it's me. I've never seen anyone…"

A rush of anger washed over Harvey. "I've never seen anyone die, either," Harvey gritted out, fingers shaking as he unbuttoned his dress shirt. While Narinder gaped, Harvey shrugged it off and threw it in a heap at the edge of the landing. His flimsy cotton undershirt reeked from sweat and smoke, but at least he wouldn't be wearing some whiteboot's blood. "I'm not a monster."

"But the day I rescued you, you'd killed her, didn't you?" Narinder asked. "You murdered Zula Slyk. Did you do it for Bryce?"

Harvey let out a strained, delirious laugh. "You know what I am to..." He choked on Harrison's name. "I didn't have a choice."

Narinder's already grim expression darkened. "There *was* a choice. There's always a choice."

It shouldn't bother him what Narinder thought of him. After all, Harvey had betrayed him. He'd betrayed all of them. The only reason Narinder was still with him now was because they'd fled Scythe together, and because everyone else was gone, and someone needed to watch him. Someone needed to make sure he didn't escape and run back to Bryce.

But it did bother him, and he didn't have the words to defend himself. And so he defended Bryce instead.

"Bryce was as horrified as you are now!" Harvey said, pacing in the cramped stairwell instead of doing the rational thing—lunging for the exit, for freedom. "He didn't want to do any of this! But he's trying to save Rebecca—he's obsessed with saving her, with being a hero. Even if that makes him a villain to all of you."

"I don't care what he is to all of us," Narinder shot back. "I care what you are."

Harvey stopped pacing and swallowed hard. "You shouldn't."

"You're not a villain, Harvey."

Harvey hated the way Narinder said his name. Not because he cursed it, but because he didn't. It reminded him how much he hated that Narinder had converted his old church into a nightclub, how he still somehow looked holy in it. He was the kind of good and honest that didn't take effort. Didn't take second-guessing or sleepless nights or terrible mistakes.

Narinder was afraid, he knew. But his fear didn't twist him

the way it did to Harvey. Harvey was more scared of being alone than he was of being loathed.

"It's my fault," Harvey whispered. "If I hadn't stopped you all, maybe they could've killed the Bargainer. And then Scythe would be dead, too. And Roy—"

Narinder stood up. "They couldn't kill the Bargainer. They couldn't have even with your help."

That was probably true, but Harvey still said, "You don't know that."

"I don't know much, but I know you took Harrison's omerta to save Bryce's life, and Bryce kicked you out for it."

Harvey hadn't told Narinder that, but he supposed he could've guessed why Harvey had shown up at the Catacombs in the first place. Why someone who would sacrifice everything for someone still had nowhere else to go.

"I was a threat!" Harvey said, his voice strangled. "If Bryce had let me stay, I could've ruined everything."

"Then what's changed, Harvey?" Narinder asked sadly. Harvey cursed him for using his name again, for making him feel like this: breathless and pathetic and weak. "Omertas are unbreakable. If Harrison dies, you die. And once the game is over, once Bryce is no longer protected as the Gamemaster, what is to stop Harrison from ordering you to kill him?"

Harvey opened his mouth to respond, but he didn't know how. He hadn't thought of that. But even Harrison wasn't that cruel.

"Bryce is manipulating you," Narinder continued. "His game didn't go to plan, and so he's using you."

Harvey shook his head vigorously, once again feeling sick. "He cares about me. I'm his closest friend—"

"Even if that's true, your friendship isn't healthy. You know that."

Narinder stepped closer, but Harvey backed up until he pressed against the cinder block wall. His mind swam with

memories. Of when he and Bryce met, of how Harvey had just left home and had less than no one. Of when they established the Orphan Guild, with Bryce as manager and Harvey the slimiest, most efficient of salesmen. Of how Harvey had thought he'd had everything, when really all he had was him. Of all the ways Bryce reminded him of that.

Harvey knew what Narinder said was true, but it hurt. He felt it like the cut of a knife in his stomach, a knife that had always been there, a wound he'd been letting fester.

"They hate me," Harvey choked out, unable to hold back memories of the way Enne had looked at him, of how Levi had talked about him, or how Grace had screamed at him.

"*I* don't hate you," Narinder said gently.

Something fluttered in Harvey's stomach. "You should."

"I would never have helped them, if it weren't for you," he said. "I would never have walked into a crowd of whiteboots with a gun in my hand. I wouldn't have risked myself."

The fluttering disappeared, replaced by guilt. "I didn't ask you. You shouldn't have—"

"You didn't *need* to ask me." The musician placed a hand on Harvey's shoulder, and Harvey flinched. "You helped me realize some things are worth taking a risk for. *You're* worth taking a risk for."

Narinder's hand slid from his shoulder down his chest and settled along his waist. Even through the cotton of his undershirt, the touch burned, as holy things should.

Harvey froze, a statue beneath him. It hadn't been long since he and Bryce were in a similar position, and his pathetic heart leaped in the same manner. Narinder, in many ways, was proving his point. Harvey was so easy to manipulate. His thoughts had already roamed to these places—of course they had, in those nights he'd spent awake instead of resting. After all, Narinder was so *good*. Talented, charismatic, charming, at ease with himself and his soul in a way Harvey had never been.

The kind of attractive that everyone noticed, everyone liked, everyone wanted. And oh, Harvey had wanted.

But he wanted Bryce, too, and even now, he didn't believe Bryce to be a monster. The others didn't know Bryce the way Harvey did. Harvey had seen Bryce cry, and laugh, and be human in the same way they all were. Someone wasn't evil by default, just for being on the opposing side.

And as Narinder pressed his forehead against Harvey's, as Harvey felt the musician's breath hot on his cheek, his heart still struggled to tell the difference.

But still—his hands grasped for him. He found Narinder's hips and pulled him closer. He needed this. He needed an anchor. He needed to figure out the difference.

"I'm so furious with you," Narinder breathed, slipping his other hand behind Harvey's neck, lifting his face, his lips, closer to him.

"Then why are you doing this?" Harvey asked, then immediately wished he hadn't. He didn't want Narinder to stop.

"I'm not going to kiss you." But he said it more like he was talking to himself. Harvey wondered, deliriously, what he could do to convince him otherwise.

"Why not?" Harvey asked. He immediately cursed himself for such a question he could think of a hundred answers to. Because they had just watched a lot of people die, people who didn't deserve it. Because they were in a cold stairwell in a hospital, and it smelled of it—like sickness and antiseptic. Because this was all a trick, someone else trying to plant an idea in Harvey's head, to break him from inside out.

"Because I can't fix you," Narinder answered.

Harvey's anger and desire battled one another. He should push him off him—he wouldn't be called someone's broken toy. He should kiss him the way he'd thought about for weeks, he should make this both of their mistakes, so someone besides him would have something to be sorry about for a change.

Before either terrible emotion could win, Narinder pulled away. With one hand, he pushed on Harvey's chest, keeping him pinned to the wall.

"Everyone deserves good," Narinder said. "Even if they haven't done good things."

"The others don't think that."

"I don't give a muck what the others think," he growled. "I'm telling you what I think. I think there's no such thing as a happy ending—not in this, not for everyone. But if anyone is going to get it, I want it to be *us*. But you won't choose that because you don't think you deserve it."

His anger won. "You don't think I *want* myself to be happy?"

"If you did, you wouldn't have stayed with Bryce as long as you did." Narinder gritted his teeth. "You'd rather be a martyr. As long as Bryce feels a pang of guilt when he thinks of you, at least he thinks of you, right?"

Harvey pushed him away. "You're only manipulating me."

Narinder gaped. "*I'm* the one manipulating you?"

Harvey should know—he was an expert manipulator. All it would take was the right kind of smile and Narinder's shoulders would relax. He'd lower his voice. He'd forget about the soot on their skin and the blood on his shirt.

"You're only doing and saying the things I want you to," Harvey accused, "because you think you can change my mind."

"So your mind is made up, then?" Narinder challenged. He took another step back and raised his hands. "Then go ahead. Go back to Bryce. I can't stop you—or help you."

Harvey nearly did as he said, but then he hesitated. He wasn't finished. "I didn't ask for your help."

"You kind of did, when you asked to stay with me," Narinder said flatly.

"I asked for a room. Not to be your charity case."

Narinder squeezed his hands into fists. "You're infuriating.

You're determined to believe the worst of *everyone* except the one person who deserves it."

"Yeah, well, I'm the broken one, remember?" Harvey said viciously, shrugging.

"When did I ever call you broken?"

"You said you can't fix me!"

Narinder took a deep breath. "I meant I won't kiss you, because I don't think it will be good for you. You've always depended on other people to take you in—you need to fix *yourself*."

"I *can't* fix myself!" Harvey shouted. "That's the whole point! I'm never going to be healthy—I don't even know if it's possible for me to be *better*. So if I'm broken, fine. Then call me shattered. Call me beyond repair. But don't pretend like I have the power to fix myself. Because I...I'm sick. And that isn't how being sick works!"

Harvey didn't know if Narinder understood, but Narinder at least had a look on his face like he felt guilty.

"I'm sorry," he said gently. "But if it counts for anything, if help is what you need, then I want to help you. I'd do anything to help you." He shook his head. "But Bryce isn't something I can help you with. He means something to you I can't understand, and I don't know how to help you unravel all of it. I can only tell you that I think you deserve better than that."

Harvey's face grew heated—not in anger now, but in shame. He could hear himself, but he didn't know why he was yelling. He only knew that every word hurt. Because Narinder was right. Harvey should've left Bryce years ago, as soon as he'd started dating Rebecca. Harvey had used his work at the Orphan Guild as an excuse, he'd used *anything* as an excuse, but Bryce hadn't stabbed his knife into Harvey's side. Harvey did. He'd walked into it, willingly, gladly, because the pain of staying seemed better than the pain of leaving.

Narinder wasn't rejecting him because Harvey was broken

or terrible or unworthy. But because Harvey shouldn't need someone else to prove him that.

He had the urge to disappear. His flaws coated his skin more than the residue smoke. He wanted to be nothing, no one. He wanted someone who loved him without ever seeing the worst of him.

But that wasn't love. He could, he finally thought, tell the difference.

"I should stop him," Harvey murmured.

Narinder's expression softened, and it hadn't even taken a smile. "I think you should, too." He moved closer and kissed Harvey, softly, on the side of his head, and even Harvey couldn't find any manipulation in it. He took Harvey's hand and slid something into his palm. "Please. Please be careful."

Harvey looked down and saw Judgment, Narinder's Shadow Card. Harvey's target. His hand shook. "You shouldn't give this to me."

"I'm taking a risk," Narinder whispered. "I want to."

"When this is over," Harvey said, "I want us to be happy, too."

And, clinging to those words, squeezing Judgment, Harvey pushed the door open and left the stairwell, prepared to face Bryce Balfour for the last time.

XX

THE EMPEROR

"It's children who fight the wars their parents cause."

Royalist. "The Great Street War."
The Antiquist
8 Aug YOR 18

LEVI

"I—I don't know if I can do this," Delaney stammered, hugging her arms to her chest as Levi felt for the light switch. He found it, and the lights in the empty patient room flickered on. "And I left Poppy waiting for a doctor, after she just went through—"

"Poppy is with Tock," Levi assured her, trying not to feel guilty for dragging Delaney away. But only twenty minutes had passed since Levi, Enne, and Sophia had returned from the House of Shadows, and they couldn't afford to waste any time. "I don't think you could've left her in more capable hands."

"And we need your help," Enne pressed. She fished her king's token out of her dress pocket and held it up. "Take a look at this. What do you see?"

"A coin," she said flatly, tucking the fraying strands of her blond ponytail behind her ear. "Look, I'm exhausted. I *shot* someone today. I just want to make sure my girlfriend is—"

"No. Take it." Enne impatiently thrust it into her hands. "Now what do you see?"

Delaney furrowed her eyebrows as she examined it. She turned it over a few times, tracing her fingertips over the grooves of the cameo. "It's warm. There's a shade in here. It's..." Her eyes widened, and she threw it back into Enne's hands. "Where did you get this?"

"It doesn't matter where she got it," Levi said, leaning against the patient table and stifling a yawn. It was hard to imagine that this morning he'd been preparing the Irons to open his casino, a casino that was little more than ashes now. "Can we use it?"

"Use it?" Delaney repeated.

"The Bargainer wants the Mizer talent," Enne said. "And Veil's talent...my father's talent is sealed inside this coin."

Delaney frowned at Enne, as though she hadn't heard correctly, and Enne flushed. Levi knew Enne hadn't wanted to tell the others like this, the night it seemed they could all feel the heat of history breathing down their necks. But with the Bargainer still out there, they didn't have a choice.

Delaney shuddered. "It's not right, to steal a talent." Then she drummed her manicured nails against the patient table, considering. "And I don't understand why you'd want to give the Bargainer what she wants."

"We don't. That's why we had this idea," Levi said, which was a lie—the idea technically was Veil's. But whether he'd been terrible or not, Levi trusted the ideas of the City of Sin's most notorious mastermind. "You're a split shade-maker. Can't you alter the shade inside of the coin? Warp it?"

"Can you alter volts once they're in an orb?" Delaney snapped.

"I've never tried," he admitted. "But—"

"*You* have to try," Enne finished.

Delaney narrowed her eyes at both of them. She took the coin back. She tapped the metal and slid her fingers over its

grooves. Levi's breath hitched when, to his shock, black coils appeared out of it, like shadows or smoke. They reminded him of volts, only they consumed light rather than emitted it, and they spun and knotted around Delaney's finger as though a spider's web.

"That's what malison energy looks like once it's a shade," Delaney said. She tugged her finger, but the coils didn't break. "Volts are light, like static. But shades are heavy—better to be sealed into metal, like a key, a coin, a timer. But both, of course, can be carried in someone. In their skin."

"I could carry the shade in my skin," Enne offered.

"Absolutely not," Levi countered. "It should be me."

"I'm already a Mizer," Enne said. "And I—"

"Shut up. Muck. Both of you," Delaney growled, which were harsh, ugly words to come out of someone so pretty and put together. She frowned and smoothed back her hair a second time. "I need to think. So you want to meddle with this and give it to the Bargainer, like you're poisoning it. But once a shade is within the metal, it's done. Same as volts. A shade-maker can't manipulate it more than it already—"

Voices—screams—rang out from somewhere on their floor, and Levi's breath hitched. The color drained out of Delaney's face, and she chucked the coin back to Levi. "Poppy," she breathed, and ran out.

Levi, however, didn't move toward the commotion. His mind frantically mapped out the route to the closest exit.

Run, his father whispered.

No, Tock was out there. So was Harrison, Narinder, and plenty of others he cared about.

Beside him, Enne reached into her pocket and retrieved her knife. She white-knuckled the handle, her hand trembling. And Levi knew she felt as scared as he did. They'd both faced so much danger that part of their minds never truly left it.

"Look at me," Levi told her. "We don't die here."

Enne nodded seriously and breathed, "We won't."

She moved first, pushing open the door and racing into the hallway. Levi followed, rounding a corner toward the direction of the noise. He skidded to a stop when he saw Scythe dragging Lola's brother by his throat into the elevator. The Dove thrashed against him, but in comparison to Scythe, he was scrappy and small. In Scythe's other hand, he carried a machine gun.

"No!" Lola screamed, clambering after them. Levi didn't—too shocked by Scythe's appearance when he'd expected the Bargainer. But by the time Lola reached the elevator, the doors closed. "No!" She slammed the button over and over.

Levi didn't know why Scythe was here, but if he was going upstairs, Levi could only assume he was seeking out Harrison. "Come on. He's headed to the fourth floor," Levi croaked, already bolting toward the stairs.

Lola ran to follow him, but Tock grabbed her by the shoulder and twisted her around. "Let me go!" Lola yelled, squirming in Tock's grip. "He can't—I just got him back—"

"There are dozens of whiteboots upstairs," Tock told her. "He'll be all right. He—"

Regardless, Lola broke away toward the stairwell. The four of them—Levi and Enne, Lola and Tock—tore up the stairs. Before the door closed behind them, Levi noticed a figure out of the corner of his eye. Someone new had entered the ground floor by the emergency exit.

The Bargainer.

He cursed and picked up his pace, skipping steps at a time. "Run faster."

"What is it?" Tock asked.

"Just don't turn around."

By the time they'd reached the third floor, there was a sound of new footsteps entering the stairwell, and the hairs on the back of Levi's neck stood on end. The Bargainer certainly had

a speed talent, yet she climbed steadily while they ran. She was being purposefully slow, savoring the chase.

Upstairs, he heard the echoes of rapid gunfire, and he nearly stuttered to a stop.

Lola shoved him forward. "*Keep* moving. My brother is up there."

"But—" Levi started.

"Levi," Enne squeaked, leaning over the railing and peering down. Levi glimpsed the Bargainer, less than a minute from reaching them.

Levi squeezed the king's token in one hand and grabbed his gun with the other. Without Delaney, they didn't have a plan. Even if Veil *had* been the greatest mastermind of New Reynes, Levi had no one to warp the shade in the token. And that meant he was all out of ideas, caught between a choice of the Bargainer or gunfire.

Run, his father suggested.

He chose the gunfire.

Despite fleeing for their lives, as soon as the group threw open the double doors into the fourth floor hallway, they each skidded to a halt. Levi slammed into Enne's back, nearly sending them both crumpling to the ground. Lola screamed, then slapped her hands over her mouth.

In front of them, a collection of bodies littered the floor, butchered with the kind of efficiency only the second of the Doves could accomplish. Medical staff had swarmed the fallen whiteboots, scouring amid the dead for the wounded. Levi's heart pounded as he searched their faces, too, waiting for that inevitable pain of recognizing someone he cared about. Though he spotted no one, acceptance settled over him fast—too fast. He'd experienced it when Reymond had died, when Levi had watched helplessly surrounded by grieving Scarhands. Or when Bryce had murdered hundreds in St. Morse. After Jac. After the whiteboots who were slaughtered in his own casino. The

sea of red should've sickened him, but he only numbly trudged forward.

"You need to get out of here," Levi told those in the hallway, barely managing more than a rasp. He reached for Grace, who stood outside of Harrison's hospital room, frozen still. He shook her shoulder. "The Bargainer is..."

Then he saw it. It didn't matter how much death he'd seen—his whole body shuddered, revolted. Scythe and the Chancellor might've deserved this, but Roy had not.

"Don't come closer—" Levi warned to the three behind him. But then Lola's brother pushed past him out of Harrison's room and into the hallway. He staggered over to his sister and threw his arms around her. Lola let out a relieved sob into his shoulder.

"I did it," he breathed. "I killed him."

Tock watched uncertainly from the side. Until Lola turned to her.

"Leave," Lola said frantically. "Arabella is—"

"Here," came a voice from the stairwell.

Levi's breath hitched. The Bargainer stood at the edge of the hall. She took in the scene before her—eyes moving from the blood to Lola. She grimaced. While the Bargainer's attention was elsewhere, Levi grabbed at Enne's shirtsleeve, yanking her closer to him.

"You need to leave," he whispered into Enne's ear. "It's you and your talent she—"

"But the token!" Enne squeaked. "We haven't—"

"I thought the game would be over by now," the Bargainer said softly.

"Yeah, I bet you did," someone growled, appearing out of Harrison's hospital room. Levi realized with a start it was Sophia. "Did you feel it? Did you feel your omerta snap?"

"An omerta?" Lola repeated, confused. The Bargainer's face darkened, and Lola's face went sheet white. "Th-that's what

you meant, when you said you'd made your moves. Scythe is your omerta. You've been playing the game for months. You've just had Scythe playing it for you."

Levi's mind spun trying to fit the pieces together. When did the Bargainer get an Augustine talent?

But he couldn't get distracted. Because Levi knew this part of the game. It was the final round of Tropps, where every remaining player had the choice to bet one last hand or fold entirely. The Bargainer was here. Another of his friends was dead. It was time for Levi to make a decision, pluck one of his grand ideas out from nothing, emulate the legend he'd spent so many years treating as a hero.

But all he had instead were questions. Most importantly, the ones Delaney had no answer to: Who had created the shade that bound him and Enne? What did it mean?

An idea, he thought desperately. *Something. Anything.*

When no idea came, Levi finally listened to the only thought that remained. His father's voice—grave, furious, weary—as he whispered, *Run.*

Levi linked his arm around Enne's and pulled her around the corner, past the fallen whiteboots, charging to another elevator, another way out.

Levi slammed the close-doors button repeatedly. "Come on, come on," he breathed. In his other hand, he fiddled with the token. He could feel the traces of...something in there. The shade, he guessed.

Maybe that was all it took, being able to feel it.

The elevator doors closed, and they descended.

And Levi found his idea.

"We need to figure something out," Enne said hoarsely. "And fast."

"I'm *trying*," he answered, biting his lip in concentration. Orb-making required focus. When he and Enne had extracted volts, they'd been alone, in the quiet of the workshop. Where

he could clear his mind of outside distractions. He couldn't focus with his heart pounding hard enough to crack his breast-bone, with the Bargainer in the same building, hunting them.

The doors opened, and they sprinted to the exit. It reminded him of when they'd fled the Shadow Game, only this time, there was nowhere safe for them to hide.

"We can't just *leave* everyone," Enne huffed.

"She'll follow," Levi said.

"But where are we going?"

"I don't know."

The February wind greeted them fiercely as they stepped outside. The hospital was at the northeastern quarter of the South Side, in the Park District. He turned them right—toward the Brint. There were no busy roads by the river, no pedestrians to endanger. There was only the quiet that he needed.

When they'd raced the two blocks to the riverside, when—at last—there was nowhere else to flee except the water, Levi stopped. He panted and put his hands on his knees. It was hard to catch his breath in this cold, and the city was at its coldest in the dead of night.

"We need to—" Enne started,

"I'm going to try to corrupt it," Levi told her, handing her his gun. "Just keep watch—"

"But you're not a shade-maker." She kept his gun at an arm's distance from herself.

"Veil used *orb-maker* and *shade-maker* interchangeably," he pointed out.

"But they're not the same thing," Enne pressed. She reached to snatch the token out of his hands, but he ripped his hand away.

"They're not, but we don't have any other options. I have to try."

He could tell by Enne's frown that she wanted to argue. Not

only could he fail, he could hurt himself. And so Levi turned away from her entirely. He needed quiet. He needed to think.

He rubbed the token, feeling for the energy within. It did remind him of volts, a little bit. Which made sense. It was Veil's talent trapped inside, and Veil was a Mizer. But the power felt encased in the shade, a sticky, impenetrable sheath. It was going to be hard to work with.

Nevertheless, Levi reached for the volts, the same way he'd extracted volts from Enne. The smoky tendrils Delaney had shown them emerged from the coin—she'd been manipulating the shade, while he was manipulating the volts inside it, he realized. The threads looked waxy, as though coated in tar.

Raw volts were limp and malleable—an orb-maker breathed life into them, warped them into static, something bright and alive. But when Levi tried to do that with these volts, they sprung back to the metal of the coin. He gritted his teeth.

Enne placed her hand on his shoulder, and he tried to force himself to relax. Even though it was freezing. Even though the Brint smelled like muck. Even though the Bargainer could appear at any moment and kill them both.

He needed to fight his instincts. He didn't need to bend these into volts. He didn't need to remove the shade. He only needed to corrupt the power that was already there.

He snapped his fingers, and the black tendrils snapped, too. White light bled out, like a glowing wire encased in rubber. Shadows seeped from where it had broken and slithered up his fingertips, turning his nails an inky black. He cursed as pain shot across his skin. Burning, he realized. He'd never been burned before.

But he didn't wrench his hand back. He broke as much of the power as he could. He watched the light fade out, until only the tar-like shade remained. The token looked dipped in smoke.

"Tossing coins into the river?" the Bargainer spoke behind them. "Looking for a wish?"

When Levi whipped around, Enne's eyes flickered to his first, questioning. *Have you finished it?* he could see her ask. He couldn't be sure, but he thought he might have.

But his hand still burned. He looked down to find his skin blistered and raw, the nails gone entirely black, as though charred. The pain of it made his eyes water, but he blinked the tears away. He couldn't alert the Bargainer to what he'd done.

The Bargainer took a long, deep breath. "I've waited so long for this," she said. Which were eerie words to hear from someone who otherwise looked no older than them. She stepped down toward them, to the sidewalk at the water's edge. "Until the very last Mizer was gone."

Enne stiffened beside him. She shakily pointed Levi's gun at the Bargainer. "Careful," she rasped, her hand trembling. "I don't miss."

Levi put his hand on her arm and lowered it. "It won't work. You know that."

"Clever, that one," the Bargainer said.

Levi watched her warily. Lola had called her Arabella, like they'd known each other, like they'd been friends. And Arabella had been furious when they'd taken Lola.

She still looked furious. Her harsh features were twisted, the lights of the Factory District behind them dancing off the frown of her lips, the deep set of her red eyes.

Her next step was fast—a blur, even. One moment, she stood feet in front of them, along the sidewalk. The next, her hand was around Enne's throat. With the other, she shoved Levi back, so hard the breath was knocked out of him, and he skidded backward on the cobblestones. The token fell out of his hand and clinked to the ground.

"I'm faster than either of you," Arabella said softly. And she was. Faster than Chez when Levi had fought him. "I'm stronger than you, too."

Grace and Roy must've trained Enne well, because she

reacted as though by instinct. She knocked Arabella's wrist enough to loosen her grip, then kicked her in the stomach. She managed to squirm free, but she stumbled back so far she nearly toppled into the river.

Arabella snorted. "Would you really prefer to fight me?"

Levi scrambled for the fallen token in the dark. "We want to bargain with you!" he said desperately, lifting the coin high enough for the bronze to catch the light. He could feel the power in it, pulsing, knotted, fraying. Smoke seeped from it, betraying what he'd done, but he hoped the nighttime hid it.

"For what?" She smirked. "Will you challenge me to a card game?"

"Would that work?" he joked, trying to keep his voice level even when he was terrified. But fighting wasn't their best strategy. They were tricking Arabella—and Levi was good at tricking people. He'd built an empire on it. And in his experience, tricking people was done better when he didn't point a gun to their head.

"I don't know," Arabella said, licking her lips. "I'm pretty good at them."

Below her, Enne backed away, closer to Levi. Following along with him, she rested Levi's gun on the pavement at her feet.

"We don't need to fight," Enne said carefully. "We can just talk—"

"You'd like that, wouldn't you?" Arabella sneered. "But since when has violence not been to your liking? Lola originally tried to convince me I had it wrong. That you were just some unlucky schoolgirl from Bellamy, who got mixed up in things over her head. But I think she was right, in the end. How many people have you killed?"

Enne swallowed. "Fewer than you."

Levi winced, watching Enne's gaze flicker back to the gun she'd relinquished. They'd always disagreed about this—to

fight or to negotiate—but this was the one moment when they needed to be partners. He hoped Enne could see that as clearly as he could.

"What matters is that we're willing to trade," Levi spoke up. "Our lives for a Mizer talent."

Arabella's eyes lit up. "Well, maybe you *are* different from the other Mizers. You'd give up your power?"

"We didn't ask to be part of this game, same as you," Levi told her.

"But I didn't ask you. I asked *her.*"

Enne stiffened beside him, and Levi braced himself for her to snap back. Instead, she cleared her throat and said, "Yes, we're making this trade together."

Arabella studied the coin, her expression dark. Something in it made Levi take a step back, pulling Enne with him. Muck. She knew they were bluffing.

"I expected better of you both, but especially you, orbmaker," Arabella said. "You should know—you can't play against someone who already holds all the cards."

"We need to run," Enne whispered to Levi.

"She's faster."

Levi eyed their surroundings. There was no one—not a passerby, not even a bum. No one to interfere. No one to save them. "Do you trust me?" he asked her.

She squeezed his hand. "Haven't I already proven that?"

Before Arabella could reach forward to land a strike, Levi grabbed Enne around the waist and threw both of them into the Brint.

The coldness of the river shocked his senses. His skin screamed—his burns the worst. He tried to keep his mouth closed, to hold his breath, but he could still taste the water. And it tasted horrible—like all the waste of the City of Sin, its drains and its sewers, seeping out into the ocean.

The current wasn't fast—it wouldn't sweep them away to

safety, and there was only so far they could swim without coming up for air and exposing themselves.

But Levi wasn't counting on distance. He was counting on the privacy. This might be the only moment they had away from Arabella, their only chance. And the Bargainer had been right—Enne and Levi didn't have any of the right cards. But that had never been what made Levi a good card dealer. No matter his poker face, his luck, his cleverness, he'd always been the Iron Lord because he cheated.

And the key to cheating was making sure the other player never saw the sleight of hand.

Levi pressed his lips against Enne's ear. "Do you trust me?" His voice was garbled in the water.

He'd asked her the same thing moments earlier, but she must've known this time was different. He couldn't see her— not in this darkness—but he pressed his forehead to hers. He didn't know how else to convey the weight of the question. Even by cheating, it would take a great sacrifice to win this game. From each of them. And he didn't know if she'd be willing to make hers.

He felt her nod, and he wasted no time. He reached down for her hands, and he pushed up the fabric of her sleeve. Earlier, he'd wished for quiet, but concentration was impossible in the freezing water, in the darkness. His fingers slipped against her skin, and it ached to touch her with his wounded hand.

But he found what he'd been looking for—the volts. He clumsily grasped for them. They pooled into the water around them, offering the light Levi desperately needed. He was an orb-maker, but nothing about what he did felt natural or easy. He didn't even know if it would work.

He clutched at the volts. Normally, at this point, he would pull them—severing their link to Enne. But this time he held them, and waited.

Sure enough, the stain of the shade around his fingers found

the volts. It seeped over them like it had the token, swallowing the light.

Levi tried to let go, but he couldn't. The shade, rather than leaving him, spread farther. He screamed—air escaping bubbles from his mouth—as the pain stretched up his shoulder, his stomach. His head quaked from it, and he breathed in a lungful of polluted water, choking.

Something had happened to Enne, too. She stiffened, and she slipped out of his grasp. He felt the current's pushback as she swam upward to air. And he drifted down, down, the pain of the shade spreading across his body too much for him to move. He barely felt it when his back hit the riverbed. His chest felt like it was caving inward, and he accidentally sucked in a mouthful of Brint water.

I'm dying, he thought. And it wasn't just the drowning—it was the burning. He heaved violently, trying to eject the fluid he'd taken in. He tasted iron in the water. Blood.

That was when he realized what this was. He'd corrupted Enne's talent, and so he was dying, just like Rebecca was dying.

This was his sacrifice.

Levi had always been willing to die in New Reynes. If he died tonight, what legends would they tell of him? He used to measure himself in everything he'd won, but lying there, he could only think of what he'd lost. Too much.

But he no longer cared for legends—his legend, so he'd learned, was a piece of this game far beyond his control. And his story, his *real* story, was not over yet. It was the one Levi had inherited but never wanted, of tragedy and tyranny that he recognized in the way strangers looked at him, the burden of a history played out before he'd been born.

And the ending of this story came down to a choice: he could drown at the bottom of the Brint, like a common gangster not important enough to hang, but a Sinner all the same. Or he could die on the city cobblestones, facing the person who had

orchestrated the Revolution. It would be the South Side—not the North—but if he were being honest, he was better suited there, anyway.

With the last energy he had left, Levi kicked off the riverbed and swam his way up. He gasped and coughed as he broke the surface. And once he started coughing, he couldn't stop. He crawled up onto the riverwalk, the city lights spinning around him. He pressed his cheek onto the ground. He still tasted blood.

"You'd offer me your talent," he heard Arabella say slowly, "when no one else would."

Levi looked up, blinking the water out of his eyes.

"The Revolution happened before I was born," Enne answered. "I'm tired of being a relic of it."

In his pain, still coughing uncontrollably, Levi didn't see Enne and Arabella shake hands. And so he didn't know if his sacrifice had changed anything. If Arabella believed the lie.

Until he heard the scream.

"I hope your bargain was worth it," Enne spoke.

Levi heard Arabella stagger back, her boots slipping across the slick cobblestones. "You didn't give me your talent. That was—"

"A shade," Enne answered for her, her voice tight.

Levi rolled over enough to watch, still coughing. He pushed himself up enough to see Arabella doubled over, gasping, a hand pressed around her throat. In the dim streetlights, Levi watched the red of Arabella's eyes fade to brown, as all of her talents, all of her secrets, disappeared, swallowed by the corruption.

I did it, he thought deliriously. He'd pulled off Veil's trick, except instead of corrupting Veil's talent in the coin, he'd corrupted Enne's. And she'd given it to Arabella.

Enne's hands trembled as she pointed the gun at Arabella, and even though it was Levi's gun, not hers, Levi wondered if she could do it.

Then Enne asked quietly, "Would you bargain for *your* soul?"

When Arabella gave her no last words, Enne fired. And Arabella—invincible no longer—finally fell.

Levi let himself collapse. He'd seen it—the oldest, most terrible legend of New Reynes die. The person who had caused his family so much suffering. It had been worth waiting for.

"Levi, don't you dare…" Enne kneeled down and slapped his face—hard.

"Muck," he choked, his cheek stinging. He coughed up another mouthful of tinny water.

"Don't close your eyes." Her voice cracked. "We're right by the hospital. I'll get you help. Sit up." Levi didn't have a choice—she pushed him up. The gravity helped, so he stopped coughing. But the burning remained.

He took a deep, shaky breath. He was exhausted and dizzy—he wanted nothing more than to pass out. And he'd definitely earned the right to. "Even if I make it to the hospital, I don't think I'll win this one. Rebecca…" He sounded hopelessly dramatic, but they'd also killed the Bargainer—whatever cure Bryce and Rebecca had been searching for, whatever cure he also needed, it was gone now.

Then he noticed that Enne had changed, too.

"Your eyes," he said. "They're brown again. Your aura is blue. Does that mean your talent is—"

"Gone. I know." She squeezed his hand. "But we did it. It's all over."

Levi smiled weakly and reached into his pocket, to where he'd kept Jac's Shadow Card. It would be gone, now that the Bargainer was dead and the game was finished.

But he frowned. His fingers felt the foil.

"It's still here," he rasped, pulling it out and holding the gold up to wink in the moonlight. "We made a mistake. The game isn't finished yet."

XXI

THE FOOL

"I don't believe in happy endings. Whoever is peddling
them is a crook. Whoever trusts them is a fool."

Memoria. "Semper Celebrates Eighth Term in Office."
Her Forgotten Histories
5 Sep YOR 24

HARVEY

The Orphan Guild was quiet, more vacant than Harvey had ever seen it. Dust clung to the floor's corners, along with the litter the previous Guild members had left behind. Only weeks ago, these makeshift rooms had been filled, a business turned empire that he and Bryce had devised together. Once again Harvey examined the neglect that had fallen the prison over the past few months. The Guild had once felt like the culmination of all of their hopes, all their cleverness...but Bryce had let it fall to ruin.

Harvey wasn't surprised. But he *was* sorry.

He knew Bryce would be here, though. It wasn't the Orphan Guild's original location, but the Guild itself was still where it had all started. Not the story Harvey wanted, the story of Bryce and him. But this was where Bryce had met Rebecca. This was where the story had changed into something else entirely. Something romantic. Something cursed.

The hallway phone rang. Harvey wondered what client

would be calling at this hour, then he remembered that it was nearly sunrise.

He ignored the ringing and followed his feet, which guided him, subconsciously, toward Bryce's office. *Their* office. He passed the inner courtyard, aching so painfully he'd gone numb.

He's been manipulating you, Narinder had told him at South Side General, when he'd urged Harvey to leave. *His game didn't go as planned, and now he's using you. He's always been using you.*

Harvey did feel used. He felt angry, but almost entirely at himself. He'd let Bryce make a tool out of him. He'd let him trick him and kiss him and touch him and all any of it had done was make him feel worse, make people who could've been his friends hate him.

A second phone rang, this one in the common room. Harvey yelped and tripped over his own boots. He was already too on edge. He planned to confront Bryce, but he didn't know how to stop him. As the Gamemaster, Bryce was protected.

But the game would be over soon. Once Levi and Enne killed the Bargainer. *If* Levi and Enne killed the Bargainer.

Harvey tried not to consider the alternative. That he was walking in here, into his place of misery, and that he might never walk out. Even if Harvey's lowest point still felt so close—dangerously close—he didn't want to die. He'd betrayed Narinder once. He'd betrayed himself countless times. And he would start down the path to being well by first being good.

Harvey halted once he reached the office, the memory from the other day haunting him like a chilling caress against his cheek. He saw it on each piece of furniture, illuminated by the pink light of sunrise. Shameful. Embarrassed.

Used.

He tried to push his thoughts away, and it actually helped that Harvey was in this place, standing where he'd let Bryce have him. He looked at the open ledgers on the desk, at the lopsided bookshelves, the bars along the windows.

Harvey deserved better than this.

The desk phone rang.

Whoever it was clearly wasn't giving up, so Harvey picked up the receiver, if only to tell the person to stop calling. "'Lo?" he whispered.

"Harvey. Thank mucking goodness it's you."

"Lola," he said, frowning. His throat seized up, knowing what she must be thinking to hear his voice through the Orphan Guild's phone. "I'm not here because I... It's not what it seems—"

"I know. Look, you can't stay. You need to leave. Now."

Harvey heard footsteps approaching from down the hall. Finally. Bryce had come to him, just like Harvey had hoped he would.

"Are you listening to me?" Lola demanded.

"Yeah, I—"

"Arabella—the Bargainer, I mean—is dead." Her voice was hitched. She was upset, but there was something graver in her voice than grief: fear, and Harvey couldn't guess why. "She's gone. And—"

"But that doesn't make sense," Harvey choked. He reached into his pocket and held Narinder's Shadow Card. If the game had broken, the card would've disappeared.

"You're here," came a voice at the door. Harvey looked up and met eyes with Bryce, who leaned against the entrance, a smile playing at his lips, completely at ease. "I'm glad you're back."

"Is that Bryce?" Lola asked sharply through the receiver.

Harvey's hand shook. He didn't dare answer.

"Who are you talking to?" Bryce asked.

Harvey didn't have a response, couldn't think of a lie fast enough.

Bryce walked closer. Harvey's pulse sped up, and not because Bryce looked good, but because he didn't. The red of his eyes

had never looked so dark. The veins along his face had also deepened, the purple and blue more vibrant, as though his skin was translucent. And there was a gray cast to him, as though he, too, was coated in the dust of this place.

"Listen, Harvey. You need to leave," Lola repeated. "Something isn't right. You can't be—"

"Why do you look like that?" Harvey asked Bryce.

Bryce cocked his head to the side. "Like what?"

Like a monster, Harvey wanted to say but couldn't bring himself to. "You just don't look like yourself."

"I can hear her, through the phone. My ears are much better now. 'Lo, Lola. We've missed having you around," Bryce purred. He perched on the edge of the desk beside him, and Harvey froze. "I can do a lot of things better now."

"Where's Rebecca?" Harvey asked.

"Rebecca is here. We're celebrating. But I was waiting for you."

"For me?"

"Did you think I'd celebrate without you?" Bryce let out a light laugh, almost enough to make Harvey's shoulders relax. "You're my best friend. Now that she's better, we can have the empire we always talked about. Why did you think I spent months buying all those properties on the boardwalk? The Bargainer might've caught on, but she should've known that burning a few wouldn't intimidate me. I'm—"

"Wait, Rebecca is better?" Harvey croaked, struggling to follow it all. "How?"

Bryce grinned. "I thought you would've figured it out by now. It was strange coming up with the plan without you. But I wasn't sure if you'd go along with it, at first." Bryce reached forward and placed his hand on Harvey's, the one holding the phone's speaker. Harvey gradually, shakily, lowered it, but the receiver still trembled against his ear. "But now I know you will."

Bryce's hand rested on his seconds too long to be normal. It was heavy, suggestive. And with every moment that passed, more of Harvey's world began to unravel.

He's tricking you, Harvey warned himself.

"Harris... The om..." Harvey started but choked on the words.

"Just ask me, and it'll be gone," Bryce said. His hand traveled higher, to Harvey's chin. He cupped him gently.

"I—I don't understand. The Bargainer is dead. I thought you'd be... How did Rebecca...?"

"I cured her myself weeks ago, before she told me she saw you. Don't you see? Everything happened *exactly* as I planned."

Bryce brushed his thumb over Harvey's lip, and the touch that had made him melt only days ago now made him flinch away.

Bryce frowned. When he blinked, Harvey noticed marks on the backs of his eyes—faint, but there. Zula's talent. He hadn't seen them before. He hadn't looked for his tricks before.

"There's someone else now," Bryce said. "I can see it. Someone else you care about."

He can't know that, Harvey thought deliriously. But he did. Somehow, Bryce had Zula's talent. He had...

"What have you done?" Harvey asked, aghast.

"I am the Gamemaster," Bryce said. "When someone dies in the game, their talents transfer to me. When the shade-maker died at the House of Shadows, I became what the Bargainer already was. A malison and a shade-maker. I cured Rebecca."

"Then why didn't you stop this?" Harvey growled. "You got what you wanted! You could've—"

"But I didn't just want that. The woman known as the Bargainer is dead. I am the Bargainer now."

Harvey grabbed his Creed. He'd never liked Bryce's talent, but now the thought of his power truly sent a chill up his spine. This was wrong. Harvey had thought Bryce was a ro-

mantic, who had done everything for Rebecca. And maybe part of him was. But this kind of greed, this pride, was something more toxic. Something Harvey couldn't see past, no matter how much he tried.

"You're a monster," Harvey murmured.

Bryce's face fell. He looked actually hurt. "You don't mean that."

"Get out of there," Lola said again into the receiver. Harvey agreed with her—he wasn't safe. He should leave. But he'd come to be honest with Bryce, and so he needed to know the answers. All of them.

"If the Bargainer is dead, why isn't the game over?" Harvey asked. "You tied the game to—"

"To a person, yes," Bryce said carefully. "To the player I cared the most about."

"Rebecca?" Harvey guessed. He knew that didn't make sense, but nothing made sense.

Bryce groaned. "*You*, Harvey. This game has always been bound to you."

Harvey stilled and lowered the telephone. *Him?* After months of being thrown out, discarded, Harvey could hardly believe these words.

"You kicked me out," Harvey said flatly.

"Only because of the omerta. You couldn't stay here."

"But I...should be sick," Harvey croaked. "I should be dying like she is."

Bryce shook his head. "Only shade-makers and orb-makers can be corrupted. Not—"

"You still told me nothing!"

"I couldn't risk anyone finding out!" Bryce's voice rose, and he leaned closer, threateningly closer. "I never wanted to make you leave. I hated not telling you. And I was being honest when I told you that I missed how things were between us. When

you came back..." He swallowed. "I thought I had you back. But I don't, do I?"

He wasn't manipulating me, Harvey realized. *He did want this. Us.*

But where did that leave Harvey?

Guilt washed over him, in all the familiar places. Bryce wasn't a monster. He wasn't.

"I have the Bargainer's talents, her deals. And so I can remove the omerta," Bryce continued. "It'll be an easy exchange. You could forget about everyone else. You could forget the someone else, literally. We could start over. You—"

"I could *forget* him?" Harvey repeated incredulously. He didn't want to forget Narinder. "Is that what you'd do? You'd take my memories?"

"I...I didn't mean that. I just—"

"What did you mean?"

Bryce's red eyes flashed. "I meant that I miss you! You can't leave! If you leave, I'll..." He ripped the receiver and speaker out of Harvey's hand and slammed them down, ending the call. "I've been so sick. Rebecca nearly died trying to save me from Vianca—it was all my fault! I always mess things up. I can't be better without you. I'll do something terrible. I need you—"

"No," Harvey said. Harvey knew enough about guilt to know that Bryce wasn't his responsibility. He was not Bryce's possession. He wasn't his justification. And he loved Bryce—he'd always love Bryce—but he couldn't do this anymore.

He knew the difference now.

"No," Harvey repeated, shoving Bryce away. Except Bryce was stronger than him now—wildly so. He didn't move at all. Harvey pushed again, fear clawing up his throat. "Let me leave. This is wrong and...I want to leave."

"The others can't stop me," Bryce told him quietly. "It happened exactly as I planned it, when I made the shade to bind the Mizer and the orb-maker together. I led them to the hall-

way. I led them to the *answer*. It was the only way to kill the Bargainer." He smiled monstrously. "So who is left to kill me?"

Me, Harvey wished he could say. He'd never wished for power before, but in that moment, he'd give anything for it. Just because Rebecca was cured didn't mean Bryce would stop wreaking havoc. And if the last Mizer had given up her talent already, then there really was no one left to defeat him.

But even so, it wasn't Enne's responsibility.

It was Harvey's. It had always been Harvey's.

Complicit.

Complicit.

Complicit.

Footsteps thundered down the hallway, and Rebecca appeared. She wore her own face instead of Ivory's, and Harvey realized he should've noticed the difference in her health the last time they'd spoken, that she wasn't just improved, she was *well*. He might've, had he ever worked up the strength to ask harder questions.

"We have visitors," Rebecca told them, Ivory's bone blade clutched in her hand. "Do we leave?"

"No," Bryce answered, turning away from Harvey. "No, we don't."

It wasn't until they both left, until Harvey had a moment alone in the room where he'd loved Bryce, in the room where he'd hated him, that he realized something.

He wasn't powerless.

He had done countless favors for Bryce—anything Bryce could want, anything he could ask for, anything to please. And it might've made him pathetic, but over the years, those debts had added up.

He smiled a Chainer smile, wide and slick with false charm, the best weapon he'd ever had.

ENNE

As the sun rose, as the casinos and clubs of the North Side closed their doors and patrons stumbled onto the sidewalks, half-finished bottles or half-drained orbs still clutched in their hands, Enne's motorcar sped north. She disregarded every sign—she knew these streets too well to need them. But she was distracted, her gaze flickering to her rearview mirror to inspect Levi in the backseat, his head tilted back onto the cushions, his breathing haggard. And when she caught her own eyes—once again her natural brown instead of purple—a burst of panic flared inside her. She swerved slightly, the car jostling as the tires ran the curb, making her four passengers groan.

"Careful," Levi croaked weakly.

Enne swallowed down a fit of nervous laughter. Tampering her talent and cursing himself in the process was far from careful. But she didn't trust herself to speak. Tears already blurred her vision, and she blinked them away. They were speeding toward the Orphan Guild, and Enne knew she needed to brace

herself to face Bryce. But Levi was dying, and her blood talent was gone. Even if the game continued, it felt like—in all the ways that mattered—Enne had already lost.

Beside Levi in the backseat, Poppy blotted the blood on his chin with a silk handkerchief, and Delaney examined him warily. "You look like you might swoon," warned Delaney.

He swatted Poppy's hand away. "I don't *swoon*." He smirked, but it was lopsided with dizziness. "I black out. Or collapse. Much more gangst—"

"Shut up," Grace growled from the passenger seat, her volume startling everyone—even Enne. Enne slammed on the brake. "We're here."

After the car screeched to a halt and the three other girls climbed out, Enne turned around to Levi. Her heart seized, taking him in. Each of his breaths sounded like a rattle in his chest. "You need to stay here," she told him.

"Not a chance," he answered, shoving the door open and nearly falling out onto the pavement.

Enne jumped out and hurried around the car to his side. "Lola said Harvey and Bryce are here, but we don't know what we're walking into." While Lola had called, trying to reach Harvey, the five of them had left. Sophia, Lola, Justin, Tock, and Narinder had all sworn to follow in the next car.

"You might need me," Levi rasped.

"You can't fight, Levi." As much as Enne always preferred to have Levi at her side, Levi was barely strong enough to stand—if he came along, he'd only be a burden. Or worse, he'd risk hurting himself more. This was a game they needed to win without him.

"And you hesitated, when you shot Arabella."

His voice wasn't unkind, but still, Enne flinched. Even miles away from St. Morse, it'd been hard to aim the gun and feel anything other than helpless. But after she'd waited for Jac's

last words and Arabella never spoke, Enne managed what had to be done.

"I still—" Enne started.

"You're *not* playing for my life again," he told her fiercely, and their eyes met. She remembered only a few months ago, when Levi had looked nearly this terrible in the House of Shadows, during the Shadow Game. No—he looked worse now.

"This isn't that," Enne murmured.

"No, it's bigger than that," Levi grunted. "It's *all* our lives, and you're not doing this without me."

"How exactly do you *think* you're going to help?" Grace snapped from behind them. She carried a knife in one hand and a pistol in the other, and she'd never looked so much like murder. If Enne wasn't so panicked about Levi and capable of being a better friend right now, she would've insisted that Grace stay behind, too. But Grace was their most capable fighter, and no matter how much she deserved space, they needed her.

"We need to talk through what we plan—" Levi started.

"We're not talking," Grace snarled.

Poppy put her arm around Levi to hold him upright. "Don't worry, Enne. I'll make sure nothing happens to your North Side boy."

A prima ballerina hardly seemed like a suitable bodyguard, and Levi shouldn't be coming at all. He should be waiting in the car where he could focus on breathing and hiding and staying alive. But Enne didn't have time to argue. Grace was already charging into the abandoned prison.

They each followed.

The prison was dark, vacant, and silent except for the rhythmic echo of someone clapping. The steady pulse of it reminded Enne of the Shadow Game's timer, the *tick tick tick*. Her heart sped up, and she shakily pointed Levi's gun into the blackness.

"You did it," Bryce said as they turned into the prison's mess hall, lowering his hands. He'd changed since Enne had last seen

him—his skin as gray as the New Reynes coastline, his posture taller, grander. It was hard to imagine that this was the same boy that she'd met over the summer, cradling the radio as it narrated a romantic story—a boy whose desperation cast the longest shadow.

"The Mizer and the orb-maker," Bryce breathed, beaming at Enne and Levi, his two chess pieces. "And now the Bargainer is truly dead."

"You planned this," Enne growled. "*All* of this."

Bryce grinned wider, and he had a smile like a sneer. "After I turned in Lourdes Alfero, her possessions remained in the House of Shadows—my old home. I'd suspected she knew you, of course. Imagine my surprise when I broke into her account and found two orbs from the Shadow Game, each filled with the life source of the last remaining Mizer."

Enne remembered that day well—she'd visited the bank with Lola. But they'd found only one of those orbs left behind.

"That's how you tied the shade to me," Enne realized. Delaney had said shades needed something of the person to bind to. "And Levi?"

"We were both already connected to Vianca, and thus, connected to each other." Bryce took out his Shadow Card, the Magician, and examined its artwork fondly. "The game was more complicated. I didn't have belongings of all of yours—especially not the Bargainer. And so I cast a shade that delivered the cards to each of you, and a second once they were in your possessions. I'm quite proud of that trick. Irons-worthy, wouldn't you say?"

He sent Levi an especially wide smile, which Levi, glaring and half-slumped over Poppy's shoulder, didn't return.

Not even Vianca, the Chancellor, or Sedric Torren had ever made Enne feel so powerless. Nearly every detail of her life in New Reynes had been orchestrated. No wonder Rebecca didn't kill her that day in the Mole station. Enne been worse

than a chess piece—she'd been her and Bryce's puppet. The overly complicated, bloody game had not been designed to be won, but to trick her. All because they needed a Mizer and an orb-maker to kill the Bargainer. And that made everything she was—everything she had ever been—meaningless.

Beside Enne, Grace pointed her pistol at Bryce's head.

"You know that won't work against me," he told her calmly. "Besides, it's all over now, isn't it? I've gotten what I wanted. The shade remains, but the game is finished."

"No. Not until we've won," Grace snapped.

Behind him, Rebecca appeared. She placed a hand on Bryce's shoulder, and there was something regal about how they stood, silhouettes in the dark.

Grace squeezed Enne's shoulder. "Don't hesitate," she murmured, and Enne nodded, even though inside, she struggled to regain herself. She didn't have Grace's anger to fuel her through what seemed an impossible battle. And she was tired of fighting. Tired of losing people she cared about.

Then Grace strode away and pointed her knife at Rebecca. "She's mine."

As if in response, Rebecca grinned and changed form in front of their eyes. She grew taller, her features older. In moments, she morphed into the figure of Ivory, with all the ease of exchanging one mask for another. And the long white hair, the haunted expression, was certainly more menacing than the nineteen-year-old's. Though Rebecca had never been the true Ivory, only an impersonator, there was a weight to that legend. Fear.

Even more so. After all, Ivory had been the most notorious killer of the North Side.

And Rebecca had been the one to kill her.

"Grace," Enne warned, reaching for her. No matter how much Grace wanted this, Enne couldn't lose two friends tonight.

But Grace seemed to change, too. Into the girl Enne recognized from when they'd first met, the girl who'd settled for a life of butchery because she was desperate.

"You're not sick anymore?" she called to Rebecca.

Rebecca shook her head. "Good as new."

"Good," Grace said, laying her gun on the ground and kicking it away. Delaney frowned and hastily picked it up. "Then this will be a fair fight."

The two girls threw themselves at one another. They were equally skilled, equally matched, their movements mesmerizing in their deftness.

But Enne's thoughts snagged on something both Bryce and Rebecca said. That Rebecca was better now. That they'd gotten what they wanted.

"If you *are* the Bargainer," Enne said to Bryce carefully. "Then you could cure Levi, too."

At the room's edge, Levi's eyes widened. "I'm not taking any help—"

"You're *dying*, Levi," Enne growled at him, tears springing from her eyes. "I know you want to be the hero, but it doesn't have to end like this." She studied the way his legs quaked at keeping him upright, even as he leaned against the wall. Sweat glistened across his forehead. "I don't want you to be some North Side legend. I want you to be *alive*. With *me*."

Behind them, the second group arrived: Sophia, Lola, Tock, Justin, and Narinder ran in. And unlike Enne, who was only just mustering her resolve, Justin wasted no time making a decision. He lifted his gun and fired.

To Enne's shock, the bullet hit Bryce—it didn't go through him as if Bryce were smoke, the way it once had in St. Morse Casino. But, much the same as Arabella, it didn't faze him. The metal pellet fell to the ground.

"Just because you're not a player doesn't mean you can hurt me, either," Bryce told him coolly. Enne realized now why the

bullet had struck—Justin didn't have a card, so Bryce wasn't his Gamemaster.

The almost genius of Justin's attack seemed lost on him. He frowned and turned to Lola. "What's he talking about? Gamemaster?" Lola cursed under her breath.

Then, to Enne's repulsion, Bryce started clapping a second time. Enne felt her fury rising. No, she refused to let herself be bullied into powerlessness. No matter what parts of her life Bryce had orchestrated, she was still the girl who'd broken the Shadow Game, who'd slain the wolf, who'd survived the witch. She'd seen the city hate her; she'd seen the city love her. She was the daughter of Lourdes Alfero, the bravest person she'd ever known. She was the daughter of Gabrielle Dondelair, who'd died to protect her. She was the daughter of Veil, who'd bested his foes, even in death.

She was the last surviving Mizer, and the one who'd put a bullet in the Bargainer's head.

It didn't matter how much Bryce or the City of Sin took from her, if she'd been stripped of her identity and left as no one. She was still more powerful than anyone had ever given her credit for.

And she wasn't alone—her friends flanked her on either side.

"You're going to heal him," Enne told Bryce scathingly. "You've manipulated everyone's lives. You have so much blood on your hands. So you are going to *fix Levi* or—"

"Or what?" Bryce asked, smirking. He studied Levi without sympathy. "I don't care if you gave me what I wanted. You were Vianca's favorite—I haven't forgotten."

"Vianca's the reason I'm doomed?" Levi asked, laughing. Enne didn't understand how he could be laughing. She hoped it was shock. She hoped it wasn't the sound of the Iron Lord giving up. "I'm sure she's pleased down there." He stomped the ground lightly, as though the donna might hear.

Enne was torn between launching herself at Bryce or fall-

ing to her knees. Their bullets were futile. Their pleas were worthless.

Enne did have one trick remaining, and it rested secretly in her pocket. If Enne could overpower Bryce, she could give him the king's token with Veil's talent sealed inside—she could corrupt him the same way she'd corrupted Arabella. But if she took away his power, then he wouldn't be able to heal Levi.

"It's seven against one," Sophia breathed. "But it's a million to one, if you're counting the odds."

"You've beaten worse odds," Delaney said. "Haven't you, Enne?"

"Does it count if you've cheated?" Enne asked nervously.

"Absolutely," Levi answered.

"Are you just going to stand there?" Bryce goaded, holding his arms out like a man crucified, like he wanted to be attacked. "Why not try your luck?" He licked his lips. "Hit me."

She wanted to, but she knew such an attack would be pointless. For all Grace and Roy had taught her, Bryce had truly outsmarted them. They had no moves left. This was checkmate.

"Enough," a voice called out, and Enne's eyes widened as Harvey approached them, unsure from the determined look on his face who he'd been speaking to, which side he was on. "Bryce, that's enough."

Bryce laughed. "I don't know what you mean. I haven't even made a move." He attempted to take a step toward Harvey, but his foot halted midair, as though he'd knocked into something. He reached out in front of him and placed his palm out, slamming it down, as though an invisible barrier blocked his path.

"No," he said hoarsely. "No. No! NO!" He pounded on the wall Enne couldn't see, pounded on it from all sides. It was like he was boxed into the corner where he stood, trapped.

Bryce's head whipped to Harvey, and only then did Enne understand what had happened. Harvey had Chained him.

"I can break this, Harvey," Bryce snarled. "I'm strong now.

I…" But even as he pounded faster, harder, the enclosure around him remained.

"I have done so much for you," Harvey said softly, stepping closer. Enne let him pass, so he could look Bryce face-to-face. "I've done everything for you. And you may be powerful, but can even you surpass the power of all that debt?"

Bryce's expression settled into horror, and Enne could hardly believe it herself. That Harvey had really stopped him.

"No!" Rebecca shouted, dodging out of the way of yet another one of Grace's blows. She pointed a shaking finger at Harvey. "Don't you *dare.*"

Normally, Enne wouldn't trust Harvey. Not after what he'd done. Not under any circumstances.

But now she stepped in between him and Rebecca. "Don't touch him," she snapped.

Delaney, Sophia, Lola, Tock, and Poppy all joined her, forming a barricade between Harvey and the Dove Lord. Rebecca gritted her teeth.

Enne turned around and looked Harvey in the eyes. "Can we trust you?" she asked.

He squeezed his Creed. It reminded her of Jac. "Yes."

She glanced at Levi, who had finally slid down to the floor, watching with a mixture of relief and shock.

"Make Bryce heal Levi," she said to Harvey. "This was all Bryce's plan—make him fix what he'd done. And then I will give him this." She took the king's token out of her pocket. If this game had played out differently, then maybe Enne could've used Veil's talent sealed inside to restore her own. To reclaim the identity that history had already laid out for her: the last surviving Mizer.

But Enne didn't need this power to know who she was. She'd always had the power to define herself.

"What will it do?" Harvey asked her.

"It will strip him of his power," Enne answered, the same way her own corrupted talent had done to Arabella.

"But then..." Harvey glanced at Levi fretfully. "Whether or not he heals Levi, it won't matter. You can't save Levi unless you save—"

"I'll never take that," Bryce spat.

"I can make you," Harvey murmured. "I don't want to, but I—"

"You were my *friend*," Bryce growled. "You always whined at the thought of using your talent. You were always holier-than-thou. But you'd stoop that low, after all, wouldn't you? How does that make you any better than me?"

"It doesn't," Harvey answered. "It just makes me better than who I used to be."

Then Harvey smiled. Wide, toothy, and charming. It was unsettling, watching the spell it cast over Bryce, how his shoulders relaxed, how a matching, lopsided grin stretched across his own face. Utterly placated.

Then Rebecca lunged forward, and Grace leaped. She landed on Rebecca's back and brought her to the ground. "If you take away his talents, then the bargains will all break. And I'll..."

Grace pinned Rebecca's arms to the floor. "Please go on," Grace sneered at her. "Cry to me about your happy ending."

Across the room, Levi had heaved himself back up to standing, and he staggered to Enne's side. He rested his hand on Enne's shoulder, and she squeezed it, blinking back more tears. "I haven't given up," he whispered in her ear. "And neither should you."

Enne nodded shakily, hating that he was right. They had bested impossible choices before.

She held out the token.

"I'm going to make a deal with you, Bryce," Harvey said, his voice shaking. "I want you to take Enne's coin—take it,

take the shade inside of it. And you can have…" He hesitated. "What is it you want in return?"

Bryce still had the eerie grin on his face. But his voice cracked when he rasped, "Please, I don't want to die."

"We're not *sparing you*," Delaney snapped.

But Harvey paid her no attention. "That's fine," he said sadly. "We can do that."

"Bryce!" Rebecca called. "Bryce, don't—"

Bryce grasped Enne's hand and took the token.

Without her talent, Enne could no longer see the shade as it snaked up Bryce's arm, but she could see from the pain flashing across Bryce's face once the curse took hold. He screamed and sank to his knees, and Harvey crumpled with him, his arms wrapped around Bryce's shoulders.

Rebecca's face shifted back to her own, and Grace wrenched herself off of her as Rebecca vomited. The sick was crimson and thin like water. Enne shuddered watching Rebecca as the illness Bryce had cured unwound, as she got sick again and again and again, each heaving weaker than the one preceding it.

To Enne's left, Sophia blinked wildly then stumbled back until she pressed against the prison's cinder block wall. Her hand clutched at the scarlet bodice of her dress, nails digging into the fabric. "I…I remember. I remember my name. I…"

"*Tock,*" Lola breathed, dropping her scalpel to the ground with a clatter.

Tock's breath hitched as Lola turned around and threw her arms around her.

"I'm sorry. I'm sorry, I'm sorry, I'm sorry," Lola told her, and Tock hugged her back, squeezed her until she lifted Lola off the floor.

"I missed you," Tock told her, her voice muffled in Lola's blazer.

In the midst of it all, Harvey's smile had faded, and Bryce's eyes flew open, finally wide and alert. Without his talent,

they were an almost colorless shade of blue. "Get *off* me," he croaked, shoving Harvey away. He scrambled to where Rebecca lay dying, surrounded by a pool of so much blood it was a wonder any was left inside her.

Paying no mind to the sick, Bryce wrapped his arms around her. "Please don't go," he told her. "I never meant to do this to you."

Unable to watch, Enne looked to Levi. He studied Rebecca's last moments with terror. Because the same corrupted shade would one day come for him—and probably soon.

But seconds later, when Levi met Enne's eyes, he was grinning.

"Why are you smiling?" she asked him, her own voice shaken.

"Because..." He reached into his pocket and turned it inside out. "The cards are gone. The game is over."

Enne wanted to feel victorious—she really did. Now that all of the Bargainer's shades had broken, they had plenty of reason to celebrate.

But even though the game was over, this didn't feel like winning.

She squeezed his hand tighter. *I don't care if all the bargains are done, if I have nothing left to give up,* Enne thought. *He will not die.*

And even if the game was over, they stayed until the story finally finished. Until Bryce held Rebecca's body and wept.

XXII

THE EMPRESS

"I am tired of calling the histories of New Reynes 'legends'
when they are only gruesome truths."

Lola Sanguick. "The Story of New Reynes."
The Crimes & the Times.
22 Feb YOR 26

LEVI

Levi groaned as their motorcar skidded to a halt in front of the House of Shadows. The building that had haunted his memories and dreams for months now looked plain and unassuming in the morning daylight.

His consciousness teetered, exhaustion dragging him down like a ball and chain, and he still tasted blood and Brint water on his lips. But he knew better than to sleep when there was a chance he might never wake up. When the same curse that had claimed Rebecca only an hour before might claim him, too.

"Come on," Delaney muttered, hoisting him up. He blinked deliriously as he stumbled out onto the lawn, leaning heavily into her side.

"Thanks," Levi told her.

"Don't thank me yet. Thank me when someone figures out how to fix you."

Enne, unwilling to waste another second, marched ahead

to the door. She pounded on it as Delaney and Levi lagged behind her.

"You need a key," Delaney told her. "Or an invitation."

"Why didn't you mention that earlier?" Enne asked, her voice cracking.

Delaney rolled her eyes, pushed ahead of her, and turned the knob. "Because *I* have one," she said. The door creaked open, revealing an empty foyer and sitting room.

"Where's the party?" Levi asked, feigning disappointment.

"No party. We're going downstairs," Delaney explained.

"To the hallway?" He wasn't sure he wanted to go back there. He certainly didn't want to die there.

"That's where the apartments are. Distant cousins of mine." Delaney's expression softened, seeming to sense his hesitance. "I know it means something different to you, but I'm not surprised Bryce cast his shade on that hallway. Bryce lived there, at one point. I think all people, some way or another, are marked by the place they come from."

Levi wished he disagreed. He'd once believed that coming to New Reynes would put distance between him and his parents' home, that he could fashion himself a new story and be reborn from it. But in the end, Bryce had chosen Levi as a pawn in his game not because Levi was a street lord, but because he was an orb-maker. Vianca had singled him out for the same reason. History had left a mark on him long before he could leave a mark on history.

They crept down the stairs, and Levi was surprised to find many of the apartment doors ajar, revealing ordinary living rooms. At the sound of their approach, a figure appeared at the edge of one door, a middle-aged woman with perfectly coiffed blond hair. Levi felt Delaney stiffen beside him.

"'Lo, Auntie," Delaney said sheepishly. "I've come to ask a favor."

"Creighton said you'd come back," she said flatly. "So nice of you to visit."

"You told me not to."

"I first told you to *stay*. There's a difference."

Enne cleared her throat. Even after all this time, there were still some things she did that looked so uppity. The way she tapped her foot impatiently, lifted up her chin.

"We've come to ask for help," Enne told her. "It's urgent. He needs care. He's…" She swallowed. "Dying."

The woman's eyes flickered to Levi, and Levi attempted to straighten, attempted not to look so pathetic. But as he took a deep breath, his chest heaved in staggers, and he shuddered from the pain of it.

"I can see that," the woman said, softening.

"It's the same as what happened to Rebecca, isn't it?" Delaney asked, and Levi flinched at the defeated quality to her voice.

"It's not," the woman answered. "A Slyk could have told you as much. Rebecca was a split shade-maker. But orb-making is his blood talent."

"Does that mean you can help him?" Enne asked hopefully.

The woman sighed. "Creighton was the shade-maker who helped craft that curse in the token—at Veil's request. Unfortunately, Creighton is dead."

"You have to be able to do something," Enne pushed.

It should've bothered Levi how Enne and Delaney spoke for him, but it didn't. He was happy not to acknowledge his condition. He'd watched his mother die from sickness. The pneumonia had come on gradually, changing from something dismissible to deadly seemingly overnight, and she'd passed the next day. Levi had always known he couldn't choose the way he died, but a bullet, the gallows, a crash—he would've preferred any of them to this.

The woman pursed her lips. "I can try." Then she walked into the apartment and motioned for them to follow.

The home was an uninviting place, clean but poorly decorated, and lacking in any natural light. The four of them sat down at a kitchen table, and Levi wished that he had a pack of cards—something to keep his hands busy, his mind occupied. Instead he could only fiddle with the buttons of his sleeves.

"How do you feel?" the woman asked, finally speaking to him directly.

"How do you think I feel?" he shot back. Harsh—too harsh. It would be far easier to stay calm if he didn't have to think about dying in the very place where he'd come close to it before. He'd prefer to crawl back to Olde Town and let the place he'd once claimed claim him.

But truthfully, despite his fondness for Olde Town, he didn't want to die in New Reynes.

It was a strange thought—all he'd ever cared about was this city. But there was a world beyond this place. And he'd like to see it. He'd like to see Caroko especially. Orb-makers hadn't been permitted to travel far beyond New Reynes since the Revolution, but he had a feeling Harrison would make an exception for him. Or maybe change the laws entirely.

"Mizers leave traces on volts that they've created," the woman said. "I'm sure you know that."

"Obviously," Levi said flatly. It was why he'd never used to like to make orbs, why his blood and split talents never blended well together.

"Malisons do much the same. I can't remove it—not entirely. But I can drain it. It'll only be temporary, I'm afraid. The curse will grow back."

Enne breathed a sigh of relief, but Levi wasn't ready to relax—not yet. "How temporary?"

"A few days, at most. Then you'd have to come back, and I'll drain it again."

Levi bit his lip. "You're telling me this is forever? That I'll always have this?"

"Shades live in metal, and you let a corrupted shade into your blood. What did you expect would happen?"

Levi hadn't been expecting anything—all he'd thought about was winning, same as all he'd thought about for a long time.

Levi let out an inappropriate burst of laughter, shaking his head. There was a joke in this. He'd always wanted to be the Iron Lord. Well, he'd finally earned that title.

Enne's face darkened at his illogical reaction. She reached out and squeezed his hand. "I'm sorry, Levi. But it's…it's better than—"

"Better than dying?" Levi finished for her. "I wanted to leave. But now I can't ever leave, can I? I can't risk it. I'll always have to stay in New Reynes."

The glimmer of a new dream, of who he might've been, flickered out. He was done with his story—he wanted a new one. But it seemed this story wasn't done with him.

The woman nodded solemnly. "That's how it would appear, yes."

Despite his disappointment, it wasn't an offer Levi could refuse. An hour ago, he didn't think he had a chance to survive at all.

He thrust out his hand. "Just do it," he told her.

"Levi…" Enne started.

"Just *do* it," he repeated again, making Enne wince. He instantly felt sorry. He hadn't meant to snap at her. Especially at her. He wasn't the only one who'd sacrificed something great for ending the game. Enne had lost her blood talent forever.

The process only took a few minutes. Enne and Delaney talked in the sitting room, whispering low enough so that Levi couldn't hear, so that Levi knew they were talking about him. The woman extracted the shade from him much the way he extracted volts. Within moments, the nausea in his stomach settled, and the burning inside him faded.

"You can use my phone, you know," the woman told Levi while she worked.

He furrowed his eyebrows. "For what?"

"For that call you want to make."

He cursed inwardly. He hated the House of Shadows. The people here unnerved him, playing with souls and curses the way he'd play for volts.

Or maybe he was only losing his poker face.

"Fine," he muttered. It wasn't that he needed to make this call now—unlike everything that had happened to them in the past year, the stakes weren't life-or-death.

But the life he'd wanted for himself had been stolen from him. He didn't want to wait to secure himself a new one.

When she finished, he stood up and took the phone. He dialed the number he'd long ago memorized.

"'Lo?" the voice asked on the other end.

"It's me," Levi said.

"Levi, you're…" Harrison stopped himself, and Levi was surprised to detect notes of worry in his voice. Harrison cleared his throat awkwardly. "You're all right, then?"

"I've been better," Levi said dryly. "I'm surprised you're still awake, but I'm not surprised you're home."

"I'm in the middle of a very important meeting. I don't exactly like to do those from my hospital bed," Harrison told him. "But when the operator tells you that you have a call from the House of Shadows, you take it. So this better be important."

"I have a favor to ask you," Levi said smoothly.

"You want something of me? How unlike you."

"I want you to give me a job."

Harrison paused. "The previous Chancellor tried to have me killed. What makes you so certain I even *have* a job?"

"Call it a gambler's hunch," he said, certain Harrison could sense his smirk over the phone.

"I thought you'd rather be caught dead than end up on the South Side."

"Didn't you hear? I nearly did die."

"Careful—people might start calling you a public hero, and not just people on the North Side. That might sully your reputation beyond repair." Harrison paused, and Levi tapped his fingers anxiously against the counter, afraid that for as friendly as they'd become over the past few months, Harrison might actually say no. "Fine. I'll see what I can do."

Levi's shoulders sagged with relief. "Thank you," he said seriously.

"Try not to call me during a meeting again. We're making history here." Harrison hung up.

Levi lowered the phone, feeling only a tiny bit sorry for himself. It would've been nice to travel with Enne, to places where their legends didn't follow. But he would stay here. One day, he would die here. And despite years of working toward the same dream, he wouldn't die a king.

That wasn't his story, after all.

HARVEY

Harvey woke in the golden light of a stained glass window.

He'd hoped to sleep longer—after sunset, at least. But nevertheless, he got up, got dressed, and went to work.

He started with the dishes. Bar glasses and grease-coated fryers had been abandoned in the sink, piling up in the extra day the Catacombs had temporarily closed so that Narinder could finally get some sleep. Harvey washed them and wiped down the counters until the kitchen was immaculate.

He moved to the bar next, replacing the crates of glasses with fresh ones, digging the soggy napkins out from the drain on the tiled floor. It was hard work, gross work, but *honest* work. And it kept his mind quiet, so he didn't have to think about Bryce Balfour, his closest friend in the world, locked in a jail cell and awaiting judgment. Just because he, Enne, and Levi had spared him didn't mean the rest of the world would. But Harvey couldn't let himself remain responsible for Bryce's crimes.

He worked harder. He scrubbed and polished and washed

until these thoughts dissipated. He picked at sauce stains on chair cushions and gum beneath the tables, as if he could clean his mind and soul the way he could clean this church.

But the thoughts never truly disappeared. Not entirely.

With no chores remaining, he grabbed his coat and left.

As evening fell, the Street of the Holy Tombs locked up for the night. The fortune-tellers, the trinket sellers—all shops Harvey recognized from his childhood—closed their doors to the tune of rattling wind chimes. The reverent quiet pleased him. Harvey would always have a complicated relationship with his faith, but it'd given him strength when he'd needed it, and that was at least one thing Harvey could look back on with more than just regret.

Regret, but not shame. He wasn't complicit anymore.

Tropps Street, meanwhile, was coming alive, its neon signs flickering on, its performers taking to the sidewalks. An already drunken crowd wandered through a block of food stalls, and Harvey joined them.

"I don't normally see you here at this hour," Amara told him. "Where's Narinder? Didn't he come here with you?"

"I'm actually grabbing food for the both of us," he answered.

Amara narrowed her eyes. "Tell him I'll retire if he doesn't visit more. That'll teach him to start coming here and keeping me company."

"I'll let him know," Harvey said, amused. A long line waited at Amara's stall—Narinder was clearly not the only one keeping her in business.

Several minutes later, she presented him with two boxes of her noodles and seafood. She wouldn't take his volts, but Harvey discreetly fed them to her meter, anyway.

By the time he returned to the Catacombs, it was sundown, and pleasant music wafted through the macabre hall. He found Narinder sitting at the edge of the stage, a sitar poised below his

arm. He stopped playing the moment Harvey walked through the door.

"Why did you clean this whole place?" Narinder asked him. His voice was slurred as if still half-asleep. "You think that was going to be my first thought this morning when I came down here? 'Oh, there goes Harvey, slacking off again?'"

Harvey walked toward him and cocked an eyebrow. "Have I slacked off before?"

"My point is that you didn't have to do all this."

He shrugged. "I wanted to clear my head."

"I should hire more live-in employees like you. Sad, tortured gangsters who find it therapeutic to wash my dishes." Narinder eyed the boxes in Harvey's hands. "And bring me food."

Harvey handed him his meal and sat beside him on the stage. "About living here… I was actually thinking I could find my own place. Stop infringing on your hospitality."

Narinder stiffened. "You *can* stay here, you know."

"I know," Harvey answered, "but I've never had a place of my own. Next time I have nowhere else to go, I want to have—"

"Next time?" he shot back.

"I *mean*, I'm tired of being a guest."

Narinder's lips were a thin line as he picked at his food, not actually eating it.

Harvey smirked. Maybe Narinder thought this was how he said goodbye. That he cleaned an entire business establishment, brought someone takeout, and then left. Not even Harvey enjoyed cleaning *that* much.

"Maybe *you* could be my guest, for once," Harvey suggested coyly, bumping his shoulder into his.

A smile crept up Narinder's mouth. "I'm not cleaning your floors."

"I was thinking it could be here, on the Street of the Holy Tombs."

"Here? No one wants to live here."

"I like it here."

"It's creepy here."

"It's…sentimental."

Narinder set his food aside and leaned into Harvey's shoulder. "I'm proud of you, of what you did yesterday. I know it wasn't easy."

Harvey didn't want to talk about Bryce, but he knew he should. It was better to talk about what happened than to do what he'd made a habit of—keeping it in his thoughts to haunt him when he should've been resting, when he should've been happy. Harvey might never be truly well. But what mattered was that he was trying. And he deserved better.

"Bryce tied the game to me," Harvey blurted. "I think he really did care about me. And I…"

"People are never as good or as bad as we hold them up to be," Narinder said gently.

"I'm glad I did what I did, but I feel like I betrayed him. Will that feeling ever go away?"

"I don't know," he answered. "But for what it's worth, you made the right decision for *you*." He slipped his hand into Harvey's. "I'm glad I took a risk for you."

Harvey interlaced their fingers. His heart sped up in nervous sputters, and it felt good to wish for something without hating himself for it. A desire not laced with any guilt.

"Do you still want this?" Narinder whispered, moving closer. His fingers tapped against Harvey's thigh, playing his skin like an instrument.

Harvey's breath hitched. This morning, he'd been avoiding these thoughts, too. The moments in the stairwell, when Narinder had been so close to kissing him. He'd replayed them so many times that a flush crept across his cheeks—and he was certain Narinder could tell.

"Yes," Harvey answered, with no guilt, no regret, no tricks.
And so he kissed him, the first prayer in a long time that
didn't beg forgiveness.

LOLA

Lola sat at the dining table in Madame Fausting's Finishing School, aware of the other girls' eyes on her as she dumped out the contents of her briefcase. Papers and files spilled across the surface, some of them hers, some of them Jonas's. Now that Lola had regained her memories, she finally had the full truth she'd been looking for—but it was scattered, some of it in photographs, some in notes, some in her own recollections. It was time to make sense of it all.

She reached for the Scar Lord's file on Bryce Balfour. She'd start there.

"I brought you coffee," said Marcy beside her, her voice tentative and sleepy this late at night. She clutched a mug in one hand and a cat toy in the other.

Lola had forgotten how much she missed living here. The thought made her stomach twist into a knot of guilt. For months, her mind had been so twisted with anger over who'd betrayed her that she had betrayed everyone else.

"Thanks," she said softly, taking the drink.

Marcy studied the mess spread across the table. "What are you working on?"

"A story," Lola answered, turning back to her work.

"About what?"

"About what happened."

It was the story Lola had always intended to write—the one she'd once told Jac she would. But now she wasn't sure she was the best person to tell it. Just because the secrets had untangled didn't mean her emotions had. Enne had tried to kill her brother before Lola ever made her deal with Arabella, but Enne had been desperate. It wasn't until Lola stopped watching from the sidelines, until Lola truly *joined* the story, that she understood what that desperation felt like.

There was no way to make a villain out of Enne without making a villain of herself.

But still, the urge to write burned in her. The City of Sin made legends out of stories, exaggerating details, redefining the players into characters grander and larger than life. And that was how they would all remain, unless someone told the truth. About the Revolution. About the Second Street War. About all of it.

Lola pulled out a chair in front of her typewriter, but a new voice interrupted her.

"What is all this?" Tock asked from the edge of the room.

Lola stiffened. She and Tock hadn't spoken much since sunrise, when they'd returned here and slept until evening. It was hard to look at Tock, remembering the times they'd interacted when Lola had been different. When they'd been strangers. Lola hated to think of how she'd hurt her.

Marcy must've noticed the awkwardness, because she watched them both with wide eyes, made wider by the magnification of her glasses.

"Marcy, could you give us a moment?" Lola asked.

Marcy took her time leaving the room. Once they were left to their privacy, Lola instantly regretted it. She didn't think she could face Tock. She wasn't ready. So she turned away, pretending to focus back on the typewriter.

"Did you know?" Tock asked her. "When you bargained away your memory, did you know what you were doing?"

Tock was direct—Lola had always liked that about her. But now she wished she wouldn't be.

"I didn't," Lola murmured.

Tock's face softened. She put a hand on Lola's shoulder. "Then you—"

"But I should have," Lola said sharply, shrugging her away. "If I'd paused to consider her words, if I'd thought *at all*, then I would've known. And that makes it my fault."

"You don't have to be clever all the time," Tock told her.

Lola snorted bitterly. "Clever would've been not making a deal at all."

Tock didn't respond to that. She grabbed one of the files off the table—Lourdes's file. She flipped through the pages. "So this is what you bargained for?"

"No, I got the files from Jonas," Lola explained, still too ashamed to look at her. "But the notes I added—those I bargained for. I needed to know how the pieces fit."

"Why?" Tock asked.

"Because no one else cared. Because I was the only one paying attention."

The words sounded ridiculous as soon as Lola said them. Paranoid. Were these secrets worth all the heartache? She'd been cruel to so many people—Enne, Levi, her own girlfriend. She'd begun to identify with a monster. And she hated herself for it.

But Lola wouldn't have made the same choices if she'd remembered Tock. If she'd remembered the good in all this.

"Aren't you going to ask me?" Tock spoke. Now Lola finally

dragged her gaze from the typewriter, and she was surprised to see Tock grinning coyly. She remembered that expression all too well. Tock had a smile like a suggestion.

"Ask you wh-what?" she stammered.

"If I forgive you."

Lola frowned. "You shouldn't."

Tock reached forward and pulled Lola toward her by the belt loops of her trousers. "All the best stories have happy endings, you know. You should really keep that in mind when you're writing it. Otherwise, who will want to read it?"

Lola tried very hard not to smile, but she did, anyway. "This isn't that kind of story."

"I'm talking about *our* story," Tock said. When Lola's smile slid away, she added, "I swear, you'd rather I yell at you than flirt with you. You look ready to debate all the reasons why I love you."

"I w-wasn't going to *debate* you," Lola stammered, flushing.

"You're very argumentative."

"No, I'm not."

"And you suffer from a lot of denial." Tock smirked, sliding her hands up around Lola's waist, careful to be gentle with Lola's broken rib. Lola didn't push her away this time. "In case there's anything else you've forgotten."

Lola winced, even if it was a joke. Even if Tock's lips now grazed her cheek, trailing down her jaw. But she still didn't push her away. "That's not funny."

"It's a little funny," Tock said, and Lola could feel her smiling against her skin. "What else didn't you remember?"

Lola flushed. But she'd also given up. She could keep apologizing, and she would. She'd apologize over and over because she would never let herself forget again.

But even hours later, when Lola returned to her typewriter with a lantern and a mug of spiked coffee, Lola knew she still had one person she needed to face.

QUEEN OF VOLTS

Lola wandered around the Irons' museum, pacing through every room that wasn't the cardroom, where Enne now sat, reading the article Lola had given her.

"This place is filthy," Lola muttered to herself, examining the collection of dirty glasses left on the kitchen counters, or the crumbs littering the sofa cushions. She almost didn't want to touch anything. This place had been condemned when Levi first found it, and somehow the Irons had made it even worse.

But hovering here was better than reading over Enne's shoulder. Lola had stayed up all night writing and rewriting the story, and she had every intention of hand delivering it to *The Crimes & The Times* office this afternoon. But it would be remiss for Lola not to let Enne read it first, if Lola had any intention of bridging what had broken between them.

But she still wasn't sure if she did. Lola had never wanted this life, after all. Maybe it was finally time to leave it.

"It's really good," Enne said, making Lola jolt and spin around to where she stood in the doorway. "You're really talented."

"I wasn't asking for feedback on how it *sounded*," Lola told her, exasperated but pleased. "I want to know if you approve of it."

Enne bit her lip. "Well, it wasn't what I expected. You omitted a few things that I did. Levi, Veil, Harrison—"

"I want to do something good with the truth," Lola said. "Not make a weapon out of it." Arabella had put too much responsibility on Lola's shoulders—a burden Lola hadn't wanted or deserved. But Lola *did* want to tell this story, and that came with its own share of responsibility. Its own share of burden. And she was determined to do right by it.

Enne said nothing, only handed the papers back to her.

Lola accepted them warily. "Would you rather I'd portrayed you harsher?"

It would've been easy. Even if Enne hadn't known the truth about her talents until she'd come to New Reynes, no matter how clear Lola made that fact, Enne had adapted quickly to the unsavory nature of this city. Lola had taken care to always refer to her by her name, and not by Séance—the one the city had given her.

Unless that was really the one Enne wanted.

Enne smiled weakly. "You know, you're the only person who never underestimated me, even from the beginning."

"I did initially try to fight you," Lola said, shrugging.

Enne snorted. "That was overestimating yourself."

Then, to Lola's surprise, Enne threw her arms around her.

"Ow! Careful! Rib," Lola grunted.

"Oh, sorry," Enne said, quickly pulled away. "I'm just glad you're back." Lola froze. She'd never claimed to be back. "And I'm so very sorry. For your brother. For your ear. For…everything. Even if we won, there are a lot of things about the story I wish had been different."

Lola's thoughts flickered first to Jac, and her heart gave a painful clench, thinking of what he would've thought of everything that had happened since his death. If he'd learned that Lola had known the Bargainer better than anyone—the sort of legend that would've had him reaching for his Creed—he would've bet volts that she'd been lying.

But she also thought he would've been proud of her. She'd found her place in the story. And written him an impressive ending, the kind he would've wanted.

Arabella's ending, on the other hand, still left Lola conflicted. Even if Lola understood that a tragic past did nothing to negate the wrongs Arabella had done, Lola *had* been her one friend in the world, and she didn't know whether the story of a monster should be told by its friend or by its victim. But really, Lola had been both, and so she'd tried to pen Arabella's

truth, in the most earnest way she could. Arabella would have respected that.

Enne swallowed, obviously nervous. "I was wondering if you'd be interested in working with me. I have...plans in mind—good ones, I think. The Spirits are still at the National Bank, and you and I were always the ones who weren't counters. It was just the two of us, before anyone else."

After everything that had happened between them, Lola had never imagined Enne to make such an offer. And Lola's thoughts suddenly flashed—not to the times that Enne had hurt her—but to when she and Arabella had spoken in the alley. Lola had been one breath away from condemning Enne, and even if she'd ultimately made the right call, the depths to which she'd fallen left a lump of shame in her throat.

"I'm not sure that's a good idea, Enne," she said carefully, trying not to feel guilty by the look of hurt that crossed Enne's face. "But...about the story. Is there anything you'd like me to change?"

Enne shook her head numbly. "No, I think you told the story well."

The Crimes & The Times did, too, when Lola presented it to them. They paid her two hundred volts to publish it—a small fortune, and the first honest voltage that Lola had earned in months. She hardly knew what to do with it. She could buy a thousand copies of the newspaper, just to cover her walls with her name in print.

But as she shared as much with her brother at Madame Fausting's, Justin handed her a fresh orb, sparkling with volts. She furrowed her eyebrows. "Where did you get this?" she asked. Justin had never been the sort for legitimate employment.

"I want you to go to university," he told her seriously. "That's what you always wanted, isn't it?"

"It is..." she said slowly. "But you know that two hundred

and…" She glanced at the orb. "Twelve volts aren't enough to pay tuition."

"What if I brought in eighty volts a week?" he asked.

"I'd still say you're bad at math," she said. "And I'd ask where you were getting the volts."

"I took a job at the Catacombs as a musician. Tock put in a good word for me."

Lola's heart swelled. A job at the Catacombs sounded permanent. Like he wasn't going anywhere. "That's still barely enough to pay rent."

"Why can't we stay here?" he asked.

"Because Marcy would pass out nearly every day if another new boy lived here." Lola smirked. "And because I'm not sure Enne and I…" Just because Enne had liked her story didn't mean they were back to being friends.

"You know, it's not easy to go back to the way things used to be," Justin told her. "But I'm glad I did. And you spent so long looking for me—wasn't Enne the only reason you stopped?"

Lola nodded. Enne had once hurt her, but that was when Enne had been the worst version of herself. And Lola knew what it felt like to be reduced to nothing but anger and fear, and Enne had forgiven her for it. Tock had forgiven her for it. Lola needed to learn how to move past Enne's mistakes, too.

"I'm the one who rejected her offer," Lola murmured. "What would I even say to her?"

"You start with the obvious—that you're sorry."

Enne had apologized, over and over again. Lola was the one who hadn't. Because even when she knew she was wrong, she hated to admit it.

She sighed. Enne wasn't here right now—she had an inauguration to attend. But Justin was right; Lola didn't want to leave this place, her home.

Lola walked into the headmistress's office and found a note-

book resting on the edge of the desk. She opened it, uncapped a pen with her mouth, and scribbled across a blank page.

I'm sorry.

And, in larger letters:

I'm back.

SOPHIA

"Do I have to wear this?" Sophia asked, tugging at the gold filigree medal around her neck. It was heavy and ceremonial, and it looked terrible with her outfit.

"Semper's and Fenice's families wore them," Harrison told her, adjusting his necktie for the twelfth time. They, along with a small militia of secret service officers, Enne, and Levi, were sequestered in a conference room in the Capitol. A makeshift prep room, with stale coffee, baked goods, and stylists who'd fussed for thirty minutes with the knots in Sophia's long black curls. "They're tradition."

"There's only been two Chancellors before you," Sophia muttered. "That's not a tradition. That's coincidence."

Harrison let out an exasperated sigh. "Then don't wear it."

"But the families wear them," Sophia repeated stubbornly.

Harrison gave her a small smile. "They do."

Sophia had thought she'd feel different, once she had her memories back. That maybe, locked in her past, she'd been a

different person. For so long, she'd been driven by what felt like insurmountable goals: to destroy her Family's empire, to regain her memories. And she'd made so many sacrifices—terrible sacrifice—to achieve that.

As it turned out, she hadn't been as different as she'd thought.

She'd been raised with Charles and Delia like a sister—that much had been true. But her uncle had never kept the truth from her. About Leah. About Harrison. Sophia had gladly given that part of herself to the Bargainer. Omertas were despicable talents, and whether or not Vianca Augustine ever knew about the existence of her granddaughter, Sophia had never wanted to know *her.* And Harrison, for as long as she'd ever remembered, had been gone—a character from the North Side's history so mysterious he'd been downgraded to ghost.

But there was another good that had come from Bryce's demise. Once all of Bryce's and the Bargainer's shades had been undone, Sophia had gotten her split talent back.

And omertas couldn't be cast on an Augustine. It was impossible.

That contradiction made Harrison's omerta over her snap. It made *all* his omertas snap. Delaney and Harvey were no more prisoner to them than she was.

"Are you sure this is still a good idea?" Sophia asked. "Some people look at you and see, well…"

"See what?" Harrison asked.

"The Families. A don as Chancellor." She frowned. "And at least before you'd been, well, family-less. But once you tell everyone that I'm your daughter…and I'm a Torren—"

"Then they'll be pretty surprised when my first act is to institute a term limit," he responded.

"And a new currency," Enne said politely from the room's corner.

"And Roy's medal," Levi added.

Harrison cocked an eyebrow. "Are you two even old enough to vote?"

Levi laughed. "Are you old enough to be a dad?"

Harrison snorted, then cringed, placing a hand to his stomach where he'd been shot. One of the service members instantly lunged over to make sure he was all right, and Harrison swatted away the offered crutch.

"The last two Chancellors died within months of each other," Harrison said. "I need to look—"

"Youthful?" Levi suggested.

"Spry?" Sophia added.

He frowned. "Capable."

One of the staff members cleared their throat. "Sir? We're going to need to start soon."

Harrison nodded, then turned to Enne. "Is there anything you'd like to say?"

She smiled faintly. She'd worn a simple gray dress today, one she must've bought for herself to work at the National Bank. A dress that told Sophia that after months attempting to sway New Reynes' hearts, today Enne didn't want to be seen. "Actually, there isn't. If that's all right."

Harrison straightened his tie again. "It's quite all right. I think Miss Sanguick's article said more than enough, don't you?"

"She told the story better than I could've," Enne managed.

Harrison gave himself one last look-over in the mirror. He licked his finger and slicked down a stray hair, and Sophia resisted the urge to tell him not to do that, it made him still look gangster. But then she caught her own reflection—dressed in green, rather than her usual red. Even with the medal adornment, wearing her usual thigh-high boots, her bright lipstick, and with her dice clutched in her hand, she looked no more reformed than he did.

"If only my mother could see me now," Harrison muttered.

"She would hate it," Sophia told him.

He grinned, but then his expression faded into something more serious, something better suited for a politician. He placed his hand on her shoulder. It was very paternal, and though Sophia didn't mind, though she did care about Harrison, it reminded her of how fast her life had changed. Even after losing Jac, she had people around her to support her. Not just Harrison, but Poppy, Delaney, and the others. She could be defined by more than a goal, more than a sacrifice.

"When they offered me this position, I wasn't sure if I should accept," Harrison told her. "A lot of the things they say about me are right. I have been far from good."

"I don't need an explanation," Sophia said. She wasn't perfect, either.

"No, but I've always been especially hopeless with family. And that was where I wanted to start. But I remembered when you told me that my destiny was my responsibility, and I thought of what I could do with this position. And I hope you don't mind that I've started here, instead."

"I'm proud that you started here." She tapped the medal. "Otherwise I wouldn't have worn this thing."

He grinned. "Then let's hurry up. All those people are waiting in the cold." He followed the servicemen down the hallway to the door.

Sophia trailed after him, Enne and Levi beside her. It was hard not to steal glances at Enne as the doors opened, as they walked down the marble steps. A crowd of hundreds—maybe thousands—spread across the lawn, including citizens of New Reynes and politicians from all across the Republic. If things had gone differently, Enne might've watched this same crowd from Liberty Square.

Enne must've been thinking the same thing, because she gave Sophia a weary sort of smile. "This is what lucky looks like."

But Sophia knew a thing or two about luck, or destiny, or

whatever the City of Sin liked to call it. And too many among them had died to call this day lucky.

"No," Sophia murmured. "This is what winning looks like."

ENNE

The Office of Auditory Responsibility in the National Bank had been dissolved, its departmental funds and staff reallocated instead to the most pressing matter of the institution: the creation and implementation of a new currency. The keys of typewriters and calculators clattered. Cats roamed the cubicles, knocking over coffee mugs and scratching the cushions of desk chairs. The Spirits had worked through the night, and the air smelled like it—of sweat masked with perfume, and the remnants of last night's takeout.

Enne knocked on the door to the office next to hers, where Grace hunched over a portfolio of inflation graphs. "I was hoping I could talk to you," Enne said.

"You're here," Grace said flatly. "You're talking."

Enne held her breath as she slid into the chair opposite Grace's desk. A week had passed since Harrison's newest inauguration...and since they'd buried Roy Pritchard. To Grace, however, Enne suspected that time had been a haze. She'd

done nothing but throw herself in her work, and Enne, unsure how to help her, had merely let her. Enne had her own grief and uncertainties to figure out, and she knew both she and her friend needed time.

"You're my person, you know," Enne told her. "You're the one I go to when I need to figure something out."

Grace looked up coolly. She wasn't wearing her usual rings of black eyeliner, and even her most lethal expression lacked its usual edge. "You've brought me a puzzle?"

"I'm leaving this—the Bank and the Spirits," Enne spoke.

"To do what?" Grace asked, eyebrows raised.

"I want to rebuild the Ruins District, the museums, the historical sites. I want the history of the Revolution and the Street Wars to become more than the city's scar." Enne swallowed. "I asked Lola to help me, and she's agreed, after she finishes applying to university. But I'd also like to ask you, if you'd want to join me."

"I don't know anything about history," Grace grunted. "But I know fighting. And math."

"You also hate math."

"I like solving problems."

"What happened to Roy isn't a problem you can solve," said Enne gently.

Grace grimaced, then she swept her arm out—pushing her calculator and portfolios off her desk to the carpet. She stood up. "So I'm broken now, that's it?" she demanded. "I see how everyone tiptoes around me. I'm fine! Roy wasn't supposed to be my problem. I had a plan for myself, and it didn't include any gold medal–winning, honorable whiteboots dying on me before I got there. So it's fine. I can go back as if it never happened. I can—"

"You'd rather pretend that Roy never happened?" Enne asked incredulously. "Roy made you happy."

"Yeah, well, I always knew how to make myself happy. I paid back my debts myself. I'll fix all this myself, too."

Enne didn't want to fight with Grace, but she didn't know how to help her when Grace clearly didn't want help. It disappointed Enne, to be leaving so many friends behind.

But then she saw tears spill down Grace's cheeks, and Grace frowned and furiously rubbed them away. "He was considering leaving the Spirits, after we stopped treating him like a hostage," Grace said, her voice catching. She cursed. "But I changed my plans for him. I convinced him to stay. And now he's dead because of it."

Enne stood and threw her arms around her. Grace stiffened but didn't push her away. "None of this is your fault. And you can keep working at the Bank, if you want to. I won't make you leave."

"I don't *want* to stay here." Though Grace never broke into sobs, her voice wobbled. "But what's the point of having plans if they don't go the way you wanted them to?"

Roy had been Enne's friend, but Enne obviously didn't grieve for him in the same way as Grace. But she did know how it felt to have your future robbed from you. It'd happened to her time and time again, and it'd made her feel helpless. It was why she'd clung so fiercely to whatever story the world gave her—a lady, a street lord, a Mizer. To want and feel fiercely was to make oneself vulnerable.

But Enne knew her story now, and she hoped she could still write it with her friends beside her.

"You're brilliant, Grace," Enne told her. "You're a planner and a problem-solver. You're tenacious. You're an excellent teacher. And you cannot give up." Enne pointed to the horrifying beige walls and gray carpet of the office. "*This* is you giving up."

Someone cleared their throat, and Enne turned to see Charlotte and Marcy hovering by the door.

"You both can't just *leave* us here," Charlotte said, aghast. "Who will run this place without you? Marcy?"

Marcy glared at her from behind her wide-rimmed glasses. "I'd be a great boss."

"Enne, your contract is gone. You can kiss Pup up and down the Brint and no one will care. Please don't make us stay here."

Even Marcy looked downcast. "The Secretary of the Treasury won't let us keep our cats at the office."

Enne beamed—she wouldn't be without her friends, after all. Then she looked to Grace hesitantly. "What do you think? Whatever you're ready for, it's your call."

A small smile played on Grace's lips.

"I think *muck* them. I hate auditing—it's like math with extra rules. Tell everyone to dump the litter and pack their desks. Enne's taking us back to the North Side."

But Grace and Enne didn't return to the North Side—not yet.

"Why are you dressed like that?" Enne asked Levi.

He did a spin as he entered the conference room. "What? I dressed for the meeting. You're wearing pearls."

"I almost always wear pearls," she countered. "You're wearing purple."

"It's mauve," he said. "It's dapper." He grinned widely, and Enne let out an unladylike snort. She personally thought he looked ridiculous—Levi had taken Harrison's old advice to buy new suits so seriously it had become a joke. He was wearing a polka-dot necktie with a matching pocket square, and it didn't make him look smart. It made him look like he was making fun of the whole South Side.

But it was relieving to see him like this. Well. Not just physically, but emotionally. The City of Sin had once been the whole world to him. Now it had to be.

"You look absurd," Grace told him flatly as she reapplied her eyeliner with her compact mirror.

"You're not even looking at me," Levi said, frowning.

"I don't need to."

"Did Harrison approve of your new look?" Enne asked. Today had been Levi's first day as one of the Chancellor's staff, in the illustrious role of intern. Well, the day wasn't quite over. Levi claimed he'd joined this meeting in an official capacity.

He smirked. "Oh, you'll see what Harrison thinks of it."

The door swung open, and Chancellor Augustine entered the room. He scowled as soon as he spotted Levi. "I told you to change. You look like you work at Kipling's Department Store, not the government." Then he sighed and shook Enne's and Grace's hands. "Good to see you again. It's been...busy."

"Thank you for meeting with me," Enne said smoothly.

"I always make time for my friends," Harrison said, then he checked his watch. "But I don't have *much* time. The Senate has a vote in—"

"We'll be fast," Enne assured him, and she took a deep breath, ready to begin her rehearsed speech. "It's just that I recently started looking into who owns the land of the Ruins District, which is when I found out that the city does. And I was wondering if you'd let me help to develop that land—to restore all of the historic sites in the North Side, whether from the Revolution or otherwise. The National Bank isn't the right place for me. This is a better legacy for me."

The speech must not have done the trick, because Harrison heaved another sigh. "The city will take a lot of convincing to develop such historic land."

"It's not historic," Enne countered. "It's abandoned. Looted. Nearly everything that would've been salvageable for renovation has been destroyed over the years."

Levi elbowed her sharply in the side, and Enne plastered on a smile. "I mean," she started, "it *does* have history, but that

isn't what I'm interested in preserving. It's disrespectful to let it remain in such shambles, to all the people who died there, revolutionaries or otherwise."

Levi elbowed her a second time, and she shot him an annoyed look. Until she realized that he was smiling. He only meant that she'd spoken well. She shot him a proud smile.

"It's out of the question," Harrison said flatly.

Enne stiffened. "What?"

"I've already been pushing the limits as it is with all the reforms I've instituted in my first week of office, and I have no desire to force you into the type of suffocating contract Fenice offered you. But I have the Senate to answer to, and I simply cannot succeed in spearheading the idea of a Mizer having such a pivotal role in shaping the way New Reynes treats its history."

"Who *better* than me?" Enne demanded.

"Even if you have people swooning over your romance once again," Harrison told her, "just as many are still wary of your reputation. I'm sorry—I believe in you, and I know how much this means to you. But even in this position, there's only so much I can do."

Enne slumped into her seat. "Without the city's money, it's impossible." Just another story for herself stolen away from her.

"You know," Grace said slowly, "there are lots of ways of getting money. You see this new currency some thickhead came up with? Paper! Ha! It's like they're asking for some North Sider to counterfeit it."

Enne's eyes widened, shocked at Grace suggesting something criminal in front of Harrison. But a smile played at Harrison's lips. He stood up.

"I think I best be going. You're no doubt planning a nightmare for my administration, and I can't go incriminating myself so early in my term."

Before he exited, Enne swore she saw Harrison wink.

"Can we actually do this?" Enne asked Grace.

"This is the City of Sin. We can do whatever we want," she answered.

Though Enne knew she could've fit in wherever she wanted in New Reynes—the North or the South Sides—she *had* always made a far better gangster than she had a lady. And revitalizing the Ruins District felt…right. If the world would never see Enne as anything other than a criminal, then Enne was not opposed to criminal measures.

"Careful, this could really sully my new reputation, having a gangster for a girlfriend," Levi said, smirking. "But I think I know a few Irons who might be interested in new employment."

"And the gangs have all been dissolved," Grace pointed out. "It's like the North Side is *asking* for someone to take advantage of it. It might as well be us, really."

Enne's heart sped up. Barely three weeks ago, she'd convinced the City of Sin that she was nothing more than a lovestruck teenager. Before that, she'd been one of its most notorious street lords in almost two decades. And before that, just a girl, lost, naïve, in way over her head.

But the City of Sin wasn't finished with her yet.

"Do you have a deck of cards?" Enne asked Levi. "Or a coin? Something to—"

"Of course I do. Who do you think I am?" Levi asked. He reached into his pants pocket and pulled out a deck of classic playing cards, and Enne slid them out of the packaging. "What are you doing?"

"A black card means doing this is too dangerous, because it is—we know it is. And I'll find some other way to fix the Ruins District. I'll keep playing the good girl until the world really sees me that way."

Grace snorted. "That's a game you'll be playing for a long time."

"A red card," Enne continued, "means we play it as Sinners."

Enne glanced at the card, careful to keep the suit hidden from Levi and Grace beside her, to mold her face into the neutral countenance that suited any lady or gangster. Because the point of this gimmick wasn't to let the powers of fate make Enne's decisions for her—it was to remind herself of the greatest lesson of New Reynes.

It didn't matter what cards you were dealt.

The City of Sin was a game, and the only way to win was to stack the cards in your favor.

★ ★ ★ ★ ★

ACKNOWLEDGMENTS

As a writer, it's hard to know where one story is going to take you.

The offer to publish *Ace of Shades* came as a surprise. Two years had passed since it had failed its submission journey and had been mournfully, permanently shelved, and even more time had lapsed since its original conception—time during which I'd aged from adolescent to adult. And so accompanying my bewildered excitement was a tremendous fear: because I had changed so much—both as a writer and a person—since first journeying into the City of Sin, was it possible for me to publish a story that both my seventeen-year-old and my adult selves would be proud of?

Thanks to the help of many incredible people, I am pleased to say that I did.

To Christine Lynn Herman, thank you for everything. I could list that everything, but this is my fourth acknowledgments, and I'm running out of clever ways to say that I have no idea how I'd do this author thing without you.

To my team at Inkyard, including Bess Brasswell, who guided this book from incorrigible draft to finished novel; Rebecca Kuss, who reminded me why I love this story so dearly; Cam Sato, without whom Enne would never have found her way; Lauren Smulski, a marvelous cheerleader and without whom none of these books would exist. To my marketing and publicity teams, including Laura Gianino, Brittany Mitchell, and Linette Kim. To Kathleen Oudit, cover designer extraordinaire. And to Tashya Wilson, Connolly Bottum, Kristin Errico, and Allison Draper. Thank you all for giving this book an extraordinary home.

To my agent, Whitney Ross, who has been a fantastic source of support and who ensured that this book reached its finish line, you have my eternal gratitude.

To Writers Block Party, thank you for being the best cult and writer gang I could ask for. Hugs to Akshaya Raman, Katy Rose Pool, and Meg Kohlmann for reading this book at its fraughtest stages, and to Kat Cho, Mara Fitzgerald, Erin Bay, Axie Oh, Tara Sim, Amanda Haas, Maddy Colis, Melody Simpson, Claribel A. Ortega, Alexis Castellanos, Janella Angeles, and Ashley Burdin, thank you for the anti-salt love, #thepub chats, and the trees.

Thank you to my loved ones for their support, not just of this series, but of all my writing endeavors. Special thanks to Ben and Zoe who have patiently listened to me ramble about Enne and Levi since the day we met. And thanks to Jelly Bean—I'm unsure I would've made it through my deadlines without his snuggles.

Lastly and most importantly, thank you to the readers who stuck with Enne and Levi in the City of Sin for three long books. Your support for this very queer story has meant everything to me, and I hope we can set out on many new adventures together. I apologize for any broken hearts. I promise I cried over those scenes, too.